3ds max 7 Fundamentals and Beyond Courseware Manual

uncommonsource.com

Desktop extender -

12810-010000-1710-A
November 2004

3ds max 7 Fundamentals and Beyond Courseware Manual

discreet®

ELSEVIER

AMSTERDAM • BOSTON • HEIDELBERG • LONDON
NEW YORK • OXFORD • PARIS • SAN DIEGO
SAN FRANCISCO • SINGAPORE • SYDNEY • TOKYO

Focal Press is an imprint of Elsevier

Focal Press

Acquisition Editor: *Elinor Actipis*
Project Manager: *Brandy Lilly*
Editorial Assistant: *Cara Anderson*
Marketing Manager: *Christine Degon*
Cover Design: *discreet*
Interior Design: *discreet*

Focal Press is an imprint of Elsevier
30 Corporate Drive, Suite 400, Burlington, MA 01803, USA
Linacre House, Jordan Hill, Oxford OX2 8DP, UK

Library of Congress Cataloging-in-Publication Data
Application submitted

British Library Cataloguing-in-Publication Data
A catalogue record for this book is available from the British Library.

ISBN: 0-240-80739-1

For information on all Focal Press publications
visit our website at www.books.elsevier.com

05 06 07 08 09 10 10 9 8 7 6 5 4 3 2 1

Printed in the United States of America

Contributors

Courseware Manager:

Roger Cusson

Project Lead & Lead Author:

Pia Maffei

Contributing Authors:

Pia Maffei

Al Howe

James Bartlett

Jim Robb

Amer Yassine

Steve Schain

Michele Bousquet

Technical Editor:

Lynn Hannough

Print Production:

Maureen Bergamini

Contents

Contributors . iii

Installation . ix
Copying the Exercise Files from the CD ix

Introduction . xi

1 **Introduction to Computer Graphics,**
 3D Animation, and 3ds max **1**
 Objectives . **1**
 Digital Content . 1
 3D Computer Animation—
 How Does it Work? 8
 What Does 3ds max Do? 8
 Industry Workflow . 13
 Speaking 3ds max . 14

2 **User Interface** **17**
 Objectives . **17**
 Introduction . 17
 User Interface . 17
 Viewport Size and Layout 22
 Menu Bar . 28
 Toolbars . 35
 Command Panels . 39
 Dialogs . 43
 Quad Menu . 43
 Transform Type-In Dialogs 45
 Status Bar and Prompt Line 46
 Toggles . 46
 Animation Mode . 47

Time Controls . 47
Flyouts . 47
Viewport Navigation Controls 48
CUI Switcher . 49
Conclusion . 50

3 **Working with Files and Objects** **51**
 Objectives . **51**
 Introduction . 51
 File Link Manager . 57
 Creating and Modifying Objects 59
 AutoGrid . 62
 Modifier Stack Display 72
 Object Selection . 79
 Selection Sets, Groups and Layers 81
 Conclusion . 91

4 **Transforming Objects** **93**
 Objectives . **93**
 Introduction . 93
 Transforms . 93
 Cloning Objects . 101
 Object Snaps . 105
 Coordinate Systems 109
 Additional Transformation Methods 114
 Conclusion . 119

5 Overview Lab. 121
 Objectives. 121
 Introduction . 121
 Creating the Clown 130
 Animating the Scene 135
 Conclusion . 141

6 Fundamental Animation Techniques
 and Track View 143
 Objectives. 143
 Introduction . 143
 Keyframe Animation. 144
 Set Key Filters . 149
 Editing Keyframes. 149
 Using Track View 153
 Dope Sheet vs. Curve Editor 162
 Tangent Types . 162
 Euler Rotation Controller 168
 Pivots Points. 170
 Object Linking . 172
 Creating a Forward Kinematic Animation. . 174
 Delete Selected Animation 175
 Conclusion . 176

7 Camera Animation Techniques. . . 177
 Objectives. 177
 Introduction . 177
 Cameras . 177
 Adjusting Cameras 178
 The Path Constraint. 186
 Assigning a Path Constraint. 188
 Pausing Motion Along a Path 190
 Rendering Animations 195
 Conclusion . 200

8 Inverse Kinematics 201
 Objectives . 201
 Introduction . 201
 Understanding IK 201
 IK vs. FK . 202
 Making an IK Chain. 205
 Conclusion . 207

9 Animation Lab. 209
 Objectives . 209
 Introduction . 209
 Simple Animation 209
 Animating Modifiers 212
 Creating Hierarchies 218
 Animating Elements 219
 Animation Helpers 222
 Animation Control. 225
 Animating with IK. 226
 Conclusion . 230

10 Shapes . 231
 Objectives . 231
 Introduction . 231
 Shape Terminology 231
 Creating Spline Shapes 235
 Editing Shapes . 244
 The Edit Spline Modifier 246
 Shape Modifiers . 262
 Conclusion . 272

11 More Objects and Modifiers 273
 Objectives . 273
 Introduction . 273
 Modifier Concepts 273
 The Modifier Stack Display 274
 Some Example Modifiers 277
 Symmetry Modifier 283
 Compound Objects 285
 Lofts . 293
 Editing Lofts . 294
 Connect . 299
 Patch Modeling . 302
 Modeling a Vase. 311
 Conclusion . 313

12 Low Poly Modeling 315
 Objectives . 315
 Introduction . 315
 Objects and Sub Objects 317
 Basics of Low-Poly Modeling. 326
 Conclusion . 353

13 **Environment and
 Low-Poly Creation Lab** **355**
 Objectives . **355**
 Introduction . 355
 Creating the Knight Scene 355
 Edit Poly Enhancements 372
 Conclusion . 377

14 **Introduction to Materials** **379**
 Objectives . **379**
 Introduction . 379
 Material Editor Basics 379
 Customizing the Material Editor 385
 Basic Material Parameters 393
 The Standard Material 394
 Conclusion . 413

15 **More Materials** **415**
 Objectives . **415**
 Introduction . 415
 Materials . 415
 Bitmaps and Procedural maps 416
 Map Channels . 418
 Creating Materials 425
 UVW Mapping . 442
 Conclusion . 449

16 **Mapping for Real Time** **451**
 Objectives . **451**
 Introduction . 451
 Unwrap UVWs . 451
 Render to Texture 470
 Normal Map Creation Tools 478
 Conclusion . 484

17 **Materials Lab** **485**
 Objectives . **485**
 Introduction . 485
 Conclusion . 511

18 **Basic Lighting** **513**
 Objectives . **513**
 Introduction . 513
 The Properties of Light 515
 Free, Target, and Area Lights 517
 Light Parameters . 519
 Basic Lighting Concepts 539
 Conclusion . 548

19 **Basics of Global Illumination** **549**
 Objectives . **549**
 Introduction . 549
 Light Tracer . 550
 Radiosity . 551
 mental ray . 552
 Shadows . 575
 Conclusion . 581

20 **Rendering with Global Illumination 583**
 Objectives . **583**
 Introduction . 583
 Light Tracer . 583
 Radiosity . 588
 Exposure Controls 600
 Advanced Lighting Override Material 606
 Architectural Material with Radiosity 609
 Conclusion . 610

21 **Cameras & Rendering** **611**
 Objectives . **611**
 Introduction . 611
 Camera Basics . 612
 Creating Cameras 616
 Rendering . 630
 The Render Scene Dialog 632
 Using mental ray ® 653
 Conclusion . 660

22 Scene Assembly **661**
 Objectives . **661**
 Introduction . 661
 Adding Scene Elements 662
 Creating Materials 664
 Creating Effective Lighting 671
 Radiosity Rendered Animation 677
 Rendering Options and Output 680
 Light Tracer Rendering 682
 Rendering with mental ray 683
 Saving Objects to a New Scene 685
 Conclusion . 686

23 Scripting . **687**
 Objectives . **687**
 Introduction . 687
 MAXScript Listener 688
 Syntax & Organization 690
 Sample Script . 691
 Common Script Commands 692
 sScript Writing . 698
 Conclusion . 700

24 Dynamics . **701**
 Objectives . **701**
 Introduction . 701
 Using Reactor . 701
 Reactor Tools . 704
 Update MAX . 712
 Conclusion . 714

25 Effects . **715**
 Objectives . **715**
 Introduction . 715
 Basic Particles . 716
 Exploding Objects 723
 Particle Flow . 729
 Flows, Operators, and Tests 731
 Space Warps, Forces, and Deflectors 738
 Making a Particle Effect 741
 Conclusion . 750

26 Full Day Lab **751**
 Objectives . **751**
 Introduction . 751
 How to Proceed . 752
 Conclusion . 760

3ds max glossary **761**

install
Installation

Copying the Exercise Files from the CD

On the accompanying CD, there are files that you need for the exercises. You can open and use some files directly from the CD, or you can copy them to a local or network drive.

Copying the Exercise Files to a Local Drive

On the CD, the files for each chapter are located in directories named for each chapter (*\ch01*, *\ch02*, *\ch03*...).

Create a folder on any Drive called courseware. Create a folder under courseware called **Max7_fund**. (ex. *C:\Courseware\Max6_fund*). If you have space on your drive, you may elect to copy all the contents of the CD to *\Courseware\Max7_fund*.

Assigning Map Paths in 3ds max

After you have copied the chapter exercise files, you need to create a bitmap map path so that **3ds max** can find the necessary bitmap files when displaying and rendering the chapter scene files. On the CD, these files are in *\Maps*, a folder you may have already copied to your hard drive in the previous step (*C:\Courseware\Max7_fund\Maps*). Follow the next set of instructions to create the bitmap map path.

To create a bitmap map path

1. Start **3ds max**. From the Customize menu, choose Configure Paths.

 The Configure Paths dialog is displayed.

2. In the Configure Paths dialog, select the External Files tab.

3. In the External Files panel, click Add.

4. Navigate to the directory where you have copied your maps, in this case, *C:\courseware\Max7_fund\maps*. (If the maps are still on the CD, then point to X:\maps where X is your CD drive letter).

5. Click Use Path.

6. Find the bitmap path you just configured and make sure it is selected.

7. Click on the Move Up button until the path is at the top of the Configure Paths list.

8. Click the Ok button to exit the Configure Paths dialog.

Introduction

Welcome to the **3ds max**® 7 Fundamentals Courseware. If you are new to **3ds max** you find that this book has been written with you in mind. The material contained within this volume takes you from a raw beginner to a seasoned professional using **3ds max** confidently in a production environment.

This courseware manual was designed primarily for use in an instructor-led classroom, while providing complete instructions so that individuals can also use the material to learn on their own. Since a variety of instructors in a multitude of learning environments use this material, flexibility was built into its design. The manual comprises six modules: Overview, Animation, Modeling, Material, Scene Creation and Rendering, and Full Day Scenario. The Overview module should be completed first and the Full Day Scenario last, but you can complete the remaining modules in any order.

Each module has a series of theory chapters and a lab chapter. The theory chapters introduce you to new functional areas of **3ds max** and explain these features with short simple examples. The lab chapter shows you a practical application of the theory learned in a particular module. Combined, a module gives you a sound understanding of the functions, features and principles behind **3ds max**, and show you how to apply this knowledge to real-world situations.

The book begins with the Overview module and you should complete it before any other modules. It contains a functional overview of the essential tools and principles of **3ds max**. The module starts with an introduction to 3D animation and how to use **3ds max**. Next, the User Interface is discussed in detail, along with UI customization. The third chapter in this module discusses working with files, as well as creating and modifying objects. The last theory chapter in this module covers the use of various transformation tools. A lab chapter that demonstrates how to create a Jack-in-the-Box rounds out the first module.

The Animation module appears next in the courseware manual. You and your instructor decide whether to cover this module immediately after the Overview module. The Animation module contains two theory

chapters that cover basic animation creation, Track View, and Controllers. The lab chapter completes the module with an expressive animation of a toy train.

The third module in the courseware manual deals with Modeling. This module contains three theory chapters that deal with modeling in detail. Topics include: creating and modifying Shapes, more information on Objects and Modifiers, and techniques for low polygon modeling. The lab chapter illustrates the creation of a low polygon knight-in-armor character.

The Material module covers the Material Editor and the creation of simple and moderately complex materials. The first theory chapter takes you through the use of the Material Editor's UI, and how to create, manipulate, save and retrieve materials. The second chapter covers more complex mapped materials by explaining **3ds max's** map channels, map types and mapping coordinates. The lab chapter illustrates how to apply materials to an amusement park scene.

The Scene Creation and Rendering module discusses the use of Lights, Cameras and Rendering. The first chapter explains simple computer graphics lighting. The second and third chapters explains advanced lighting systems now available in **3ds max 7**. The fourth chapter illustrates the use of cameras in **3ds max** and how to render your scenes to still and animated files. The module closes with a lab in which you create and illuminate a cave scene.

The last module, called the Full Day Scenario, is a short single chapter module that you should complete last. This module gives you two suggestions for an animation project that you can reasonably expect to accomplish in a single day. It is recommended as part of an instructor-led class to allow students to create an animation of their own. Often students have their own ideas about what they would like to do in a project. This scenario provides students with two ideas for an animation as well as source files to work with. Students can modify the storyboards of these scenarios to their liking or do something completely of their choice.

Once you complete this courseware manual you are ready for the world of 3D animation with your newfound knowledge of **3ds max.** Congratulations, and have fun animating.

Introduction to Computer Graphics, 3D Animation, and 3ds max

Objectives

After completing this chapter, you are be able to:

- Recognize the industries that complement 3D animation.
- Understand how 3D animation works.
- Understand the applications for **3ds max 7.**
- Appreciate the various industry workflows.
- Understand the terminology used in the software and in the manuals.

Welcome to the **3ds max 7** fundamentals and beyond courseware. This material is designed to help you learn to use the software efficiently and creatively, whether you're new to 3D animation or already know a bit about the field.

This material has been organized for use in instructor-led classroom training. However, many new users find it excellent for self-paced learning, or for gaining practice with a particular tool.

This courseware adheres to the Discreet Animation Standards that were released for Fundamentals and Intermediate in August of 2004. To learn more about the Discreet Animation Standards, please visit www.discreet.com/training and click Discreet Certified Training Program.

If you're new to 3D computer art, this chapter helps orient you to the field in general. Experienced 3D users benefit from reviewing the *Industry Workflow* section and reading the section titled *Speaking 3ds max* to uncover terms and concepts that might have different names in other software packages.

Digital Content

Although it's certainly advantageous to know a particular software package very well, you must also have a grasp of the bigger picture. Learning to use **3ds max 7**, or any 3D software, can be likened to learning to drive a car. Even though you might be able to operate the pedals and steering wheel perfectly, and drive with good form, you can't get anywhere if you can't interpret road

signs, read a map or follow directions. 3D software is usually just one piece of a larger puzzle, fitting with the others to produce a finished whole.

2D vs. 3D Imaging

As a child, you might have had the experience of watching television and thinking that the people on the screen were actually inside the box, performing live. However, one day you realized that the picture stays the same regardless of your viewing angle. A person blocking another person in the scene continued to block them even if you moved to the side to get a better look.

This misconception perfectly describes the difference between 2D and 3D. A 2D image or animation looks the same whether you view it from the left or right or even upside-down. A 3D image changes when viewed from different angles. The world you see around you is in 3D, while anything you watch on television, at the movies or on your computer screen is in 2D.

When working with 3D software, you can change the angle and view the scene from any direction. You can even animate a virtual camera to fly through the scene. The test is, can you change your viewing angle to change what you see? If yes, then it's 3D; if not, then it's 2D.

When a 3D scene and animation has been completely set up the way the animator wants it, the animation is rendered. This process generates one or more 2D images representing the 3D setup. The animation you see on television, in films, and in AVI or MOV files played on your computer screen are all 2D images and animation. However, during the creation process they might have been 3D scenes.

The terms 2D and 3D are used frequently in the field of computer imaging, and they can sometimes be confusing. For example, before going to see the animated film *Toy Story* you probably heard that it was done entirely in 3D. From this statement, you might have expected to put on red/blue glasses to see the film in 3D. A film made in 3D used to be filmed with a special camera, and could be watched through red/blue glasses for a full 3D effect. This technique is known as stereoscopic imaging. In the last ten years, however, the expression "done in 3D" has come to mean a film created on the computer with 3D software, such as **3ds max 7**.

While 3D software creates a scene in which you can change your viewing angle, 2D software still plays an important role in computer imaging. 2D imaging packages, such as Adobe PhotoShop, are necessary for painting backgrounds or creating textures (paint or wallpaper) for your 3D objects. 2D software packages also play an important role in special effects. Special effects can be done in either 2D or 3D. The decision to use 2D or 3D software packages depends on the artist and on the desired effect.

Effects Software

The term **special effects** is used to describe the addition of explosions, smoke, fire, water, laser fire and other extreme phenomena depicted in films. In the past, most of these types of special effects were created with explosives during the film-making process.

For example, the burning of Atlanta, in the film *Gone with the Wind*, was simulated by torching several obsolete movie sets, under the close supervision of fire control experts.

Currently, many of these difficult or dangerous effects are created on a computer with specialized software, such as **3ds max**. Gaseous effects can be created with particle systems in **3ds max**. A particle system is a group of specks, or particles, that can be made to behave in a particular manner. Particles can be likened to confetti. You can make the group of particles swirl, blow in one direction or another, or dissipate on command. Particles can be changed in size and given materials that make them look like smoke, fire, dust, or any number of other substances. **3ds max** can also produce various other effects such as glows, motion blur, and lens flares. The effects created within **3ds max** are designed to complement the 3D scene they are placed in.

Most of the time, however, many software packages are utilized to make special effects. Some of these software packages come in the form of a plug-in. A plug-in is a software package that is added on to **3ds max** giving it a specific function in addition to **3ds max**'s existing features. Plug-ins take advantage of **3ds max**'s robust toolset, and give additional functionality including fire, glows and smoke effects. Because these effects work in 3D space, they are rendered more slowly than those created in 2D effects software.

If you want to make a scene comprised mostly or entirely of effects, or if the effects aren't dependent on 3D objects, consider using a software designed specifically for effects processing, such as Adobe After Effects or Discreet's **combustion**. Here, the

effects would be applied to the 2D images that result from the rendering of the 3D scene. **combustion** is a specialized stand-alone software package, which provides a complete solution for making film quality composites and special effects.

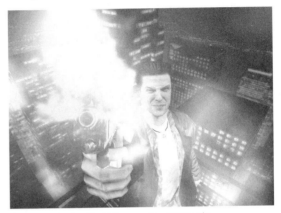

*Scene created in **3ds max** by Remedy Entertainment*

Working with All of the Components

In order to use all of these software packages together, and to obtain the desired results, you must first understand the requirements of each software package. For instance, if you decide that you need to take pictures of a variety of textures in the real world to be used in your 3D environment, then you probably need to use a 2D paint package. In the 2D paint package, you can manipulate or enhance the image based on the tools available in the package. This process is called image processing. Adobe PhotoShop is a popular 2D paint package in which you can increase contrast, paint out unwanted shadows or elements, tint the image, and perform other tasks on the pictures.

Once you have decided on the enhancements you have made to the image, you can use this image as a background, or as a texture in your 3D environment. In the 2D paint package, you need to ensure that the software saves "bitmap" images so that **3ds max** can use the file. **In 3ds max, the word "bitmap" is a catchall term representing a large group of image formats.** This image should be saved with any one of the following file extensions: AVI, MOV, TGA, BMP, RPF, RLA, JPG, TIF, PNG, YUV, CIN, FLC, PSD, IPP, GIF, IFL, and RGB. Once the file is saved, then you can use it to help create materials for your 3D environment.

If you decide to use a stand-alone package such as Discreet's **combustion** to do special effects then you have a distinct advantage when using **3ds max 7** and **combustion**. These two software packages "talk" to each other with a specific file extension called RPF, which stands for Rich Pixel Format. **3ds max** allows you to save to this file extension and **combustion** reads this file format. This file format allows **3ds max** to render, and lets **combustion** read important channels such as Z-buffer, Material Effects, Color, Object and UV Coordinates. These are important channels to read because **combustion** allows you to make a composite of images that appear to have been rendered with the original file. If you decide to change an objects material, you can do it with one simple change in **combustion** rather than having to re-render all of the frames in **3ds max**. These two software packages can save you a lot of time when it comes to rendering and making composites.

Compositing

Compositing is the art of placing one image over another to create the illusion that both elements are really present at the same time. We see this art form every day in televised weather reports, where the presenter appears to be standing in front of a large map. In reality, the screen behind the presenter is colored a uniform blue or green, and software or video equipment is used to replace all the blue or green areas with a particular map. The presenter watches a monitor to see his or her position with relation to the map, and thus is able to point out specific areas during the presentation.

A weather report is compositing in its simplest form. The actor stands in front of a colored screen, the color being one that's not likely to be found in human flesh or clothing, such as a very bright blue or green. All the blue or green pixels in the image are replaced with some other image, whether it's a beach background or an alien spaceship. This technique, called blue screen, green screen or chromakey, is quite easy to achieve with minimal software and hardware.

Compositing is not just limited to this simple process -- it can be used to create extremely complex scenes and compositions. Perhaps the most famous example of complex compositing is the series of scenes in the film Forrest Gump where the lead character appears to meet various US presidents from yesteryear. To create this illusion, the filmmakers carefully filmed Tom Hanks standing in a position that matched one of the actual bystanders in the original presidential footage. After much work, the film of Tom Hanks was made to match the coloring and

scratchiness of the older footage, and the original character was replaced with the actor. Unless you look closely, you can't tell that it's all an illusion.

Complex compositing is one of the most difficult aspects of digital imaging to master. The elements being composited must match up perfectly, and much work is often needed to make everything work together. Discreet's **combustion** is a perfect solution for both simple and complex compositing projects.

Images courtesy of Amer Yassine (www.virtex.com)

Non-Linear Editing

After all the elements, such as video, animation and music have been created, the project must be edited into its final form. Editing means putting the image sequences in order with appropriate transitions, and adding music, titles, sound effects and any other elements needed to complete the project.

In years past, a video project had to be assembled in sequence from beginning to end. Once it had been put together, it was difficult to change the length of a segment or to insert something new. Film editing was more flexible, but changes were still time-consuming and unwieldy.

Currently, there is non-linear editing software, which has made editing much easier and more efficient. Each image sequence (film, video, and animation) is assembled onto a timeline, and placed at the time it should appear. At any point in the editing process the project can be viewed, and elements can be inserted simply by moving the existing elements forward in time to make way for the new. This means an editor or client can view the work in progress, and make changes quickly and easily.

When the project is complete, it can be output to video, film, or a motion file format such as AVI.

In order to use non-linear editing software with live film or video, the image sequence must first be digitized. Digitizing means converting film or video to digital images that can be read by the computer. The special hardware required for this process varies from one software package to another. A 3D

animated sequence with editing software requires that the scene must first be rendered to a file format supported by the non-linear editing system. Live video and animated elements can easily be combined with editing software.

Suppose, for example, you want to create a scene with an enormous spaceship landing in sand, similar to a scene in the film Men in Black. You would first videotape or film a scale model of the spaceship landing in real sand. Next, you'd digitize the footage. You can then use the footage for reference, while creating particle systems in **3ds max** to make even more flying sand, which is rendered out as its own sequence of frames. The two elements: live footage and rendered sand images, are then put together in a non-linear editing program, along with sound effects and any other necessary elements. The final product is then output to a specific file format, and the editing hardware is used to record the sequence to video or film.

Examples of non-linear software are Adobe Premiere, In Sync Speed Razor, Media 100, and the Avid system for the Macintosh.

Workflow

Large 3D animation projects follow a specific workflow. Even small projects involving just one or two artists benefit from following some or all of the steps used by large production facilities.

Preproduction

Before work begins on a project, the team gathers to go over the story and toss ideas around. As the story takes shape, a storyboard is created showing a pictorial representation of each scene. This storyboard is used as a springboard for discussion in story meetings, and when completed, as the main reference for animators.

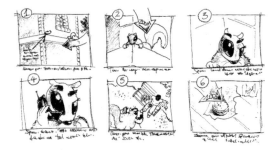

At this point, artists begin to design the characters and work out the backgrounds for each scene. The preproduction team also makes decisions that pertain to the project as a whole, such as which software/hardware to use for which portions of the project, when and how backups should be made, file naming conventions, budgets and artist scheduling and assignments.

In planning, the preproduction team works backwards from the final product. If the final product is a video, for example, first they determine which hardware and software is used to record the edited project to video. The equipment selected work with a specific resolution and, most likely, a range of file formats. The preproduction team must then choose animation hardware and software that can render images accepted by the editing system. They must also make sure the artists can use the software to produce the animation called for in the storyboard. It's not uncommon for the planning team to ask for specific storyboard sequences to be changed when they would be difficult or

impossible to animate with the selected software, or where a similar, more easily animated scene, would get the point across just as well.

Production

The production phase is the place where the actual work is done. In a large 3D project, some artists might do modeling only, while others apply materials, light scenes, or animate the camera or objects.

Artists work from sketches, physical models, photographs, or other reference materials. 3D work is always more productive when artists can focus on the tools and the scene, rather than having to imagine what they're supposed to produce.

While work is in progress, the animation is rendered and viewed frequently for critiques. It's not unusual for a project to be rendered 20 or 30 times before it is considered complete and satisfactory.

Rendering

The final rendering is the last part of the production process, but planning for this step starts in the preproduction phase and continues through production. Several factors must be taken into account when preparing to render a 3D scene or animation:

Frame Rate—Accurate previews depend on the correct frame rate being set within the software. Video plays at 30 fps (frames per second) with NTSC format, the format used in the USA and Canada. European and Asian countries usually use PAL format, which plays at 25 fps. Film usually plays at 24fps, while web content can play at 12 fps or lower.

Speed of Rendering—A bold, innovative effect might look fantastic in production tests, but if it takes too long to render, a faster solution must be found. For example, a rendering time of 10 minutes per frame seems insignificant when rendering a handful of frames, but for a 1-minute animation playing at 30 fps (1800 frames), this adds up to 300 hours, or 12.5 days. Having **3ds max** render across a network of computers can reduce this time. Even so, the available resources must be evaluated to find out how much total rendering time is feasible for the project.

Output Resolution—For high-resolution film output, every detail would be visible on the big screen. In scenes that are eventually rendered to low resolutions (as for web content), fine detail is lost, and might even muddy the scene. Rendering for print requires a calculation of dots per inch (dpi) times the print area. For example, if the image is printed at 300 dpi in an 8"x 6" area, the image must be rendered with a resolution at least 2400 x 1800 in order to print clearly.

File Format—The file format is dependent on the final destination of the project and the hardware used to get it there. Film and video output hardware usually specifies a preferred file format and resolution. For web design, the file format depends on the players available to the viewing public.

Post production

Once the elements are complete, the final project is edited as part of the postproduction process. Compositing is also part of postproduction.

For live film or video projects, special effects are considered part of postproduction. 3D elements, sparks, glows, particle systems, explosions and other effects are combined with the live footage, using effects software such as **combustion**.

In a 3D project, special effects can be part of production or postproduction. If the effect interacts with the 3D elements, as with a particle system flying around a 3D object, the effect is created in production as part of the 3D scene. If the effects are to be laid on top of the 3D scene, or if they need further work (such as punching up the color of a glow for a stronger effect), the effects can be part of the postproduction phase.

When the project has been edited, it is output in its final form, to film, video, print, or to a motion file format.

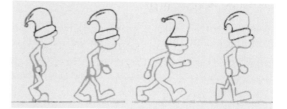

The process of drawing key frames and in betweens by hand is very labor-intensive. In addition, the artists are unable to see how the drawings all work together until they are filmed and projected.

With computer animation, a similar approach is used. You set the character's pose at important frames, and the software creates the in-betweens for you. In addition, you can play back the animation immediately after setting keyframes, to see how it's shaping up.

3D Computer Animation— How Does it Work?

Many aspects of 3D computer animation have been taken from traditional animation. One of the most important concepts from traditional animation is the idea of a keyframe.

When the story is complete, it is broken into scenes. A senior animator draws the key (important) poses for a scene. These poses are called keyframes. A junior animator then draws the frames in between the keyframes, called in-betweens.

What Does 3ds max Do?

3ds max allows you to build virtual objects, characters, and environments on the computer. You then apply virtual paint or wallpaper to the objects, giving them different surface properties such as shininess or bumpiness. Lights, which simulate real-life lighting, can be added to the scene. You can then animate the objects in the scene or the virtual camera to create an animated sequence.

While you're working on a project, you can preview your work at any time, then make changes and preview again. The final image or image sequence is then rendered into its final output format, which can be any one of the many file formats and output types that were discussed earlier.

Types of Animation

Most animation falls into one of four categories. Any one project might incorporate more than one of these types of animation.

Technical Representation

3D is an excellent medium for presenting designs and technical illustrations. A design can be shown before it has been built, and hard-to-understand technical subjects can be explained with the help of 3D animation.

If you know your tools, technical animation is the easiest type to do. Getting a usable result is fairly straightforward, especially if the animation is expected to be representative rather than realistic. A working representation requires little more than knowledge of modeling and the subject at hand.

New users find that creating a technical representation before working on more advanced types of animation orient them to the software and the tools, and help them learn to think in 3D. For example, creating a model of your computer or a common household object can be a very educational experience.

Fantasy / Sci-Fi

The beauty of 3D animation is that you can create anything you like regardless of whether it exists in reality. Animators have even used **3ds max** to reproduce the works of the 19th century artist Escher, who specialized in drawing "impossible" worlds.

Traditional fantasy and sci-fi art is rich in color and texture, and depicts scenes that look almost believable. The realism comes from recognizable elements in the scene. For example, the terrain in the image might be purple and spotted with strange-looking plants, but you still recognize these elements as ground and foliage.

The best 3D fantasy/sci-fi art uses these principles, making imaginary, or unseen worlds recognizable. The ability to create and edit rich 2D textures is essential to this art form, as is the knack of making familiar forms in new ways that are both recognizable and unreal.

Scene created by Animal Logic

Character Animation

Perhaps the most alluring aspect of 3D animation is the idea of bringing characters or inanimate objects to life. This practice is called character animation. Character animation has its roots in the earliest hand-drawn cartoons. In the 1940's and 50's, Disney animators developed the approach used today by most character animators, for both hand-drawn and 3D animation.

Image courtesy of Applied IDEAS, Inc. (www.applied-ideas.com)

Effective character animation requires some insight into the structure and workings of both human and animal bodies. Studies of the human form, bone and muscle structure, and animal motion are essential to good character design. If the 3D character is to be used in an interactive environment, such as a game or educational program, it has to be created with a minimum of detail, while still maintaining its form and personality.

In animating a character, knowledge of traditional animation methods is extremely helpful. Squashing and stretching, anticipating the next motion, calling the viewer's attention with a double take, and other techniques developed by experienced traditional animators, provide a complete "bag of tricks" for the character animator.

3ds max 7 provides many built-in tools for the character animator. In addition, the **character studio** plug-in for **3ds max** takes over many repetitive tasks, such as the creation of a skeleton and the animation of a basic walk cycle. Many artists new to character animation have also found **character studio** to be an excellent learning tool.

Applications of 3ds max

3ds max is currently used in a variety of industries. Following are some examples of these industries.

Game Development

3ds max has become the mainstay of many game development companies. The necessity to keep playback time fast means that game modelers must pay close attention to the level of detail in each scene, and they find that **3ds max**'s modeling tools allow this freedom.

Models are created with individual flat surfaces called polygons. The fewer polygons a model has, the less time it takes to render. Modelers creating characters and background elements for games must be skilled at creating believable scenes with a minimum of polygons. Game developers often work to tight deadlines, and artists must be able to complete their models quickly and efficiently.

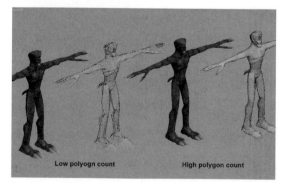

Low polyogn count High polygon count

Image courtesy of Applied IDEAS, Inc. (www.applied-ideas.com)

Backgrounds, environments and pre-game introductory animation are often needed to complete a game package. Depending on the production process, backgrounds can be interactive 3D environments or pre-rendered images. For images that are rendered ahead of time, polygon count is not nearly as much of an issue. If the game takes place in a futuristic, alien, or cartoon environment, ease in creating fantasy/sci-fi worlds is essential.

Some companies that have embraced **3ds max** as their main production tool for game development include Westwood Studios, Blizzard Entertainment, Lucas Arts and Midway.

Film

Creating 3D scenes for film requires a high level of detail to stand up to big-screen viewing. While videos and pre-rendered game sequences often use a medium resolution such as 640x480, films are more likely to use a wide-screen format with a much higher resolution, such as 4096 x 3112.

3ds max is widely used for creating digital mattes for film. A digital matte is a background image used for compositing live footage of actors filmed against a green screen or similar device. **3ds max** has also been used to add explosion and fire effects to films.

Films for which **3ds max** has been used include *South Park*, *Starship Troopers*, *The Matrix*, *Charlie's Angels*, and *Spiderman 1 and 2* just to name a few.

Video/Cable Television

Perhaps the widest use of **3ds max** is for video presentations, which include educational videos, television commercials, and short films. With the advent of cable television, almost any business can afford to broadcast a local commercial, and the demand for content has skyrocketed. Affordable video hardware can make a new user into a video producer overnight.

Major cable channels make liberal use of 3D animation for program openers and channel identification. The Sci-Fi channel's logo, for example, consists of a ringed planet rendered in a variety of 3D animated sequences. Mainstream cable channels, such as CNN, use 3D for news and sports openers. Major networks use 3D for identification, as is the case with NBC's signature peacock and the CBS eyeball logo.

Although the artistic and technical standards are generally not as stringent as for film, the artist creating 3D for video and television has to call upon a much wider range of skills. One job might require simple compositing, while the next requires mastery of basic character animation. Video production offers an excellent training ground for developing skills and learning about many aspects of the 3D craft.

Visualization

The art of presenting a design in 3D is called visualization. Architects and engineers use visualization to get approval on designs, or to sell the product or building before it is actually created. Visualization is also used to show how a machine or product works. For

example, infomercials for fitness and beauty products sometimes include a simple 3D animation showing how the product works with the human body.

When used for architecture or engineering presentations, visualization is closely related to CAD (computer-aided design), which uses precise measurements to create a model. **3ds max 7** has now incorporated tools from Autodesk's VIZ, and is now capable of Design Visualization applications. A separate Courseware is available for Design VIZ applications with **3ds max 7**.

Internet

With **3ds max** you can also create 3D buttons, images and titles, and Animated GIF files, as well as Flash animation for the Web.

Animation for the Web is usually compressed in some way to reduce the file size, which makes for faster playback when Internet connections are slow. When creating the 3D scene, you must keep the imagery simple. With the small screen size of web animation, fine details are lost and might even make the animation unrecognizable. Compression tools used to reduce file size work best when fewer colors are used, and when fine detail is left out of the image.

New techniques are always being developed to facilitate 3D web development. Discreet's Plasma, (www.discreet.com) which is based on **3ds max** technology, incorporates Macromedia's Shockwave Exporter (www.macromedia.com), is available for the artist to export animations to create sophisticated character animation, visually appealing 3D banner ads, and interactive game environments. Viewpoint

The Illustrate! plug-in (www.davidgould.com) for **3ds max** can be used to give a rendered 3D animation the appearance of cel animation, or even to render directly to Flash format. Both techniques reduce the number of colors in the final animation, which provides the compression necessary to view the file over the Internet.

The Cult 3D utility (www.cult3d.com) makes it possible for website visitors to rotate and view a **3ds max** model interactively over the Internet.

Additional services on the Internet include Turbo Squid (www.turbosquid.com). This service is used by animators to quickly locate, buy and sell models and textures online.

Industry Workflow

Now that you have learned about the various industries that use 3ds max, now you can look at some images that detail specific workflows for that industry.

Design Visualization

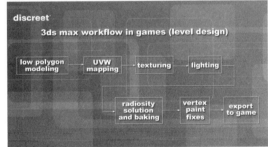

discreet
3ds max workflow in design & vizualisation

modeling — material design — lighting — animation — rendering

physical properties

autocad
ADT
3ds max
VIZ render
inventor
catia

material definition
surface properties
texture mapping
architecture materials

camera
objects
visual effects
reactor

global illumination
radiosity
stills or video
photorealistc output

Games Level Design

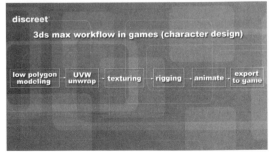

discreet
3ds max workflow in games (level design)

low polygon modeling — UVW mapping — texturing — lighting

radiosity solution and baking — vertex paint fixes — export to game

Games Character

discreet
3ds max workflow in games (character design)

low polygon modeling — UVW unwrap — texturing — rigging — animate — export to game

Visual Effects

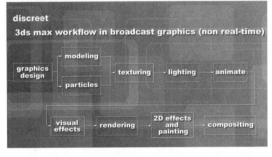

discreet
3ds max worflow in visual effects

track the film shot — modeling film shot references — modeling virtual elements — UVW mapping — animate

generate particle systems

material creation and texturing — matched lighting — visual effects — rendering — compositing

Broadcast Non Realtime

discreet
3ds max workflow in broadcast graphics (non real-time)

graphics design — modeling — texturing — lighting — animate

particles

visual effects — rendering — 2D effects and painting — compositing

Broadcast Realtime

discreet
3ds max workflow in broadcast graphics (real-time)

template design — table of transitions — low polygon modeling — texturing — animate all transitions

scene structuring and naming of dynamic elements — export to real-time 3D engine — design controls and data flow with scriptor

Speaking 3ds max

If you're new to 3D, you find that you have become familiar with its terminology. If you've been using other 3D packages, check this list of terms to find the unfamiliar, and prepare yourself for **3ds max**.

Units—The smallest, whole amount for a measurement or a quantity.

Viewport—In **3ds max**, one or one of several main display windows which show the artist's work-in-progress.

Modeling—The creation of a 3D scene on the computer, similar to sculpting.

Object—An element of a 3D scene, such as a 3D item that you have modeled. In **3ds max**, 2D shapes, lights and cameras are also referred to as *objects*.

Wireframe—a simple, skeleton-like way of showing objects in a computer graphics or computer-aided design program. Only lines and curves at the edges of things and where things meet or join are shown. A wireframe view appears on the screen very quickly so it is used when a person wants to move around a scene quickly or move it often.

Faces—In computer animation, a small, flat, three-sided part of a mesh surface.

Polygons—A polygon is made up of two or more coplanar, adjacent faces. This means that the faces touch, and there is no angle between them.

Vertex—The point where lines or edges intersect. The plural for vertex is vertices.

Animation—The playing of single images (frames) quickly to give the illusion of movement.

Keyframes—Any frame of an animation upon which the animator has placed a key to mark the start or end point of a change in position, shpae, form or appearance.

Shape—A 2D line, closed or open.

Spline—A spline is any 2D object such as a line, text, circle, ellipse etc. You can edit these objects by using the edit spline modifier. This modifier allows you to access the sub-object parts of a 2D object. These parts included splines, vertices, and segments. A spline is a continuous line that is open or closed. A vertex is a point where segments meet. A segment is the line between two vertices. For example if you had the letter V, this text object has vertices, segments, and one continuous closed spline.

NURBS—Non-Uniform Relational B-Splines, a modeling tool that creates objects using smoothly curved lines rather than polygons.

Modifier—Procedures that are applied to objects to change or affect them in some way.

Transform—To change the location, direction or scale (size) of an object. An operation that changes the location, direction or scale (size) of objects.

Dialog—Also called a *dialog box*. A window that appears temporarily in programs to request information from or to provide information to the user.

Materials—The whole definition of a surface's appearance including its shininess, smoothness, color, etc.

Map—A term that can have several meanings. It can refer to a map type - a bitmap for example. It can also refer to a map channel - which holds the specific options for a given material type.

Procedural Map—A pattern of colors generated by parameters. **3ds max** has numerous procedural maps.

Mapping—Refers to placing and positioning a 2D map type such as a bitmap on a 3D object. In 3ds max, one option is to use the UVW map modifier to place your map correctly on an object. Mapping sometimes could refer to making the maps as well.

UVW—A coordinate system used to place a 2D map on a 3D object.

Gizmo—A device that allows the user to manipulate objects and do certain effects. If you select an object and choose a command that uses a gizmo, the gizmo device appears. Changing the gizmo causes those changes to be made to objects that the gizmo belongs to.

Rendering—To create images; what the computer and software does with all your input to calculate, create and output images and animations.

Resolution—The amounts of detail in an image on a computer screen, TV, etc. based on the size of the small or very small parts in the image and how many parts are used to make up the image. If the amount of detail is high, then it is called "high resolution". When referring to computer animation models, resolution is also called "level-of-detail (or LOD for short)."

2

User Interface

Objectives

After completing this chapter, you are able to:

- Understand the **3ds max 7** interface.
- Adjust viewport size and layout.
- Use the Command panels.
- Customize the User Interface.

Introduction

3ds max 7 is a powerful 32-bit, object-oriented three-dimensional modeling, animation, and rendering program. It provides an advanced yet user-friendly environment in which to design, model and animate 3D scenes.

This chapter introduces you to the basic features and functionality of the **3ds max** interface.

User Interface

When you launch **3ds max**, the main interface is displayed.

At first glance, the sheer number of icons and menu options seems daunting. It's important to realize that you don't need to know every icon intimately to start creating scenes. As the various parts of the interface are discussed, you gain familiarity by experimenting with several of the options.

Interface Layout

Each part of the user interface has a specific name. These names are used not only in this courseware, but also in the manuals and the online help. It's important to know the names of these components in order to be able to understand and use this courseware and the other learning tools effectively.

Viewports

The largest area of the **3ds max** user interface is divided into four equal rectangles called viewports. In these viewports you create and manipulate objects, and you can see your work. Each viewport has a label at its upper left corner. The default viewports are labeled Top, Front, Left and Perspective.

You notice that each viewport contains vertical and horizontal lines. These lines make up the home grid. The home grid contains a black vertical line and a black horizontal line. The two lines meet at the center of 3D space which is X 0, Y 0, and Z 0.

The Top, Front and Left viewports display the scene without perspective, meaning that the grid lines are always parallel and never meet. The Perspective viewport shows an angled view of the scene with converging grid lines, similar to what the eye or a camera would see.

Menu Bar

The menu bar is located at the very top of the interface. It contains many commonly used menus such as File > Open and File > Save, as well as menus specific to **3ds max** such as Rendering > Ram Player and Customize > Preferences.

File Edit Tools Group Views Create Modifiers Character Reactor Animation Graph Editors Rendering Customize MAXScr

Main Toolbar

Below the menu bar is the main toolbar. This toolbar contains frequently used tools for transforming objects, selecting objects, and rendering options. You can pan the main toolbar to see more tools.

Command Panels

At the right side of the interface are the six tabs, which comprise the command panel, which contain all of the necessary commands for creating objects, manipulating geometry and creating animation. Each panel has its own set of options. For instance, the Create panel contains tools for creating a variety of

different objects, such as standard primitives, compound objects, and particle systems. The Modify panel contains specific tools for modifying the geometry that you create.

Viewport Navigation Controls

The bottom right of the interface contains the viewport navigation controls. The icons found in these controls allow you to use various zoom options to control the objects in the viewports.

Time Controls

To the left of the viewport navigation controls are the time controls. These controls are similar to the controls in any media player. You can play an animation, step forward or backward one frame at a time, or type-in the exact frame location you want. This is also the place where you decide on the total number of frames to have in your animation.

Animation Mode

To the left of the Time controls are the Animation controls. The Auto Key button turns red when pressed, indicating that you are in record mode, and any transformation or change that you make is recorded on the current frame. The Set Key button, when pressed also turns red, but does not record the change until you press the large Key button. You learn more about these controls in the Animation module.

Status bar and Prompt line

To the left of the time controls are the Status bar and the Prompt line. The Status bar has many features to assist in the creation and manipulation of objects. These tools are explained in more detail later in this chapter.

Track Bar and Time Line

Above the Status bar is track bar. This area displays keyframes when objects that are selected have been animated. You can edit the timing of your animation by moving the keyframes, or by choosing the pop-up Curve Editor icon. When you choose this icon, track bar is replaced with the Curve Editor for the selected object. When you close the pop-up editor, track bar returns.

track bar with keyframes

Curve Editor replacing track bar

The Time Line is above the track bar. Use the time line to scrub the animation or to move forward or backward one frame at a time.

Getting Started with the User Interface

Now that you know the names of the tools that make up the interface, it is time to create an object and move it around in 3D space.

1. On the menu bar, choose File > Reset

2. If you have created an object or attempted a command, the following message is displayed.

3. In the dialog, click No.

Whether you have made changes or not, a reset confirmation dialog is displayed.

4. In the dialog, choose Yes.

The screen returns to its original startup appearance.

5. On the Command panels, choose Create.

Note: By default, the Create panel is selected.

6. On the Create panel, choose Sphere.

7. In the Top viewport, drag in the center of the viewport to create a sphere that is almost the same size as the viewport.

The sphere appears in all four viewports. In three of the viewports, it is represented by a series of lines, or a wireframe. In the

Perspective viewport, the sphere is shaded.

8. ⊞ In the viewport navigation controls, choose Zoom Extents All.

 The sphere fills the view in all of the viewports.

 Note: The sphere has not changed in size, it has simply filled the viewport to the fullest extents of its size.

9. ✥ On the main toolbar, choose Select and Move.

10. In the Top viewport, drag the sphere to move the sphere.

 The sphere is moved.

 You now have a scene. Read the following area and use this scene to practice.

Reviewing the Terminology

You have encountered the following terms.

- **Wireframe**—A representation of an object as a series of lines or wires with no shading.

- **Shaded**—Colored and made to look like a solid object.

- **Model**—One or more objects created in **3ds max**.

- **Scene**—An object or a collection of objects arranged in the viewports. The objects can include lights and cameras, and any of these objects can be animated as part of the scene definition.

- **Extents**—The degree to which the object in the scene extends in space. To zoom to the extents of the scene means to zoom out until the entire scene is visible in the viewport.

Left- and Right-Clicking

Left- and right-clicking have different functions in **3ds max**. In general, a left-click is used to choose and execute a command. Right-clicking shows a menu with further options for the task at hand. Right-clicking can also be used to cancel a command.

Note: The documentation specifies when you need to right-click.

Viewport Size and Layout

Since much of your work consists of clicking and dragging in viewports, it's important to have a viewport layout that you can easily work with. Many users find that the default viewport layout serves most of their needs. However, as you work with **3ds max**, you sometimes need to change the viewport layout, resize the viewports, or change the way objects are displayed.

Resizing Viewports

Viewports can be resized and changed in a variety of ways to suit your preferences. Regardless of how you resize the viewports, the total space used by all viewports does not change.

Moving Crossbars

As a default, the four viewports are of equal size. You can re-size the viewports to make one or more viewports larger than the others.

1. Continue from the previous exercise.

2. Move the cursor in between the Perspective and Front viewports.

A double-headed arrow is displayed.

3. Drag up to move the crossbar.

4. Release the mouse to view the resized viewports.

Note: Both the vertical and horizontal crossbars can be moved when resizing viewports.

5. Right-click at the same location where you re-sized the viewport.

 A right-click menu is displayed.

6. Choose Reset Layout.

The viewports are returned to their original size.

Changing Viewport Layout

The ability to re-size the viewports is a useful feature to have but it does not give you the option to change the viewport layout. Suppose, for example, you want to have three viewports arranged vertically down the right side of the screen, with the remaining area to be taken up by a large, fourth viewport. This arrangement can only be achieved by changing the viewport layout.

To select a different viewport arrangement:

1. On the menu bar, choose Customize > Viewport Configuration.

 The Viewport Configuration dialog is displayed.

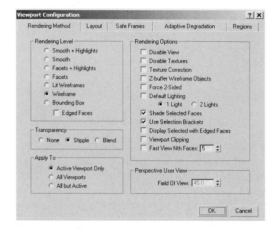

2. In the Viewport Configuration dialog, click the Layout tab.

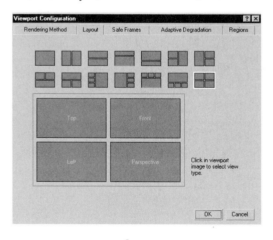

 Across the top of the dialog are fourteen viewport layouts to choose from.

3. In the Layout tab, click the fourth layout in the second row then click OK.

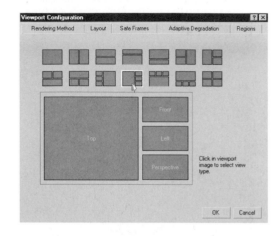

4. Move the crossbars to further customize the layout.

Tip: Right-clicking anywhere in the viewport navigation controls also gives you access to the Viewport Configuration dialog.

Viewport Menu

Each viewport has a label at its top left corner. A viewport menu can be accessed by right-clicking the viewport label. This menu allows you to change the type of shading for the objects in the scene, to access the Viewport Configuration dialog and to change the current viewport to another viewport.

To change to a different viewport, right-click over the viewport label and choose Views from the right-click menu. A second menu appears where you can choose a new viewport for the currently selected viewport.

Using Shortcut Keys

Shortcut keys are also available for changing the current viewport. To use a shortcut key to change the viewport, first activate the viewport you want to change by right-clicking anywhere in the viewport. Then choose one of the following shortcut keys to change the viewport.

Viewport Name	Shortcut
Front	F
Top	T
Bottom	B
Back	User Definable
Left	L
Right	User Definable
User	U
Perspective	P
Camera	C

Tip: In any viewport, you can type *v* and a quad menu displays with the keyboard shortcuts for each viewport. So you can type *vk* for the Back viewport, and *vr* for the Front viewport.

Viewport Shading

The Shading setting available from the right-click menu of the viewport label is an important option. The shading lets you define how you view your 3D scene. This is important for lighting, camera work, modeling, and animation.

As default, the Perspective viewport is set to Smooth + Highlights. This makes it easy for placing lights in the scene, and for viewing where the highlights are placed on the objects. The shading default for the Orthographic (Top, Front, Left) viewports is Wireframe. This is a convenient setting for system resources because wireframe shading requires fewer system resources than shaded mode. You can, however, customize any viewport to make it display any shading mode.

Shaded + Highlights and Wireframe are the two most commonly used shading modes, however more can be chosen from the Other sub-menu.

From this sub-menu you have options such as Smooth, Facets + Highlights, Facets, Flat, Lit Wireframes, and Bounding Box.

Flat shading accurately displays your objects' textures with no highlights or shading. This mode is ideal for checking the results of bitmaps created with Render to Texture, which you learn about in Chapter 16.

Another common Shading option to use while modeling is Edged Faces. When Edged Faces is turned on, the objects in the selected viewport display your objects' edges.

Working with Viewports

1. On the menu bar choose, File > Open and open *Chap02_01.max* from the courseware CD.

 This scene shows a mechanical bug made with **3ds max**.

2. Right-click in the Top viewport to make it active.

3. On the keyboard, press B.

 The Top viewport changes to the Bottom viewport, showing the scene from the bottom instead of the top.

4. ⊞ In the viewport navigation controls, choose Zoom Extents All.

5. In the Left viewport, right-click the viewport label and choose Smooth + Highlights.

 This displays the model in shaded mode.

6. 🔍 In the viewport navigation controls, choose Zoom.

7. Click-and-drag in the Perspective viewport to zoom in on the mechanical bug.

8. In the Perspective viewport, right-click the viewport label and choose Other > Flat.

 This displays the model in flat mode.

9. In the Perspective viewport, right-click the viewport label and choose Edged Faces.

 This displays the model with Flat Shading and Visible Edges.

Menu Bar

The tools found on the menu bar can also be found in other areas of the interface. It is important to become familiar with several tools almost immediately; particularly the file management tools and the help options.

File Menu

Most of the options on the File menu do not appear elsewhere. This is the place where you open and save MAX files, import and export files with an extension other than MAX, check the number of polygons in your scene and perform a number of other operations on files. The last few files opened and/or saved can be opened from the Open Recent sub-menu. This list remains in the File menu even after you exit and reload **3ds max**, making it easy to pick up where you left off in the previous session.

Edit Menu

The options on the Edit menu are mostly for editing the set of selected objects rather than for editing the scene. You can also undo or redo the last command.

Tools Menu

The Tools menu contains many commands for selecting, organizing, renaming and measuring objects in your scene. **3ds max** offers the versatility of being able to locate many of the Tools menu options on the toolbars, as well as in the command panel.

Tools	Group	Views	Create	Modifie
Transform Type-In...		F12		
Selection Floater...				
Display Floater...				
Layer Manager				
Light Lister...				
Mirror...				
Array...				
Align...		Alt+A		
Quick Align		Shift+A		
Snapshot...				
Spacing Tool...		Shift+I		
Clone and Align ...				
Normal Align...		Alt+N		
Align Camera				
Align to View...				
Place Highlight		Ctrl+H		
Isolate Selection		Alt+Q		
Rename Objects...				
Assign Vertex Colors...				
Color Clipboard...				
Camera Match...				
Grab Viewport...				
Measure Distance...				
Channel Info...				

Group Menu

The Group menu contains tools for grouping and ungrouping more than one object. Grouping is a great way to organize objects in your scene. For instance, if you have ten candlesticks and ten wicks that are part of a chandelier, you can place all of the objects that make up the chandelier into one group.

Grouped objects can be ungrouped without deleting objects. You can also open groups to edit objects individually and then close the group when you have finished editing.

Group	Views	C
Group		
Ungroup		
Open		
Close		
Attach		
Detach		
Explode		
Assembly	▶	

Views Menu

The Views menu contains tools for undoing or redoing the last viewport navigation. It also contains options for grids, and allows you to show certain features that pertain to specific commands. For instance, you can show Key Times on a trajectory or hide the Transform Gizmo. The Views menu also contains the option to display a 2D image in a viewport background. This 2D image can appear as a still file or an animated file. This is an important option for modeling and animation when you need to use reference images to help you model organic objects, or animate walk and run cycles.

Create and Modifiers Menus

The options on the Create and Modifiers menus have tools for creating and editing objects and adding animation to a scene. All the options found on these menus are also available on the command panels.

Character Menu

The Character menu contains options for inserting an animation on an existing character. One of the most important features of this menu is the ability to access the original Skin Pose for an object. This feature becomes increasingly useful when using Set Key mode for keyframing.

Reactor Menu

The reactor menu contains many objects and tools which make up the Reactor dynamics product. Consult the User Reference for more information.

reactor	Animation	Graph E
Create Object	▶	
Apply Modifier	▶	
Open Property Editor		
Utilities	▶	
Preview Animation		
Create Animation		
About reactor...		

Animation Menu

The Animation menu contains options for setting up an Inverse Kinematics (IK) solution. This menu also contains options for adding custom attributes to existing rollouts, and for wiring parameters from one object's parameters to another. For more information on these commands, refer to the Online Help.

Animation	Graph Editors	Render
IK Solvers	▶	
Constraints	▶	
Transform Controllers	▶	
Position Controllers	▶	
Rotation Controllers	▶	
Scale Controllers	▶	
Parameter Editor...		
Parameter Collector...		
Wire Parameters	▶	
Reaction Manager		
Make Preview...		
View Preview...		
Rename Preview...		
Delete Selected Animation		

Graph Editors Menu

Graph Editors are graphical views of the relationships between scene elements. The Track View Editor contains two modes: Dope Sheet and Function Curve, which display animation keys, and the relationships between them, for several objects at once. It is the premier option in **3ds max 7** to edit the timing of your animation, and to view how the animation is behaving in between keyframes. Schematic View displays all of the objects in your 3D scene in a color coded graphical display. You can view which materials and modifiers have been applied to objects. You can also use Schematic View to hierarchically link one object as a child to another object as a parent.

Graph Editors	Rendering	Customize
Track View - Curve Editor...		
Track View - Dope Sheet...		
New Track View...		
Delete Track View...		▶
Saved Track Views		▶
New Schematic View...		
Delete Schematic View...		
Saved Schematic Views		▶
Particle View		6

Rendering Menu

The Rendering menu contains the basic rendering controls, and access to advanced tools. The Environment option can be used to add a background image to a rendering, or to enable effects such as fog. The Effects option allows you to add special effects such as glows, blurring and film grain. You can also use this menu to access the advanced lighting controls such as Radiosity and Light Tracer.

Customize Menu

The Customize menu contains options for changing the user interface. For example, the Customize User Interface option displays a dialog to help you set up keyboard shortcuts, or change the viewport background color. Once you've customized the screen, you can choose Save Custom UI Scheme to save your UI setup. Later, you can use Load Custom UI Scheme to load the settings for a different session. The last UI setup used is the one displayed when **3ds max** is next launched. This means that if you change the toolbars, and customize the UI, those changes take effect the next time you launch **3ds max**.

MAXScript Menu

3ds max supports a programming language called MAXScript. Users experienced in programming can write short programs, called scripts, to automatically perform specific **3ds max** functions. The options on the MAXScript menu are for creating, testing and running scripts. For more information on MAXScript and the options on this menu bar, access the on-line documentation.

Help Menu

Help is available through the Help menu in a variety of formats. The User Reference is a good starting point for most general questions about **3ds max**, while the Tutorials provide task-oriented exercises for common scenarios. The HotKey Map is an interactive approach to learning the default keyboard shortcuts. The Additional Help option is specifically for third party plugin developers to supply Help for their products. The **3ds max** on the Web accesses information from the Discreet website, which requires an Internet connection.

Help
New Features Guide...
User Reference...
MAXScript Reference...
Tutorials...
HotKey Map...
Additional Help...
3ds max on the Web ▶
Activate 3ds max...
License Borrowing ▶
About 3ds max...

Using the Menu Bar

1. On the menu bar, choose File > Open and open *Chap02_01.max* from the courseware CD.

2. On the menu bar, choose File > Summary Info.

The Summary Info dialog allows you to see the number of objects in the scene, which materials have been applied to which objects, and how much memory you are using.

Note: This information can be saved to a file and printed.

3. Close the Summary Info dialog.

4. ✛ On the main toolbar, choose Select and Move.

5. In the Top viewport, move any part of the bug.

6. On the menu bar, choose Edit > Undo Move.

 Tip: CTRL + Z is the keyboard shortcut for Undo.

7. 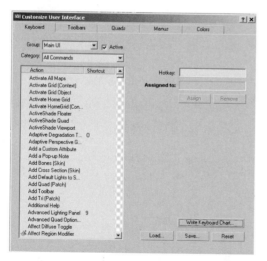 In the viewport navigation controls, choose Zoom Extents All Selected.

8. Right-click in the Perspective viewport to make it active.

9. On the menu bar, choose Views > Undo View Change.

 The Perspective view returns to the view it had before you clicked Zoom Extents All.

 Tip: **SHIFT** + Z is the keyboard shortcut for Undo View Change.

10. On the menu bar, choose Customize > Customize User Interface.

 The Customize User Interface dialog is displayed.

11. In the Customize User Interface dialog, choose the Colors tab.

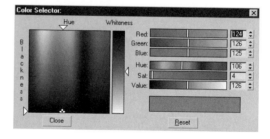

12. In the Elements drop-down list, be sure Viewports is chosen.

13. In the listing, choose Viewport Background.

14. Click the color swatch at the upper right side of the dialog.

 A Color Selector dialog is displayed.

15. In the Color Selector dialog, use the sliders to choose a purple color.

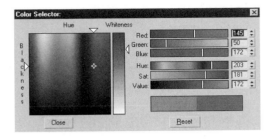

16. In the Color Selector dialog, choose Close.

17. In the Customize User Interface dialog, choose Apply Colors Now.

The viewport backgrounds turns purple.

18. Close the Customize User Interface dialog.

Toolbars

The **3ds max 7** interface displays the main toolbar and the reactor toolbar by default. This shows the user the important transform and selection options found on the main toolbar, and reminds the user of the added power that reactor can offer a 3D scene. The amount of available drawing space decreases with every toolbar displayed. Screen resolution is an important option to consider when adding toolbars to your interface. The recommended resolution to run **3ds max** is 1280 x 1024.

Other toolbars are either hidden or floating. Floating toolbars can be docked on any side of the viewports. The methods for docking floating toolbars and displaying hidden toolbars are discussed later in the chapter.

The main toolbar includes object selection tools, axis constraints for specifying axes, and so on.

You can hide and unhide a toolbar by right-clicking the empty space on any toolbar and choosing their name from the right-click menu.

Main toolbar—The tools contained in the main toolbar are discussed briefly here.

The main toolbar contains tools for selecting objects in your scene.

The Render buttons provides quick access to the Render Scene dialog. You can also use the presets list and Quick Render button to render your scene without having to use the Render Scene dialog.

The Link/Unlink buttons let you link, unlink, and bind object to space warps.

The editing buttons provide quick access to the Layer Manager, Curve Editor, Schematic View, and the Material Editor.

The transform buttons provide an alternative way to change between Select and Move, Select and Rotate, and Select and Scale modes, as well as tools for changing the coordinate system and pivot points, and for applying mirror, or align operations.

The main buttons are quick alternatives to using the same commands from the Edit menu.

The Selection Sets buttons provides quick access to the Named Selection Sets dialog and quick selection of existing selection sets.

Axis Constraints toolbar —The Axis Constraints toolbar lets you specify one or two axes along or about which transforms takes place.

Layers toolbar—The Layers toolbar provides several tools for working with layers. You can create a new layer, manage existing layers, add a selection to the current layer and select all of the objects in the current layer.

Reactor toolbar—The Reactor tools are for dynamics simulation. They perform automatic physics calculations to create animation.

Extras toolbar—The Extras toolbar has the Autogrid, Keyboard Shortcut Override Toggle, Array and Render Presets tools.

Render Shortcuts toolbar—The Render Shortcuts toolbar gives you access to the Render Presets drop-down list and three definable render preset buttons.

Snaps toolbar—The Snaps toolbar contains many of the snap options found in the Grid and Snap Settings dialog. Choosing an option from this list does not turn on Snap.

The toolbars do not contain tools for creating or modifying geometry.

Working with Toolbars

The **3ds max 7** interface contains many toolbars, and unless your screen is maximized, you might not be able to see them all. You might want to rearrange or

even hide some toolbars, depending on your work habits. Also consider changing your screen resolution to the recommended 1280 x 1024.

Sliding a Toolbar

If your resolution is less than the recommended 1280 x 1204, some of the longer toolbars might not display all of the possible icons. To view the other icons on the toolbar, simply move the cursor over an area between any two icons until the pan hand displays, then drag to see the remaining icons on the toolbar.

Relocating or Docking a Toolbar

There are two ways to relocate a toolbar: you can either right-click the double lines at the left side of the toolbar and move the toolbar using a menu, or you can drag the double lines to move the toolbar manually.

When you right-click the double bars, you can choose Dock or Float from the right-click menu. These terms are defined in the next section.

When you drag on the double lines, a black border around the toolbar indicates that it has been successfully picked up.

Docking a Toolbar

When you move a toolbar and the cursor comes close to the edges of the viewport display area, a black outline of the toolbar is displayed at its edge.

If you release the mouse at that moment, the toolbar snaps to the indicated position.

Note: You docked a toolbar horizontally above. A toolbar can be docked vertically too. When a docked toolbar is against a vertical viewport edge, a single line used for moving the toolbar is displayed at the topmost edge of the toolbar.

Toolbars can be docked on the left side or the top of the viewports.

Floating a Toolbar

You can also place a toolbar anywhere in the viewport area. A toolbar placed in the viewport area is called a floating toolbar.

While docked toolbars have no displayed title, a floating toolbar's title is displayed just above the buttons themselves. The toolbar title bar can be used to pick up and move the toolbar.

Using Toolbars

1. Continue from the previous exercise.

2. On the menu bar, choose Customize > Revert to Startup UI Layout.

 A message is displayed.

3. Choose Yes.

 The interface reverts to its original appearance.

4. On the main toolbar, locate the double bars at the leftmost end.

 Note: By default, the main toolbar is the leftmost toolbar in the user interface.

5. Drag the double bars, and move the toolbar to the center of the screen.

The toolbar is now a floating toolbar.

6. Right-click the main toolbar title bar, and choose Axis Constraints from the list.

The Axis Constraints toolbar is displayed.

7. Drag the Axis Constraints toolbar to the left of the screen until a vertical black outline is displayed.

8. Release the cursor to dock the Axis Constraints toolbar to the left side of the interface.

9. On the menu bar, choose Customize > Revert to Startup Layout and click Yes in the dialog.

Customize	MAXScript	Help
Customize User Interface...		
Load Custom UI Scheme		
Save Custom UI Scheme		
Revert to Startup Layout		
Custom UI and Defaults Switcher		
Show UI		▶
Lock UI Layout		Alt+0
Configure Paths...		
Units Setup...		
Grid and Snap Settings...		
Viewport Configuration...		
Plug-in Manager...		
Preferences...		

The interface reverts to its original appearance.

Command Panels

The command panels contain all of the options necessary for creating and editing objects. You can also use the menu bar to access most of the commands found on the command panels. The command panels contain six panels from which you can create, modify, or simply organize objects in your scene.

When you choose a command from the command panels, options for that command are displayed. For example, when you choose to create a sphere, parameters such as Radius, Segments, Hemisphere etc. are displayed.

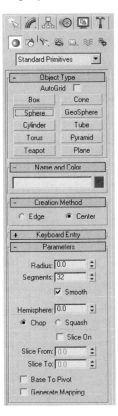

Navigating in the Command Panel

Some commands offer a wide choice of parameters and options. All of the choices are neatly displayed in rollouts. A rollout is a titled bar that contains specific parameters. The rollout has a plus sign (+) or a minus sign (–) at the left side of the title. When a minus sign (-) is displayed, you choose the rollout title to collapse the rollout and make more room. When a plus sign (+) is displayed, you choose the title to expand the rollout and display its parameters.

In some instances, as you close rollouts, you notice that more rollouts display below. It's important that you navigate carefully in the command panels, to make sure you are accessing all of the tools available in the various rollouts. One way to navigate in the command panels is to place your mouse over a blank area in the rollout. You notice a pan hand appear indicating to you that you can pan the rollout.

Another way to navigate the command panels is to right-click in a blank area in the rollout. A right-click menu is displayed with all of the rollout titles. The right-click menu also features an option to open all of the rollouts at once.

Note: The above image displays the right-click menu for a particle system object. Depending on the type of object you create, you get a right-click menu specific to that object type.

It can be useful to open all of the rollouts at once, but this could result in too much panning, depending on how many rollouts are associated with the object. There are two ways to alleviate this problem. First you can move rollouts from one location to another. For instance, if a rollout is at the bottom of the command panel, you can move it to the top of the command panel. Second, you can expand the command panels to show all of the rollouts. By doing this, however, you begin to lose valuable viewport space.

Using the Command Panel

1. On the menu bar, choose File > Reset.

2. On the command panel > Object Type rollout, choose Sphere.

 The command panel defaults to Create.

3. In the Top viewport, drag to create a sphere.

4. On the Create panel, click the Keyboard Entry rollout title to expand the rollout.

Standard Primitives

Object Type

AutoGrid

Box	Cone
Sphere	GeoSphere
Cylinder	Tube
Torus	Pyramid
Teapot	Plane

Name and Color

Sphere01

Creation Method

○ Edge ● Center

Keyboard Entry

X: 0.0
Y: 0.0
Z: 0.0
Radius: 0.0

Create

Parameters

Radius: 42.989
Segments: 32
☑ Smooth
Hemisphere: 0.0
● Chop ○ Squash
☐ Slice On
Slice From: 0.0
Slice To: 0.0
☐ Base To Pivot

5. On the Create panel, move the cursor over a blank area of the Keyboard Entry rollout.

A Pan hand is displayed.

Note: When working in the recommended screen resolution of 1280x1024, the command panel is large enough to accommodate the expanded menu without panning/scrolling. In this case, the pan hand does not appear.

6. Drag upward to see more of the Create panel.

7. On the Create panel, choose the Keyboard Entry rollout title to collapse it.

8. On the Create panel, drag the Parameters rollout title to just below the Creation

Method rollout title, and release the mouse.

The blue line above the Creation Method rollout title indicates that the Parameters rollout is moved there when the mouse is released.

9. Place your mouse between the Perspective viewport and the command panel until your cursor displays a double-sided arrow.

 This arrow indicates that you can re-size the command panel.

10. Drag to the left to re-size the command panel.

Note: The Customize > Revert to Startup UI command does not reset the changes made to the rollout order and the sizing of the command panel.

Dialogs

In **3ds max 7,** depending on the command that you choose, you might get another interface that displays options such as check boxes, radio buttons and/or spinners. This interface is called a dialog. Many of the options found on the toolbars access dialogs, such as Mirror, and Align. You can also access other dialogs such as the Material Editor and the Curve Editor. However, there is a difference between these types of dialogs.

The difference between these two types of dialogs is that one is called modal and the other is called modeless.

Modal Dialog

Modeless Dialog

A modal dialog requires you to click OK or Cancel before you can use another tool. A modal dialog always contains an OK button and a Cancel button. Changes made to the dialog often (but not always) cause the scene to be updated immediately, but any changes can be canceled by choosing Cancel. The Mirror dialog is an example of a modal dialog.

A modeless dialog can be left onscreen while you use other tools. When a parameter is changed, it goes into effect immediately. Modeless dialogs might have a Cancel or Apply button, but simply clicking the X at the upper right of the dialog closes some modeless dialogs. The Curve Editor is an example of a modeless dialog.

Quad Menu

When you right-click in the active viewport, a quad menu appears. Depending on the state of the object, you might see two parts or four parts to the quad menu. You can also customize the display to show one quad panel at a time, or all quad panels at once. The images below display the quad panel, at various states of an object, and options for customization.

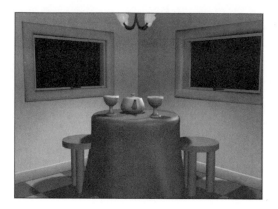

As you move the cursor from one square to another, a different menu appears for each square. These four squares are called a quad, and the four-part menu is known as the quad menu.

The quad menu contains commonly used commands that can be accessed from other areas of **3ds max**. You can also customize the quad menu to include commands that you use frequently. As you gain experience with **3ds max**, you find that it can save time to choose options from the quad menu rather than a toolbar or command panel.

Using the Quad Menu

1. On the menu bar, choose File > Open and open *Chap02_02.max* from the courseware CD.

 This file contains a simple dining room scene.

2. In the Camera viewport, select the teapot.

3. On the main toolbar, choose Mirror Selected Objects.

 A modal dialog is displayed, and the teapot is mirrored to face the opposite direction.

4. In the Mirror dialog, choose OK.

 This accepts the mirror operation.

5. In the Camera viewport, right-click to display the quad menu.

 Only two parts of the quad menu appear when you perform this type of operation.

6. Choose Move from the quad menu.

 This is the same as choosing Select and Move from the main toolbar.

7. In the Top viewport, move the teapot to another area of the table.

8. Right-click in the Camera01 viewport to make it activate.

9. On the main toolbar, choose Render Scene.

 Note: You might have to scroll the main toolbar to the left to see the Render Scene icon.

 The Render Scene dialog that appears is a modeless dialog.

10. In the Render Scene dialog > Output Size group, choose 320x200.

11. In the Render Scene dialog, choose Render.

 The scene renders. The rendered frame window and the Render Scene dialog are still displayed.

12. Close both the Render Scene dialog and the rendered frame window.

Transform Type-In Dialogs

For precise control over Move, Rotate, and Scale values, there is a Transform Type-In dialog that allows you to enter text values. This dialog is available through the settings button next to Move, Rotate, and Scale in the Quad Menu. Choosing one of the symbols opens the associated Transform Type - In dialog.

Each dialog is divided into two parts: Absolute and Offset.

Absolute—Allows you to set the position and rotation of the object based on the world origin, and the scale based on its original size.

Offset—Allows you to adjust the object's position, rotation, or scale relative to the object's current position, rotation, or scale.

Note: The Offset option for Scale appears differently when you have different scale options selected from the flyout on the Main Toolbar. When Uniform Scale is selected you may only change the overall scale of the object; while when you have Non-Uniform Scale or Squash selected you may adjust all three axes separately.

These dialogs are also available by right-clicking on the Move, Rotate, and Scale tools on the Main Toolbar, or from the Transform Type-In area of the main user interface.

Status Bar and Prompt Line

The Status bar at the bottom left of the interface displays information and messages related to your current scene activity. This group also displays a macro recording feature that is available for creating MAXScripts. When macro recording is turned on, text is displayed in the pink area; this area is called the Listener Window. For more information on MAXScript and the macro recorder, please refer to the **3ds max** on-line documentation.

Next to the macro recording group is the Prompt line. The top of the Prompt line displays the number of selected objects. The bottom of the Prompt line gives hints or instructions as to what you might do next, based on the current command.

The X, Y and Z display groups, also known as the Transform Type-In area, informs you of the position of the currently selected object, or by how much the object is being moved, rotated, or scaled.

Toggles

At the bottom center of the status bar are a couple of icons, called toggles, which are used for turning features on and off. A toggle is turned on or off by choosing it to change its state.

Lock Selection—Locks the current selection of objects. By default, the icon is grey, or turned off. It turns yellow when it is turned on.

Absolute/Offset Mode Transform Type-In—Toggles the X, Y and Z entries on the status bar between Absolute and Offset mode.

Animation Mode

To the right of the toggles are several buttons, which control how you create keyframes. If Auto Key is turned on, and the display is at a frame other than 0, any changes made to an object animates the object. For example, if you turn on the Auto Key button and move an object to a frame other than 0, you create a keyframe at that frame, and a starting keyframe at frame 0.

If Set Key is turned on, and you move an object to a frame other than 0, a keyframe is not set until you press the large Key button. For example, to use Set Key, you turn on the Set Key button in the Animation mode, make a change to your object, and to record the change you made, you choose the large Key button. A keyframe is only set at that particular frame. It does not create a starting keyframe at frame 0.

When the Auto Key and the Set Key buttons are turned off, you are in Layout mode. You can use the large key button in Layout mode to create "blank" keyframes.

You learn more about Auto Key, Set Key, and Layout in the Animation module.

Time Controls

To the right of the Animation controls are several buttons resembling those on a VCR. These are the time controls. Here you can play an animation onscreen, or step through an animation frame by frame. The entry box just below the buttons moves the display to a specific frame number. The Play Animation button plays the scene animation onscreen.

Flyouts

Flyouts are available on the toolbars and on the viewport navigation controls. Flyouts are icons that have a small black triangle on the bottom right corner. You can press these icons and choose more options for the specific tool.

Note: The flyout contains both the icon chosen, and all its additional selections.

Viewport Navigation Controls

As you work with **3ds max**, you find you frequently need to zoom into a specific part of the scene so you can work with it more closely. At the bottom right of the screen are the viewport navigation controls, which allow you to zoom into or out of the scene in a variety of ways.

Zoom—Zooms into or out of the active viewport.

Zoom All—Zooms all viewports.

Zoom Extents or Zoom Extents Selected—This is a flyout with two options. The first icon is grey, and when chosen, all of the objects in the active viewport zoom to the scene extents. The second icon is white and when chosen, the selected viewport zooms to the extents of the the selected object(s).

Zoom Extents All or Zoom Extents Selected All—This is a flyout with two options. The first icon is grey, and when chosen, all of the objects in all of the viewports zoom to the extents of the scene. The second icon is white and when chosen, the viewports zoom to the extents of the selected object(s).

 Region Zoom—Zooms to a specified region of a viewport.

Pan—Moves the view in any direction.

Arc Rotate, Arc Rotate Selected and Arc Rotate SubObject—This is a flyout with three options. The first icon is grey, and when chosen, rotates the view around the scene. The second icon is white and when chosen rotates the view around the selected object. The third option is yellow and when chosen rotates the view around the sub-object.

Min/Max Toggle—Toggles the active viewport between full-screen and divided display.

Note: All of the viewport navigation controls have keyboard shortcuts. To view the keyboard shortcuts, choose Customize > Customize User Interface, and choose the Keyboard tab. You may also view the keyboard shortcuts by choosing Help > Hotkey Map.

Navigating 3D Space

1. On the menu bar, choose File > Open and open *Chap02_01.max* from the courseware CD.

2. In the viewport navigation controls, choose Zoom.



2. In the viewport navigation controls, choose Zoom.

3. In the Front viewport, choose in the center of the viewport and drag upward.

The Front viewport zooms in.

4. In the Front viewport, drag downward.

The Front viewport zooms out.

5. In the viewport navigation controls, choose Zoom All.

6. In the Front viewport, drag upward.

All of the viewports zoom in.

7. Right-click in the Perspective viewport to make it active.

8. In the viewport navigation controls, choose Arc Rotate.

A yellow circle appears in the Perspective viewport to indicate that arc rotation is active.

9. In the Perspective viewport, click at the center of the viewport and drag to the right.

The viewport is rotated.

CUI Switcher

The CUI Switcher allows you to easily switch between several preset tool options and user interface schemes. This allows you to configure 3ds max 7's options to match the type of work you are doing, as well as allowing multiple users to create their our UI's and switch between them easily.

When you choose one of the options on the top, the lower area shows a comprehensive list of that selection's features. Any custom UI's you create are also included in the list, however no information is shown in the lower area when they are selected.

When you change the various tool options, you change how 3ds max works in various areas. For example: when you choose Max.mentalray, the mental ray extensions are enabled by default; and when you choose DesignVIZ, all materials start as Architectural materials.

After choosing the Tool Options and UI Scheme that you want, pressing Set loads them. A dialog appears to let you know that the default settings take effect the next time you restart 3ds max.

```
Custom UI and Defaults Switcher                        [X]

   !\    The Defaults settings will take effect the next time you restart 3ds max.

                        [    OK    ]
```

The CUI Switcher can be found on the menu bar by selecting Customize > Custom UI and Default Switcher.

Conclusion

The command panel is used to create objects, while the toolbars contains tools to transform and work with these objects. The viewport navigation controls allow you to move in, out and around viewports in a variety of ways.

The **3ds max** user interface contains everything you need to create and manipulate objects in the scene. In this chapter, you learned to use various features to customize the user interface, and to use the basic tools to help you create your own scenes.

3

Working with Files and Objects

Objectives

After completing this chapter, you should be able to:

- Open, Close, Save, and Merge Files.
- Understand the use of units in a 3D drawing.
- Create 3D primitive objects.
- Create AEC objects.
- Create 2D shapes.
- Understand the modifier stack display.
- Working with DRF Files.
- Use object selections.
- Group objects.
- Organize objects in Layers.

Introduction

To use **3ds max 7** effectively, you need to understand the basics of organizing files and creating objects. In this chapter, you learn to work with files, and set up measurements for your scene. You also learn the basics of drawing, selecting, and modifying objects.

Opening and Saving files

In **3ds max**, you can open only one scene at a time. To open another scene, you must start another session of **3ds max**. Open and Save file commands are common to all Windows programs. These commands are found on the File menu bar.

Opening a file in **3ds max** is a simple task. You choose File > Open from the menu bar. The Open File dialog is displayed, and you navigate to the directory that contains the file you want to open. Opening a file in **3ds max** means you open a file with a MAX extension. You can also open a file by choosing from the last nine files that were opened on the File menu > Open Recent submenu.

Saving a file in **3ds max** is also a simple task. You choose File > Save from the menu bar. The Save File As dialog is displayed, and you navigate to the directory you want to save the file. If you have already saved the file, it saves to the same file name. On the menu bar, there is also a File > Save As option, which saves the scene to a new file name.

Save File As Dialog

When you choose one of the saving options from the menu bar, the following dialog is displayed.

This dialog has a unique feature. There is a + button near Save. When you choose the + button, the file is saved automatically with a new file name. If the file name has a number at the end, the number is increased automatically by increments of 1. If the file name doesn't have a number at the end of it, the numbers "01" are appended to the end of the file name. The next time you save with the + sign, the file name is appended with "02," then "03," etc. This feature is handy for saving successive versions of a file as you develop the scene.

Holding and Fetching

Instead of saving a scene, you can temporarily hold it in memory by choosing Edit > Hold from the menu bar. You can then either work with the current scene, or load a new scene altogether. When you're ready to reload the "held" scene, choose Edit > Fetch from the menu bar. This causes the held scene to replace the current scene completely. Only one scene can be held at a time.

Merging Files

Merging files allows you to take one or more objects from one scene into the current scene. For example, you might have a current scene that consists of an interior of a living room. In another MAX file that is unopened, you have a character. If you want the character to be in the current scene of the living room, then you use File > Merge to merge the character into the living room. Merge allows you to choose one or more objects to merge in the current scene.

Merging a File

1. Launch **3ds max**.

2. On the menu bar, choose File > Open and open *Chap03_01.max* from the courseware CD.

 An interior environment with a table and stools is displayed.

3. On the menu bar, choose File > Merge and merge *Goblets.max* from the courseware CD.

The Merge – Goblets.max dialog is displayed with two objects listed.

4. In the Merge dialog, choose Goblet 01 then click OK.

 The goblet is merged into the scene.

 Note: Merged objects retain their original sizes and positions in world space. Sometimes merged objects have to be moved or changed in scale to fit the scale of the current scene.

Externally Referencing Objects and Scenes (Xref)

3ds max 7 makes it possible for teams of artists to work from a single MAX file, while they are connected to the same network. On the menu bar, there are two options for artists to reference each other's work in real time: File > Xref Objects and File > Xref Scenes.

For example, suppose you're making a 3D environment for a scene while another artist is animating a character for the same scene. You could use File > Xref Objects to open a read-only version of the character into your 3D environment to see how the two components work together. You can also refresh the referenced objects periodically to see the progress made on the file by other artists.

Asset Browser

The Asset Browser is another option available for you to use for opening, merging, or externally referencing files. The advantage to using the Asset Browser is that it displays thumbnail images of 2D bitmaps, MAX files, or MAXScript files.

You can also use the Asset Browser to get a live link to the Internet. This means you can browse the web for MAX files or bitmap images, then drag and drop these images or models directly from the Internet into your current **3ds max** scene.

The Asset Browser has its own toolbar across the top of the dialog. To the left of the dialog is a hierarchy area. From here, you navigate to the folder where the images and/or scenes are stored. Simply choose the directory from the hierarchy area and thumbnail images display. You can drag and drop the thumbnail image into any viewport or drag and drop a texture on to an object in the scene.

Using the Asset Browser

1. On the menu bar, choose File > Open and open *Chap03_01.max* from the courseware CD.

 The scene is displayed.

2. On the command panels, choose Utilities.

3. On the Utilities panel > Utilities rollout, choose Asset Browser.

 The Asset Browser is displayed.

4. In the Asset Browser, Navigation area, navigate to the courseware CD that contains the folder for this chapter.

 All files in that directory display as a thumbnail.

5. In the thumbnail area, choose *Tablecloth.max*.

 Note: Do not double-click a MAX file, as this opens another **3ds max** session.

6. Drag and drop this file into the Camera viewport.

7. Choose Merge File from the menu displayed.

```
Open File
Merge File
XRef File

Cancel
```

8. The tablecloth is merged into the scene but it is "stuck" to the mouse.

9. In the Camera viewport, move the tablecloth into position, and then click.

10. In the Asset Browser, choose *Hanging Lamp.max*.

11. Hold down CTRL and drag and drop the file into the Camera viewport.

12. Choose Merge File from the menu.

The lamp is not "stuck" to your mouse. Holding down CTRL tells it to retain its location in space based on when the file was saved.

13. Hold down CTRL and drag and drop *Goblets.max* into the current scene.

14. Choose Merge File from the menu.

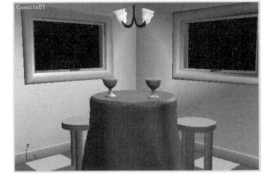

Note: The objects merged in the previous scene match the scale of the scene because care was taken during the modeling process. If scale is not considered when modeling, you might find that contents of merged files from other sources do not match the scale of your current scene. In these cases, you have to transform the objects to match the scale and orientation of your scene.

You can also Open or Merge files in **3ds max** by dragging and dropping them into **3ds max** from the Windows Explorer or a directory window.

DRF Files

The Discreet Render Format (DRF) is the file format for VIZ Render. This rendering tool is included with Autodesk Architectural Desktop 2004, and is quite similar to MAX files from previous versions of Autodesk VIZ. The DRF file type can be accessed from the File > Open dialog.

DRF files cannot be merged or imported into an existing scene. Once open, they have to be saved as MAX files to save the changes.

When opening DRF files, you are often told that maps are missing. To locate the maps, use the Configure Paths dialog to add the VIZ Render directories to the dialog.

VIZ Render Objects are called Linked Geometry. You can continue to add modifiers to these objects, and the modifiers are added to all instances of that object.

Opening DRF Files

In the next procedure, you open a DRF file.

1. On the menu bar, choose File > Open.

2. In the Open File dialog > File of Type drop-down list, choose VIZ Render (*.drf)

3. Choose *desert_house.drf* from the courseware CD.

4. On the main toolbar, choose Layer Manager.

5. In the Layer dialog, open houseIO layer and choose Body.

6. On the Layer dialog toolbar, choose Select Highlighted Objects and Layers.

7. On the command panels, choose Modify.

The Object type is Linked Geometry and there is an instanced UVW XForm modifier assigned.

8. Press Delete.

Note: On the Status Bar, it reads Actively Linked Objects cannot be deleted.

9. Right-click to activate the Quad Menu.

Note: Objects cannot be Converted to another object type.

File Link Manager

File Link allows the artist to import geometry from DWG files and work with the data in 3ds max. If changes are then made to the original file, 3ds max can "reload" that file and all changed data is reliably reflected in the 3ds max file. You access File Link, by choosing File > File Link Manager from the menu bar.

Similar to DRF files, the object type is Linked Geometry and cannot be deleted or converted into another object type.

File Link Manager has a Bind option that stops the Linking and converts the objects into either Editable Splines or Editable Meshes depending on whether they are 2D or 3D objects.

Using File Link

1. Start 3ds max.
2. On the menu bar, choose File > File Link Manager.
3. In the File Link Manager > Attach tab, choose File.

4. In the Open dialog, choose *desert_house.dwg* from the courseware CD.
5. In the File Link Manager, choose Attach this File.

Note: Multiple files can be Linked.

6. In the File Link Manager > Files tab, the name of the file displays and confirming it is Linked.

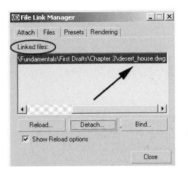

7. In the Perspective viewport, choose one of the objects.
8. On the command panels, choose Modify.

 The Object type is Linked Geometry.
9. In the File Link Manager dialog > Files tab, choose Bind.
10. In the dialog, choose Proceed with Bind.

11. Choose one of the objects.

The object type is Editable Spline since this is a 2D object and the link is broken.

Units

When discussing units, you must be aware that there is an internal system unit **3ds max** uses to track all measurements. **3ds max** uses many numerical values. For example, when making a sphere, the Radius is set with a number. But what does this number represent?

By default, **3ds max** uses a measurement called a generic unit. A generic unit can be defined to represent any distance you like. For example, a generic unit can represent one inch, one meter, three meters, or ten miles. When working on projects where multiple scenes are combined, all artists must agree on the measurement attributed to the generic unit.

You can specify use of a particular unit measure in all displays throughout **3ds max**. For example, you can state that a feet/inches system is used in a particular scene. Instead of a sphere's Radius expressed as a lone number, the measure appears on the command panel with feet/inches notation such as 3'6". This feature is useful when precision is required, as with architectural or engineering models.

No matter what kind of units you use, the program maintains measurements in an absolute unit for storage and computation. This means you can merge a model created with any standard unit into your scene at true scale. The software converts the model to the units currently active in your scene.

The default system unit in this program is defined as 1.000 inch. As long as the system unit is left at one inch, you can freely share models and change units on the fly with no effect on the underlying geometry. Except in rare circumstances, you never need to change this default scale.

Do not reset the system unit unless you have a clear need to do so.

Working with Units

1. On the menu bar, choose File > Reset to reset **3ds max**.

2. On the menu bar, choose Customize > Units Setup.

The Units Setup dialog is displayed.

3. In the Units Setup dialog, click System Unit Setup.

 The System Unit Setup dialog is displayed, and you can verify that 1 System Unit is equal to 1 inch.

4. In the System Unit Setup dialog, choose OK.

5. In the Units Setup dialog, choose Metric.

6. From the Metric drop-down list, choose Meters.

7. Choose OK to close the dialog.

8. On the Create panel, choose Sphere.

9. In the Top viewport, click and drag to create a sphere of any size.

Note: The Radius is now expressed as a number with the letter m after it. This m is the abbreviation for meters.

10. On the menu bar, choose Customize > Units Setup.

11. In the Units Setup dialog, choose US Standard.

12. From the US Standard drop-down list, choose Feet w/Fractional Inches.

13. Choose OK to close the dialog.

 The sphere's Radius value is now displayed in feet and inches.

Creating and Modifying Objects

On the Create panel, seven icons are available for creating seven different types of objects.

Geometry—Creates 3D objects for modeling and animation.

Shapes—Creates 2D shapes for modeling and animation.

Lights—Creates light objects to illuminate the scene.

Cameras—Places virtual cameras to view the scene from a specific angle.

Helpers—Creates non-renderable objects that "help" with animation and precision.

Space Warps—Creates non-renderable objects that affect objects bound to them based on world space.

Systems—Creates multi-part objects for special purposes.

Each icon displays a different set of commands. A drop-down list is also displayed for each option. The default interface for **3ds max** has the Create panel chosen and the Geometry icon selected, with the Standard Primitives option displayed on the drop-down list.

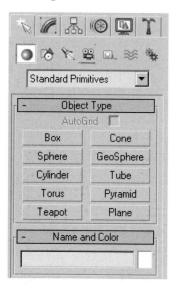

Primitives

In the world of 3D, the basic building block is called a primitive. Primitives are usually simple objects that can serve as the basis for more complex objects.

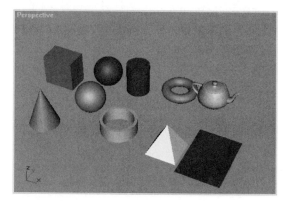

Primitives are parametric objects, meaning they can be shaped by changing parameters specific to the object. All primitives have the same rollout names on the command panel, and similar parameters on the rollouts. Objects can be created interactively on the screen, or by using the options in the Keyboard rollout. While creating primitives interactively, you can see which parameters you are affecting by watching the values in the Parameters rollout.

There are two categories of primitives: Standard and Extended.

To create a primitive, choose the type of primitive from the command panel, then click and drag in a viewport. Some objects require just one click and drag operation, while others require additional mouse movements and clicks to complete the object.

All objects are created on the Home grid. The Home grid is a fixed-sized plane in 3D viewports such as Perspective, Camera, and Light. Its default size is 140 x 140. In the 2D orthographic viewports, and the User viewport, the home grid is infinite, and resizes as you zoom into and out of the view.

In **3ds max**, you can build your own grids as Helper objects, or you can choose to turn on Autogrid. When Autogrid is turned on, you are able to create an object off the surface of an existing object.

Creating Primitives

1. On the menu bar, choose File > Reset to reset **3ds max**.

2. On the command panels, choose Create.

 Note: Create is the default.

3. On the Create panel > Object type rollout, click Sphere.

4. In the Top viewport, click and drag anywhere to create a sphere of any size.

 Note: Leave some room in the viewport for additional primitives.

5. On the Create panel > Object type rollout, choose Box.

6. In the Top viewport, click and drag to create the base of the box, then release the

mouse and drag upward to create the height of the box. Click to set the height.

Tip: Watch the values in the Parameters rollout.

Note: If you are running out of drawing space, in the viewport navigation controls, choose Zoom and zoom out in the Top viewport.

7. On the Create panel > Object type rollout, choose Cylinder.

8. In the Top viewport, click and drag to create the base of the cylinder. Release the mouse and drag upward to create the height of the cylinder, and then click to set the height.

9. Continue to create all primitives listed in the Object Type rollout.

AutoGrid

AutoGrid is a feature that allows you to align and snap an object you are creating to the surface of another object. When AutoGrid is turned on, any object you create is oriented to a coordinate system tangent to the face the cursor is over when you start creating, and the object's pivot point is positioned on that face.

AutoGrid is accessed via a checkbox located on the Create panel, in the Object Type rollout. It is available for all objects that can use the AutoGrid feature. An object type has to be selected before you can turn AutoGrid on and off.

When AutoGrid is turned on an axis tripod follows your cursor, to help you orient the grid. When a primitive object has Smooth turned on, the tripod is oriented to the implied surface, not the actual face.

While you are creating, a temporary grid is shown, allowing you to see the orientation of your object. If you want to make the grid permanent, hold down the ALT key before you click. The grid is added to your scene as a Grid helper object and is set as the active grid. When you extract a Grid Helper object with the ALT key, AutoGrid is turned off.

Using AutoGrid

1. Start a new scene in 3ds max.

2. On the Create panel, choose Box, and create a Box in the Top viewport.

3. On the Create panel, choose Cylinder.

4. On the Create panel > Object Type rollout, turn on AutoGrid.

5. In the Perspective viewport, move the cursor over the box to see the tripod orientation.

6. Create a Cylinder on the side of the box.

Notice the grid showing you the orientation of the Cylinder.

7. Hold down the ALT key and create a Cylinder coming off of the cylinder you just created at an angle.

This time the grid remains in the scene.

8. Create another Cylinder.

Now objects that you create in the scene are oriented to the grid.

To return to creating objects using the original grid, select the new grid, right-click, and choose Activate HomeGrid from the quad menu.

AutoGrid and the Asset Browser

Adding further functionality to the AutoGrid feature, if AutoGrid is turned on and you merge a file into your scene using the Asset Browser, the objects from the merged scene are attached to your cursor and auto-align their orientation to the surface of the object your cursor is over. The world origin from the merged scene is attached to your cursor, and the Z-Axis from the scene is aligned to point away from the object.

If your scene has several levels in it, such as a landscape, this saves you the time of having to move objects into place after merging. This method can also be used to merge pictures and light fixtures onto walls.

Note: To turn AutoGrid on and off to be used with the Asset Browser, an object type must be selected in the Object Type rollout.

Using AutoGrid with Asset Browser

1. Start 3ds max.

2. On the menu bar, choose File > Open and open *Chap03_01.max* from the courseware CD.

3. On the Create panel, choose Box and turn on Auto Grid.

Any object can be chosen.

4. On the command panels, choose Utility.

5. In the Utilities rollout, choose Asset Browser.

6. Navigate to Chapter 3 on the courseware CD, and choose Goblets.

7. Drag and drop the file into the Perspective viewport, and choose Merge File from the menu.

8. Move your cursor around and notice the objects align to the surfaces of the objects in the scene.

9. Place them on top of the table and make sure to click to accept the location.

Modifying Objects

Immediately after an object is created and before you choose anything else, you can still change the object's parameters on the Create panel. However, once you choose another option or object, you have to use the Modify panel to adjust the object's parameters.

The Modify panel displays a Parameters rollout for the selected object. This rollout is identical to the Parameters rollout on the Create panel.

The Modify panel is where parameters are changed after creation of an object, and modifiers are applied to further manipulate its shape. The use of the Modify panel is covered in more detail later in this chapter.

Note: To avoid creating unwanted geometry while in Create mode, choose Modify from the command panels immediately after creating an object.

Changing Parameters

When a parameter is set by a numerical value, you can change it in any of the following three ways:

- Highlight the original value, type in a new value to overwrite the existing value, and press **ENTER** on the keyboard.

- Click either one of the spinner arrows to increase or decrease the value by a small amount.

- Click and drag upward or downward on the spinner arrows to increase or decrease the value by a large amount.

Tip: Holding down CTRL while manipulating a spinner increases or decreases the numbers by greater increments. Holding down ALT while manipulating a spinner increases or decreases the numbers by smaller increments.

Object Name and Color

When an object is created, it is assigned a color and a unique name. The name consists of the type of object created and a number. For example, the first sphere created in the scene is given the name Sphere01, while the next sphere is named Sphere02. The name of the object is displayed in the Name and Color rollout on the Create panel, and at the top of the Modify panel.

By default, **3ds max** assigns object colors randomly. This makes objects distinct during the creation phase.

Both the default object name and color can be changed at any time, either in the Name and Color rollout on the Create panel, or at the top of the Modify panel.

Note: An object's default color differs from its material. Default colors are assigned to objects to differentiate them from one another during the modeling process, but you will want to create specially designed materials to assign to objects for a final rendering.

By choosing the color swatch next to the Name area, the Object Color dialog is displayed.

Here you can select from a number of preset colors, or choose Add Custom Colors to create a custom color. If you don't want random colors assigned to objects, you can turn off the Assign Random Colors check box.

Changing Parameters

1. On the menu bar, choose File > Reset to reset **3ds max**.

2. On the Create panel > Object Type rollout, click Box.

3. In the Top viewport, create a box of any size.

4. On the Create panel > Parameters rollout, change Length to **95**, Width to **90**, and Height to **80**.

5. On the Create panel > Object Type rollout, choose Sphere.

6. In the Top viewport, create a sphere about the same size as the box.

 Note: You can no longer see the box's parameters on the command panel.

7. ▷ On the main toolbar, choose Select object.

8. In the Top viewport, choose the box to make it active.

 Note: To select the box, you must choose its outline.

9. ▨ On the command panels, choose Modify.

 The box's parameters are displayed near the bottom of the panel.

10. In the Parameters rollout, begin to adjust the box's parameters as desired.

11. At the top of the Modify panel, highlight the default object name Box01.

12. Type in **Package** and then press **ENTER**.

13. Choose the color swatch to the right of the name.

 The Color Selector is displayed with 64 default object colors to choose from.

14. In the Color Selector dialog, choose a different color for the object.

15. Choose OK to set the color and close the dialog.

AEC Extended Objects

AEC Extended objects include Foliage, Railing, and Wall. These objects are designed for the architectural and construction fields. Like Primitives, they are parametric objects. You simply choose the type of object you want to create, watch the settings in the Parameters rollout, and create your specific AEC object. Some AEC objects, such as Wall, have a sub-object level available from the modify stack display. This allows you to further edit the object, and add details such as gables. You build this object next.

Creating a Wall and Door

1. Start **3ds max 7**.

2. On the menu bar, choose Customize > Units Setup.

3. In the Units Setup dialog > Display Unit Scale group, choose US Standard.

4. In the drop-down list, choose Feet w/ Decimal Inches, and then choose OK.

5. Press **S** to turn on Snaps.

6. On the main toolbar, right-click Snap Toggle.

7. In the Grid and Snap Settings dialog, choose Home Grid.

8. In the Grid Dimensions group, change Grid Spacing to **1'0.0"**, and close the dialog.

9. On the command panels, choose Create.

10. In the Geometry drop-down list, choose AEC Extended.

11. In the Object Type rollout, choose Wall.

12. In the Top viewport, pan the 0,0,0 grid line to the bottom left of the viewport.

13. In the Top viewport, click once at 0,0,0, move up 10 feet, and click.

14. Continue to click and move to create a wall structure like the following image.

15. Answer Yes to weld the walls, and right-click to stop creating more wall objects.

16. On the command panels, choose the AEC Extended drop-down list, and choose Doors.

17. In the Object Type rollout, choose BiFold.

18. In the Top viewport, move your mouse to X: 3'0"; Y: 10'0".

19. Click and drag three times to create a door.

20. In the Parameters rollout, change Height to **6'6"**, Width to **4'0"**, and Depth to **5"**.

Note: Make sure the door is inside the Depth of the Walls.

21. In the viewport navigation controls, choose Arc Rotate.

22. In the Perspective viewport, Arc Rotate to view the front of the door.

23. In the Parameters rollout, set Open to **75%**.

24. In the Parameters rollout, turn on Flip Swing.

Note: The door is opened and cuts a hole in the wall object automatically.

Adding a Gable

Next you add a gable to the wall object.

1. Continue from the previous exercise.

2. In the Perspective viewport, choose the Wall object.

3. On the command panels, choose Modify.

4. In the modify stack display, choose the plus sign next to Wall to open the sub-object level.

5. In the modify stack display, choose Profile.

6. In the Perspective viewport, choose the Front Wall.

7. In the Edit Profile rollout, set Height to 5'0".

8. In the Edit Profile rollout, choose Create Gable.

Splines

A spline, also referred to as a 2D shape, is one (and sometimes more than one) continuous line (open or closed) without depth. Splines are a crucial ingredient in 3D object modeling. Splines serve as the basis for simple 3D geometry such as extruded text, and for complex geometry such as heads. For example, you can create a rectangle and define an extrusion amount to create a cube. Or, you can create a collection of splines to use with specific modeling techniques for creating more organic objects.

By default, splines are set as non-renderable objects. This means that if you create a spline and render, the spline does not display in the rendered frame window. However, you can turn on a thickness setting for each spline. This option works well for neon text or for modeling a lot of wires or cables.

Splines can also be used in animation. For example, you can assign a camera to follow a path.

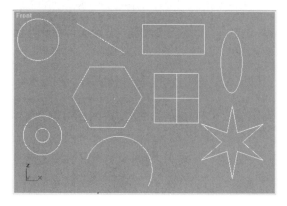

You can choose to create 2D shapes by choosing Shapes from the command panel.

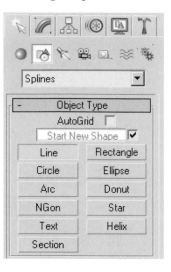

On the Create panel, notice a Start New Shape check box in the Object Type rollout. This check box can be turned off to create a series of splines as part of the same shape. For example, the default is set to create a new object each time you choose to create a shape. Frequently, you will want to turn off the Start New Shape check box to build nested polygons. Nested polygons are shapes within shapes like the letters A, D, O, and others.

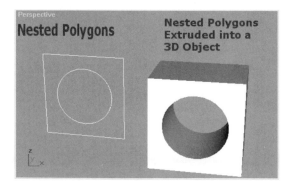

When you create shapes, notice they too are parametric objects. You can edit their parameters after you create them. For example, the following Parameters rollout shows the options available for manipulating a text object after it has been created. You can change the Font, Size, Kerning, Leading, and even the Text itself after it has been created.

Creating Shapes

1. On the menu bar, choose File > Reset to reset **3ds max**.

2. On the Create panel, choose Shapes.

3. On the Create panel > Object Type rollout, choose Circle.

4. In the Front viewport, click and drag to create a circle.

5. On the Create panel > Object Type rollout, choose Rectangle.

6. In the Front viewport, click and drag to create a Rectangle.

7. In the viewport navigation controls, choose Pan.

8. In the Front viewport, pan to make room for more shapes.

9. On the Create panel > Object Type rollout, choose Star.

10. In the Front viewport, click and drag to create the outer size of the star. Release the

mouse and move the cursor toward the center of the star to create its points.

11.On the Create panel > Parameters rollout, change Points to **5**.

The star now has 5 points.

12. 🖐 In the viewport navigation controls, choose Pan.

13.In the Front viewport, pan to make room for more shapes.

14.On the Create panel > Object Type rollout, choose Line.

15.Click in the Front viewport to start the line.

16.Move the cursor and click again to make a straight line.

17.Continue to move the cursor and click to create more segments for the line.

18.Right-click to end the line.

Modifier Stack Display

As soon as you create an object, whether it is a 2D shape, a 3D primitive, a light, or a camera, the next thing you want to know is how to modify what you created. Modifying what you created can mean changing the size of an object by changing the Radius parameter. It can also mean distorting or manipulating the object in some way other than by changing the parameters. Once you decide what to modify, you need to become acquainted with the options in the Modify panel. The Modify panel is divided into two areas: the modifier stack display, and the

rollouts specific to the type of object you created.

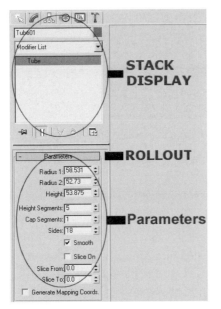

Note: Each rollout have there own set of parameters.

In this area, you learn some basic concepts of the modifier stack display. Chapter 10 discusses specific workflow features and modeling techniques in more detail.

Near the top of the Modify panel, you find the words Modifier List displayed in the drop-down list. You can either choose or right-click the drop-down list.

When you choose the drop-down list, a long list of options are displayed. These options are called modifiers.

A modifier changes an object in some way. The modifiers on the list are displayed in different categories according to their functions. Although the list might seem overwhelming at first, you become accustomed to using some modifiers more frequently than others.

When you right-click the drop-down list, a right-click menu is displayed.

Configure Modifier Sets

Show Buttons
Show All Sets in List

>Selection Modifiers
Patch/Spline Editing
Mesh Editing
Animation Modifiers
UV Coordinate Modifiers
Cache Tools
Subdivision Surfaces
Free Form Deformations
Parametric Modifiers
Surface Modifiers
Conversion Modifiers

This menu allows you to do the following:

- Filter the modifier display in the drop-down list.
- View categories of modifiers as buttons that display below the drop-down list.
- Configure your own modifier sets.

Adjusting the Modifier Stack Display

1. On the menu bar, choose File > Reset to reset **3ds max**.

2. On the command panels, choose Create > Geometry > Box.

3. In the Top viewport, click and drag to create a box.

 This size does not matter.

4. On the command panels, choose Modify.

5. On the Modify panel, choose the Modifier List drop-down.

 The list of modifiers is displayed.

6. Choose the drop-down again to close the list.

7. On the Modify panel, right-click the Modifier List drop-down.

8. On the right-click menu, turn on Show All Sets in List.

9. Choose the Modifier List drop-down.

Use Pivot Points

Selection Modifiers
 Mesh Select
 Patch Select
 Poly Select
 Vol. Select
Patch/Spline Editing
 Edit Patch
 DeletePatch
Mesh Editing
 DeleteMesh
 Edit Mesh
 Face Extrude
 Normal
 Smooth
 Tessellate
 STL Check
 Cap Holes
 VertexPaint
 Optimize
 MultiRes
Animation Modifiers
 Skin
 Morpher
 Flex
 Melt
 Linked XForm
 PatchDeform
 PathDeform
 SurfDeform
 * PatchDeform
 * PathDeform
 * SurfDeform
UV Coordinate Modifiers
 UVW Map
 Unwrap UVW
 UVW Xform
 * Camera Map
 Camera Map
 * MapScaler
 * Surface Mapper
Cache Tools
 Point Cache
 * Point Cache
Subdivision Surfaces
 HSDS
 MeshSmooth
Free Form Deformations
 FFD 2x2x2
 FFD 3x3x3
 FFD 4x4x4
 FFD(box)
 FFD(cyl)
Parametric Modifiers
 Bend
 Taper
 Twist
 Noise
 Stretch

The modifiers are listed differently.

10. Choose the drop-down list again to close the list.

11. Right-click the Modifier List drop-down.

12. Choose Parametric Modifiers from the right-click menu.

13. Right-click the Modifier List drop-down.

14. Choose Show Buttons from the right-click menu.

Configure Modifier Sets

✔ Show Buttons
Show All Sets in List

Conversion Modifiers
Surface Modifiers
>Parametric Modifiers
Free Form Deformations
Subdivision Surfaces
Cache Tools
UV Coordinate Modifiers
Animation Modifiers
Mesh Editing
Patch/Spline Editing
Selection Modifiers

Buttons showing the Parametric Modifiers are displayed below the drop-down list.

Box01

Modifier List

Bend	Taper
Twist	Noise
Stretch	Squeeze
Push	Relax
Ripple	Wave
Skew	Slice
Spherify	Affect Region
Lattice	Mirror
Displace	XForm
	Preserve

Box

— Parameters
Length: 27.243
Width: 32.558
Height: 25.914
Length Segs: 1
Width Segs: 1
Height Segs: 1
☐ Generate Mapping Coords.

15. Right-click the Modifier List drop-down.

16. Choose Configure Modifier Sets from the right-click menu.

17. The Configure Button Sets dialog is displayed.

This dialog allows you to create a custom modifier setup. As you increase your use of **3ds max 7,** and develop a personal work style, you will want to revisit this area and put the modifiers you use most in your own button sets.

18. In the Configure Button Set dialog, choose Cancel to close the dialog.

Applying a Modifier

To use a modifier, you simply select it from the list. Once you have chosen the modifier, you see it in the modifier stack display. Think of the modifier stack display as a history stack; each time you choose a modifier from the modifier list drop-down, it appears in the stack display. The history begins with the type of object, which is called the base object,

then continues with the modifiers that have been placed on top of the base object. In the following image, the base object is the Cylinder and the modifier applied is Bend.

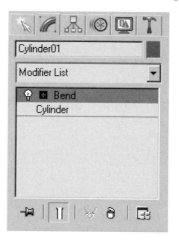

When a modifier is applied to an object, it does not change immediately. On the Modify panel, notice the displayed parameters are for the current modifier selected in the stack display. For the modifier to affect the object, you must adjust the parameters in the Parameters rollout.

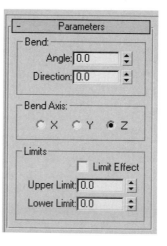

Several modifiers can be applied to an object by choosing them from the drop-down list. As modifiers are applied to the object, they appear at the top of the modifier list in the order they are applied. The last modifier applied to the object appears at the top of the list. The base object is always at the bottom of the list.

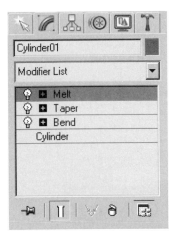

To display a particular modifier's parameters when there is more than one modifier in the stack display, simply choose the modifier for which you want information.

All modifiers cannot be used with all types of objects. For example, some modifiers can be applied to 2D shapes, but not 3D objects. When you choose the drop-down list to display the available modifiers, only those applicable to the selected object are displayed.

Modifiers can be dragged and dropped from one object to another. They can also be re-arranged interactively in the modifier stack display. More modifier stack display options are discussed in the Modeling Module.

Using Modifiers

1. On the menu bar, choose File > Reset to reset **3ds max**.

2. On the command panels, choose Create > Geometry > Sphere.

3. In the Top viewport, create a sphere with a Radius of approximately 40 units.

4. On the command panels, choose Modify.

 Note: Show buttons might still be active if you continued from the previous exercise.

5. On the Modify panel > Modifier List drop-down, choose Taper.

 Tip: Pressing **T** cycles down the list to Taper.

 The Taper modifier is applied to the sphere, and appears on the modifier stack display .

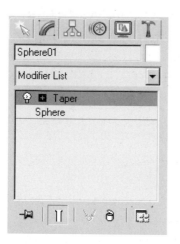

6. On the Modify panel > Parameters rollout, change Amount to **–1.35**.

7. In the Parameters rollout, change Curve to **–1.1**.

 The sphere now resembles a Hershey's Kiss candy.

8. On the command panels, choose Create.

9. On the Create panel > Object Type rollout, choose Cylinder.

10. In the Top viewport, create a cylinder next to the sphere.

11. On the Create panel > Parameters rollout, change Radius to **5**.

12. In the Parameters rollout, change Height to **150**.

13. On the command panels, choose Modify.

14. On the Modify panel > Modifier List drop-down, choose Bend.

 The Bend modifier has been applied to the cylinder, and appears in the modifier stack display.

15. On the Modify panel > Parameters rollout, change Angle to **–80**.

The cylinder bends.

Object Selection

Before you can change an object's parameters, transform the object, animate, or even delete an object, you must first select it. Your skill in selecting one or more objects plays a vital role in how successfully you work with **3ds max**.

Selecting One Object

The simplest way to select an object is to choose it in the active viewport. You can use any of the following options to select an object.

- Choose Select object from the main toolbar.

- Choose an object with any active transform.

- Press **II** or choose the Select by Name Icon from the main toolbar.

- Click and drag in the viewport to create a rectangular selection around the object.

Selecting More than One Object

When Selecting objects, you often want to select more than one object or omit certain objects from the selection. This is done by using Keyboard functions and interface options. Here is a list of options to use to select more than one object.

- CTRL + CLICK adds objects to the selection, or removes a selected object from the selection.

- ALT + CLICK unselects an object from the current selection.

- Clicking and dragging in a viewport draws a rectangular bounding area around objects. When you release the mouse, objects inside the bounding area are selected.

Note: By default, the bounding area is drawn as a rectangle. If you change the Rectangular Selection Region flyout from

the main toolbar, you can alter this to a Circular, Fence, Lasso, or Paint Selection.

Window and Crossing

When you select objects with a rectangular selection, a toggle found on the main toolbar determines the effect of the bounding area on the objects. The toggle has two options explained below.

Window Selection—Any object (s) that is/ are fully inside the bounding area is/are selected.

Crossing Selection—Any object (s) inside the bounding area or object(s) touching the bounding edge is/are selected.

Select by Name

Objects can also be selected by choosing the Select by Name icon from the main toolbar. The Select Objects dialog displays a list of all objects in the scene. You can also access this dialog by pressing the **H** key.

Tip: When a scene has many objects, which overlap in viewports, it can be difficult to select them by clicking in the viewport. The Select Objects dialog solves this problem.

Making Selections using Select by Name

1. On the main toolbar, choose File > Open and open *Chap03_01.max* from the courseware CD.

2. On the main toolbar, choose Select by Name.

3. In the Select Objects dialog, choose Table base.

4. In the Select Objects dialog, hold down CTRL and choose Floor.

Two objects are now selected in the list.

5. In the Select Objects dialog, choose Stool leg 02-01.

6. Hold down SHIFT and choose Stool seat 02.

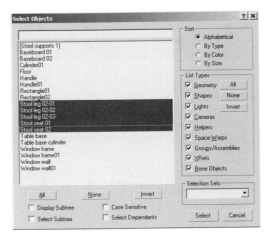

All objects between the two chosen become selected.

7. In the Select Objects dialog, choose Select.

The objects are selected in the viewport.

Note: By using this method of selection, you can see the importance of giving your objects recognizable names. Selection by name can be difficult when an object retains its default name.

Locking a Selection

When multiple objects are selected, it is a good idea to lock your selection. Locking your selection ensures you cannot choose another object or "lose" your current selection of objects.

Locate the Lock Selection icon on the Status bar, or activate the Lock Selection icon by pressing the SPACEBAR.

Selection Sets, Groups and Layers

Selection Sets, Groups, and Layers are ways in which you can organize objects in your scene. These three options perform similar functions but the workflow for each differs. Also, Selection Sets are extremely useful at the sub-object level of an object whereas Groups are useful at the object level. Users familiar with CAD will welcome Layers as an easy way to manage the information in their scenes.

Selection Sets

Selection Sets allow you to assign a name to a set of selected objects. This feature is useful because as you place objects in your scene, you often want to transform the same selection of objects. When a Selection Set has been defined for a set of objects, you can select those objects with just one click, rather than selecting the objects each time with the Select by Name icon.

Naming a Selection Set

1. Continue from the previous exercise.

2. On the main toolbar, choose Select by Name.

3. In the Select Objects dialog, choose Cylinder01.

4. In the Select Object dialog, hold down CTRL and choose Table base and Table base cylinder.

5. In the Select Objects dialog, choose Select.

The three objects that make up the table are selected.

6. 🔒 On the Status bar, choose Lock Selection Toggle.

7. In the Front viewport, begin to choose other objects.

You cannot choose other objects because the Lock Selection Set is turned on.

8. On the main toolbar, click inside the drop-down list.

9. In the Named Selection Sets Type-In area, type **Table** and then press **ENTER**.

The selection set is named.

Note: If ENTER is not pressed, the Selection Set is not created.

10. Press **SPACEBAR** to turn off Lock Selection Set.

11. Click anywhere in the Front viewport.

The selected objects are no longer selected.

12. On the main toolbar > drop-down list, choose Table.

The objects for the table are selected.

13. Press the **H** key.

The Select Objects dialog is displayed.

14. In the Select Objects dialog, the objects are selected as individual objects.

Note: The Select Objects dialog has a Selection Sets drop-down list.

15. In the Select Objects dialog, choose Cancel.

Editing a Selection Set

You can edit a named selection set once it has been created. Your reasons for doing so

might include correcting a spelling error made when typing your selection name, or deciding to add/remove an object from the selection set. Whatever the reason, you will want to edit your named selection sets.

1. Continue from the previous exercise.

2. On the main toolbar, choose Named Selection Sets.

3. In the Named Selection Sets dialog, choose the plus sign next to Table.

The Named Selection Sets dialog is displayed with the name of the selection set, and the objects in the selection set are displayed.

4. In the Named Selection Sets area, choose Table.

The icons at the top of the dialog, and the objects inside the selection set, become active.

5. In the Named Selection Sets dialog, right-click Table.

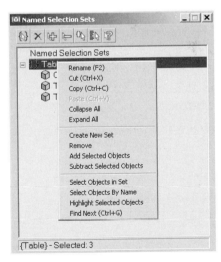

A right-click menu is displayed for options to delete the selection set, add/

remove individual objects from the selection set, and to rename the selection set.

6. In the Named Selection Sets dialog > right-click menu, choose Remove.

7. Close the dialog.

8. On the main toolbar > choose the Named Selection Sets drop-down list.

 The Selection Set is removed.

9. On the main toolbar, choose Named Selection Sets.

10. On the main toolbar, choose Crossing.

11. In the Front viewport, region-select the left stool.

12. In the Named Select Sets toolbar, choose Create New Set.

13. Name the new set Left Stool.

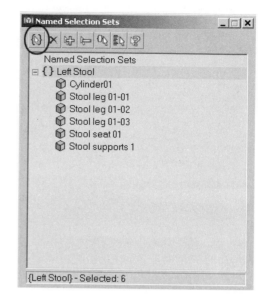

You can name, rename, add, remove, and combine selection sets within this dialog.

Groups

Groups are also used for organizing multiple objects in the scene. However, their workflow and edit features differ widely from Selection Sets. The following list outlines the main differences between Selection Sets and Groups.

- When you create a group, individual objects that are grouped are treated as one object.

- Individual objects that are grouped are displayed with the group name rather than their object name.

- The group name appears on all object lists with brackets.

- In the Name and Color rollout, a group name is shown in bold.

- When you select any object that is part of a group, the entire group is selected.
- To edit an object within a group, you must first open the group.

You can apply modifiers and animation to a group. If you decide to ungroup the objects, each object retains the modifier but loses the animation.

As a general rule, you should avoid animating objects within groups or selection sets. There are specific linking options used for animating multiple objects.

If you decide to animate a group, you discover that all objects carry keyframes. This means if you animate the position track of the group, and display the trajectories for the animated group, then a trajectory is displayed for each group object. In groups with many objects, this can cause a confusing tangle of crisscrossed lines to fill the screen. In practice, grouping works best for a set of objects that need to be accessed together, but which won't be animated.

Creating a Group

1. Continue from the previous exercise.

2. On the main toolbar, choose Crossing Selection.

3. In the Front viewport, click and drag a rectangular selection from the top of the right- side stool and the top of the legs.

The objects are selected.

4. On the menu bar, choose Group > Group.

The Group dialog is displayed.

5. In the Group dialog > Group name, type Stool and then press OK.

6. On the Modify panel > Name and Color area, the name Stool appears in bold.

7. Press the **H** key.

8. In the Select Objects dialog, Stool appears in brackets and the objects that form part

of the group are no longer listed individually.

9. In the Select Objects dialog, choose Select.

10. In the Front viewport, choose a different object.

11. In the Front viewport, choose any object in the Stool group.

 All objects within the group are selected.

12. On the menu bar, choose Group > UnGroup.

 The group named Stool is now ungrouped.

13. Press the **H** key.

The objects are listed individually.

Layers

Another way to organize the contents of your scene is to use Layers. Layers resemble transparent overlays on which you organize and group different kinds of scene information. The objects you create have common properties including color, visibility, renderability, and display. An object can assume these properties from the layer on which you create it. For example, you might want to set up a layer for merging only detailed characters. To do this, you create a layer and set Viewport Display to Bounding Box. This quickens the viewport display. Then, whenever you want to merge detailed characters, switch to this layer. You don't need to set up your viewport display every time you import new characters. Also, if you don't want to render the character, you can turn off that layer's Renderable property.

Using Layers

1. On the menu bar, choose File > Open and open *Chap03_01.max* from the courseware CD.

2. In the Front viewport, choose Cylinder01, Table base, and Table base cylinder.

3. On the main toolbar, choose Layer Manager.

There is a plus sign next to Layer 0 and a check mark after the name. The plus sign lists all objects in the layer, and the check mark indicates this layer is active.

4. In the Layer dialog, choose Create New Layer (containing Selected Objects) from its toolbar.

5. Click Layer01 and type **Table**.

Note: The new Layer becomes the active Layer.

6. Open the Table layer by choosing the plus sign.

The three objects are part of the Table layer.

7. In the Hide column, click the dash next to Table.

All objects in the Table Layer are hidden. You can also use the Freeze column to freeze all objects in a layer.

8. In the Hide column, choose the glasses to see the Table layer again.

The Render column differs slightly from the Hide and Freeze columns. Currently the Render column shows all teapots, meaning all objects will render. If you turn off the teapot for the Table Layer, the teapots on the objects in the layer stay on, and the objects still render.

Clicking the object's teapots differs slightly though: they cycle through a dash, dot, and a teapot. A dash means the object will not render at all, a teapot means the object will render, and a dot means the object inherits its renderability from the layer.

The Radiosity column works the same as the Render column.

9. In the Render column, leave Table base on a teapot, set Table base cylinder to a dash, and set Cylinder01 to a dot.

10. Right-click in the Camera viewport to make it active.

11. On the main toolbar, choose Quick Render.

The Table base cylinder does not render because you have its rendering turned off.

12. In the Render column, click the teapot for the Table Layer.

13. On the main toolbar, choose Quick Render.

This time the table top does not render because you have it set to follow the layer's rendering.

14. Repeat the previous steps with all three objects set to dots so you see how easy it is to block an entire layer from rendering.

15. In the Layer dialog, make sure Table is selected and active. If Table is not active, click in the column between Layers and Hide to activate it.

A check mark appears next to the Table layer, indicating this is the active layer.

16. On the command panels, choose Create > Teapot.

17. In the Camera viewport, create a Teapot on top of the table top.

Tip: You might want to turn on Autogrid to make the teapot.

18.In the Layers dialog, notice the teapot was added to the active layer.

Objects are created on the active layer.

Removing objects from Layers and Deleting Layers

1. Continue from the previous exercise.

2. Click in the Front viewport to unselect all objects.

3. In the Layer dialog, choose Create New Layer.

4. Rename the Layer to Teapot.

5. In the Table layer, right-click teapot, and choose Cut from the right-click menu.

6. Right-click the Teapot Layer, and choose Paste.

The Teapot is now part of the Teapot layer, and this layer is active.

7. Right-click Table and choose Paste.

The Teapot is now part of the Table layer again.

8. Activate the Table Layer.

9. Right-click the Teapot Layer, and choose Delete from the right-click menu.

The Teapot Layer is now deleted.

10.In the Camera viewport, choose Teapot01, Table base, Table base cylinder, and Cylinder01.

11.Right-click in the Camera viewport and choose Properties from the quad menu.

12.In the Object Properties dialog > Display Properties group, choose By Object to set it to By Layer.

13. In the Layers dialog, click the Layer Properties button to the left of Table.

This opens the Layer Properties dialog.

The Layer Properties dialog gives you the ability to control how objects on the layer appear in the viewports and in renders. At the top, you can choose a layer color, and use the Display drop-down list to choose how objects in the layer are displayed in

the viewports, regardless of how the viewport is set.

The Display drop-down list includes four options:

Viewport - The layer is displayed using the current viewport settings.

Bounding Box - The objects in the layer are displayed as bounding boxes.

Wireframe - The objects in the layer are displayed as wireframe.

Shaded - The objects in the layer are displayed with Smooth and Highlights.

The lower area (General and Adv. Lighting tabs) offers more settings to affect how objects in the layer appear, such as transparency, or casting no shadow. For the most part, these are the same settings found in the Object Properties > General tab.

14. In the Layer Properties dialog > Display drop-down list, choose Bounding Box, and then choose OK.

The objects in the layer are displayed as boxes.

Conclusion

In this chapter, you learned to reference and merge files across networks and the Internet with a variety of methods, including the Asset Browser.

You gained a basic understanding for creating 3D objects and 2D shapes. The modifier stack display was also introduced to show how objects are further manipulated using modifiers.

To work with these objects and create scenes efficiently, understanding the options for organizing objects in your scene is important. The tools you learned in this chapter play an important role in your overall scene creation.

Transforming Objects

Objectives

After completing this chapter, you are able to:

- Directly transform objects using the tools found on the main toolbar.
- Transform objects by typing exact amounts.
- Use the snap tools.
- Understand the different coordinate systems.
- Use the alignment tools.

Introduction

3ds max 7 supports many different features and effects although many of the tools in 3ds max are not used in every scene. For example, not every scene uses particles systems, or space warps. Every scene, however, requires you to move, rotate, and scale objects. These basic and very necessary tools are called transforms. When working with transforms, you also need to understand the different reference coordinate systems that are available, and when they can be used. By using the transforms with the various reference coordinate systems, you can place and orient objects in 3D space with ease. When it comes to placing objects in the scene, the proper use of snapping tools also becomes important.

When you begin to transform objects, you also need to know how to clone (copy) one object to another location in space. Cloning in 3ds max is a powerful option that has three different features. These features and their uses are described later in this chapter.

Finally, three other transforms are also discussed. They are mirror, array and align. These tools are useful for making clones, and for perfectly placing one object onto another object in your scene.

Transforms

You use transforms to move, rotate and scale objects. You can access transforms either from the main toolbar or from the quad menu.

 Select and Move

U Select and Rotate

Select and Uniform Scale

Select and Non-uniform Scale (from Select and Uniform Scale flyout)

Select and Squash (from Select and Uniform Scale flyout)

Transforming Along an Axis

When an object is selected and no transform is chosen, then each selected object is displayed with a tripod axis. A tripod axis (or pivot point) is a three-pronged set of arrows. Each arrow, or *axis*, has a label of X, Y or Z. All objects that are created automatically have a tripod axis.

Note: Pivot points are discussed in the Animation module.

When a transform is chosen, the tripod axis turns into the transform gizmo. Each Transform has a specific gizmo that represents its function. The following images display the specific gizmo for that transform.

Move Transform—The axes are labeled the same way as the tripod axis, but the X, Y and Z arrowheads are colored red, green and blue respectively.

Rotate Transform—Three color-coded circles represent the X, Y, and Z-axes. When you place your mouse on an axis that is perpendicular to the viewport, and begin to rotate the object, a visual aid displays to indicate the amount of rotation.

Scale Transform—The scale gizmo is similar in appearance to the Move gizmo however, it contains, what appear as triangles, joining the three axes. These triangles are to accommodate the various Scale options, such as: Uniform, Non-Uniform, and Squash.

Note: The keyboard shortcut R cycles through the different scale options.

You can use the transform gizmo axes when transforming an object. When a transform is chosen, you can place your mouse on a specific axis. When the mouse is on a specific axis, that axis turns yellow, indicating that it is the axis on which the transformation occurs. When you have specified the axis, you can drag, and perform the specific transform on the restricted axis.

The Transform gizmo also allows you to transform along two axes. For the Move transform, you simply place your mouse on one of the right angles or planes.

Movement is now restricted to the Y and Z axes.

Note: The restricted axes turn yellow indicating that it transforms in that direction.

Tip: Press the (-) and (=) keys to resize the transform gizmo.

Transforms and the Modifier Stack

When you choose Select and Non-uniform Scale, or Select and Squash, you must understand the way transforms work with the modifier stack.

Internally, a transform is always applied to an object after all the modifiers on its stack are applied. Even if you later apply another modifier to the object, the transform is still be treated as if it were being applied to the object after all the modifiers were applied.

This can sometimes cause problems, especially with scaling operations. For example, suppose you use Select and Non-Uniform Scale to scale a sphere to a hot dog shape. Next, you want to bend the sphere to look more like a wiener, so you apply the Bend modifier. You find that the sphere is uncooperative and bends only slightly, no matter how much you change the Bend modifier's Angle parameter. This occurs because the Non-Uniform Scale is being applied after the Bend, ruining the effect you are trying to create.

You can get around this problem by using the XForm modifier. This modifier works just like a transform, but it resides in the modifier stack display and holds its place after other modifiers are applied. When XForm is the current modifier, you can move, rotate and scale the object as usual, using the transform options on the main toolbar.

Using the example above, if the XForm modifier was applied to the sphere first, and the scale was done at that level, you could then apply the Bend modifier and achieve the hot dog shape.

Transformation Tips

Transforms are highly useful tools, but they should not be used as a substitute for good modeling practices. Before using a scaling transform, for instance, consider whether you can achieve the same effect with a parameter change. For example, if you want to scale a sphere, you can reduce its Radius rather than use Select and Uniform Scale.

When moving, rotating and scaling objects, work in non-perspective viewports for the actual transformations, and use the Perspective viewport only for checking your work. If you try to move objects in the

Perspective viewport, you have difficulty getting the scene to look right. If objects are placed correctly in the Top, Front and Left viewports, they are correctly positioned in the Perspective viewport.

Transform Manipulator

Select and Manipulate found on the main toolbar allows you to interactively change object parameters by clicking and dragging the mouse, rather than having to change values on the command panel.

To use this tool, click Select and Manipulate, and select an object. If a manipulator is available for the object, it appears as a green line delineating the area that can be manipulated. For example, on a sphere, the manipulator line appears around the sphere, indicating that the radius can be changed interactively.

Move the cursor over the manipulator line to turn it red, then drag to manipulate the object.

You can also use manipulators to connect one object's parameters or transforms to another. This is called "wiring" two parameters together. For example, if you wire a sphere's Radius parameter to a cylinder's Height parameter and then change the sphere's radius, the cylinder's height would automatically change to the same value. You can also wire a value to an onscreen slider that allows you to change the value by dragging on the slider interactively. These techniques are covered in more detail in the **3ds max 7** on-line documentation, and in the Advanced Character Design courseware from Discreet.

Note: You do not need to activate a transform to use the Select and Manipulate tool.

Transform Type-In

Depending on your workflow and work practices with other software packages, you might be used to typing, rather than clicking and dragging or using the spinners. **3ds max** supports many type-in functions including typing in the exact placement of objects in the scene. This functionality is called the Transform Type-In dialog. This dialog is accessible by right-clicking on the selected transform from the main toolbar, selecting the appropriate symbol from the quad menu, or using the transform type-in found in the Status bar.

The Transform Type-In dialog consists of two columns of numbers: one that reads Absolute and the other that reads World. The values under Absolute transforms the object precisely, according to the values entered in World Space. For example, on the Move Transform Type-In dialog, entering X, Y, Z values of 0, 0, 40 under the Absolute column moves the object to the 0, 0, 40 position in World space.

Entering values in the Offset column transforms the object relative to its current position, rotation or scale. For example, entering 0, 0, 40 under the Offset column moves the object from its current position to 40 units further along the Z-axis.

The Transform Type-In dialog is a modeless dialog, meaning that it can be left on the screen while you perform other tasks.

The Transform Type-In is also available on the status bar. It gives you the same functionality as the dialog except that it uses a toggle for Absolute and Offset.

Transform Type-In with Absolute Toggle for the Move transform

Transform Type-In with Offset Toggle for the Move transform

Arranging Objects with Transforms

1. On the menu bar, choose File > Open and open *Chap04_01.max* from the courseware CD.

 This is a simple scene with a table and stools.

2. On the main toolbar, click Select by Name.

3. In the Select Objects dialog, select *Goblet01* then click Select.

 In the Camera viewport, the goblet on the right has a bounding box around it signifying it is selected.

4. On the main toolbar, click Select and Move.

5. Right-click in the Top viewport to make it active.

6. Press ALT + W to maximize the Top viewport.

7. In the Top viewport, place the cursor over the Y-axis until the cursor changes to look like the Select and Move icon.

8. Drag up on the Y-axis to move the goblet to the edge of the table.

9. Press ALT + W to minimize the Top viewport.

10.View the changes in the Camera viewport.

11.In the Camera viewport, select the *teapot*.

Note: The teapot's transform gizmo is at the base of the teapot.

12. On the main toolbar, click Select and Rotate.

13.In the Top viewport, place the cursor over the Z-axis of the teapot's transform gizmo.

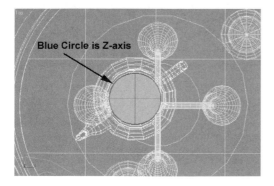

The Z-axis is the blue circle before it is chosen, once the mouse is placed over the circle, the color changes to yellow.

14.Drag to rotate the teapot approximately **135** degrees.

Tip: As you are rotating the teapot, the amount of rotation is displayed in the active viewport.

15.In the Camera viewport, select *Goblet02*.

16. On the main toolbar, click Select and Uniform Scale.

17.In the Camera viewport, place your mouse inside the first triangle shape, and scale *Goblet02* approximately 120%.

Tip: As you are scaling the goblet, watch the transform type-in on the status bar.

18. On the main toolbar, right-click Select and Uniform Scale.

The Transform Type-In dialog is displayed.

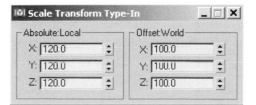

19. In the Transform Type-In dialog > Absolute column, change each of the axes values to **100**.

This resets the goblet to its original size.

20. Close the Scale Transform Type-In dialog.

21. In the Camera viewport, select one of the stool tops.

These stool tops are made from a standard cylinder primitive.

22. On the main toolbar, click Select Object and then click Select and Manipulate from the main tool bar.

The cylinder now has a green circle around it.

23. In the Top viewport, move the cursor over the stool until the green outline turns red.

24. In the Top viewport, Select the red line and drag to the right to increase the radius of the stool cylinder.

You have just changed the Radius parameter for the cylinder, rather than scaling the cylinder.

Note: In Manipulate mode, it does not matter which transform is chosen. When you drag, the radius of the cylinder is changed regardless of the transform.

Cloning Objects

Creating geometry for a scene is called modeling. An important and useful modeling technique is to create clones of your objects. These clones can be used as exact replicas, or they can be used as a base for further modifications. For instance, if you need a lot of candles in a scene, you can simply create one and clone the rest. Alternatively, if you need a lot of candles in the scene but want the clones to be slightly different then you can clone the original and add subtle changes to the copies.

There are three ways in which you can clone an object. You can either hold down the SHIFT key while you perform a transformation (move, rotate, scale), you can choose Edit > Clone from the menu bar, or you can choose to use the keyboard shortcut CTRL + V.

When you choose to clone an object by using one of these methods, the Clone Options dialog is displayed.

In the Clone Options dialog, you specify the number of clones and the type of clone. There are three types of clones available:

- Copy
- Instance
- Reference

The Copy option makes a clone that is completely independent from the original object.

An Instance is a clone that remains related to its original. For example, if you clone a sphere by making an Instance of it, and later change the Radius of either sphere, the other changes as well. Instances are related through parameters and modifiers, but not through transforms. This means that if you apply a modifier to one object, it is automatically applied to the other as well. However, if you transform one object, the other won't transform. In addition, an Instance object can have a different material and animation applied to it. Scenes load and render more quickly when Instances, rather than Copies, are used, because an Instance object takes up less memory and file space than a Copy.

A Reference is a special kind of Instance. Its relation to the clone is one way. For example, if you have two clones in the scene, the original object and a reference, and you decide to place a modifier on the original, then the reference also gets the modifier. If you decide to place another modifier on the reference object, it only affects the reference object and not the original object. In practice, reference objects are usually used for certain modeling procedures such as Patch modeling.

Cloning Game Pieces

1. On the menu bar, choose File > Open and open *Chap04_02.max* from the courseware CD.

This file contains a simple game board with one game piece. You create clones of the game pieces to complete the set.

2. In the Camera viewport, select *GamePieceRed01*.

3. ⊕ On the main toolbar, click Select and Move.

4. Right-click in the Top viewport to make it active.

 Note: You might want to right-click on the Top viewport label and choose Smooth + Highlights from the right-click menu.

5. Hold down **SHIFT** and move the game piece to one of the white squares.

The Clone Options dialog is displayed.

Tip: The suggested name of the clone is GamePieceRed02. The suggested name always has a number appended to it. Since the original object's name had the numbers 01 at the end of it, the Clone Options dialog suggests the same name, but with the numbers 02. If you're planning to clone an object, it's helpful to put the number 01 at the end of the object name so clones are named appropriately.

6. In the Clone Options dialog, leave the default settings, and click OK.

7. In the Camera viewport, select the original game piece.

8. In the Top viewport, hold down **SHIFT** and move the original object to the opposite starting location from the clone.

 Note: Refer to the image in Step 10.

9. In the Clone Options dialog, choose Instance and then click OK.

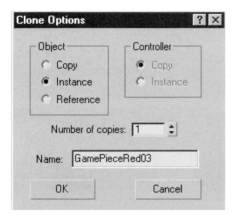

10. In the Camera viewport, select the original object.

11. In the Top viewport, create another Instance of the original object in the same fashion.

 You now have four red game pieces on the board: three are Instances (including the original), and one is a Copy.

Suppose you decide that the game pieces are too tall. You can change all the Instanced game pieces at once by changing just one of them.

12. In the Camera viewport, select the original game piece.

13. On the Command panels, click the Modify tab.

14. In the Modify panel > modifier stack display, select *ChamferCyl*.

15. Answer Yes to the Warning dialog.

Note: Modifiers and the modifier stack display is discussed in the modeling module.

The parameters for the ChamferCyl are displayed.

Parameters
Radius: 4.0
Height: 15.0
Fillet: 1.0
Height Segs: 6
Fillet Segs: 1
Sides: 12
Cap Segs: 1
☑ Smooth
☐ Slice On
Slice From: 0.0
Slice To: 0.0
☐ Generate Mapping Coords.

16. In the Parameters rollout, change the Height parameter to **12**.

In the Front viewport, you see that three of the game pieces have changed in height, while one has not. All the Instances have changed, but the Copy has not.

17. In the Camera viewport, select *GamePieceRed02* and press Delete on the keyboard.

18. In the Camera viewport, select any one of the remaining game pieces.

19. In the Top viewport, create two more instances of that game piece, and place them on different squares on the board.

20. In the Camera viewport, select one of the red game pieces.

21. On the Modify panel, click the color swatch next to the object name.

The Object Color dialog is displayed.

Object Color	? X
Basic Colors: ● 3D Studio MAX palette ○ AutoCAD ACI palette	
Custom Colors:	
Add Custom Colors...	
☑ Assign Random Colors Current Color: OK Cancel	

22. In the Object Color dialog, select a yellow color, and then click OK.

23. In the Top viewport, make three Instances of the yellow game piece and place them around the game board.

You may continue on in the same way to create four blue and four green pieces for the board.

Object Snaps

When you begin to translate (move) objects, many times you need to snap to grid points or to vertices of other objects. **3ds max 7** supports object snapping for precision. The snap options are found on the main toolbar.

Snaps for Drawing

There are three snapping options supported for drawing operations. They are:

- 3D Snap

- 2.5D Snap

- 2D Snap

Regardless of the snap option chosen, you can choose to snap to grid points, vertices, edges and a number of other choices. To choose the elements to snap to, do one of the following:

- Choose which snap option you want, then right-click the snap icon. Right-clicking the snap icon displays the Grid and Snap Settings dialog.

- Choose the snap option you want, then right-click a blank area on the main toolbar and choose the Snaps toolbar from the right-click menu.

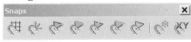

Once a snap option such as 2D or 3D is chosen, then you can choose what you want to snap to. For instance, Vertex, Edge, Grid etc. More than one element can be on at a time. If this is the case, when you are drawing, the cursor snaps to the element nearest to it that is on.

Note: After making selections in the Grid and Snap Settings dialog, or the Snaps toolbar, you can leave them onscreen or close them.

The settings that are turned on remain in effect even after the dialog or toolbar is closed.

Using Object Snap

1. On the menu bar, choose File > Open and open *Chap04_01.max* from the courseware CD.

2. On the main toolbar, choose 3D snap.

3. Right-click in a blank area of the main toolbar and choose Snaps from the right-click menu.

4. On the main toolbar, choose Select and Move.

5. In the Snaps toolbar, turn on Vertex.

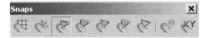

6. In the Camera viewport, choose Goblet01.

7. Identify a vertex on the goblet that you want to use as the start of the snap to vertex option.

8. Once the vertex is identified, click and drag over some of the other objects in the scene.

9. The vertices of other objects are identified and a line from the initial vertex location of Goblet 01 and the vertex on other objects displays.

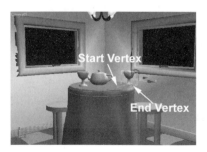

10. Once you have a vertex you want to snap to showing, release your mouse.

3D Snap

When you draw a shape or object with 3D Snap turned on, the cursor snaps anywhere in 3D space. For example, if you choose the Vertex option in the Grid and Snap Settings dialog, the cursor snaps to the nearest vertex on any object or shape in the scene anywhere in 3D space.

2D Snap

While 3D Snap snaps to any element in 3D space, 2D snap works only with elements on the construction plane facing the active viewport. For example, if you turn on 2D Snap and draw in the Top viewport, the cursor snaps only to elements lying on the XY plane.

2.5D Snap

2.5D Snap is a hybrid of 2D Snap and 3D Snap. 2.5D Snap causes snapping to elements anywhere in 3D space, but the shape or object always sits on the facing construction plane.

The following example demonstrates how this works: suppose you have a slanted structure in the shape of the letter E, as shown below. Both the Top and Perspective viewports are shown. The object is positioned below the construction plane, which faces the Top viewport.

To trace the shape of the E, a Line can be drawn in the Top viewport with the Vertex snap option selected. If 3D Snap is on, the line drawn snaps to the actual vertices on the 3D object.

If 2.5D Snap is on, the line is traced on the construction plane, as shown in the Perspective viewport above the object.

Incremental Snaps

Aside from object snaps, **3ds max 7** also supports incremental snaps. These snap options allow you to rotate an object every 10 degrees, rather than having to rotate every degree by choosing the Angle Snap toggle. They also allow you to scale at a certain percentage by using the Percent Snap, and allow the numbers in the spinners to snap incrementally by using the Spinner Snap toggle.

Angle Snap Toggle—Causes any rotation of objects or viewports to change by a specific increment. By default, this increment is 5 degrees. For example, if you turn on the Angle Snap Toggle and rotate an object, it rotates first by 5 degrees, then 10, then 15 and so on.

Note: Angle Snap also works with Arc Rotate. When Angle Snap Toggle is turned on and a viewport is rotated with Arc Rotate, the viewport changes by the rotation increment.

Percent Snap—Works with scaling, which uses percentages to measure by how much the object is being scaled. For example, when Percent Snap is turned on, any scaling of objects occurs in 10% increments.

Spinner Snap Toggle—Causes a parameter value to increase or decrease by a set amount when a spinner arrow is clicked.

Changing the Increment

The Angle snap and Percent snap options can be adjusted by using the Options tab in the Grid and Snap Settings dialog.

Right-clicking the Spinner Snap Toggle allows you to change the Spinner snap increment amount. When you right-click Spinner snap, the Preference Settings dialog is displayed.

The spinner snap increment is set by the Snap value in the Spinners area of the Preferences dialog.

Using Snaps to Transform Objects

1. On the menu bar, choose File > Open and open *Chap04_01.max* from the courseware CD.

2. In the Camera viewport, select the *teapot*.

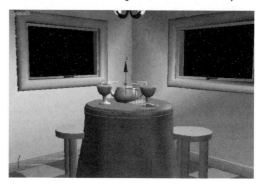

3. On the main toolbar, choose Select and Rotate.

4. On the main toolbar, choose Angle Snap Toggle.

5. Right-click in the Top viewport to make it activate.

6. In the Top viewport, rotate the object on the Z-axis.

 Note: The Z-Axis is the blue circle, when your mouse is placed on top of the blue circle it turns yellow to indicate that is the current axis.

7. Watch the Z-axis amount in the viewport.

 The rotation changes in increments of 5 degrees.

8. In the Camera viewport, select one of the *goblets*.

9. On the main toolbar, choose Percent Snap.

10. On the main toolbar, choose Select and Uniform Scale.

11. In the Top viewport, scale the goblet while watching the status bar.

 The goblet increases or decreases in size by increments of 10%.

 Note: Place your mouse inside the first triangular area of the Scale gizmo. This ensures that you uniform scale the goblet.

Coordinate Systems

In the lower left corner of each viewport, there is a visual aid of a small red, green, blue tripod axis. This visual aid represents the World Reference Coordinate System as defined in **3ds max 7**. All objects in 3D viewports (Camera, User, Perspective, Light) use the World Reference Coordinate System. The direction of the axes for the World Reference Coordinate System is displayed in the following illustration.

By learning what each coordinate system does to the axis tripod, you can set up the axes in the way that makes the most sense to you. Then you can use the restriction options of the individual transform gizmos successfully.

Changing the Coordinate System

Choosing the Reference Coordinate System on the main toolbar, then choosing a coordinate system from the drop-down list can change the coordinate system. By default, the View Coordinate System is chosen.

When an object is selected, the axes for the selected coordinate system appear at the object's pivot point or center location. By default, the coordinate system is set to View. In order to understand how this coordinate system works, you must first be familiar with the World and Screen Coordinate systems.

World Coordinate System

You have already seen that the World coordinate system axes are always displayed at the lower left of each viewport. If you want to use this coordinate system for transforming objects, choose it from the Reference Coordinate System drop-down.

When the World Coordinate System is chosen, the axis tripod for each selected object displays the World coordinate system axes.

You can then use these axes to move, rotate or scale the object.

Screen Coordinate System

When the Reference Coordinate System is set to Screen, the axis tripod of each object changes each time a different viewport is activated. No matter which viewport is active, the X-axis always points to the right of the viewport, and the Y-axis always points up vertically. This means that the transform XY plane is always facing you in the active viewport.

The Screen coordinate system is designed to make it easy for you to intuitively move and rotate objects. If you place your mouse specifically on one of the transform gizmos, you can pick up and move an object in your viewing plane, no matter which viewport is active.

The Screen coordinate system is convenient for working in orthographic viewports (flat 2D views) such as Top, Front and Left. However, in the Perspective (or 3D) viewport, the XY plane is tilted to face the view, making transformations in this viewport unpredictable. This problem is solved with the View Coordinate System.

View Coordinate System

The View Coordinate System is a hybrid of World and Screen. The View Coordinate System uses the Screen method in orthographic viewports, but uses the World Coordinate System in the Perspective (or 3D) viewport.

The View Coordinate System offers the best of both worlds – the intuitive use of the Screen coordinate system combined with the predictability of the World Coordinate System.

Local Coordinate System

When an object is created, it is internally assigned local axes specific to the object. The axes' directions depend on the viewport in which the object is created. For example, when a cylinder is created, its local Z-axis points up out of the viewport in which it is drawn, and its local XY plane is parallel to the computer screen. Even if you switch viewports or rotate the cylinder, its local Z-axis continues to point up the height of the cylinder.

These local axes are only visible when you select the Local Coordinate System from the Reference Coordinate System drop-down.

Note: An object's local axes can be moved or rotated by changing its pivot point. An object's local axes are defined by the position and orientation of its pivot point.

Additional Coordinate Systems

Three additional coordinate systems are also available:

The Parent Coordinate System works with objects linked in a hierarchy of Child > Parent. When a child object is transformed, it uses its parent's coordinate system for transforms.

The Gimbal Coordinate System is a form of local mode. This coordinate system is specific for rotations using the Euler controller. To learn more, refer to the **3ds max** online documentation.

The Grid Coordinate System uses the 0,0,0 origin point of the currently active grid system as the transform center.

The Pick Coordinate System uses a specific object to determine the transform center. The use of this coordinate system is described in more detail in the section that follows.

Transforms and Coordinate Systems

A different coordinate system can be set for each transform. **3ds max 7** "remembers" what the coordinate system was the last time you used a particular transform. To test this, click Select and Move, and then change the coordinate system to Local. Then click Select and Rotate and change the coordinate system to World. When you go back to Select and Move, the coordinate system automatically changes back to Local.

Tip: When you want to use a particular coordinate system, choose the transform icon first, then choose the coordinate system. This ensures that you use the correct coordinate system when performing your transforms.

Transform Center

The Transform Center flyout is next to the Reference Coordinate System on the main toolbar. You might have noticed that every time you perform a rotation or scale, the transformation is based on the object's pivot point. This occurs because the default transform center is based on the object's pivot point.

The Transform Center has three options:

Use Pivot Point Center—Uses the selected object's pivot point for transforms.

Use Selection Center—Finds the center point of the selected object. When more than one object is selected, a point at the center of the selection is used for transforms.

Use Transform Coordinate Center—Uses the center of the currently active coordinate system.

These options are particularly useful when more than one object is selected for rotation. Use Pivot Point Center rotates each object around its own pivot point, while Use Selection Center rotates the entire selection set around a point at the center of the selection.

Note: Transform Coordinate Center is very useful when using the Pick coordinate system.

Pick Coordinate System

Rotating a series of objects around a particular point in space can be accomplished with the Pick coordinate system. Even if other objects are selected, the center of the transform remains at the specified object's pivot point.

The Pick coordinate system is useful for placing objects in a circular arrangement around another object. For example, this option can be used to arrange chairs around a table, or to rotate spokes around a gear. In the next procedure, you use the Pick coordinate system to arrange the petals of a flower around its pistil.

Creating a Flower

1. On the menu bar, choose File > Open and open *Chap04_03.max* from the courseware CD.

This scene contains the pistil and one petal. You clone and rotate the petal around the flower center (pistil) to create a complete flower.

2. On the main toolbar, click Angle Snap Toggle.

3. On the main toolbar, click Select and Rotate.

4. From the Reference Coordinate System drop-down, choose Pick.

5. In the Front viewport, select the flower center.

 The object name Flower Center appears on the Reference Coordinate System drop-down list.

6. On the main toolbar, click Use Transform Coordinate Center.

 Next, you rotate the flower petal around the center while cloning it.

7. In the Front viewport, select flower petal.

The rotate transform gizmo sits at the center of the flower center even though the petal is selected. This is because you have chosen to use the transform coordinate center, and the current coordinate system is set to center on the flower center.

8. In the Front viewport, hold down **SHIFT** and rotate the petal **−45** degrees on the Z-axis.

 When you release the mouse, the Clone Options dialog is displayed.

9. In the Clone Options dialog, choose Instance.

10. In the Clone Options dialog, change Number of copies to **7**, and then click OK.

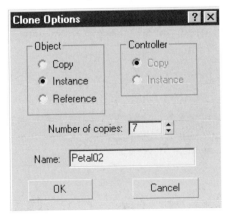

Seven instanced copies of the petal are created around the flower center.

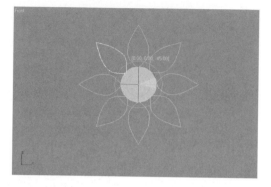

Additional Transformation Methods

Additional options are available on the main and Extras toolbar, that also transform objects. These additional tools are:

Align—Aligns an object's position, rotation and/or scale with another object. Objects can be aligned by physical center, pivot point, or bounding area along one or more axes. The picture on the left shows objects before alignment, while the picture on the right shows them aligned with the bottommost object along the viewport's X-axis.

Mirror—Mirrors an object along any axis and clones the object at the same time, if desired.

Array—Creates a series of clones arranged evenly in one, two or three dimensions. Array supports position, rotation and/or scale.

Note: The Array icon is a flyout that is available in the Extras toolbar. To display the Extras toolbar, right-click in a blank area of the main toolbar, and choose Extras from the right-click menu. The Array dialog may also be accessed by going to the menu bar and choosing Tools > Array.

Align Dialog

To align objects, you must first have one object selected, click Align from the main toolbar, then Select the object you want to align with. Once you have done that, the Align Selection dialog is displayed.

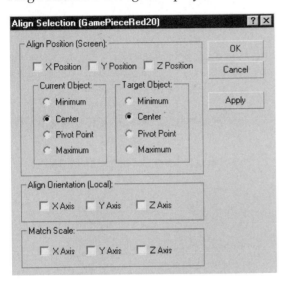

There are three groups to this dialog for aligning position, orientation and scale. The titles of the position and orientation group tell you which coordinate system is being used for alignment.

As you turn on an option, the object being aligned changes position, rotation and scale immediately in the viewports.

You might have noticed that Align is a flyout with several other options. These options are explained below.

Quick Align—Aligns one object's position to another, based on their pivot points, without using any dialogs. This works the same as Align with X, Y, and Z Positions turned on, and Pivot Point selected for both objects.

Normal Align—Aligns two objects using a selected face normal on each object, placing one object flush against another to make the faces coplanar.

Place Highlight—Places a light in such a way that it shines a highlight on a specified face.

Tip: This option can also be used to place an object to reflect in a mirrored surface.

Align Camera—Places a camera to view a specified face.

Align to View—Aligns an object or camera with a specific viewport. This option is useful when you have set up a Perspective viewport with the desired view of a scene, and would like to quickly place a camera that views from the same angle.

Tip: The menu bar command Views > Create Camera from View (shortcut Ctrl+C) is another way to create a camera that sees the same view as an active Perspective viewport.

Aligning the Teapot

1. On the menu bar, choose File > Open and open *Chap04_01.max* from the courseware CD.

 This scene contains a table, stools, and two walls.

2. In the Camera viewport, select *teapot*.

3. 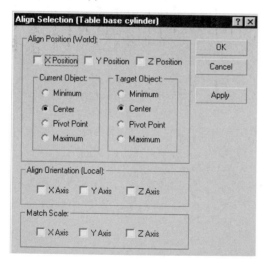 On the main toolbar, click Align.

4. In the Front or Left viewport, select the *center table support*.

 The Align Selection dialog is displayed.

5. In the Align Selection dialog, turn on X Position and Z Position.

 The teapot is now centered on the table.

6. In the Align Selection dialog, click OK to close the dialog and set the alignment.

Mirror Dialog

When you mirror an object, you must have an object selected before choosing Mirror from the main toolbar. The options available for Mirror are displayed in the Mirror dialog.

In the Mirror dialog, you can choose the axis or axes over which to mirror. You can also choose whether to clone the object, and which type of clone to use. As you change selections on the dialog, the object being mirrored changes in the viewport display.

Array Dialog

To array an object, first select the object, and then click Array from the Extras toolbar or select it from the Tools menu. All of the options for Array are displayed in the Array dialog.

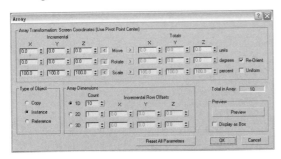

The Array dialog is divided into four groups: Array Transformation, Type of Object, Array Dimensions, and Preview.

The Array Transformation group tells you which coordinate system and pivot point options are used when the array is performed. In this group, you decide whether to perform a positional, rotational and/or scale array. You also decide how you want to calculate the numbers, whether you want to move an individual object every 10 units (Incremental) or whether all of the objects in the array should be placed a total distance (Totals) of 100 units.

In the Type of Object group, you pick the type of clone you want the array to make.

In the Array Dimensions group, you decide on the number of objects in the direction of the array. For instance, if you want 10 objects to be on the X-axis every 10 units then the dialog would look like the following:

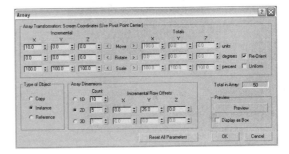

If you want 10 objects to be on the X-axis every 10 units and 5 objects to be on the Y-axis every 25 units, the dialog would appear as follows:

Note: The Total in Array group reads 50. This means fifty objects are in the total array.

To perform a 3D array, choose 3D in the Array Dimensions group and type the desired amount of objects in the Count group. Next, insert the desired distance between the objects on the Z-axis.

The Rotate and Scale options work in a similar fashion. You choose the axis, and decide whether you want to calculate the angle or percentage incrementally or by total. Below is an example of settings for a radial array and the result.

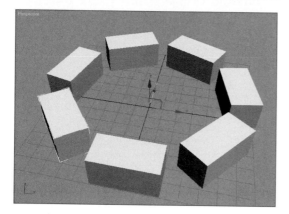

The Preview group gives you the option of previewing the results of your array settings before choosing OK. When the Preview button is selected, your array is updated in all four vieworts in real time. If you turn off the Preview, the array does not update to any changes you make until you select Preview again or click OK.

If the object you are using in Array is complex, or you have a high total number of objects, 3ds max might update slowly when Preview is turned on. To speed up your work, you may turn on Display as Box. All array objects except the original are then represented by their bounding boxes.

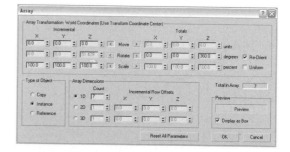

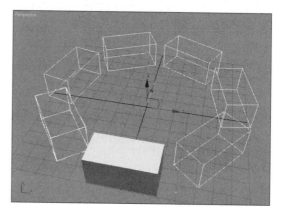

Array is also a flyout with two additional options. These are explained in the following text.

Snapshot—Works with animated objects. A series of clones are created along the object's animation path, giving the effect of a "snapshot" being taken at intervals during the animation.

Spacing Tool—Creates clones and spaces them apart by a specified distance. Clones can also be placed along a path.

Conclusion

Transformation of objects is a vital part of creating and building scenes in **3ds max**. In addition to the transforms themselves, many other tools come into play. An understanding of coordinate systems is important to the use of transforms, while additional tools for cloning and placing objects can save much time when transforming numerous objects.

Overview Lab

Objectives

In this lab you explore the basic creation, modification and animation tools available in **3ds max**. In this lab, you:

- Use modeling tools to create parts of a Jack-in-the-Box.
- Apply modifiers to reshape objects.
- Create lights and a camera.
- Use animation tools to bring your design to life.

Introduction

A Jack-in-the-Box is a favorite children's toy. When a small crank is turned, a spring-loaded clown pops out of the top of the box unexpectedly.

Creating Basic Scene Objects

You begin by "setting the stage" for the Jack-in-the-Box. In this section you:

- Create and transform a Plane object to help orient you into the 3D space.

- Merge a file containing some parts of the Jack-in-the-Box scene.
- Add lights to help illuminate the scene.
- Create a camera view to render the scene.

Creating a Plane Object

1. Start **3ds max**.
2. Right-click in the Top viewport to make it active.
3. On the command panels, choose Create > Geometry > Plane.

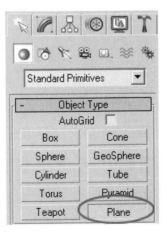

4. In the Top viewport, drag to create a plane of any size.

5. 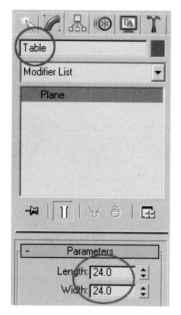 On the command panels, choose Modify.

6. In the Name and Color group, type Table.

7. On the Modify panel > Parameters rollout, set both the Length and the Width to 24.

This sets the size of the Plane to 24 x 24 units.

8. In the viewport navigation controls, choose Zoom Extents Selected All.

Transforming the Table Object

Next, you transform the plane using the Transform type-in group found in the Status Bar. This ensures accuracy when changing the Position, Rotation, or Scale of any object.

1 Object Selected X: Y: Z: Grid = 10.0

1. On the main toolbar, choose Select and Move.

2. In the Top viewport, Select the Table.

The Move transform gizmo is displayed at the center or pivot point of the plane.

Note: The Move gizmo is made up of three colored-arrows and right angles. You can adjust the size of any transform gizmo by using the keyboard shortcuts '+' and '-'. You can toggle the transform gizmo by pressing the 'X' key on the keyboard.

3. In the Top viewport, slowly move the table along the X and Y-axes, while keeping an eye on the Transform Type-In group in the Status Bar.

The numerical values represent the pivot-point center of the plane object.

Tip: You can position an object by typing values into the X, Y and Z fields.

4. On the Status Bar > Transform Type-In group, be sure Absolute is turned on,

and change the Axes values to X=0, Y=0, Z=0.

The plane objects pivot point becomes centered at X = 0, Y = 0, Z = 0, which is the origin of world space.

5. In the viewport navigation controls, choose Zoom Extents All.

Merging a File

In the following procedure, you merge a file that contains objects for the Jack-in-the-Box scene.

1. On the menu bar, choose File > Merge.

2. In the Merge File dialog, browse to your courseware CD, and double-click *ch05_box.max*.

The Merge dialog displays with a list of all of the objects in that scene.

3. In the Merge dialog, choose All, and then click OK.

4. The merged objects are now part of the current scene.

The merged file contains several objects:

• A box made up of two objects: a *Boxbottom* and a *Boxtop*. These box-objects have been modified to have one open side, as you see later.

• A crank made using the Line tool. The line is set to render with a thickness value.

• A handle made from a Capsule primitive.

Finishing the Crank and Handle Assembly

1. On the main toolbar, choose Select by Name.

2. In the Select Objects dialog, turn on Display Subtree.

 Notice that the Handle object is indented under the Crank object. This indicates that the Handle object is a child of the Crank object.

3. In the Select Objects dialog, select both the Handle and the Crank.

4. In the viewport navigation controls, choose Zoom Extents Selected All.

5. On the command panels, choose Create > Helpers > Dummy.

A dummy object is a non-renderable object that is often used in animation for additional hierarchical linkages.

6. In the Top viewport, drag to create a Dummy helper object.

The Dummy01 object needs to be translated to the end of the Crank object. You then link the Crank to the Dummy01 object to complete the Crank assembly.

7. On the main toolbar, choose Select and Move.

8. On the Status Bar > Transform Type-In group, make sure Absolute is turned on.

9. In the Transform Type-In group, set the following values: X= -2.74, Y=1.163, Z=0.

 Dummy01 is moved to the end of the Crank object.

10. In the Top viewport, select the Crank object.

11. On the main toolbar, choose Select and Link.

12. In the Top viewport, drag from the Crank object to the Dummy.

 This links the Crank assembly to the Dummy01 object.

13. ⬉ On the main toolbar, choose Select Object.

14. Press H on the keyboard to display the Select Objects dialog.

The Crank object and the Handle object are both indented below the Dummy01 object, indicating that they are now children of the dummy.

15. In the Select Objects dialog, choose Cancel.

16. ✛ On the main toolbar, choose Select and Move.

17. In the Top viewport, select *Dummy01*.

18. 🔲 In the viewport navigation controls, choose Zoom Extents All.

19. Use the Top and Left viewports to position the dummy against the side of the *Boxbottom* object.

Note: Use the zoom options in the viewport navigation controls to adjust your viewports accordingly.

20. Ultimately position the Dummy01 object at: X= -2, Y= 0, Z= 1.6.

Save your Work

Save your file in the Courseware directory on your hard-drive.

1. On the menu bar, choose File > Save.

2. In the Save File As dialog, browse to your local directory structure and save your file as *ch05_myjack.max*.

Creating Lights

In the next procedure, you add lights to the scene to add realism, and to cast shadows. All scenes in **3ds max** contain default lights. Once you create lights, the default lights are turned off.

Creating a Spotlight

1. Continue from the previous exercise, or choose File > Open from the menu bar, and open *Ch05_02.max* from the courseware CD.

2. 🔲 In the viewport navigation controls, choose Zoom Extents All.

3. On the command panels, choose Create > Lights > Target Spot.

4. In the Front viewport, drag from the upper-right of the viewport, to the center of the screen.

 This places a Target Spot in the scene.

5. On the main toolbar, choose Select and Move.

6. In the Top viewport, move the spot and its target to the position indicated below.

Adjusting the Spotlight properties

1. Continue from the previous exercise.

2. In the Top viewport, select *Spot01*.

3. Right-click the Perspective viewport label.

 The viewport title menu displays.

4. In the viewport title menu, choose Views > Spot01.

The Perspective viewport changes to the Spot01 viewport. You are looking directly down the barrel of the spotlight.

5. Make sure the spotlight is chosen, and open the Modify panel.

The spotlight parameters are displayed.

6. On the Modify panel > Spotlight Parameters rollout, change the Falloff/ Field value to 60.

Note: The closer the values are for the Hotspot and Falloff, the harder the edge, giving the effect of a spotlight found in a theater.

Spotlight Parameters

Light Cone
☐ Show Cone ☐ Overshoot

Hotspot/Beam: 43.0
Falloff/Field: 60.0

● Circle ○ Rectangle

Aspect: 1.0 Bitmap Fit...

7. On the Modify panel > General Parameters rollout > Shadows group, turn on Shadow.

Shadow Map is the default shadow-type.

8. On the Modify panel > Shadow Parameters rollout, adjust the Dens. (shadow density) value to 0.7.

This lightens the objects in the shadows created by this light.

Shadow Parameters

Object Shadows:
Color: ■ Dens. 0.7

☐ Map: None

☐ Light Affects Shadow Color

Atmosphere Shadows:
☐ On Opacity: 100.0
Color Amount: 100.0

Cloning the Light

The process to cloning a light is the same process as cloning geometry. In the next procedure, you clone the light by holding down SHIFT while moving the light. As long as SHIFT is held down, and you use any one of the transforms, you get a clone.

1. Continue from the previous exercise.

2. On the main toolbar, choose Select and Move.

3. In the Top viewport, choose *Spot01*.

4. In the Top viewport, hold down **SHIFT** and move the Spotlight to the left.

5. In the Clone Options dialog, choose Copy, and then click OK.

Clone Options

Object
● Copy
○ Instance
○ Reference

Controller
● Copy
○ Instance

Number of copies: 1

Name: Spot02

OK Cancel

Spot02 has inherited all of the parameters from Spot01.

Creating Cameras

In **3ds max**, you can render from any viewport, at any stage of the production. An important role in the production of any scene is the creation of cameras. Cameras give you the advantage of setting multiple views, so you can easily look through one camera, and then another camera. This saves you time from having to constantly use the viewport navigation controls to adjust your Perspective viewport. Cameras also have the added advantage of being animatable. You can animate the camera's motion, as well as its parameters like lens, field-of-view and even depth-of-field. In the procedure below, you create a Target Camera. You learn more about cameras in the Cameras and Rendering chapter.

Creating a Target Camera

1. Continue from the previous exercise.

2. On the Create panel, choose Cameras.

3. In the Object Type rollout, choose Target.

4. In the Top viewport, drag from the Lower left of the viewport to the middle.

The Camera and its Target are created.

5. Right-click in the Spot01 viewport and press C on the keyboard to look through the lens of the camera.

The viewport now reflects the view as seen by the camera; but the camera is located on the Z=0 level, or on the table surface.

6. ⊕ On the main toolbar, choose Select and Move.

7. In the Status bar > Transform Type-In group, change the Z value to 6.0.

8. ▨ On the main toolbar, choose Select by Name.

9. In the Select Objects dialog, choose *Camera01.Target* and click Select.

10. In the Status bar > Transform Type-In group, change the Z value to 2.0.

Rendering the Scene

There are many rendering options available for you to use. Most of the rendering options are available from the Rendering menu and the Render Scene dialog. Rendering is an important option for every scene. You learn more about these options in the Cameras and Rendering chapter. Now that all of the elements are in place, you render a single frame from the Camera viewport.

Rendering a Camera View

1. Continue from the previous exercise.

2. Right-click in the Camera viewport to make it active.

 Note: If a view is already active when you right-click in it, the Quad menu is displayed. If this occurs, right-click again to close it.

3. On the menu bar, choose Rendering > Render.

The Render Scene dialog is displayed.

4. In the Render Scene dialog > Common Parameters rollout > Time Output group, make sure Single is chosen.

5. In the Common Parameters rollout > Output Size group, make sure Width =640, Height =480

6. In the Render Scene dialog, choose Render.

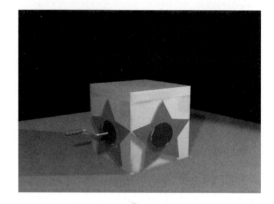

7. On the menu bar, choose File > Save As, and save your file as *ch05_myjack2.max*.

Creating the Clown

In this section you create the toy that pops up from inside the box. You discover that the Boxtop object has animation values already assigned to it. In this section you:

- Create the Clown's head, body and hat
- Apply textures to the head, body and hat
- Add a nose to the head

Modeling the Clown Elements

Creating the head

1. Continue from the previous exercise, or choose File > Open from the menu bar, and

open *Ch05_03.max* from the courseware CD.

2. On the command panels, choose Display.

3. On the Display panel > Hide by Category rollout, turn on Lights and Cameras.

 This turns off the display of the lights and camera objects in the viewports but does not affect the rendered view.

4. Press **H** and choose *Boxbottom* and *Boxtop* from the list.

5. In the viewport navigation controls, choose Zoom Extents All Selected.

6. On the Create panel, choose Geometry > Sphere.

7. In the Top viewport, click in the center of the *boxbottom* object and drag slightly upwards.

8. On the command panels, choose Modify.

9. On the Modify panel > Parameters rollout, set Radius to **1.2**.

10. In the Name and Color group, rename *Sphere01* to **Head**.

11. On the main toolbar, choose Select and Move.

12. On the Status bar > Transform Type-In group, adjust the values to X = 0, Y= 0, Z= 2.0.

X: 0.0 Y: 0.0 Z: 2.0

Creating the Body with the Hose Primitive

1. Continue from the previous exercise.

2. On the Command panels, choose Create > Geometry.

3. In the Standard Primitives drop-down, choose Extended Primitives.

4. In the Object Type rollout, choose Hose.

5. In the Top viewport, drag from the center of the Head outward. Release to set the radius. Drag up slightly and click to set the height and finish the Hose creation.

 Don't worry about size and placement of the Hose; you adjust those settings next.

6. On the Modify panel > Name and Color group, rename *Hose01* to **Body**.

7. In the Hose Parameters rollout, turn on Bound to Object Pivots.

8. In the Hose Parameters rollout > Binding Objects group, choose Pick Top Object.

9. Press H and select Head from the list.

10. In the Binding Objects group, set the Tension for the Top Object to **0**.

11. In the Binding Objects group, choose Pick Bottom Object.

12. Press H and select Boxbottom from the list.

13. Set the Tension for the Bottom Object to **0**.

14. In the Common Hose Parameters group set the following:

 • Segments= **16**

 • Cycles= **19**

15. In the Hose Shape group set the following:

 • Diameter= **2.2**

 • Sides= **8**

Creating the Hat

Now you use the Cone primitive object to create a hat for the clown.

1. Continue from the previous exercise.

2. Right-click in the Top viewport to make it active.

3. On the command panels, choose Create > Geometry > Standard Primitives > Cone.

4. On the Command panels, Keyboard Entry rollout, enter the following values:

 • X = **0**

 • Y = **0**

 • Z = **2.5**

 • Radius 1: **1.2**

 • Radius 2: **0.0**

 • Height **2.0**

5. Make sure the Top viewport is active.

6. In the Keyboard Entry rollout, choose Create.

 The cone is created. Don't worry if the cone goes through the upper box.

7. On the command panels, choose Modify.

8. On the Modify panel > Name and Color group, rename *Cone01* to **Hat**.

9. On the menu bar, choose File > Save As, and save your file as *ch05_myjack3.max*.

Hiding objects

1. Continue from the previous exercise, or choose File > Open from the menu bar and open *Ch05_04.max* from courseware CD.

2. On the command panels, choose Display.

3. On the Display panel > Hide rollout, choose Hide by Hit.

4. In the Front viewport, select *Boxtop* and *Boxbottom*.

 The objects are hidden.

5. Right-click in the Front viewport to end the Hide by Hit function.

Applying Materials to Objects

1. On the menu bar, choose Rendering > Material/Map Browser…

 The Material/Map Browser dialog is displayed.

2. In the Material/Map Browser > Browse From group, turn on Mtl. Library.

3. In the Material/Map Browser > File group, choose Open.

4. In the Open Material Library dialog, browse to your courseware folder, and choose *Ch05_MatLib.mat*, and then choose Open.

5. Position the Material/Map browser to the left of the screen in order to see the Front viewport at the same time.

6. In the Material/Map Browser > Show group, make sure Root Only is turned on.

 At this time, you don't need to see all the components that make the material.

 Show
 ☑ Materials
 ☑ Maps
 ☐ Incompatible

 ☑ Root Only
 ☐ By Object

7. In the Material/Map browser dialog, choose the Material named body (Standard).

8. Drag and drop the material from the Material/Map browser onto the Body (spring) object.

 You can see the material in the shaded Perspective viewport.

9. Continue to drag and drop the CLOWNHEAD material to the Head object and the Hat material to the Hat object.

Creating a Nose

Now you create a nose from a new Sphere object and position it on the front of the Clown's face.

1. Continue from the previous exercise.

2. Close the Material/Map Browser.

3. On the menu bar, choose Create > Standard Primitives > Sphere.

4. In the Top viewport, drag to create a sphere of any size.

5. On the Create panel > Parameters rollout, change the Radius to: **0.3**.

6. On the Create panel > Name and Color rollout, change the name of Sphere01 to **Nose**.

7. In the Name and Color rollout, choose the color swatch.

8. In the Object Color dialog, select a red color.

 The object color for the Nose object is now red.

9. ⊕ On the main toolbar, choose Select and Move.

10. Position the Nose object on the front of the Head object.

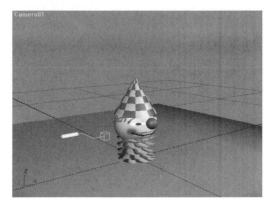

Grouping the Head Objects

1. On the main toolbar, choose the Window/Crossing toggle.

2. In the Front viewport, drag a crossing selection that crosses the Head, Nose and Hat objects.

3. On the menu bar, choose Group > Group.

4. In the Group dialog, change the name to **Head Group**.

5. On the menu bar, choose File > Save As, and save your file as *ch05_myjack4.max*.

Animating the Scene

You have two sets of objects to animate to complete the project:

- Animate the crank rotating prior to the Boxtop object opening.

- Animate the clown popping up from the bottom of the box.

To animate the crank, you only need to animate the *Dummy01* object. If you recall, the remainder of the crank is linked to the *Dummy01* object.

To animate the clown, you need to animate the Head Group. The Hose primitive that you used for the body is joined to the Head and the *Boxbottom*, and stretches as needed when the Head Group is moved or rotated.

Animating Objects

Animating the Dummy Object

1. Continue from the previous exercise, or choose File > Open from the menu bar, and open *Ch05_05.max* from the courseware CD.

2. ⊡ On the Command panels, choose Display.

3. On the Display panel > Hide rollout, choose Unhide ALL.

 The Box objects re-appear in all of the viewports.

4. ⟳ On the main toolbar, choose Select and Rotate.

5. Press **H** and Select *Dummy01* from the list.

6. ⊶ [Auto Key / Set Key] In the animation controls, turn on Auto Key.

 The viewport and the time slider turn a dark red, indicating that you are in "record mode". You learn more about the different Auto and Set key options in the animation chapters.

7. Move the time slider to frame **45**.

8. Right-click in the Left viewport to make it active.

9. Press **A** to turn on Angle Snap.

10. In the Left viewport, place your mouse on the blue circle of the Rotate gizmo (it turns yellow indicating that this is the current axis), and rotate the dummy on the Z-axis **1080** degrees which is **3** revolutions.

11. In the animation controls, turn off Auto Key.

12. Right-click in the Camera01 viewport to make it active.

13. |◄◄| ◄ll ▶ ll▶ ▶▶| In the time controls, choose Play.

 The animation plays.

 Click Play again to stop the animation.

 |◄◄| ◄ll ll ll▶ ▶▶|

Animate the Clown

1. Continue from the previous exercise, or choose File > Open from the menu bar, and open *Ch05_06.max* from the courseware CD.

2. Move the time slider to frame **0**.

3. In the animation controls, turn off Auto Key.

4. In the Left viewport, select Head Group.

5. Use a combination of Move and Rotate in the Left viewport to adjust Head Group so that the hat no longer pokes through the *Boxtop* object.

6. In the animation controls, turn on Auto Key.

7. In the viewport navigation controls, choose Zoom Extents All.

8. Move the time slider to frame **50**.

9. Make sure Head Group is selected.

10. On the main toolbar, choose Select and Move.

11. In the Left viewport, move the Head Group up and out of the *Boxbottom*.

 Note: The bottom of the *Body* object stays connected to the *Boxbottom*.

12. On the main toolbar, choose Select and Rotate.

13. In the Left viewport, rotate the Head Group on the Z-axis approximately **50** degrees.

 The head is looking up slightly.

14. In the animation controls, turn off Auto Key.

15. In the track bar, drag the keyframe at frame **0** and drag it to frame **40**. Watch the display to stop the drag on frame 40.

 Note: The track bar is just below the time slider.

16. Right-click in the Camera viewport to make it active.

17. In the time controls, choose Play.

 The clown is timed to come out of the box.

18. On the menu bar, choose File > Save As and save your file as *ch05_myjack5.max.*

Adding More Motion to the Jack-in-the-Box

You can add additional motion to the movement of the Jack-in-the-Box.

1. Continue from the previous exercise.

2. Move the time slider to frame **60**.

3. Turn Auto Key on.

4. In the Front viewport, move Head Group down and to the left slightly.

5. Move the time slider to frame **70**.

6. In the Left viewport, move Head Group up slightly again but to the left as well.

7. Turn Auto Key off.

8. Right-click to activate the Camera viewport.

9. ▶. In the time controls, choose Play.

10. Continue adding keyframes (with Auto Key on) until you get to frame **100**.

11. On the menu bar, choose File > Save As and save your file as *ch05_myjack6.max*.

Rendering a Preview Animation

A preview animation is a quick way to check your timing. A preview does not display all of the shading and lighting; it is simply a fast way to see your motion.

1. On the menu bar, choose Animation > Make Preview.

 The Make Preview dialog is displayed.

2. In the Make Preview dialog, accept all of the defaults, and choose Create.

An AVI animation is created, and played back in the Windows Media Player when it is completed.

Note: You can playback a preview animation at any time by choosing Animation > View Preview from the menu bar. Remember however, that only one preview is stored at a time. If you have many to create, use the Rename Preview option to save the current preview to the hard drive.

Rendering a Final Animation

1. Continue from the previous exercise.

2. Right-click in the Camera01 viewport.

3. Press **F10** to open the Render Scene dialog.

4. In the Render Scene dialog > Common Parameters rollout > Time Output group, choose Active Time Segment.

5. In the Output Size group, choose 320 x 240.

This sets the pixel size of the animation. Start small then render a higher resolution animation later, if needed.

6. In the Render Output group, choose Files.

7. In the Render Output File dialog, specify a name and location to store your animation.

8. In the Save as type field, choose AVI File (*.avi).

9. In the Render Output File dialog, choose Save.

 The Video Compression dialog is displayed.

10. In the Video Compression dialog, choose Cinepak compression algorithm, and set the Compression Quality to **100**, and then choose OK.

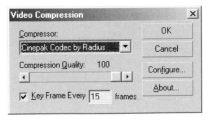

11. In the Render Scene dialog, choose Render.

 The Rendering Status dialog is displayed, as well as the Rendered Frame window.

Note: This animation may take some time to render.

Playing an Animation using Ram Player

1. On the menu bar, choose Rendering > Ram Player.

 The Ram Player dialog is displayed.

2. On the Ram Player toolbar, choose Open Channel A.

3. In the Open File, Channel A dialog, browse to find your animation file.

4. In the Ram Player Configuration dialog, choose OK.

 The animation loads.

5. On the Ram Player toolbar, choose Play.

Conclusion

This overview lab has introduced you to the basic concepts of **3ds max**. You have learned how to model simple geometry, to apply materials to objects effortlessly by dragging them from the Material/Map Browser, and you have also experimented with animation and keyframing concepts by bringing the Jack-in-the-Box scene to life.

If you have time, experiment a little more in the scene: create different hats or nose shapes, and other objects that might belong in this environment, and add more materials and animation to the new elements.

Fundamental Animation Techniques and Track View

Objectives

After completing this chapter, you are able to:

- Understand the concepts of keyframe animation.
- Work with the track bar to edit animation keys.
- Create keyframes using Auto Key and Set Key.
- Display Motion Trajectories.
- Apply tangent types.
- Understand the basics of Animation Controllers.
- Use Track View to create and edit animation parameters.
- Create a hierarchy of linked objects.
- Create a simple forward kinematic animation.

Introduction

Animation is created by rapidly playing back a series of slightly different still images. The power of **3ds max 7** lies in its ability to generate the animation quickly and automatically based on a few still images, or keyframes. **3ds max** does this by calculating intermediate object positions and rotations automatically for all objects that are animated.

At the beginning of this chapter, you learn how to create and edit the individual keyframes. Once the keyframes are defined, **3ds max** generates the animation using interpolation. Animation controllers perform the interpolation. Learning how to influence and change the controller parameters gives you more control over the animation.

The behavior of an animated object depends somewhat on its local coordinate system, or pivot point. This chapter introduces you to object pivots, and the techniques for changing pivot position and orientation.

Creating animation typically involves defining how multiple objects behave with respect to one another. **3ds max** provides a feature called Object Linking, which you can use to define a hierarchical relationship between participating objects. This chapter demonstrates not only how to create a linked hierarchy but also how to use it to create a simple forward kinematic animation.

Keyframe Animation

Keyframes and Traditional Animation

Animation is created by first defining a series of still images, each different in some small way. The still images, which are also called frames, are then played back to provide the illusion of continuous motion. To perceive the motion as continuous, the images have to be played back rapidly. Depending on the media format, the playback might be at a rate of up to 30 frames per second. At this rate, a single minute of animation would require 1,800 individual frames. The difficulty with traditional animation is the daunting task of creating all these still images. Animation studios recognized that there were relatively minor differences between successive frames. They were able to increase productivity with the master artists creating only the important or defining frames in the sequence, and their assistants completing the rest. The most important frames are called keyframes, which could illustrate the start and end of a motion sequence, for example. The in-between frames are referred to as tweens.

Planning the Animation

As an animator, you have to decide what to change and when you want that change to occur. A clear idea of what you're trying to accomplish before you start animating is always helpful. One common tool for planning is a storyboard. A storyboard is a series of sketches describing the key events in the story, along with a short written description of the characters and scene elements. You could also create a simple list of the events you want to occur, along with their associated times. Either way, planning helps the animation process.

Keyframes within 3ds max

Consider the task of animating an object moving from one position to another. Defining an object's position manually in every frame is very time consuming. **3ds max** simplifies the job considerably. You can define the object's position at several "key" points in time, and **3ds max** calculates its position automatically for each of the intermediate frames. The frames in which you define the position explicitly are termed keyframes.

Position is by no means the only characteristic that can be animated. Almost anything that can be changed within **3ds max** can be animated, including position, orientation, scale, object creation parameters, and material characteristics. So a keyframe within **3ds max** is just a marker that specifies a certain value at a particular point in time.

Interpolation

The process of determining the scene configuration for each frame between the keyframes is termed interpolation. **3ds max** has several interpolation methods available.

Time Configuration

Internally, **3ds max** defines animation in terms of time. The precision or smallest unit of time with which it works is called a tick, which is 1/4800 second. However, the default representation of time is in frames in the user interface. It's important to recognize that frames don't represent an absolute measure of time. In film production, the standard is 24 frames per second; with NTSC video it's 30 frames per second, and for the Web or multimedia presentations it's normally 15 frames per second. Because **3ds max** stores all animation values with respect to time, you can change the frame rate or output format after animation has been created and the timing is correctly adjusted.

By default, **3ds max** is configured to display time in frames and uses an output of 30 frames per second.

The use of frames for describing time is prevalent, and that practice continues here. However, be aware that what's actually recorded internally is time.

The frame rate and time display are set within the 🗔 Time Configuration dialog. This dialog is found in the time controls.

The time configuration dialog includes controls for each of the following groups.

Frame Rate

You can choose between NTSC (National Television Standards Committee), Film or PAL (Phase Alternate Line) presets, or use a custom setting to specify a custom frame rate. The rate for NTSC is 30 frames per second, (fps). The frame rate for PAL is 25 fps and for Film is 24 fps.

Time Display

The time display can be set for the following formats:

- Frames (the default)

- SMPTE standard (Society of Motion Picture and Television Engineers), which is minutes, seconds, and frames.
- Frames:Ticks
- MM:SS:Ticks

Playback

This section controls how the animation is played back within the viewports. You can use real-time playback, which drops frames to keep up with the specified frame rate. You can also specify playback at a rate faster or slower than the specified frame rate.

Animation

The animation group specifies the active time segment. The active time segment is the range of frames accessed with the time slider. This group also allows you to re-scale the total frames in an animation. For example, if your animation contains 300 frames and you want to keep the keyframes but stretch the animation to 500 frames, then you would use Re-Scale time.

Creating a Keyframe

You have three options to create a keyframe using the key options found to the right of the Status bar.

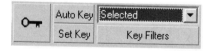

The first option is to change an object at a non-zero frame while the Auto Key button is on. As soon as you make the change, the original value is recorded at frame 0, and the new value, or key value, is recorded at the current frame. At this point, both frame zero

and the current frame are keyframes. For example, if you create a sphere, and then turn on Auto Key, go to a frame past 0, and change the Radius setting, **3ds max** creates a keyframe for you. As long as Auto Key is on, you are in record mode, and **3ds max** knows to record any changes you make beyond frame 0.

The second option is to turn on Set Key. Set Key works with the large key button. You first turn on Set Key, choose an object, and then make a change. The change is recorded only when you choose the large key button. Once the large key is selected, a keyframe is created. The keyframes generated are based on the choices selected on the Set Filters button.

The third option is to have Set Key and Auto Key turned off, and simply use the large key button. A keyframe at the object's current location is set. This option does not interpolate between the objects location to another location in space. This option works well if you want to create keyframes and then type in their exact locations or amounts.

After you create a keyframe, you can view the animation by dragging the time slider from side to side. This is called "scrubbing" the time slider. You create keyframes using all three options later.

What's Animatable?

The previous section described how to create a keyframe. You may be wondering what characteristics can be animated in **3ds max**. Probably the most common animated characteristic is an object's transform. The transform defines an object's position,

rotation, and scale. You can also animate parameters associated with the base level of an object or the parameters associated with any applied modifiers.

Playing an Animation

Once you have created keyframes, you normally want to view the animation. As stated in the previous section, you can scrub the time slider to view the changes you made. You can also use the playback options in the time controls. The time controls are nestled between the Animation controls and the viewport navigation controls. They are used to play the animation and to set the current time.

Time Controls

▶️ The Play icon is used to play the animation in the active viewport. When chosen, all animated objects are played in the active viewport.

⏸️ Just after you choose the play icon, the stop icon appears in its place. The animation stops at the current time when you choose the stop icon.

▶️ The Play Selected icon is contained within the play flyout. It causes only selected objects to play in the active viewport. Non-selected objects are suppressed from view.

⏮️ The Go to Start icon causes the time slider to move to the first frame in the current animation range. If an animation is playing when you click it, the playback stops.

⏭️ Go to End places the time slider at the end of the animation range.

⏩ The Next Frame icon moves the time slider forward a single frame. When the Key Mode toggle is active, clicking Next Frame moves to the next keyframe for the selected object(s).

⏪ The Previous Frame icon moves back a single frame. When the Key Mode toggle is active, it moves to the previous keyframe for the selected object(s).

You can enter a frame number in the Go to Time field to set the current time.

⏮️ When the Key Mode toggle is pressed, the next frame and previous frame options function as the next keyframe and previous keyframe options, respectively.

Creating a Keyframe using Auto Key

In this sequence, you create a few keyframes using Auto Key to define the motion of a jet. Then you view the keyframe values on the track bar.

1. On the menu bar, choose File > Open and open *Ch06_01.max* from the courseware CD.

 The file contains a model of a jet fighter located at the origin of the World Coordinate System. It does not have any animation defined.

2. Scrub the time slider to verify that the jet is not animated.

3. Auto Key Turn on Auto Key.

 Note: If Auto Key is not on, a keyframe is not created.

4. In the Perspective viewport, choose the *jet*.

5. 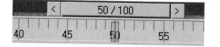 On the main toolbar, choose Select and Move.

6. Use the time slider to go to frame **50**.

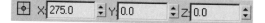

7. In the Transform type-in group of the status bar, enter 275 in the X-axis.

8. Turn off Auto Key.

9. In the time controls, choose Play.

 The jet moves from its original position to 275 units on the X-axis over the first 50 frames. It stops at frame 50 since there are no keyframes defined beyond that point.

10. In the time controls, choose Go to Start to stop the animation playback and return the animation to frame 0.

 Look on the track bar. You can see that two keyframes have been created. One is at frame 0, and the other at frame 50. The keyframe values are X=0 and X=275 respectively. When the first keyframe is created for an object, a keyframe is created automatically at frame zero using the Auto Key method.

Note: The track bar does not show an object's keyframes if the object is not selected.

Verifying Keyframes

1. Continue from the previous exercise.

2. In the Perspective viewport, click in a blank area to remove the jet from the selection.

3. Verify the time slider is at frame 0.

 A set of brackets surrounds the model indicating that this is a keyframe for the object.

4. Drag the time slider from frame 0 to frame 50.

 Again, brackets surround the model. The brackets appear around an object whenever you move the time slider over one of its keyframes.

 Note: This is easier to see when the object is not selected.

Creating a Keyframe using Set Key

1. On the menu bar, choose File > Reset. Do not save your changes.

2. Choose Yes when prompted to confirm the reset.

3. On the menu bar, choose File > Open and open *Ch06_01.max* again from the courseware CD.

4. In Animation mode, turn on Set Key.

5. Make sure you are at frame 0.

6. Select the *Jet*.

7. In the animation controls, choose the large key button.

 This key records the plane's current location in space.

8. Use the time slider to go to frame 50.

9. ✥ On the menu bar, choose Select and Move.

10. In the Transform type-in group of the Status bar, enter 275 in the X-axis.

11. In Set Key animation mode, choose the large key button.

When Set Key is turned on, the large key button records the object's new location in space.

12. Turn off Set Key.

13. Scrub the time slider to view the animation.

Key Filters—Decides which parameters of an object have keyframes applied when you choose to animate using Set Key.

Set Key Filters

To the right of Auto Key and Set Key you see a drop-down list and a Key Filters button.

Selected drop-down—Works with named selection sets object. If you choose a selection set from the drop-down, and begin to use the large key button, then only the objects in the selection set have keyframes, even if another object is selected in the viewport.

Editing Keyframes

A keyframe consists of both a time and a value. To create an effective animation, you typically go through an iterative approach of keyframe creation and editing. Editing a keyframe might involve changing its timing, its value, or both.

3ds max offers several ways to access the keyframes for editing.

- **In the Viewports**—There is always a currently defined time while working within **3ds max**. A common way to set the current time is to drag the time slider. Objects within the viewports can be set to display a set of surrounding brackets when the time slider passes over a keyframe. If the current time coincides with a keyframe for an object, you can edit a key by pressing the Auto Key button and altering the animated value. Alternatively, you can turn on Set Key,

make the change, and then record the change by choosing the large key button.

- **Track bar—** The track bar runs horizontally under the time slider. When an animated object is selected, its keyframes are displayed as rectangles within the track bar. The track bar provides convenient access to keys for changing either their value or time. It also includes an icon to the left of frame 0 that allows you to view the Track View curve editor.

- **Motion panel—**The Motion panel is one of the six command panels. The Motion panel contains tools that let you change the key timing or its value.

- **Track View's Curve Editor and Dope Sheet—** Track View is a dialog that provides a detailed view of the keyframes, with methods for editing their timing and values. Track View contains a comprehensive set of tools for manipulating animation.

Regardless of which method is used to edit a keyframe, the result is the same: its timing, its value, or both, are modified. In the following sections of this chapter, you edit keyframes using the track bar and in Track View.

Using the Track Bar

The track bar is the region below the time slider. It displays the keyframes for selected objects and provides a convenient point of access. Common keyframe operations include changing its value or timing, as well as moving and copying keys. The track bar supports each of these operations. The following sequence provides an example of each.

1. On the menu bar, choose File > Open and open *Ch06_02.max* from the courseware CD.

 The file contains text that has been animated. Two keyframes are associated with the text. The first is at frame 0 and the second at frame 50.

2. In the Front viewport, choose the text.

3. On the track bar, right-click over the keyframe at frame **50**.

4. Choose Text01: Z Position from the list.

5. The Key Info dialog is displayed.

The Key Info dialog contains the following information:

1. On the dialog's upper left is the field indicating the keyframe being referred to, in this case, number 2.

2. The Z Value field represents the object's position at keyframe 2. The Z-coordinate is 0.652.

3. The In and Out buttons are the key's tangent types, which influence the interpolation through the keyframes. Tangent types are covered in more detail later in the chapter.

4. In the Key Info dialog, set the Value to -20.0.

5. Close the dialog.

6. ▶ In the time controls, choose Play.

 The animation plays in the active viewport. The text drops down further from its original end frame.

 Note: The Key Info dialog can also be used to alter key timing.

7. ∎ In the time controls, choose Stop.

8. On the track bar, right-click the keyframe at frame **50**.

9. Select *Text01: Z Position* from the list.

10. In the Key Info dialog, change the Time to **65**.

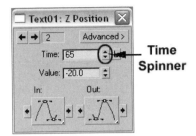

11. On the track bar, notice there is a keyframe at frame **50**, and a keyframe at frame **65**.

12. On the track bar, right-click the keyframe at frame **50**.

Text01: X Position
Text01: Y Position
Controller Properties ▶
Delete Key ▶
Delete selected keys
Filter ▶
Configure ▶
Go to Time

The Z Position is no longer in the list.

13. Right-click the keyframe at frame **65**.

Text01: Z Position
Controller Properties ▸

Delete Key ▸
Delete selected keys

Filter ▸

Configure ▸

Go to Time

The Z Position is the only track with a key at frame 65.

14. In the Key Info dialog, set the Time back to **50**.

15. Close the Key Info dialog.

Changing Key timing using the track bar

You can also change key timing directly on the track bar.

1. Continue from the previous exercise.

2. On the track bar, position your cursor over the keyframe at frame **50**.

3. Drag the key to the right.

As you drag the keyframe, the displacement from the current position and the new position are displayed on the status line.

1 Shape Selected

Moving key(s) from 50 to 60 (10)

4. Move the keyframe to frame **60**.

Note: When you drag a keyframe, its value remains the same, and only the timing changes. The displacement value is only shown in the status line while the keyframe is being dragged. As soon as the mouse is released, the status line is cleared.

Copying a Keyframe using the track bar

A quick method to copy a keyframe on the track bar is to hold down SHIFT while you move the keyframe. The timing of the copied key is different, but its value remains the same as the keyframe from which it was copied.

1. Continue from the previous exercise.

2. On the track bar, choose the keyframe at frame **60**.

3. Hold down the **SHIFT** key and move the keyframe to frame **80**.

1 Shape Selected

Copying key(s) from 60 to 80 (20)

A keyframe with the same values has been copied from frame 60 to frame 80.

4. On the track bar, right-click the keyframe at frame 80 and choose Text01: Z Position from the right-click menu.

5. In the Key Info dialog, set the Value to **0**.

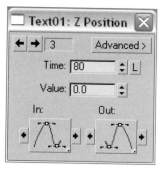

Note: The new keyframe number 3 is shown in the top left of the Key Info dialog.

6. In the Key Info dialog, choose the left arrow.

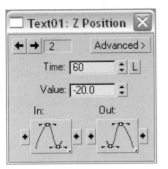

The Key Info dialog now displays the values for keyframe 2.

7. You can move quickly between keys and adjust values within the Key Info dialog.

8. Close the Key Info dialog.

9. ▣ In the time controls, choose Play.

The text drops down, and then rises up quickly from frames 60 to 80.

Using Track View

In the previous section, you saw several adjustments could be made to the animation using the track bar. Track view provides even greater control of the animation. It has two modes called Curve Editor and Dope Sheet. Track View is a modeless dialog, meaning it can remain open while you continue to work within your scene. Track View's Dope Sheet mode displays a list of all objects in your scene, along with their parameters and associated animation keys. In the Dope Sheet, you can change key values and timing individually, or edit ranges of multiple keys.

Track View's Curve Editor mode displays animation values in a graph as a function of time. The Curve Editor allows you to view the behavior of the keyframes between the key times. You can change one keyframe or multiple keys at a time.

Using Track View, you can change controllers for animated parameters, which changes the way **3ds max** interpolates the values between keyframes. Track View also allows you to alter the animation behavior outside an object's range of keys, to establish a repetitive motion.

This section describes the following aspects of Track View:

• Accessing Track View's Curve Editor and Dope Sheet

• Animation Controllers

• Editing Key Tangent Types

• Parameter Curve out of Range Types

Accessing Track View—Curve Editor & Dope Sheet

Track View's Curve Editor can be accessed from the following groups of the interface:

• Graph Editors menu for both the Dope Sheet and the Curve Editor

• Quad menu

• Main toolbar

• Icon from the track bar

The Graph Editor menu option allows you to open multiple Track View dialogs. This is useful for customizing various dialogs with different toolbar icons and layouts for specific objects in the scene.

In the following steps, you try each Track View access method.

1. On the menu bar, choose File > Open and open *Ch06_03.max* from the courseware CD.

 This file contains a butterfly with its wings flapping.

2. On the menu bar, choose Graph Editors > Track View > Dope Sheet.

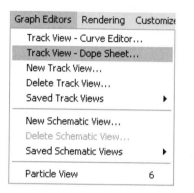

 The Track View Dope Sheet dialog is displayed.

 Note: You learn more about this layout later in this chapter.

3. ✖ Close the Track View dialog.

4. ▦ On the main toolbar, choose Curve Editor (Open).

 Track View's Curve Editor is displayed. This layout is discussed later in the chapter.

5. ✖ Close the dialog.

6. In the Perspective viewport, choose *wing right*.

7. Right-click in the Perspective viewport and choose Curve Editor from the quad menu.

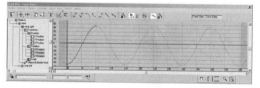

 Track View is displayed with the right wing's animation track displayed.

8. ✖ Close the dialog.

Click filter,
chose object
and 'ok'.

9. On the track bar, choose the Curve Editor icon.

A pop-up version of the Curve Editor replaces the track bar.

Note: You can open as many Track View dialogs as you want, and they can all have unique names. This is useful for viewing specific keyframes on specific objects in the scene.

10. Close the Curve Editor.

The Track View Interface

Track View's two modes, Curve Editor and Dope Sheet, have four main components:

- Menu Bar
- Toolbar
- Hierarchy
- Edit window

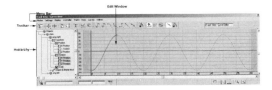

Menu Bar

The Menu Bar differs for the Curve Editor and the Dope Sheet. This group allows you to switch from the Dope Sheet to the Curve Editor. It also contains many tools found on the toolbar. The Menu bar also allows you to change an object's controller type.

Modes Settings Display Controller Tracks Keys Curves Utilities
Menu Bar for the Curve Editor

Modes Settings Controller Tracks Keys Time Utilities
Menu Bar for the Dope Sheet Editor

Toolbar

The toolbar differs for the Curve Editor and the Dope Sheet. You have the option to add toolbars and change the layout of various toolbars. Right-click the toolbar and a menu displays with options for customization. The default toolbar contains important tools for adding keys, sliding keys, changing the tangent, drawing your own specific curves, and reducing keys.

Toolbar for the Curve Editor

Toolbar for the Dope Sheet Editor

Hierarchy

The Track View Hierarchy is similar for the Curve Editor and the Dope Sheet Editor. It provides a hierarchical listing of all objects contained within the scene, as well as their materials and other animatable parameters. Clicking the plus sign to the left of Track View Hierarchy accesses the hierarchy for an object or collection. Each object within the hierarchy has an associated track in the Edit

window. If an object, or any of its parameters, has been animated, you see a range bar in the edit window, indicating the range of time covered during the animation. Expanding the hierarchy for that object exposes the animated characteristic.

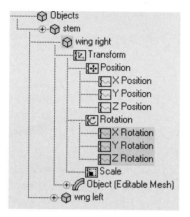

Edit Window

The edit window differs greatly in both Track View modes. However, both groups provide a detailed view of the established animation keys and ranges.

Edit Window for the Curve Editor

Edit Window for the Dope Sheet Editor

What displays in the edit window has a lot to do with the tool you choose from the toolbar. For instance, the Dope Sheet Editor defaults to Edit Keys mode. This mode displays color-coded boxes at specific frames that indicate keyframes. The Dope Sheet Editor also has an Edit Ranges mode, which displays the animation for each track in a range bar.

- Edit Keys mode.

- Edit Ranges mode.

The Curve Editor's Edit window also changes based on the tool you choose from the toolbar. For instance, it defaults to color-coded curves showing the keyframes, and the behavior of those keyframes between keys. This mode allows you to change the in and out behavior of a keyframe. You can draw your own curves to define the behavior of motion, and repeat motions with specific patterns using the Parameter Curve out of Range types.

- Default display of the Curve Editor.

- ![icons] Icons that set the behavior of an object as it enters and exits a keyframe, referred to as the tangent Types.

Tangent set to Step

- ![draw icon] Allows you to draw your own curve.

Result of Drawing your own Curve

- ![range icon] Setting Parameter Curve out of Range types.

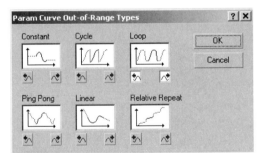

Setting Parameter Curve out of Range types dialog

Result viewed in Curved Editor

The Dope Sheet and Curve Editor also share some common icons.

- ![filter icon] Filtering the items included in the Hierarchy.

Note: Right-clicking this icon displays a condensed version of the options.

- ![operations icon] Performing operations on the keyframes, such as sliding, scaling and moving.

Track View's Layout

In this section, you get a more detailed look at the layout of Track View.

1. On the menu bar, choose File > Open and open *Ch06_03.max* from the courseware CD.

2. On the main toolbar, choose Curve Editor (Open).

3. In the Track View Hierarchy, Objects > stem is displayed.

4. In the Perspective viewport, choose each object, one at a time, and view the Hierarchy window change based on the object selected in the scene.

5. In the Perspective viewport, click in a blank area to unselect any objects.

6. In the Hierarchy window, choose the first plus sign.

Wing right and wing left display below the stem object, and each of the words has a plus sign next to them.

7. In the Hierarchy window, choose the plus sign next to stem.

 The tracks that can be animated are displayed, including the Transform track, the Object track, and the Material track. The stem object does not currently have any animation assigned.

8. In the Hierarchy window, choose the plus sign next to wing right.

 The animated tracks are highlighted automatically and displayed in the edit window.

9. On the Track View menu bar, choose Modes > Dope Sheet.

10. In the Perspective viewport, choose wing right.

 The Hierarchy window displays the objects in the scene, and the Edit window displays two sets of green boxes for wing right and wing left, indicating these objects have animation.

 Note: The Rotation animation tracks are selected automatically as in the Curve Editor.

Track View Hierarchy Icons

Each icon within the Track View hierarchy has a specific meaning. The grey cube next to the object name indicates it is an object. The icon adjacent to Transform indicates that it's an animation controller. The default transform controller itself consists of three other animation controllers. They are Position, Rotation, and Scale.

The bent pipe next to Object (Editable Mesh) or Modified Object indicates that it is a container. A container holds other parameters. In this case, the wing left object container is made up of animation controllers for each of the object's modifiers. Each modifier has animatable parameters.

Track View Edit Window

The Track View Edit window displays animation tracks and any animation keys that have been defined. The Ruler at the bottom of the Edit window indicates the current animation range.

1. Continue from the previous exercise.

2. Make sure Track View is set to Dope Sheet Editor, and that you chose the plus sign next to wing right.

3. In the Edit window, notice the gray-colored keyframes next to wing right: Transform, and Rotation. These are ghost keyframes, which are visual queues for the

animator showing tracks for animated objects.

4. In the Edit window, drag the vertical blue bar.

This scrubs the animation.

5. As you scrub past frame 10 in the Dope Sheet, the wings continue to flap but there is no visual indication of the keyframes in the Edit window.

6. On the Track View menu bar, choose Modes > Curve Editor.

7. In the Perspective viewport, select *wing right*.

8. In the Hierarchy window, choose X Rotation, then Y Rotation, and then Z Rotation.

 Color-coded curves appear, RGB = XYZ. There is a distinct curve set for the Y-axis, which is the green curve. The curve is solid from frames 1 – 10, and then it is a dashed curve for the rest of the animation. This rotation track has a Parameter Curve out of Range type set.

9. In the Hierarchy window, make sure Y Rotation is chosen.

10. On the Curve Editor's toolbar, choose Parameter Curve out of Range type.

The range type is set to Ping Pong.

11. In the Parameter Curve out of Range type dialog, choose Constant, and then click OK.

12. In the Edit window, scrub the animation.

 Wing right stops animating after frame 10 but wing left continues to flap.

13. Set the Parameter Curve out of Range type back to Ping Pong for wing right.

Creating Position Keys Using Auto Key for the Stem

You now continue from the previous exercise to create position keys for the stem. You view and edit the keyframes using both modes within Track View.

1. Continue from the previous exercise.

2. In the Perspective viewport, choose *stem*.

3. Turn on Auto Key.

4. Move the time slider to frame **10**.

5. In the Perspective viewport, move the stem up on the Z-axis approximately **100** units.

6. In the Track View navigation controls, choose Zoom Value Extents.

7. On the Track View menu bar, choose Modes > Dope Sheet.

 The position keyframes are colored red. The same color-coding for the X, Y, and Z-axis is set for the transforms. Position track is Red, Rotation track is Green, and the Scale Track is blue.

8. On the Track View menu bar, choose Modes > Curve Editor.

9. In the Edit window, scrub to frame **20**.

10. In the Perspective viewport, move the stem on the Y-axis approximately **100** units.

11. In the Edit window, scrub to frame **30**.

12. In the Perspective viewport, move the stem on the Z-axis approximately **–60** units.

13. In the Track View navigation controls, choose Zoom Value Extents.

14. In the Edit window, choose the Z-axis (Blue curve) keyframe at frame **10**.

15. On the Track View toolbar, change various in and out tangents, and then after each edit, scrub to view the animation.

 Some tangents, such as the Step tangent, show considerable difference in the animation. Others, such as the Auto tangent to the Custom tangent, do not show much of a difference. You learn more about tangents in the next section.

16. In the Hierarchy window, make sure X, Y, and Z Position are highlighted.

17. On the toolbar, choose Parameter Curve out of Range types, and then choose Relative Repeat.

18. Zoom out of the Perspective viewport, and play the animation.

 The animation continues for another 30 frames.

Editing Keys in the Curve Editor

1. Continue from the previous exercise.

2. In the Curve Editor > Edit Window, region select the Position keyframes for the stem at frame **30**.

3. On the keyboard, press Delete.

4. Scrub the animation.

 The stem does not move down anymore, but continues to repeat the motion because of the Parameter Range setting.

5. In the edit window, region select the keys at frame **10**.

6. On the Curve Editor toolbar, choose Slide Keys.

7. In the Edit window, slide the keys five frames to frame **15**.

 The keyframes at frame **20** also get pushed five frames.

8. In the Edit window, region select the keyframes at frame **25**.

9. On the toolbar, choose Move Keys Horizontal.

10.In the Edit window, hold down **SHIFT** and copy the keyframes to frame **35**.

11.Scrub the animation.

12.The butterfly flaps its wings while staying still, and then continues to repeat the animation because the range type is set to Relative Repeat.

Editing the Range Bars

You can move all animation keys by dragging the range bar. This is useful for multiple objects in the scene when you need to change the timing of one with respect to another.

1. Continue from the previous exercise.

2. From the Track View menu, choose Modes > Dope Sheet.

3. On the Dope Sheet toolbar, choose Edit Ranges.

4. Verify nothing is selected in the viewports.

5. In the Hierarchy window, choose the plus sign next to stem.

6. On the Dope Sheet toolbar, right-click Filters.

7. In the right-click menu, choose Animated Tracks Only.

You see the range bars for the tracks that are animated only.

Tip: Click the plus signs to see all the animated tracks.

8. On the Dope Sheet toolbar, choose Move Keys Horizontal.

9. In the Hierarchy window, choose Position.

 The edit window highlights the Position track, making what you want to edit easier to see.

10.In the edit window, choose the end of the range and move it to frame **20**.

11.In the edit window, scrub the animation.

 The butterfly has the identical keys, except the timing has changed. The animation repeats itself over a longer period of time.

12.On the menu bar, choose File > Save As, and save your file to your local directory.

Dope Sheet vs. Curve Editor

In 3D animation there are different times when you would want to use Curve Editor versus when you would use the Dope Sheet.

The name Dope Sheet comes from traditional animation, where the animator would use a sheet of paper with a column for each frame of the scene. The lead artist would mark down which frames were keyframes, midpoints, and inbetweens; and then draw each of the keyframes, and some of the midpoints. It was then up to a large group of artists to use the keyframe pictures to make the inbetweens.

The benefits of using the Dope Sheet are that it allows you to see when all the keyframes are occurring in your animation, and align the animation of an object with other animation in the scene. For example, if one ball is going to hit another, Dope Sheet allows you to make sure that the key in which the first ball hits the second lines up with the first key of the second ball's animation. When you are doing more than just a simple animation, you should have some form of Dope Sheet written down on paper. This makes animating a lot easier, and you spend less time tweaking the animation.

Dope Sheet is often used with facial animation and lip synching because it is important that the animator be able to see when each morph starts and stops during the animation. Each morph must be timed accurately or the result won't be realistic.

The Curve Editor allows you to see the sharpness and/or smoothness of an object's animation over time. Curve editing began with 3D animation software. It gives you a good idea of how your objects are moving around in an animation. If an object moves smoothly, it needs to have smooth curves, however if there is a sharp change in motion, the curve has a point in it.

Curves are very important when animating most objects. For example, a bouncing ball has smooth animation while it is in the air, but a sharp change in animation when it hits the ground. The Curve Editor allows the animator to adjust the curves by moving the keyframes. It also gives the animator the ability to adjust the in and out tangents of the motion at each keyframe. Many animators use the Curve Editor after setting up their animation to make sure the objects are moving the way they should.

Tangent Types

In the previous exercise, you had a chance to experiment with several tangent types for Position keyframes. In this section, you consider the tangent types in more detail.

When multiple keyframes are created, **3ds max** must determine how to interpolate the animated value between them. This interpolation depends on the controller in effect for the characteristic you are animating.

The default controller for the Position track of all objects is Position X, Y, Z. This controller allows independent animation of the X, Y, and Z coordinate values. Each axis in turn has a default controller termed Bezier Float.

With some animation controllers, such as Linear Float, you have no further influence over the shape of the value curve once the keyframes are set. However, with the Bezier Float controller, you can significantly change the shape of the value curve by specifying different tangent types at each keyframe. The tangent type allows you to control the direction of the value curve entering and exiting the keyframe. The default tangent type is Auto, which is exclusive to **3ds max 7.** The primary feature of the Auto tangent type is it ensures a gradual change in the direction of the value curve between adjacent keyframes. In practical terms, this means that the animated object moves in a non-abrupt manner. A second important feature becomes evident when adjacent keyframes have the same value. In this case, the Auto tangent type ensures that the value remains constant between those keyframes, avoiding overshoot.

Consider the following diagram, (taken from the Curve Editor's edit window). The curve represents the X, Y, and Z coordinate values of an object over a range of 100 frames. The default Position X, Y, Z Controller is in effect. Each axis has a Bezier Float controller. The vertical axis represents value, and the horizontal axis represents time.

The object being animated has six keyframes for each axis. Instead of passing directly from key 1 to key 2, the curve gently moves up and gradually moves down toward key 3. The curve passes through the second keyframe without a sudden change in direction. This indicates the motion now appears smooth in the viewports as the animation is played. You also notice a straight line from keyframes 3 to 4. This indicates the object maintains that location before entering the fifth and sixth keyframes. However, there are occasions where you want the motion to be more abrupt. Examples include robots, mechanical systems, or when a billiard ball bounces off the rail of a billiard table. In these cases, the curve direction should change abruptly as shown in the following illustration.

The tangent type associated with the keyframe determines the nature of the curve transition through it. There are two tangent types associated with each keyframe. One controls the direction of the curve coming into the keyframe, while the other determines the direction of the curve going out of the keyframe. By mixing tangent types, it is possible to have an object gradually approach and abruptly leave a keyframe, for example.

As you have seen, tangent types are available through the Curve Editor. You can also access tangent types by right-clicking a keyframe either in Track view or on the track bar and displaying the Key Info dialog, or by going directly to the Motion panel.

The Available Tangent Types

The available tangent types are shown in the following illustration. This display appears when you right-click a key and display the Key Info dialog. Although those illustrated are from the In tangent type, a symmetrical set is available for the Out tangent type.

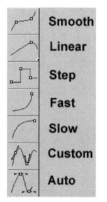

The tangent type icons, along with flyout, are also displayed in the Curve Editor toolbar.

**Flyouts
to control In and Out**

- The Smooth tangent type adjusts the curve so that it has the same tangent direction coming into, and going out of, the key.

- The Linear tangent type causes the tangent direction to point directly at the previous or subsequent key, depending on whether it's used on the In or Out side of the key. Having one keyframe set to the Linear tangent type does not by itself cause the value curve to pass in a straight line between keyframes. For this to occur, the keys on both sides of the segment must be set to linear.

- The Step tangent type maintains the previous key's value until the frame before the current key. As the name implies, it causes a step or sudden change in a value.

- The Fast tangent type causes the curve to change rapidly in the direction of the adjacent key value.

- The Slow tangent type causes the curve to move into or out of the current key's value in a gradual fashion.

- The Custom tangent type provides Bezier handles, allowing you to adjust the tangent direction to any orientation. You can also use the tangent handles to adjust the tangent strength, meaning that the curve maintains the tangent direction longer.

- The Auto tangent type is the default, and offers the most flexibility. It provides a value curve with gradual changes in tangent direction and remains horizontal between keyframes of equal value. It also has tangent handles, which can be adjusted within the Curve Editor.

To set each of the tangent types, select the appropriate button from the tangent type drop-down menu. Small copy buttons appear on either side of the tangent type buttons, with which you can copy a tangent type to the left or right.

Tangent Type Copy Button

Changing Tangent Types

1. On the menu bar, choose File > Open and open *Ch06_04.max* from the courseware CD.

2. ▶ In the time controls, choose Play.

 The text starts from a far position then rises and advances a couple of times until it reaches the final keyframe at frame 100.

3. ▦ On the main toolbar, choose Curve Editor (Open).

4. Choose the plus sign to the left of Text01 to open its hierarchy.

 The Curve Editor displays the motion for the text's three axes.

5. In the edit window, region select all of the keyframes.

6. On the Curve Editor toolbar, choose Set Tangents to Linear.

7. 🔍 Zoom into the Left viewport.

8. In the edit window, scrub the animation.

 The interpolation between the keys is linear.

9. In the edit window, region select the keyframes at frame **50**.

10. On the Curve Editor toolbar, choose Set Tangents to Auto.

11. In the edit window, adjust the handles similar to the following image.

12. In the edit window, scrub the animation.

 The text moves forward, and then moves back, and then continues forward.

13. Continue to work with the various tangent types. When you're done, save your file to your local directory.

Changing Controller Types

A controller stores key values and performs interpolation between keyframes. In the previous exercise, you learned that changing tangent types alters the interpolation between keys. In this section, you learn how to change the controller itself. In particular, you change the default position controller from Position X, Y, Z to Bezier.

A Bezier controller does not give you as much control as does the Position X, Y, Z controller. When you create keyframes using this controller, the keys are created on the X, Y, and Z-axes. Their curves are not laid out individually or as editable as with the Position X, Y, Z. If you decide to use the Bezier controller type, it is beneficial to work

with the default trajectory that it builds. You can turn on the trajectory from the Objects Properties dialog, and edit through the Motion panel.

There are similarities between these two controller types. The Position X, Y, Z controls the individual axis motions with a Bezier curve. While the Bezier animation controller does not allow you to edit an individual axis independently, it does use the same Bezier tangent types for the interpolation between keys.

Changing the Animation Controller

The default controller for the Position track of all objects is called Position XYZ. It is an extremely flexible animation controller, and you use it for most of your animations. Other animation controllers are available for the Position track, however you switch to Bezier Position in the following exercise.

1. On the menu bar, choose File > Open and open *Ch06_04.max* from the courseware CD.

2. In the Top viewport, choose the text.

3. On the main toolbar, choose Curve Editor (Open).

 The individual axes are displayed.

4. In the edit window, choose keyframe **2** at frame **25** for the Y-axis (green line).

5. On the Curve Editor toolbar, make sure Move Keys is active.

6. In the edit window, move the keyframe, and notice that only the keyframe is transformed.

7. On the main toolbar, choose Undo.

8. On the Command panels, choose Motion.

9. On the Motion panel > Assign Controller rollout, choose Position XYZ.

10. In the Assign Controller rollout, choose Assign Controller.

 The Assign Controller dialog is displayed.

11. In the Assign Controller dialog, choose Bezier Position and click OK.

The Curve Editor's specific X, Y, and Z-axes are no longer available.

12. In the Curve Editor > Hierarchy group, choose Position.

13. In the edit window, choose keyframe 2 at frame 25 for the Y-axis.

14. Move the keyframe, and notice other keyframes also move at that time.

15. Close the Curve Editor.

16. Right-click in the Camera viewport.

17. Choose Properties from the quad menu.

18. In the Object Properties dialog > Display Properties group, turn on Trajectory.

The trajectory is a red line with white boxes displayed in the viewport. The white boxes indicate the keyframes. Edit the trajectory by activating the Motion panel.

19. On the menu bar, choose Views > Show Key Times.

20. On the Command panels, choose Motion.

21. On the track bar, right-click the keyframe at frame **25**.

22. Choose *Text01:Position* from the menu.

The Key Info dialog is displayed.

23. In the Key Info dialog, change the In tangent to Linear. You can see the changes take affect directly on the trajectory.

24. On the Motion panel, choose Trajectories.

25. On the Motion panel, choose Sub-Object.

26. On the main toolbar, choose Select and Move.

27. In the Left viewport, begin to move keyframes to adjust the motion.

Continue to experiment with various tangent types, and with editing the trajectory.

Euler Rotation Controller

Up to this point, you have been concentrating on creating keyframes for the Position track of an object. Keyframes can also be set for the Rotation track of objects. When rotation keyframes are set for objects, animation controllers are also used to manage the rotation keyframes and the interpolation between these types of keys. By default, the controller defining the Rotation track is called Euler (pronounced Oiler). The Euler controller has specific tracks for the X, Y and Z-axes. Each track has a Bezier Float controller, similar to the Position track.

The technique for creating a rotation keyframe is the same as for a position keyframe. You simply turn on either Auto Key or Set Key, and start creating keyframes. Editing rotation keys also uses the same methods as for position keys. The track bar and Track View display the keyframes in the same way, allowing you to move, copy, delete, or edit the keyframes.

Setting Rotation Keyframes

In this exercise, you work with the Euler rotation controller to animate the second hand of a timepiece. You make it rotate through a full circle in 60 seconds. With a frame rate of 30 frames per second, the total animation time is 1,800 frames. Each second takes 30 frames. The angular displacement for each second is 360/60=6 degrees.

1. On the menu bar, choose File > Open and open *Ch06_Timepiece.max* from the courseware CD.

 The file contains a watch face.

2. In the time controls, choose Time Configuration.

3. In the Time Configuration dialog > Animation group, enter **1800** for the Length value.

4. In the Time Configuration dialog, click OK to close the dialog.

5. [Auto Key] Turn on Auto Key.

6. | < | 30 / 1800 | > | Use the time slider to go to frame **30**.

7. In the Perspective viewport, choose *Second Hand*.

8. ↻ On the main toolbar, choose Select and Rotate.

9. In the Status bar > Transform Type-In group, enter -6 for the Z-axis.

 | ⊕ | X: 0.0 | Y: 0.0 | Z: -6.0 |

10. Turn off Auto Key.

11. ⏮ In the time controls, choose Go to Start.

12. ⏹ In the time controls, choose Play.

 The hand rotates for one second and stops.

13. Verify that the second hand is selected.

14. Right-click in the active viewport and choose Curve Editor from the quad menu.

15.The Hierarchy group has the rotational axes selected.

16. On the Curve Editor toolbar, choose Parameter Curve Out-of-Range Types.

17.In the dialog, choose Relative Repeat.

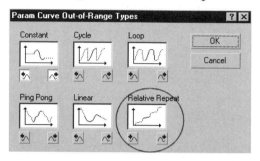

18.In the dialog, click OK to close the dialog.

19. In the time controls, choose Play.

The second hand rotates every second and gently pauses as it gets to its keyframe. This is a realistic effect, and is probably the preferred rotation. However, sometimes the second hand rotates continuously without pausing. You make that change next.

20.Verify that the second hand is still selected.

21.In Curve Editor > Edit Window, select the keyframes at frame **0** and **30**.

22. On the Curve Editor toolbar, choose Set Tangents to Smooth.

23.In the edit window, scrub the animation.

The second hand does not pause after each second; it rotates continuously throughout the whole animation.

24.Experiment with a variety of tangent types and view the animation after each edit.

Pivots Points

The pivot point is an object's local coordinate system. It determines how an object behaves under transform operations such as Rotation and Scale, and also how it functions within a linked hierarchy.

3ds max provides several tools for setting the position and orientation of the object pivot. You can move the pivot point while the object remains stationary, or you can keep the pivot point fixed while the object is adjusted. Any transformations you apply to the object pivot are stored. A reset pivot tool is available to place the pivot to its original position.

The tools for manipulating the object's pivot point are available within the Hierarchy panel.

In the following section, you manipulate an object's pivot point and observe its influence on applied transforms.

Moving Pivot Points

1. On the menu bar, choose File > Open and open *Ch06_06.max* from the courseware CD.

The file contains a single object (named "bar") with its pivot point centered on the object and located at the world origin.

2. On the main toolbar, choose Select and Rotate.

3. Local ▼ On the main toolbar, set the Reference Coordinate system to Local.

4. In the Perspective viewport, select *bar*.

5. In the Perspective viewport, rotate the object on its Z-axis.

 The bar rotates around its pivot point.

6. Right-click to cancel the rotation.

 Note: If you applied any rotation, choose Undo from the main toolbar.

7. Repeat the rotation on both the X and Y-axes, and then right-click to cancel.

 In each case, the bar rotates around its pivot point. In the following steps, you adjust the object pivot to make it rotate around one end of the bar object.

8. Right-click in the Top viewport to make it active.

9. Press ALT + W to go to full screen.

10. On the Command panels, choose Hierarchy.

The Hierarchy panel is divided into 3 groupss: Pivot, IK, and Link Info. Pressing the associated button at the top of the panel activates each of these parts. This section uses only the tools found in the Pivot group.

11. Affect Pivot Only In the Adjust Pivot rollout, choose Affect Pivot Only.

 The Pivot Point is now accessible, and can be moved to a new location.

12. On the main toolbar, choose Select and Move.

13. In the Top viewport, move the pivot point down so that it's located approximately in the center of the lower end of the object.

14. In the Adjust Pivot rollout, turn off Affect Pivot Only.

15. Press **ALT + W** to go back to all four viewports.

16. 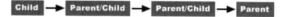 On the main toolbar, choose Select and Rotate.

17. In the Perspective viewport, rotate the bar on its local Z-axis.

 The bar rotates about the new pivot location.

18. Right-click to cancel the rotation or press Undo if you accepted any rotation.

19. Rotate the bar about the X- and Y-axes to verify the rotation behavior.

20. Choose Undo to cancel the rotation.

Object Linking

Object linking within **3ds max** creates a Child => Parent relationship between participating objects. The child object by default inherits the motion of its parent, while remaining free to move itself.

Object linking facilitates animation of connected objects. Without linking, maintaining objects in a correct, logical relationship would be challenging. A group of linked objects is called a linked hierarchy or a kinematic chain. The hierarchy extends from the parent object to the furthest descendent, or child object. An object can be linked to only one parent, but a parent can have any number of children.

The object linking tools are located on the main toolbar. They allow you to create a link, or break an existing link. When you link objects, you indicate the child object first, and then specify its parent. You can select the objects in the viewport, or use the Select By Name dialog.

You can verify whether links have been created in the Select By Name dialog. Its display subtree option causes all linked objects within the hierarchy to appear

indented progressively below one another in the list. The parent object is at the top, and successive descendants appear indented below it.

Note: Child objects by default inherit the transforms of their parents. However, you can override this behavior. The Link Info section of the Hierarchy panel contains an Inherit rollout where you can specify which transforms are inherited.

Creating a Hierarchy

1. On the menu bar, choose File > Open and open *Ch06_09.max* from the courseware CD.

 The file contains two objects that you link during this exercise. The blue object, link1, is the parent of link2.

2. On the main toolbar, choose Select and Rotate.

3. Press H to open the Select by Name dialog.

4. In the Select Objects dialog, choose *Link1* and then click Select.

5. Randomly rotate Link1 about its Z-axis. Notice that Link2 does not follow.

6. Click Undo to remove the rotation just applied.

7. On the main toolbar, choose Select and Link.

 Note: To establish a link, choose the child object and then drag and release it over its parent.

8. In the Perspective viewport, select Link2 and then drag and release on Link1.

9. On the main toolbar, choose Select Object.

Verifying the Link

You can verify successful creation of a link with the Select by Name dialog.

1. Continue from the previous exercise.

2. Press H to open the Select Objects dialog.

3. In the Select Objects dialog, turn on Display Subtree.

Link2 appears indented below Link1.

4. Click Cancel to close the dialog.

Testing the Link

1. Continue from the previous exercise.

2. ↻ On the main toolbar, choose Select and Rotate.

3. In the Perspective viewport, Select *Link1* and rotate it around its Z-axis.

 Link2 remains attached to Link 1 and inherits its rotation.

4. ✛ On the main toolbar, choose Select and Move.

5. In the Perspective viewport, move Link1 a small distance on the X-axis.

 Link 2 also inherits Link1's translation or positional information.

6. Press **CTRL + Z** twice to undo any transformation you applied to Link1.

7. In the Perspective viewport, choose *Link2*.

8. ↻ On the main toolbar, choose Select and Rotate, and then right-click to choose the Transform Type-In.

9. In the Transform Type-In, enter **30** in the Offset Z-axis.

Rotate Transform Type-In

Absolute:Local		Offset:Local	
X: 0.0	⬍	X: 0.0	⬍
Y: 0.0	⬍	Y: 0.0	⬍
Z: 0.0	⬍	Z: 30	⬍

10. Link2 is the child object, thereby permitted to rotate independently of Link1.

Creating a Forward Kinematic Animation

To create a forward kinematic animation, you begin the animation with the parent objects typically, and then animate the child object. You use many of the same tools and methods as for animating single objects. The procedure for creating a forward kinematic animation is as follows:

- Link the participating objects into a meaningful hierarchy by first choosing the child, and then choosing the parent. For example, the foot is linked to the calf, the calf to the knee, the knee to the thigh, and so on. When the thigh is rotated, the knee, calf and foot follow the parent.

- Position the pivot points so that each object transforms appropriately.

- Animate the hierarchy, starting with the parent objects.

 Note: The third option is not a strict rule, but simply a practice that makes the desired results easier to obtain.

Creating a Simple Animation

1. On the menu bar, choose File > Open and open *Ch06_10.max* from the courseware CD.

2. Use the time slider to go to frame **50**.

3. Turn on Auto Key.

4. On the main toolbar, choose Select and Rotate.

5. In the Perspective viewport, rotate *Link1* **85** degrees on the Z-axis.

6. In the Perspective viewport, rotate *Link2* **-75** degrees on the Z-axis.

7. Turn off Auto Key.

8. In the time controls, choose Play.

 The links rotate simultaneously.

Delete Selected Animation

There are times when you want to remove all the animation on an object. 3ds max includes several ways to do this. You have already learned that you can select keys and delete them, however there is a quicker method located in the Animation menu.

To remove all the animation on one or more objects, just select the objects and choose Animation > Delete Selected Animation from the menu bar. This deletes all the keys for the objects, regardless of which keys are selected.

When you use Delete Selected Animation, or if you select all the keys and press Delete, your objects remain in their positions and orientations that are currently showing in the viewports. If you want the objects to be in their original positions, make sure you have the time slider on frame 0 before removing any animation.

Note: If you want to delete certain keyframes while keeping others, you still have to select and delete them from either Track Bar or Track View.

Conclusion

Animation is based on keyframes and the interpolation **3ds max** performs between them. The keyframes are created using the Auto Key or Set Key buttons and one or more of the transform tools. You can edit the keyframes using the track bar, the Motion panel, or track view.

You can adjust the interpolation between keyframes by changing the tangent types or switching to a different animation controller. Using the Move transform with the Bezier animation controller, you can choose to turn on a trajectory, which displays a red line the object follows. You can edit the trajectory directly by choosing the keys at the sub-object level on the Motion panel.

The Rotation and Scale transforms of an object are influenced by the position and orientation of its pivot point. Use the tools within the Hierarchy panel to adjust the object's pivot point.

Placing related objects into a linked hierarchy facilitates their animation. The hierarchy creates a child => parent relationship between objects. By default, all transformations of the parent objects are inherited by the child objects. You can override individual transform inheritance in the Link Info group of the Hierarchy panel.

After creating the linked hierarchy, you can create a forward kinematic animation by animating the parent objects and working towards the child object.

Camera Animation Techniques

Objectives

After completing this chapter, you are able to:

- Use the Camera viewport navigation controls.
- Apply a path constraint.
- Use a path constraint with a free camera.
- Pause a free camera along the path.
- Render animation to a file.

Introduction

This chapter deals with several important topics related to animation and rendering. When the objects within a scene are set up for animation, you typically create one or more cameras to view the animation. This chapter first covers the creation of cameras, as well as the manipulation of their viewport navigation controls. Animations can be viewed with a stationary camera or with a camera moving through the scene. An effective tool for implementing camera motion is the path constraint. Finally, you consider the rendering process, rendering options, and the steps to send the output to a file.

Cameras

Within 3ds max, cameras are object types that define viewing direction and projection parameters. Two types of cameras are available within **3ds max**: target and free cameras.

You can set a viewport to display the scene as the camera would see it. When the camera viewport is active, the viewport navigation controls become camera controls. Adjusting these controls changes the position of the camera, or alters its parameters.

To animate the point of view, you must create a camera and animate its position. In 3D work, this is called a walkthrough. A common example of a walkthrough occurs when you build an environment and animate a camera moving through it to show the audience how it looks.

Creating and Selecting Cameras

The camera objects are available from the Create panel or from the Create > Cameras menu. When cameras are created, they appear on the active construction plane of the current viewport.

Target cameras have two objects, one for the camera and the other for the target. A line running between them indicates the association between the camera and target. Although they are connected, the camera and its target are separate objects. You can select and transform one or both in the viewports.

A single camera icon represents a Free camera.

Cameras can also be selected by choosing the camera in the viewports, using the quad menu, or with the Select by Name dialog.

Note: For more information about cameras and camera angles, please see Chapter 21.

Adjusting Cameras

After you have created cameras, you ordinarily need to adjust their position and orientation to obtain a satisfactory view of the scene. Cameras may be adjusted in several ways by:

- Transforming the camera and its target in the viewports.
- Altering the camera's projection parameters using the Modify panel.
- Using the viewport navigation controls.

Camera Viewport Navigation Controls

When a Camera viewport is active, the viewport navigation controls become specific to camera manipulation. When you modify the camera using the navigation controls, you enjoy the advantage of immediate feedback on the effect of these modifications.

Target and Free Cameras

In most instances, working effectively either with a target or a free camera is possible. However, in some cases, one type has advantages over the other.

For still images, or animations where the camera is in a fixed position, the target camera offers a little more flexibility in positioning. You can select the camera or the target in the viewports and use the transform tools to put them into the desired position.

On the other hand, if you are preparing an animation where the camera moves through the scene, such as the walkthrough example, a free camera allows you to forgo animation of the target position.

Camera Display

Once you have positioned a camera, you can hide its display in the viewports, thus improving clarity and reducing the likelihood that you move the camera accidentally as you work within the scene.

Creating a Camera

1. On the menu bar, choose File > Open and open *Ch07_01.max* from the courseware CD.

 The file contains a jet fighter.

2. Right-click in the Top viewport to make it active.

3. Press **ALT + W** to enlarge the Top viewport.

4. On the command panels, choose Create > Cameras.

5. In the Object Type rollout, choose Target.

6. Zoom and pan the Top viewport so the plane is on the right side of the viewport and there is enough room to create the camera.

7. In the Top viewport, click and drag to first create the camera and then drag to define the target.

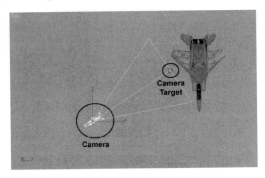

8. Right-click in the viewport to end camera creation mode.

9. Click in an empty area of the viewport to deselect the camera.

 The camera consists of an icon that represents the camera itself, and a small box that represents the camera target.

10. Right-click the Top viewport label.

11. From the right-click menu, choose Views > Camera01.

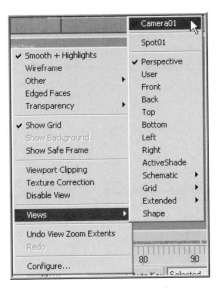

The viewport changes to the Camera viewport.

12. To change any viewport to a Camera viewport, you can also use the keyboard shortcut C.

Selecting the Camera

1. On the menu bar, choose File > Open and open *Ch07_02.max* from the courseware CD.

 The file contains a single target camera.

2. On the main toolbar, choose Select and Move.

3. In the Top viewport, select the camera icon.

4. On the Status Bar > Transform type-in area, enter **35** for the Z-axis.

5. With the Move tool still selected, click the blue line between the camera and its target. (You might need to click twice.)

The camera and its target are selected.

6. ⊕ On the main toolbar, right-click Select and Move.

The Move Transform Type-In is displayed.

7. In the Transform Type-In dialog > Offset: Screen area, enter **20** on the Z-axis.

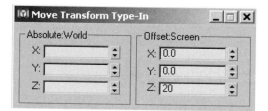

8. Close the Transform Type-In dialog.

9. Click in the open area of the viewport to deselect the camera.

10. Press **H** to open the Select Objects dialog.

The camera and its target are displayed in this dialog, and you can select one or both.

11. Click Cancel to close the Select Objects dialog.

Setting a Camera Viewport using Match Camera to View

In the following exercise, you create a camera, and then match that camera to the existing Perspective viewport. This is useful when you have adjusted the Perspective viewport in such a way that you like that view as your first frame of animation, or your first still shot. Perspective viewports cannot be animated; therefore you have an advantage in creating a Camera viewport.

1. On the menu bar, choose File > Open and open *Ch07_03.max* from the courseware CD.

The completed Weebles village proposed as a one-day project in Chapter 26 is displayed. There is one Camera viewport already displayed.

2. Right-click to activate the Perspective viewport.

3. Press CTRL + C.

4. The Perspective viewport changes to the Camera02 viewport.

 The camera looks exactly like the Perspective viewport.

5. In the Top viewport and Front viewport you see the Camera is created

Now you are able to use the camera controls to adjust the view, and animate the camera, if you want.

Using the Camera Viewport Navigation Controls

When a Camera viewport is active, the viewport navigation controls become the camera navigation controls, with specific controls to manipulate the camera.

These controls play an important role when you compose your scene. Try each of them and view their effect. As you adjust the camera viewport in each case, watch how the camera is affected in the other viewports.

Tip: Several of the camera navigation controls are nested within flyouts. A small triangle on the lower right of the icon indicates these flyouts. To verify the tool you are selecting from a flyout, read the status bar on the lower left of the main interface.

The following camera navigation controls are available regardless of the type of camera created.

Dolly Camera—This control moves the camera along its line of sight, which is the line between the camera and its target. The camera lens setting remains constant during a dolly camera. As a result, the camera appears to move closer to, or further away, from the object.

1. Continue with your previous exercise.

2. Right-click over the *Camera01* viewport label.

3. From the right-click menu, choose Select Camera.

Tip: Having the camera selected while you work with the camera viewport controls allows you to see changes more easily.

4. In the camera navigation controls, choose Dolly.

There are three Dolly options. If Dolly Camera is not the option on top, press and hold whatever occupies the top position and simultaneously choose Dolly Camera from the flyout.

5. In the *Camera01* viewport, drag up and down.

The scene objects appear smaller or larger as the camera is moved away from or closer to the target. Pay attention to the camera's motion in the Top and Camera02 viewports.

6. Right-click in the *Camera01* viewport to end Dolly mode.

7. On the main toolbar, choose Undo to remove any changes you made to the camera.

Dolly Target—This control moves the target further from, or closer to, the camera. The lens parameter and the composition of the scene remain unchanged. The camera orbit control is based on the target position. Therefore, you can use Dolly Target if you want to influence a subsequent orbit motion of the camera.

1. Continue from the previous exercise.

2. Verify that *Camera01* is still selected.

3. In the camera navigation controls, press and hold Dolly Camera.

4. Choose Dolly Target from the flyout.

5. In the *Camera01* viewport, drag up and down and then right-click to cancel the Dolly Target.

The target point moves back and forth along the line of sight in all viewports other than the *Camera01* viewport.

6. Right-click in the viewport to end Dolly Target mode.

7. Press CRTL + Z if you accepted the Dolly Target changes before right-clicking to cancel.

Dolly Camera and Target—This moves both the camera and the target along the line of sight. The effect is the same as a Dolly Camera, except the distance between camera and target is preserved.

Use Dolly Camera and Target when you want to move the camera closer to the subject and preserve the orbit behavior.

1. Continue from the previous exercise.

2. Make sure *Camera01* is still selected.

3. In the camera navigation controls, choose Dolly Camera + Target from the flyout.

4. In the camera viewport, drag, and then right-click to cancel.

Both the camera and its target move.

5. In the Camera viewport, right-click to end Dolly Camera + Target mode.

Perspective—Perspective moves the camera closer to its target, but unlike Dolly Camera, changing the Perspective causes the lens to change. Lens sizes of 35-50 mm produce effects comparable to human visual perception. Shorter focal lengths exaggerate the perspective distortion but can give a striking artistic effect. You might use Perspective to increase perspective distortion of a villainous character, for instance, making the scene appear more ominous. Longer focal lengths reduce perspective distortion and give the scene a flatter appearance, tending toward orthographic projection.

1. Continue from the previous exercise.

2. In the camera navigation controls, choose Perspective.

3. In the *Camera01* viewport, drag upward.

 Note: If the perspective changes only slightly, press and hold CTRL as you use Perspective. This multiplies the effect of the mouse movement. As you drag upwards, the camera moves closer to the scene objects, amplifying the perspective distortion as it gets closer.

4. In the *Camera01* viewport, drag down.

 The scene appears flatter.

5. You might want to do this a few times to view the affects.

6. Right-click to end Perspective mode.

7. Press **CTRL + Z** to undo any Perspective distortion.

Roll Camera—This control causes the camera to roll about its line of sight. The effect resembles tilting your head as you look at a subject. For instance, Roll Camera might be used to simulate the rolling motion of an aircraft as it navigates a low-level flight over mountainous terrain.

1. Continue from the previous exercise.

2. In the camera navigation controls, choose Roll Camera.

3. In the *Camera01* viewport, drag the cursor horizontally.

 The camera rolls about its line of sight.

4. On the main toolbar, choose Undo to remove whatever camera roll you have applied.

5. Right-click to cancel roll camera mode.

Field of View—This control produces an effect like the one Perspective control produces, except in this case, the camera position remains fixed while the field of view changes. This control is also available for Perspective viewports.

1. Continue from the previous exercise.

2. In the camera navigation controls, choose Field of View.

3. In the *Camera01* viewport, drag the cursor vertically.

 The field of view narrows as the cursor is drawn upwards, and widens as it is moved down. A narrower field of view decreases the Perspective distortion, leading to a flatter scene appearance.

4. Right-click to cancel Field of View mode.

5. On the main toolbar, choose Undo to restore the camera to its previous settings.

Truck Camera—The Truck tool causes the camera to move in the view plane, perpendicular to its line of sight. Only the camera position changes; all other parameters remain the same. When animated, Truck Camera simulates the effect of looking out the side window of a car, as objects in the scene appear to pass through the field of view.

1. Continue from the previous exercise.

2. In the camera navigation controls, choose Truck.

 Note: This is the same icon used to represent pan in non-camera viewport controls.

3. Drag horizontally within the *Camera01* viewport.

 The camera moves moves horizontally within the picture plane.

4. Drag vertically within the Camera viewport.

 The camera moves vertically within the view plane.

5. Right-click to end Truck mode.

6. On the main toolbar, choose Undo to restore the camera to its previous position.

 Tip: Holding Shift while using the Truck tool constrains the camera motion to either the horizontal or vertical direction within the view plane.

Walk Through—Walk Through is located in the Truck Camera flyout or the Pan flyout when using a Perspective viewport. The keyboard shortcut is the Up Arrow.

Walk Through allows you to navigate through your scene like a player in a first-person game. You can use it to preview how your scene would look in a first-person game, and you can use the controls to finely position the Perspective view or a Camera's position.

When you select Walk Through, click-and-drag in the viewport to use the mouse to rotate the view. You can turn to look up, down, left, and right.

The W, A, S, and D keys, and the arrow keys, are used to move through the scene, as in most first-person games.

Tip: If you use two keys simultaneously; for instance W, A, or the up and left arrows, then you can move diagonal.

The E and C keys are used to move the view up or down without rotating the camera, Q toggles acceleration on or off, and Z toggles deceleration.

Four more keypresses can be used to help you navigate:

- [decreases the step size
-] increases the step size
- Alt + [restores the default step size
- Shift + Space levels the view horizontally

1. Continue from the previous exercise.

2. In the camera navigation controls, choose Walk Through in the flyout.

3. Click-and-drag within the *Camera01* viewport.

 This starts the walkthrough and rotates the view.

4. Use W, A, S, and D to navigate the scene while rotating the mouse to turn left, right, up, and down.

 You travel through the scene like it is a first-person game.

5. Release the mouse button, and then right-click to end Walk Through mode.

6. On the main toolbar, choose Undo to restore the camera to its previous position.

Orbit Camera—This tool causes the camera to rotate about its target point. By pressing Shift in combination with orbit, you are able to limit the rotation to a horizontal or a vertical plane. The Orbit Camera tool might be used to simulate spinning around a subject.

1. Continue from the previous exercise.

2. In the camera navigation controls, choose Orbit Camera.

3. Press and hold **SHIFT** while you drag horizontally in the *Camera01* viewport.

 The camera revolves around its target in a horizontal plane.

4. Press and hold the **SHIFT** key while you drag vertically in the *Camera01* viewport.

 The camera revolves around its target in a vertical plane.

5. Right-click to end Orbit camera.

6. On the main toolbar, choose Undo to restore the camera to its original position.

Pan Camera—Pan Camera is located within the Orbit camera flyout. It causes the target point to rotate around the camera. Pan Camera may be used to follow a motorcycle as it speeds past a standing observer, for example.

1. Continue from the previous exercise.

2. In the camera navigation controls, choose Pan Camera.

3. Press and hold **SHIFT**.

4. In the Camera viewport, drag horizontally.

 The camera target moves in a horizontal plane around the camera.

5. Press and hold **SHIFT**.

6. In the Camera viewport, drag vertically.

 The camera target moves in a vertical plane around the camera.

7. In the Camera viewport, right-click to end Pan Camera mode.

8. On the main toolbar, choose Undo to restore the camera to its original position.

Hiding the Cameras

The following sequence illustrates how to hide the camera icon in the viewports.

1. Continue from the previous exercise.

2. Verify the *Camera01* viewport is active.

3. Right-click the *Camera01* viewport label.

4. On the Command panels, choose Display.

5. On the Display panel > Hide by Category rollout, turn on Cameras.

```
-        Hide by Category
  □ Geometry      All
  □ Shapes       None
  ☑ Lights       Invert
  ☑ Cameras
  □ Helpers
  □ Space Warps
  □ Particle Systems
  □ Bone Objects
                  Add
                 Remove
                  None
```

The camera icons are hidden, but the views still display the camera's perspective.

Note: This method hides all cameras in the scene. If you wish to hide a specific camera, choose the camera, then choose Hide Selected from the Hide rollout. Hide Selected is also available in the quad menu.

The Path Constraint

Animation Controllers were described in Chapter 6, where you used the default controller types for position and rotation. In this section, you work with the path constraint. A path constraint uses one or more shapes to define an object's position in space during animation.

Before applying a path constraint, you may animate an object with the default position controller by transforming it and using the Auto Key or Set Key method for animation. When you apply a path constraint to an object by using the Animation menu, it adds a Position List controller to the default Position X, Y, Z controller type. This list controller is simply a container, allowing you to layer controllers. It becomes the current controller with both the Position X, Y, Z, and path constraint controllers defined, however the path constraint becomes the active controller for that specific object.

The path can be any 2D shape, open or closed. If the shape is comprised of multiple splines, the path constraint uses only its first spline.

The path constraint in **3ds max** allows you to specify more than one path; then the trajectory becomes a weighted blend of the paths. For example, if you have two splines that define the banks of a winding river, using both of them within a path constraint allows you to sail a boat down the middle.

When you assign an object to use the path constraint, the following options are available in the Path Parameters rollout.

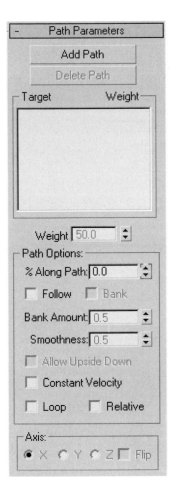

The Follow Option

The Follow option causes an object to maintain one of its local axes tangent to the path it follows. You can specify which of the object's axes to use, but X is the default. The object's local Z-axis is placed parallel to the world Z-axis. When a path constraint controller is applied to a camera, the Follow option can be used to ensure that the camera always looks forward, towards the direction of motion.

The Bank Option

The Bank option causes the objects local Z-axis to bank toward the center of curvature. The Bank option is available only when the Follow option is selected. The bank angle depends on the Bank Amount parameter. Higher settings increase the bank angle. The bank angle is also influenced by the curvature of the path. Tighter curves increase the bank angle.

Use the Bank option to represent the motion of an aircraft. The banking effect mimics the roll angle as the heading is changed.

The Smoothness Parameter

The Smoothness parameter is available when the Bank option is set. The Smoothness parameter averages the bank angle over the path, resulting in smaller bank angles and a more gradual transition into the curves. A higher smoothness value results in smaller banking angles.

Constant Velocity Option

Typically, splines are made up of several segments. When a path constraint is first applied to an object, the time required for the object to get to each segment of the path are not equal. As a result, the object moves slower where there are short segments and faster where there are long segments. If this is not appropriate for your project, you can change the motion to constant velocity by choosing Constant Velocity in the Path Parameters rollout.

Controlling the Distance Along the Path

The path constraint contains several tracks, each containing a controller for one of the path constraint parameters, such as the Bank amount and Smoothness. There is also a Percent track. Its controller specifies the percentage of the path that the object has traveled.

When a path is first selected, keyframes are created in the Percent track at both the start and end of the current animation range. The key values are a number between 0 and 100, representing the percentage of the path traveled. The key value of the first keyframe is 0 percent, which represents the start of the path. The key value of the second keyframe is 100 percent, which represents the end of the path.

You can move, copy, or delete the Percent track keys. As with the keys for other controllers, you can change both their timing and value.

Assigning a Path Constraint

Several ways are available to assign a path constraint to an object. However, the easiest way is to use Animation > Constraints > Path Constraint from the menu bar. Use the following simple steps to assign a Path constraint:

- Select an object, such as a camera, light, or geometry.
- Have a 2D open or closed shape in the scene.
- Make sure the object is selected.
- On the menu bar, choose Animation > Constraints > Path Constraint.
- Select the 2D shape.

Assign a Camera to a Path

In this sequence, you create a free camera, assign a path constraint, and use an existing 2D shape for the camera's animation.

1. On the menu bar, choose File > Open and open *Ch07_04.max* from the courseware CD.

 The Weebles village is displayed with an added 2D open line. This line is used as the path for the camera to follow.

2. On the command panels, choose Create > Cameras.

3. In the Object type rollout, choose Free.

4. In the Front viewport, click once to create a free camera, and then right-click to exit Create.

 It does not matter where you place the camera because once you assign the path constraint, the camera jumps to the start of the line (path).

5. Make sure the Free camera is selected.

6. Right-click to activate the Top viewport.

7. On the menu bar, choose Animation > Constraints > Path Constraint.

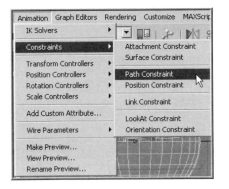

A dashed line is attached to your mouse.

8. Move your mouse to the line and click.

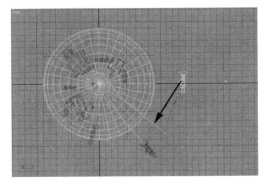

The free camera gets positioned at the start of the path.

Note: The Motion panel is displayed automatically.

9. Right-click in the *Camera01* viewport, and press C.

10. Scrub the time line.

The free camera is animated along the path. Notice how the camera behaves

around the curvature of the path. It does not turn with the curves in the path.

Using Follow

1. Continue from the previous exercise.

2. ▶️ In the time controls, choose Play.

3. Observe the camera orientation without the Follow option.

The camera travels along the path and maintains its orientation.

4. Stop the animation.

5. In the Path Parameters rollout > Path Options group, turn on Follow.

Now the camera is aligned to the X-axis.

6. In the Path Parameters rollout > Axis group, choose Y.

The camera's local Y-axis now points in the direction of the path.

Using Bank

1. Continue from the previous exercise or choose File > Open from the menu bar, and open *Ch07_05.max* from the courseware CD.

2. Make sure the free camera is selected.

3. On the Motion panel > Path Parameters rollout > Path Options group, turn on Bank.

4. Scrub the animation.

The camera banks as it follows the path, but the amount seems excessive.

5. In the Path Options group, set Bank Amount to **0.1**.

6. Scrub the animation.

The banking is more subtle.

Note: A lower setting for Bank Amount creates smaller bank angles. The radius of the path corners also influences object banking. A smaller radius leads to increased banking.

Using the Smoothness Parameter

1. Continue from the previous exercise.

2. In the Path Parameters rollout > Path Options group, set Smoothness to **0.1**.

3. Drag the time slider to view the animation.

Notice how the camera banks more abruptly.

Using Constant Velocity

1. Continue from the previous exercise.

2. In the Path Parameters rollout > Path Options group, turn off Bank.

3. In the Path Parameters rollout > Path Options group, turn off Constant Velocity.

4. In the time controls, choose Play.

The camera moves along the path not at a constant rate, it's slowing down and speeding up, based on the distance between the vertices of the path.

Pausing Motion Along a Path

When a camera has a path constraint assigned, you often have to adjust the timing of the camera's motion along the path. This can be done on the track bar or in Track View.

When you animate an object to follow a path, you might want to pause its motion at a specific point. For example, for a path constraint applied to a camera object, you might want to stop the camera at a certain point and look around. You can accomplish this by creating two keyframes with the same value. The time interval between these subsequent keyframes represents the length of the pause.

Curve Editor Mode

You will generally find it convenient to adjust timing using Track View's Curve Editor. This mode provides a graphical display of key values as a function of time. When you view a Percent track in the Curve Editor mode, you see the percent value changing between keyframes, making motion manipulation easy. The following illustration shows the Percent track within Track View's Curve Editor.

Using the Curve Editor to Pause the Camera

In this sequence, you adjust the position of the camera so that it stops along the path.

1. On the menu bar, choose File > Open and open *Ch07_06.max* from the courseware CD.

 This is the same file you've been working with.

2. Use the time slider to go to frame **120**.

 This is the frame in which you pause the camera.

3. Make sure the free camera is selected (*Camera03*).

4. ▦ On the main toolbar, choose Curve Editor (Open).

5. ▦ On the Curve Editor toolbar, right-click Filters.

6. From the right-click menu, choose Animated Tracks Only.

Your hierarchy window displays the animated tracks for the free camera only.

7. ▱ On the Curve Editor toolbar, choose Add Keys.

8. In the edit window, click at frame **120**, and then click again at frame **180**.

9. ✛ On the Curve Editor toolbar, choose Move Keys.

10. In the edit window, choose the keyframe at frame **120**.

11. In the Curve Editor status bar, the first box is the current frame, and the second box is the percentage the camera has traveled along the path.

12.Change Percentage to **35**.

13.In the edit window, choose the keyframe at frame **180**.

14.In the status bar, change the percentage to **35**.

The curve is a straight line from frame 120 – 180, indicating a pause.

15. ▶. In the time controls, choose Play.

The camera pauses from frame 120 – 180.

16. ■■. In the time controls, choose Stop.

Re-Scaling the Animation

In this next procedure, you re-scale the animation from 300 frames to 500 frames. The pause is maintained, but at a different time because you extend the whole animation 200 frames.

1. Continue from the previous exercise.

2. In the time controls, choose Time Configuration.

3. In the Time Configuration dialog > Animation group, choose Re-scale Time.

4. In the Re-scale Time dialog > New group, type **500** in the End Time, and then click OK.

5. In the Time Configuration dialog, click OK.

6. [] In the Curve Editor > navigation controls, choose Zoom Horizontal Extents.

7. In the Curve Editor, scrub the animation.

 The animation is identical except that it is 500 frames instead of 300 frames.

8. On the menu bar, choose File > Save As and save your file as *village_500.max* in your local directory.

Assign a Path Constraint to Geometry

In this next procedure, you assign a Path constraint to one of the Weeble characters. You use the same procedure as for the camera, but this time you apply the path to geometry.

1. On the menu bar, choose File > Open and open *ch07_08.max* from the courseware CD.

2. In the Top viewport, select *Dad Weeble*.

3. Right-click to activate the *Camera02* viewport.

4. Press P to change it to the Perspective viewport.

5. [] In the viewport navigation controls, choose Zoom Extents Selected.

6. In the viewport navigation controls, choose Arc Rotate Selected.

7. In the Perspective viewport, rotate around the Weeble until he is facing the viewport.

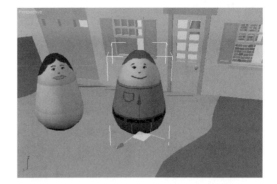

8. Right-click to activate the Top viewport.

9. On the menu bar choose, Animation > Constraints > Path Constraint.

10. Select the line named *Dad Path*.

11. Scrub the time slider.

 The Weeble character is animated, but it does not turn with the curvature of the path.

12. On the Motion Panel > Path Parameters rollout, turn on Follow.

13. Scrub the time slider.

 The Weeble turns as it follows the path.

14. In the Path Parameters rollout, turn on Bank.

The default Bank value is too much.

15. Change Bank to **0.05**.

16. Scrub the time slider.

The Weeble rotates and banks as it follows the path.

17. Make sure Constant Velocity is turned on.

18. On the menu bar, choose File > Save As and save your file as *weebles_animation.max* in your local directory.

You use this file later to create a Preview animation.

Look At Constraint

The Look At constraint allows you to make one object remain directed at another. In this next procedure, you continue working with the Weeble village. You have Mom weeble look at Dad weeble for the whole animation.

The Look At constraint is assigned as part of a Rotation List controller on an object's Rotation's track.

1. On the menu bar, choose File > Open and open *Ch07_lookat.max* from the courseware CD.

2. In the Top viewport, select *Mom Weeble*.

3. On the menu bar, choose Animation > Constraints > LookAt Constraint.

A dashed line is attached to your mouse.

4. In the Top viewport, select *Dad Weeble*.

The Motion panel is displayed, and the Mom Weeble needs to be aligned.

5. On the Motion panel > LookAt Constraint rollout > Select LookAt Axis, choose Y, and then turn on Flip.

LookAt Constraint

| Add LookAt Target |
| Delete LookAt Target |

Target Weight
Dad Weeble 50

Weight 50.0

☐ Keep Initial Offset

Viewline Length 100.0

☑ Viewline Length Absolute

Set Orientation

Reset Orientation

Select LookAt Axis:
○ X ● Y ○ Z ☑ Flip

Select Upnode:
☑ World None

6. Use the time slider to scrub the animation.

Mom Weeble looks at Dad Weeble throughout the animation.

7. On the menu bar, choose File > Save As and save your file as *weeble_lookat.max* to you local directory.

You use this file later to render an animation.

Rendering Animations

Once you have animated your scene with the animation controllers of your choice, you're ready to render it – that is, to playback the animation with all the materials, lights, and animation you applied to the objects in the scene. When you render a scene, you should consider whether the rendering is played back in video or as part of a multimedia presentation. Whatever the case, the following options help you make an informed decision.

Animation File Formats

You can take several different approaches when rendering an animation. One approach is to render directly to an animation format file, such as AVI or MOV. When complete, these files are ready for playback. Depending on the output size and your system capabilities, the playback rate might be slower than the desired frame rate.

A second approach is to render the animation as individual bitmaps such as TGA, BMP or PNG. You may then assemble the complete animation from individual files using non-linear editing software such as Adobe's Premiere, and then format the output for computer, DVD or video playback. Some of these output options might require special-purpose hardware.

The following section focuses on rendering to an animation file format.

Rendering Times

Rendering animations can take a considerable length of time. Consider this example: You have 45 seconds of animation to render. The playback rate is 15 frames per second. Each frame takes an average of two minutes to render. The total rendering time is given by:

Total rendering time = 45 sec x 15 frames/sec x 2 min/frame 1350 minutes or 22.5 hours

When rendering times are long, you want to avoid the risk of repeating the rendering. You can take some steps prior to rendering to ensure the results are correct.

Test Renders

Select several frames in the animation and render single frames. This allows you to verify lighting and camera positions.

Preview Animation

The Make Preview option is found within the Animation menu. This feature allows you to render to an AVI file with fast, but lower quality, shading. The preview illustrates problems with camera or object animation.

The Render Scene Dialog

This dialog contains many options for rendering either a still image or an animation. These options are described in detail in Chapter 21.

The following section makes you familiar with options available in the Common Parameters rollout.

The Render Scene Dialog

The Time Output Group

This group specifies the time range you want to render. By default, it's set to single, rendering the current frame only. You can choose to render the active time segment or render only specific frames in the active time segment.

The Output Size Group

The output size dictates the output resolution of the animation. The drop-down list contains a variety of output presets.

The Render Output Group

Use the Render Output group to specify the output filename and file type.

Rendering a Preview

In the following procedure, you render a preview. The preview is useful to check the timing of your animation. You want to make sure that objects are not going through one another, or that the camera is moving too slowly or quickly. The preview animation helps you do this type of "fine-tuning."

1. On the menu bar, choose File > Open and open *weebles_animation.max* from your local directory, or any of the other files you saved throughout this chapter. You may choose to open *ch07_render.max* from the courseware CD.

2. Right-click *Camera03* to make it active.

3. On the menu bar, choose Animation > Make Preview.

4. In the Make Preview dialog, accept the defaults, and then click Create.

5. In the Video Compression dialog > Compression drop-down list, choose Cinepak, and then click OK.

6. Each frame gets drawn. When **3ds max** is done drawing each frame, media player displays the preview animation.

 In this preview, you see that after the camera stops, it speeds up. If this effect is not desirable, now is the time to adjust the timing using the Curve Editor. You do not want to render the scene if you are dissatisfied with the preview.

Rendering to a File

In the next procedure, you render a range instead of rendering the whole animation. Rendering a range before you render the animation is a good idea because you test lighting, shadows, and materials. If the test renders work out, then you render the complete animation.

1. On the menu bar, choose File > Open and open the file you want to render from your local drive.

2. On the menu bar, choose Rendering > Render.

 The Render Scene dialog is displayed.

3. In the Render Scene dialog > Common Parameters rollout, choose Range.

4. In the Range area, enter **175** in the first spinner and **450** in the To spinner.

```
┌──────────── Common Parameters ────────────┐
│ ─Time Output─────────────────────────────  │
│  ○ Single              Every Nth Frame: 1  │
│  ○ Active Time Segment:  0 To 500          │
│  ● Range:  175    To  450                  │
│            File Number Base:  0            │
│  ○ Frames  1,3,5-12                        │
└────────────────────────────────────────────┘
```

This range includes a portion of the time the camera is stopped, and most of the end of the animation.

5. In the Common Parameters rollout > Output Size group, choose 320 x 240.

 The Image Aspect is the ratio of image width to height. For example 320/240=1.33.

```
┌─Output Size──────────────────────────────────┐
│ Custom      ▼   Aperture Width(mm): 36.0      │
│ Width:   320     320x240    720x486           │
│ Height:  240     640x480    800x600           │
│ Image Aspect: 1.333   Pixel Aspect: 1.0       │
└──────────────────────────────────────────────┘
```

6. In the Render Output group, choose Files.

7. In the Render Output File dialog, choose a location to save the file.

8. In the Save as type drop-down list, choose AVI File.

```
┌──────────────────────────────────────────┐
│ Ch07 sample                               │
│                                           │
│ AVI File (*.avi)                       ▼  │
│ All Formats                               │
│ AVI File (*.avi)                          │
│ BMP Image File (*.bmp)                    │
│ Kodak Cineon (*.cin)                      │
│ Encapsulated PostScript File (*.eps,*.ps) │
│ Autodesk Flic Image File (*.flc,*.fli,*.cel) │
│ Radiance Image File (HDRI) (*.hdr,*.pic)  │
│ JPEG File (*.jpg,*.jpe,*.jpeg)            │
│ PNG Image File (*.png)                    │
│ MOV QuickTime File (*.mov)             ▼  │
└──────────────────────────────────────────┘
```

9. In the File name area, type *Ch07_Sample.AVI*, and then click Save.

10. In the Video Compression dialog, choose Cinepak.

```
┌─AVI File Compression Setup ──────────── ✕ ┐
│                                            │
│  Compressor                                │
│  ┌──────────────────────────────────┐     │
│  │ Cinepak Codec by Radius       ▼ │     │
│  └──────────────────────────────────┘     │
│  Quality (100 = Best)     100              │
│  |  '  '  '  '  '  '  '  '  '  |           │
│                                            │
│  Keyframe Rate:    Default                 │
│  P Frame Rate:     Default                 │
│                                            │
│   Setup        OK        Cancel            │
└────────────────────────────────────────────┘
```

The compression quality specifies the degree of file compression. The greater the compression quality value, the higher the output quality. However, it might result in larger files.

11. Verify the Compression Quality is set to **100**.

12. Leave the other settings at their default values, and then click OK.

13. In the Render Scene dialog, choose Render.

14. The Render progress dialog is displayed.

15. When the animation has completed rendering, close the Render Scene dialog.

16. On the menu bar, choose File > View Image File.

17. In the View File dialog, open *Ch07_Sample.avi* from your local directory and play the rendered animation.

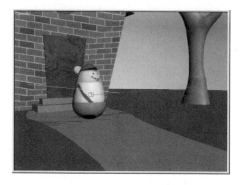

Conclusion

In this chapter, you learned when to use a target and free camera. You learned how to adjust the camera using the interactive camera controls when the camera viewport is active. Using the camera navigation controls gives immediate feedback on how the scene appears.

A path constraint is an effective method for animating camera motion. Path constraints causes the camera to follow a spline path. You can use the Curve Editor mode of Track View to view the camera's displacement along the path as a function of time. The Curve Editor also facilitates detailed motion adjustment.

Animations can be rendered as a series of individual bitmaps or directly as an animation format file. When rendering to a file, you need to specify the output size and time. Working with smaller output sizes and skipping frames results in faster rendering times.

8

Inverse Kinematics

Objectives

After completing this chapter, you should be able to:

- Understand why Inverse Kinematics (IK) is used in animation.
- Know the difference between IK and Forward Kinematics (FK) animation.
- Create a simple IK chain.

Introduction

IKis an important and powerful tool used in animation. Almost every computer animated character uses IK to animate its legs, and usually its arms.

When you use IK on a character's leg, for example, you are able to position the foot directly without rotating the hip or the knee. Instead, the hip and knee are rotated for you as you move the foot around. It makes animating a character's arms and legs easier by moving the other bones for you.

The opposite of IK is FK. Forward Kinematics is the standard way of animating a hierarchy, where adjusting each object affects its children only. Animators use this method of character animation when they animate the spine, (and the) head, and neck.

In this chapter, you look at FK and IK, as well as create a simple IK chain and animate it.

Understanding IK

IK works on a hierarchy of three or more objects in a row linked parent to child. A good example is the arm and hand: Upper Arm -> Forearm -> Hand. For a character, these objects are bones inside the mesh, but you can use any linked objects After adding IK, the linked objects are called an IK chain.

When you create an IK chain, a special object is created at the pivot point of the lowest child in the chain. This object is called the goal. When you move the goal, the objects in the chain rotate in an attempt to follow the goal as closely as possible. It provides an enormous benefit to animators because rather than having to keyframe animation for

each object in the chain, you only have to animate the goal. It makes modifying an existing animation a lot easier. Also, when the goal for a foot is placed at ground level, the foot stays attached to that spot on the ground while you move and position the rest of the bones.

3ds max ships with four IK solvers for adding IK to a hierarchy, each with its own features.

HI (History-Independent) Solver —The HI Solver is used most often in character animation. It is fast, easy to use, and reliable.

HD (History-Dependent) Solver —The HD Solver is used most often for animating machines and sliding joints. This solver runs slowly as it progresses through an animation, so use it in short sequences.

IK Limb Solver —The IK Limb Solver resembles a HI Solver, but it only works on a three-bone chain.

Spline IK Solver —This IK Solver enables you to use a Spline to determine the curvature of a series of linked objects. It works a little differently from the others in that you can't directly affect the goal. It is positioned by editing the spline.

The HI Solver is the one that is used most often , while the other solvers are used in special cases.

IK vs. FK

It is important to learn when to use either IK or FK in setting up a hierarchy for animation. In the following exercise, you experiment with IK and FK on a **character studio** biped. You experiment with the biped because it is easy to use and the limbs support both IK and FK motion.

Using FK

1. Start **3ds max** with a new scene.

2. On the Command panels, choose Create.

3. On the Create panel, choose Systems. In the Object Type rollout, choose Biped.

4. In the Front viewport, click and drag to create a Biped.

5. On the main toolbar, choose Select and Rotate.

6. In the Reference Coordinate drop-down list, choose Local.

It is important to use the Local Coordinate system for a biped otherwise the bones won't rotate the way you expect them to.

7. Select the right upper arm (Bip01 R UpperArm). Using the Front, Left, and Perspective viewports; rotate the arm so it points up, slightly in front of the body.

8. Press Page Down to select the right forearm (Bip01 R Forearm) and rotate it so it is angled back towards the head.

9. Select the right hand (Bip01 R Hand) and rotate it so it is flat.

10. Continue to edit the bones' rotations so it looks like the character is saluting.

It takes some time to get a proper salute this way.

11. Select and rotate the Biped's pelvis, spine, neck, and head bones to pose the Biped.

It is a lot easier to pose the character's body with FK than it is to get the hands where you want them

FK is useful when animating hierarchies that move naturally in a parent-to-child direction, such as from a character's hips to the head , a handle on a door, and a chandelier suspended from the roof with a chain..

Using IK

1. Continue from the previous exercise.

2. On the menu bar, choose File > Reset. Don't save your file, and choose Yes.

3. On the Command panels, choose Create.

4. On the Create panel, choose Systems.

5. In the Object Type rollout, choose Biped.

6. In the Front viewport, click and drag to create a Biped.

7. On the main toolbar, choose Select and Move.

8. Select the right hand (Bip01 R Hand).

9. In the Front viewport, move the hand straight up until the wrist is at the Biped's eyebrow level.

Notice the upper arm and forearm move in alignment with the hand.

10. In the Top viewport, move the hand so it is in front of the Biped's eyebrows.

11. On the main toolbar, choose Select and Rotate.

12. Rotate the right hand so it is flat.

It is a lot easier and looks more realistic to position the hand using IK.

Making an IK Chain

Now that you have used IK with the **character studio** biped, you next create an IK chain in **3ds max**. The IK solvers in **3ds max** are located in the Animation menu > IK Solvers sub-menu.

Before you start an IK chain, make sure you have linked your objects into a hierarchy. To apply an IK solver, select the end child in the hierarchy that will become the IK chain. Choose an IK solver from the menu, and then select the beginning parent in the chain. This adds the IK solver and the goal.

Note: You may also select the parent first and the end child second.

You next create an IK chain using the HI Solver. The scene you use contains a desk and a table lamp. You link the lamp's components and add IK. You then adjust the goal to see how the IK works.

1. Start **3ds max**.

2. On the menu bar, choose File > Open and open *Ch08_IK_Lamp.max* from the courseware CD.

This scene contains a desk, and four parts to a lamp. There is also a spotlight linked to the inside of the Lamp Shade.

3. On the main toolbar, choose Select and Link.

3. On the main toolbar, choose Select and Link.

4. Click and drag from the Lamp Shade to Lamp Support 2.

5. Click and drag from Lamp Support 2 to Lamp Support 1.

6. Click and drag from Lamp Support 1 to the Lamp Base.

7. On the main toolbar, choose Select and Move.

8. In the Top viewport, select the base. Move and Rotate it to a position of your choice on the table.

9. Select the Lamp Shade.

10. On the menu bar, choose Animation > IK Solvers > HI Solver.

Animation	Graph Editors	Rendering	Customize	MAXScript
IK Solvers		▶	HI Solver	
			HD Solver	
Constraints		▶	IK Limb Solver	
Transform Controllers		▶		
Position Controllers		▶	SplineIK Solver	

In the viewport, you see a dashed line connecting the Lamp Shade to the cursor.

11. Select Lamp Support 1.

IK Chain01 and its goal are added to your scene. The command panels display the Motion panel.

12. Select the goal and move it in the viewports.

Wherever you move the goal, the Lamp Shade follows.

13. Select the Lamp Base and move it in the viewports.

The Lamp Shade tries to stay with the goal.

Conclusion

In this chapter, you learned about Inverse Kinematics and its importance in animation. You explored the differences between IK and FK, and learned when to use them. You also set up and experimented with your own IK chain to position a desk lamp.

Animation Lab

9

Objectives

After completing this chapter, you are able to:

- Move an object over a period of time.
- Navigate within different modes of Track View.
- Edit keyframes.
- Use the Path Constraint.
- Animate using dummy objects.
- Fine-tune an object's movement.

Introduction

Almost everything you can make and modify in **3ds max** can be animated. Simply turn on the Auto Key button and **3ds max** records any changes that you make to your scene. Alternatively, you can use Set Key, and define the keyframes manually. In this lab, you use both of these methods to create keyframes for a toy train.

You start by animating the movement of the train. Next, you animate the loading of the cargo and link it to the train so that it moves as the train moves. Finally, you give the train secondary animation so that it appears to be dancing down the tracks.

Simple Animation

Moving Objects

You start by moving the toy train in space.

Moving the Toy Train

1. On the menu bar, choose File > Open and open *CH09-01.max* from the courseware CD.

2. Press F to change the Perspective viewport to the Front viewport.

3. In the navigation controls, choose Zoom Extents Selected.

4. **Auto Key** Turn on Auto Key.

5. Use the time slider to go to frame **100**.

6. On the main toolbar, click Select Object.

7. Select the engine.

8. On the main toolbar, click Select and Move, and then right-click the tool to display the Transform Type-In dialog.

9. In the Transform Type-In dialog > Offset: Screen, type **2000** for X, and then press Enter.

10. This moves the train 2000 units to the right from its current position.

11. Close the Transform Type-in dialog.

12. In the Front viewport, zoom out to see the camera and the train.

13. **Auto Key** Turn off Auto Key.

14. On the track bar, click Curve Editor.

The red curve indicates movement on the X-axis. The green and blue curves are straight because there is no movement on the Y and Z-axes.

15. In the time controls, click Play.

You have created a simple animation with two keyframes. The first keyframe was created automatically for you at frame 0 since you are using the Auto Key method. The second keyframe is the one you created at frame 100. Next, you create more interesting elements.

Adding Time

In the next procedure, you add animation before the train moves, therefore, you first have to add time. You use the options available in the Time Configuration dialog.

Extending the Animation Length

1. Continue from the previous exercise, or choose File > Open from the menu bar, and open *ch09_02.max* from the courseware CD.

2. In the Time Controls, click Time Configuration.

3. In the Time Configuration dialog > Animation area, type **200** for the Length amount, then click OK to close the dialog.

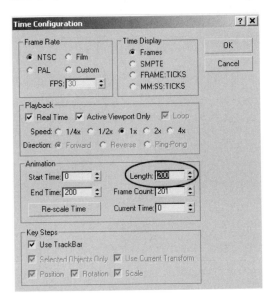

This adds 100 frames to the end of the animation.

4. Scrub the animation.

Nothing happens from frame 100-200.

Next, you adjust the animation so that the train moves between frames 100 and 200 only.

Sliding the Range Bar

An animation is controlled for the most part through Track View's Dope Sheet Editor and Curve Editor. However, some operations can be done in the track bar just as easily.

1. Continue from the previous exercise.

2. Make sure the train is selected.

3. In the track bar, notice two keyframes at frames 0 and 100.

4. Right-click the track bar, and choose Configure > Show Selection Range.

5. In the track bar, region-select both keyframes.

The range bar displays.

6. In the track bar, drag the range bar to the right between frames 100 and 200.

7. In the track bar, click anywhere to de-select the selected keyframes.

8. In the track bar, choose the keyframe at frame **100** and move it to frame **50**.

The train starts moving from frame 50 to frame 200.

Animating Modifiers

Secondary Motion

You now give the engine some personality. You use both the Stretch and the Bend modifiers to make the train dance from side to side as it moves along. To see this motion, choose File > View Image File from the menu bar, and open *Train01.avi* from the courseware CD.

Animating a Stretch Modifier

1. Continue from the previous exercise, or choose File > Open and open *ch09_03.max* from the courseware CD.

2. Make sure you are in the Front viewport, and Auto Key is turned off.

3. Make sure the Train is selected.

4. On the menu bar, choose Modifiers > Parametric Deformers > Stretch.

5. Use the time slider to go to frame **10**.

6. Turn on Auto Key.

7. On the Modify panel > Parameters rollout, set Stretch to **0.5** and set Stretch Axis to **Y**.

To keep the wheels of the train on the ground during this stretch, you need to adjust the center point of the Stretch modifier.

8. Turn off Auto Key.

9. On the Modify panel > modifier stack display, click the plus sign next to Stretch.

10. In the modifier stack display, choose Center.

11. On the main toolbar, click Select and Move.

12. In the Front viewport, move the center point to where the wheels come in contact with the ground.

This moves the center point of the transform to ground level and makes the train stretch up from the ground instead of in all directions from the center of the train.

Now you repeat the stretch for the entire animation.

13. On the main toolbar, click Curve Editor (Open).

14. In the Curve Editor's navigation controls, click Zoom Value Extents.

The Hierarchy window highlights the position tracks, and all other non-animated parameters are displayed. You use the Filter option to display the animated tracks only.

15. In the Curve Editor toolbar, right-click Filters.

16. In the right-click menu, choose Animated Tracks Only.

Next, you copy keys to bring the train to its starting point.

17. In the Hierarchy window, right-click the engine label, and choose Auto Expand > Modifiers.

18.In the Hierarchy window, choose Stretch.

A curve with two keyframes is displayed in the Edit window.

19.In the Edit window, choose the keyframe at frame 0. Hold down **SHIFT** and then move/copy the keyframe to frame **20**.

20.In the Edit window, scrub the animation.

The train stretches up and down and then stops. Next, you make this motion repeat using the Parameter Curve out of Range types.

21. Make sure Stretch is still chosen in the Hierarchy window, and then on the toolbar, click Parameter Curve Out-Of-Range.

22.In the Parameter Curve Out-of-Range dialog, click the Cycle End-Range and then click OK.

This repeats the Stretch indefinitely, starting from the created keyframes.

23.In the Edit window, you see the motion repeat.

24.In the Edit window, scrub the animation.

You see the Stretch repeats for the entire 200 frames.

The Stretch is only part of the train's dancing movement. Next, you add a side-to-side motion to make the train dance as it moves forward. On the menu bar, choose File > View Image File and open *Train02.avi* from the courseware CD to view the animation.

Adding a Bend Modifier

1. Continue from the previous exercise, or choose File > Open from the menu bar, and open *ch09_04.max* from the courseware CD.

2. Close the Curve Editor.

3. Use the time slider to go to frame **0**.

4. Make sure the engine is selected, and Stretch is selected in the modifier stack display.

5. On the Modifier List drop-down, choose Bend.

 You relocate the Gizmo's center point to the ground, as you did with the Stretch modifier.

6. In the modifier stack display, click the plus sign next to Bend, and then click Center.

7. Right-click the Front viewport label, and choose Views > Right.

8. ⊞ In the viewport navigation controls, click Zoom Extents All Selected.

9. In the Right viewport, move the center point to the ground level just below the tires.

10. In the Right viewport, right-click and choose Sub-objects > Top-Level.

To animate the train bending from side to side, you first need to bend the toy train to the left, and return it to its starting point, then bend it to the right, and finally return it to its starting point.

11. Use the time slider to go to frame **10**.

12. Turn on Auto Key.

13. On the Modify panel, set Angle to **60** and Bend Axis to Y.

Parameters panel:
Bend:
Angle: 60.0
Direction: 0.0
Bend Axis:
X ●Y Z
Limits
☐ Limit Effect
Upper Limit: 0.0
Lower Limit: 0.0

Next, you bring it back to the center.

14. On the menu bar, choose Graph Editors > Track View - Curve Editor.

15. If necessary, on the Curve Editor toolbar, right-click Filters, and choose Animated Tracks Only.

16. In the Hierarchy stack, choose Bend > Angle.

17. In the Edit window, choose the keyframe at frame 0, hold down **SHIFT**, and move/copy the keyframe to frame **20**.

You also need to bend the train in the other direction.

18. Use the time slider to go to frame **30**.

19. On the Modify panel, set Angle to **–60**.

Parameters panel:
Bend:
Angle: -60.0
Direction: 0.0
Bend Axis:
X ●Y Z
Limits
☐ Limit Effect
Upper Limit: 0.0
Lower Limit: 0.0

You need to bring the train to the middle once more.

20. In the Curve Editor, move/copy the keyframe from frame **0** to frame **40**.

21. In the Curve Editor, navigation controls, choose Zoom Value Extents.

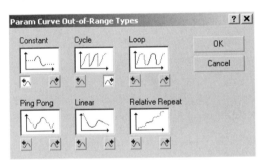

22. In the Hierarchy panel, make sure Angle is chosen.

23. On the Curve Editor toolbar, click Parameter Curve Out-Of-Range.

24. In the dialog, click Cycle End-Range and then click OK.

The only detail left is to make sure that the train is dancing only when it moves.

25. On the Curve Editor menu bar, choose Modes > Dope Sheet.

26. On the Dope Sheet toolbar, choose Edit Ranges.

27. In the Hierarchy window, right-click Modified Object, and choose Auto Expand > Modifiers.

28. In Edit window, move the Range Bar (next to Modified object) to frame **55**.

The Bend and Stretch modifi ers start moving slightly after the train starts to move.

29. Minimize the Curve Editor.

30. If necessary, press ALT + W to view all four viewports.

31. Right-click to activate the Camera viewport.

32. In the time controls, click Play.

33. On the menu bar, choose File > View Image File and open *Train03.avi* from the courseware CD.

Creating Hierarchies

You link the child object to its parent to make one object follow another. This creates an elaborate hierarchy of objects that work in relation to one another.

Creating a parent/child relationship

In this section, you link objects and edit keyframes in Track View.

Linking the Box Car to the Engine

1. Continue from the previous exercise, or choose File > Open and open *ch09_05.max* from the courseware CD.

2. Make sure Auto Key is turned off, and that you are at frame 0.

3. ▣ On the Command panels, click Display.

4. On the Display panel > Hide rollout, choose Unhide by Name.

5. In the Unhide Objects dialog, choose *rear car*.

6. In the Right viewport, press **F** to go to the Front viewport.

7. ▣ In the viewport navigation controls, click Zoom Extents All.

 A box car is behind the train engine. Next, you are going to link it to the train so it follows the engine.

8. ▣ On the main toolbar, click Select and Link.

9. In the Front viewport, choose *rear car*.

10. Drag from the rear car to the engine, and then release the mouse.

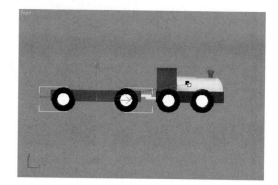

11. Scrub the time slider.

 The rear car follows the engine.

12. ▣ On the main toolbar, click Select Object.

13. Use the time slider to go to frame zero.

14. Make sure all four viewports are displayed. If not, press **ALT + W**.

15. Right-click to activate the Camera viewport.

16. On the menu bar, choose Animation > Make Preview.

17. ▣ In the Make Preview dialog, leave the default parameters as they appear and then click Create.

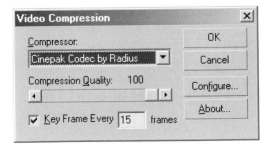

18. In the Video Compression dialog, choose Cinepak Codec by Radius and set the Compression Quality to **100**.

A preview is created more quickly than a fully rendered animation. When the preview calculation is done, Windows Media Player is launched and you can view the animation. This allows you to check whether your animation is working properly, or if you need to edit it.

Animating Elements

In this section, you animate toy blocks so that they jump on the train before it leaves. Each block is animated in a slightly different manner from the previous one. You also learn how to use dummy objects for more complex animations.

Animating the blocks in the scene

You start with the blue block, then the yellow, and last, the red. You use Set Key to create keyframes for both the blue and yellow blocks next.

Animating the Blue Block

1. Continue from the previous exercise, or choose File > Open and open *ch09_06.max* from the courseware CD.

2. On the Command panels, choose Display.

3. On the Display panel > Hide rollout, choose Unhide by Name.

4. In the Unhide Objects dialog, choose *blue block*.

5. Right-click to activate the Left viewport.

6. In the viewport navigation controls, click Zoom Extents.

7. Use Zoom and Pan until your viewports looks like the following image.

The blue block is placed exactly where you want the block to land. You work backwards to set the keys.

8. **Set Key** Turn on Set Key.

9. In the Left viewport, choose blue block.

10. Use the time slider to go to frame **30**.

This is the frame where you want the block to land.

11. Click the large key button.

A keyframe is created.

12. Use the time slider to go to frame **15**.

13. On the main toolbar, choose Select and Move.

14. In the Left viewport, move the block up and to the right.

15. Click the large key button.

16. Use the time slider to go to frame **0**.

17. Move the blue block to ground level, a bit further to the right.

18. Press the large Key button.

19. Scrub the animation.

The blue block lands in the rear car, but does not follow the train.

20. Turn off Set Key.

21. On the main toolbar, click Select and Link.

22.In the Top viewport, drag from the blue block to its parent, the rear car.

23.Scrub the animation.

24. On the main toolbar, click Select Object.

The block now follows the train.

Animating the Yellow Block

1. Continue from the previous exercise, or choose File > Open and open *ch09_07.max* from the courseware CD.

2. Unhide *yellow block*, and use the same method to animate the *yellow block* as you did for the *blue block*.

3. Make the *yellow block* jump on the train from the opposite side this time.

Next, you change the timing of the yellow block. You have it start slightly after the blue block.

Shifting Keys in the Track Bar

1. Continue from the previous exercise, or choose File > Open and open *ch09_08.max* from the courseware CD.

2. Make sure the *yellow block* is selected.

3. Region select the three keyframes for *yellow block* in the track bar.

4. The range bar is displayed. If not, right-click the track bar, and choose Configure > Show Selection Range from the right-click menu.

5. Move the range bar to frame **15**.

6. On the menu bar, choose Animation > Make Preview, and make a preview animation.

7. Alternatively, you can choose File > View Image File from the menu bar, and open *train05.avi* from the courseware CD.

Animation Helpers

Helpers are non-renderable objects that help control your animation. The most common animation helper is the dummy object.

Path Constraint and Dummy Objects

Now you add the last block. The red block is tardy and never actually makes it on the train. It jumps along, trying to catch up to the train, but it never does. You use a combination of a dummy object and a Path Constraint to complete this step.

Animating a Dummy Object along a Path

1. Continue from the previous exercise, or choose File > Open and open *ch09_09.max* from the courseware CD.

2. Right-click in the Left viewport, and choose Unhide By Name from the quad menu.

```
Isolate Selection
Unfreeze All
Freeze Selection
Unhide by Name
Unhide All
Hide Unselected
Hide Selection
               display
              transform
Move              □
Rotate            □
Scale             □
Select
Clone
Properties...
Curve Editor...
Dope Sheet...
Wire Parameters...
```

3. In the Unhide Objects dialog, choose the objects named *red block* and *block path*.

4. Right-click to activate the Top viewport.

5. In the viewport navigation controls, choose Zoom Extents All.

6. On the Create panel, choose Helpers.

7. In the Object type rollout, choose Dummy.

 You use a dummy object because you want the box to both follow a path, and to jump up and down. Using a dummy object makes the task easier.

8. In the Top viewport, drag to create a dummy anywhere in the scene.

Dummy Object

Note: Since the dummy is not renderable, its size does not matter. However, try and make it slightly bigger than the box, so it is easy to select.

9. On the menu bar, choose Animation > Constraints > Path Constraint.

 A dashed line is attached to your mouse.

10. Drag the mouse to the block path, and then click.

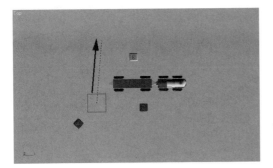

11. Zoom out of the Top viewport to view the dummy at the start of the path.

12. On the Motion panel > Path Parameters rollout > Path Options, turn on Follow.

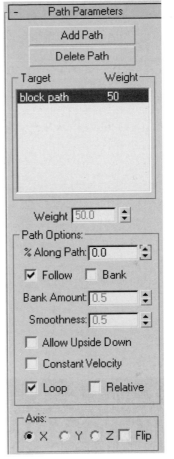

The dummy follows the path for the entire animation. Next, you make the red block follow the dummy.

13. Use the time slider to go to frame 0.

14. In the Top viewport, choose *red block*.

15. On the main toolbar, choose Quick Align from the flyout.

16. In the Top viewport, choose the dummy.

The red block's X, Y, and Z-axes are aligned to the Dummy.

17. On the main toolbar, choose Select and Link.

18. Drag from the red block to the dummy.

19. On the main toolbar, choose Select Object.

20. Scrub the time slider.

21. The red block follows the dummy.

Bouncing the block up and down

1. Continue from the previous exercise, or choose File > Open from the menu bar, and open *ch09_10.max* from the courseware CD.

2. In the Front viewport, region zoom around the red block and the space to the left of it.

3. Turn on Auto Key.

4. Use the time slider to go to frame **10**.

5. On the main toolbar, choose Select and Move.

6. Make sure *red block* is selected.

7. On the status bar, choose the Offset Mode Transform Type-In toggle.

8. In the status bar, set Y to **150**.

9. Use the time slider to go to frame **20**.

10. In the status bar, set Y to **-150**.

11. Auto Key Turn off Auto Key.

12. On the main toolbar, choose Curve Editor (Open).

13. In the Curve Editor > Navigation controls, click Zoom Value Extents.

14. On the Curve Editor toolbar, click Parameter Curve Out-of-Range Types.

15. In the dialog, click the Cycle graph.

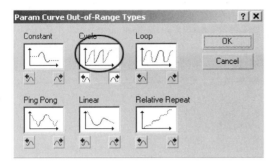

This makes the block bounce repeatedly.

16. On the menu bar, choose File > View Image File, and open *train06.avi* from the courseware CD.

Animation Control

The animation is complete and looks quite good. Notice you have not adjusted the tangents. The default interpolation between keys is set to Auto. This tangent type is exclusive to **3ds max** and does an excellent job in determining a keyframe's interpolation. Although the animation looks good the way it is, you can use other tangent types. Alternatively, you can edit the Auto tangent to adjust the movement of the blocks onto the rear car, and the movement of the engine. In the next procedure, you draw your own tangents, and then reduce the number of keys created.

Drawing Tangents

You use the Curve Editor to adjust the interpolation of the blocks and the engine by drawing your own tangent.

Changing Tangent Types

1. Continue from the previous exercise, or choose File > Open and open *ch09_11.max* from the courseware CD.

2. Use the time slider to go to frame **0**.

3. On the main toolbar, choose Curve Editor (Open).

4. In the Camera viewport, select *engine*.

5. In the Hierarchy window, choose X Position.

6. On the Curve Editor toolbar, click Draw Curves.

7. In the Edit window, drag the existing curve to create a new curve.

As you can see, a lot of keyframes get created, and you need to have quite a steady hand to use this option. You use Reduce Keys to lessen the amount of keyframes, but still maintain the shape of the curve.

8. On the Curve Editor toolbar, choose Move Keys.

9. In the Edit window, select all keyframes.

10. On the Curve Editor toolbar, click Reduce Keys.

11. In the Reduce Keys dialog, set Threshold to **15.0**.

The number of keys is greatly reduced. The larger the threshold, the more keys are deleted, and your curve loses its shape.

12. Scrub the animation to see the animation with the custom curve.

Animating with IK

To add to the effect of the toy train, you animate a toy robotic arm to start the train. To do this, you use IK to get the arm to follow the robotic hand as it pushes on the smokestack to start the train.

Hierarchies and IK

To finish your scene you add a robotic arm, link it together, and then add IK so you can control the arm by moving the hand. As the train bounces away, the arm turns to watch the train leave. You animate the Swivel Angle of the IK Chain to keep the arm upright as it watches the train.

Animating an IK Goal

1. Continue from the previous exercise, or choose File > Open and open *ch09_12.max* from the courseware CD.

2. Right-click in the Left viewport, and choose Unhide All from the quad menu.

The robotic arm is visible in the scene.

3. Right-click to activate the Left viewport.

4. In the viewport navigation controls, choose Zoom Extents All.

5. On the main toolbar, choose Select and Link.

6. In the Left viewport, choose *Arm Finger*.

7. Drag from the finger to the forearm.

8. Drag from the forearm to the upper arm.

9. On the main toolbar, choose Select and Move.

10. In the Left viewport, choose *Arm Finger*.

11. On the menu bar, choose Animation > IK Solvers > HI Solver.

12. In the Left viewport, choose the upper arm to make the IK Chain.

13. Turn on Auto Key.

14. Move the time slider to frame 50.

Note: Your train should start its animation around frame 55. If it is not, adjust the time slider so it is about 5 frames before the frame on which the train starts moving.

15. Make sure the IK Goal is selected.

16. In the Left viewport, move the IK Goal so the robotic finger is touching the train's smokestack.

It is important that you set the keys for the key actions first. You can then go back and add more keys between.

17. Move the time slider back 8 frames to frame 42.

18. In the Left viewport, move the IK Goal approximately 40 units on the Y-axis.

19. Move the time slider to frame 25 which is about halfway between frame 0 and the current frame.

20. In the Left viewport, move the IK Goal approximately 100 units on the Y-axis.

This causes the arm to follow an arc on its way to the smokestack.

21. Move the time slider to frame 58 which is 8 frames after the robotic arm touches the smokestack.

22. In the Left viewport, move the IK Goal approximately 60 units on the Y-axis.

23. Move the time slider to frame 90.

24. In the Left viewport, move the IK Goal so the arm looks as it did at frame 0.

25. Move the time slider to frame 70 which is about halfway between this frame and the previous frame with a key.

26. In the Left viewport, move the IK Goal up so the arm follows an arc on the way back also.

27. Scrub the animation to watch the arm start the train.

Animating the Swivel Angle

1. Continue from the previous exercise, or choose File > Open and open *ch09_13.max* from the courseware CD.

2. Make sure Auto Key is turned on.

3. Move the time slider to frame 130.

4. Select the IK Goal.

5. In the Top viewport, move the IK Goal so it is facing towards the train.

Notice that the more you move the goal around the side, the more the arm rotates.

6. On the Command Panels, choose Motion.

7. In the IK Properties rollout > IK Solver Plane group, adjust the Swivel Angel until the arm is upright again.

8. Move the time slider back to the previous frame with a key.

9. In the IK Properties rollout > IK Solver Plane group, set Swivel Angel to 0.

10. Scrub the animation to see the arm watch the train leave.

You can also continue to animate the robotic arm to have it wave good-bye to the train as it leaves the scene.

11. The finished scene is named *ch09_14.max*, and its corresponding animation is named *train08.avi*.

Conclusion

In this lab, you have learned the basics of animation in **3ds max**. You have learned about the concept of keyframes and how to create them. You have also learned to control your animations using both the track bar and Track View, and to constrain the motion of an object based on the behavior of another. Practice these techniques to make your animations behave realistically.

If you have time, add animated modifiers to the blocks to make loading them more interesting. You may also wish to add boxcars and cargo to the train, and to move the train along a zigzag path.

Shapes

Objectives

After completing this chapter, you are able to:

- Create shape objects.
- Edit and manipulate shapes at the sub-object level.
- Adjust shape-rendering and interpolation parameters.
- Use modifiers to create 3D objects.

Introduction

Shapes are an important feature within 3ds max 7, and play a key role in modeling and animation. **3ds max** shapes are curves based on one of two underlying curve types:

- Spline curves
- NURBS curves

These two curve types have a lot in common. Both are used as the basis for 3D objects, or as paths for a Path Constraint. They are distinguished from one another, however, by their internal mathematical representation. NURBS curves are the more complex of the two, but their control vertices allow different levels of influence over the resulting curve.

This chapter focuses on the spline-based shapes, beginning with a discussion of the terminology used when working with shape objects.

Shape Terminology

A shape is an object made up of one or more splines. Each spline is a curve that's defined by a sequence of points. The points are collectively referred to as vertices. Each vertex defines coordinates that mark its location, and information that specifies how the curve passes through it. The portion of the spline that connects two consecutive vertices is referred to as a segment.

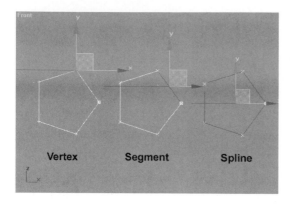

Vertex Segment Spline

Uses for Shapes

Shapes are most commonly used as the basis for 3 dimensional objects. Modifiers operate on the shapes to generate the 3D object. Commonly used modifiers include Extrude, Bevel, Bevel Profile, and Lathe. Each of these is discussed later in the chapter. Another common use for shapes is to define a path for use with a Path Constraint. Shapes can also be used as renderable splines to create neon text or to create wiring/cabling type objects.

Vertex Types

Its vertices define each spline within a shape. The vertices can be one of four types, which determine the smoothness with which the spline passes through the vertex. The four types are:

- **Corner**—The Corner vertex type makes the direction of the incoming and outgoing spline segments independent. There are no conditions of tangent continuity imposed. The spline can enter and leave the vertex at different directions.

- **Smooth**—The Smooth vertex type causes the spline segments on either side of the vertex to have an equal tangent direction.

This gives the curve a smooth appearance at that vertex.

- **Bezier**—The Bezier vertex type is similar to the Smooth vertex type in that the tangent directions are equal for the incoming and outgoing spline segments. The distinction is that the Bezier type also provides tangent handles for adjusting the magnitude of the tangent vectors. You can control the adjacent spline segments to a greater extent.

- **Bezier Corner**—The Bezier Corner vertex type provides Bezier handles for the vertex's incoming and outgoing spline segments, but they are independent. Both the tangent direction and tangent magnitude may be adjusted independently.

The Line Tool

The Line tool is used for creating general spline based shapes. The term Line might lead you to believe it creates straight segments only, but this is definitely not the case. By specifying or editing the different vertex types the Line tool creates shapes with complex curve segments or any combination of curved and straight segments.

The Line tool allows you to create a shape with an arbitrary number of vertices. You can specify in advance which of the four vertex types to create as you pick points in the viewport. You can specify different default vertex types for clicking and dragging. When you click to create a line, you can choose between the corner or the smooth vertex initial type. For dragging, you can specify a corner, smooth or bezier vertex type. Using this feature you can quickly create a spline that contains different vertex types.

If the last vertex in a sequence is coincident with or close to the starting vertex, **3ds max** prompts you as to whether or not you want the shape closed. Closing the shape creates a common vertex for the start and end of the shape. Leaving the shape open makes two vertices at a common location. If the shape is closed the curve is smooth through the start/ end point.

Standard Shape Objects

In addition to the Line tool, **3ds max** provides several other standard spline shapes. Examples are the Rectangle, Circle and Text tools. It's important to recognize that these shapes share the same internal spline representation as shapes created with the Line tool. The distinction is that the standard shapes are encapsulated within a higher-level parametric control. This control evaluates vertex locations, vertex types, and tangent directions so that they appear as the shape they were designed to represent.

The standard shape objects are:

- Circle
- Arc
- Ngon
- Text
- Rectangle
- Ellipse
- Donut
- Star
- Helix

-	Object Type	
AutoGrid □		
Start New Shape ☑		
Line	Rectangle	
Circle	Ellipse	
Arc	Donut	
NGon	Star	
Text	Helix	
Section		

In contrast to the Line tool, these shapes have a set of creation parameters that can be edited in the Modify panel subsequent to their creation. For example, the Rectangle has length, width, and corner radius parameters while the Text object has a font type, size and text value.

Common Shape Properties

The Line and standard shape objects carry a set of common Rendering and Interpolation properties.

In the rendered scene, **3ds max,** by default, displays the geometry derived from shapes, rather than the shapes themselves. There is an option to make the shapes renderable and if that option is chosen, the shapes adopt a cylindrical mesh of a specified thickness. Making shapes renderable provides a convenient way to represent objects like a length of rope, tubing, or an electrical cord. Specifying the number of sides controls the density of the mesh. You can indicate whether the shape is renderable in the viewports, in the rendered output, or both. The mesh size and density settings can also be independently set for the viewports and the scanline renderer.

Internally a spline has a continuous mathematical definition. However, when the spline is displayed or rendered it's approximated by a series of straight line segments. Its interpolation settings determine how many straight line segments are used. A step parameter defines the number of intermediate points that are calculated on the spline between each of its defining vertices. A line is then displayed between each step. You can set the Steps parameter to a value between 0 and 100. Zero corresponds to a single line segment between the vertices. Higher numbers improve the approximation. Avoid using unnecessarily high step values; the improvement in spline approximation might be indistinguishable, but the processing and rendering times increase.

There are Optimize and Adaptive options for spline interpolation. When Optimize is chosen, **3ds max** detects spline curvature and reduces the steps on nearly straight segments. The approximation quality is maintained and the model might be simplified. The Adaptive option transfers all control over spline approximation to **3ds max**.

Start New Shape Option

It was stated earlier that shapes could contain one or more splines. When you create a shape you have the option of combining it with a previously created shape or starting a new one. You specify whether to create a new shape with the Start New Shape option in the Create panel. There is no requirement that splines contained within compound shapes share common endpoints. An example is the Text object, a compound shape that can contain multiple splines that are separated from one another.

Creating Spline Shapes

In this section you work with the Line, Rectangle and Text shape objects. Access the standard spline shapes through the shapes category of the command panel or from Create menu > Shapes.

1. On the menu bar, choose File > Reset to reset **3ds max**.

2. On the menu bar, choose Create > Shapes > Line.

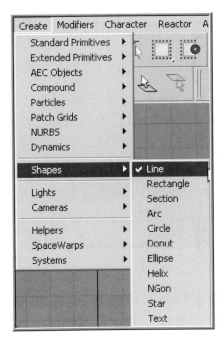

Note: The Shapes category of the Create panel is opened and the Line tool

selected. The built in shape objects are displayed in the Object Type rollout.

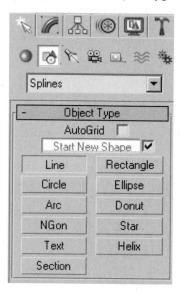

3. In the Front viewport, click to create the first vertex, then move the mouse to create the second vertex.

4. Right-click to end the Line tool.

The Line Tool

1. On the menu bar, choose File > Open and open *Ch10_01.max* from the courseware CD.

2. Right-click in the Top viewport to make it active.

3. Press **ALT + W** to view the Top viewport in full screen.

4. On the menu bar, choose Create > Shapes > Line.

5. On the Create panel, look at the settings within the Creation Method rollout.

These settings determine whether the transition between the spline segments is smooth or abrupt. The setting for the Initial type is Corner. This means that as you click to create vertices the adjoining segments form abrupt corners.

6. In the Top viewport, click to create 3 vertices as shown and then right-click to end the line creation.

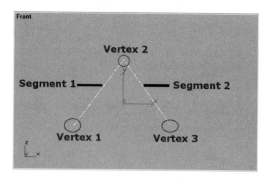

The transition between segments is abrupt since vertex 2 is a corner type.

7. On the Create panel > Creation Method rollout, set Initial Type to **Smooth**.

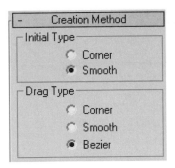

8. In the Top viewport, create another line in the viewport just below the original.

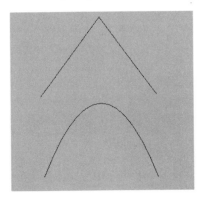

The Smooth initial type creates a smooth transition between the spline segments.

The Drag Type setting determines the vertex type created when you drag the mouse. The Corner type makes each vertex a corner, whether or not you drag the mouse cursor. The Smooth type makes a non-adjustable smooth transition through the vertex. The Bezier type produces a smooth and adjustable curve through the vertex. With the Bezier Drag-type, the distance you drag the mouse from the first point that you click determines the curvature and tangent direction through the vertex.

9. In the Creation Method rollout, set Initial Type back to **Corner**, and leave Drag Type set to Bezier.

10. In the Top viewport, create another line just below the first two. This time, drag to define the second vertex. Your line should look similar to the one shown in the following illustration.

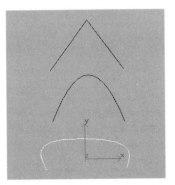

Later in the chapter you see how to edit the vertices and change their type after they have been created.

The Rectangle Tool

1. On the menu bar, choose File > Reset to reset **3ds max**.

2. On the menu bar, choose Create > Shapes > Rectangle.

3. In the Top viewport, drag to create a rectangle.

4. On the Create panel > Parameters rollout, set the following values:

• Length = **100**

• Width = **200**

• Corner Radius = **20**

5. Right-click in the active viewport to end rectangle creation.

 The rectangle is a shape containing a single spline. The spline has 8 vertices and 8 segments.

6. On the command panels, choose Modify.

7. On the Modify panel > Parameters rollout, the rectangle parameters are available for editing.

The Text Tool

1. On the menu bar, choose File > Reset and reset **3ds max**.

2. On the menu bar, choose Create > Shapes > Text.

3. On the Create panel, the Parameters rollout is displayed with the default Text settings.

The default font is Arial. Its size is 100 units and the text value is MAX Text.

4. On the Create panel > Parameters rollout, click in the text window and remove the word Text.

Text:

MAX

5. In the Top viewport, click to create the text.

The text is a single shape consisting of four splines, one each for the letters M and X and two splines for the letter A. A polygon within a polygon is called a nested polygon.

6. Verify the text is still selected.

7. On the command panels, choose Modify.

8. On the Modify panel > Parameters rollout, set Font to **Italics** and change the Size to **60**.

The Text updates in the viewport to reflect the changes made to its parameters.

Like the rectangle, text is parametric, meaning its characteristics are controlled by an editable group of parameters that you can modify after its creation.

Start New Shape

A shape can contain multiple splines, just as the text object did. When the Start New Shape option is set, **3ds max** makes a new shape for each new spline you create. For example, when you create 3 lines, each one is a distinct object. Turning off the Start New Shape option stops subsequent objects to be added to the same shape.

1. On the menu bar, choose File > Reset to reset **3ds max**.

2. On the command panels, choose Create.

3. On the Create panel > Shapes > Object Type rollout, turn off Start New Shape.

4. In the Object Type rollout, choose Line.

5. In the Top viewport, create two lines.

6. On the main toolbar, choose Select and Move.

7. In the Top viewport, move the cursor over the X-axis of the transform gizmo and drag it to the right.

 Both lines move together since they are part of the same shape. In the next section you see how to attach separate shapes and how to detach one shape from another.

 Note: Shapes don't have to be the same type to be combined into a single shape object, for example a line can be combined with a circle and text within a single shape.

Renderable Splines

1. On the menu bar, choose File > Open and open *Ch10_02.max* from the courseware CD.

 The file contains the default text object.

2. Right-click in the Top viewport to make it active.

3. On the main toolbar, choose Render Scene.

4. In the Render Scene dialog > Common Parameters rollout > Output Size area, choose 320x240.

5. Leave the remaining render options at their default values, and choose Render.

 The text isn't visible in the rendered frame window.

6. Close the rendered frame window and the Render dialog.

7. Verify the text is selected.

8. On the command panels, choose Modify.

9. On the Modify panel, open the Rendering rollout.

 The Viewport and Renderer options are displayed at the top of the Rendering rollout. You can decide whether to apply Thickness, Sides and Angle values to the

model in the viewports or to the scanline renderer.

10. In the Rendering rollout, verify that Renderer is selected, and turn on Renderable.

11. On the main toolbar, choose Quick Render (Active Shade) button.

Note: The Quick Render (ActiveShade) button is available from the Quick Render flyout.

12. The text is displayed in the rendered frame window.

13. Close the rendered frame window.

14. In the Rendering rollout, change Thickness to **4**.

15. On the main toolbar, choose Quick Render (Active Shade) button.

The text is rendered with the higher thickness.

16. Close the rendered frame window.

17. In the Rendering rollout, turn on Display Render Mesh.

The text is displayed as a mesh in the viewports.

Note: The mesh is sized according to the settings for the scanline renderer, by default.

18. In the Rendering rollout, turn on Use Viewport Settings option.

The text is reduced in size because the viewport settings still use a Thickness value of **1.0**.

Using the Interpolation Settings

The internal representation of splines is continuous but their display in the viewports is approximated. The spline approximation settings are located within the Interpolation rollout.

1. On the menu bar, choose File > Reset to reset **3ds max**.

2. On the menu bar choose Create > Shapes > Circle.

3. In the Top viewport, create a Circle.

4. Right-click in the Top viewport to end the circle creation.

The circle is a closed spline with 4 vertices, one at each quadrant.

5. On the command panels, choose Modify.

6. On the Modify panel, click to expand the Interpolation rollout.

Steps specifies the number of intermediate points calculated for each spline segment. The higher the number, the better the curve approximation. Avoid increasing Steps beyond the point where the effects are distinguishable in the viewports.

7. In the Interpolation rollout, reduce Steps to **1**.

You should start to notice the degradation in the circle representation with a Steps value of 3 and fewer. With just one step calculated per segment the circle appears as an octagon.

8. In the Interpolation rollout, reduce Steps to **0**.

Without any intermediate steps within the spline segments the circle appears as a square.

Note: The internal representation is still a perfect circle, the display is only due to the interpolation settings.

9. In the Interpolation rollout, turn on Adaptive.

The circle is restored to a smooth approximation and the Steps and Optimize controls are greyed out.

Using Pan and Zoom while Modeling Lines

A very useful set of features that aid you in the creation of lines is the ability ability to Pan and Zoom while modeling the line.

While creating a line, you may, at any time, press I on the keyboard to pan the viewport so the area marked by the cursor is now in the center of the viewport. The cursor also moves to the center of the viewport, and you may continue to move the mouse with I held down to pan the viewport interactively.

Also while creating a line, you may press Alt + Shift + Z to zoom out and see more of your scene, or press Alt + Shift + Ctrl + Z to zoom in.

Note: These viewport controls work at all times, not just while creating lines.

1. On the menu bar, choose File > Reset to reset **3ds max**.

2. On the menu bar choose Create > Shapes > Line.

3. In the Top viewport, click several times to start creating a line.

4. Press the I key and keep it held down.

The viewport centers on the cursor's location.

5. Move the mouse to pan in the viewport.

6. Release the I key.

7. Add a few more vertices to your line.

8. Press Alt + Shift + Z.

The viewport zooms out.

9. Press Alt + Shift + Ctrl + Z.

The viewport zooms back in.

10. Finish creating your line.

Editing Shapes

The previous section illustrated several tools for creating shapes. **3ds max** provides several methods for editing shapes. This section describes those methods.

Accessing Sub-Objects

Opening the Modify panel for a selected shape gives access to its rendering and interpolation parameters, which are common to all shapes, and to its creation parameters, which are specific to each shape type.

The Line object is unique because it doesn't have any editable creation parameters. After creation it's automatically converted to a shape, which can be edited at the vertex, segment and spline levels, referred to as the sub-object levels.

1. On the menu bar, choose File > Reset and reset **3ds max**.

2. On the menu bar choose Create > Shapes > Line.

3. In the Top viewport, create a line similar to the one illustrated below.

4. On the command panels, choose Modify.

5. On the Modify panel > modifier stack display, choose the plus sign to the left of Line.

The Sub-Object levels are displayed.

Line01	
Modifier List	▼
⊟ Line	
⋯ Vertex	
⋯ Segment	
⋯ Spline	

6. You can access each of the sub-object levels by choosing them within the modifier stack display.

7. In the modifier stack display, choose Vertex.

8. In the Top viewport, choose any one of the vertices.

9. ⊹ On the main toolbar, choose Select and Move.

10. In the Top viewport, move the selected vertex.

11. On the Modify panel > modify stack display, choose Line.

This takes you out of sub-object editing.

Manipulating other Shapes

You can manipulate other shape objects as you manipulated lines. To do this, you must gain access to their sub-object levels in one of the following ways:

- Convert the shape to an editable spline
- Apply an Edit Spline modifier.

The method you select influence the operations you can perform with the resulting shape. If you convert the shape to an editable spline, you gain the ability to animate it at the sub-object level, but you lose access to its creation parameters. If you apply an Edit Spline modifier, you retain access to the shape's creation parameters for static or animated changes but you won't be able to animate it at the sub-object level.

To convert an object to an editable spline you can right-click over the name in the modifier stack display and choose Convert to Editable spline from the right-click menu. You can also convert a shape to an editable spline by right-clicking in the viewport and choosing Convert to Editable Spline from the quad menu.

To add an Edit Spline modifier, simply open the Modify panel for the object and choose Edit Spline from the modifier list.

Regardless of the method you use to access the shape sub-object levels, the tools available for editing them are the same. The following discussion assumes the Edit Spline modifier is used to gain access, but the concepts are the same if the shape is converted to an editable spline.

The Edit Spline Modifier

The Edit Spline modifier has 3 rollouts:

- Selection
- Soft Selection
- Geometry

Each one of these rollouts is briefly described in the following sections.

Selection Rollout

The Selection rollout lets you specify either one of the vertex, segment or spline sub-object levels for editing. Once the editing level is set, you can select sub-objects of that level in the viewport. Selection can be done with the standard **3ds max** selection tools. The Selection rollout enhances selection with an area option. Using this option, you can specify a radius centered on a selected point. You can select any sub-object within that radius with a single click. You can also name selection sets of sub-object for future retrieval. All vertices, segments and splines within a shape are given a numeric index at creation time. As you select them their indices are displayed in the selection rollout.

Note: The tools that are enabled depend on the sub-object level that is in effect.

Geometry Rollout

The Geometry rollout contains a large set of sub-object tools. The tools available in this rollout also depend on the sub-object level chosen.

Spline Sub-Object Options

The Spline sub-object level includes tools for:

- **Attaching Splines**—Allows you to add one or more shapes to the current object. The added shapes can themselves be compound shapes consisting of multiple splines.

- **Detaching Splines**—Allows you to remove segments or entire splines

- **Creating 2D Booleans**—Booleans support combining splines with the Union, Subtraction and Intersection options. Union takes two splines and forms a single spline that encompasses their combined area. The subtraction option removes the

area encompassed by one spline from another. The intersection option creates a single spline that encompasses the area that is common to two splines.

- **Outlining Splines**—Creates a thickness for the selected spline.

Segment Sub-Object Options

The Segment sub-object level allows you to refine segments by adding vertices. You can also suppress their visibility or detach them.

Vertex Sub-Object Options

The Vertex sub-object level includes support for the following operations:

- Switch vertex types
- Adjust Bezier vertex handles
- Cycle the selected vertex
- Insert vertices - creates additional vertices in a segment
- Weld vertices - combines multiple vertices into one
- Fillet—applies a fillet radius between curve segments
- Chamfer—applies a chamfer between curve segments

Soft Selection Rollout

The Soft Selection tools are intended for use when transforming at the sub-object level. Soft Selection defines a region of influence. Sub-objects lying within this region are soft selected. The soft selected sub-objects are affected by an applied transformation, but not to the same extent as those that are explicitly selected. For example, if you move a selected vertex a distance of 5 units, the soft selected vertex might only move 2.5 units. The following illustration shows a helical

shape with only its center vertex selected. Soft selection is active, and the other vertices are displayed in different colors that indicate their distance from the selected vertex.

If the center vertex is moved, the others move, but to a lesser extent.

Working with the Vertex Sub-Object Level

Selecting Vertices and Changing their Types

1. On the menu bar, choose File > Open and open *Ch10_03.max* from the courseware CD.

 The file contains a line, that looks like a rectangle, and contains 4 segments.

2. In the Top viewport, select the line.

3. On the command panels, choose Modify.

4. On the Modify panel > modifier stack display, click the plus sign to the left of the Line.

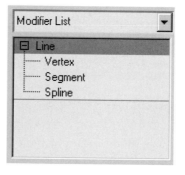

The line's sub-object levels are displayed.

5. In the modifier stack display, choose Vertex.

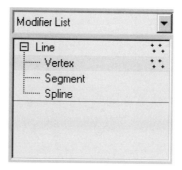

6. On the Modify panel > open the Selection rollout.

The Vertex option is selected.

7. In the Selection rollout, look at the bottom.

It indicates that there are currently no vertices selected.

8. In the Top viewport, choose the vertex in the upper left corner.

The Selection rollout indicates that Vertex 1 of Spline 1 is selected.

Note: There is only one spline in this shape so all vertices are associated with Spline 1.

9. In the Selection rollout > Display section, choose Show Vertex Numbers.

The vertex numbers are displayed adjacent to each of the vertices in the viewport.

10. In the Top viewport, right-click.

The quad menu is displayed.

Note: You do not have to right-click the vertex directly, anywhere in the active viewport works.

11. From the quad menu, choose Smooth.

Reverse Spline	
Make First	
Divide	
Bind	
Unbind	
Bezier Corner	
Bezier	
Corner ✓	Isolate Selection
Smooth	Unfreeze All
Reset Tangents	Freeze Selection
Spline	Unhide by Name
Segment	Unhide All
Vertex ✓	Hide Unselected
Top-level	Hide Selection
tools 1	display
tools 2	transform
Create Line	Move ☐
Attach	Rotate ☐
Detach Segment	Scale ☐
Connect	Select
Refine	Clone
Refine Connect	Properties...
Cycle Vertices	Curve Editor...
Break Vertices	Dope Sheet...
Weld Vertices	Wire Parameters...
Fuse Vertices	Convert To: ▶

12. In the Top viewport, select Vertex 2, right-click, and choose Bezier from the quad menu.

Bezier handles appear on either side of the vertex.

13. ✛ On the main toolbar, choose Select and Move.

14. In the Top viewport, select one of the handles and adjust it approximately as shown.

Note: The Bezier handles on either side of the vertex remain co-linear and have the same length.

15. In the Top viewport, select vertex 3, right-click, and choose Bezier Corner from the quad menu.

16. In the Top viewport, move the Bezier handles as shown.

As you move the handles, watch the different effects as you change the handle's direction and length.

With the Bezier Corner vertex type, you have independent control of the vertex handle's direction, and length.

17. In the Top viewport window, select all four vertices.

18. In the Top viewport, right-click and choose Smooth from the quad menu.

Multiple vertices can be changed at once.

19. In the Top viewport, choose Vertex 1.

20. Cycle On the Modify panel > Geometry rollout, choose Cycle.

Vertex 2 is selected in the viewport.

21. In the modifier stack display, choose Line to exit vertex sub-object mode.

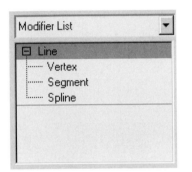

Inserting vertices

1. On the menu bar, choose File > Open and open *Ch10_04.max* from the courseware CD.

2. In the Top viewport, select the shape.

3. On the command panels, choose Modify.

4. On the Modify panel, modifier stack display, choose Vertex.

5. Insert On the Modify panel > Geometry rollout, choose Insert.

6. In the Top viewport, click the segment between vertex 2 and vertex 3.

The vertices are renumbered sequentially around the shape.

Tip: The Refine tool also adds a vertex on the curve without changing its shape.

7. In the Top viewport, click to create the vertex then right-click to accept the vertex and to turn off Insert.

8. In the Top viewport, right-click the spline.

9. From the quad menu, choose Sub-objects > Top Level.

10. Choosing Top-level takes you out of Sub-object mode.

Welding vertices

1. On the menu bar, choose File > Open and open *Ch10_05.max* from the courseware CD.

2. On the Create panel > Shapes, choose Line.

3. Press **S** to activate snap.

4. In the Top viewport, create a triangle by creating vertices in a counter-clockwise order.

When you click over the first vertex to close the triangle a dialog is displayed prompting you to close the spline.

5. In the Spline dialog, choose No.

6. In the Top viewport, right-click to end the spline.

7. In the Top viewport, right-click to end line creation mode.

8. Press **S** to turn off Snap.

9. On the command panels, choose Modify.

10. On the Modify panel > Selection rollout, choose Vertex.

11. In the Top viewport window, select all the vertices.

 The selection rollout indicates that 4 vertices are selected.

12. In the Top viewport, right-click over one of the vertices.

13. From the quad menu, select Smooth.

The overlapping vertices at the coincident start and end points don't exhibit a smooth transition. Since there are two distinct

vertices, **3ds max** can't apply a constant tangency between them.

14. In the Top viewport, window select the coincident start and end vertices.

15. On the Modify panel > Geometry rollout, choose Weld.

The vertices are welded and the smooth vertex type takes effect.

16. In the Selection rollout, turn on Show Vertex Numbers.

There are just 3 vertices in the shape now.

17. In the Selection rollout, choose Vertex to return to the object level.

Filleting and Chamfering

1. On the menu bar, choose File > Open and open *Ch10_06.max* from the courseware CD.

2. In the Top viewport, select the shape.

3. In the Top viewport, right-click the spline and choose Cycle Vertices from the quad menu.

Reverse Spline	
Make First	
Divide	Isolate Selection
Bind	Unfreeze All
Unbind	Freeze Selection
Spline	Unhide by Name
Segment	Unhide All
Vertex	Hide Unselected
Top-level ✓	Hide Selection
tools 1	display
tools 2	transform
Create Line	Move ☐
Attach	Rotate ☐
Detach Segment	Scale ☐
Connect	Select
Refine	Clone
Refine Connect	Properties...
Cycle Vertices	Curve Editor...
Break Vertices	Dope Sheet...
Weld Vertices	Wire Parameters...
Fuse Vertices	Convert To: ▶

3ds max takes the shape into vertex sub-object mode.

4. In the Top viewport, window select all 3 vertices.

5. On the Modify panel > Geometry rollout, set Fillet to **25**.

3ds max creates a fillet radius of 25 at each of the selected vertices and adds vertices at each point of tangency.

Note: The Fillet spinner returned to 0 as soon as you pressed enter. The fillet is not retained as a parametric feature and at this point cannot be edited.

6. On the main toolbar, choose Undo to remove the fillets.

7. On the menu bar, choose Edit > Select All.

All the vertices are selected.

Tip: Ctrl + A is the keyboard shortcut for Select All.

8. On the Modify panel > Geometry rollout, set Chamfer to **20**.

Chamfers are added at each of the selected vertices. As with fillet, the chamfer is not retained as a parametric feature.

9. On the Modify panel > modifier stack display, choose Line to return to the object level.

Working with the Segment Sub-Object Level

Refining Segments

1. On the menu bar, choose File > Open and open *Ch10_07.max* from the courseware CD.

2. In the Top viewport, select the shape.

3. On the command panels, choose Modify.

4. On the Modify panel > modifier stack display, expand the Line hierarchy and choose Segment.

5. On the Modify panel > Geometry rollout, choose Refine.

6. In the Top viewport, click to add four vertices on the top segment.

Moving Segments

1. Continue with your previous file.

2. On the main toolbar, choose Select and Move.

3. In the Top viewport, choose the middle segment at the top.

4. On the Modify panel > Selection rollout, verify that Segment 5 is selected.

Spline 1/Seg 5 Selected

5. In the Top viewport, move the segment down.

6. In the Top viewport, right-click over the shape.

7. On the quad menu, choose Vertex.

 Tip: Turn on Show Vertex Numbers.

8. In the Top viewport, choose Vertex 6.

9. On the main toolbar, click and then right-click 3D Snap on the main toolbar.

 The Grid and Snap Settings dialog is displayed.

10. In the Grid and Snap Settings dialog, turn off Grid Points and turn on Vertex.

11. Close the Grid and Snap Settings dialog.

12. On the main toolbar, right-click a blank area of the toolbar and choose Axis Constraints from the right-click menu.

13. On the Axis Constraints toolbar, choose X.

14. In the Top viewport, **SHIFT** + right-click to open the Snap menu.

15. In the Snap menu, choose Options > Transform Constraints.

 This restricts applied transforms to the selected axes.

16. In the Top viewport, move the cursor over the selected vertex and drag it to the left.

17. Move the cursor to vertex 7 to pick up its X-axis.

Vertex 6 snaps into alignment with Vertex 7.

18. Press **S** to turn off Snap.

19. In the Top viewport, right-click and choose Segment from the quad menu.

20. In the Top viewport, select Segment 6.

21. In the Top viewport, move Segment 6 to the left using the X-axis restriction of the transform gizmo.

22. On the Modify panel > modifier stack display, choose Line to return to the Object level.

Working with the Spline Sub-Object Level

Attaching Shapes

1. On the menu bar, choose File > Open and open *Ch10_08.max* from the courseware CD.

2. On the main toolbar, choose Select by Name.

Three shapes exist in the scene.

3. In the Select Objects dialog, choose *Line01*, and then click Select.

4. On the command panels, choose Modify.

5. Attach On the Modify panel > Geometry rollout, choose Attach.

6. In the Top viewport, choose both circles.

 Tip: Be sure to select the lines of the circles.

7. In the Top viewport, right-click to end Attach mode.

8. On the main toolbar, choose Select by Name.

 The circles are no longer visible in the dialog. They are now spline sub-objects within Line01.

9. In the Select by Name dialog, choose Cancel.

Using Outline

1. Continue with your previous file.

2. In the Top viewport, choose the shape.

3. On the Modify panel > modifier stack display, choose the Line.

4. In the modifier stack display, choose Spline.

5. In the Top viewport, select the front circle.

6. On the Modify panel > Geometry rollout, set Outline to –2.0.

7. Repeat the Outline for the rear circle.

8. In the Top viewport, right-click over the shape and choose Top Level from the quad menu.

9. On the main toolbar, choose Select by Name.

 All the splines are still contained within the Line01 shape.

10. In the Select by Name dialog, choose Cancel to close the dialog.

Using Booleans

1. On the menu bar, choose File > Open and open *Ch10_09.max* from the courseware CD.

2. In the Top viewport, select the shape.

3. On the Modify panel > modifier stack display, choose Spline.

4. In the Top viewport, select the body spline.

5. On the Modify panel > Geometry rollout > Boolean group, choose Subtraction.

6. In the Geometry rollout, choose Boolean.

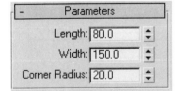

7. In the Top viewport, choose the outer circles at the front and rear.

8. In the Top viewport, right-click to end Boolean mode.

9. On the Modify panel > modifier stack display, choose Line to return to the Top level.

Accessing Sub-Object Levels with Edit Spline Modifier

1. On the menu bar, choose File > Open and open *Ch10_10.max* from the courseware CD.

The file contains a rectangular shaped object.

2. In the Top viewport, select the shape.

3. On the command panels, choose Modify.

Three rollouts are displayed; Rendering, Interpolation and Parameters. The first two are common to all shape objects.

4. On the Modify panel, open the Parameters rollout.

Parameters	
Length:	80.0
Width:	150.0
Corner Radius:	20.0

The Parameters are specific to the rectangle object.

Note: There's currently no access to the shape sub-objects you saw in the previous sections.

5. On the Modify panel > Modifier List drop-down, choose Edit Spline.

6. On the Modify panel, move the mouse cursor until it turns into a pan hand.

7. On the Modify panel, right-click and choose Close All.

The rollouts available with the Edit Spline modifier are the same ones you previously used with the Line object.

8. On the Modify panel > modifier stack display, choose Rectangle.

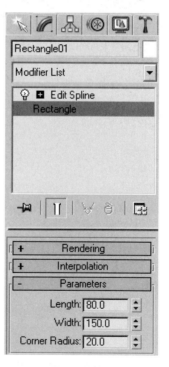

The creation parameters for the Rectangle are still accessible.

9. On the Modify panel > modifier stack display, choose the plus sign next to Edit Spline.

The Vertex, Segment and Spline sub-object levels can be accessed from within the Edit Spline hierarchy.

10. Close the hierarchy by choosing the minus sign to the left of Edit Spline.

11. On the Modify panel > modifier stack display, choose Edit Spline.

12. On the Modify panel > modify stack display toolbar, choose Remove modifier from the stack.

Accessing Sub-Object Levels by Converting to Editable Spline

Continue with the previous file.

1. In the Top viewport, right-click the rectangle.

2. From the quad menu, choose Convert To > Editable Spline.

The creation parameters are no longer available, but all sub-object levels are accessible from the Editable Spline hierarchy.

3. On the Modify panel > modifier stack display, click the plus sign to the left of Editable Spline.

Shape Modifiers

Shape modifiers convert a shape into a 3D object. Four commonly used modifiers are Extrude, Bevel, Bevel Profile, and Lathe. You work with each of them in the following sections.

Extrude

The Extrude modifier sweeps a shape along its local Z-axis, giving it a depth. You can specify a negative or a positive extrusion height, as well as the number of segments to create along the extrusion direction.

If the source shape is closed, you can specify whether the resulting object includes a cap surface at the start, or at the end, or both.

The output of the Extrude modifier can be a patch, a mesh or a NURBS object. The default is mesh. For more information on patch and NURBS surfaces please refer to the on-line help.

The Extrude modifier contains an option for generating material IDs. You work with materials in a later chapter. For now just be aware that a multi/sub-object material type can be applied to 2D objects and that ID's play an important role in identifying the specific areas that work with a multi/sub-object material type.

The Extrude modifier has an option for applying smoothing. Smoothing causes both the interactive and scanline renderer to blend pixel intensities across edges, giving the illusion of a smooth surface, even when the underlying geometry is not smooth.

The Extrude modifier is accessible from the Modifier Menu on the main menu bar.

Working with Extrude

1. On the menu bar, choose File > Open and open *Ch10_11.max* from the courseware CD.

2. In the Perspective viewport, select the circle.

3. On the Modify menu > Mesh Editing> choose Extrude.

4. On the Modify panel > Parameters rollout, set Amount to **40**.

5. The shape is extruded along its local Z-axis.

6. On the Modify panel > Parameters rollout, set Segments to **3**.

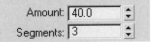

Three segments are created along the extrusion direction.

7. Press **F3** to toggle to the shaded viewport display.

8. In the Parameters rollout, turn off Cap End to remove the top cap surface.

Note: The back surfaces appear to have been removed also. In fact, they are not being rendered because their surface normals are pointing away from you. You can force their display by configuring the viewport to double sided rendering.

9. Right-click the Perspective viewport label and choose Configure from the right-click menu.

The Viewport Configuration dialog is displayed.

10. In the Viewport Configuration dialog > Rendering Method tab, turn on Force 2-Sided.

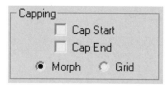

The rear faces are now visible in the viewport.

11. Press **ALT + W** to toggle back to a single viewport.

12. On the Modify panel > Parameters rollout, turn off Cap Start.

The top and bottom caps are both removed from the extruded shape.

The Smooth Option

The Smooth option causes smoothing groups to be applied to the side surfaces of the extruded object.

1. On the menu bar, choose File > Reset to reset **3ds max**.

2. On the menu bar, choose File > Open and open *Ch10_12.max* from the courseware CD.

3. In the Perspective viewport, choose the circle.

4. On the Modify panel > Modifier List drop-down, choose Extrude.

5. On the Modify panel > Parameters rollout, set Amount to **40**.

6. On the Modify panel, turn off Smooth.

 The side facets are displayed in the viewport even though the underlying geometry hasn't changed.

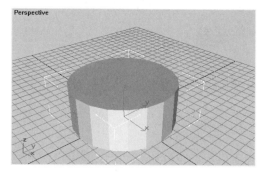

Lathe

The Lathe modifier revolves a shape about a specified axis direction. You can specify a revolve angle from 0 to 360 degrees. Lathe is useful for modeling objects like goblets, plates and vases. The shape should be a cross section of the intended object.

Lathe Axis Direction

The lathe axis direction, which can be set parallel to the underlying shapes local X, Y or Z-axis directions, is fundamental to determining the shape of the lathe object. The

lathe axis location can be set to the minimum, maximum or center of the bounding box extents in the direction perpendicular to the lathe axis. By accessing the Axis sub-object level of the Lathe modifier, you can use the transform tools and specify any arbitrary location and orientation of the axis.

Other Lathe Parameters

The Lathe modifier has several other important parameters and settings. The number of segments generated determines the approximation of the resulting surface to an ideal surface of revolution.

If the lathe angle is less than 360 degrees you can close the resulting surface with the Cap start and Cap End options.

The output from a Lathe modifier can be a patch, mesh or a NURBS surface. Generate mapping coordinates prepares the output surface for the application of mapped materials.

Using Lathe

1. On the menu bar, choose File > Open and open *Ch10_13.max* from the courseware CD.

2. In the Perspective viewport, choose *Line01*.

3. From the Modifiers menu, choose Patch/Spline Editing > Lathe.

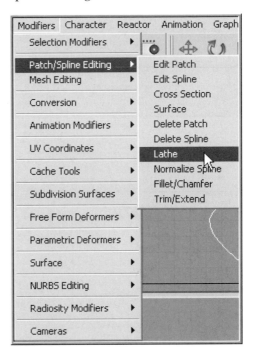

The lathe is about the Y-axis, but it's centered on the shape.

4. On the Modify panel > Parameters rollout > Align group, choose Max.

The axis of revolution is moved to the shape's maximum extents in the X direction.

5. In the Parameters rollout, turn on Weld Core.

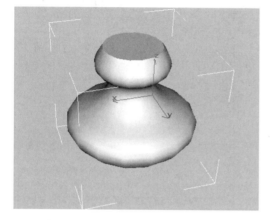

6. In the Parameters rollout, set Degrees to **240**.

7. In the Parameters rollout > Capping area, turn off Cap Start and Cap End.

8. In the Parameters rollout, turn off Smooth.

9. On the Modify panel > modifier stack display, choose the plus sign next to the Lathe modifier to expand the hierarchy.

10. In the modifier stack display, choose Axis.

11. In the Perspective viewport, position the cursor over the X-axis of the transform

gizmo and drag the axis a short distance to the left.

12. On the main toolbar, choose Undo.

13. Turn on Smooth and set Degrees back to 360.

14. Right-click the Perspective viewport label and choose Configure.

15. In the Viewport Configuration dialog, turn off Force 2-Sided and then click OK.

16. Press 7 to display the total number of faces.

17. In the Parameters rollout, adjust the Segments spinner to above and below the default. Settle at 13

You see that the complexity of the geometry increases and decreases considerably.

18. In the modify stack display, choose Line.

19. In the modify stack display toolbar, turn on Show End Result.

20. In the Interpolation rollout, change the steps to from 10 to 4. The default is 6.

The complexity of the geometry is now 416 faces. Interpolation defines the curvature of a segment. When modeling with 2D objects and using procedural modifiers, you should always be aware of the default options that can increase your objects complexity. Ultimately, you determine how detailed an object should be based on its distance to the final camera view.

21. In the modify stack display, choose Vertex.

22. In the Front viewport, edit the two side vertices to change the shape of the vase.

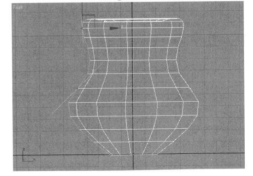

Since Show End Result is turned on, you are able to edit the line and see the edits on the final 3D Vase.

23. In the modify stack display toolbar, turn off Show End Result.

24. In the Selection rollout, choose Segment.

25. In the Front viewport, select the long vertical segment and the two top horizontal segments and then press Delete.

26. In the Geometry rollout, choose Refine.

27. In the Front viewport, click in-between the lower curved segment to add a vertex.

28. In the Selection rollout, choose Spline.

29. In the Geometry rollout, choose Outline.

30. In the Front viewport, click and drag to add an Outline or thickness to your spline.

31. In the modify stack display toolbar, turn on Show End Result.

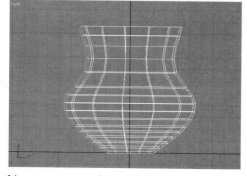

Your vase now has thickness.

32. In the modifier stack display, choose Spline to get out of sub-object and then choose Lathe to return to the top level.

Bevel

The Bevel modifier is similar to Extrude in that it sweeps a shape along its local Z-axis to create a 3D object. It's distinguished by its ability to adjust the shape offset at up to 3 levels along the sweep direction. Each level is defined by a height offset and a shape offset amount.

Bevel provides the option of capping the resulting object at its upper and lower extents. The sides can be set to linear or curved. With the curved option the tangent direction of the surface is maintained across the level transition.

The number of segments in the extrusion direction can be set in a similar fashion to the Segments parameter of the Extrude modifier. In the case of Bevel, the segment count is applied between each level. The segments are especially suited to help define the object when the curved sides option is selected.

An option called Smooth Across Levels is available to set smoothing groups across the level transitions. This causes the object to render smoothly in both the viewports and scanline renderer.

Depending on the relative sizes of the offset values and the source shapes it's possible for the shape to intersect itself at one or more levels. You can prevent this behavior by turning on Keep Lines from Crossing. When you turn on this option, you can specify a minimum separation to be maintained between shape segments.

Using Bevel

1. On the menu bar, choose File > Open and open *Ch10_14.max* from the courseware CD.

2. In the Perspective viewport, select the shape.

3. On the Modify panel > Modifier List drop-down, choose Bevel.

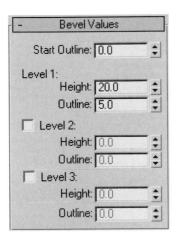

4. On the Modify panel > Bevel Values rollout, set Level 1 Height to **20**, and Outline to **5**.

5. In the Bevel Values rollout, turn on **Level 2**.

6. In the Bevel Values rollout, set the Level 2 Height to **30** and leave Outline at **0**.

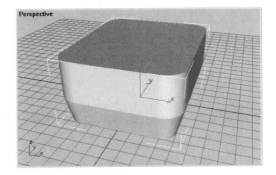

7. In the Bevel Values rollout, turn on Level **3**.

8. In the Bevel Values rollout, set Level 3 Height to **–20.0** and Outline to **–5.0**.

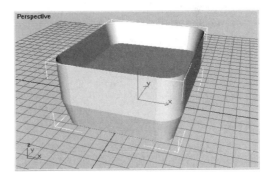

9. Press **F3** to set the viewport display to Wireframe.

10.In the Parameters rollout, set Segments to **6**.

11.Press **F3** to toggle back to the Shaded display.

12.In the Parameters rollout > Surface group, turn on Smooth Across Levels.

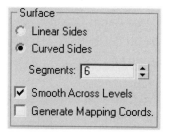

The subtle seams between levels are smoothed.

13.In the Bevel Values rollout, set Start Outline to **–20.0**.

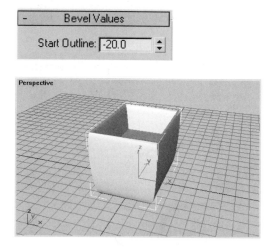

The Outline values are relative to the previous level. The change to the start outline was propagated to the other levels.

Bevel Profile

The Bevel Profile modifier is a variation on the Bevel modifier. Instead of using specific heights and outlines Bevel Profile uses a shape to define the nature of the extrusion. That shape is termed the profile.

The profile remains visible in the viewport after it's been selected and used by the modifier. If the profile shape is modified, the bevel profile updates dynamically.

The profile can be an open or closed shape. If it's open you can cap the start and end of the resulting bevel profile surface.

Using the Bevel Profile

1. On the menu bar, choose File > Open and open *Ch10_15.max* from the courseware CD.

 The file contains two shapes.

2. In the Perspective viewport, select the large arch shape.

3. On the Modify panel > Modifier List drop-down, choose Bevel Profile.

 The Bevel Profile modifier is displayed above the Line in the modifier stack display.

4. On the Modify panel > Parameters rollout, choose Pick Profile.

5. In the Front viewport, select the small shape.

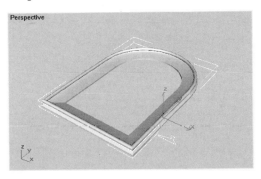

6. In the Front viewport, select the small shape again.

7. On the Modify panel > modifier stack display, choose Segment.

8. In the Front viewport, select the short vertical segment on the left side of the profile.

9. On the main toolbar, choose Select and Move.

10. In the Front viewport, use the transform gizmo to restrict movement on the X-axis and move the segment back and forth. While you do so, watch how the Bevel Profile updates in the Perspective viewport.

11. In the modifier stack display, choose the Line to return to the profile's object level.

Conclusion

Shapes are made up of one or more splines. Each spline defined by its vertices. The region of the spline between adjacent vertices is termed a segment. Different vertex types can be specified to control the smoothness of the curve as it passes through each vertex.

All shapes have a set of common properties related to rendering and interpolation. If shapes are renderable, you can specify their thickness and their mesh density. The interpolation settings specify the approximation of the rendered shape.

The Line tool creates general shape objects, while the standard shapes carry a set of creation parameters that can be adjusted via the modify panel. Shape sub-objects include splines, segments and vertices. To access these sub-objects for a line, you use the Modify panel or quad menu. For the other shape objects, you must either apply an Edit Spline modifier or convert the shape to an Editable Spline.

Shapes can be converted to 3D objects by applying a 2D modifier. Common shape modifiers are Extrude, Bevel, Bevel Profile and Lathe.

More Objects and Modifiers

Objectives

After completing this chapter, you are be able to:

- Apply modifiers to scene geometry.
- Access different levels in the modify stack display.
- Create compound objects using Booleans, Lofts and Connect.
- Create and work with patch surface models.

Introduction

This chapter begins with an introduction to the application and use of modifiers. You then cover a category of object types called compound objects. Specifically you work with the Boolean, Loft and Connect compound objects. Finally you look at patch modeling; a flexible spline based surface creation tool. Each topic forms an important part of modeling in **3ds max**.

Modifier Concepts

Modifiers, as their name suggests, are tools you use to modify the characteristics of your scene geometry. **3ds max** contains many modifiers. Each one has its own set of parameters that control the extent and nature of its application. In the previous chapter you worked with 2D modifiers, this chapter extends to 3D modifiers.

Workflow for Applying Modifiers

You can apply modifiers to one or more objects in a scene. You modify objects according to their parameter settings.

Multiple modifiers can be applied to the same object. Each modifier uses the result of the modifier that came before it. The order in which you apply modifiers is significant; changing the order of application might alter the result significantly.

The Modifier List Drop-Down

| Modifier List ▾ | The modifier list is a drop-down available on the Modify panel. It contains many modifiers, which can be divided into functional categories, namely:

- Selection modifiers
- Patch/Spline editing
- Mesh editing
- Animation modifiers

You can customize how the modifier list is displayed by right-clicking the drop-down, and choosing Show All Sets in List from the right-click menu.

The modifier list is enabled once you select a scene object. As soon as you select a modifier, it is applied to the selected geometry.

The Modifier Stack Display

A list containing the base object and its added modifier creates what is known as the modifier stack display. You access modifiers and their parameters through the modifier stack display. The following modifier stack display illustrates a box with an Edit Mesh, Taper, and Bend modifier applied.

Box01	
Modifier List	▾
⚇ ⊞ Bend	
⚇ ⊞ Taper	
⚇ ⊞ Edit Mesh	
Box	

As you select each modifier in the modifier stack display, its parameters are displayed in rollouts on the modify panel.

The modifier stack display provides several other features. For example you can:

- ⚇ Turn modifiers off.

- ⊟ Delete modifiers.

| Rename |
| Delete |
| Cut |
| Copy |
| Paste |

- Rename, Copy and Paste modifiers.

⚇ A light bulb icon is displayed adjacent to every modifier. Choosing this icon turns the modifier off and on. When a modifier is turned off, its effects are suppressed, and the state of the object before you modified it appears in the viewport.

You can delete a modifier by right-clicking it in the modifier stack display and selecting Delete from the right-click menu. You can also select Rename from the same dialog. You can apply the name of your choice to a modifier using the Rename feature. The right-click menu also offers options for copy and paste.

| Rename |
| Delete |
| Cut |
| Copy |
| Paste |

You can drag modifiers from the modifier stack display and drop them on scene objects. You can also drag and drop the modifiers in the modifier stack display to change the order in which you apply them.

Collapsing the Stack

The modifier stack display maintains the data structure of the base object and each applied modifier. If you're not going to alter the geometry further you can collapse the stack. This reduces the object to an editable mesh, saving file size. Once the stack is collapsed you can manipulate the geometry by either modifying the object at the mesh level or applying modifiers above the editable mesh state. Any animation that was applied using modifiers is lost when the object is collapsed.

Sub-Object Levels

Most modifiers have sub-object levels. The nature of these levels depends on the modifier. In general you can access them through the modifier stack display. In many cases you can change certain characteristics of modifiers through its sub-object level only.

Working with the Modifier Stack Display

1. On the menu bar, choose File > Open and open *Ch11_01.max* from the courseware CD.

 The file contains two cones, one of which has Bend and Taper modifiers applied.

2. In the Perspective viewport, choose *Cone 1*.

3. On the command panels, choose Modify.

The modifier stack display indicates that the Bend modifier was added first, followed by the Taper modifier.

4. In the modifier stack display, choose Taper and drag it onto *Cone 2*.

The Taper modifier is applied to *Cone 2*.

5. In the Perspective viewport, choose *Cone 1*.

6. In the modifier stack display, choose the Bend modifier and drag it onto Cone 2.

7. In the Perspective viewport, click in an open area to deselect *Cone 2*.

Both cones have the same modifiers applied, but they look different due to the order in which the modifiers have been applied.

8. In the Perspective viewport, select *Cone 1*.

9. In the modifier stack display, choose the Bend modifier, and drag it above the Taper modifier.

With the modifiers in the same order the cones now look identical.

10. In the Perspective viewport, choose *Cone 2*.

11. In the modifier stack display, right-click the Bend modifier.

12. From the right-click menu, choose Delete.

The Bend modifier is removed from the cone.

13. In the Perspective viewport, select *Cone 1*.

14. Right-click in the modifier stack display.

15. From the right-click menu, choose Collapse All.

Make Unique

Collapse To
Collapse All

On
Off in Viewport

16. Click Yes in the Warning dialog.

The modifiers and base object are collapsed to an editable mesh.

Cone 1

Modifier List

⊞ Editable Mesh

Working with meshes is discussed in detail in Chapter 12.

Some Example Modifiers

Free Form Deformation (FFD) Modifier

The Free Form Deformation modifier, as its name suggests, is used for deforming objects. The modifier consists of an organized group of control points termed a lattice. The lattice initially surrounds the geometry that it's applied to. By moving the control points, the underlying geometry is deformed in a controlled fashion.

FFD Sub-Object Levels

Sphere01

Modifier List

⊟ FFD 3x3x3
Control Points
Lattice
Set Volume
Sphere

There are three sub-object levels associated with the FFD modifier:

• **Control Points**—You can transform control points individually or in groups. The underlying geometry changes shape as the control points are transformed.

• **Lattice**—At the lattice sub-object level, you can transform the lattice, independent of the geometry, thereby changing the modifier's influence.

• **Set Volume**—You can transform the lattice control points to better fit the geometry with the set volume. While these adjustments are made, the object is not deformed.

FFD Parameters

FFD Parameters

Display:
- ☑ Lattice
- ☐ Source Volume

Deform:
- ⦿ Only In Volume
- ○ All Vertices

Control Points:

Reset

Animate All

Conform to Shape

- ☑ Inside Points
- ☑ Outside Points

Offset : 0.05

About

The FFD Parameters rollout contains three main groups. The Display group lets you control whether the lattice is displayed in the viewport. You can also choose to display the lattice in its original symmetrical configuration.

The Deform group lets you specify whether the modifier affects geometry located outside the lattice.

Using the Control points group, you can put all control points back to their original positions. It is a tool to make the lattice conform to the geometry automatically.

Using the FFD Modifier

1. On the menu bar, choose File > Open and open *Ch11_02.max* from the courseware CD.

2. Press **ALT + W** to show four viewports.

3. In the Perspective viewport, choose the brown object named *Ngon01*.

4. On the command panels, choose Modify.

5. On the Modify panel > Modifier List drop-down, choose FFD 3x3x3.

Free Form Deformations
FFD 2x2x2
FFD 3x3x3
FFD 4x4x4
FFD(box)
FFD(cyl)

6. In the modifier stack display, choose the plus sign to the left of FFD 3x3x3.

7. In the modifier stack display, choose Control Points.

NGon01

Modifier List

FFD 3x3x3
 Control Points
 Lattice
 Set Volume
 Extrude
NGon

8. In the Front viewport, region select the top control points.

9. On the main toolbar, choose Select and Uniform Scale.

10. In the Perspective viewport, place the cursor inside the inner triangular area of the Transform Gizmo and scale the top control points until they are close together

11. In the Front viewport, region select all the mid level control points.

12. Right-click in the Perspective viewport to make it active.

13. In the Perspective viewport, place the cursor inside the inner triangular area of the Transform Gizmo.

14. In the Perspective viewport, scale the control points out as shown in the following illustration.

15. On the main toolbar, choose Select and Rotate.

16. In the Perspective viewport, place the cursor over the Z-axis of the transform gizmo and rotate it approximately 45° to add a twist.

17. In the modifier stack display, choose FFD 3x3x3 to return to the object level.

Noise Modifier

The Noise modifier displaces the geometry in a random pattern. You can set the strength of the displacement for each of the coordinate directions. The Noise can be animated so that the surface displacement changes with time. The rate of change is controlled with the Animation Frequency parameter.

The Seed value of the Noise modifier changes the random pattern. If you apply the Noise modifier with the same parameter settings to two identical base objects, they both displace in the same way. Changing the Seed value makes them distinct.

Using the Noise Modifier

1. On the menu bar, choose File > Open and open *Ch11_03.max* from the courseware CD.

2. In the Front viewport, select the box.

3. On the command panels, choose Modify.

4. On the Modify panel > Modifier List dropdown, choose Noise.

Parametric Modifiers
Bend
Taper
Twist
Noise
Stretch
Squeeze
Push

5. On the Modify panel > Parameters rollout > Strength group, set Z to **20.0**.

The box is distorted.

6. In the modifier stack display, choose the plus sign to the left of Noise.

 The Noise modifier sub-object levels are displayed.

 Box01

 Modifier List

 Noise
 ├── Gizmo
 └── Center
 Box

7. In the modifier stack display, choose Center.

8. On the main toolbar, choose Select and Move.

9. In the Perspective viewport, move the Center in the XY plane.

Moving the Noise center alters its effect on the box.

10. 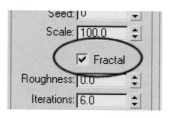 On the main toolbar, choose Undo.

This places the Noise center at its original location.

11. On the Modify panel > Parameters rollout, turn on Fractal.

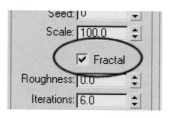

12. In the modifier stack display, choose Box.

Box01	
Modifier List	▼

```
💡 ⊟ Noise
      ┆····· Gizmo
      └····· Center
    Box
```

The Box creation parameters are displayed.

13. In the Parameters rollout, set Length Segs and Width Segs to **10**.

While you do so, watch the box change shape in the viewport.

–	Parameters
Length:	200.0
Width:	200.0
Height:	3.0
Length Segs:	10
Width Segs:	10
Height Segs:	1
☐ Generate Mapping Coords.	

14. In the modifier stack display, choose Noise to return to the top level.

15. In the Parameters rollout > Animation group, turn on Animate Noise.

Animation:
☑ Animate Noise
Frequency: 0.25
Phase: 0

16. ▶ In the time controls, choose Play.

17. ◀◀ In the time controls, choose Go to Start.

18. On the Modify panel > modifier stack display, choose the light bulb icon adjacent to the Noise modifier.

Box01

Modifier List ▼

💡 ⊟ Noise
 Gizmo
 Center
 Box

The modifier is still present, but its effect is suppressed. Its gizmo can still be seen in the viewport.

19. 🖰 In the modifier stack display toolbar, choose Remove modifier from the stack.

The Noise modifier is removed, leaving the box in its original condition.

Symmetry Modifier

The Symmetry modifier is a combination of the Mirror modifier, and the Weld vertex operation. This is an excellent modifier for character modeling. For instance, when modeling a head, you usually model half. The Symmetry modifier allows you to view the other half while you're modeling, and it welds the coincident vertices.

Using the Symmetry Modifier

1. On the menu bar, choose File > Open and open *Ch11_04.max* from the courseware CD.

 A half of a completed head is displayed. You add the Symmetry modifier, and make several minor changes.

2. In the Perspective viewport, choose *Female Head*.

3. 🖼 On the command panels, choose Modify.

4. On the Modify panel > Modifier List drop-down, choose Symmetry.

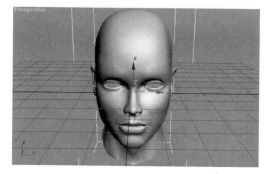

The head is mirrored along the X-axis and the seam is welded.

5. In the modifier stack display, choose Editable Mesh.

6. ⌠⌡ In the modifier stack display, choose Show End Result.

7. ⊡ In the Selection rollout, choose Vertex.

The original side of the head's vertices is displayed.

8. Right-click to activate the Front viewport.

9. ⌗ In the viewport navigation controls, choose Region Zoom.

10. In the Front viewport, region zoom into the eye area.

11. In the Front viewport, choose three vertices on the right side of the eye.

12. In the Soft Selection rollout, turn on Use Soft Selection.

13. In the Soft Selection rollout, set Falloff to **5**.

14. 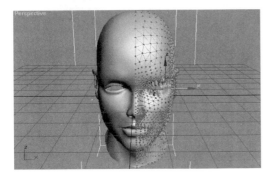 On the main toolbar, choose Select and Move.

15. In the Front viewport, move the selected vertices along the XY plane to a location that is visually pleasing to you.

While you are transforming, make sure you look in the Perspective viewport, to see both sides get adjusted.

16. Continue to transform various areas of the head.

17. When you are done editing, first choose Editable Mesh, to get out of the sub-object level, and then choose Symmetry in the modify stack display area.

Compound Objects

Compound objects are those formed by combining two or more objects. Examples of Compound objects include Booleans, Lofts and Connect. The following sections describe these objects.

Booleans

Defining Booleans and Operands

Combining two existing 3D objects based on the volume they occupy forms a Boolean object. Each participating object is named an operand. Normally Booleans are performed with operands that share some common volume. Valid operations include:

- Generating an object representing the sum of the volumes.

- Removing the common volume from one of the operands.

- Creating a new object defined by the common volume only.

Each of these operations describes a Boolean type.

Boolean Operation Types

The three ways in which the operands within a Boolean can be combined are:

- **Union**—This option creates an object with the combined volume of the operands.

- **Subtraction**—This option creates an object with the volume of the first object minus any commonly occupied volume of the

second object. You have the option of subtracting Operand B from Operand A, and vice versa.

- **Intersection**—This option creates an object whose volume is the common volume of the participating operands.

A variation on the Subtraction operation is the Cut. Cut doesn't apply any portion of Operand B to the resulting mesh. For example, a tall cylinder cut from a box would not leave cylindrical walls in the box. It would create holes in the top and bottom surfaces only.

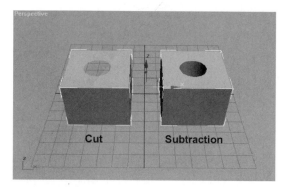

Creating Booleans

To create a Boolean, you first select an operand. Then you can access the Boolean tool via the Compound Objects category of the Create panel. You can also create a Boolean from the Create menu > Compound > Boolean.

The user interface contains operands referred to as A and B. When the Boolean operation is initiated, the selected object is designated Operand A. The object with which you combine it becomes Operand B.

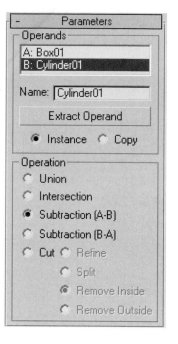

When you select Operand B you specify whether the operation is a Union, Intersection or Subtraction. The Boolean is complete once you select Operand B, and the viewports are updated to reflect the operation.

Note: It's possible to create nested Booleans. To do so, an existing Boolean is used as an operand in another Boolean operation.

Operand Type

Operand B can be brought into the Boolean in several ways:

- **Reference**—This option is similar to Instance, except that changes made to the Reference copy (the one associated with the Boolean) are not applied to the original.

- **Move**—This option takes the designated Operand B and uses it in the Boolean. The object is then removed from the scene.

- **Copy**—This option makes a copy of the selected object to use as the B operand in the Boolean. The original is retained in the scene and can be modified without influencing the Boolean.

- **Instance**—This option makes a copy of the selected object to use as Operand B, but the copy is tied to the original. Any changes made to Operand B are made to the original, and vice versa.

Display and Update Options

With the display options for a Boolean object, you can view the operation in several ways:

- **Result**—This option is the default. It displays the normal result of the Boolean operation according to the operation type (Union, Subtraction, or Intersection).

- **Operands**—This option displays Operand A and B as they were prior to the Boolean operation.

- **Result + Hidden Operands**—This option displays the final result. Missing portions of the operands are displayed in wireframe.

Surface Topology Requirements

The term *surface topology* refers to the surface characteristics of an object. The surface characteristics can influence the success of a Boolean operation. When preparing objects to use as operands within a Boolean, consider the following:

- The operands consist of similar complexity. Combining an object with

significantly different mesh densities can lead to long narrow faces, which might not render correctly.

- There should be no missing or overlapping faces on the operands.

- The face normal directions should be consistent.

Editing Booleans

When a Boolean is created from an object, the base object is displayed as a Boolean in the modifier stack display.

Booleans and their operands can be edited via the Modify panel. The modifier stack display shows the Boolean at the top of the hierarchy. You can expand the Boolean hierarchy to display the operands, which provides access to either operand used in the current Boolean or in nested Booleans. If applicable, you can alter the operand's creation parameters or apply modifiers to it. By default, changes to the operands update the Boolean in the viewports.

Note: If you're working with a nested Boolean you can navigate to any level in the hierarchy to access the associated operands.

Extracting Operands

You can extract an operand from a Boolean either as a copy or as an instance. If you extract it as a copy it is completely independent and can be changed without affecting the Boolean. If it's extracted as an instance, it is tied to the Boolean and any changes directly influences the Boolean. Extracting an instance provides a useful method to alter an operand and its Boolean, without navigating in the Boolean hierarchy. You can make all changes at the object level in the Modify panel.

For example, you might want to adjust a door or window opening made by a Boolean. Adjusting the extracted operand allows you to change the size of the opening easily.

When an object is extracted from a Boolean, it is located in the same position as its associated operand. It has to be moved to see the Boolean object clearly.

Creating a Boolean Union

1. On the menu bar, choose File > Open and open *Ch11_05.max* from the courseware CD.

 Three boxes are visible in the viewport. A portion of each occupies a common volume.

 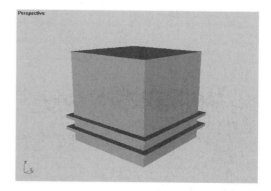

2. Press **H** to display the Select Objects dialog.

 Box01, *Rib1* and *Rib2* are displayed in the list.

3. In the Select Objects dialog, choose Cancel.

4. In the Perspective viewport, select the large box.

5. On the command panels, choose Create.

6. On the Create panel > Objects type drop-down list, choose Compound Objects.

7. **Boolean** In the Object Type rollout, choose Boolean.

8. On the Create panel > Operation group, set the operation type to Union.

Operation
- ● Union
- ○ Intersection
- ○ Subtraction (A-B)
- ○ Subtraction (B-A)
- ○ Cut ● Refine
 - ○ Split
 - ○ Remove Inside
 - ○ Remove Outside

9. **Pick Operand B** In the Pick Boolean rollout, choose Pick Operand B.

10. In the Perspective viewport, select the lower box (*Rib1*).

The name of the object is displayed in a tooltip if you place the cursor over it for a moment.

The lower box is joined to the larger one.

11. In the Parameters rollout, the operands are listed.

Operands
A: Box01
B: Rib1

12. Right-click in the Perspective viewport to cancel the Boolean operation.

13. On the command panels, choose Modify.

The Boolean is shown as the base object in the modify stack display.

Creating a Nested Boolean

1. Continue from the previous exercise.

2. **Boolean** On the Create panel > Object Type rollout, choose Boolean.

3. In the Pick Boolean rollout, choose Pick Operand B.

4. In the Perspective viewport, select *Rib2*.

5. Right-click in the active viewport to end the Boolean.

You've created a nested Boolean. The box was joined to the first rib, and the result was joined to the second rib.

6. Press **H** to display the Select Objects dialog.

Only the box object is shown. It is now a Boolean and the ribs are contained in it as sub-objects.

7. In the Select Objects dialog, choose Cancel to close the dialog.

8. On the command panels, choose Modify.

9. On the Modify panel > modifier stack display, choose the plus sign to the left of Boolean to display its hierarchy.

10. In the Parameters rollout, look at the operands listed.

Box01 and *Rib2* are displayed. *Box01* is itself a Boolean.

11. In the Parameters rollout, choose *Box01*.

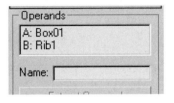

Boolean is listed twice in the modifier stack display; once for each of the two Boolean operations you performed.

Note: The order of operands listed in the Parameters rollout: *Box01* is listed as Operand A since it was selected when the Boolean was initiated. *Rib2* is shown as Operand B.

12. In the modifier stack display, choose the plus sign to the left of the lower Boolean, and then choose operands.

13. In the Parameters rollout, look at the operands listed.

14. *Box01* and *Rib1* are the operands of the first Boolean.

15. In the modifier stack display, choose Boolean to return to the object level.

Creating a Boolean Subtraction

1. Continue from the previous exercise.

2. On the command panels, choose Display.

3. Unhide All On the Display panel > Hide rollout, choose Unhide All.

 Two Arch objects are displayed.

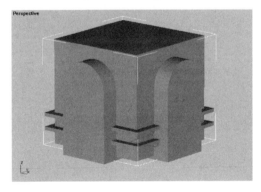

4. Verify that *Box01* is selected.

5. On the menu bar, choose Create > Compound > Boolean.

The Create panel is automatically opened with Boolean selected.

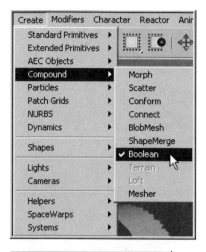

6. On the Create panel > Operation group, choose Subtraction [A-B].

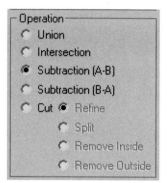

7. In the Pick Boolean rollout, choose Pick Operand B.

8. In the Perspective viewport, select *Arch1*.

9. Right-click in the Perspective viewport to end Boolean creation.

10. In the Object Type rollout, choose Boolean.

11. In the Pick Boolean rollout, choose Pick Operand B.

12. In the Perspective viewport, choose *Arch2*.

13. In the active viewport, right-click to end Boolean creation.

Lofts

Sweeping one or more shapes along a path creates lofts. The shapes define the cross section of the loft at the point along the path at which they are assigned. The region of the loft between shapes is obtained through interpolation.

Terminology

Both the path and loft cross sections are shape objects. However, the user interface refers to path and loft cross sections as path and shapes respectively. This section of the chapter follows that convention: objects defining the loft cross sections are referred to as shapes, and the spline defining the sweep axis is referred to as the path.

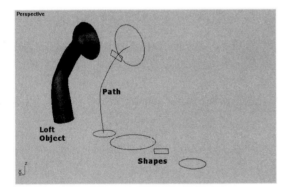

Creating the Loft

Before you use Loft, you must select either a path or a shape. If you select the path first, the starting shape is positioned so that its local Z-axis is tangent to the path's start point. If a shape is selected first, the designated path is moved so that its tangent aligns with the local Z-axis of the shape.

The first shape you specify is swept along the entire length of the path. To add other shapes to the Loft, designate the point along the path where it is to be located, and then select the shape.

Interpolating between each of the shapes along the path creates the loft surface. **3ds max** uses each shape's start point to establish the loft surface alignment. If the start point of the shapes is significantly different, the loft surface is twisted. You can control the twist by rotating the shapes at the sub-object level after adding them to the loft.

Specifying Shape Placement

There are three measurement methods for specifying shape placement along the path:

- **Percentage**—Percentage specifies placement as a percentage of the overall path length.
- **Distance**—Distance specifies location as an absolute distance measured from the start point of the path.

- **Path Steps**—Path Steps specify placement at the vertices and steps of the spline representing the path.

Tip: When setting the measurement method, you can use the Snap option. With the Snap option you can maintain a constant distance between shape locations.

Skin Parameters

You can adjust several aspects of the loft using skin parameters. You can specify whether to cap the start and end of the loft. Shape steps determine the number of divisions in the mesh between shape vertices. Path Steps determine the number of mesh divisions between shapes in the path direction.

The default interpolation between shapes is smooth. You can, however, set the interpolation to linear. Linear creates a surface with sharper surface transitions over the shapes.

Editing Lofts

The Path Sub-Object Levels

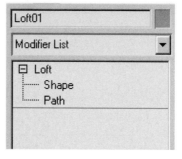

Lofts are edited via the Modify panel. The loft exists at the top level of the modifier stack display. The loft hierarchy contains the shape and path sub-object levels. Shapes can be edited by highlighting the shape sub-object level and then selecting the one you want to edit in the viewport. You can change the location of the shape along the path, or access its creation parameters if applicable.

The path sub-object level in the modifier stack display provides the option of making a copy or instance of the path for the scene.

The Shape Sub-Object Levels

The shape sub-object level provides access to the Compare dialog. The purpose of this dialog is to compare the start points and positions of different shapes in the loft. As described previously, the start point alignment determines the twist in the loft surface. The Compare dialog graphically superimposes specified loft shapes and displays start point and center alignment clearly. The dialog updates as the shapes rotate in the viewport.

The Compare dialog is displayed.

Shape and Path Instances

A convenient way to edit both paths and shapes is to bring them into the loft as instances. Doing so allows you to edit the shapes interactively at the object level. The alternative is to copy the shapes. In this case, editing the shapes does not influence the loft.

Working with Lofts

In this exercise you model a cobra using the Loft tool. You place different shapes at various levels along a path.

1. On the menu bar, choose File > Open and open *Ch11_06.max* from the courseware CD.

2. In the Perspective viewport, choose the large helical spline.

3. On the command panels, choose Create.

4. On the Create panel > Object Type drop-down, choose Compound Objects.

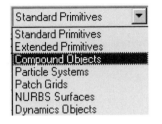

5. In the Object Type rollout, choose Loft.

 The start of the path is the tail. You start by placing the small circle there.

6. In the Creation Method rollout, choose Get Shape.

7. In the Perspective viewport, select *Circle01*.

 Circle01 is swept along the length of the path.

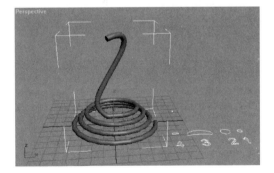

8. In the Path Parameters rollout, set Path Level to **10**.

This specifies the placement of the next shape along the path at an interval of 10%.

9. In the Skin Parameters rollout > Display group, turn off Skin.

This allows you to see the shapes and the percent marker clearly.

Note: The image below shows the yellow X located 10% of the way along the path.

10. In the Skin Parameters rollout, turn on Skin.

11. In the Creation Method rollout, choose Get Shape.

12. In the Perspective viewport, select *Circle02*.

13. In the Path Parameters rollout, set Path Level to **90%**.

This is the point where you add *Circle02* again.

14. In the Creation Method rollout, choose Get Shape.

15. In the Perspective viewport, select *Circle02*.

16. In the Path Parameters rollout, set Path Level to **93%**.

This defines where *Ellipse01* is placed.

17. In the Creation Method rollout, choose Get Shape.

18. In the Perspective viewport, select *Ellipse01*.

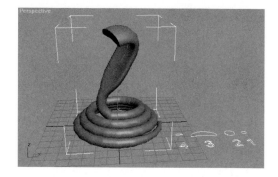

19. In the Path Parameters rollout, set Path Level to **100**.

20. In the Creation Method rollout, choose Get Shape.

21. In the Perspective viewport, select *Ellipse02*.

22. In the active viewport, right-click to end Loft creation.

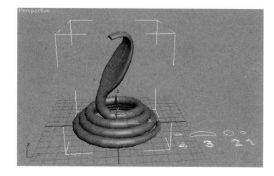

Adjusting the Loft

The head proportions need adjusting. The third shape needs to be moved closer to the head.

Continue with your previous file or open *Ch11_07.max* from the courseware CD.

1. Make sure the loft object is selected.

2. 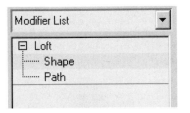 On the command panels, choose Modify.

3. On the Modify panel > modifier stack display, choose the plus sign to the left of Loft to open its hierarchy.

Loft01	
Modifier List	▼
⊟ Loft	
┊······ Shape	
┊······ Path	

4. In the modifier stack display, choose Shape.

Modifier List	▼
⊟ Loft	
┊······ Shape	
┊······ Path	

5. In the Perspective viewport, place the cursor over *Ellipse01* in the loft, and click to select it.

The shape turns red when selected. The spinner value also displays **93%** for the Path Level.

Path Level:	93.0	⬍

6. In the Shape Commands rollout, set Path Level to **98%**.

—	Shape Commands	
Path Level:	98.0	⬍
	Compare	
Reset		Delete
Align		
Center		Default
Left		Right
Top		Bottom
Put		
	Put...	

The shape moves further along the path, improving the appearance of the head.

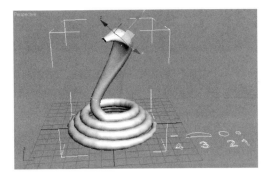

7. In the Perspective viewport, select *Ellipse02* within the loft.

8. 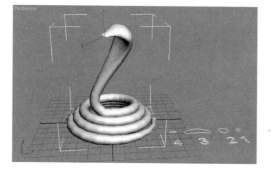 On the main toolbar, choose Select and Rotate.

9. In the Transform Type-In dialog, enter **45** for Offset: Local X-axis.

This rotates the last shape to improve the appearance of the Loft.

10. Close the Transform Type-In dialog.

11. On the main toolbar, choose Select Object.

The tip of the head is angled inward.

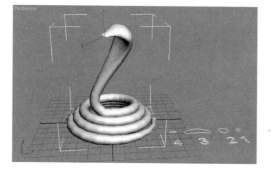

12. In the Shape Commands rollout, choose Compare.

13. In the Compare dialog, choose Pick Shape.

14. In the Perspective viewport, select the four shapes in the Loft.

Note: The Display Skin option can be turned off via the Skin Parameters rollout to make it easier to distinguish and select shapes.

15. In the Compare dialog, choose Zoom Extents.

The shapes are superimposed in the dialog. The squares indicate the start points of each shape. If the squares aren't aligned, the loft might appear twisted. If you transform the shapes in the viewport, they update interactively in the compare dialog.

16. Close the Compare dialog.

17. In the modifier stack display, choose Loft to return to the object level.

Connect

The Connect compound object creates a connecting surface between two mesh objects with holes in their surfaces. The connecting surface is formed between the missing faces on the operands.

Orientation of the Operands

The missing faces on both operands should face one another approximately. The connecting surface is created as long as the missing faces are within ±90° of one another.

Multiple Holes

Multiple connections can be made between operands if each contains multiple holes. The minimum number of holes on either operand dictates the maximum number of connections. If multiple holes exist, you want to try to align the holes approximately. Otherwise the connections might intersect between objects.

Connecting Surface Properties

The connection made between operands can be controlled parametrically. You can specify the number of segments and its smoothing to use on the connecting mesh. You can control the number of segments and its tension on the connecting geometry. Higher Tension values tend to pull the connecting surfaces toward one another, causing it to narrow at its center. Lower positive Tension values tend toward a linear interpolation between operand holes, while negative values increase the connection size.

You can also control the smoothing assignments used on the connection and their associated surfaces. By default, the ends are not smooth, resulting in a sharp edge at the connection points.

Editing Connect

Connect is edited in the Modify panel. Connect appears at the top of the modifier stack display. Its sub-object levels are operands and Edit Mesh. The operand level provides access to the creation of mesh parameters for each operand. The Edit Mesh level provides access to the mesh used for the connection.

Working with Connect

1. On the menu bar, choose File > Open and open *Ch11_08.max* from the courseware CD.

 The file contains two mesh objects. The box has one hole in its mesh, while the cylinder has nine distributed around its circumference. In this exercise you'll create a Connect compound object.

2. In the Perspective viewport, select the Box.

3. On the command panels, choose Create.

4. On the Create panel > Object type drop-down, choose Compound Objects.

5. On the Create panel > Object Type rollout, choose Connect.

6. In the Pick Operand rollout, choose Pick Operand.

7. In the Perspective viewport, select the cylinder.

8. In the Perspective viewport, right-click to end Pick Operand.

9. In the Perspective viewport, right-click again to end Connect creation mode.

A connection is made between the cylinder and the box.

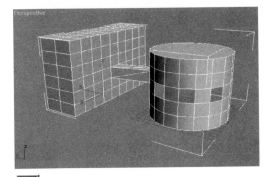

10. 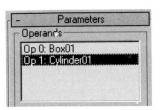 On the commands panel, choose Modify.

11.On the Modify panel > modifier stack display, choose the plus sign next to Connect.

The level of the operands is displayed.

12.In the modifier stack display, choose Operands.

13.In the Parameters rollout, choose *Cylinder01*.

14. On the main toolbar, choose Select and Rotate.

15.In the Perspective viewport, place the cursor over the Z-axis of the transform gizmo and drag side to side in the viewport.

16.In the Perspective viewport, right-click to cancel rotation.

The connecting surface snaps onto the nearest hole.

17.In the Parameters rollout, select *Box01*.

18.In the modifier stack display, choose the plus sign next to Edit Mesh.

19.In the modifier stack display, choose Polygon.

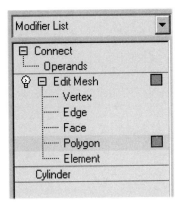

20.In the Perspective viewport, choose the polygon 2 squares to the left of the existing connection.

21.Press **Delete** to remove the selected polygon.

A second connection is made between the box and cylinder.

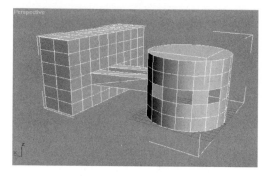

22. In the modifier stack display, choose Connect to return to the object level.

23. In the Parameters rollout > Interpolation group, set Segments to **3** and Tension to **0**.

The mesh density on the connections is increased.

Patch Modeling

In Chapter 10 you worked with 2D modifiers to build 3D geometry. In this chapter you have seen what you can accomplish with 3D modifiers and compound objects. You now look into patch modeling, which is another technique for combining 2D shapes to build a 3D object.

Patch modeling includes two specific steps:

• Building a spline cage.

• Adding an Edit Patch modifier.

When modeling a line, or editable spline, you have several features available to help model a spline cage. The resulting Edit Patch object is made from patches. This modeling technique is well suited for both high and low polygon models, as well as organic shapes.

What are Patches?

Patches are Bezier surfaces formed from spline based edges. The advantages of patch modeling include intuitive surface creation and the ability to adjust mesh density of the finished surface parametrically. There are two types of patches: quads and tris.

The Spline Cage

The network of splines that define a patch is called the spline cage. Spline cage creation allows considerable flexibility. Spline cages can be made manually with free form lines or by Attaching standard shapes and using the CrossSection tool or modifier. You can also combine both methods.

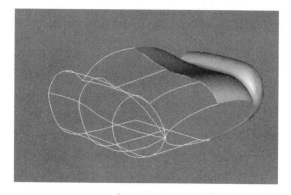

Creating the Surface

You create the patch surface by applying an Edit Patch modifier to the spline cage. The modifier analyzes the cage and creates a patch surface over all regions that meet the spline cage requirements.

Spline Cage Requirements

A patch can be created from a perimeter of 3 or 4 edges. Spline vertices must enclose each edge, and the vertices bounding each of the edges must intersect. The cage resembles a net, where each region of the net can have three or four sides.

Using the CrossSection Tool

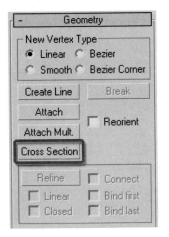

The Cross Section tool builds the spline cage from a series of splines. It creates splines running between the vertices of each spline, forming a valid cage for surface creation. The splines don't have to be created in any particular order, and they can have differing numbers of vertices, but they all have to be sub-objects of the same shape. To attach splines, add an Edit Spline modifier, or

convert to an Editable Spline, and use the Attach tool. To make the crossing lines, choose the splines in the order you want them to be connected. The following illustration shows a series of Ngons. The CrossSection tool has been used on the object on the left.

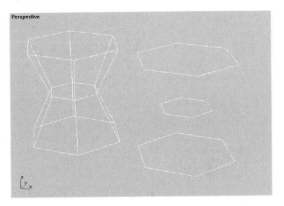

To edit the vertices, you may continue to select and edit them.

Note: Having a large difference in the number of vertices between two levels of the spline cage may cause surface problems.

Using Connect Copy

Connect Copy is a group found in the Geometry rollout. When Connect is turned, you may Shift + move/rotate/scale splines, and the cross section lines are created for you between the new and previous splines. Connect Copy may also be used with line segments.

Threshold determines the distance soft selection uses when Connect Copy is turned on. The higher the threshold, the more splines are created.

Using the CrossSection Modifier

The CrossSection modifier is very similar to using the CrossSection tool with three differences.

- The splines used in the modifier must be created, or Attached, in the same order that they will be connected. Otherwise, the created splines will not form the shape you want.

- The vertices in the splines created by the CrossSection modifier can be set to any of the four standard vertex types: Linear, Smooth, Bezier and Bezier Corner. The vertex types influence the smoothness of the subsequently applied surface.

- The CrossSection modifier works with all the splines in the entire model. So to add a new part using CrossSection, it must be made separately, and then attached.

In the following illustration, linear splines have been applied to the Cross Section modifier on the left, while the one on the right uses smooth.

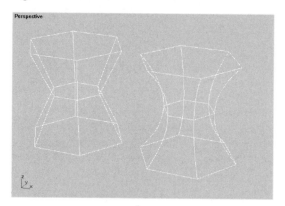

Applying the Edit Patch Modifier

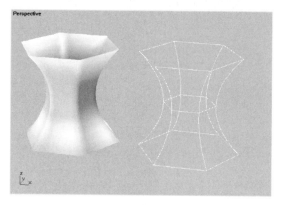

Once the spline cage is defined you can apply the Edit Patch modifier. This modifier generates the Bezier surfaces over the cage. The surface creation parameters and settings are located in the Geometry rollout, in the Spline Surface and Surface groups, and include the following:

- Flip the surface normals.
- Remove interior patches.
- Adjust the number of steps used in surface interpolation.

The surface normals indicate the outside of the surface and influence rendering, both in the viewports and the scanline renderer.

By default, patches are not applied to interior closed shapes in the spline cage. Often these surfaces are completely obscured and can cause discontinuities in the outside surface. They may be turned on if you need them.

The steps used in surface interpolation are an important feature, which adjusts the density of the patch parametrically. If a patch surface is converted to an editable mesh, the mesh density matches that of the patch surface. By creating multiple copies of a patch model, you can convert them to mesh surfaces with high and low polygon counts.

Working with Patch Surfaces

In this exercise you model a hat using patch surfaces.

1. On the menu bar, choose File > Open and open *Ch11_09.max* from the courseware CD.

 The file contains four circles to create a hat. Another hat already exists in the scene. You use the existing hat as a guide for modeling, however, you do not make an exact copy.

2. In the Perspective viewport, select *Circle01*.

 This is the outer circle that defines the brim.

3. On the command panels, choose Modify.

4. On the Modify panel > modifier list drop-down, choose Edit Spline.

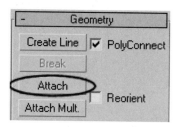

5. On the Modify panel > Geometry rollout, choose Attach.

6. In the Perspective viewport, select *Circle02*, *Circle03* and *Circle04* in that order.

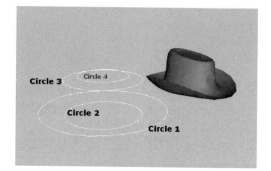

Note: You use the CrossSection modifier on the splines, so they must be Attached in the order that they should be connected.

7. In the Perspective viewport, right-click to end Attach mode.

8. On the Modify panel > modifier list drop-down, choose CrossSection.

A set of splines connects the circles and prepares them for application of an Edit Patch modifier.

9. In the Parameters rollout, choose both the linear and smooth spline options to see their effect.

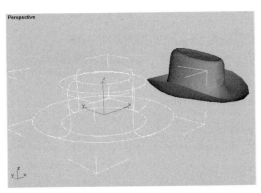

10. In the Parameters rollout, choose Bezier.

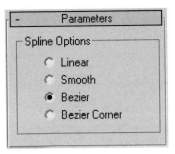

11. On the Modify panel > Modifier List drop-down, choose Edit Patch.

A basic hat shape is displayed.

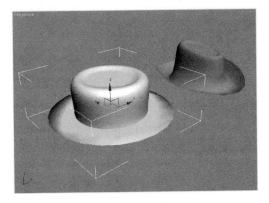

12. In the Geometry rollout > Spline Surface group, turn on Flip Normals and make sure Remove Interior Patches is turned on.

13. In the Surface group, turn on Show Interior Edges.

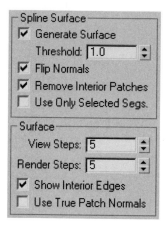

Note: When Show Interior Edges is on, you can see each patches' interior edges, based on the number of View Steps. When it is off, you can only see the outline of each patch.

14. In the modifier stack display, choose the plus sign to the left of Edit Patch.

15. In the modifier stack display, choose Patch.

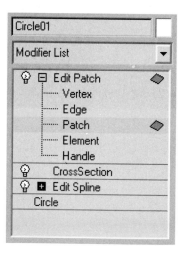

16. In the viewport navigation controls, choose Arc Rotate.

17. In the Perspective viewport, adjust the view as shown.

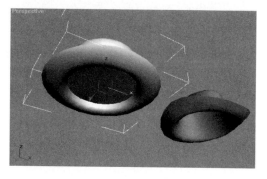

There is a filled region just below the brim. The Surface modifier put patches on the first and last splines in the cage because they were made from circles, with four vertices each.

In the next few steps you remove the unwanted surface.

18. Press **F3** to go to Wireframe.

19. In the Perspective viewport, choose the patch that was placed within *Circle01*.

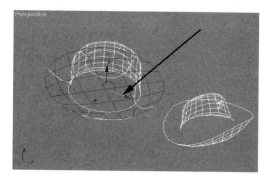

20. Press Delete.

The surface is removed.

21. Press **F3** to go back to Shaded.

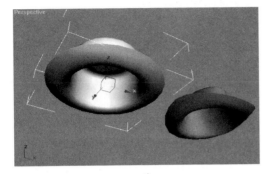

Shaping the Hat

1. Continue from the previous exercise.

2. In the modifier stack display, choose Vertex.

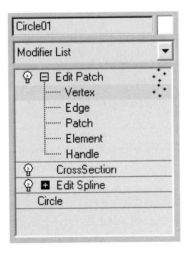

3. Right-click in the Front viewport to make it active.

4. Press Alt + W to enlarge the viewport.

5. In the viewport navigation controls, choose Zoom Extents.

6. In the Front viewport, region select the vertices at the top of the hat.

7. On the status bar, choose Lock Selection.

8. On the main toolbar, choose Select and Non-uniform Scale.

 Note: The other two scale tools will also work.

9. On the main toolbar, choose Use Selection Center.

10. In the Front viewport, place the cursor over the X-axis of the transform gizmo and scale the vertices approximately **70%**.

 As you do so the scaling value is displayed in the transform type-in field on the status bar.

11. In the Front viewport, press **L** to activate the Left viewport.

12. Press **F3** to view Shaded.

13. In the Left viewport, non-uniform Scale the vertices **80%** along the X-axis.

14. On the main toolbar, choose Select and Rotate.

15. On the Status bar > Transform Type-In area, choose Offset.

16. In the Transform Type-In, enter **-8** in the Local Z-axis.

17. On the status bar, choose Lock Selection.

18. Press F to switch to the Front viewport.

19. In the Front viewport, select the outer vertices on the brim.

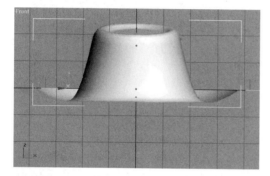

20. On the main toolbar, choose Select and Move.

21. In the Transform Type-In, enter **7** in the offset Y-axis.

22. Press L to go to the Left viewport.

23. In the Left viewport, choose the front vertex.

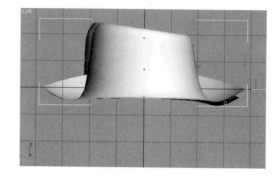

24. In the Transform Type-In, enter **–7** in the offset Y-axis.

25. Continue to edit the Hat until you get something that you like.

26. In the modify stack display, choose Edit Patch to return to the object level.

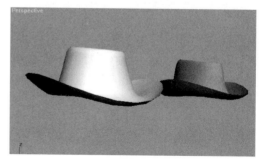

Modeling a Vase

In the next example, you create a vase with patch surfaces.

1. On the menu bar, choose File > Open and open, *Ch11_10.max*.

A series of splines display. You have one object made up of multiple N-Gons. Each N-Gon spline has 6 vertices.

2. In the Perspective viewport, choose any one of the splines.

3. On the command panels, choose Modify.

4. In the modify stack display, choose Spline.

5. In the Geometry rollout, choose Cross Section.

6. In the Front viewport, click and drag click to connect the remaining splines from bottom to top.

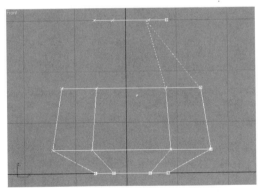

7. Right-click twice in the Front viewport to get out of Connect.

8. In the modify stack display, choose Vertex.

9. In the Front viewport, select the vertices of the two center splines.

10. Right-click and choose Smooth from the quad menu.

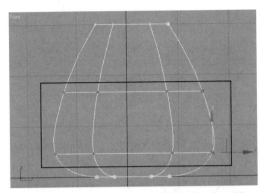

11. In the modify stack display, choose Vertex to get out of sub-object.

12. In the Modifier List drop-down, choose Edit Patch.

A patch surface is created.

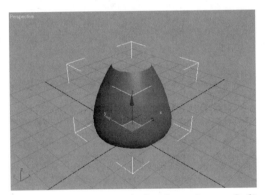

13. In the modify stack display, choose Spline.

14. In the modify stack display toolbar, turn on Show End Result.

15. In the Geometry rollout > Connect Copy group, turn on Connect.

16. In the Front viewport, choose the top spline, hold down SHIFT and move the spline down approximately 6".

17. In the modify stack display, choose Vertex.

18. In the Front viewport choose the vertices from the copied spline.

19. On the main toolbar, choose Uniform Scale.

20. On the main toolbar, make sure Selection Center is turned on.

21. In the Front viewport, scale the vertices approximately 65%.

22. In the modify stack display, choose Vertex to get out of sub-object.

23. In the Perspective viewport, arc rotate to see the bottom of the vase.

There's a hole at the bottom of the vase because valid patch surfaces are made from 3 or 4 sides. You need to connect two of the vertices at the base of the vase to make two valid four sided patches.

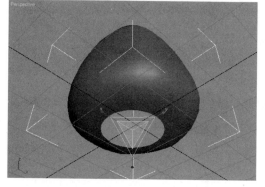

Closing the Vase

Next you use the Create Line tool to close the bottom of the vase.

1. Continue from the previous exercise, or choose File > Open and open *Ch11_11.max* from the courseware CD.

2. Make sure the Vase is selected.

3. In the modify stack display toolbar, turn off Show End Result.

4. On the main toolbar, choose Snaps and then right-click.

5. In the Grid and Snap Settings dialog, turn on Vertex and turn off any other Snap setting, then close the dialog.

6. In the Geometry rollout, choose Create Line.

7. In the modify stack display, choose Vertex.

8. In the Perspective viewport, click and drag from one vertex to another to close the hole, then right-click to finish the line and the command.

9. In the modify stack display, turn off Vertex.

10. In the modify stack display, choose Edit Patch.

11. In the Geometry rollout, turn on Flip Normals.

The bottom of the vase is closed.

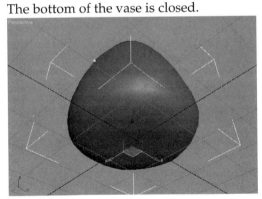

12. Arc Rotate the Perspective viewport to look at the Vase straight up.

13. Press F4 to turn on Edged Faces.

14. In the Geometry rollout > Surface group, turn on Show Interior Edges.

Now you see the full complexity of the geometry.

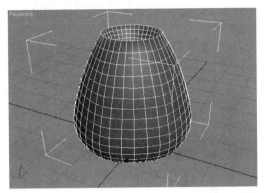

15. In the Surface group, turn down the View Steps.

As you decrease the steps the object becomes less complex.

Conclusion

Modifiers are the primary tools for editing scene objects in **3ds max**. When you apply a modifier, it alters the model according to its parameter settings. The resulting geometry is passed along the modifier stack display to the next modifier.

To reduce file size and simplify the scene, you can collapse the modifier stack display to an editable mesh; doing so removes all modifiers and any animation associated with those modifiers.

Several compound object types are available within **3ds max**, including Booleans, Lofts and Connect. Booleans combine objects based on their volume and relative placement to one another. Valid Boolean operations include Union, Subtraction and Intersection.

Lofts are used to sweep shapes along a spline based path. Multiple shapes can be placed at different locations along the path, and the Loft surface is interpolated between them.

The Connect compound object creates a mesh surface between holes in mesh operands. If there are multiple holes in both operands, multiple surfaces are created.

Patch modeling creates a Bezier based surface. Creating a spline cage and applying an Edit Patch modifier creates the surface. Patch models have the advantage of adjustable mesh densities.

12

Low Poly Modeling

Objectives

After completing this chapter, you are able to:

- Identify various types of surfaces in **3ds max**.
- Navigate and understand the various mesh sub-object levels.
- Be familiar with the differences between mesh sub-object modeling and modeling with modifiers.
- Make correct selections at the sub-object level.
- Use the Polygon Counter utility.
- Use smoothing.
- Use Editable Poly and Edit Poly.

Introduction

Whether you are modeling for games or for other purposes, optimizing your models to the proper resolution is a key part of successful production. It's always desirable to make rendering times as short as possible.

Unnecessary detail in models increases rendering times, and makes for unwieldy workflow due to long screen refreshes and slow calculation times.

How much detail is the right amount? This is the place where the art of modeling and the eye of experience combine to play an important role. If a character is going to be running in the background, or a jet fighter zooming overhead, or clutter is needed to fill out the scene, each of these can easily be replaced with less-detailed models.

Modeling for games requires a firm grasp of what is known as "low-poly modeling." Models that have an excessive face count can slow down a game engine, and therefore make the game unplayable.

When you are modeling for games, issues other than low-poly counts also arise. Models must be "airtight," which means that they contain no holes that a camera could look through. Sometimes models must also be non-intersecting. Generally, when models intersect one another, the renderer in **3ds max** generates an image and the image normally looks fine. This is not the case when the same scene is exported to certain game

engines. In these game engines, the intersecting polygons cause flickering because the polygons conflict with one another in terms of their distance from the camera.

Low-poly modeling is not the only consideration you must make when modeling for games. A firm knowledge of materials, textures and mapping are all-important tools to master in order to transform that odd looking lump into a scary monster or battle droid. For more information on materials, textures, and mapping, refer to the Materials chapters and the **3ds max** help file.

Surfaces in 3ds max

When you decide to model a character or a scene in **3ds max,** you can choose to model from several types of surfaces.

- Meshes
- Polygons
- Bezier Patches
- NURBS

Meshes

A mesh is a group of faces (triangles) connected by edges (lines) and vertices (points). Edges can be visible, or invisible. The simplest mesh is a surface defined by three discrete points in space. It might not sound like much, but it is the basis for all of the complicated forms that you could ever produce with **3ds max**. This chapter consists of the exploration of the parts of meshes, and polygons, and how they can be manipulated. There are three methods of obtaining the mesh properties on an object: two modifiers, Mesh Select and Edit Mesh, and one state, Editable Mesh. The state of an object is something that you must convert the object into; and once converted, you no longer have access to anything that was on the stack before.

Polygons

Similar to a mesh surface except there are no inivisble edges. A polygon is a flat surface with a minimum of three visible edges. The most commonly used polygon consists of four rectangular edges, and is called a quad. To access the polygon properties you can use the Edit Poly or Poly Select modifiers, or convert to the Editable Poly state.

Patches

When you apply an Edit Patch modifier to an object, or convert it to an Editable Patch object, **3ds max** converts the object's geometry into a collection of separate bezier patches. Each patch is made up of three or four vertices connected by edges, defining a surface.

In chapter 11, you might have noticed that a patch object is useful for creating gently curved surfaces, and that it provides very detailed control for manipulating complex geometry.

NURBS

NURBS is another object state. The term NURBS stands for *Non-Uniform Rational B-Splines*:

- *Non-Uniform* means that you can vary the influence of control across the object, making the construction of irregular surfaces possible.

- *Rational* means that the equation used to represent the curve or surface is expressed as a ratio of two polynomials, rather than a single summed polynomial. The rational equation provides a better model of some important curves and surfaces, especially conic sections, cones, spheres, etc.

- A *B-spline* (for *basis spline)* is a spline that is constructed by defining it with three or more control points. These points stand away from the spline, unlike the splines that you create using the Line tool and other shape tools. Those splines are bezier curves, which are a special case of B-splines.

This all breaks down to a way to create very precise surfaces that are mathematically defined. Many modern automotive designs rely heavily on NURBS geometry to make the smooth, graceful curves that comprise a top-selling design. An added benefit of NURBS surfaces is that they contain *parameter space*, which is a two-dimensional map of the surface. This is quite useful for adding sub-surfaces, and precision texture mapping.

Objects and Sub-Objects

All scenes in **3ds max** are built on a collection of objects; each of these objects can be comprised of sub-objects. Manipulating sub-objects is a modal process; once you begin to edit the constituent parts of an object, you cannot transform the object as a whole until you get out of sub-object mode.

Getting to the Sub-Object Level

In this exercise, you discover the fundamental parts that make up a standard piece of geometry in **3ds max**.

1. Reset **3ds max**.

2. Choose Create menu> Standard Primitives > Sphere.

3. In the Top viewport, create a Sphere with a radius of approximately **50** units.

4. On the command panels, click Modify.

The Parameters rollout displays the various values that make up the specifications for the sphere.

5. On the Modifier List drop-down, choose Edit Mesh.

3ds max now considers your sphere to be an assemblage of sub-object levels, rather than its original primitive sphere definition.

6. On the Modify panel > modify stack display, click Sphere.

The rollouts return to their previous state, back at the primitive object level. **3ds max** uses the modify stack display to allow for a series of edits to be performed on an object in a non-destructive manner. This means that you can go back to an earlier state if you don't like the results of an operation.

7. Right-click in the Top viewport and choose Convert to Editable Mesh from the quad menu.

The state of the object can also be changed to editable mesh within the modify stack display by using the right-click pop-up menu. The options available for Editable Mesh behave exactly the same as in Edit Mesh; the only difference being that the definition of the sphere is lost.

Collapsing to an Editable Mesh vs. the Edit Mesh Modifier

The Edit Mesh modifier is primarily used to convert geometry, such as primitives, Bezier Patches or NURBS, to a mesh object for editing. When this happens, it adds another layer in the modify stack display. The model retains its original properties, and can still be manipulated by selecting the appropriate level in the modify stack display.

Collapsing your model to an editable mesh takes all of the modifiers applied in the modify stack display as well as the object's original parameters and creates an Editable Mesh state. An object in this state can be edited at the mesh sub-object level. It is good practice to convert your models to editable meshes when they are nearing completion because the overhead required to keep the history in the modify stack display can prove to be quite costly. If your work is to be exported to a realtime game engine, collapsing to an editable mesh may be mandatory.

The exercises with the F/A 18 Hornet that follow show the two different approaches; direct editing on the mesh for simplicity and speed, and using a procedural approach for a visual history in the modify stack display.

Sub-Object Mesh Levels

Once an object is collapsed into an editable mesh or an Edit Mesh modifier has been applied, then the following sub-object levels are available.

Vertex Editing mode—Vertices are points in space. They define the structure of the object at its most basic level. When vertices are moved or edited, the faces they form are also affected.

Any change in the shape of an object is caused by a re-arrangement of its vertices. Though there are countless ways to accomplish this in **3ds max**, the most direct way is to transform the vertices at the Vertex sub-object level.

The diagrams above illustrate the vertex moved along the X-axis.

Edge Editing mode—An edge is a line, visible or invisible, forming the side of a face and connecting two vertices. Two faces can share a single edge.

Edges can be manipulated in much the same way as vertices, but they are more frequently used as methods to define the mesh by means of polygon orientation, and to increase the detail of the mesh by dividing its edge.

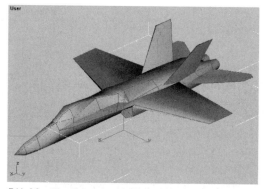

F/A 18 with all edges visible and selected. Every face is a polygon.

F/A 18 with key edges made invisible. The model is easy to read by defining polygons.

Face Editing mode—A face is the smallest possible mesh object. A face is a triangle formed by three vertices and bordered by edges. While a vertex can exist as an isolated point in space, a face cannot exist without vertices.

Faces are the visible portions of a mesh that you see when you render your model; vertices and edges are invisible to the renderer. They comprise the lowest level of geometry that is used by both polygons and elements. Faces can be given various smoothing options so that they blend in with neighboring faces.

Polygon Editing mode—Polygons consist of all of the faces in the area you see within the visible wire edges. Also, if two faces meet at a hidden edge at more than a specified Planar Threshold angle, they will be considered parts of separate polygons.

Polygons are a convenient method of dealing with faces. As was seen in the edge illustration above, models are far easier to read when they have good polygon definitions. Also, polygons are used by some realtime rendering engines that work with quads, instead of the native triangles that **3ds max** defines when using the Edit Mesh modifier or collapsing to an editable mesh.

Element Editing Mode—An element is one of two or more individual mesh objects (that is, groups of contiguous faces) combined together into one larger object.

The left wing is one of the elements comprising the jet.

When a separate object is joined to a particular mesh with the Attach option, it becomes an element of that mesh. This is a good way of maintaining an on-the-fly selection set, because groups of faces that make up sub-assemblies can easily be edited as a unit.

Working at the Sub-Object Level

1. On the menu bar, choose File > Open and open *FA18.max* from the courseware CD.

2. In the User viewport, select the *FA18* object (jet).

3. ⊕ On the main toolbar, click Select and Move.

4. In the User viewport, move the jet around the scene.

 All of the component parts move together as a single object

5. ⌒ On the main toolbar, click Undo.

6. On the command panels, click Modify.

7. ⋮⋮ On the Modify panel > Selection rollout, click Vertex.

8. In the User viewport, select the vertex at the tip of the jet's nose.

9. In the User viewport, move the vertex around.

 Only the Vertex sub-object level is affected by the transformation.

10. Press **CTRL + Z** to undo the last operation.

11. ◁ In the Selection rollout, click Edge.

12. In the User viewport, select the edge at the top of the tail.

13. In the User viewport, move the edge around.

The edge and the two vertices that make up the edge move.

14. Press **CTRL + Z** to undo the last operation.

15. In the Selection rollout, click Face.

16. In the User viewport, select the face on top of the wing.

Tip: Press **F2** to shade the selected face.

17. In the User viewport, move the face around.

The face and the three vertices that make up the face move.

18. Press **CTRL + Z** to undo the last operation.

19. 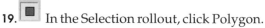 In the Selection rollout, click Polygon.

20. In the User viewport, click outside the jet to deselect the face selection.

21. In the User viewport, select the polygon on top of the wing.

This time the entire top of the wing is selected.

22. In the Selection rollout, click Element.

23. In the User viewport, select the near wing again, and move it away from the fuselage.

The wing moves as a unit because it was originally modeled separately, and combined later, using the Attach option found in the Edit Geometry rollout.

Attaching objects is covered in a later exercise.

Selecting at the Sub-Object Level

In the last exercise, you became familiar with the various sub-object levels. You used Move to transform the various sub-object selections. Its workflow was consistent to transforming entire objects. All of the transform tools (Select and Move, Select and Rotate and Select and Scale) operate the same way at the sub-object level as they do at the object level. Many of **3ds max's** other tools and procedures also work the same at the sub-object level as they would at the object level.

Tools for Selecting

 The main toolbar contains **3ds max's** Selection Region options. The default is set to the Rectangular Selection Region.

Multiple sub-objects can be selected by dragging a Rectangular Selection region around the area. When you release the mouse, the sub-objects become selected.

The Selection Region flyout has four other selection options. The Circular Selection region works similarly to the rectangular option, except that it works from the center outwards to define its region.

The Fence Selection region allows you to make an irregular-shaped selection. It works slightly differently from its counterparts; you initially drag to start the selection, then click to set the corners of the region. When you are done, either position the cursor directly over the start point (it changes to a small cross) and click to finish; or double-click to set the last point.

The Lasso Selection region also allows you to make an irregular-shaped selection. However, instead of dragging to define the area of selection, you simply click and move your mouse around the area you want to select, and a "cloud" like selection is displayed.

The Paint Selection region allows you to drag a "brush" across your object, selecting the sub-objects that the brush touches. To set the size of the brush, choose Customize >

Preferences on the menu bar, and in the Preferences Settings dialog > General tab > Scene Selection group, adjust the Paint Selection Brush Size.

As you begin to select at the sub-object level, you might want to add or subtract from the current selection. CTRL adds to the current selection and ALT de-selects from the current selection.

Useful Sub-Object Editing Options

Named Selection Sets

Selection sets are quite useful when used at both the object level and at the sub-object level. You often find yourself having to refer to the same group of vertices for editing. Instead of re-selecting the vertices every time you are at the Vertex sub-object level, simply place the vertices in a named selection set. This means that you can choose the various sub-object levels, and when you need to access particular vertices, you can simply choose the named selection set and the same vertices are selected.

Backfacing Sub-Objects

As you select various sub-object levels, it is easy to select unwanted geometry on the opposite side of the object that might not be visible in the viewport.

Vertices region selected on one side of the model.

Vertices selected by accident based on the selection in the previous illustration.

3ds max has a check box in the Selection rollout called Ignore Backfacing that addresses this issue.

If Ignore Backfacing is turned on, all sub-objects that face away from the active viewport are not selected. However, always leaving Ignore Backfacing turned on could deny you the freedom of selecting all of the sub-objects that you might want.

Faces region selected with Ignore Backfacing turned on.

Backfacing faces not selected.

Basics of Low-Poly Modeling

A popular form of constructing low-poly meshes is commonly referred to as box modeling. The general workflow for creating a model using box modeling is to first create a basic primitive, such as a box. Then you decide to do one of the following:

- Convert to either Editable Mesh or Editable Poly.

- Work procedurally and add either Edit Mesh or Edit Poly.

Depending on the choice you made, you begin to manipulate geometry at the various sub-object levels. This means, transforming at the various sub-object levels and extruding faces/polygons until the box begins to look like the target object. Combining face/polygon extrusion with vertex editing is a powerful method for object creation.

Note: The screen shots reflect the Editable Mesh option.

Transforms

Using transforms at the sub-object level is crucial in low-poly modeling. Inevitably, you want to move vertices, scale vertices and rotate polygons.

Manipulating Faces

Extrude	0.0	
Bevel	0.0	
Normal: ● Group ○ Local		

Faces are manipulated with the Extrude and Bevel options available in the Edit Geometry rollout. You can create an extrusion by either numerically typing the desired amount, or by interactively clicking and dragging the selection in the active viewport. You can extrude either a single face or a selection of faces at once.

Extrude

The basic way to increase the complexity of an object is to add more faces. One way to accomplish this is to extrude one or more faces.

Mesh with one face selected.

Mesh with face extruded.

Bevel

You also have the option to Bevel a face rather than Extrude. When performing a bevel interactively in the viewport, it is a two-step process: the selection is first extruded to the desired height, then the edges are moved in or out.

When you enter a Bevel amount, or drag on the spinner, the selection edges are only moved in or out.

Mesh with one face beveled.

Creating a Vertex by Dividing Edges

The easiest way to create a vertex is by dividing an edge.

While faces and polygons are created directly, dividing edges and tessellating faces indirectly creates vertices. Single vertices can be created in **3ds max**, but they are independent points in space, and do not directly relate to the existing mesh.

Mesh with one edge selected.

Edge divided: one vertex added.

After an edge is divided, the result is one new vertex and two new edges. These edges are invisible by default. If you need to edit an edge, then that edge needs to be visible. You can choose to have edges be visible by either choosing the Visible option in the Surface Properties rollout or by turning off Edges Only from the Object Properties dialog.

Cutting Edges

A more refined way to divide multiple edges is to use the Cut option found in the Edit Geometry rollout.

Cut allows you to draw a new edge over various contiguous faces interactively.

Editable mesh

Editable mesh with 2 Cuts

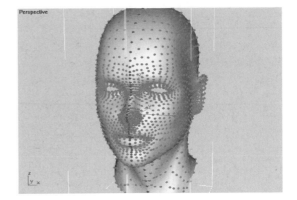

Welding Vertices

One of the most important techniques used when modeling low-poly models is the ability to weld vertices. Many times the modeler only creates half of the model and mirrors the other half. This would be the case if you were modeling a head or a body.

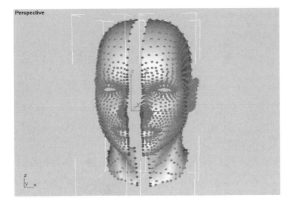

When you mirror and copy one side of the head, the vertices from each side of the model should be coincident (vertices on top of one another). Then, the modeler can weld the two sides together and thus eliminate the coincident vertices.

When you weld vertices together, the potential gaps in the model are gone and all the stray vertices are removed. Vertices can be welded in two ways: by selecting a number of vertices and setting a threshold, or by target welding individual vertices.

Weld Selected

This option is commonly used with the example explained above. You select two or more vertices (these vertices can be coincident or not), and choose Selected. The vertices are either welded together, or the following dialog appears.

Weld

No vertices within weld threshold.

OK

The type-in area next to the Selected button sets the threshold distance between vertices that are welded. If the vertices are coincident, the threshold number can be small, but if there is a significant distance between the selected vertices, then the threshold type-in area needs to be increased.

Note: If some vertices are within the threshold, and some aren't, the vertices within the threshold are welded, and no warning pops up.

Weld Target

You can also get very specific when welding vertices by using the Target Weld option. Once the Target option is turned on, you can drag one vertex on top of another to weld the two together.

Polygon Counter

When modeling using low-poly techniques, the ability to track the number of faces, as you build your model, is extremely useful. There is a utility in **3ds max** that gives you this option. The Polygon Counter utility is available on the Utility panel.

Notice that you can set it to count triangular faces or polygons.

You can also press the keyboard shortcut 7 to get a small Vertex/Face count in the upper left corner of the active viewport. When you are in Vertex mode, the number of vertices is shown. In all other modes, the number of faces is shown. Press 7 again to turn it off.

Modifying an Editable Mesh

In the exercise below you experiment with the face extrusion options.

Constructing the canopy with Face Extrude and Vertex Editing

1. Open the menu bar, choose File > Open and open *FA18nocanopy.max* from the courseware CD.

 Note: The Properties > Edges Only option for the jet has been turned off, and the Edged Faces viewport property has been set for the User viewport. This setup can greatly enhance low-poly modeling by

clearly displaying all of the faces of a mesh.

Our jet is missing the glass enclosure for the cockpit.

2. In the User viewport, select the jet.

3. On the command panels, click Modify.

4. In the Selection rollout, click Polygon.

5. In the User viewport, click the two polygons in the cockpit area.

Tip: Holding down CTRL while you choose the polygons adds to your selection.

Note: You can verify your selection by looking at the bottom of the Selection rollout. This display is available for all of the sub-object levels.

Named Selections:
Copy | Paste
4 Faces Selected

6. In the Edit Geometry rollout, set Extrude to **23**.

Extrude | 23
Bevel | 0.0
Normal: ● Group ○ Local

The canopy begins to take shape.

Note: You can either type-in the value, or you can choose Extrude and interactively drag in the viewport.

7. In the Selection rollout, click Vertex.

8. In the Front viewport, region select the indicated areas to select all of the vertices.

 Tip: Region select selects the vertices behind the ones in the front also.

9. In the Front viewport, move the vertices one area at a time until your model resembles the illustration below.

10. On the main toolbar, click Non-uniform Scale.

11. In the Right viewport, region select the remaining two top vertices indicated by the white arrows in Illustration A below, and Non-uniform Scale them along the X-

axis until they are in the position in Illustration B.

12. The jet now has a canopy.

If you did not get the desired results, you can choose File > Open from the menu bar and open *FA18canopyA.max* from the courseware CD.

Turning Edges

When you are modeling polygons with greater than three sides, you'll find that there are different configurations that the interior edges can take. A simple quadrilateral, for instance, can have two different configurations:

The act of shifting the interior edge from one set of vertices to another is called Edge Turning.

In the case of the 2D quad above, it matters little where the interior edge lies. As you progress into more complicated 3D shapes, the edge orientation becomes crucial. The extruded hexagon below has all of its edges in the proper positions:

If you were to turn the edges on the top, the object would look substantially different:

Note: The vertex location is unchanged from one figure to the other.

Modifying the Canopy with Edge Turning

Continue from the previous exercise or choose File > Open from the menu bar and open *FA18canopyA.max* from the courseware CD.

1. ⬚ In the viewport navigation controls, click Arc Rotate SubObject.

2. In the User viewport, Arc Rotate around the canopy.

3. You can see that the two sides of the canopy are not symmetrical.

The long skinny triangles give the canopy an unnatural crease. These types of triangles tend to be problematic within game engines. To fix this problem, you turn that edge.

4. In the User viewport, select the jet.

5. On the command panels, click Modify.

6. In the Selection rollout, click Edge.

7. Turn In the Edit Geometry rollout, click Turn.

8. In the User viewport, select the edge in the front half of the canopy, on the left side of the aircraft.

The left side of the cockpit now mirrors the right side.

9. In the viewport navigation controls, click Arc Rotate SubObject.

10.In the User viewport, arc rotate around the jet so that you can see the right side of the canopy.

11.With Turn still on, select the edge that defines the rear skinny triangle of the canopy.

The canopy now is fully symmetrical. If you did not get the desired results, you can choose File > Open from the menu bar and open *FA18canopyC.max* from the courseware CD.

Adding and Minimizing Geometry

Using Edge Divide and Weld Vertex

1. On the menu bar, choose File > Open and open *FA18canopyD.max* from the courseware CD.

2. On the command panels, click Utilities.

3. In the Utilities rollout, click More.

4. In the Utilities dialog, choose Polygon Counter, then click OK.

5. In the User viewport, select the jet.

6. The Polygon Count dialog, reads that there are 414 faces in the jet.

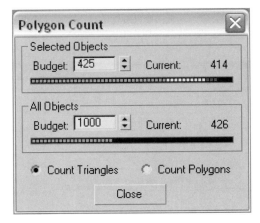

7. On the command panels, click Modify.

8. In the Selection rollout, click Edge.

9. In the Selection rollout, turn on Ignore Backfacing.

This keeps you from modifying unseen edges.

10. Divide In the Edit Geometry rollout, click Divide.

11. In the Top viewport, select the three places on the edges indicated by the arrows in the illustration below.

New vertices appear in the middles of the edges.

12. The Polygon Counter displays the jet contains 420 polygons.

13. In the Edit Geometry rollout, click Divide to turn it off.

14. Turn In the Edit Geometry rollout, click Turn.

15. In the Top viewport, turn the edges on the canopy (indicated below in red) until they resemble the illustration. When you are finished, turn off Turn.

As you can see by the illustration below, you might have added three more vertices, but the look of the model remains unchanged. You must move the vertices if you wish to alter the model.

Target Welding

1. In the Selection rollout, click Vertex.

2. Now you work with the vertices indicated below.

3. **Target** In the Edit Geometry rollout > Weld group, click Target.

4. In the User viewport, one at a time, drag the vertices indicated above and move them the center vertex.

The three vertices are welded into one vertex.

Tip: You might find it easier to weld the vertices from the Front viewport.

5. When you are done, click Target to turn it off.

Selection Welding

While target welding is the precise way to get rid of excess vertices, selection welding can be much faster.

1. Continue from the previous exercise.

2. In the Top viewport, region select all of the vertices on top of the canopy.

Tip: You might want to change your viewport display to Smooth + Highlights.

3. In the Edit Geometry rollout > Weld group, increase Selected to **20**.

Weld Selected can be set to work over a distance. You want to weld the lateral sets of vertices together, but not the row along the top of the canopy.

4. In the Weld group, click Selected.

The vertices close to one another are welded, and the shape of the canopy is as it should be.

5. The Polygon Count dialog, now displays 408 polygons.

 If you did not get the desired results, you can choose File > Open from the menu bar and open *FA18canopyE.max* from the courseware CD.

Building the Thruster Cones with the Face Extrude Modifier and Bevel

One of **3ds max's** many strengths is its flexibility which allows you to accomplish similar tasks with different tools or workflow options.

In the following exercise, you build thruster cones in the rear of the aircraft. This requires that you take a slightly different approach from the one you used when you built the canopy. Instead of doing all of the editing at the sub-object levels of the editable mesh state, you add modifiers to extrude faces and manipulate various sub-object levels.

By adding modifiers, you have a history list of what you have done. This allows for more flexibility in the editing of the finished model. You have the option of going back and changing parameters that you defined during the editing process. This contrasts with the method you have been using in the previous exercises which didn't allow for modifier stack manipulation.

The modifiers that you use in the following exercise are Face Extrude, Mesh Select, and Edit Mesh.

1. On the menu bar, choose File > Open and open *FA18cnoCones.max* from the courseware CD.

2. In the User viewport, select the jet.

3. On the command panels, click Modify.

4. In the Selection rollout, click Polygon.

5. In the User viewport, select the blank area on the right where one of the cones will be located.

6. On the Modify panel, choose the Modifier List drop-down menu.

FA18	
Modifier List	▼

7. In the Modifier list display, choose Face Extrude.

```
         Edit Patch
    DeletePatch
Mesh Editing
    DeleteMesh
    Edit Mesh
    Face Extrude
    Normal
    Smooth
    Tessellate
    STL Check
```

8. In the Parameters rollout, set Amount to 20 and Scale to 80.

The cone begins to take shape. The polygons are extruded out from the fuselage, and scaled in.

9. On the Modifier list drop-down, choose Mesh Select.

10. In the Mesh Select Parameters rollout, click Polygon.

11. In the User viewport, select the other blank area on the left side of the tail.

12. In the modify stack display, right-click the Face Extrude modifier and choose Copy from the right-click menu.

13. In the modify stack display, right-click the Mesh Select modifier, and choose Paste Instanced.

The font for Face Extrude turns to italic to show that the modifier is instanced twice.

The modifier is identical for both cones, and was accomplished in two mouse-clicks.

14. On the Modifier List drop-down, choose Edit Mesh.

15. ◼ In the Selection rollout, click Polygon.

16. In the User viewport, select both of the end polygons on the cones.

17. In the Edit Geometry rollout, set Extrude to **–30**.

Note: It is important to either type in **-30**, or use the spinner to set the number without releasing the mouse. If you were to drag twice on the spinner controls then you would build two sets of faces.

18. In the Edit Geometry rollout, set the Bevel to **-5**.

The exhaust cones are finished.

If you need to make any changes to the Face Extrude amounts, you can simply go back to the history listed in the modify stack display to modify the way the cones look.

19. On the modify stack display, choose either one of the Face Extrude modifiers and answer Yes to the warning.

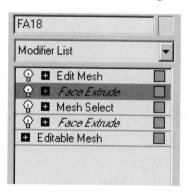

20. In the Parameters rollout, change Amount to **40**, and Scale to **60**.

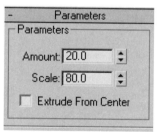

As you can see, being able to go back into the modify stack display to modify initial parameters can make for a flexible system of modeling that is easily edited. As was mentioned previously in the Editable Mesh section, it's a good idea to collapse your models when you are satisfied with the way they look. This helps to prevent inadvertent changes to the finished piece.

If you did not get the desired results, you can choose File > Open from the menu bar and open *FA18Cones.max* from the courseware CD.

Smoothing Groups

Smoothing is a rendering property that blends edges between faces to produce an even, curved surface. Smoothing is generally required so that a low-poly model does not appear faceted. It is important to understand that smoothing does not add any geometry, it simply makes the geometry appear evenly blended.

Typically, most new geometry created by **3ds max** is properly smoothed. An exception occurs when the face extrusion process has built new geometry; these new faces do not have any smoothing applied. It is up to you to apply smoothing to the new geometry.

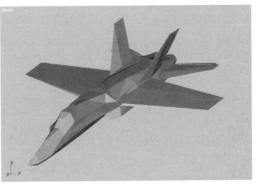

The F/A 18 with smoothing turned off.

The F/A 18 with proper smoothing.

Using Smoothing to Delineate

1. On the menu bar, choose File > Open and open *FA18badshade.max* from the courseware CD.

This is probably the worst possible scenario. All of the polygons have been given the same smoothing group. The model looks like it has been lit very oddly, because all sides are being treated as if they were facing in the same direction.

2. In the User viewport, select the jet.

3. On the command panels, click Modify.

4. In the Selection rollout, click Element.

5. Right-click the viewport label and choose Edged Faces from the right-click menu.

 This allows you to see what you're doing as you edit the model.

6. In the User viewport, select both wings, both stabilizers, both rudders and both of the exhaust cones.

The FA18 with the parts selected

7. Hide In the Selection rollout, click Hide.

 Only the fuselage remains visible.

8. In the Selection rollout, click Polygon.

9. In the viewport navigation controls, click Min/Max Toggle.

 All four viewports are displayed.

10. In the User viewport, select all of the canopy polygons.

11. In the Surface Properties rollout > Smoothing Groups group, turn off **1**, and select **2**.

 The shading on the canopy changes.

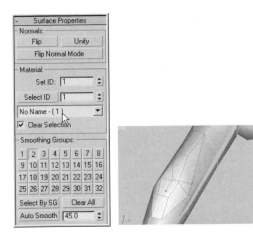

12. In the User viewport, click anywhere outside of the fuselage to deselect the canopy.

13. Right-click the viewport labels and turn off Edged Faces.

The canopy now stands out from the fuselage, but is still smooth.

If you did not get the desired results, you can choose File > Open from the menu bar and open *FA18canopy.max* from the courseware CD.

Using Subdivision Surfaces

Generally, building low-poly models first makes for good modeling practices, even if the final mesh is supposed to be high-poly. High-poly meshes are required for film and video renderings. These models contain more detail and appear smoother after they are rendered. It is a simple task to convert a low-poly model to a high-poly model. The converse however is not true. If you do not use optimization tools, it is a time-consuming process to reduce a high-poly mesh to a low-poly version.

Increasing the geometry of a low-poly model is as simple as adding a modifier. The types of modifiers that are available to add geometry are:

- **MeshSmooth**—The MeshSmooth modifier smoothes geometry in your scene by adding faces at corners and along edges.

- **TurboSmooth**—TurboSmooth is a condensed version of the MeshSmooth modifier. It is faster and more memory efficient, yet only has one smoothing method and few parameters.

- **HSDS (Hierarchal SubDivision Surfaces)**—This modifier is meant as a finishing tool. Use this modifier to add detail and adaptively refine the model.

- **Tessellate**—This modifier adds geometry to either a selection of faces or to the whole object.

Using these modifiers should not be confused with altering smoothing groups or applying a Smooth modifier to change smoothing groups within the modify stack display. Actual face count is increased, which could have dramatic consequences on rendering speed.

MeshSmoothing a Low-Poly Model

1. On the menu bar, choose File > Open and open *Mr_BlobbyBase.max* from the courseware CD.

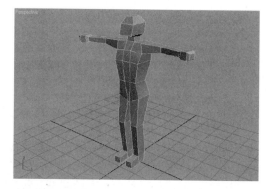

2. In the Perspective viewport, select the character.

3. On the command panels, choose Modify

4. On the Modify panel > Modifier List drop-down, choose MeshSmooth.

Point Cache
Subdivision Surfaces
 HSDS Modifier
 MeshSmooth
Free Form Deformations

The model is rounder.

5. In the Subdivision Amount rollout, notice Iterations is to **1**.

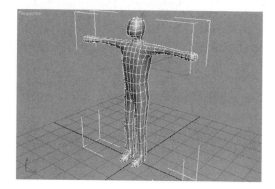

6. In the Local Control rollout, turn off Isoline Display.

 The model has the same amount of smoothness however the level of detail displayed in the viewport corresponds with the Iterations setting. When Isoline Display is turned on it adjusts the geometry to the Iterations amount however the edge detail maintains its original structure.

7. Press 7 to turn on Face Count.

8. Increase the Iterations to **2**.

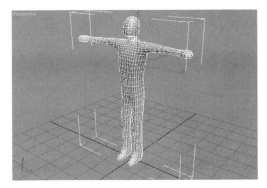

The mesh is very smooth, and ready for high-resolution work.

Note: The face count has increased from 126 to 2016, a significant amount in only two iterations.

Comparing the results of the MeshSmooth modifier side-by-side with the original, you can see that the MeshSmoothed version looks smoother and thinner.

You fix this next by using a reference control mesh of the low-poly version while viewing the high-poly version.

9. In the Local Control rollout, choose Display Control Mesh.

10. In the Local Control rollout, choose Vertex.

11. In the Perspective viewport, region select the four vertices on top of the head.

12. Try manipulating some of the vertices; the high-poly mesh deforms smoothly while you are working with the low-poly control mesh.

This type of editing, along with extrusions at the sub-object level, can be performed by choosing the editable mesh state in the modify stack display area. These options make box modeling quite powerful. All of the techniques that you practiced in the earlier exercises can be used to smoothly modify the high-poly mesh.

Converting to Editable Poly

In the procedure that follows, you convert the low poly character you used in the procedure above into an editable poly object. You apply the Symmetry modifier, and use the sub-object options available at the Editable Poly state.

1. On the menu bar, choose File > Open and open *Mr_BlobbyBase_Poly.max* from the courseware CD.

 The low-poly model is displayed along with a 2D spline, which you use later.

2. In the Perspective viewport, select the character.

3. On the command panels, choose Modify.

4. On the Modify panel > Selection rollout, click Edge.

5. In the Perspective viewport, place your mouse in the middle of any polygon and click.

A hidden edge is selected.

6. Click outside of the character to deselect the edge.

7. Right-click in the Perspective viewport, and choose Convert To > Convert to Editable Poly.

Ignore Backfacing	
View Align	
Make Planar	
Turn Edges Mode	
Flip Normals Mode	
Divide Edges	
Divide Polygons	
Cut Polygons	Isolate Selection
Element	Unfreeze All
Polygon	Freeze Selection
Face	Unhide by Name
Edge	Unhide All
Vertex	Hide Unselected
Top-level ✓	Hide Selection
tools 1	display
tools 2	transform
Create Polygons	Move
Attach	Rotate
Detach	Scale
Bevel Polygon	Select
Extrude Polygons	Clone
Extrude Edge	Properties...
Chamfer Edge	Curve Editor...
Chamfer Vertex	Dope Sheet...
Break Vertices	Wire Parameters...
Target Weld	Convert To: ▶

Convert to Editable Mesh
Convert to Editable Poly
Convert to Editable Patch

The character's surface has changed from mesh to poly.

8. In the Selection rollout, choose Edge.

9. Place your mouse in the middle of any polygon, and click.

Notice there are no hidden edges to select.

10. In the Selection rollout, click Edge to get out of sub-object.

11. On the Modify panel > Modifier List dropdown, choose Symmetry.

12. In the Parameters rollout, make sure Mirror Axis is set to X, and turn on Weld Seam.

A mirrored copy of the object displays, and is automatically welded at the seam.

13. In the modifier stack display, click Editable Poly.

14. In the modifier stack display toolbar, choose Show End Result On/Off Toggle.

15. In the Selection rollout, choose Polygon.

16. In the Perspective viewport, select the polygon for the arm.

Tip: Press **F2** to shade the selected polygon.

17. In the Edit Polygons rollout, click the Settings button next to Extrude Along Spline.

18. In the Extrude Along Spline dialog, click Pick Spline.

19. In the Perspective viewport, select the line.

20. In the Extrude Along Spline dialog, turn on Align to face normal.

21. Set Taper Amount to **-0.58**.

22. Set Taper Curve to **-0.78**.

23. Set Segments to **9**.

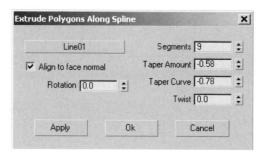

24. Click OK.

25. In the modifier stack display, click Editable Poly to exit sub-object mode, and then click Symmetry.

26. On the Modify panel > Modifier List dropdown, choose TurboSmooth.

27. In the TurboSmooth rollout > Main group, change Iterations to **2 and turn on Isoline Display**.

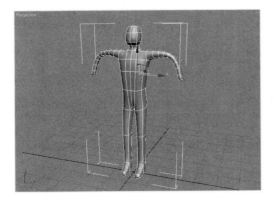

More Editable Poly and Edit Poly

Poly objects have a set of parameters that are similar to those of Mesh objects, with one major difference. Many of the poly's editing tools include a Settings button that allows you to enter Interactive Manipulation mode. This opens a non-modal dialog that allows you to preview your changes before you Accept, OK, or Cancel them. When you Accept a change, you may continue to use the tool again with the same selection, or a new one. When you OK or Cancel a change, the dialog is closed, and the change is either applied (in the case of choosing OK) or undone.

As with Editable Mesh objects, Editable Poly also has a modifier version named Edit Poly. This modifier has all the functionality of Editable Poly with a few minor changes, and the added ability of being removed from the stack, and/or copied and pasted to other objects.

Poly objects have many more available features, including, but not limited to:

- **Extrude, Bevel, Weld, and Chamfer**—Similar to the features for a mesh object, with an additional settings dialog.

- **MeshSmooth Sub-Object**—Allows you to use MeshSmooth on a sub-object selection to add geometry.

- **Tessellate Sub-Object**—Allows you to use Tessellate on a sub-object selection to add geometry.

- **Slice Plane**—Shows a plane in the scene that can be moved and rotated. Where the plane crosses your object, vertices will be shown. Click Slice to add them. If there is a polygon selection, vertices will only be added to those polygons.

- **QuickSlice**—Similar to Slice Plane, and accomplished with two clicks. After the first click, a line will show you where vertices will be added. Also works with a poly selection.

- **Enhanced Cut Tool**—Poly's cut tool allows you to cut from any spot on the geometry to any other. It has three cursors to let you know if you are cutting at a vertex, on an edge, or in a face; and as you move the

mouse after your first click, you can see exactly where the cut will go.

- **Turn Edges**—In Edge mode you can Turn edges; similar to Turn with a Mesh object. This allows you to turn problem hidden edges, but cannot be used to affect visible edges.

- **Select Poly by Angle**—This allows you to select all polygons within a specified angle of a polygon. This must be checked before it can be used.

- **Relax Vertices**—Acts like the Relax modifier, but can be used on vertex selections.

- **Paint Deform**—Lets you use a circular brush to Push, Pull, or Relax geometry.

In the following exercise, you use several of Poly's features.

1. On the menu bar, choose File > Open and open *Mr_BlobbyBase_Poly2.max* from the courseware CD.

2. In the Perspective viewport, select the character.

3. On the command panels, choose Modify.

4. In the Modify Stack display, choose Symmetry.

5. On the Modify panel > Modifier List drop-down, choose Edit Poly.

6. On the Modify panel > Selection rollout, choose Polygon.

7. On the Modify Stack display toolbar, turn off Show End Result.

8. In the Perspective viewport, select both polygons for the arms.

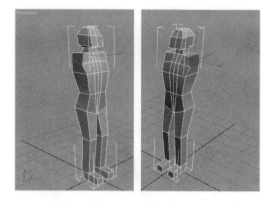

9. In the Edit Polygons rollout, choose the Settings button next to Bevel.

10. In the Bevel Type group, select Local Normal.

11. Set Height to 10 and Outline Amount to -0.75.

12. Click Apply.

13. Set Height to 3 and Outline Amount to 0.8. Then click Apply again.

14. Set Height to 8 and Outline Amount to -1.5. Then click Apply a third time.

15. Set Height to 2 and Outline Amount to 0.7. Then click Apply a fourth time.

16. Set Height to 4 and Outline Amount to -0.85. Then click OK.

You have used Bevel to add arms to the character.

17. In the Front viewport, region select the character's arms.

18. In the Edit Polygons rollout, choose the Settings button next to MSmooth.

MSmooth is MeshSmooth, working on a sub-object selection.

This gives you more geometry to work with. Notice that only one iteration can be applied at a time.

19. In the dialog, choose Cancel.

The character is returned to its state before using MSmooth.

20. In the modifier stack display, choose Edit Poly to exit sub-object mode, and then click TurboSmooth.

21. In the TurboSmooth rollout, make sure Isoline Display is turned off.

Isoline Display shows the smoothed geometry, but only shows the smoothed edges from the original mesh. When it is off, you can see all the edges.

22. In the Perspective viewport, right-click the viewport title and turn off Edged Faces.

23. On the Modify panel > Modifier List drop-down, add another Edit Poly modifier.

24. On the Modify panel > Selection rollout, click Polygon.

25. Scroll down to the bottom of the Modify panel and open the Paint Deformation rollout.

26. In the rollout, select Push/Pull, set Push/Pull Value to 1, and set Brush Size to 2.

27. Click-and-drag the cursor over the character to pull the geometry.

28. In the Paint Deformation rollout, set Push/Pull Value to -1.

29. Click-and-drag the cursor over the character to push the geometry.

30. Take a look at the geometry in other viewports. It is probably too jagged.

31. In the Paint Deformation rollout, choose Relax, set Brush Size to 6, and set Brush Strength to 0.5.

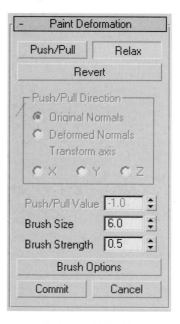

32.Click-and-drag the cursor over the character to relax the geometry.

Repeating this process several times is an easy way to add detail to a poly object.

Conclusion

In this chapter, you have learned about the basics of low-polygon modeling. You were introduced to the components of polygon mesh sub-objects: vertices, edges, faces, polygons and elements. You were shown the differences between modifiers and transforms. By using techniques like face extrusion and edge dividing, you were able to increase the complexity of existing geometry. Target and selection welding of vertices allowed you to reduce the face count in a predictable manner.

You also covered poly objects, and took a look at some of their special features. You learned about using the settings dialogs with the various tools, and you learned another way to add detail to an object by painting it on.

Most importantly, two popular methods of modeling in **3ds max** were covered: an editing approach that is useful for its speed and simplicity, and the use of modifiers to make geometry that can be edited with ease.

13

Environment and Low-Poly Creation Lab

Objectives

After completing this chapter, you are able to:

- Use reference images to give your model the proper proportions.
- Build objects from simple geometry.
- Reshape the models at a sub-object level.
- Manipulate vertices, edges, and polygons.
- Use Edit Poly to add low-poly geometry to an object.

Introduction

Low-polygon modeling is an important aspect of 3D design for use in any industry. In some instances, you might need to create a highly detailed and complex model, but in general you try to keep a minimum face count to save resources and rendering time. This is particularly applicable to models created for the gaming industry, which requires keeping the frame rate at its highest possible level.

Creating the Knight Scene

If you are learning to model a human character, beginning with a figure such as a medieval knight wearing a helmet and a robe, makes sense since it eliminates the detail needed in the anatomy of the human figure.

Creating the Knight

You begin modeling the knight by opening a file that contains some reference images upon which to base the model. For **3ds max** to display the images properly, you must add a map path to the Configure Path dialog, as indicated at the beginning of this book. This is a good time to take a step back and follow the procedures found in the Installing the CD section of this book before moving on with the lab.

Creating the Helmet

1. Start **3ds max**.

2. On the menu bar, choose File > Open and open *Knight01.max* from the courseware CD.

A scene appears with three reference images of a knight seen from different angles.

Note: If you cannot see all images or if some reference planes appear white, press the backwards quote to the left of 1 (`) on the keyboard to refresh the screen.

3. In the Perspective viewport, hold down control and select all of the reference planes.

4. Right-click in the Perspective viewport, and choose Freeze Selection from the quad menu.

Isolate Selection	
Unfreeze All	
Freeze Selection	
Unhide by Name	
Unhide All	
Hide Unselected	
Hide Selection	
display	
transform	
Move	☐
Rotate	☐
Scale	☐
Select	
Clone	
Properties...	
Curve Editor...	
Dope Sheet...	
Wire Parameters...	
Convert To:	▶

5. Right-click in the Top viewport to make it active.

6. On the command panels, choose Create > Geometry > Cylinder.

7. In the Parameters rollout, set Height Segments to **2**, Sides to **6**, and turn off Smooth.

This helps you control the number of polygons in the scene.

In the Top viewport, drag to create the base of the cylinder where the helmet should be. Release the button and move the mouse up to define the height. Use the image as a reference but do not worry about accuracy at this time.

8. On the command panels, click Modify.

9. On the Modify panel > Name and color group, rename the cylinder to *Helmet*.

10. Make sure the Top viewport is active and press **F4** to turn on Edge Face Mode.

Edge Face mode is an indispensable tool when using low-poly modeling. It allows you to see the view in shaded mode as well as the underlying wireframe structure of an object.

11. Right-click each of the viewports, and turn on Edge Face mode.

12. On the main toolbar, click Select and Move.

13. Move the cylinder so that its base is on top of the knight's shoulders. Center it using the image as a reference.

Notice the cylinder object prevents you from seeing the reference image behind it. You fix that in the next step.

14. Right-click in any viewport and choose Properties from the quad menu.

Isolate Selection
Unfreeze All
Freeze Selection
Unhide by Name
Unhide All
Hide Unselected
Hide Selection
display
transform
Move ☐
Rotate ☐
Scale ☐
Select
Clone
Properties...
Curve Editor...
Dope Sheet...
Wire Parameters...
Convert To: ▶

15. In the Object Properties dialog > Display Properties group, turn on See-Through.

This makes the object transparent in the viewport but not at rendering time.

However, because you set the viewport display to Edge Face mode, you are still able to see the structure of the model.

16. Right-click in the active viewport, and choose Convert to > Convert to Editable Poly.

Since the geometry doesn't need editing at the hidden edges level, you use the Editable Poly state to shape the cylinder into a helmet.

17. Right-click in the Front viewport to make it active.

18. In the viewport navigation controls, click Region Zoom.

19. Region Zoom the helmet in both the Front and Right viewports.

20. On the Modify panel > Selection rollout, click Vertex.

21. In the Front viewport, region select the top row of vertices.

22. In the Front viewport, move the vertices so that they sit on top of the Helmet in the reference image.

23. On the main toolbar, click Select and Uniform Scale.

24. In the Front viewport, scale the vertices approximately **53%**.

25. Repeat the previous steps to adjust the second and third level of vertices.

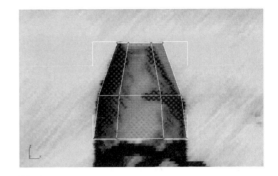

26. ✥ On the main toolbar, click Select and Move.

27. In the Front viewport, region select the vertices at the far left and far right of the bottom row of vertices.

28. In the Front viewport, move the vertices approximately **−28** units.

29. Continue using Move and Scale to adjust vertices. Make sure you region select the vertex area.

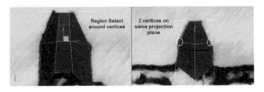

Note: To ensure you select all vertices located in the same projection field, use region select as much as possible when applying these techniques.

30. On the Modify panel > Selection rollout, turn off Vertex.

31. Right-click in the active viewport and choose Properties from the quad menu.

32. In the Object Properties dialog > Display Properties group, turn off See-Through.

Creating the Boot

There are different ways to approach a particular model. We used a cylinder primitive with six sides to convey the round shape of the helmet. You can easily use a four-sided cylinder to create the Boot.

1. Continue working on your file or choose File > Open from the menu bar and open *Knight02.max* from the courseware CD.

2. In the Perspective viewport, select the Helmet.

3. Right-click in the Perspective viewport, and choose Hide Selection from the quad menu.

4. On the command panels, choose Create > Geometry > Cylinder.

5. In the Parameters rollout, change Sides to **4**.

Creating the Knight Scene

6. In the Top viewport, create a four-sided cylinder near the heel of the right foot.

7. On the command panels, click Modify.

8. On the Modify panel > Name group, rename the cylinder to *Boot_Right*.

9. In the Parameters rollout, set the various parameters as follows:

Parameters	
Radius:	14.0
Height:	30.0
Height Segments:	1
Cap Segments:	1
Sides:	4
☐ Smooth	
☐ Slice On	
Slice From:	0.0
Slice To:	0.0
☐ Generate Mapping Coords.	

10. On the main toolbar, click Select and Move.

11. Use the Front and Right viewports to position the boot with the right foot.

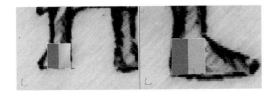

12. Right-click in the active viewport and choose Convert to > Convert to Editable Poly from the quad menu.

13. Right-click again and choose Properties from the quad menu.

14. In the Properties dialog > Display Properties group, turn on See-Through.

15. Right-click in the Perspective viewport to make it active.

16. In the viewport navigation controls, click Zoom Extents Selected.

17. On the Modify panel > Selection rollout, click Polygon.

Selection
∴ ◁ ⊃ ■ ⬗

18. In the Perspective viewport, select the polygon on the top of the cylinder.

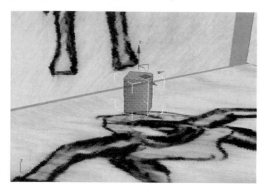

Tip: Press **F2** to turn on the Shade Selected toggle.

19. Right-click in the Perspective viewport, and choose Bevel from the quad menu.

20. In the Perspective viewport, position the cursor on the selected face until you see the Bevel icon, then drag to extrude the polygon.

21. Keep an eye on the Front viewport; release the cursor when the extrusion is slightly above the bottom of the Robe.

22. Move the cursor up slightly to scale the top of the Boot at the shin level.

23. In the Perspective viewport, hold down CTRL to select the two polygons at the front of the foot as seen in the following illustration.

24. Right-click in the Perspective viewport, and choose Extrude from the quad menu.

25. In the Front viewport, extrude the polygons to the base of the toes.

26. On the main toolbar, click Select and Non-Uniform Scale.

Note: You can use the scale gizmo for all three scale tools to non-uniform scale along specific axes, without choosing Non-Uniform Scale from the main toolbar.

27. In the Front viewport, set the Non-Uniform Scale on the Y-axis to approximately **50%**.

28. On the main toolbar, click Select and Move.

29. In the Front viewport, move the polygons down. Use a combination of Move and

Non-Uniform Scale in various axes to get a result similar to the following picture.

30. Right-click in the Front viewport, and choose Bevel from the quad menu.

31. In the Front viewport, bevel the polygons to create toes.

32. On the main toolbar, click Select and Move and position the toes.

33. On the Modify panel > Selection rollout, click Vertex.

34. In the Front viewport, use region select to move vertices and shape the boot based on the reference image.

35. In the Selection rollout, click Vertex to exit sub-object mode.

36. On the command panels, click Hierarchy.

37. On the Hierarchy panel > Adjust Pivot rollout, click Affect Pivot Only.

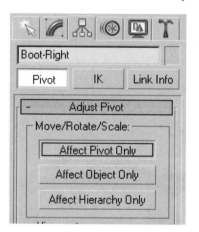

38. On the main toolbar, click Select and Move.

39. In the Front viewport, move the pivot point to where the boot meets the robe.

Note: This step is not necessary for modeling purposes but can be useful if you decide to animate the legs later. In this case the pivot point is moved so the boot can be rotated.

40. Turn off Affect Pivot Only.

41. On the main toolbar, click Select and Rotate.

42. In the Top viewport, rotate the boot on the Z-axis approximately **−11** degrees.

43. Right-click in the Top viewport, and choose Properties from the quad menu.

44. In the Object Properties dialog > Display Properties group, turn off See-Through.

45. Make sure the Top viewport is active.

46. On the main toolbar, click Mirror Selected Object.

47. In the Mirror dialog > Mirror Axis group, choose Y. In the Clone Selection group, choose Copy and click OK.

48. In the Top viewport, move the copied boot into position.

49. On the Modify panel > Name group, rename the object to *Boot_Left*.

Note: The left boot could also have been added by placing a Symmetry modifier on the stack. By using Mirror, you create a new object. When you use Symmetry, the two sides are considered the same object.

Creating the Robe

The robe can be modeled much the same way as the other objects in the scene. You start at the waist (belt) and move your way up or down.

1. Continue working on your file or choose File > Open from the menu bar, and open *Knight03.max* from the courseware CD.

2. In the Perspective viewport, select both boots.

3. Right-click in the Perspective viewport, and choose Hide Selection from the quad menu.

4. On the command panels, choose Create > Geometry > Cylinder.

5. In the Top viewport, create a six-sided cylinder to simulate the belt. Set its parameters as follows:

6. On the main toolbar, click Select and Move.

7. Position the cylinder in the various viewports.

8. Convert the cylinder into an editable poly.

9. Right-click in the active viewport and choose Properties from the quad menu.

10. In the Object Properties dialog > Display Properties group, turn on See-Through.

11. Then click OK.

12. On the Modify panel > Name area, type Robe.

13. On the Modify panel > Selection rollout, click Vertex.

14. In the Front viewport, use the transform tools to adjust the vertices so that the cylinder is equal in size to the belt in the reference image.

15. In the Selection rollout, click Polygon.

16. Right-click to activate the Perspective viewport.

17. In the viewport navigation controls, click Arc Rotate.

18. Arc Rotate in the Perspective viewport to view the bottom of the robe.

19. In the Perspective viewport, select the bottom polygon.

20. Right-click in the Perspective viewport and choose Bevel from the quad menu.

21. In the Perspective viewport, drag to create an extrusion where the robe opens up (keep an eye on the Right viewport for reference), and then move the mouse up to taper the robe.

22. On the main toolbar, click Select and Non-Uniform Scale.

23. In the Front viewport, non-uniform scale the polygons on the X-axis.

24. Right-click in the Perspective viewport, and choose Extrude from the quad menu.

25. In the Perspective viewport, extrude the polygons down to reach the bottom of the robe in the reference image.

26. On the Modify panel > Selection rollout, click Vertex.

27. Begin to adjust the vertices in the various viewports for a little variety in the shape of

the robe. This is one instance that you prefer an asymmetrical object.

28. In the viewport navigation controls, click Arc Rotate.

29. In the Perspective viewport, Arc Rotate to view the top of the robe.

30. In the Selection rollout, click Polygon.

31. In the Perspective viewport, select the top polygon.

32. In the Perspective viewport, bevel the selected polygon to reach a level near the middle of the chest.

33. Switch between Vertex mode and Polygon mode in various viewports to transform this area to match the reference images.

34. Add an extrusion to reach the armpits.

35. Use Bevel to add an extrusion to reach the top of the shoulders.

36. Add one final extrusion to create the neck.

37. On the main toolbar, click Select and Non-Uniform Scale to scale down the polygons.

Creating the Arms

Many times when you model a symmetrical character, you use the Symmetry modifier as you have in Chapters 10 and 11. Although this is a useful technique, you notice in the following steps that it is not always necessary.

1. Continue working on your file or choose File > Open from the menu bar and open *Knight04.max* from the courseware CD.

2. In the Perspective viewport, select the *Robe*.

3. On the command panels, click Modify.

4. On the Modify panel > Selection rollout, click Vertex.

5. On the main toolbar, click Select Object.

6. On the main toolbar, click Window.

7. In the Right viewport, hold down CTRL and region select the four vertices at the bottom of the armpit.

8. On the main toolbar, click Select and Non-Uniform Scale.

9. In the Right viewport, Non-Uniform Scale the vertices on the X-axis approximately **109%**.

10. On the Modify panel > Selection rollout, click Polygon.

11. In the Right viewport, hold down CTRL and region select the two polygons to extrude and create the arms.

12. Press **SPACEBAR** to lock your selection.

Note: You can also lock the selection by choosing the lock icon on the Status bar.

13. Right-click in the Right viewport, and choose Extrude from the quad menu.

14. Extrude the selected polygons until they reach a point just short of the elbow level. Keep an eye on the Top viewport for reference.

15. On the main toolbar, click Select and Move.

16. In the Top viewport, move the polygons on the X-axis approximately −9 units.

17. In the Right viewport, move the polygons on the Y-axis approximately −6 units.

18. Create another small extrusion to reach the other side of the elbow.

19. On the main toolbar, click Select and Rotate, and set the Reference Coordinate System to Local.

20. In the Top viewport, rotate the selected faces on their local X-axis by approximately −24 degrees to orient them in the direction of the forearm.

21. Use Select and Move to make any slight adjustments.

22. Use Bevel on the selected polygons to create and taper the wrists.

23. Use the Move tool to make slight adjustments so that the selected polygons follow the image to the gloves.

24. In the Selection rollout, turn off Polygon.

25. Press **SPACEBAR** to unlock the selection.

26. Turn off See-Through.

If you have time, try to model the gloves using the same techniques you learned in this lab. The gloves are simple objects that can be derived from box primitives.

To view the finished model, choose File > Open from the menu bar, and open *Knight05.max* from the courseware CD.

Smoothing the Result

When modeling with low polygons, often you end up with rough geometry. Some ways to smooth the model include tessellating or adding faces to the model, thus making it impractical for real-time gaming. There are other ways to achieve the illusion of a smooth model without effectively adding to the geometry. You use the smooth modifier to smooth the model without adding geometry.

1. On the menu bar, choose File > Open and open *Knight05.max* from the courseware CD.

2. Right-click to activate the Perspective viewport.

3. On the main toolbar, choose Quick Render.

4. In the Rendered Frame window toolbar, click Clone Rendered Frame window.

5. Minimize both (Rendered Frame window) windows.

6. In the Perspective viewport, window select all of the objects in the scene.

7. On the command panels, choose Modify.

8. On the Modify panel > Modifier List drop-down, choose Smooth.

9. In the Parameters rollout, click **1**.

Smoothing Groups:

1	2	3	4	5	6	7	8
9	10	11	12	13	14	15	16
17	18	19	20	21	22	23	24
25	26	27	28	29	30	31	32

Select By SG Clear All

Auto Smooth 45.0

When two adjacent faces share the same smoothing group, 3ds max removes the

edge between them. In this case, putting all objects (all faces) on the same smoothing group prevents the display of any hard edges.

10. On the main toolbar, choose Quick Render.

11. Compare this image with the one you rendered earlier.

Edit Poly Enhancements

You have finished a relatively easy low-poly character. He is currently made up of 6 objects. If you open the Polygon Counter, you can count how many faces he is made from.

Note: If you press 7 to view the face counter, it shows the number of polygons in your model, not the number of faces because the knight is a poly surface. Once you define a surface type then you can switch between Face or Poly count in the Polygon Count dialog. This is not the case using the viewport display (keyboard shortcut 7). If you define a surface as poly then the viewport display is polys even though it says Faces.

If you don't define a surface such as mesh or poly then faces are always counted. For example, if you create a box and open Polygon Counter and switch between Face or Polygon it counts mesh because the box is not defined as a mesh or poly surface.

Using the Polygon Counter to count the faces, the knight is made from 364 faces. This is rather low compared to todays current game standards, which often include poly counts as high as 5000 or more for in-game characters. It is still very important that you start modeling low-poly characters as low as possible. It's easier to take a 500 poly character up to 5000 polys, than it is to bring a 6000 poly character down to 5000.

In this section you continue to add detail to your model by adding Edit Poly modifiers and using several of Poly's tools.

Additions to the Helmet

1. Continue from the previous exercise, or choose File > Open and open *Knight06.max* from the courseware CD.

2. Select the Helmet.

3. Right-click and choose Hide Unselected from the quad menu.

4. On the Modify panel > Modifier List drop-down, choose Edit Poly.

5. In the Selection rollout, choose Polygon.

6. Arc Rotate in the Perspective viewport so you can see the bottom of the helmet.

7. In the Perspective viewport, choose the polygon on the bottom of the helmet.

8. On the Modify panel > Edit Polygons rollout, choose the Settings button next to Bevel.

9. In the dialog, set Height = 6 and Outline Amount = -0.5. Then click OK.

10. In the Modify Stack display, choose Edit Poly to exit Polygon sub-object mode.

11. In the Modify Stack disply, drag Edit Poly under the Smooth modifier.

The helmet now doesn't turn black at the bottom due to the smoothing. This same procedure can be used to keep the gloves from getting too dark near the arms.

12. In the Selection rollout, choose Edge.

13. In the Perspective viewport, hold down CTRL and select the two edges down the front of the helmet shown in the picture below.

Tip: Press F4 to turn on Edged Faces mode so you can see the edges.

14. On the Modify panel > Edit Edges rollout, choose the Settings button next to Chamfer.

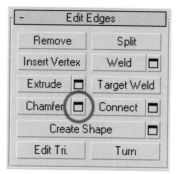

15. In the dialog, set Chamfer Amount to 12 and click OK.

16. On the main toolbar, choose Select and Move.

17. In the Front viewport, move the selected edges about 6 units on the X-axis.

18. In the Selection rollout, choose Vertex. Keyboard shortcut 1.

19. In the Edit Vertices rollout, choose Target Weld.

20.In the Perspective viewport, choose the first vertex shown below, then choose the second.

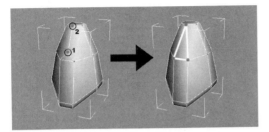

21.In the Edit Geometry rollout, choose Cut.

22.In the Right viewport, click at the five locations shown below to start an opening for the eyes.

23.Right-click to turn off Cut.

24.In the Selection rollout, choose Polygon. Keyboard shortcut 4.

25.In the Right viewport, select the three polygons in the opening.

26.On the Modify panel > Edit Polygons rollout, choose the Settings button next to Bevel.

27.In the dialog, set Height = -8 and Outline Amount = -2. Then click OK.

28.In the Right viewport, move the selected polygons up about 1 unit on the Y-axis.

Additions to the Robe

You now add some geometry to the robe.

1. Continue from the previous exercise, or choose File > Open and open *Knight07.max* from the courseware CD.

2. Right-click in the active viewport and choose Unhide By Name.

3. Choose all objects except the three Planes, and click Unhide

4. In the Perspective viewport, choose the Robe.

5. On the Modify panel > Modify Stack display, choose Editable Poly, and then open the Modifier List drop-down and add an Edit Poly modifier.

6. In the Selection rollout, choose Polygon.

7. In the Right viewport, region select the polygons for the belt.

The bottom of the Selection rollout should show 6 Polygons Selected.

8. On the Modify panel > Edit Polygons rollout, choose the Settings button next to Bevel.

9. In the dialog, select Local Normal, set Height = 4, and set Outline Amount = -1. Then click OK.

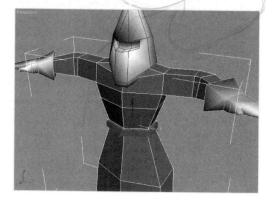

10. In the Selection rollout, choose Edge.

11. In the Right viewport, region select the six vertical edges directly below the belt.

12. On the Modify panel > Edit Edges rollout, select the Settings button next to Connect.

Notice that Connect adds one or more connecting edges between each two selected edges that touch the same polygon. In this case you created an extra horizontal row of edges.

13. In the dialog, keep Connect Edge Segments at 1 and click OK.

14. In the Right viewport, move the selected edges up about 14 units.

If you wish to, you may continue to add more geometry to your knight. Remember to keep the poly count as low as possible, while adding only the polygons that are necessary.

Conclusion

In this lab, you have learned to model various objects from simple geometry by shaping the model at a sub-object level using vertices and polygons. These techniques are powerful, and as you become more comfortable using them, you find yourself modeling objects you wouldn't have thought possible.

If you have time, keep working on your file. Create a few objects to fill the scenery with the tools you have learned in this lab. Try to create a sword from a simple box, or a mace from a sphere. Be creative. Add some landscape with boulders and rocks.

To give you a few ideas, choose File > Open from the menu bar and open *Knight_Done.max* from the courseware CD, and render the camera view.

Introduction to Materials

Objectives

After completing this chapter, you should be able to:

- Describe the Material Editor layout.
- Adjust Material Editor settings to your needs.
- Apply materials to scene objects.
- Create a basic material and apply it to an object in the scene.
- Create a material library from scene materials.
- Retrieve a material from a material library.
- Rename a material.
- Get a material from the scene to adjust settings.
- Use the Material/Map browser to navigate complex materials.

Introduction

The Material Editor is a powerful tool in the **3ds max** toolbox. With the Material Editor, you can create beautiful scenes with lush textures or solid-colored objects. In this chapter, you are introduced to the **3ds max** Material Editor and the function of its various options. You learn not only to manipulate basic materials, but also to retrieve and apply materials. Moreover, you explore the basic components used in materials, and learn to create and use material libraries.

Material Editor Basics

The Material Editor allows you to build colored and textured surface properties for use on objects in your scene. Many tools and settings within the Material Editor help you create materials.

A material may range in complexity from a simple solid color to a highly complex multi-image texture. For example, a material could be a flat blue paint for a wall, or the same wall could be painted blue brick, with patches of peeling paint exposing the brick. The Material Editor gives you many options.

Material Editor Layout

You spend a good deal of time using the Material Editor and it is important you become comfortable with the layout.

You can access the Material Editor in three ways:

- Choose the Material Editor Icon from the main toolbar.
- On the menu bar, choose Rendering > Material Editor.
- Use the keyboard shortcut **M**.

The Material Editor dialog is comprised of five areas:

1. Material Editor menu bar
2. Material Sample Windows
3. Material Editor Toolbars
4. Material type and Name area
5. Material Parameters area

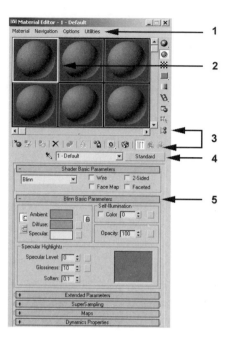

Material Menu Bar

The material menu bar contains many options found on the toolbars or by right-clicking a sample window. Use the menu bar to navigate through the material's levels, assign a material to selected objects in the scene, and place materials into material libraries.

Material Sample Slots

The Material Sample windows area is where you see your material before applying it to an object. By default, you can see six of the twenty-four sample windows in the workspace. There are three ways to see the remaining Sample Windows.

- Pan the Sample Window workspace.
- Use the scroll bars at the side and bottom of the Sample Windows.

- Increase the number of visible windows.

Panning and Using the Sample Window Scroll Bars

One method of accessing new material slots is to pan around in the sample window area using your mouse.

1. Start **3ds max**.

2. ⠿ On the main toolbar, choose Material Editor.

3. In the Material Editor > Sample Window area, place your mouse on the line separating two slots.

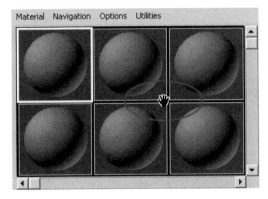

4. Click and drag in the Sample Window area.

 More Sample Windows are displayed.

5. Use the Scroll bars at the side and at the bottom of the Sample Windows.

 More Sample Windows are displayed.

Showing More than 6 Windows

If you need to see more than the standard six material windows, two Column/Row settings are available. They are 5 x 3 and 6 x 4. You can access these settings in the following ways:

- Right-click menu.

- Options dialog.

- On the menu bar, choose Options > Cycle.

- Press **X** to cycle among options.

Right-clicking in the active Sample Window area shows a right-click menu. From the right-click menu, you can choose the number of Sample Windows.

The image below shows the Sample Window with a 5 x 3 setting.

You can control the Sample Window settings by choosing Options from the side toolbar. When you choose Options, the Material Editor Options dialog is displayed and you change the settings from the Slots group.

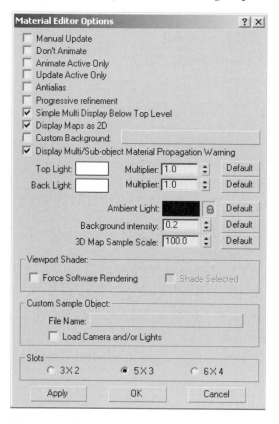

The image below shows the Sample Window with a 6 x 4 setting.

Note: A white border indicates the active material slot; this is the material you are currently working with.

You can also choose Options > Cycle from the menu bar, or press the keyboard shortcut X to cycle among the three different settings.

Magnifying a Sample Window

While the 3 x 2 setting provides a large sample slot, there are times you want to work with a single sample window at a larger size. **3ds max** allows you to magnify a single sample window to any size. You can double-click the active sample window to enlarge it, use the right-click menu, or use the menu bar.

1. Continue from the previous exercise.

2. In the Material Editor, right-click the selected window.

3. From the right-click menu, choose Magnify.

Note: You can adjust the size of the sample window by dragging the corners of the dialog.

The Sample Window Indicators

The sample window not only provides you with a visual representation of your work but also indicates the status of each material in the Material Editor. These indications become increasingly important as scenes grow in complexity. When you assign a material to an object in a scene, the sample window appears with white or grey triangles at its corners. These triangles indicate that the material is used in the current scene. If the triangles are gray, the material is assigned to an object in the scene. If the triangles are white, the material is assigned to the currently selected object in the scene.

Understanding Indicators

1. On the menu bar, choose File > Open and open *Candles_01.max* from the courseware CD.

2. Press M to open the Material Editor.

The Material Editor appears, with some sample windows that have gray triangles in their corners.

3. In the Material Editor, choose the third Sample Window in the top row.

 The border around this sample window becomes white, indicating it is now the active material.

4. In the Material Name area, the name of the material is Wrought Iron.

The corners have gray triangles indicating this material is assigned to an object in the scene.

5. In the Camera viewport, choose the sphere named Globe.

The triangles of the globe material turn white, indicating the material in that sample window is applied to the selected object in the scene.

6. In the Material Editor, choose the material named Wick.

The corners of this material don't have triangles. This indicates the material has not been assigned to any object in the scene.

Applying a Material to an Object

One of the basic functions of the Material Editor, apart from the creation of materials, is the application of materials to various scene objects. 3ds max provides several different ways to apply materials to objects in your scene. You can use the Assign Material to Selection icon found on the bottom toolbar. You can also simply drag and drop the material to single or multiple objects in the current scene. In addition, you can choose Material > Assign to Selection from the menu bar.

Assigning to Selected Objects.

You can easily assign a material to multiple objects by first selecting one or many objects.

1. Continue from the previous exercise or open *Candles_02.max* from the courseware CD.

2. In the Material Editor, make sure the material named Wick is selected.

3. In the Camera viewport, choose the two Wick objects.

Tip: Holding down CTRL while clicking adds to the selection.

4. In the Material Editor > bottom toolbar, choose Assign Material to Selection.

The corners of the sample slot are white, indicating the material is applied to the selected scene objects.

Drag and Drop

The drag and drop method allows you to apply the material to one or more objects. It works well in scenes with easily accessible objects. However, assigning the material properly can prove difficult if objects are hidden or within other objects.

1. Continue from the previous exercise.

2. Right-click the Camera viewport label, and choose Smooth + Highlights from the right-click menu.

3. In the Material Editor, choose the material named floor.

4. Click and drag from the sample window onto the floor object in the Camera01 viewport.

Note: When you release the mouse, the material is applied to the floor.

Customizing the Material Editor

When creating materials, you often need to adjust the default Material Editor settings. Various settings allow you to change the shape of the sample window objects, turn on or off backlighting, show a background in the sample window, set tiling, and more.

You can access all customization settings from the menu bar or the toolbar to the right of the sample window area. The right toolbar contains the following icons:

Sample Type flyout—Allows you to change the sample material object in the sample windows.

Backlight—Shows how the material looks with backlighting.

Background—Allows you to turn on a background in the sample window. This is especially useful for transparent materials.

Sample UV Tiling flyout—Allows you to change the tiling of the material in the Editor without affecting the tiling of the material applied to the object.

Video Color Check—Checks for any invalid video colors.

Make Preview—Allows you to preview animated materials.

Options—Displays the Material Editor Options dialog.

Select By Material—Selects objects in the scene using the Select Object dialog.

Material/Map Navigator—Allows you to view each level of the material in an organized hierarchy.

Choosing items from the menu bar accesses many of the same tools.

Material	Navigation	Options	Utilities	
		Propagate Materials to Instances		
		Manual Update Toggle		
		Copy/Rotate Drag Mode Toggle		
		Background		B
		Custom Background Toggle		
		Backlight		L
		Cycle 3X2, 5X3, 6X4 Sample Slots		X
		Options...		O

Sample Window Shape

By default, the object in the sample window is a sphere. However, you might want to use a shape other than a sphere while creating materials for your scene. For example, if you create a material for a flat surface, such as walls or floors, you probably want to change your sample window to show an object with flat sides. In the Material Editor, you are able to select from three default objects. They are:

- Sphere
- Cylinder
- Box

Note: You can also specify your own custom shape.

Changing the Sample Type

1. Continue from the previous exercise or open *Candles_03.max* from the courseware CD.

2. In the Material Editor, choose the material named globe.

3. On the right toolbar, click and hold the Sample Type flyout to display the Sample Type options.

4. In the Sample Type flyout, choose Cylinder.

Note: Using a cylinder as the sample window object shows how maps for soda

cans or bottles look when applied to a scene object.

5. In the Sample Type flyout, choose Box.

Note: Using a box in the sample slot shows how a map works on flat or rectangular objects such as a table top or a brick wall.

Using Custom Objects

A custom sample window object expands the capabilities of the Material Editor. It also saves you guesswork by replacing the default sample window objects with one that better represents the scene object. The Material Editor uses the scan line renderer to place a complicated object in the sample window. You can then design your materials and observe their progress with the help of the custom sample window object. This saves you the trouble of applying the material to the object in the scene and rendering it every time.

1. Continue from the previous exercise.

2. On the side toolbar, choose Options.

 The Material Editor Options dialog is displayed.

3. In the Material Editor Options dialog > Custom Sample Object group, choose the button next to File Name:

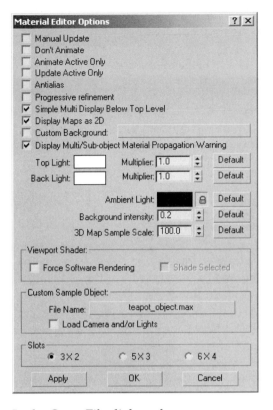

4. In the Open File dialog, choose *teapot_object.max* from the courseware CD.

 Note: To use an object from the current scene, select the object and choose Save Selected from the File menu bar first, before loading. To use a Custom Sample Object, you must load it from a separate file. Make sure you select one object only.

5. Choose OK to close the dialog.

6. In the Material Editor, click and hold the Sample Type flyout.

 There is a new icon for the custom object.

7. Choose the custom object icon from the flyout.

The sample window displays a teapot as the custom object.

8. Change the sample window back to a sphere.

Material Editor Light Settings

The look of any material depends on proper lighting to a great extent. Photographers and filmmakers spend hours getting the lighting just right for a scene. **3ds max** is, in effect, a digital photography studio. You become more effective at creating materials if you understand how to adjust the lighting within the Material Editor. There are three light settings available in the Material Editor:

- Top light
- Back light
- Ambient light

 Note: Changing the light settings is a global change, affecting all sample windows.

Adjusting the Material Editor Lighting

1. Continue from the previous exercise.

2. Press **M** to open the Material Editor.

3. ⬛ In the Material Editor > side toolbar, choose Options.

4. In the Material Editor Options dialog, choose the Top Light color swatch.

The Top light is also known as the Key light, which is brightest light shining on an object and provides most of the surface illumination. Adjusting this light changes not only the color and intensity of the light, but also the look of the material surface. To illustrate this, make drastic changes to the light color to see the effect on the material.

5. In the Color Selector dialog, change the color to red and close the dialog.

6. In the Material Editor Options dialog, choose Apply to view the changes.

Note: Try different colors to see the results you get. The Material Editor lighting does not affect the scene lighting.

7. In the Material Editor Options dialog, choose the Back Light color swatch.

Backlighting, a basic photography concept, involves placing a light behind the subject to make the subject stand out from the background. Backlighting plays the same role in the Material Editor, but also serves a second purpose: to provide a second light source that helps you visualize your material.

8. In the Color Selector dialog, change the color to blue and close the dialog.

9. In the Material Editor Options dialog, choose Apply to view the changes.

Note: Observe how changes in the backlight alter the look of the materials in the Material Editor.

10. In the Material Editor Options dialog, choose the Ambient Light color swatch.

Ambient light is the light reflected from objects, walls, or anything else in a scene. Since ambient light does not come from a directional light source, it provides a subtle illumination that surrounds an object from all sides.

11. In the Color Selector dialog, change the color to green and close the dialog.

12. Next to the Ambient Light color swatch, turn off Lock.

13. In the Material Editor Options dialog, choose Apply to view the changes.

Note: If the small lock button next to Ambient Light is turned on when you change the ambient color, the ambient light in the scene changes also. If the button is turned off, the scene is unaffected.

Resetting the Light Colors

3ds max provides default light settings that work under most conditions. If you change the settings, you might want to return them to the default settings for other materials.

1. Continue from the previous exercise.

2. In the Material Editor Options dialog, choose Default to return the colors to their default settings.

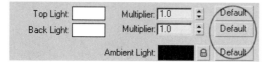

3. In the Material Editor Options dialog, choose Apply.

Adjusting the Light Brightness

Along with changing the color of the Material Editor lights, there is a way to change the brightness only. Called the Multiplier, the value goes from 0.0 to 1.0. At a setting of 1, it is 100% bright.

1. Continue from the previous exercise.

2. In the Material Editor Options dialog, change the Backlight Multiplier to **0.5**.

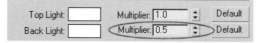

This sets the brightness of the Back Light to 50%.

3. In the Material Editor Options dialog, choose OK to close the dialog.

Turning the Backlight Off and On

Once the Material Editor lighting is set, you can turn the Back Light off and on from the side toolbar.

1. Continue from the previous exercise.

2. In the Material Editor > side toolbar, choose Backlight.

Backlighting is turned off in the selected sample window.

3. On the side toolbar, choose Backlight again to turn on the backlighting.

Changing the Map Tiling

When you create a material using an image map, you might want to see what it looks like as a tiled image, as in the case of a floor tile material.

1. Continue from the previous exercise or open *candles_03.max* from the courseware CD.

2. Press M to open the Material Editor.

3. In the Material Editor > side toolbar > Sample Type, choose Sphere.

4. On the side toolbar, click and hold the Sample UV Tiling flyout to reveal the Sample UV Tiling options.

There are four tiling values to select from: 1 x 1, 2 x 2, 3 x 3, and 4 x 4, depending on your visualization needs.

5. From the Sample UV Tiling flyout, choose 3 x 3.

Note: This tiling is for previewing in the Material Editor only and does not affect scene materials.

Other Material Editor Options

The Material Editor Options dialog offers many ways to customize the settings of your Material Editor. Some options affect the sample windows directly, while others are designed for productivity.

Adjusting the 3D Map Sample Scale

You might often need to change the value of the 3D Map Sample Scale setting, which determines the scale of the sample object in relation to objects in your scene. This option allows you to preview the scale of 3D procedural maps based on the size of your scene object without having to render your scene. For example, if your scene object is 15 units in size, set the 3D Map Sample Scale to 15 to display the maps correctly.

Procedural maps are maps created using a mathematical formula. Noise, Perlin Marble, and Speckle are three examples of 3D

procedural maps. They provide values you can adjust to obtain a desired material effect.

An example of Noise, Perlin Marble, and Speckle.

1. On the menu bar, choose File > Open and open *candles_03.max* from the courseware CD.
2. Press **M** to open the Material Editor.
3. In the Material Editor, choose Wrought Iron.
4. On the menu bar, choose Options > Options.
5. In the Material Editor Options dialog, choose Default to the right of the 3D Map Sample Scale value.

 Note: By default, the 3D Map Sample Scale is set at 100, which represents an object the size of 100 units within a scene.

6. In the Material Editor Options dialog, choose Apply.

 Note: Observe the appearance of the surface closely. With the value at 100, the sphere appears smooth. To obtain a better representation of the surface, set the scale value smaller.

7. In the 3D Map Sample Scale value, enter **2.0**.

8. In the dialog, choose Apply.

With a value of 2.0, the sphere now appears rough and bumpy.

9. Choose OK to close the dialog.

Productivity Enhancers

As scenes and materials become increasingly complex, the Material Editor can slow down, especially if there are many animated materials. Four options dramatically enhance productivity in the Material Editor. They are:

Manual Update—This option deactivates the automatic material update and forces you to update the material by clicking once in the sample window. When Manual Update is active, changes you make to the material are not reflected in the sample window in real-time. You see these changes only when you update the sample window.

Don't Animate—This option is helpful if several animated materials exist in the Material Editor. As with many other features in **3ds max**, animated materials are updated in real-time when you scrub the frames in the timeline. This not only slows down the Material Editor but also can slow down viewport playback on slower computers. Selecting the Don't Animate option stops the animation of all materials in the Material Editor and the viewport. This can greatly increase productivity on slower computers.

Animate Active Only—This option works the same as Don't Animate, except it allows only the currently active sample window to animate along with the viewport playback.

Update Active only—This option resembles Manual Update, except it allows only the active sample window to update in real-time.

Basic Material Parameters

In this section, you further explore Material Editor customization and begin to create materials. **3ds max** provides you with the basic building blocks you need to create many different types of materials. You begin with the basics.

How do Materials Work?

As you look around, you see materials everywhere. Some are simple in appearance, like the wall in the beginning of the chapter, while others present a highly complex appearance. They all have one thing in common; they affect light reflected from the surface. Light is the reason we see not only materials and textures, but also the means by which we see at all. When you build a material, you must think about how the light and the material interact. Will the material be shiny or matte? Will it reflect its surroundings? Will it be bumpy or smooth, old or new, dirty or clean?

Understanding Material Types

The Material Editor contains several Material types available for objects in the scene. Each Material type serves a unique purpose, ranging from specific Matte/Shadow Materials to complex Multi/Sub-Object and Ray-traced Materials to the Standard Material type. The default material type is the Standard Material type. Although many Material types have a specific purpose, many nonetheless have similar parameters. Learning the default Standard Material type helps you understand it and able to use most other Material types with ease.

There are two ways to choose a Material type. You can choose the Standard button next to the Material name or Get Material from the bottom toolbar, or from the menu bar. Either way, the Material/Map Browser dialog displays and you can choose a new Material

type. **3ds max** displays Material types with blue spheres next to their name. The green parallelograms signify Map types. Map types are discussed later in this chapter.

The Standard Material

The Standard Material type is extremely flexible, and you can use it to create an unlimited number of materials. The most important part of any material is the so-called shader, a mathematical formula that defines the way a surface is affected by light. In the Standard Material, you can choose from several shaders located in the Shader Basic Parameters rollout. Each shader has parameters specific to it, and depending on the shader you select, its parameters rollout changes accordingly. You choose a shader according to the surface you hope to create.

Shader Basic Parameters

The Shader Basic Parameters rollout is where you determine the type of shader to use and choose among four other material options. These options are explained next.

The Shader Basic Parameters rollout

The Shaders

When you choose the shaders drop-down list, you are presented with eight different shaders. The Blinn shader is available by default.

Each shader has several items in common: Ambient, Diffuse, Self-Illumination, Opacity, and Specular Highlights. Each shader also has its own set of parameters. Some have a Specular color value, Anisotropy, a second Specular Highlight, Roughness, or Metalness.

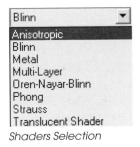

Shaders Selection

Anisotropic—Creates a surface that can have non-round specular highlights.

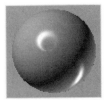

The Anisotropic shader can be used for surfaces like brushed metal.

Note: Certain parameters can be represented by either a color or an amount, the Self-Illumination channel for example. With the check box to the left of the value turned off, you can enter a value. If you turn on the check box, you can use a color or map instead.

Blinn—Serves as a basic all-purpose shader with a round highlight.

Blinn can be used for a wide range of materials, from rubber to stone to highly polished surfaces.

Metal—Made to simulate metallic surfaces.

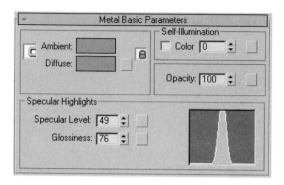

Multi-Layer—Contains two anisotropic highlights that work independently of each other.

You can use the Multi-Layer to create complex surfaces like satin, silk, and pearlescent paint.

Oren-Nayar-Blinn (ONB)—Creates Blinn style highlights, but with a much softer look.

ONB is often used for cloth, adobe-type clay, and human skin.

Phong—Remains from earlier versions of **3ds max** and functions similarly to Blinn. However, Phong highlights are looser and not as round as Blinn.

Phong is a flexible shader and can be used for hard or soft surfaces.

Strauss—Designed for quick creation of a wide variety of surfaces. It has few parameters and can create surfaces ranging from matte to metal.

Strauss is an easy way to create any material, including glossy paint, brushed metal, and chrome.

Translucent—Similar to the Blinn shader but this shader allows light to pass through an object. This shader is designed to work with the Radiosity Advanced Lighting.

Use the Translucent Shader to simulate backlight that illuminates an object.

Shader Basic Parameters Material Options

Wire—Makes your object render as a wireframe object.

Many objects are made up of some kind of wire mesh. For example, you could be making a wireframe effect for an object, or a chain link fence.

2-Sided—Sets the material so **3ds max** renders both the front and back sides of an object.

2-sided materials can be used for transparent plastic bottles, a fishing net, or the strings of a tennis racket.

Faceted—Forces the object with this setting to render with no smoothing.

Faceted materials can be used to make cut diamonds and other gemstones, or any other surface with hard edges.

Face Map—Sets the mapping coordinates of the material to place one image on each face of an object.

Ray-Trace Material Type

As with the Standard Material type, the Ray-trace Material offers you the ability to use Phong, Blinn, Metal, Anisotropic, and Oren-Nayar-Blinn shaders. The Ray-trace material differs from the Standard material in its use of shaders. The Ray-trace material attempts to physically model a surface instead of simulating it. Because of this, ray-traced materials take longer to render.

Ray-tracing is a form of rendering that calculates rays of light from the screen to the lights in a scene. The Ray-trace Material uses this to allow for added features, such as luminosity, extra lighting, translucency, and fluorescence. It also supports advanced transparency parameters such as fog and color density.

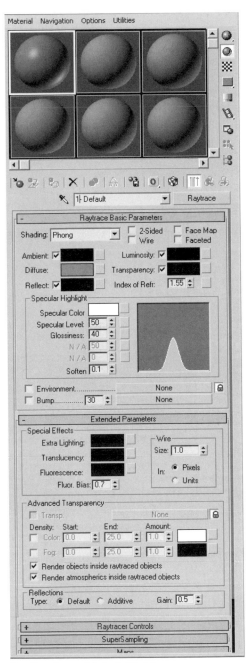

The Ray-trace Material Type

Luminosity—Similar to Self-Illumination.

Transparency—Acts as a filter value, blocking the selected color.

Reflect—Sets the level and color of the reflection value, ranging from no reflection to a mirror surface.

Extended Parameters

All controls in the Extended Parameters rollout are unique to the Ray-trace Material, except for the Translucency and Wireframe controls.

Extra Lighting—Functions like ambient lighting, but on a material-by-material basis, rather than global. It can be used to simulate light reflected from one object onto another, as when a white wall picks up a bit of blue reflected from a nearby blue couch.

Translucency—Can be used to make a "rice paper" effect on the surface of a thin object, where a shadow can be cast onto the surface of the paper. When used on a thick object, it can serve to make a "wax candle" effect.

Fluorescence and Fluorescence Bias—

Fluorescence causes the material to illuminate as if lit by a white light, no matter the color of the lights in the scene. The Bias determines how pronounced the effect is, with 1.0 as full brightness and 0.0 as none.

Architectural Material Type

The Architectural Material type differs significantly from the two previously mentioned. It provides the greatest amount of realism when rendering with Photometric Lights and Radiosity. Using the Architectural Material with Photometric Lights and Radiosity, you can create lighting studies with a high degree of accuracy. The settings for this material are actual physical properties.

It is recommended that you do not use the Architectural Material with standard lights or the Light Tracer.

When you first choose an Architectural Material, notice the interface differs from the Standard and Raytrace Material types.

The Architectural Material Type

Templates—The Templates rollout includes a drop-down list of preset material parameters. The templates give you a set of materials to get your material started, and then you adjust the settings to improve its appearance.

The Physical Properties rollout includes features for controlling the look of the material.

Diffuse Color Swatch & Map button—Resemble those in the Standard material. The Set Color to Texture Average button (arrow button) sets the Diffuse Color to the average of the colors in the Diffuse Map.

Shininess—Controls the size of the Specular highlight and how reflective the material is.

Transparency & Translucency—Transparency controls the opacity of the material, while Translucency controls how much of the material's color is added to light passing through it.

Index of Refraction—The Index of Refraction (IOR) controls the bending of light passing through a transparent or translucent material. It also controls how shiny opaque and transparent materials appear. An IOR of 1.0 means all light is transmitted into a material, showing no specular highlight regardless of the Shininess setting.

Luminance cd/m² and Set Luminance from Light—Luminance is the self-illumination of the object based on candelas per square meter. Set Luminance from Light allows you to choose a Photometric Light in the scene to base the material's luminance on.

Special Effects—This rollout includes a check box named Emit Energy Based on Luminance. When it is turned on, the material emits light based on its Luminance value, in a Radiosity rendering.

Note: For more information about rendering with Architectural Materials and Radiosity, see Chapters 19 and 20.

The Candlesticks

Create a basic material for one of the candlesticks and name it brass. Access the other material by using the material library.

1. On the menu bar, choose File > Open and open *Candles_03.max* from the courseware CD.

2. Press M to open the Material Editor.

3. In the Material Editor, choose the next available sample window.

4. In the Name area, type **Brass**.

5. In the Shader Basic Parameters rollout, choose Metal from the drop-down list.

Note: There are four check boxes in the Shader Basic Parameters rollout.

6. In the Metal Basic Parameters rollout, choose the Diffuse color swatch.

7. In the Color Selector dialog, set the color value to R=**234**, G=**214**, and B=**77**.

8. Close the Color Selector dialog.

9. In the Metal Basic Parameters rollout > Specular Highlights group, set the Specular Level to **59** and the Glossiness to **73**.

Note: The Specular Highlights group shows how soft, hard, matte, or glossy the material on the object is. You can change the option of the Specular Level to make a sphere look like a soft rubber ball or a hard billiard ball.

10. In the Maps rollout, choose None next to Reflection.

11. In the Material/Map Browser, choose Raytrace and then choose OK.

12. On the bottom toolbar, choose Go to Parent.

This returns you to the main material settings area.

Note: Two buttons help you navigate simple materials: Go to Parent and ![] Go to Sibling. The previous step is an example of Go to Parent. (You use Go to Sibling when you have more than one map type, such as a Diffuse map and a Bump map. In this case, Go to Sibling permits you to go directly from the Diffuse map to the Bump map.)

Look at the material sample window for the Brass material. It does not really give you a sense of the material. To see the reflection you've just added, turn on the background for the sample window.

13. ![] In the Material Editor > side toolbar, choose Background.

The material now looks more like brass with the reflection added.

14. Drag and drop the material from the Material Editor to the Left-hand Candlestick in the Camera viewport.

15. On the main toolbar, choose Quick Render.

The material on the candlestick now has the appearance of brass.

16. Close the Rendered Frame Window.

Retrieving Materials from a Material Library

One advantage of the **3ds max** Material Editor is its ability to use and reuse materials created by yourself or others and stored in material libraries. Several materials come with **3ds max** and can be loaded and used as they are, or modified for your particular needs. In the next section, you use a material from a material library and apply it to the other candlestick.

1. Continue from the previous exercise or open *candles_04.max* from the courseware CD.

2. In the Material Editor > pan the sample windows to the left to reveal more sample windows.

3. Select a blank sample window.

4. On the toolbar, choose Get Material.

5. In the Material/Map Browser > Browse From group, choose Mtl. Library.

7. Choose *RayTraced_01.mat* from the courseware CD.

8. In the Material/Map Browser toolbar, choose View List + Icons.

9. In the Show group, choose Root Only.

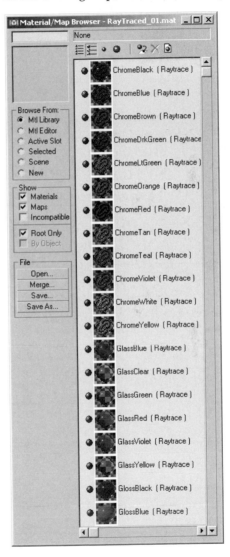

6. In the File group, choose Open.

10. From the material list, double-click GlossYellow.

This copies the material to the active sample window.

Note: If you have all the sample windows full, you can still get a new material or a material from a library, without removing the original material from the scene. You overwrite the material in the Material Editor only, not the material in the scene.

11. Close the Material/Map Browser.

This is a type of material called Raytrace. The Ray-trace Material is different from the material you created earlier. You can still create a variety of materials with the Ray-trace Material, however it has additional controls for many material effects, including material density, fluorescence, and translucency.

12. Drag and drop this material to the right side candle holder in the Camera viewport.

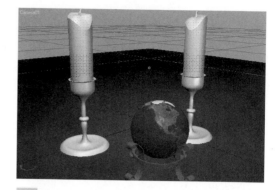

13. On the main toolbar, choose Quick Render.

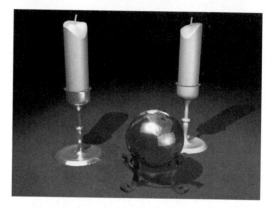

Notice the difference between the two candleholders: both are yellowish in color, have some reflection and high specular values. However, they look very different due to the shader type and Material type. The left-hand candleholder was created using a Standard Material with a Metal shader and a Ray-trace map in the Reflection channel, and the right candleholder uses the Ray-trace Material with a Phong shader, and a Falloff Map in the Reflect channel.

14. Close the Rendered Frame Window.

Modify the New Material

Now that you have retrieved a new material from an existing material library, you want to modify it to look the way you want. Let's say you want to make the right candleholder a little more reflective and richer in color.

1. Continue from the previous exercise or open *candles_05.max* from the courseware CD.

2. In the Material Editor, choose GlossYellow.

3. In the Raytrace Basic Parameters rollout, choose M in the Reflect channel.

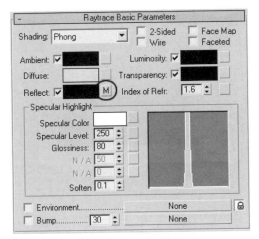

4. In the Falloff Parameters rollout > Front: Side group, click the Falloff Type drop-down list and choose Perpendicular/ Parallel.

 This causes the reflection to dramatically increase at the edges. The Falloff map is a very useful map type, however it takes some experimentation to understand how it works.

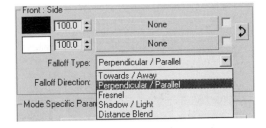

5. In the Front:Side group, choose the Black color swatch.

6. In the Color Selector dialog, change the color to R=**64**, G=**64**, B=**64**.

7. On the Material Editor toolbar, choose Go to Parent.

8. In the Raytrace Basic Parameters rollout, choose the Diffuse color swatch.

9. In the Color Selector dialog, change the color to R=**240**, G=**218**, B=**10**.

10. Close the Color Selector dialog.

11. Set the Specular level to **150**, and the Glossiness to **60**.

 When adjusting the Specular and the Glossiness values, pay close attention to hot spots on the sample sphere; raising the Specular level brightens it, while increasing the Glossiness makes it sharper and smaller.

12. Make sure the Camera viewport is active.

13. On the main toolbar, choose Quick Render.

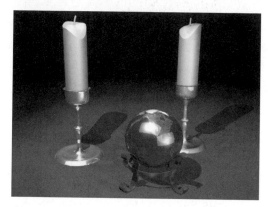

14. Close the Rendered Frame Window.

Change the Name

Now that you've changed the material, it no longer looks like a Glossy Yellow material. It now looks like a polished gold material. So you need to change the material name.

1. Continue from the previous exercise.

2. In the Material Editor, choose the GlossYellow sample window.

3. In the Material name area, type Polished Gold and press ENTER to accept the name change.

Using the Strauss Shader

Next you create another gold metal material but this time you use the Strauss Shader. This shader is the most streamlined of all shaders but also offers some flexibility.

1. Continue from the previous exercise.

2. Make sure the Material Editor is open.

3. Choose an empty sample slot.

4. Name the Material Gold Strauss.

5. In the Shader Basic Parameters rollout > Shader drop-down list, choose Strauss.

6. In the Strauss Basic Parameters rollout, choose the Diffuse color swatch.

7. In the Color Selector dialog, set R=237, G=200, and B=52.

8. Set the Glossiness to 93 and the Metalness to 40.

9. On the Material Editor > side toolbar, choose Background.

10. In the Maps rollout, choose None next to Reflection.

11. In the Material Map Broswer, double-click Falloff.

12.In the Falloff Parameters rollout, choose the first None button and double-click Raytrace.

13.In the Material Editor > bottom toolbar, choose Go to Parent.

14.In the Falloff Parameters rollout, choose the second color swatch.

15.In the Color Selector dialog, set R=181, G=183, and B=54.

16.In the Mix Curve rollout, move the end points to something similar to the following image.

17.Drag and drop this Material onto one of the candlesticks.

18.Make sure Camera01 is active.

19.On the main toolbar, choose Quick Render.

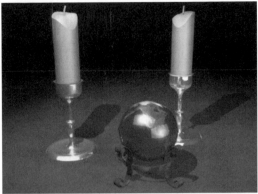

You created three metal variations, and each one is quite different. There are many approaches to creating materials, experiment with the various options and find one that fits your style.

Making the Globe Material Transparent

1. Continue from the previous exercise or open *candles_06.max* from the courseware CD.

2. Press M to open the Material Editor.

3. In the Material Editor, choose the globe material.

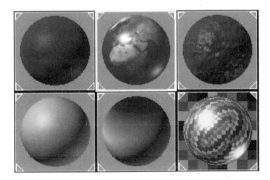

4. In the Shader Basic Parameters rollout, turn on 2-sided.

Turning on 2-sided causes the sphere to have an inside surface. If you look at an actual balloon, the surface is transparent and the inside surface is visible.

5. In the Blinn Basic Parameters rollout, change Opacity to **65**.

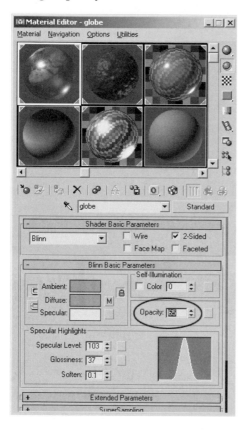

Lowering the Opacity makes the object more transparent. A value of 0 is

completely invisible, while 100 is completely solid.

6. In the Camera viewport, the globe appears transparent.

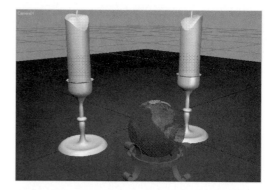

7. Make sure the Camera viewport is active.

8. On the main toolbar, choose Quick Render.

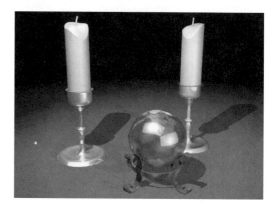

The globe is transparent, and you see the inside surface because of the 2-sided option.

Making a Material Library from the Scene

Though you might have materials in up to 24 sample windows at one time, you often have more than 24 objects in a scene. One of the strengths of **3ds max** is you can have more materials in your scene than the sample windows allow in the Material Editor. In these instances, you need to save your materials to a Material Library. You can save all materials in the sample windows to a library. You can also save all materials applied to objects in the scene into a library. Once a material is saved to a library, you can clear that material from the Material Editor and create a new material to apply to another object in the scene.

Once the library is saved, you can open Material Libraries that hold other materials used in other scenes. This flexibility can save you a great deal of time. For example, if you have spent hours creating a material with the appearance of water, you can save that material to a library and reuse it on other objects in other scenes.

Creating a Material Library

In the following procedure, you create a Material Library.

1. On the menu bar, choose File > Open, and open *candles_07.max* from the courseware CD.

2. Press M to open the Material Editor.

3. On the Material Editor toolbar, choose Get Material.

4. In the Material/Map Browser > Browse From group, choose Scene.

5. On the Material/Map Browser toolbar, choose View List + Icons.

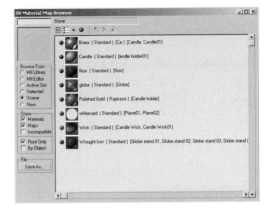

6. In the Material/Map Browser > File group, choose Save As.

7. In the Save Material Library dialog, save the library as *candlestick.mat* to your Matlibs directory, then choose Save.

 You have now created a new library based on the materials applied to the objects in the current scene.

Navigating Complex Materials

As you progress in your material creation abilities, you begin to build increasingly complex materials. The Material/Map Navigator is a tool that allows an easy and visual way of navigating through complex materials.

A Sample Navigation

1. On the menu bar, choose File > Open and open *Street.max* from the courseware CD.

2. Press **M** to open the Material Editor.

3. In the Material Editor, choose the Street material.

4. On the side toolbar, choose Material/ Map Navigator.

5. In the Material/Map Navigator toolbar, choose View List + Icons.

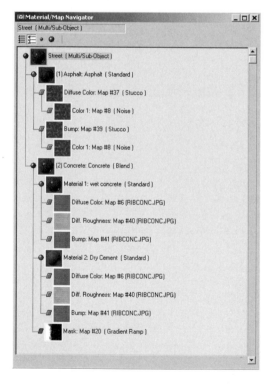

Note: The hierarchy of the material starts at the top with the parent material, then

works down and to the right for child materials.

This particular material is a multi/sub-object material with two sub-materials. One sub-material contains maps within maps. This is not readily visible by simply looking at the Material Editor. The second material contains a Blend material with two more materials and a map that acts as a mask. Going even further, the Blend materials contain maps as well.

Without the Material/Map Navigator, it would be tedious to constantly use Go to Parent, then Go to Sibling, then click a lower level. The Material/Map Navigator allows you to go directly to the material or map you want to edit.

6. In the Material/Map Navigator, choose (2) Concrete (Blend).

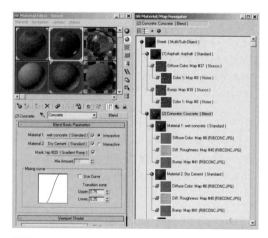

7. In the Material Editor toolbar, turn off Show End Result.

8. In the Material/Map Navigator, choose Dif. Roughness Map #40.

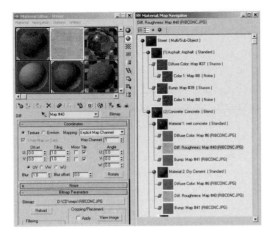

As you can see by turning off the Show End Result, you are able to see the current level of the material only.

Conclusion

In this chapter, you learned the basics of the Material Editor. This includes using and customizing the features available in the Material Editor interface and understanding its basic parameters. You learned to access material types such as Standard and Ray-trace, and to use Map types within the material's map channels. Finally, you learned to create a material library and navigate through complex material types.

15

More Materials

Objectives

After completing this chapter, you should be able to:

- Understand how mapped materials work.
- Use various map channels.
- Create a simple material using bitmaps.
- Create a complex material using both procedural maps and bitmaps.
- Modify bitmaps in the Material Editor.
- Use and modify procedural maps.
- Apply UVW mapping to objects.
- Modify UVW mapping coordinates.
- Use UVW map channels.
- Address difficult mapping situations.

Introduction

In the previous chapter, you created some basic materials by adjusting the diffuse value to set the color of the material. You also adjusted several other parameters to get the desired specular, shininess, and opacity

levels for your material. Adjusting the basic parameters of a material works in certain situations. However, when objects and scenes get more complex, the need for materials based on image maps becomes more important. The Material Editor in **3ds max** gives you the ability to use bitmaps or procedural maps to replace the color and value of many material attributes.

Materials

When you want to turn a piece of geometry into a piece of wood or pitted metal, you need to create a material that defines the look of that surface. **3ds max** offers a variety of types of materials to choose from:

- Advanced Lighting Override
- Architectural
- Blend
- Composite
- Double Sided
- Ink 'n Paint
- Lightscape Mtl

- Matte/Shadow
- Morpher
- Multi/Sub-object
- RayTrace
- Shell Material
- Shellac
- Standard
- Top/Bottom

Materials fall into two categories. In the first category, each material directly affects the surface of an object. Ink 'n Paint, Matte/Shadow, RayTrace, and Standard fall into the first category and are used to create surfaces containing multiple maps. In this group, the Standard material is most commonly used and offers the most flexibility.

The remaining materials act as containers and make up the second category of materials. Advanced Lighting Override, Blend, Composite, Double Sided, Morpher, Multi/Sub-object, Shellac, and Top/Bottom are used to create complex surfaces that contain multiple materials.

The Standard Material

One of the first things you need to learn is how materials and maps work together. For example, the Standard material on its own is used to create a variety of surfaces. The Standard material offers various Shaders to control the look of the surface, as well as channels where Maps are used to add more flexibility to the material.

Think of the Standard material as an easel, while the shaders are the surface type, canvas, paper, metal, etc. Maps are your paints and brushes; use them to add color and texture to the finished surface.

When using materials such as the Blend material, the Standard material becomes an integral component as a sub-material with the blend controlled with a Map.

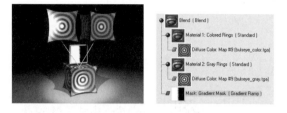

The previous image shows a Blend material and its Material and Map components. Pay close attention to how the map is used to control the blend.

Bitmaps and Procedural maps

The two types of maps you deal with in the **3ds max** Material Editor are Bitmap and Procedural. Although the maps look similar at times, they work differently.

Bitmaps

A bitmap is a two dimensional image made up of individual picture elements (pixels) measured horizontally and vertically. The more pixels in an image, the larger it becomes and the closer you can look at it without noticing the pixels. The size of the bitmap is important as you create animation where the camera closes in on a material containing a bitmap. A small- or medium-size bitmap works for objects that don't get too close to

the camera. A larger bitmap might be needed if the camera zooms in on part of an object. The following example shows what happens when the camera zooms in on an object with a medium-size bitmap.

Notice the blocky look in the map image on the right; this is called pixelation.

In the previous images, using a larger bitmap would reduce the amount of pixelation. Be careful since larger bitmaps require more memory and take longer to render.

Note: Large in this instance refers to the size of the bitmap. For example, 640 x 480 is larger than 320 x 240.

Procedural Maps

Unlike bitmaps, procedural maps are derived from simple or complex mathematical equations. One advantage to using procedural maps is that they do not degrade when you zoom in on them. You can set up procedural maps so that when you zoom in, more detail is apparent.

When you zoom in on an object, such as the brick in the image on the right, more detail

becomes obvious. Notice the jagged edges of the brick and the noise in the mortar. Procedural maps offer another advantage; they are 3D. They fill 3D space, so a marble texture, for example, goes through an object as if it were solid.

The flexibility of procedural maps offer a variety of looks. **3ds max** presents various procedural maps such as noise, water, speckle, swirl, gradients, and many more.

*Here is a sample of **3ds max**'s procedural materials.*

Combining Maps

3ds max allows you to combine both bitmaps and procedural maps in the same material, giving greater flexibility.

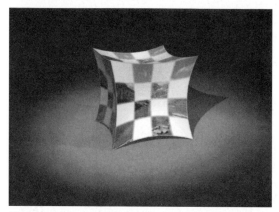

Here is a checkered Procedural map with a Bitmap.

Map Channels

When creating simple or complex mapped materials, you must use one or more of the map channels available in the Material Editor. Map channels give you the ability to use a bitmap or procedural map as the diffuse color, bump, specular, or any other map channel available. Maps can be used alone or in combination to get the look you want.

Map channels vary from shader to shader, but several common map channels are available. All map channels can be accessed in several ways.

Note: A shader is a mathematical definition of the properties of a surface. Specifically, shaders change the way a surface responds to light.

Accessing Map Channels

To choose a map, click the Map box to the right of the channel swatch in the Basic Parameters rollout for the selected shader. These map boxes appear next to the color swatches and spinner amounts. However, not all map channels are available in the Basic Parameters rollout.

To view all map channels specific to the shader, open the Maps rollout. When you do, all map channels are displayed.

You can change the Amount setting for the map by accessing the Map channels from this rollout. The Amount setting controls how much of the map is used to determine the look of the material.

The image on the left shows the map at 100%, while the image on the right shows the map at 25%, using the same gray diffuse color.

Here is the Maps rollout for the Blinn shader.

Map Channels

Several shaders offer additional map channel options. For example, the Multi-Layer, Oren-Nayar-Blinn, and Anisotropic shaders offer more map channels than the Blinn shader. This is due to the nature of shaders; more complex shaders offer more map channels

for customizing materials. See the following image of common map channels, using the Multi-Layer shader as an example.

Here is the Maps rollout for the Multi-Layer material.

Ambient Color—The Ambient map controls the amount and color of the ambient light on an object. The amount of ambient light on an object is affected by the Ambient value in the Environment dialog.

Note: Increasing the Ambient value in the environment causes the Ambient map to become brighter.

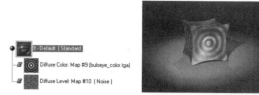

By default, this value is locked to the Diffuse value. You can unlock it by choosing the unlock button.

The left image shows the gray-scale bitmap used as the Ambient map; the right image shows the map applied to the surface of the object.

Diffuse Color—The Diffuse map channel is one of the most frequently used map channels. It determines the visible surface color of an object.

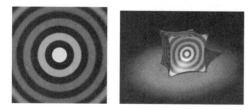

The left image shows the color bitmap used as the Diffuse map. The right image shows the map applied to the surface of the object.

Diffuse Level—This map channel determines the value of the Diffuse Color map channel based on the gray value of the map. This varies the brightness of a Diffuse Color map, which is useful for simulating dirt.

Note: You can use color or gray-scale images in any map channel. However, certain map channels only use the gray value of the map and discard the color information. Diffuse Level is one of these channels.

Diffuse Roughness—When using a map for this channel, the brighter values give the material a matte finish, a good feature for aging a surface.

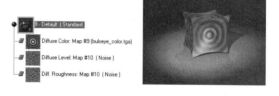

Changing the Diffuse Roughness value generally makes subtle changes in the look of the material.

Specular Color—This determines the color of the specular highlight on a material. Using a map or changing the specular color provides a variety of special surface effects.

Note: As a general rule, the specular highlight color of a surface in nature is based on the color of the light source, not the color of the surface.

Specular Level—Using a map in this channel varies the amount of the specular based on the gray-scale value of the map. With this feature, you can add surface dirt, smudges, or scuff marks to a material.

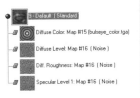

Glossiness—Glossiness affects the size of the specular highlight; darker values spread it out while brighter values sharpen it and make the highlight smaller. You can create a variety of surface types, from flat to shiny, in the same material.

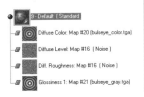

Notice the difference between the dark rings and the lighter rings in the surface of the object.

Anisotropy—The Anisotropy value determines the width of the specular highlight. Anisotropy works well for brushed metal, silk, and satin.

Orientation—This parameter deals with the rotation of the anisotropic highlight. You can add complexity to the specular portion of a material using this feature.

Self-Illumination—The Self-Illumination value has two options; the map uses the gray-scale value of a map to determine the self-illumination value, or the map acts as the self-illumination color.

Self-illumination as a Value

Self-illumination as a Color

Opacity—The Opacity value determines the opacity or transparency of a material based on a black or white setting. White is opaque and black is transparent. Opacity also presents several other options; it can be rendered with a filter color, as additive or subtractive.

Note: When using Opacity, the two-sided option makes the object appear whole by rendering the back of the interior faces.

2-Sided Off

2-Sided On

Opacity as Additive

The transparent parts of the material are added to the colors behind it, making the background brighter.

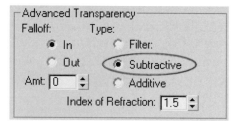

Opacity as Subtractive

The transparent parts of the material are subtracted from the colors behind it, making the background darker.

Filter Color—When creating transparent materials, you might want to add color to different areas of your material. The filter color can be used to create a stained glass effect.

Bump—The effect of a bump on an object can be dramatic. Bump maps create the illusion of sunken and raised portions of a surface by setting a positive or negative value in the amount area. This effect allows you to fake geometry such as a rocky surface or dents.

Reflection—Use this parameter to create reflective materials, such as mirrors, chrome, shiny plastic, etc. You have many map type options when it comes to using the Reflection map channel.

Raytrace map as a Reflection

Using the Raytrace map in the Reflection channel gives you realistic results, due to the nature of ray-traced reflections. However, complex scenes can take long to render, but it's worth the wait.

Reflect/Refract map as a Reflection

The second method of creating a relatively realistic reflection is to use the Reflect/Refract map. While this doesn't generate as realistic a reflection as the Ray-trace map, it can render faster and works in most circumstances.

Bitmap as a Reflection map

While the two previous types of reflection maps generate a reflection automatically, you might not always need an automatic reflection. In instances where you are trying to make an object look shiny or metallic, you can use a bitmap as the reflection.

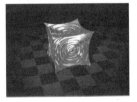

Flat Mirror as a Reflection

The Flat Mirror map is specially made for flat, planar objects, such as mirrors, floors, or any other flat surface. It provides a good quality reflection while rendering quickly. Notice the reflection on the floor in the following image.

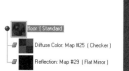

Refraction—Use refraction to create glass, crystal, water, or any other transparent object that contains an index of refraction. You have many options when it comes to using the Refraction map channel.

Index of Refraction (IOR)—Refraction happens when light passing through an object is bent. The amount the light bends depends on the type of material the light is passing through. For example, a diamond bends light differently than water. The amount of bend is known as the Index of Refraction.

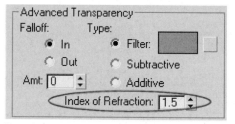

Here is the Index of Refraction value type-in.

Raytrace as Refraction Map

Using the Raytrace map in the Refraction map gives you realistic results. Due to how ray tracing works, it is particularly well suited for refraction as well as reflection. Achieving realism comes at the price of render time. Ray-tracing refraction can take quite a long time, even on a fast computer. But once again, it's worth the wait.

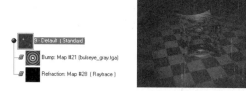

Reflect/Refract as Refraction map

While the Reflect/Refract map is not physically accurate like Ray tracing, it can be used effectively as a Refraction map. It renders relatively quickly compared to ray tracing.

Thin Wall Refraction as a Refraction map

As with the Reflection map, you can use Thin Wall Refraction as a Refraction map. While it is not correct refraction, it can be effective to get the point across.

Displacement—This map has a unique function; instead of affecting the look of the material, it changes the topology of the object it's assigned to. The visual results resemble the bump map. However the displacement map creates new geometry, and pushes or pulls it based on the gray-scale value of the map used. The Displacement map can create everything from terrain to the raised plastic letters on a credit card. To use this map, you must add a Displace Approx. World Space Modifier to your object or the object must be an Editable Mesh.

Caution—This map generates additional geometry based on the values in the Displace Approx. modifier. Do not set these values too high or your render time increases dramatically.

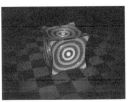

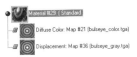

Maps are essential for the creation of high-quality materials that work with the geometry in your scene. Keep in mind you can use the many different map types **3ds max** offers in all of the map channels, giving you unlimited possibilities.

Creating Materials

Once you understand the basics of using maps, you can begin creating texture-rich environments.

The Poster

In this exercise, you add the poster image to the poster geometry in the scene. This material is one of the most basic, using only one bitmap image in the Diffuse color channel.

1. On the menu bar, choose File > Open and open *StreetScene_01.max* from the courseware CD.

Notice there are several missing textures and the curb map doesn't quite look right. You correct these problems as you progress through this chapter.

2. ⣿ On the main toolbar, choose Material Editor.

3. In the Material Editor, choose the first window in the second row, currently named Material #0.

4. In the Shader Basic Parameters rollout, choose Oren-Nayar-Blinn.

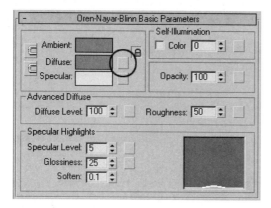

5. In the Oren-Nayar-Blinn Basic Parameters rollout, choose the Map box to the right of the Diffuse channel color swatch.

6. In the Material/Map Browser, double-click Bitmap.

7. In the Select Bitmap Image File dialog, open *Poster.tga* from the courseware CD.

8. In the Material Editor > bottom toolbar, choose Show End Result.

9. In the Bitmap Parameters rollout, choose View Image.

This opens the Specify Cropping/ Placement dialog.

Notice the white border around the poster. Instead of re-editing the image in a paint program, **3ds max** allows you to crop the image in the Material Editor. The Specify Cropping/Placement dialog gives you the option to either crop the image to a specific size or place the image to move it within the map.

Cropping the Poster

1. Continue from the previous exercise.

2. In the Specify Cropping/Placement dialog, choose UV from the toolbar.

 This option changes the method to determine where the image is cropped. UV is active by default; this crops the image based on the image's UV mapping coordinates. XY, however, is better suited for cropping bitmap images because it is based on the number of pixels in the bitmap and is a bit more straightforward.

3. In the Specify Cropping/Placement dialog, change X=**10**, Y=**10**, W=**450**, and H=**750**.

4. Close the Specify Cropping/Placement dialog.

 Note: This dialog sets cropping values to crop out the white border only. The image itself has not yet been cropped.

 When setting the crop values, the origin 0,0 is in the upper left corner of the image. The width and height is determined to the left and down from the origin.

5. In the Bitmap Parameters rollout, Cropping/Placement group, turn on the Apply check box to crop the bitmap.

 Make sure that the Crop feature is selected.

Applying the Material

Continue from the previous section.

1. In the Camera01 viewport, choose the Poster object.

2. In the Material Editor > bottom toolbar, choose Assign Material to Selection.

Note: The corner indicators are now white, indicating the material is applied to the selected object.

3. In the Material Editor > bottom toolbar, choose Show Map in Viewport.

This makes the bitmap display in the shaded viewport.

4. In the Material Editor > side toolbar, choose Material/Map Navigator.

5. In the Material/Map Navigator, choose the top-level material.

This returns you to the parent material parameters.

6. In the Oren-Nayar-Blinn Basic Parameters rollout, change Roughness to **31**, Specular Level to **44**, and Glossiness to **32**.

This gives the surface a look more like a poster printed on semi-gloss paper.

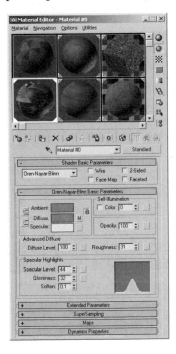

7. In the Material Editor > Name area, rename the material Poster.

Creating Complex Materials

While a simple material is sufficient at times, most materials in the real world are fairly complex. In the next example, you learn to create a complex material that incorporates several different map types. Look around you; examine the texture of objects and surfaces in the real world. You begin to realize that no surface has a simple texture. Some surfaces contain multiple layers and others are intricately designed. These aspects of material creation are important to keep in mind while working in the Material Editor.

The Street

The materials you create for the street surface are two distinct materials, the asphalt and the concrete gutter.

Creating the Asphalt Material

1. On the menu bar, choose File > Open and open *StreetScene_02.max* from the courseware CD.

2. Press M to open the Material Editor.

3. In the Material Editor > side toolbar, choose the Material/Map Navigator.

 This way, you see the progress made to the material as you build it and move around in the material easier.

4. In the Material Editor, use the scroll bars to choose a new Material window.

 Note: You are presented with a Standard material.

5. In the Material Editor > Name area, rename the material Asphalt.

6. In the Material Editor, right-click the Asphalt material window.

7. Choose Options from the right-click menu.

8. In the Material Editor Options dialog, set 3D Map Sample Scale to **2** and then choose OK.

 Note: This amount normally defaults to 100.

 You use 3D maps to create this material. The default size of the 3D map does not match the scale of the objects in the scene. Changing the size allows you to view the material closer to what will be rendered.

9. In the Blinn Basic Parameters rollout, choose the Map button next to the Diffuse Color swatch.

10. In the Material/Map Browser, double-click Stucco.

11.In the Stucco Parameters rollout, set Size to **0.2**, the Thickness to **0.0**, and the Threshold to **0.55**.

This makes the stucco smaller and increases the contrast between the white and black components of the map.

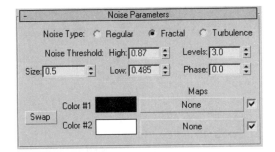

12.In the Stucco Parameters rollout, change Color #2 to R=**129**, G=**129**, and B=**129**.

13.In the Stucco Parameters rollout, choose the Color #1 Maps button.

14.In the Material/Map Navigator, double-click Noise.

15.In the Noise Parameters rollout, change Noise Type to **Fractal** and Size to **0.5**. Set Noise Threshold High to **0.87** and the Low to **0.485**.

16.In the Noise Parameters rollout, change Color #1 to R=**44**, G=**44**, and B=**44**. Change Color #2 to R=**146**, G=**146**, and B=**146**.

17.In the Material/Map Navigator, go to the top of the material.

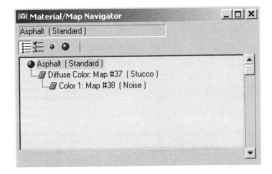

18. In the Maps rollout, drag the Diffuse Map button to the Bump map button.

This is a simple way of duplicating maps for use in other map channels.

19. In the Copy [Instance] dialog, choose Instance and then choose OK.

This makes an instance of the map so that changes in one channel are reflected in any other channel containing an instance of the same map.

	Amount	Map
☐ Ambient Color . . .	100	None
☑ Diffuse Color	100	Map #37 (Stucco)
☐ Specular Color . .	100	None
☐ Specular Level .	100	None
☐ Glossiness	100	None
☐ Self-Illumination .	100	None
☐ Opacity	100	None
☐ Filter Color	100	None
☑ Bump	30	Map #37 (Stucco)
☐ Reflection	100	None
☐ Refraction	100	None
☐ Displacement . .	100	None

20. In the Shader Basic Parameters rollout > Shader drop-down list, choose Oren-Nayar-Blinn shader.

This makes the material look more like a flat, asphalt surface.

21. In the Oren-Nayar-Blinn Basic Parameters rollout, set Roughness to **70**, Specular level to **12**, and Glossiness to **22**.

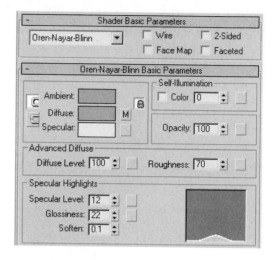

This adjusts the surface to look more like an asphalt surface.

22. Press the **H** key.

23. In the Select Objects dialog, choose Street and then choose Select.

24. In the Material Editor > bottom toolbar, choose Assign Material to Selection.

25. Right-click in the Camera viewport to make it active.

26. On the main toolbar, choose Quick Render.

You have just made a Quick procedural Asphalt. Experiment with these settings to get a variety of results.

Creating a Material for the Gutter

The Blend Material type is made up of three main components, namely two Material types and a Mask. The Mask can be either a bitmap or a procedural map. The Mask uses the value of the image to reveal Material 2 behind Material 1. The Blend Material can also be a straight cross fade between Material 1 and 2 by adjusting the Mix Amount, where 0.0 is 100% Material 1 and 1.0 is 100% Material 2.

To create the material for the cement gutter, you combine Standard Materials containing bitmaps and a procedural map for the Mask. The material uses a Gradient Ramp map as a Mask between a material that looks like wet concrete and one that looks like dry concrete. This adds realism to the look of the gutter where the water is flowing.

Creating a Blend Material

1. On the menu bar, choose File > Open and open *StreetScene_03.max* from the courseware CD.

2. Press **M** to open the Material Editor.

 Note: Depending on your system, you might experience a delay opening the Material Editor.

3. Use the scroll bars to choose a new Material window.

4. In the Material Editor > next to the Name area, choose the Material Type button.

 The Material/Map Browser is displayed with a list of different Material Types. — *Standard*

5. In the Material/Map Browser, double-click Blend.

6. In the Replace Material dialog, choose Discard old Material and then choose OK.

7. In the Material Editor > Name area, rename the material **My Concrete**.

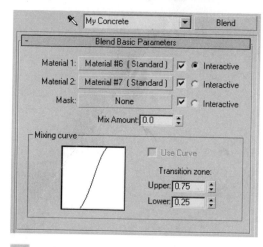

8. 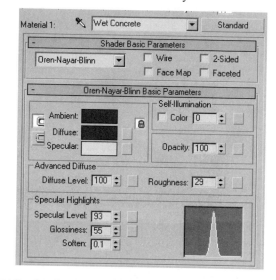 In the Material Editor > side toolbar, choose Material/Map Navigator.

9. In the Blend Basic Parameters rollout, choose Material 1.

10. In the Material Editor > Name area, rename Material 1 **Wet Concrete**.

11. In the Shader Basic Parameters rollout > Shader drop-down list, choose Oren-Nayar-Blinn.

 This gives a flatter-looking surface.

12. In the Oren-Nayar-Blinn Basic Parameters rollout, change the Diffuse color to R=**34**, G=**36**, and B=**36**.

 This changes the base color.

13. In the Oren-Nayar-Blinn Basic Parameters rollout, change Roughness to **29**, Specular level to **93**, and Glossiness to **55**.

This makes the surface shiny.

14. In the Oren-Nayar-Blinn Basic Parameters rollout, choose the Map button next to the Diffuse Color swatch.

15. In the Material/Map Browser, double-click Bitmap.

16. In the Select Bitmap Image File dialog, open *RIBCONC.JPG* from the courseware CD.

17. In the Material/Map Navigator, choose Material 1: Wet Concrete.

18. In the Maps rollout, drag the Diffuse Color Map to both the Diffuse Roughness Map and the Bump Map channels.

19. Choose Copy for the Diffuse Roughness Map and Instance for the Bump Map from the Copy [Instance] dialog.

20. In the Maps rollout, change Diffuse Color amount to **55** and Bump to **70**.

 Changing the Diffuse amount causes the Diffuse color to bleed through the bitmap image in the Diffuse channel; this is an

easy way to alter the color of a bitmap. Raising the Bump amount increases the effect of a bump.

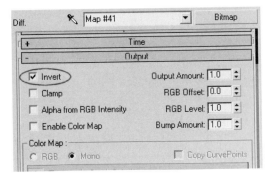

21. In the Maps rollout, choose the Diffuse Roughness Map channel.

22. In the Output rollout, turn on Invert.

This makes a negative of the bitmap in that channel.

23. In the Material/Map Navigator, go to the top of My Concrete Blend Material.

24. Drag and drop Wet Concrete from Material 1 onto Material 2.

25. Choose Copy from the Copy [Instance] dialog.

26. In the Blend Basic Parameters, choose Material 2.

27. Rename the material Dry Concrete.

28. In the Oren-Nayar-Blinn Basic Parameters rollout, change Roughness to **60**, Specular Level to **17**, and Glossiness to **22**.

This dulls the material since it is supposed to be dry and appear less shiny.

29. In the Maps rollout, change Diffuse Color amount to **100**.

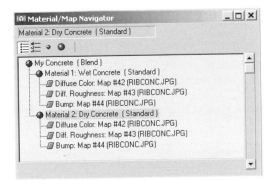

Tip: ||↑ Toggle Show End Result to see the material.

30. Your Material/Map Navigator should resemble the following image.

The Mask

Once the materials are set up, it's time to add a mask.

1. Continue from the previous exercise.

2. In the Material/Map Navigator, choose My Concrete Blend material.

3. In the Blend Basic Parameters rollout, choose None next to Mask.

4. In the Material/Map Browser, double-click Gradient Ramp.

5. In the Gradient Ramp Parameters rollout, click between the left and middle flags to add a fourth flag.

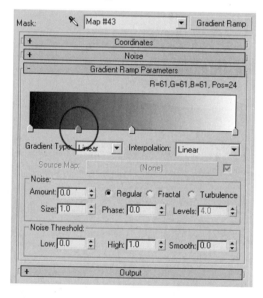

6. Right-click the flag on the far left, and choose Edit Properties from the right-click menu.

 Note: The flag on the far left is Flag #1 and the flag on the far right is Flag #2.

7. In the Flag Properties dialog, choose the color swatch and change the color of Flag #1 to white, R=**255**, B=**255**, and G=**255**.

8. In the Flag Properties dialog, choose the up arrow spinner to the right of the flag name to advance to the next flag.

 Flag #2's properties are displayed.

9. In the Flag Properties dialog, choose the color swatch and change the color of flag #2 to Black, **0,0,0**.

10. Advance to Flag #3 and change its color to black and its Position to **47**.

11. Advance to Flag #4, change its color to white and its Position to **31**.

This positions the flag on the gradient bar where it corresponds with the wet to dry boundary on the concrete.

12. Close the Flag Properties dialog.

13. In the Gradient Ramp Parameters rollout > Noise group, set Amount to **0.3**, Size to **5.49**, Type to Turbulence, and Levels to **7.0**.

This gives the edge of the wet concrete a varied, more realistic appearance.

14. In Material Editor > bottom toolbar, turn off Show End Result.

This displays only the current map.

15. In the Material/Map Navigator, choose My Concrete Blend Material.

16. In the Camera01 viewport, choose the Gutter object.

17. In the Material Editor > bottom toolbar, choose Assign Material to Selection.

18. On the main toolbar, choose Quick Render.

mental ray and the Multi-Material Workflow

The mental ray renderer offers a whole new set of Materials and Maps for use specifically with mental ray. These Materials and Maps do not render properly with **3ds max**'s scanline renderer, so while you use the default renderer, they are usually hidden.

While working with the Material/Map Browser, you might have noticed a check box named Incompatible. It is in the Show group. When you turn on this box, you can see the hidden materials and/or maps. They are shown as unavailable to remind you they won't render properly.

mental ray Materials:

Several mental ray Maps:

When you use the mental ray renderer, these Materials and Maps become active and appear with a yellow sphere or parallelogram next to them. mental ray refers to these materials and maps as shaders.

Note: 3ds max refers to shaders as Phong, Blinn, Metal, etc.

These shaders were written for the mental ray renderer to produce realistic, natural effects, and include the Lume Tools maps.

An example of several mental shaders being used.

Descriptions of several of the shaders are as follows:

Edge —Simulates complex edges, such as fur.

Glass—Accurately represents glass with proper transparency and reflection.

Glow—Simulates an object having internal lighting.

Landscape—Helps you map materials to terrain in situations where a bitmap is impractical. With this map, you can set different effects for lowlands, mountains, cliffs, etc.

Material to Shader—Allows you to use another material in one of mental ray's map channels. Use Material to Shader to set up how you want a material to look, with highlights, etc. Then use it with the mental ray material, which doesn't include highlight control.

Metal—Creates realistic looking metal quickly and easily.

Water Surface—Accurately simulates water, and determines whether other materials are wet or dry.

Wet-Dry Mixer —Allows a material to change as it becomes wet. Simulates specular highlight and color saturation change. The wet change is shown on any material in an object using the Water Surface.

Note: The mental ray shaders can be used with the standard **3ds max** material types.

The mental ray materials include:

DGS Material—DGS stands for Diffuse-Glossy-Specular. This material can be used to simulate a variety of textures, from mirrors to shiny paint to brushed metal and frosted glass.

Glass—A glass-specific material for creating realistic glass.

Invisible—Makes objects invisible.

mental ray—Gives you the access to several advanced material mapping effects in mental ray.

The Basic Shaders group includes Surface and Shadow. Surface and Shadow provides choices for the kind of surface of an object and the type of shadow it casts.

The Caustics and GI (Global Illumination) group allows you to assign maps to affect the reaction of an object to indirect illumination.

The Extended Shaders group is where you set up special effects. Bump adds a bump map effect. Displacement adds special maps to control the surface of your object, such as a 3D Displacement map, or the Ocean map. Volume allows you to create fascinating volume effects, such as light beams, mist, and under-water effects.

Environment is for creating environment effects such as fog.

In the Optimization group, if you flag the material as opaque, mental ray won't spend time on transparent or translucent effects, speeding up render time.

In the Advanced Shaders rollout, you can add special maps for Contour and Light.

Note: Light maps are not provided with **3ds max**.

SSS materials—The four SSS materials allow you to simulate subsurface scattering. This is for materials that let some light through near the edges, such as jade, wax, and skin. SSS Fast Material is highly customizable and made for translucent objects. SSS Fast Skin Material is made to simulate human skin. SSS Fast Skin Material+Displace is like Fast Skin with support for a displacement map. SSS Physical Material is a more sophisticated version of the Fast Material.

Creating a mental ray Material

Next, you create two materials to use in a mental ray render.

1. On the menu bar, choose File > Open and open *mental_ray_candles.max* from the courseware CD.

 A scene with two candles and a globe loads. The renderer has been changed to the mental ray renderer.

2. Press **M** to open the Material Editor.

3. In the Material Editor, choose an unused sample window.

4. In the Material Editor > Name area, rename the material **Brass**.

5. In the Blinn Basic Parameters rollout, choose the Map button next to the Diffuse Color Swatch.

6. In the Material/Map Browser, double-click Metal (lume).

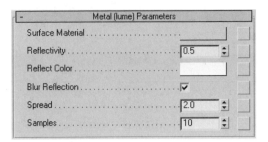

7. In the Metal (lume) Parameters rollout, select the Surface Material Color Swatch. In the Color Selector, set R=**0.922**, G=**0.846**, and B=**0.0**.

8. Set Reflectivity = **0.5**.

9. Set the Reflect Color to R=**1.0**, G=**1.0**, and B=**0.757**.

10. Turn on Blur Reflection.

11. Set Spread to **2.0**.

-	Metal (lume) Parameters	
Surface Material .		
Reflectivity .	0.5	
Reflect Color .		
Blur Reflection .	✓	
Spread .	2.0	
Samples .	10	

12. On the side toolbar, turn on Background.

13. Apply the Brass material to the two candle- holders in the scene.

14. In the Material Editor, choose another unused sample window.

15. In the Material Editor > Name area, rename the material **Candle**.

16. In the Blinn Basic Parameters rollout, choose the Map button next to the Diffuse Color Swatch.

17. In the Material/Map Browser, double-click Glow (lume)

18. In the Glow (lume) Parameters rollout, set Glow to R=**0.967**, G=**0.896**, and B=**0.706**.

19. Set Brightness = **2.0**.

20. Set Surface Material to R=**0.898**, G=**0.843**, and B=**0.749**.

21. Set Diffuse to R=**0.498**, G=**0.498**, and B=**0.498**.

22.Set Transparency to **0.8**

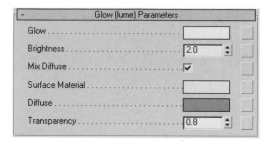

23.Apply the Candle material to the two candles in the scene.

24.On the main toolbar, choose Quick Render

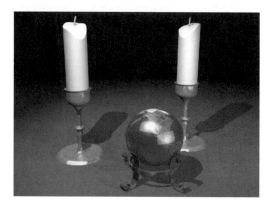

Note: The mental ray renderer renders using a different method than **3ds max**'s default renderer. Rather than rendering from top to bottom, it renders a square region that travels around the view.

To learn more about using the mental ray renderer, see chapters 17 to 19 and 21. To find out more about the mental ray materials and maps, you can use **3ds max**'s Help File, and the Additional Help file on Lume Tools.

UVW Mapping

So far, you've learned to apply materials to objects with UVW Mapping Coordinates already applied. In this section, you gain an understanding of what UVW Mapping Coordinates are and how to use them.

When using materials with 2D maps, it is important for objects to contain UVW Mapping information. This information tells **3ds max** how to project the 2D map onto the object. You apply UVW mapping coordinates to an object by adding a UVW Map modifier. The modifier allows you to control how the mapping is applied.

Many **3ds max** objects have default Mapping Coordinates, however they are preset. Loft objects and NURBS objects also have their own mapping coordinates, however their coordinates are controlled without adding a UVW Map modifier.

Objects might lose these mapping coordinates if a Boolean operation has been applied or if the object is collapsed into an Editable Mesh before a material using a 2D Map type is applied.

Note: Apply a UVW Map modifier only if you use a 2D Map types.

2D Maps:

3D Maps:

The UVW Map modifier

The UVW Map modifier is used to control the UVW Mapping Coordinates on objects. It offers the following parameters:

- Seven types of Mapping Coordinates.
- Size adjustments for each mapping type.

- Tile settings for repeating maps.
- Map channel settings.
- Alignment settings.

```
┌─────────────────────────────────┐
│  -         Parameters          │
│ ┌ Mapping: ────────────────────┐│
│ │    ⦿ Planar                  ││
│ │    ○ Cylindrical ☐ Cap       ││
│ │    ○ Spherical               ││
│ │    ○ Shrink Wrap             ││
│ │    ○ Box                     ││
│ │    ○ Face                    ││
│ │    ○ XYZ to UVW              ││
│ │                              ││
│ │  Length: [30.289  ] ◆        ││
│ │  Width:  [100.469 ] ◆        ││
│ │  Height: [65.01   ] ◆        ││
│ │                              ││
│ │  U Tile: [1.0   ] ◆ ☐ Flip   ││
│ │  V Tile: [1.0   ] ◆ ☐ Flip   ││
│ │  W Tile: [1.0   ] ◆ ☐ Flip   ││
│ └──────────────────────────────┘│
│ ┌ Channel: ────────────────────┐│
│ │  ⦿ Map Channel: [1 ] ◆       ││
│ │  ○ Vertex Color Channel      ││
│ └──────────────────────────────┘│
│ ┌ Alignment: ──────────────────┐│
│ │   ○ X   ○ Y   ⦿ Z            ││
│ │   [   Fit    ] [  Center   ] ││
│ │   [ Bitmap Fit] [Normal Align]││
│ │   [ View Align] [ Region Fit]││
│ │   [  Reset   ] [  Acquire  ] ││
│ └──────────────────────────────┘│
└─────────────────────────────────┘
```

Mapping Types:

The Mapping selection determines how to apply the UVW coordinates to an object.

Planar:

This applies the UVW coordinates on a flat plane projected onto an object. It is used for flat surfaces such as paper, walls, or to apply a 2D map to any planar surface.

Cylindrical:

This mapping type uses a cylinder to project a map onto an object. Screws, pens, telephone poles, and pill bottles are some uses for a cylindrical map.

Note: Turning on the Cap option places a planar map projected from the top and bottom of the cylinder.

Spherical:

This wraps the UVW coordinates around an object in a spherical projection, creating a seam where the sides of the map meet and singularities at the top and bottom where the corners unite.

Shrink Wrap:

Like the Spherical map, this projects the map onto an object using a sphere. However, Shrink Wrap pulls all the corners of a map to one point, eliminating a seam and creating only one singularity.

Box:

A Box map is projected onto an object from six sides; each side is a Planar map. The face normals determine the placement of the map on an irregular surface.

Face Map:

This applies UVW Map Coordinates planar to each face of an object.

XYZ to UVW:

This type of mapping is designed for 3D Maps. It causes the 3D Map to "stick" to the surface when the surface is animated.

Mapping the Curb

In this exercise, you learn to apply a UVW Map modifier to an object and adjust the mapping coordinates.

The Curb, while a simple object, offers several opportunities to overcome some common concerns. The two objects you deal with require different types of UVW Map types. The Curb is not a simple, flat surface; it requires a Box type of UVW Map, while the broken chunk missing from the curb needs a modified Spherical map.

Applying UVW Map modifiers

1. On the menu bar, choose File > Open and open *StreetScene_mapping.max* from the courseware CD.

2. In the Camera viewport, choose the Curb object.

3. On the command panels, choose Modify.

4. On the Modifier panel > Modifier List drop-down, choose UVW Map.

```
Curb
Modifier List                      ▼
  ♀ ⊞  UVW Mapping
    ⊞  Editable Mesh
```

5. In the Parameters rollout, change the mapping type to Box, and set the Size to a Length, Width, and Height of **1'0.0"**.

```
─         Parameters         ─
┌ Mapping:
        ○ Planar
        ○ Cylindrical  ☐ Cap
        ○ Spherical
        ○ Shrink Wrap
        ◉ Box
        ○ Face
        ○ XYZ to UVW

  Length: 1'0.0"   ↕
   Width: 1'0.0"   ↕
  Height: 1'0.0"   ↕

   U Tile: 1.0      ↕ ☐ Flip
   V Tile: 1.0      ↕ ☐ Flip
   W Tile: 1.0      ↕ ☐ Flip
```

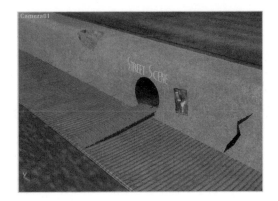

The Missing Chunk

1. Continue from the previous exercise.

2. In the Camera viewport, choose Curb Crack 02.

3. On the Modify panel > Modifier List drop-down, choose UVW Map.

4. In the Parameters rollout, change the Mapping type to Spherical, set Length to **0'9.0"**, Width to **0'9.0"**, and Height to **1'0.0"**.

```
─         Parameters         ─
┌ Mapping:
        ○ Planar
        ○ Cylindrical  ☐ Cap
        ◉ Spherical
        ○ Shrink Wrap
        ○ Box
        ○ Face
        ○ XYZ to UVW

  Length: 0'9.0"   ↕
   Width: 0'9.0"   ↕
  Height: 1'0.0"   ↕

   U Tile: 1.0      ↕ ☐ Flip
   V Tile: 1.0      ↕ ☐ Flip
   W Tile: 1.0      ↕ ☐ Flip
```

Adjusting the UVW Map Gizmo

Once the shape and size of the UVW Map is set, you need to position the Gizmo correctly.

1. Continue from the previous exercise.

2. In the modifier stack display, choose + next to UVW to open the UVW Map modifier.

3. In the modifier stack display, choose Gizmo.

4. In the Front viewport, move the spherical Gizmo as shown in the following image.

5. In the Top viewport, line the Gizmo up with the crack in the concrete as shown in the next image.

6. In the modifier stack display, choose UVW Mapping to get out of the sub-object level for the UVW Map modifier.

7. Right-click in the Camera viewport to make it active.

8. On the main toolbar, choose Quick Render.

Conclusion

In this chapter, you learned how mapped materials work and how to use a map as part of a material. You also learned what a procedural map is and to mix materials and maps to create complex textures.

You created a simple material using one bitmap and created a complex material using both procedural maps and bitmaps. The mental ray material and map types were used to create materials for candle holders and candles when using the mental ray renderer. Finally, you applied UVW mapping to objects and learned about different types of UVW mapping coordinates.

Mapping for Real Time

Objectives

After completing this chapter, you should be able to:

- Use the Unwrap UVW's modifier to make your own custom mapping.
- Use Render to Texture.
- Understand the benefits of texture baking.
- Understand and use the Normal Map creation tools.

Introduction

Once you have a core understanding of how to make materials in **3ds max**, you are ready to explore some of the more advanced features of mapping. These features include: the Unwrap UVW's modifier to make a custom UVW map; texture baking, a process used in the 3D industry to speed up rendering and add lighting and shadows to bitmaps; and Normal map creation, which is used to make a low-poly object look much more complex.

Unwrap UVW's

Unwrapping the UVWs on an object means you are making a custom UVW Map for your object. Rather than using one of the default UVW maps, you can place each polygon from your object to the position of your choice in the map. The UVW map options work well for certain objects, however you discover using Unwrap to map more complex objects makes sense. When you apply a 2D bitmap to your object afterward, **3ds max** looks in that area of the bitmap to figure out the part of the map to put on that polygon.

The Unwrap UVW modifier includes its own Edit UVW's dialog with many features to make the unwrap process easier.

In the Edit UVW's dialog, the goal is to divide your object's mesh into clusters. Clusters are a group of attached polygons that make creating the bitmap much easier. Clusters are usually divided into groups of polygons that face a similar direction, or polygons that have the same material. The larger the clusters, the easier it is to make the map. However you want to make sure you can identify the clusters while keeping warped polygons to a minimum. Warped polygons cause streaking, where pixels from the bitmap look more like blurred lines.

These clusters are arranged in UVW space, where U is the X-axis and V is the Y-axis in your map. The W is for the Z-axis, which is used most often with 3D procedural maps. The letters U, V, and W are used so you won't mix them up with the XYZ 3D space in your viewports.

When your object has an Unwrap UVW modifier in the Modify Stack display, the seams between various clusters are shown as green lines in the viewports.

Edit UVW's UI

When you add the Unwrap UVW's modifier, you see that it has a large button named Edit at the top of the Parameters rollout. Use this button to open the Edit UVW's dialog.

The dialog has its own menu bar, an upper and lower toolbar, and an Options Panel that appears below the dialog. The Options Panel includes tools you use while creating your clusters.

One key part of the Options Panel is the Selection Modes group. In this group, you choose if you want to select vertices, edges, or faces. When Select Element is turned on, you select the entire cluster when you choose it. This group also includes: buttons to increase and decrease the selection; a paint selection feature; the ability to select edge loops in Edge mode; and a Sync to Viewport check box.

Also located on the options panel are a Soft Selection group, buttons for rotating a selection +90 or -90 degrees, and access to more options.

You see your object's map layout in the Edit window. When you first open it, the map is displayed from one side of your object. Right-clicking in this window gives you access to a specific Edit UVW's quad menu with its own commands. These commands are also found in the Edit menu bar.

File Menu —Used to save and load your UVWs for this map. You may also reset your UVW map to what it was before you added Unwrap. These options are also available under the Edit button in the Parameters rollout.

Edit Menu —Allows you to choose among different transforms or to copy and paste UVs.

Select Menu —Converts selections among different selection modes.

Tools Menu —Offers you several tools to use while setting up your map. Most of the tools are also found in the special Unwrap quad menu.

Mapping Menu —Gives you three tools to start your clusters.

Options Menu —Allows you to change your Edit UVW's options.

Display Menu —Gives you several options for the display of your mesh and the background map.

View Menu —Lists the view controls also found on the bar at the bottom of the Edit dialog. They work just like the viewport tools.

The Edit UVW's toolbar includes the transform tools: Move, Rotate, Scale, and Mirror. They work as you would expect them to. Freeform Mode is different, and is probably the tool you use most.

When Freeform is active, selected sub-objects have a yellow box around them. Click and drag inside this box to move the selection, click and drag one of the side handles to rotate the selection, and click and drag a corner handle to scale the selection.

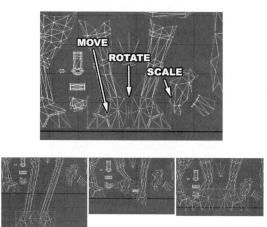

Holding down Shift constrains Move and Scale to one axis. Holding down Ctrl makes scale uniform and rotate work in five-degree increments. Holding down Alt scales about the center and makes rotate works in one-degree increments.

To help you with unwrapping, the Unwrap UVW modifier has a sub-object level named Select Face. You want to be in Select Face mode while you are setting up your clusters. When Select Face mode is selected, you cannot close the Edit window accidentally by deselecting your object in the viewports, and any selection in the Edit window is shown in the viewports. You are also able to select faces on your mesh by selecting them in the viewports instead of the Edit window. Selecting faces you want in the same cluster in a shaded viewport is easier at times than trying to find the faces in the Edit window.

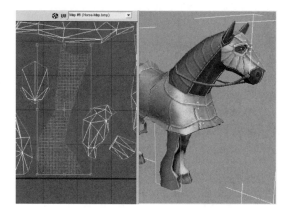

Any selected faces in the viewports select the corresponding sub-objects you have chosen in the Option Panel. So if you have Vertex chosen, selecting faces in a viewport will select the vertices around that face in the Edit window.

Unwrap Workflow

Here is the workflow to follow when using Unwrap UVWs.

- Typically, you start by using one of the mapping tools to get an initial group of clusters.

- Separate the clusters into groups that eventually combine into one cluster. This might include Breaking clusters apart.

- Use Stitch or Target Weld on the clusters that belong together.

- Check your clusters with a map and make sure you have little or no pixel stretching or squeezing.

- Arrange the clusters into a square and scale them to fit in the blue map square.

Mapping Tools

The Mapping tools are located on the menu bar in the Mapping menu. These tools can be used on the entire mesh or on a sub-object selection in the Edit window. There are three options:

Flatten Mapping —Opens a dialog that allows you to set an angle to divide the mesh into clusters. The algorithm starts with one face, and continues adding faces until it reaches a face that is rotated more than the angle you set. Flatten mapping is very versatile, and useful for most meshes to get a good starting point. If you set the angle too low, you get many single faces, but if you set the angle

near 90 degrees, you get a lot of distorted faces at the edges of the clusters. Normal or Unfold Mapping might give you an easier starting point, depending on the mesh.

Flatten Mapping with a Face Angle Threshold of 45 degrees.

The same model with a Face Angle Threshold of 80 degrees.

Normal Mapping —Opens a dialog allowing you to make clusters by starting with the direction in which the mesh's normals are facing. Options include Back/Front, Left/Right, and Box, among others.

Unfold Mapping —Unfolds the mesh's polygons so they are all perfectly flat in the Edit window. The downside: this feature is quite difficult to divide into useable clusters with complex meshes.

1. Start **3ds max**.

2. On the menu bar, choose File > Open and open *Ch16_UnwrapUVWs_1.max* from the courseware CD.

3. In any viewport, select the horse.

4. On the Modify panel > Modifier List drop-down, choose Unwrap UVW.

5. In the Modify Stack display, choose the + sign next to Unwrap UVW and then choose Select Face.

6. In the Parameters rollout, choose Edit.

 The Edit UVW'ss dialog is displayed.

7. On the menu bar, choose Mapping > Flatten Mapping.

8. In the Flatten Mapping dialog, set Face Angle Threshold to **75.0**, Spacing to **0.01**, and turn off Rotate Clusters. Click OK.

This is a nice starting point with several good clusters underway. However, there are also a lot of small faces that need sorting.

9. On the Options Panel > Selection Modes group, choose Face Sub-Object mode and then turn on Select Element.

10. Select several of the clusters in the Edit window.

The selected faces are highlighted in the viewports.

11. Make sure no faces are selected.

12. On the Mapping menu, choose Unfold Mapping.

13. Click OK in the dialog.

All the faces are unwrapped so they are flat, but they are difficult to cluster.

14. On the Mapping menu, choose Normal Mapping.

15. In the Normal Mapping dialog, choose Left/Right Mapping, and then turn off Rotate Clusters. Click OK.

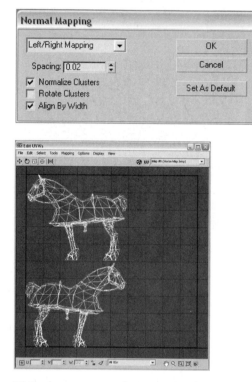

This gives you two large main clusters. For the horse, this is the optimal starting point.

Grouping Clusters

After you have your initial mapping layout, it's time to separate the faces into groups you later make into one cluster. Deciding which faces to put into each cluster can be difficult, but with time you'll know the clusters you want before you start the Unwrap process.

To help you know how the faces, edges, and vertices match up in your original mesh, when you make a selection, any vertices or edges coincident with the edges of your selection are highlighted in blue. This can save you time when you are trying to find adjacent faces in a selected cluster.

When one cluster has faces that you want to place into different clusters, use the Break command to break them apart.

While unwrapping, keep the following tips in mind:

• Whenever two faces in the unwrap don't meet, there is a seam along the edge between them.

• Keep seams in areas where they are difficult to notice or easy to hide on the map.

• Areas that have different looks can be in different clusters.

• Keeping the shape of the clusters similar to the mesh makes the map easier to paint.

1. Continue from the previous exercise, or choose File > Open and open

Ch16_UnwrapUVWs_2.max from the courseware CD.

2. If the Edit UVW's dialog is not open, select the horse. On the Modify panel > Parameters rollout, choose Edit.

3. On the Options Panel > Selection Modes group, choose Face Sub-Object mode.

4. Make sure Select Element is turned off.

5. In the Edit window, select the faces for the front leg on the upper cluster. Select from the hoof to the large polygons on the upper leg.

6. On the Options Panel > Selection Modes group, choose Expand Selection twice.

This selects the entire upper leg.

7. Right-click in the Edit window and choose Break from the quad menu.

8. Move the new clusters to an open area.

9. Repeat the previous steps to break the clusters for the front legs from the lower cluster.

10. On the Options Panel > Selection Modes group, turn on Select Element.

11. Click and drag the clusters for the front legs until you can see all four of them.

12. On the Options Panel > Selection Modes group, turn off Select Element.

13. Select the ears on both large clusters.

14. On the Options Panel > Selection Modes group, choose Expand Selection once.

15. Right-click and choose Break from the quad menu.

16. On the Mapping menu, choose Normal Mapping.

17. In the Normal Mapping dialog, keep Back/Front Mapping, and turn off Rotate Clusters. Click OK.

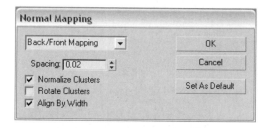

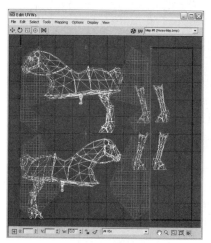

The ears are now mapped front to back, but they are large and the backs of the ears are missing a polygon.

18. Hold down Ctrl and scale the ears until they are about the size they used to be. Move them into an open space.

19. To find the missing faces for the backs of the ears, move the two large horse clusters (using Select Element) until you see the

extra clusters in the face. The missing faces are where the ears used to be.

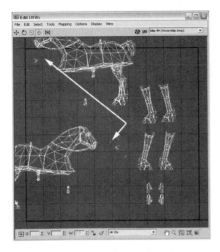

20. Select one of the faces for the ears.

When you select the correct face, the edges in the ear that it connects to turn blue.

21. Move the face next to the ear it connects to.

22. Repeat the previous procedure with the other faces.

Putting Clusters Together

You are now ready to start putting your clusters together. The two methods you use the most are Stitch and Target Weld. You can also Weld vertices but since the vertices have to be close for Weld to work, you usually use Target Weld instead.

To use Stitch, select the edge or edges on one cluster where you want to attach it to another cluster. Stitch then moves the other cluster over and attaches them at the selected edges.

To use Target Weld, click and drag a vertex over the vertex you want to Weld it to. The correct vertex is highlighted in blue, but you are able to weld any two vertices.

1. Continue from the previous exercise, or choose File > Open and open *Ch16_UnwrapUVWs_3.max* from the courseware CD.

2. If the Edit UVW's dialog is not open, select the horse.On the Modify panel > Parameters rollout, choose Edit.

3. On the Options Panel > Selection Modes group, choose Face Sub-Object mode.

4. Turn on Select Element.

5. Move the front legs so clusters that go on the same side are next to each other.

Tip: Use Select Face mode and/or the highlighted blue edges to help you.

6. On the Options Panel > Selection Modes group, choose Edge Sub-Object mode.

7. Turn off Select Element.

8. In the Edit window, select the edge shown below one of the legs.

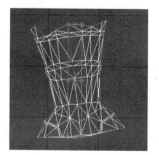

9. Right-click and choose Stitch Selected from the quad menu.

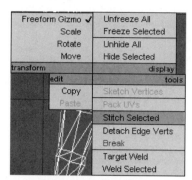

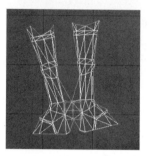

The two halves of the leg are now stuck together at that edge.

10. Pan and Zoom so you can see the leg.

11. Select the remaining eight edges on one side.

12. Right-click and choose Stitch Selected from the quad menu.

Notice that the distance between the edges is averaged when they are welded. If you had chosen all nine edges and stitched them in one step, the average would have moved the legs closer together and some of the polygons would have been very small.

This cluster works, even if it needs some work at the pixel stretching/squeezing phase because most of the faces between the sides of the leg are too big.

Note: Many artists like to stitch their clusters this way, which reduces the number of seams. With this mesh, you need to keep the legs in their left- and right-side clusters for easy painting of the bitmap.

13. Pan and Zoom so you can see the ears.

14. On the Options Panel > Selection Modes group, choose Vertex Sub-Object mode.

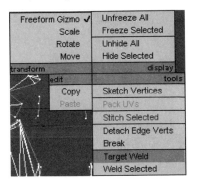

15. Right-click and then choose Target Weld from the quad menu.

16. Click and drag each vertex from the extra faces to where they belong on the backs of the ears.

Tip: When the vertex is going to weld, the cursor turns into crosshairs with white ends.

Testing for Pixel Stretching and Squeezing

At this step, you are ready to put a map on your object to see how well the map conforms to the surface. The map is usually a checkerboard pattern. You then adjust the surface to minimize the amount of pixel stretching and squeezing. Stretched areas appear as elongated checkers in the viewports, while squeezed areas contain skinny checkers.

With a checkered map on your object, it is easy to adjust the scale of your clusters. You want all the clusters at the same scale usually, otherwise the difference in image quality might be noticeable. On the other hand, a

character's faces are usually mapped at up to twice the scale of the rest of the clusters because people focus on the face more than any other part of the body.

1. Continue from the previous exercise, or choose File > Open and open *Ch16_UnwrapUVWs_4.max* from the courseware CD.

2. Close the Edit UVW's dialog.

3. 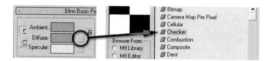 Press **M** to open the Material Editor.

4. Select the second sample slot and name it Checker.

 This material is currently applied to the horse.

5. In the Blinn Basic Parameters rollout, choose the None button next to Diffuse.

6. In the Material/Map Browser, double-click Checker.

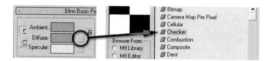

7. In the Coordinates rollout, set the tiling to **64** for both U and V.

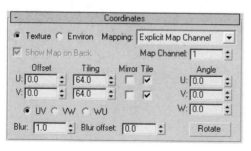

8. 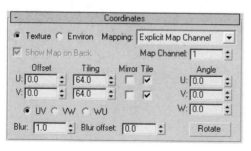 On the bottom toolbar, choose Show Map in Viewport.

9. You can see the checkerboard on the horse in the Perspective viewport. Areas where pixels will be stretched are obvious across the front of the armor and hooves.

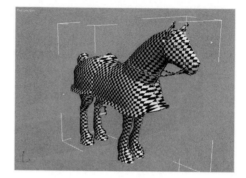

10. Press **M** to close the Material Editor.

11. Select the horse, and on the Modify panel > Parameters rollout, choose Edit.

 The checkered pattern is now shown as a background in the window. To turn it off, choose Show Map from the toolbar. The background map is useful when aligning clusters to a map, but it is difficult to see with the checkered background.

12. On the Modify panel, choose the + sign next to Unwrap UVW and then choose Select Face mode.

13. On the Options Panel > Selection Modes group, choose Vertex Sub-Object mode.

14. Turn off Select Element.

15. Region select one of the two original leg clusters and look at the selection in the Perspective viewport.

16. Right-click the Perspective viewport label and then choose Edged Faces.

17. Pan, Arc Rotate, and Zoom in the Perspective viewport so you have a good view of the selected faces.

18. If the faces are showing as solid red, press F2 so you can see the texture on the faces.

19. In the Edit window, select only the vertices along the front of the selected leg.

20. Hold down Shift and move these vertices away from the leg a little. When you release the mouse, check the Perspective viewport to see if you moved them enough.

The object is to get the checkers looking as square as possible. If the distortion is noticeable for more than one row of faces, you may want to use Soft Selection while adjusting the vertices.

21. Repeat the previous steps with the back of the leg.

When you get to the flat area in back, select a depth of two vertices because the flat area has very little distortion.

Arranging the Clusters

After you have made all your clusters and removed as much distortion in the faces as possible, it is time to arrange the clusters into a square. Ultimately, you need to fit the clusters in the blue map square shown in the Edit window, but the first step is to just get them into a square. They can then be scaled as a whole to fit the square.

Edit UVWs includes a tool named Pack UVs you can use to arrange the clusters. However, you can often get a better packing if you do it by hand. Pack UVs doesn't allow overlapping clusters, and often leaves areas with open space.

1. Choose File > Open and open *Ch16_UnwrapUVWs_5.max* from the courseware CD.

 This file contains the result of preparing all the clusters for the horse.

2. Select the horse. On the Modify panel > Parameters rollout, choose Edit.

3. On the Tools menu, choose Pack UVs.

4. In the Pack dialog, choose Recursive Packing from the drop-down list, and then set the Spacing to **0.01**. Turn on Fill Holes, and then click OK.

Pack UVs produces an acceptable layout, but there is quite a bit of wasted space.

5. Press Ctrl+Z to undo Pack UVs.

6. On the Options Panel > Selection Modes group, choose Face Sub-Object mode.

7. Turn on Select Element.

8. Try to arrange the clusters into a square layout. Keep in mind that you can rotate the clusters, but do so only at 90-degree increments.

9. When you are done, select all the clusters. Hold down the Ctrl key, and then Uniform Scale the clusters to fit the map square.

Following are two possible results.

In this layout, mapping space was optimized by overlapping similar clusters. It allows the maximum quality image for the object. The file with this mapping is saved as *Ch16_Unwrap_1.max*.

In this layout, all the clusters are separate. It allows you to map both sides of the horse differently. The file with this mapping is saved as *Ch16_Unwrap_2.max*.

After you are finished unwrapping your object, it is safe to convert the object to an Editable Mesh or Editable Poly. The unwrap information is stored as part of the object, and you can continue to edit it at a future time by adding an Unwrap UVW's modifier again.

Making the Map

Now that you are finished unwrapping your mesh, you are ready to make the map for your object. To get the layout into your paint program, you can use either the Print Screen button (PrtScn), or the Unwrap Object Texture utility, a free plug-in for **3ds max**.

Paint the map in your favorite paint program, saving the file every so often and testing it on your object to make sure lines match up across the seams. To see the map on your mesh, make a new material with a bitmap in the Diffuse Map channel. Choose your map and turn on Show Map in

Viewport. Apply the material to your object and see how it looks. You won't have much work to do to get the map to line up on your mesh correctly because you did it all when you set up the clusters.Make sure the mesh lines up at the seams.

From this point, when you save the map file, **3ds max** reloads the file automatically so you can see your changes immediately.

The images on the next page show some of the steps in the painting process.

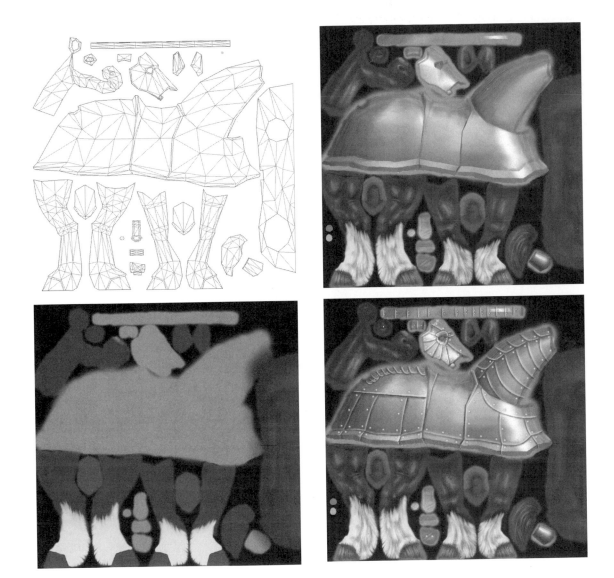

Render to Texture

Render to Texture is a feature located on the menu bar in the Rendering menu. Render to Texture takes one, or several, aspects of your texture and bakes it into one map for your object.

Texture Baking

Texture baking is a method by which an object's texture and/or other attributes, such as lighting or shadows, can be saved as a map for the object.

This process is widely used in various 3D industries. In the game industry, baked textures can be used to preserve lighting and shadows onto a character's map. Baked textures can also be used to save procedural maps to a bitmap, or multiple maps into one map. In other industries, texture baking is used on unanimated objects because it speeds up rendering considerably.

Two more common uses of texture baking are to bake Advanced Lighting (light from the Light Tracer or a Radiosity solution) or reflections onto an object. Both can add a lot of time to a render, so baking them into the texture can save time if you are doing a lot of rendering.

Note: If you bake a ray-traced reflection onto an object, the reflection is only accurate from the original view in which it was baked. This is because a ray-traced reflection depends on the point the object was viewed from, and gives unpredictable results on backfacing faces.

After baking an object's texture, that object can be excluded from all lights and no longer needs to have its lighting, shadows, reflections, or procedural maps calculated.

Scene with ray-trace maps and one light, rendered in 39 seconds.

Scene with two bitmaps and no lights, rendered in three seconds.

To bake a texture on an object, you first create the materials for the object and apply them. These can be either 3D procedural maps or 2D maps. The texture on the object is then baked and saved as a bitmap file. The bitmap is loaded automatically into the object's new texture.

Dependence on Mapping

For Render to Texture to work on an object, that object needs to have its UVWs unwrapped. If you have not already used Unwrap UVW to map your object, Render to Texture includes an automatic unwrap feature that works exactly like the Flatten Mapping described previously . The downside of using automatic unwrapping is that your unwrap is not combined into clusters, and if you have to edit the map later on it might be difficult.

It is also important that each face in the mesh have its unique UVs. If you have any overlapping faces, Render to Texture won't complain about any problems, but you see them in the map.

Notice the shadow of the reins in the following image . Rather then appearing realistic, the shadow comes to a point and mirrors at the center of the horse. The shadow on the horse's front legs is also mirrored. In this case, the first mapping from the previous section was used, which is the one optimized for space. Since similar clusters overlap, only half the texture was

rendered, and the other half ends up as mirrored.

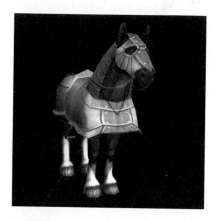

Render to Texture Process

The Render to Texture dialog has many features to help you with the render process. This dialog includes the following rollouts:

General Settings —Includes options for saving your baked image files and using the Render Settings.

Objects to Bake —Lists the selected objects in your scene so you know which are baked. You can also decide how the Projection Mapping is set up for a Normals Map (covered later in this chapter), and what

Mapping Coordinates you want to use. Unless you plan on using the automatic unwrap feature, it is important to make sure Use Existing Channel is selected here.

Output —Lets you choose the elements of the object to bake into an image. For example, you can choose to bake a complete map for your object, or perhaps just its lighting. You can also select the map size you wish to use.

```
┌─  ───────────── Output ──────────────┐
│ File Name       Element Name   Size      Tar│
│ Armored HorseCo...  CompleteMap  1024      Diffr│
│                                              │
│                                              │
│ ◄ │                 ││││                   ► │
│        Add...              Delete            │
│ ┌ Selected Element Common Settings ─────────┐│
│ │ ☑ Enable   Name: CompleteMap              ││
│ │ File Name and Type: Armored HorseCompleteMap.tga  ...│
│ │   Target Map Slot: Diffuse Color       ▼  ││
│ │ ☐ Use Automatic Map Size   Element Type: CompleteMap│
│ │  Size: 1024 ▲▼    64      256      768    ││
│ │                  128      512     1024    ││
│ ├ Selected Element Unique Settings ─────────┤│
│ │ ☑ Shadows                                 ││
│ └───────────────────────────────────────────┘│
└───────────────────────────────────────────────┘
```

Baked Material —Allows you to set how the Baked Material is created. Usually you keep the default when making a Shell Material. The Shell Material Type is covered later in this section.

```
┌─  ─────────── Baked Material ─────────────┐
│ ┌ Baked Material Settings ────────────────┐│
│ │ ○ Output Into Source                     ││
│ │ ● Save Source (Create Shell)             ││
│ │    ● Duplicate Source to Baked           ││
│ │    ○ Create New Baked                    ││
│ │    ┌ Standard:material:Blinn      ▼ ┐   ││
│ │                                          ││
│ │   Update Baked Materials   Clear Shell Materials│
│ │ ☐ Render to Files Only    ● Keep Source Materials│
│ │                           ○ Keep Baked Materials│
│ └──────────────────────────────────────────┘│
└────────────────────────────────────────────┘
```

Automatic Mapping —Includes parameters you can set for the automatic unwrap feature. They are the same as Flatten Mapping from Unwrap.

```
┌─  ─────────── Automatic Mapping ─────────────┐
│ ┌ Automatic Unwrap Mapping ──────────────────┐│
│ │ ☑ Rotate Clusters   Threshold Angle: 45.0 ▲▼││
│ │ ☑ Fill Holes            Spacing: 0.02   ▲▼││
│ ├ Automatic Map Size ────────────────────────┤│
│ │ Scale: 0.01 ▲▼         Min: 32        ▲▼  ││
│ │ ☐ Nearest power of 2    Max: 1024     ▲▼  ││
│ └────────────────────────────────────────────┘│
└──────────────────────────────────────────────┘
```

When you are ready, choose Render and wait while the texture is baked. When the render is finished, view a baked texture by setting a viewport to Flat shaded mode.

Rendering a Texture

In the following exercise, you bake a texture for the horse.

1. Choose File > Open and open *Ch16_Render_to_Texture_1.max* from the courseware CD.

 This scene contains the horse lit by four lights. Each light has its own color, and the main light casts shadows.

2. Select the horse.

3. On the Modify panel > Parameters rollout, choose Edit.

Notice that this is the version of Unwrap where each cluster has a unique location in the map. This is important for Render to Texture to work correctly.

4. Close the Edit UVW's dialog.

5. Make sure the Perspective viewport is active.

6. On the main toolbar, choose Quick Render to render the scene.

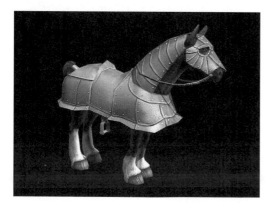

Notice that the horse has a bump map.

7. Close the Render window.

8. On the menu bar, choose Rendering > Render to Texture.

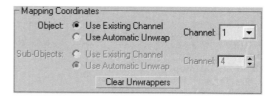

9. In the Render to Texture dialog > Objects to Bake rollout > Mapping Coordinates group, next to Object, choose Use Existing Channel.

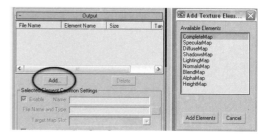

10. Scroll so you can see the Output rollout.

11. In the Output rollout, choose Add.

12. In the Add Texture Elements dialog, look at the list of available elements.

13. Choose CompleteMap and then click Add Elements.

Note: When you choose a Complete Map, the Target Map Slot is set to Diffuse Color by default. If not, choose Diffuse Color.

14. For the map size, select the **1024** button.

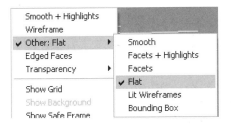

15. At the bottom of the Render to Texture dialog, choose Render.

16. While the texture is rendering, notice the lighting, colors, shadows, and bump map

are preserved as part of a new Diffuse map.

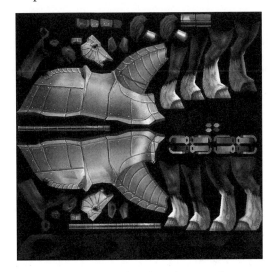

17. Minimize or close the Render window.

18. Close the Render to Texture dialog.

19. In the Perspective viewport, right-click the viewport label and then choose Other > Flat to view the horse in Flat shaded mode.

20. Use Arc Rotate to view the baked texture on the horse.

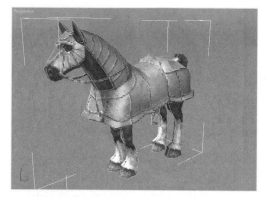

Notice that when using Flat shaded mode, the lights and shadows are ignored and all you see is the texture.

Shell Material Type

To see your map at its top quality, you want to render the viewport. However, if you render the viewport now, you see the horse with its original material, rather than the baked texture.

This is because the horse is now using a special material, called a Shell Material. The Shell Material is set to show the baked map in the viewports and the original map when you render. To see the baked material in a render, you have to go through a few steps.

Modifying the Shell Material

In the following exercise, you modify the Shell material so the baked texture can be seen in a render.

1. Continue from the previous exercise, or choose File > Open and open

Ch16_Render_to_Texture_2.max from the courseware CD.

2. Press **M** to open the Material Editor and then choose a new sample slot.

3. Choose Pick Material from Object.

4. Choose the horse to load its Shell material.

Notice the Original Material is an instance of the material that was on the horse before you used Render to Texture. The Baked Material is new. Also notice the Original Material is set to show in a Render, while the Baked Material is set to show in the viewports.

5. In the Render column, choose Baked Material.

The Baked Material will now show in a render, but the material still has the bump map, and the lights are added to it. The Complete Map is put in the Diffuse Map channel only, and everything else remains the same. You fix this in the next few steps so you see the Complete Map only.

6. In the Material Editor, choose the Baked Material.

7. In the Blinn Basic Parameters rollout, set Self Illumination to **100**. You do this because you render without lights.

8. In the Maps rollout, turn off the Bump Map.

9. In the Front viewport, select all four lights and then press DELETE.

10. Right-click to activate the Perspective viewport.

11. On the main toolbar, choose Quick Render.

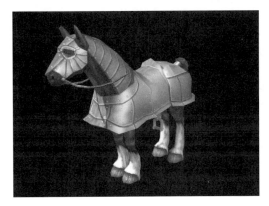

You now view the horse with the baked texture in a render. Notice that this render shows only the texture.

Normal Map Creation Tools

Normal maps are a fascinating and powerful map type that is relatively new to 3D modeling. Normal maps are used in the game industry to make a low-poly objects (3000 to 10,000 polygons) look much more complex (100,000 or more polygons).

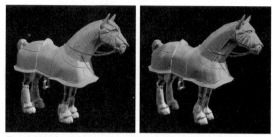

The high-poly horse (left) has 136,320 polygons, the low-poly horse (right) has 2130 polygons, and is rendered with a normals map as a bump map only.

A normal map works similar to a bump map in that it is used to make a flat surface look three dimensional. However normal maps are much more powerful than bump maps. Normal maps use RGB data in the image to store the exact angle of the surface at a particular pixel. With this information, the low-poly object looks just as complex as the high-poly object, except at the edges, where you see the low-poly silhouette.

To make a normal map, you use Render to Texture and a modifier named Projection. You also need a high- and low-poly version of the same object.

The high-poly object is usually set to Display as a Box because it might slow down the computer. The high-poly object cannot be hidden or have its Renderable property turned off, otherwise the projection does not work.

Texture Projection

When you are going to project the normals from a high-poly object, you want to make sure you have the low-poly object selected. Then you open the Render to Texture dialog. In the Render to Texture dialog > Objects to Bake rollout, there is a group named Projection Mapping. In this group, you choose Enabled to turn it on, and then choose Pick to choose the high-poly object in your scene.

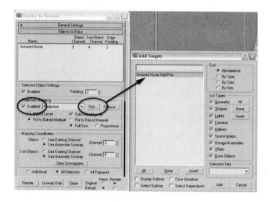

As soon as you choose Pick, a Projection modifier is added to your object. Alternatively, you can choose to add the Projection modifier first and use its Pick button in the Geometry Selection rollout to choose the high-poly object. The workflow is the same.

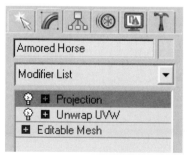

After the Projection modifier is added, you see a blue cage around your low-poly mesh. The cage shows how the high-poly mesh is going to project onto the low-poly object. You can adjust the cage from the Cage rollout if necessary, moving its faces individually if you chose Projection's Cage sub-object mode.

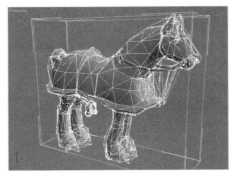

The cage is blue, but it is shown in white here to make it easier to see.

In the Render to Texture dialog > Objects to Bake rollout > Projection Mapping group, there is also an Options button. The Projection Options provide several features you can change. Most important is the Method group. Ray-trace means that the normal map is projected from one object to the other, while UV Match uses the Unwrap

UVW mapping to project the normals. UV Match is useful when the high-poly object was made from the low-poly object with the same Unwrap layout.

In the Resolve Hit group, there are two more options you should know about:

Include Working Model is the option to check if your high-poly object has holes in it, but your low-poly object doesn't. You use this if you were projecting a chain link fence onto a flat plane, for example.

Also notice that the Ray Miss Color is set to red. When you project a normal map, you see bright red in various parts of the render. This is because some areas are missed during the projection. You can try to correct it by adjusting the cage to more accurately follow the high-poly object.

To finish projecting a normals map, you use Render to Texture to render a normals map to a Normal Bump map in the Bump Map channel.

Normal Map Workflow

In the following exercise, you project a high-poly version of the horse onto the low-poly horse to make a normals map. You then view the horse with just the normals map and no texture.

1. Choose File > Open and open *Ch16_Normal_Map.max* from the courseware CD.

 This scene contains the low-poly horse and a high-poly version of the horse that currently displays as a box.

2. Select the Armored Horse object.

3. Right-click and then choose Hide Selection from the quad menu.

4. Select the box.

5. Right-click and then choose Properties from the quad menu.

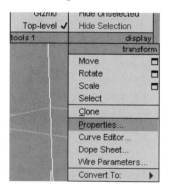

6. In the Object Properties dialog, turn off Display as Box and then click OK.

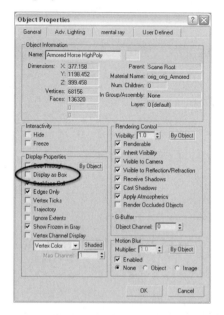

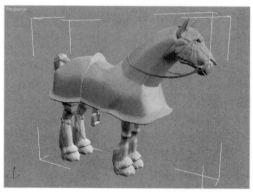

This is the high-poly version of the horse.

7. Right-click and then choose Properties from the quad menu again.

8. Turn on Display as Box and then click OK.

9. Right-click and then choose Unhide All from the quad menu.

	Isolate Selection
Element	Unfreeze All
Polygon	Freeze Selection
Face	Unhide by Name
Edge	Unhide All
Vertex	Hide Unselected
Top-level ✓	Hide Selection
tools 1	display
	transform
	Move

10. Select the Armored Horse object.

11. On the Rendering menu, choose Render to Texture.

Rendering	Customize	MAXScript	Help
Render...			F10
Environment...			8
Effects...			
Advanced Lighting			▶
Render To Texture...			0
Raytracer Settings			

12. In the Render to Texture dialog > Objects to Bake rollout > Projection Mapping group, turn on Enabled.

13. Still in the Projection Mapping group, choose Pick and then choose the Armored Horse HighPoly object.

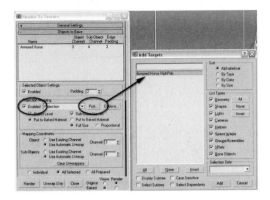

Notice that this adds the projection map with the cage. The cage is attempting to fit the high-poly horse.

Tip: If you do not see the cage, choose the Modify panel.

14. In the Mapping Coordinates group, choose Use Existing Channel for both Object and Sub-Objects.

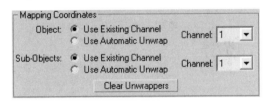

15. In the Options rollout, choose Add and then choose a NormalsMap. Click Add Elements.

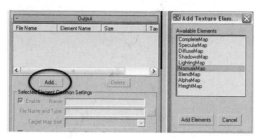

Note: When you choose a Normals Map, the Target Map Slot is set to Bump by default. If not, choose Bump.

16. For the map size, choose **1024**.

17. In the Selected Element Unique Settings group, turn on Output into Normal Bump.

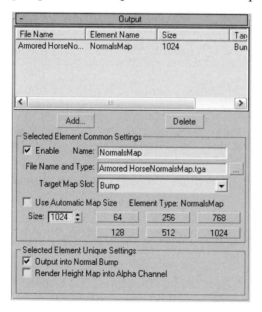

18. At the bottom of the Render to Texture dialog, choose Render.

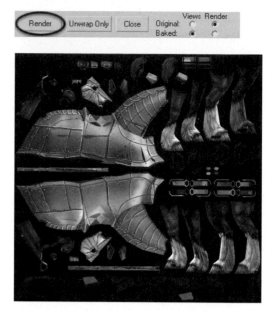

The displayed image is the Diffuse map with the two horses in the scene. Red areas show where the projection map missed. In this case, there are very few missed areas, so it is not a problem.

19. When the render is finished, close the render window.

20. Close the Render to Texture dialog.

21. Select the high-poly horse box.

22. Right-click and then choose Hide Selection from the quad menu.

23. Press **M** to open the Material Editor and select a new sample slot.

24. Choose Pick Material from Object.

25. Choose the horse to load its Shell material.

26. In the Render column, choose Baked Material.

27. 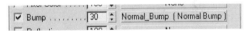 On the main toolbar, choose Quick Render.

28. The low-poly horse looks almost as good as the high-poly horse.

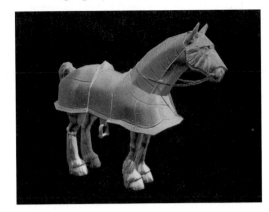

29. Close the Render window.

30. In the Material Editor, choose the Baked Material button.

31. Open the Maps rollout.

Notice there is a Normal Bump map in the Bump Map channel.

32. Select the Normal Bump map.

33. Choose the Normal channel button.

34. In the Bitmap Parameters rollout > Cropping/Placement group, choose View Image.

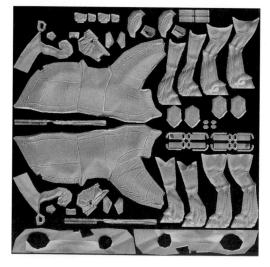

The previous image shows what a normals map looks like. Notice the use of the high-poly horse for the normal information and the horse's bump map.

Conclusion

In this chapter, you learned how to use the Unwrap UVW's modifier, bake textures, and make a normal map. You explored their features and the reasons for using them. The exercises taught you how to: unwrap your own models; bake bump maps, light, and shadow into your textures; and make a normals map so a low-poly object looks like a high-poly one. Now that you are done with the sample exercises, you can try them out on some objects of your own creation. For instance, Unwrap can be used for simpler applications than characters. For example, Unwrap is also excellent for chairs and sofas because it allows you to set the height and width of each side separately.

Materials Lab

Objectives

After completing this chapter, you should be able to:

- Apply UVW Map modifiers to objects.
- Adjust the UVW Map gizmo.
- Create Standard Materials.
- Apply various map types such as Bitmap, Noise, and Ray-trace.
- Use various Map channels such as Diffuse, Opacity, Bump, and Reflection.
- Merge objects from one scene to another.
- Projecting a Bitmap in a Spotlight.
- Use mental ray specific maps.

Introduction

In this lab, you create and apply materials to objects in an amusement park scene. Several MAX files have been created as parts of a "Tunnel of Love" amusement park ride. Using special tools, you can align the materials with the scene objects. You render the scene from time to time to check your progress.

Creating Materials for the Swan Boat

A model of a boat has been created but requires a material. The boat is in the shape of a swan. An image file, or bitmap, has been prepared that adds color to the boat when applied and aligned. In the following section you:

- Open a file and apply a UVW mapping modifier to the boat.
- Align the UVW gizmo to orient the bitmap image to the boat.
- Create and apply the material to the boat.

Applying a UVW Modifier

1. Start **3ds max**.

2. On the menu bar, choose File > Open and open *Ch17-01* from the courseware CD.

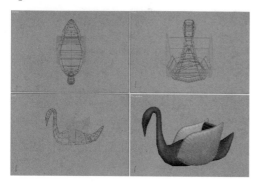

3. In the Perspective viewport, choose the Swan.

 The swan is a group composed of various objects. A texture map has been created for application from the side of the swan.

4. On the menu bar, choose File > View Image File, and then choose *swancolor.tif* from the courseware CD.

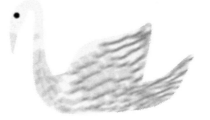

5. On the command panels, choose Modify.

6. On the Modify panel > Modifier List drop-down, choose UVW Map.

A Gizmo is displayed in all of the viewports as an orange line. The default type of the Gizmo is Planar. Planar means that the material is projected from one direction or plane.

Look at the Left viewport. The orange line cuts through the Swan group. You need to orient the mapping plane to the side of the Swan group.

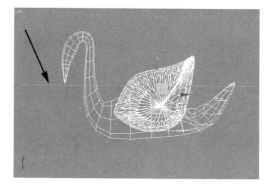

7. Right-click the Left viewport to make it active.

8. On the Modify panel > Alignment group, choose X.

The gizmo is now oriented to the World X-axis.

9. In the Parameters rollout > Alignment group, choose Fit.

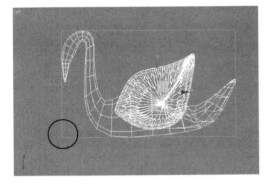

Fit adjusts the size of the gizmo to the size of the Swan group.

Note: The handle on the gizmo represents the top of the mapping orientation. Think of this handle as an antenna. If you apply a material at this point, the top of any bitmap image would appear to the left side of the screen and the image would rotate 90 degrees. You need to reorient the gizmo to have its handle pointing upwards (in the Left viewport).

10. On the Modify panel > modify stack display area, choose the (+) plus sign next to the UVW Mapping modifier to open the sub-object area of the gizmo.

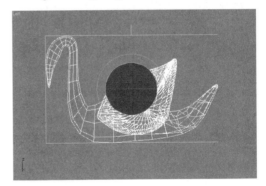

11. In the modify stack display, choose Gizmo to activate the sub-object level.

12. On the main toolbar, choose Angle Snap Toggle.

13. On the main toolbar, choose Select and Rotate.

14. In the Left viewport, rotate the gizmo –90 degrees on the Z-axis.

15. On the Modify panel > Parameters rollout > Alignment group, choose Fit.

16. On the Modify panel > modify stack display, choose *UVW Mapping* to exit Sub-Object mode.

17. On the menu bar, choose File > Save As, and save your file as *My-swan.max* in your courseware directory.

Creating the Swan Material

1. Continue working with the previous file, or choose File > Open from the menu bar, and open *Ch17-02.max* from the courseware CD.

2. 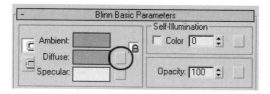 On the main toolbar, choose Material Editor.

3. In the Material Editor, choose the first sample slot in the upper left corner.

 A white box surrounds the sample sphere window, indicating this sample is current.

4. In the name area, type **Swan.**

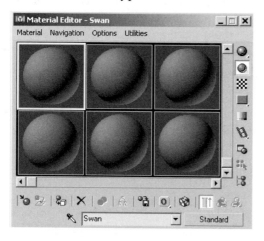

5. In the Material Editor > Blinn Basic Parameters rollout, choose the Map button to the right of the Diffuse color sample swatch.

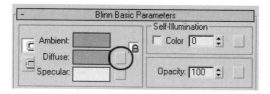

 The Material/Map Browser window is displayed.

6. In the Material/Map Browser, double-click Bitmap.

7. In the Select Bitmap Image dialog, choose *Swancolor.tif* from the courseware CD.

8. In the Bitmap Parameters rollout > Cropping/Placement group, choose View Image.

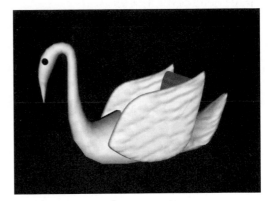

A view of the file is displayed.

Note: This group allows you to crop a smaller area of a larger image to use as the map. The bitmap image for the Swan group was created in an image-editing program.

9. Close the Specify Cropping/Placement dialog.

10. Make sure the Swan is still selected.

11. In the Material Editor > bottom toolbar, choose Assign Material to Selection.

12. In the Material Editor > bottom toolbar, choose Show Map in Viewport.

This icon shows the bitmap on the object in the viewport.

13. Right-click in the Perspective viewport to make it active.

14. On the main toolbar, choose Quick Render.

15. On the menu bar, choose File > Save As and save your file as *My-swan.max* in your courseware directory.

Creating materials for the Walls, Floor, and Ceiling

A scene has been created that contains the entrance to the "Tunnel of Love." The scene consists of walls, a floor, a ceiling and other elements that are currently hidden. You are only concerned with the walls, floor, and ceiling at this point.

Creating the Floor Material

1. On the menu bar, choose File > Open and open *Ch17-03.max* from the courseware CD.

2. Right-click to activate the Camera viewport, and then press F3 to display Smooth + Highlights.

3. Press **H**, and choose *Floor* from the Select Object dialog.

4. Press **M** to open the Material Editor.

5. In the Material Editor, choose the first Sample slot.

6. Rename the material Floor.

7. In the Blinn Basic Parameters rollout, choose the gray Map button to the right of the Diffuse color swatch.

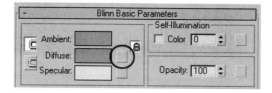

Note: If you don't see the rollout in the Material Editor, simply right-click in the open area of any rollout to select the one you want to access.

8. In the Material/Map Browser double-click Bitmap.

9. In the Select Bitmap Image File dialog, choose *Floor.tif* from the courseware CD.

10. In the Material Editor > side toolbar, choose the Material/Map Navigator.

The Material/Map Navigator dialog is displayed.

11. In the Material/Map Navigator, choose Floor (Standard) to return to the top or root of the Material.

12. In the Maps rollout, turn on Bump and change Bump Amount to **400**.

13. In the Map rollout, choose None next to Bump.

14. In the Material/Map Browser, double-click Bitmap.

15. In the Select Bitmap Image dialog, choose *Floortile-bump.tif* from the courseware CD.

16. In the Material Editor > Coordinates rollout, change the Tiling values to U=**26.0**, V=**16.0**.

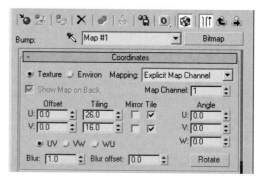

17. Drag and drop the Floor material to the floor object in the Camera viewport.

18. Right-click the Camera viewport.

19. On the main toolbar, choose Quick Render.

You get an error message because there is no default mapping coordinates for this object.

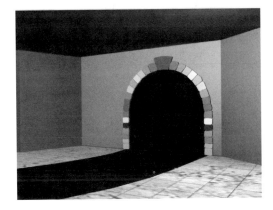

20. Choose Cancel to close the warning dialog.

21. On the Modify panel > Modifier List drop-down, choose UVW Map.

Note: You can also choose Modifiers > UV Coordinates > UVW Map from the menu bar as an alternative to the Modifier List drop-down.

22. Leave the default Planar mapping coordinates in place.

23. In the Material/Map Navigator, choose the top level of the material.

24. In the Material Editor > bottom toolbar, choose Show Map in Viewport.

25. Make sure the Camera viewport is still active.

26. On the main toolbar, choose Quick Render.

When you create objects using the standard primitives such as a Box or Sphere, **3ds max** generates mapping coordinates for that object type automatically.

☑ Generate Mapping Coords.

When objects are created or imported using other methods, mapping coordinates may not have been generated. The UVW Mapping modifier is one way to apply mapping coordinates.

27. On the menu bar, choose File > Save As and save your file as *Mytunnel.max*.

Creating the Middle Wall Material

1. Continue working on your file from the previous exercise, or choose File > Open from the menu bar, and choose *Ch17-04.max* from the courseware CD.

2. In the Camera viewport, choose Wall-mid.

 This group consists of the middle wall and the stones surrounding the tunnel.

3. On the menu bar, choose Rendering > Material/Map Browser.

4. Adjust the position of the window so you see the amera viewport.

5. In the Material/Map Browser > Browse From group, choose Mtl. Library.

6. In the Material/Map Browser > File group, choose Open.

7. In the Open Material Library dialog, choose *Walls.mat* from your courseware CD.

8. In the Material/Map Browser > Show group, choose Root Only.

9. In the Material/Map Browser, choose the Wall-mid material.

 The Material/Map Browser shows the Wall-mid Material in the window.

10. Drag the material onto the Wall-mid selection in the Camera viewport.

11. In the Assign Material dialog, choose Assign to Selection.

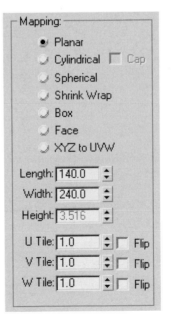

12. Make sure the Wall-mid group is selected.

13. On the Modify panel > Modifier List dropdown, choose UVW Map.

14. Right-click the Front viewport to make it active.

15. On the Modify panel > Parameters rollout > Alignment group, choose View Align.

This aligns the Planar mapping coordinates to the Front viewport.

16. In the Mapping group, set Length=**144**, and Width=**240**.

17. Right-click in the Camera viewport to make it active.

18. On the main toolbar, choose Quick Render.

19. On the menu bar, choose File > Save As and save your file as *Mytunnel.max*.

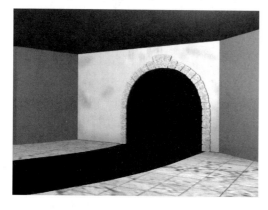

Creating the Side Wall Materials

To create the side wall material, you need to copy the Wall-mid material to the Material Editor, and make a duplicate of the material. You then change some of the parameters to make the new material unique to suit the side walls.

1. Continue working from the previous exercise, or choose File > Open from the menu bar, and open *Ch17-05.max* from the courseware CD.

2. Press M to open the Material Editor.

3. In the Material Editor, choose the second sample sphere.

4. In the Material Editor, choose the Pick Material from Object, next to the Name area.

5. In the Camera viewport, choose the Wall-mid object.

 This instances the material into the selected sample slot of the Material Editor.

 Note: White triangles appear at the corners of the sample slot. The unfilled triangles indicate that the material is used in the scene. The filled triangles indicate that the material is used in the scene *and* is applied to the selected object.

6. In the Camera viewport, choose the Wall-mid group.

 The corners of the sample slot for the Wall-mid material are filled in.

7. In the Material Editor, click and drag the Wall-mid sample sphere one slot to the right.

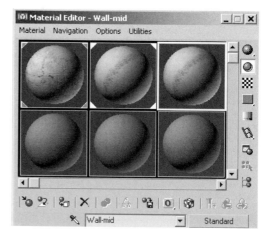

Note: The materials in sample slots 2 and 3 are named the same. It is essential to rename the copied material to a unique name, so you don't accidentally re-assign materials to objects in the scene.

8. Rename the new material Walls-side.

9. Press **H** and choose Wall-left from the Camera viewport.

10. In the Material Editor > bottom toolbar, choose Assign Material to Selection.

11. Right-click in the Camera viewport to make it active.

12. On the main toolbar, choose Quick Render.

The material seems to be mirrored from one wall to the other. You adjust the mapping of the Wall-left material to appear unique.

13. Close the Rendered Frame Window.

14. In the Material Editor > Maps rollout, choose Map#8 (*wall2.tif*) next to Diffuse Color.

15. In the Bitmap Parameters rollout > Cropping/Placement group, choose View Image.

16. In the Specify/Cropping Placement, move the handles of the cropping tool to the

lower left of the bitmap image to avoid any of the arch image elements.

17. Close the Specify Cropping/Placement window.

18. In the Cropping/ Placement group, choose Apply.

19. In the Camera viewport, choose the Wall-right object.

20. In the Material Editor > bottom toolbar, choose Assign Material to Selection.

21. On the main toolbar, choose Quick Render.

Creating a Quick Material for the Ceiling

1. Continue from the previous exercise.

2. In the Camera viewport, choose the ceiling object.

3. Select an available sample slot in the Material Editor.

4. Rename the Material Ceiling.

5. In the Blinn Basic Parameters rollout, set Self-Illumination to **33**.

The ceiling needs less lighting this way. Be careful not to set the Self-Illumination too high because you lose contrast on the object.

6. In the Blinn Basic Parameters rollout, choose the color swatch next to Diffuse.

7. In the Color Selector dialog, set the color to R=**200**, B=**200**, G=**200**.

8. Close the dialog.

9. In the Material Editor > bottom toolbar, choose Assign Material to Selection.

10. Make sure the Camera viewport is active.

11. On the main toolbar, choose Quick Render.

12. On the menu bar, choose File > Save As and save your file as *Mytunnel2.max*.

Note: It is a good idea to save different versions of your work.

Creating Materials for the Water and the Curb

Creating the Water Material

1. Continue working on the previous file, or choose File > Open from the menu bar, and open *Ch17-06.max* from the courseware CD.

2. Click in any open area of the Camera01 view to unselect all objects.

3. On the command panels, choose Display.

4. On the Display panel > Hide rollout, choose Hide Unselected.

Hide

Hide Selected
Hide Unselected
Hide by Name...
Hide by Hit

Unhide All
Unhide by Name...

☐ Hide Frozen Objects

5. In the Hide rollout, choose Unhide by Name.

6. In the Unhide Objects dialog, choose Curb and Water, and then choose Unhide.

Tip: Hold CTRL to add to the selection.

7. In the Camera01 viewport, choose the Water object.

8. Press M to open the Material Editor.

9. In the Material Editor, choose a free sample slot.

10. Rename the material **Water**.

11. In the Material Editor > Blinn Basic Parameters rollout, choose the Map button next to the Diffuse color swatch.

12. In the Material/Map browser dialog, double-click Bitmap.

13. In the Select Bitmap Image File dialog, choose *Water.tif* from the courseware CD.

14. Drag and drop this material to the Water object in the Camera viewport.

15. On the command panels, choose Modify.

16. In the modify stack display area, notice that a Displace modifier is applied to the Water geometry.

17. In the Material Editor > Bitmap Parameters rollout, drag and drop *Water.tif* to the Image Bitmap None area of the Displace modifier.

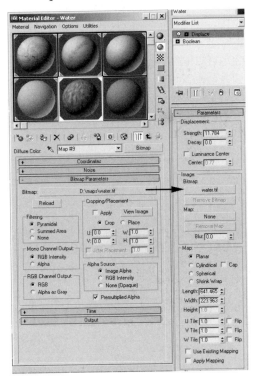

This bitmap changes the shape of the Water object based on the gray-scale value of the image and the Strength setting in the Displace modifier.

18. On the Modify panel > Modifier List drop-down, choose UVW Map.

19. In the Material Editor > bottom toolbar, choose Go to Parent.

20.In the Material Editor > Maps rollout, set Reflection to **45**.

21.In the Maps rollout, choose None next to Reflection.

22.In the Material/Map Browser, double-click Raytrace.

The Ray-trace map calculates reflections on the water's surface.

23.Make sure the Camera viewport is active.

24.On the main toolbar, choose Quick Render.

25.On the menu bar, choose File > Save As and save your file as *Mytunnel2.max.*

Creating a Procedural Map for the Curb Object

1. Continue from the previous exercise, or choose File > Open and open *Ch17-07.max* from the courseware CD.

2. In the Camera viewport, choose the Curb.

3. Press M to open the Material Editor.

4. In the Material Editor, pick an unused sample slot and rename the material Curb.

5. In the Blinn Basic Parameters rollout, choose the gray Map button to the right of the Diffuse color swatch.

6. In the Material/Map browser, double-click Noise.

7. In the Noise Parameters rollout, set Size to **2.0**.

8. In the Material Editor > bottom toolbar, choose Go to Parent.

9. In the Maps rollout, set Bump to **100**.

10.In the Maps rollout, choose None next to Bump.

11.In the Material/Map Browser, double-click Tiles.

12.In the Coordinates rollout, change the U Tiling to **4.0**.

13.In the Standard Controls rollout, change the Preset Type to Stack Bond.

14.In the Advanced Controls rollout, set Horiz. and Vert. Count to 8Set Color Variance to **0.4** and Fade Variance to **0.2**.

15. Drag and drop this material to the curb object in the Camera viewport.

16. In the Material Editor > bottom toolbar, choose Show Map in Viewport.

17. On the command panels, choose Modify.

18. Make sure Curb is selected.

19. On the Modify panel > Modifier List drop-down, choose UVW Map.

20. In the Parameters rollout > Mapping group, choose Box.

21. On the main toolbar, choose Quick Render.

Applying a Material with an Opacity Channel

1. Continue from the previous exercise, or choose File > Open and open *Ch17-08.max* from the courseware CD.

2. Close the Rendered Frame Window if it is currently open.

3. On the command panels, choose Display.

4. On the Display panel > Hide rollout, choose Unhide by Name.

5. In the Unhide Objects dialog, choose all Railing and Post objects and click Unhide.

6. Press **H** and choose the *Railing-01*, *Railing-02* and *Railing-03* from the list.

7. Press **M** to open the Material Editor.

8. Use the scroll bars to display more sample windows.

Note: As an alternative, you can display more sample slots in the Material Editor by right-clicking one slot and choosing either 5 x 3 or 6 x 4.

9. Select an empty sample slot.

10. Rename the material Railing.

11. In the Material Editor > bottom toolbar, choose Assign Material to Selection.

12. In the Maps rollout, choose None next to Diffuse.

13. In the Material/Map Browser, double-click Bitmap.

14. In the Select Bitmap Image File dialog, choose *Rail.tif* from the courseware CD.

15. In the Material Editor > bottom toolbar, choose Go to Parent.

16. In the Maps rollout, choose None next to Opacity.

17. In the Material/Map Browser double-click Bitmap.

18. Choose *Rail-alpha.tif* from the courseware CD.

19. On the bottom toolbar, choose Go to Parent.

20. On the bottom toolbar, choose Show Map in Viewport.

Note: Turning on Show Map in Viewport at the root level in this case displays both the Diffuse map and the Opacity map in the viewport.

Both the Diffuse and the Opacity channels are visible in the Camera01 viewport. (Some video cards may be unable to show this.)

21. Right-click in the Camera viewport, and choose Unhide All from the quad menu.

22. On the main toolbar, choose Quick Render.

23. On the menu bar, choose File > Save As and save your file as *Mytunnel3.max*.

Merging the Swan

1. Continue from the previous exercise, or choose File > Open and open *Ch17-09.max* from the courseware CD.

2. Close all open dialogs.

3. On the menu bar, choose File > Merge.

4. In the Merge File dialog, choose *Ch17-MergeSwan.max* from the courseware CD.

5. In the Merge dialog, choose [Swan], and then choose OK.

6. On the main toolbar, choose Select and Move, and then right-click.

7. In the Move Transform Type-In, enter the following Absolute: World values: X=**14**, Y=**-85**, Z: **45**.

8. On the main toolbar, choose Select and Rotate.

9. In the Rotate Transform Type-In dialog, set the Absolute: World Z Angle to **-20**.

10. Close the Transform Type-in dialog.

11. Make sure the Camera viewport is active.

12. On the main toolbar, choose Quick Render.

13. On the menu bar, choose File > Save As, and save your file as *Mytunnel4.max*.

Projecting a Bitmap in the Spotlight

1. Continue from the previous exercise, or choose File > Open and open *Ch17-10.max* from the courseware CD.

2. Press H, and choose Spot01 from the Select Objects dialog.

3. On the command panels, choose Modify.

4. On the Modify panel > Advanced Effects rollout, choose None next to Projector Map.

5. In the Material/Map Browser, double-click Bitmap.

6. In the Select Bitmap Image File dialog, choose *Water-bw.tif* from the courseware CD.

7. Make sure the Camera viewport is active.

8. On the main toolbar, choose Quick Render.

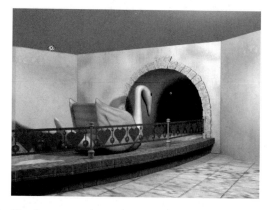

9. On the menu bar, choose File > Save As and save your file as *Mytunnel-final.max*.

Creating Materials To Use with mental ray

Next, you open the scene in a file set to use the mental ray renderer and add some mental ray shaders.

Merging the Lamp Post

1. On the menu bar, choose File > Open, and open *Ch17-11.max* from the courseware CD.

 This file is the same as the previous final file, except it is set to render with the mental ray renderer.

2. Close all open dialogs.

3. On the menu bar, choose File > Merge.

4. In the Merge File dialog, choose *LightPost.max* from the courseware CD.

5. In the Merge dialog, choose all three objects, and then choose OK.

Creating a Metal Material for the Post.

1. Continue working on the previous file, or choose File > Open from the menu bar, and open *Ch17-12.max* from the courseware CD.

2. Press M to open the Material Editor.

3. In the Material Editor, select an unused sample slot, and name it Red Metal.

4. In the Material Editor > side toolbar, turn on Background.

5. In the mental ray connection rollout, turn off Lock next to Surface.

This means you use the Standard Material type but override the default Diffuse option to use the mental ray Surface.

6. Choose None next to Surface.

7. In the Material/Map Browser, double-click DGS Material.

DGS stands for Diffuse, Glossy, Specular. You are using a mental ray material type inside a mental ray map channel option.

8. In the DGS Material (3ds max) Parameters rollout, set Shiny to **3.0**.

9. Choose the color swatch next to Glossy Highlights, and set Red, Green, and Blue to **0.412**.

10. Choose the color swatch next to Specular and set Red, Green, and Blue to **0.388**.

11. Choose the Map button next to Diffuse.

12. In the Material/Map Browser, choose Metal (lume) and click OK.

13. In the Metal (lume) Parameters rollout, set Surface Material to R=**0.851**, G=**0.361**, B=**0.255**.

14. Set Reflectivity to **0.75**.

15. Set Reflect Color to R=**0.8**, G=**0.749**, B=**0.271**.

16. Turn on Blur Reflection.

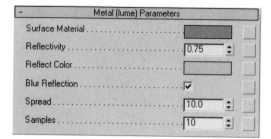

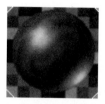

17. Drag and drop this material over the Light Post in the Camera viewport.

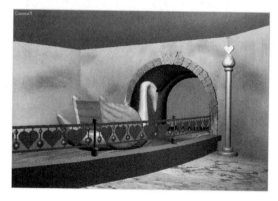

18. On the main toolbar, choose Quick Render.

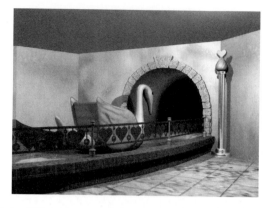

Note: It is suggested that you render to an image size of 320 x 240 each time you render. This ensures decent rendering times.

Creating a Material for the Light Cover

1. Continue working on the previous file, or choose File > Open from the menu bar, and open *Ch17-13.max* from the courseware CD.

2. In the Material Editor, select an unused material window, and name it Glass.

3. Turn on Background.

4. In the mental ray Connection rollout, turn off Lock next to Surface.

5. Choose None next to Surface.

6. In the Material/Map Browser, choose DGS Material and click OK.

7. In the DGS Material (3dsmax) Parameters rollout, choose the color swatch next to Glossy Highlights and change the value to **0.498**.

8. Choose the color swatch next to Specular, and change the value to **0.498**.

9. Set Shiny to **5.0**.

10. Set Transparency to **0.8**.

11. Choose the Map button next to Diffuse.

12. In the Material/Map Browser, choose Glass (lume) and click OK.

13. In the Glass (lume) Parameters rollout, set Surface Material to R=**0.0**, G=**0.0**, B=**0.0**.

14. Set Diffuse to R=**1.0**, G=**1.0**, B=**1.0**.

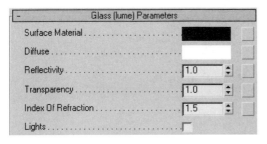

15. Drag and drop this material over the Light Cover object.

Note: Make sure your render frame window is set to 320x240.

16. On the main toolbar, choose Quick Render.

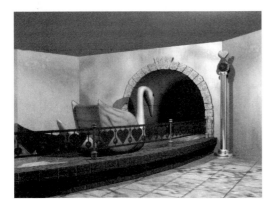

The shadow that is rendered is not transparent. You fix this next through the DGS shader options.

17. In the Material Editor > side toolbar, choose Material/Map Navigator.

18. In the Material/Map Navigator, choose Glass to go to the root of the material.

19. In the mental ray Connection rollout, turn off Lock next to Shadow.

20. Choose None, and double-click Shadow Transparency (base) from the Material/Map browser.

21. Choose the color swatch next to the Transparency setting, and change the value to **0.424**.

22. On the main toolbar, choose Quick Render.

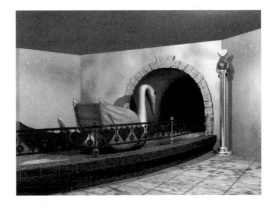

The shadow is now transparent.

Creating a Material for the Light Bulb

1. Continue working on the previous file, or choose File > Open from the menu bar, and open *Ch17-14.max* from the courseware CD.

2. In the Material Editor, select another unused material window, and name it Light Bulb.

3. Turn on Background.

4. In the mental ray Connection rollout, turn off Lock next to Surface.

5. Choose None next to Surface.

6. In the Material/Map browser, double-click DGS Material.

7. Choose the color swatch next to Glossy Highlights, and change the value to **0.525**.

8. Choose the color swatch next to Specular, and change the value to **0.525**.

9. Change Shiny to **5.0**.

10. Choose the Map button next to Diffuse.

11. In the Material/Map browser, double-click Glow (lume).

12. Choose the color swatch next to Glow, and change R=**1.0**, G=**0.976**, B=**0.953**.

13. Set the Brightness to **3.0**.

14. Make sure Mix Diffuse is turned on.

15. Choose the color swatch next to Surface Material, and change the value to **0.725**.

16. Choose the color swatch next to Diffuse and change R=**0.28**, G=**0.231**, B=**0.34**.

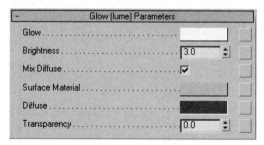

17. Press H to open the Select Objects dialog.

18. In the Select by Name dialog, choose Light Bulb01, and then choose Select.

19. ⬚ In the Material Editor > bottom toolbar, choose Assign Material to Selection.

20. Add the Light Cover and Light Post to the selection.

21. On the main toolbar, choose Select and Move.

22. Hold down SHIFT and, in the Top viewport, move a clone to the other side of the tunnel entrance.

23. In the Clone Options dialog, choose Instance and click OK.

24. On the main toolbar, choose Quick Render.

Using Render to Texture to Speed Up Render Time

To speed up render time, you use Render to Texture on the swan. Typically you would want to set up your own map using the Unwrap UVW modifier, however the swan already has a map set up for it, and the way it is set up, there are many overlapping UVs. Fortunately there is another solution; other than using Unwrap UVW and making a new map for the swan. You can use Automatic Mapping. When you use Auto-Mapping in Render to Texture, it uses the current mapping coordinates for the render, but it outputs the results to a new set of coordinates. These coordinates are set up using the same process that the Unfold Mapping tool uses in Unwrap UVW. The drawback is that after Auto-Mapping, you cannot adjust the clusters because the map is made to specifically fit the clusters that are created.

When you use Render to Texture with Automatic Mapping, an Automatic Flatten UVs modifier is added to your object's stack. This modifier works just like Unwrap UVW.

Rendering the Swan's Texture

1. On the menu bar, choose File > Open and open *Ch17-15_rtt.max* from the courseware CD.

2. In any viewport, select the swan boat.

 The Swan is currently a group containing five objects. You convert the body to an Editable Mesh and Attach the other parts so you can use Render to Texture on one object.

3. On the menu bar, choose Group > Ungroup.

4. Select the object named *body*.

5. Rename it Swan.

6. Right-click in the active viewport and choose Convert To > Convert to Editable Mesh from the quad menu.

7. On the Modify panel > Edit Geometry rollout, choose Attach List.

8. Choose *seatback*, *seatbottom*, *wingleft*, and *wingbottom*, and click Attach.

9. On the Modify panel > Modifier List drop-down, choose Unwrap UVW.

10. In the Parameters rollout, choose Edit.

You can see the UVW coordinates are overlapped because of the original Planar mapping.

11. On the Modify Stack Display toolbar, choose Remove modifier from stack.

You use the Automatic Mapping in the Render to Texture dialog to generate UV's.

12. On the menu bar, choose Rendering > Render to Texture.

13. In the Render to Texture dialog > Output rollout, choose Add.

14. In the Add Texture Elements dialog, choose CompleteMap and click Add Elements.

15. In the Selected Element Common Settings group, make sure the Target Map Slot is

set to Diffuse Color, and select the 512 size preset.

File Name	Element Name	Size	Tar
bodyCompleteMa...	CompleteMap	512	Diffi

Add... **Delete**

Selected Element Common Settings
☑ Enable Name: CompleteMap
File Name and Type: bodyCompleteMap.tga
Target Map Slot: Diffuse Color
☐ Use Automatic Map Size Element Type: CompleteMap
Size: 512 | 64 | 256 | 768 |
| 128 | 512 | 1024 |

16. In the Automatic Mapping rollout, set Threshold Angle to 65, and Spacing to 0.01.

Automatic Mapping
Automatic Unwrap Mapping
☑ Rotate Clusters Threshold Angle: 65.0
☑ Fill Holes Spacing: 0.01
Automatic Map Size
Scale: 0.01 Min: 32
☐ Nearest power of 2 Max: 1024

17. At the bottom of the Render to Texture dialog, make sure both Views and Render are set to show the Baked material.

This sets the renderer to also show the baked material. This can also be set in the Material Editor.

18. In the Render to Texture dialog, choose Render.

Render Unwrap Only Close Original: ○ ○ Baked: ● ● Views Render

When the render is finished, notice that an Automatic Flatten UVs modifier is added to the top of the stack.

☀ ⊞ Automatic Flatten UVs
⊞ Editable Mesh

Viewing Your Results

1. Continue from the previous exercise, or choose File > Open from the menu bar, and open *Ch17-16_rtt.max* from the courseware CD.

2. On the Modify panel > Parameters rollout, choose Edit.

This is the UV mapping that was created for the Swan.

3. Close the Edit UVWs dialog.

4. Press M to Open the Material Editor.

5. Choose an unused material slot.

6. Select the Pick Material from Object button, and choose the Swan to load its new material.

7. In the Shell Material Parameters rollout, select the Baked Material.

8. In the Blinn Basic Parameters rollout, select the Diffuse Map button.

9. In the Bitmap Parameters rollout > Cropping/Placement group, choose View Image.

This shows the swan's new map.

10. Close the Specify Cropping/Placement dialog.

11. In the Material Editor > bottom toolbar, choose Go To Parent.

12. In the Blinn Basic Parameters rollout, set the Self-Illumination to 100.

This causes the texture to show at full intensity when the lights are turned off. Setting the Self-Illumination to 100 is usually done for testing purposes only.

13. On the Display panel > Hide by Category rollout, turn off Lights.

14. Press H and choose Omni01.

15. On the Modify panel > General Parameters rollout > Light Type group, turn off On.

16. Select and turn off Omni02 and Spot01 also.

17. Select the swan.

18. Press ALT + Q to turn on Isolation mode.

19. In the Material Editor, set Self-Illumination to 0.

20. Right-click the camera viewport label and choose Other > Flat.

This shading option allows you to see the swan with the Render to Texture in the viewport without having to set Self-Illumination to 100.

21. Right-click the viewport label, and choose Smooth + Highlights.

22. Set the Self-Illumination back to 100.

23. Exit Isolation Mode.

24. Make sure Camera01 is active.

25. On the main toolbar, choose Render Scene.

Some of the other objects still render slowly, but the Swan renders in no time. It looks perfect, and has its own cast shadows, even though there are no lights.

Conclusion

In this LAB chapter, you applied several different types of materials to objects in a scene. The tools available in **3ds max** allow you to align, scale and control the appearance of materials. You have seen how materials control the look of objects, from color to reflection to opacity. If you have time, experiment by editing the materials you created, or create new ones to replace those suggested in this lab.

18

Basic Lighting

Objectives

After completing this chapter, you should be able to:

- Identify basic lighting principles.
- Know the difference between real-world and computer lighting.
- Understand traditional lighting setups.
- Recognize different light types.
- Create lights.
- Modify lights.
- Use Sunlight.
- Use the Light Lister.

Introduction

Look around you and notice the world is made up of textures, surfaces, shadows, and reflections. When you watch a movie, look at a photograph, or even read this book, you are seeing light. Light, specifically the visible spectrum, is what makes it possible for us to see at all. One thing to

keep in mind: any image you see comes from light absorbed, or emitted by, what you're looking at. Colors created by absorbing frequencies of light are known as subtractive, while colors created by emitting frequencies of light are known as additive.

Subtractive Colors

In subtractive colors, pigments absorb light from white light at different frequencies. These colors are hidden from view; you see the color reflected back to you only. For example, a red apple absorbs all but the red part of the visible spectrum, therefore reflecting red.

The illustration shows subtractive colors.

Additive Colors

Additive colors are created when an illuminated object contains selected frequencies and emits those frequencies together; you see their combination. A good example of additive color is a standard TV or computer monitor. They use combinations of red, green, and blue light to make an image. What you see is the image emitted from the monitor screen.

The illustration shows additive colors.

Capturing an Image

Basically, creating an image is no more than capturing light. For centuries, artists have tried to capture light in paintings and sketches. The 19th century brought a new way to capture light through photography, which changed the capture of light from an artist's interpretation to a direct capture onto film. This allowed the photographer to capture a scene in fine detail like never before. After still photography came motion pictures, and the ability to capture light over a period of time.

With the advent of electricity, artificial lighting became important in capturing images. Over the years, a variety of lights have been developed for traditional photography, cinematography, and the theater. They range from small, low-power lights to giant, high-power lights used to simulate sunlight. Each light serves a unique purpose. Highly directional lights are called spotlights. Other lights, such as the traditional light bulb, are omni-directional, which give off light in all directions.

Then along comes computer graphics and throws the idea of using traditional lights to create an image right out the window, well … not completely.

In general, the fundamentals of computer lighting differ greatly from those of the real world. In real-world lighting, a light's brightness and color is represented in watts and color temperature respectively. Watts measure how much energy a particular light uses at its rated full brightness. A light of 10,000 watts, like those on a movie set, is much brighter than a 60-watt bulb in a household lamp. Color temperature, however, measures the relative intensity of a light from red to blue in degrees Kelvin (°K). This range comes from the color of the light emitted by a "Black Body," where the color begins at red. When photographers talk about "daylight balanced" they are referring to the 5500°K range of lights.

Some typical color temperatures and sources:

- 1000°K – Candles
- 3000°K – Common studio lights
- 5500°K – Daylight at noon
- 7000°K – Slightly overcast daylight

- 9000°K – Daylight through an open window on a clear day
- 11,000°K – Overcast daylight

In addition to relying on the color temperature of a light, lights can be colored by gels. Gels are sheets of colored plastic placed in front of a light. Gels are used for a variety of purposes, ranging from colored accent lights to simulating the effect of light through stained glass.

In **3ds max**, there are two different types of lights: Standard lights and Photometric lights.

With Standard lights, the brightness and color are representative. For the brightness, 1.0 represents a fully bright white light and the color is determined by the RGB value of a color swatch. You have control over the light's attenuation, which is how the brightness fades as you move away from the light. You can turn the attenuation on and off, and set where the brightness begins to fade and eventually stops. You can also set how much the light fades at the edges of certain directional lights. There is no direct correlation between Standard **3ds max** lights and real-world lights.

Photometric lights, on the other hand, are based on real-world lights. Photometric lights use photometric (light energy) values to allow you to define the lights more accurately, as they are in the real world. Because Photometric lights simulate real-world lighting, it is important that everything in your scene be modeled to scale when you use them. If you model a room the size of a city block, a single light wouldn't illuminate it much. With Photometric lights, you set values based on real-world lights to get realistic lighting effects in your scene. Refer to Chapter 19 for more on Photometric lights in **3ds max**.

From this fact, several questions arise. How do you reproduce the qualities of a real-world light with the Standard lights in **3ds max**? And, how can you reproduce time-tested traditional lighting setups without using radiosity and photometric lighting?

The Properties of Light

Lights in the real world share one main property; they emit energy from the visible spectrum, whether the light is a fluorescent tube light or a halogen spotlight. While lights do emit light outside human perception in the infrared and ultra-violet frequencies, this chapter deals with the visible spectrum of lighting only.

Standard lights in **3ds max** differ from real-world lights. **3ds max** lights work in a completely different way than the laws of nature. Lights can be bright, dim, white, or any other color of the spectrum; the difference lies in how the light properties are obtained.

Light Types

Lights come in all shapes and sizes. **3ds max** covers three types of lights, namely Spot, Directional, and Omni. Each light has a purpose and works differently.

Spotlights

Spotlights are common, general-purpose lights. When used properly, they work in a variety of lighting situations. Their uses range from still photography to video production, movies, and theater.

Note: A good place to learn about dramatic lighting is from theater lighting. Most theater lighting setups are fairly complex because they function throughout a variety of scene changes. Film or video production lighting, on the other hand, can be customized for each shot.

Notice how shadows diverge from the subjects under a Spotlight.

Direct Lights

Direct lights differ from Spotlights and Omni lights in one major way; the shadows cast by the light are parallel and do not spread. Direct light does not have a cone that starts at a point and expands, since it is a parallel light. This light is often used to simulate sunlight, since shadows cast from the sun are nearly parallel to the earth.

Notice how the shadows remain parallel to the subject with Direct lighting.

Omni Lights

An Omni light is a point of light emitted in a 360-degree sphere. Omni lights work well to simulate light in household lamps, hanging lights, or the sun from the view of the solar system.

Free, Target, and Area Lights

3ds max provides you with three methods to create lights. For Spot and Direct lights, you can choose either a free or target version. For Spot and Omni lights, you can choose between Standard and Area Lights.

Free Lights

Free l and Omni lights are placed in the scene with a single click and have no specified target point. When Free lights are created, they face into the viewport they're created in, or down if created in a Perspective viewport. Once created, they can move to any position. So they are ideal for traditional spotlight uses such as hanging lamps and car headlights. Free lights are also ideal for specific animation uses. For example, animating a camera through a tunnel and illuminating only what the camera views is a good way to use a Free light.

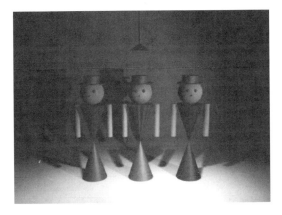

Target Lights

Target lights are created differently from Free lights. First, you must specify the initial location of the light, and then specify a target for the light to look at. Target lights are useful for stage and set lighting where you want to specify the direction in which a light points. When you create a Target light, you create two objects: a light source and a target. Both objects can be animated separately, however, the light source always looks at the target.

Area Lights

Area Lights work specifically with the mental ray renderer. They emit light from a definable area, rather than a single point source. Area Omni Lights emit light from a spherical or cylindrical area; Area Spot Lights emit light from a rectangular or disc-shaped area. Area Spot Lights use a target for determining the direction the light faces. With the default scanline renderer, area lights render exactly like standard lights, however they render a little slower.

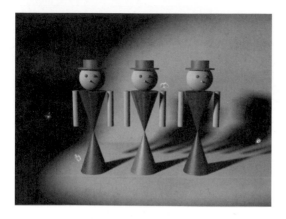

Creating a Free Spotlight

In this exercise, you add a free spotlight to a street scene that simulates a street lamp.

1. On the menu bar, choose File > Open and open *StreetLights_01.max* from the courseware CD.

2. On the command panels, choose Create > Lights > Free Spot.

3. In the Top viewport, click once to place the light in the center of the streetlight.

4. On the main toolbar, choose Select and Move.

5. On the Status bar > Transform type-in area, enter X = **-11.1**, Y = **22.0**, and Z = **220.0**.

6. Right-click in the Camera viewport to make it active.

7. On the main toolbar, choose Quick Render

You have just created a Free spotlight. Now you need to adjust the parameters of the light to make it look more realistic.

Light Parameters

You can access all Parameters for lights through the Modify panel.

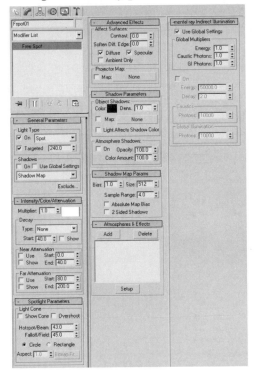

Note: This Modify panel has been widened to display the Spotlights' parameters. Regardless of the type of light you create, the parameters are the same from one light to another.

General Parameters Rollout

This rollout contains two specific groups: Light Type and Shadows. The Light Type group allows you to turn the light on and off, and change from a Spotlight to another type of light such as an Omni light. In the Shadows group, you can turn shadows on or off, decide the type of shadow, and Include or Exclude objects from receiving illumination from the light.

The General Parameters rollout.

On/Off check box —The first option is the On/Off check box. When this check box is chosen, the light is turned on; when the check box is not chosen, the light is turned off. A light that is turned off in a scene shows as black in the viewports.

Light drop-down list—To the right of the On/Off check box is the light type drop-down list. From this list, you can choose the type of light for the currently selected light. The list comes in handy when you create one type of

light, such as a Spot and realize what you really needed was an Omni light. Once you choose the type of light, then you choose whether that light has a target object, by turning on and off the Target check box.

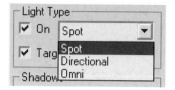

Targeted—This check box allows you to turn on and off targets for Spot and Directional lights. This area also has a spinner next to it. When the light has a physical target, it shows the target distance. To edit the target distance you must choose the target from the viewport and move it. If the light is a free light, you can change the target distance through the spinner.

Shadows On/Off—When this check box is chosen, the light casts shadows. If the check box is not chosen, the light does not cast shadows.

Use Global Settings—This check box determines whether the shadow uses local or global parameters. If this check box is turned on, global parameters affect all lights using the global parameter settings. It is useful when you want to control the shadow parameters of all lights in a scene with one set of parameters. If this check box is turned off, the shadow parameters affect that light only.

Shadow Type drop-down list—The shadow type provides five methods for casting shadows: Advanced Ray Traced, mental ray Shadow Map, Area Shadows, Shadow Map, and Ray Traced Shadows. Understanding the various shadow types is important. The way shadows look and function differ greatly. The types of shadows are explained in the Shadows section, later in this chapter. To learn more about Area Shadows and Advanced Ray Traced shadows, refer to Chapter 19.

Exclude/Include—This feature provides a way for a light to: exclude an object from illumination; keep an object illuminated but not cast a shadow; allow an object to cast a shadow but not be illuminated.

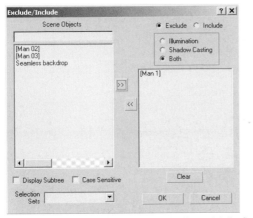

The Exclude/Include dialog shows the middle figure excluded from illumination and shadow casting.

The result of the middle figure excluded from the light and not casting a shadow.

The middle figure with Shadow Casting only.

The middle figure with Illumination only.

Shadows

When you look around, pay attention to the shadows of various objects (everything has one). The depth of the shadow depends upon the light in the scene. A single light source casts a dark, harsh shadow, whereas a fully lit room usually casts softer, less distinct shadows.

Shadows provide valuable information about the object casting it. It shows where the object is in relation to the surface beneath it, whether it's making contact with the surface or floating above it. Shadows also indicate the transparency and color of an object.

previous images. The figure in the top image might or might not be close to the floor, whereas the figure on the bottom has a shadow that shows it is on the floor.

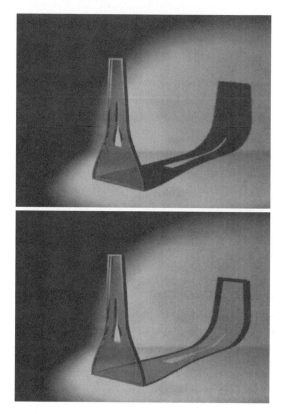

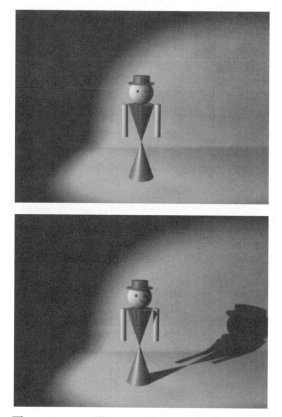

These images illustrate how a shadow can provide valuable information about the height of an object above the surface. This is readily apparent when comparing the

A shadow is also important when visually describing the surface properties of an object. In the top image, the shadow cast is a solid, dark shadow, while the glass object surface is noticeably transparent. This does not work if you want your scene to look realistic. Meanwhile, the shadow in the bottom image shows the transparency and color change of the glass object clearly.

Advanced Ray Traced Shadows

This advanced version of Ray Traced Shadows offers soft edges and makes better use of system memory when rendering. When used with Photometric lights, it computes area shadows correctly for Linear and Area lights. When rendering with Standard lights, it works in almost all situations where you do not need area shadows. When you choose this type of shadow, two specific rollouts are displayed: Adv. Ray Traced Params and Optimizations.

An Advanced Ray Traced Shadow with a soft shadow.

mental Ray Shadow Map

The mental ray Shadow Map is a special form of shadow you can use when you render with mental ray. This Shadow Map usually renders quicker than Ray Traced Shadows with the mental ray renderer, however not as accurately.

Area Shadows

You use this shadow type to achieve the effect of an area shadow with any light. You define the size and shape of the light, and the soft edges of its shadows become more noticeable as the distance between objects and their shadows increases. You can use this type of shadow to simulate shadows cast by a large light source, such as a fluorescent ceiling fixture. You can also use area shadows to give Standard lights realistic shadows that blur as they get farther away from their casting object. When you choose this type of shadow, two specific rollouts are displayed: Area Shadows and Optimizations. These options are explained in detail in Chapter 19.

An Area Shadow with default settings.

Shadow Map

A Shadow Map is a faked shadow. It is an image created from the light's point of view and mapped onto any object behind the one casting the shadow. The advantage of Shadow Mapped shadows is they render fairly quickly, with a soft edge. The drawback to using them is that they are

unrealistic shadows and don't respect transparency. While this is a fast way to render shadows, it is not as flexible as the Advanced Ray-traced Shadows.

are quite hard. These shadows also come at the cost of render time: Ray Traced Shadows are calculation-intensive, therefore take longer to render than shadow maps.

A Shadow Mapped shadow.

A Ray-traced Shadow.

Ray-traced Shadows

While a Shadow Map is a fake shadow, a Ray Traced Shadow is a physically realistic shadow. When a Ray Traced shadow is cast from a light, it takes into account the object's physical and material attributes, and provides a realistic shadow. This shadow type can be used as a general shadow generator, however the edges of the shadow

Intensity/Color/Attenuation Rollout

This rollout offers options for changing a light's intensity, color, decay and attenuation.

Multiplier—Controls brightness for the light. Adjusting this value dims or brightens a light.

Multiplier = 0.5.

Multiplier = 1.0

Multiplier = 2.0.

Color Swatch—Controls a light's gel color. When chosen, the standard color selection dialog is displayed, and you can select any color available.

The light's color is changed to yellow.

What is Attenuation?

One of the most common mistakes when lighting a scene is omitting attenuation to a light source. Attenuation occurs to all lights, no matter how bright. A light source is brightest at its source. As you move away from the light source, the light dims until it no longer provides any illumination.

In the real world, lights attenuate based on the laws of physics, specifically the inverse square law. The law states that light intensity decreases at the inverse of the square of the distance. What does this mean? If you want to create scenes with realistic lighting you need some form of attenuation. Several factors determine how far a light casts illumination. One factor is the brightness of the light source and another is the size of the light. The brighter or larger the light, the farther it casts illumination. The dimmer or smaller the light source, the less distance it illuminates.

Decay

Decay has two options to automate the attenuation of a light. The first is Inverse, which is a linear falloff of light from the source. Inverse Square is the second choice. Although Inverse Square represents how real lights behave, perform test renderings of your scenes to determine what looks best for your situation. Generally speaking, a light appears darker at a given distance from its source for Inverse Square vs. Inverse (assuming all other light settings are the same).

Note: If you use Inverse Square decay and your scene is too dark, you can increase the Multiplier of the lights to brighten the scene.

The Decay group also contains a setting for the start of the attenuation. It indicates the distance from the light where light begins to decay.

The Decay selector is displayed.

The Decay Start value is indicated by a green arc within the cone at the specified distance from the source.

Inverse Decay with Start = 80.0.

Inverse Square Decay with Start = 120.0.

Near Attenuation

Near Attenuation is unique to the computer lighting world. These settings control the distance from the light where illumination begins [Start] until it reaches full brightness [End]. To activate Near Attenuation, turn on the Use check box.

The dark blue and light blue arcs near the end of the light's cone indicate the Near Attenuation.

The effect of the Near Attenuation on objects in a scene is displayed. Notice the objects closest to the light are in the dark.

Far Attenuation

Far Attenuation sets the distance from the light where full brightness ends to where the light no longer illuminates the scene.

The light tan and the brown arcs near the end of the light's cone indicate the Far Attenuation.

The effect of Far Attenuation on the objects in a scene is displayed. Notice the objects farthest from the light are in the dark.

The two previous images illustrate how Far Attenuation can affect the qualities of a light. The first image on has Start = 203.0 and End = 529, while the second image has Start = 52.0 and End = 347.0. Both lights have the same color and Multiplier. This gives the impression that the lights are different types.

Both the Near Start and End and the Far Start and End ranges are displayed.

Note: When you set attenuation, the ranges are 3D, so adjust them from two viewports.

Spotlight/Directional Parameters Rollout

This rollout exists only if the light type is either a Spot or a Direct. Spotlights are lights that come from a single point of light and expand in a cone shape. Directional lights are parallel lights, so they don't start at a point and expand. However, both types of light have a cone, and can be edited the same way.

The Spotlight Parameters rollout.

Light Cone group

Show Cone—Turn on this check box to view the cone of light when the light object is not selected.

Overshoot—Turn on this check box when you want the Spot or Directional light to behave like an Omni light outside its cone. Light casts in all directions, but only casts shadows within its falloff cone. This can be used to speed up render time when a few objects only cast shadows, but you want to light everything else.

Hotspot/Beam—The Hotspot determines the bright portion in the center of the cone.

Falloff/Field —The Falloff determines where the light fades to black and no longer illuminates.

Note: The cone angle of a spotlight makes a dramatic difference in the look of a scene. A wide cone angle gives broad illumination that establishes a scene, although what you do with the light is entirely up to you.

A small cone angle can provide dramatic effect.

Circle—This radio button determines a circular shape to the cone.

Note: **3ds max** even allows you to non-uniformly scale the round beam to form an oval beam.

Rectangle—This radio button determines a rectangular shape to the cone.

Aspect—As a rectangle, you need not scale the light to change its shape. The Aspect value determines whether the rectangle is wide or tall.

Bitmap Fit—This button allows you to choose a bitmap to determine the aspect ratio.

An Aspect of 1.0 results in a square cone.

An Aspect of 0.5 results in a cone that is taller than it is wide.

An Aspect of 2.0 results in a cone that is wider than it is tall.

Advanced Effects Rollout

This rollout contains two groups: Affect Surfaces and Projector Map. The Affect Surfaces group provides settings to adjust how the light works in the scene. There are two adjustable settings and three check boxes.

Projector Map is the other group in the rollout. Think of the Projector Map as you would a slide or movie projector. When you put an image in it, the image is projected in the direction of the light. This feature can be used for a variety of effects; the obvious one is to make a movie or video projector. Other uses include simulating light through stained glass, disco lighting, or the effect of neon tube lighting.

The Advanced Effects rollout.

Affect Surfaces group

Contrast—Sharpens the difference between bright and dark areas. This value ranges from 0.0 to 100.0.

At a value of 100.0, a defined edge exists between the light and dark sides of an object.

Soften Diffuse Edges—This feature is adjustable from 0.0 to 100.0. At lower values, it has the subtle effect of softening the difference between the bright and dark areas of an object.

The scene shows Soften Diffuse Edges = 0.0.

The scene shows Soften Diffuse Edges = 100.0.

Note: Pay close attention to the shading on the heads of the figures. A subtle difference exists in the distance between the bright and dark side of the sphere.

Diffuse—This check box turns the diffuse shading component of the light on or off.

The specular component of the surface with Diffuse illumination turned off.

Specular—This check box turns the specular component of the light on or off.

The Diffuse component of the surface with Specular illumination turned off.

Ambient—This check box causes the light to illuminate the ambient portion of the surface only, disregarding the diffuse and specular components completely.

Only the Ambient channel is shown.

Lighting a Neon Sign

1. On the menu bar, choose File > Open and open *StreetLights_02.max* from the courseware CD.

2. In the Front viewport, choose Neon Light. This is the Free Direct light.

3. On the command panels, choose Modify.

4. On the Modify panel > Advanced Effects rollout, choose None in the Projector Map group.

The Material/Map Browser is displayed.

5. In the Material/Map Browser, double-click Bitmap.

6. In the Select Bitmap Image File dialog, open *Neon_light.tga* file from the courseware CD.

7. In the General Parameters rollout, turn on the light.

8. Right-click in the Camera viewport to make it active.

9. On the main toolbar, choose Quick Render.

This has the effect of illuminating the curb surface.

10. In the Left viewport, press **SHIFT+ 4** to change the Left viewport to the Neon Light viewport.

The viewport navigation controls are updated to the light controls.

11. In the Directional Parameters rollout, change the Hotspot and Falloff settings to **4.3** and **6.3**, respectively.

12. Press **H** to open the Select Objects dialog.

13. In the Selection Objects dialog, choose Neon illumination.

14. On the Modify Panel > General Parameters rollout, turn on the light.

15. Right-click in the Camera viewport to make it active.

16.On the main toolbar, choose Quick Render.

The result is far more effective with a light added to simulate light coming from the neon sign.

Note: The Overshoot check box is turned on. This gives the spotlight the effect of emitting light like an omni light yet casting shadows in the direction of the spotlight only.

Shadow Parameters Rollout

In **3ds max**, you can customize the shadow of a light in the Shadow Parameters rollout.

Object Shadows group

The Object Shadows group is part of the Shadow Parameters rollout. It is where you adjust color and density for the shadow, and add a shadow map.

Shadow Color —A tinting color for the shadow cast. The default color is black, however, you can choose any color.

A red shadow color.

Shadow Density—Darkens or lightens a shadow by adjusting the percentage of the shadow cast. The Density scale goes from -1.0 to 1.0, where 0.0 casts no shadow and 1.0 casts a full shadow. Negative values cast a shadow that is a negative of the shadow color. You are not limited to values between 1.0 and –1.0 though. As you increase the

Shadow Density above 1.0, the shadow becomes increasingly brighter. If you decrease it below –1.0, the shadow becomes increasingly darker.

Notice the difference in Density values of 0.0, 0.5, and 1.0.

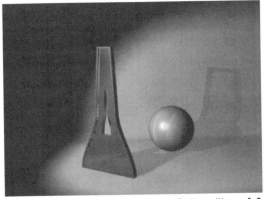

The scene shows a Blue Shadow Color with a –1.0 Density. Notice where the shadow is usually dark, a light green shadow is displayed instead.

Map—No matter the shadow type, a Shadow Map replaces a colored shadow using one of the Material/Map Browser maps. This can be used for a variety of effects. One is to give added flexibility to Shadow Mapped shadows, allowing you to simulate complex object transparency.

Using the Map check box, you can activate and deactivate the map.

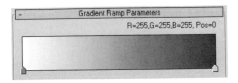

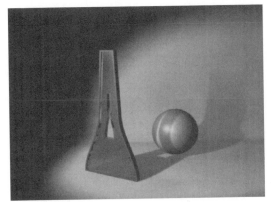

A gradient used as a map for the shadow can simulate the transparency of a glass object. Notice the sphere and frame do not cast black shadows, and use the map color as well.

Light Affects Shadow Color—When this check box is turned on, the light color is blended with the shadow color.

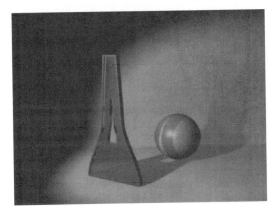

The reddish color of the light is blended with the blue of the Shadows Map.

Atmosphere Shadows

3ds max contains several effects called Atmospherics. For example, Fire Effect creates everything from fireball explosions to campfires. Normally, these effects don't cast shadows; this is when the atmosphere

shadow parameters come in handy. Turning on the check box activates the light's ability to cast a shadow through an atmospheric such as the Fire Effect.

There are two adjustable values for the atmosphere shadows: Opacity and color amount.

- Opacity adjusts how light or dark the shadow is cast from the atmospheric, with 0.0 producing no shadow and 100.0 a full shadow.

- The Color Amount value adjusts how saturated the color of the shadow is, where 0.0 is no color and 100.0 is full color saturation.

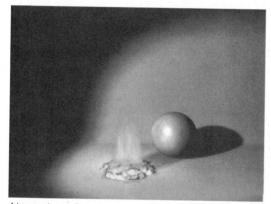

Atmosphere Shadows with Opacity = 50.0 and Color Amount = 100.0.

Shadow Map Parameters Rollout

Choosing the Shadow Map shadow makes the Shadow Map Parameters available. These parameters give you control over the quality of the shadows cast by the light. Several parameters affect the look and quality of the shadow, namely Bias, Size. and Sample Range. The last options, Absolute Map Bias and 2 Sided Shadows, are check boxes. Absolute Map Bias affects only the Bias setting, and 2 Sided Shadows affects how shadows are cast.

Bias—This setting determines the distance from the object to the start of the shadow. A Bias that is too low can cause shadow "leaks," where the shadow blurs around objects on a flat surface.

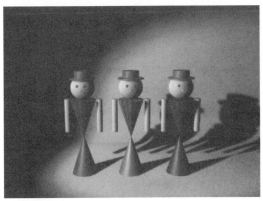

Bias = 1.0

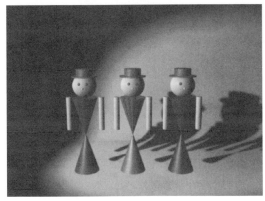

Bias = 15.0.

Size—Since a Shadow Map is a bitmap image, it must have a size. The size setting specifies the size of the map in pixels. Since the map is square, only one value is needed. The higher the value, the better the shadow quality, which creates a larger map and uses more memory. The lower the value, the smaller the map, which exhibits poorer shadow quality.

Shadow Map Size = 1000.0

Shadow Map Size = 100.0

Warning: If you use a size value that's too small, your shadows will crawl. This effect is generally unwanted and can be reduced or eliminated by increasing the size of the map. Setting the size of the shadow map is a balance between shadow quality and memory usage. Experiment to get the proper size.

Sample Range—This is the fuzziness of the shadow. A low value gives a sharp shadow, while a large value gives a softer shadow.

Sample Range = 2.0

Sample Range = 15.0.

Absolute Map Bias—When turned off, the shadow map's bias is computed from the size of the scene, and then normalized to 1.0 before the bias is used. This works well in most cases. However if the size of the scene changes quickly, or objects appear and disappear, this can cause a flicker in the

shadows produced. To fix it, turn on Absolute Map Bias. When turned on, the bias range uses the Bias value as absolute **max** units.

Both images have Bias set to 15.0, but the top has Absolute Map Bias turned on. The shadow is affected differently when the Bias is determined relative versus absolute.

2-Sided Shadows—When turned on, backfaces are included in calculating shadows. Backfaces are the sides of faces and polygons that are normally transparent unless you turn on 2-Sided. Lights from the outside do not light objects seen from the inside, such as a sphere with normals flipped to act as a sky

dome. When turned off, backfaces are ignored, which causes outside lights to illuminate the interior's objects with flipped normals.

Atmospheres & Effects Rollout

This rollout contains options to add lens effects to the lights, such as volumetric lighting effects. To learn more about the options found in the rollout, please refer to the **3ds max** help file.

mental ray Indirect Illumination Rollout

You learn about mental ray in Chapters 17, 19 and 21.

Basic Lighting Concepts

Now that you are familiar with how lights function as objects, it's time to see how to use them. The invention of studio lighting created a new art form, namely lighting design. Whether you are lighting a theater, a movie set, or a portrait, basic lighting concepts exist to guide you. The concepts include the use of different lights for various purposes and layouts, and the use of color to enhance a scene.

Lighting Setups

You begin with a basic three light setup. This setup consists of three lights, namely a Key light, a Fill light, and a Back light. All lights are Target Spots for this setup.

Key Light

This light is the brightest light of the three and provides primary illumination for the scene. The Key light also casts the primary shadows.

A scene with a Key light.

Fill Light

This light fills in the shadows created by the Key light. This light brings out the shadow detail without overpowering the Key light. The Fill light is generally placed at a lower angle than the Key light and is about half to two thirds as bright as the Key light. The shadows from this light are dimmer and less obvious than the Key light.

A scene with Key and Fill lights.

Back Light

The back light highlights the subject from the back, causing the subject to stand out from the background. This light is usually set above the subject from behind and is about one third to one half as bright as the Key light. The shadow for this light is not as noticeable as for other lights.

A scene with a Key, Fill, and Back light.

Effect Lights

Many ways exist to light a scene and subject other than the traditional three-point lighting setup. One way to enhance effect lighting is to add a Wall wash light to the background and an eye light on your subject.

Wall Wash light

This light does not add much illumination to the overall scene but it does add a way to balance the scene or bring out background details. Few rules govern this light: use it to simulate light coming from a window, or as an accent.

A projector light used as a wall wash light.

The Eye Light

Many movies use eye lights. This tightly focused light illuminates the subject's eyes only. This lighting effect can add mystery to a subject, or increase the viewers' focus towards the subject's face.

Effect lighting can also be self-illuminated materials that give the illusion of lights in objects. This "light-bulb" effect is a two-step process. Effect lighting can also be used for sconces on a wall, or colored light in a fireplace.

Exterior Lighting

So far you've been looking at lighting in an indoor setting. Now you see how to set up a basic outdoor lighting scene. Outdoor lighting presents a completely different set of lighting issues. For instance, when and where does the scene take place? Is the weather sunny or cloudy? If your scene is lit by sunlight, then you must use a Direct light. The reason for this is simple. The earth occupies a small area of the sun's sphere of illumination because the earth is so far away from the sun. Consequently, all shadows on earth from the sun are parallel. This means that a shadow from a jumbo jet flying at 28,000 feet casts a shadow on the ground equal in size to the jumbo jet.

Lighting an exterior scene requires a Direct light with the color set based on the time of day. While you can use Shadow mapped shadows and get good results, using Advanced Ray Traced shadows produces the best sun shadows. Unfortunately this increases your rendering time, but it's well

worth it. The Direct light should have the Overshoot option turned on; this lights the entire scene while limiting the shadow calculation to the Falloff area only.

In addition to a Direct light, you can add an additional Omni light for simulating bounced and scattered light. The Omni light should not cast shadows or affect the specular area of a surface.

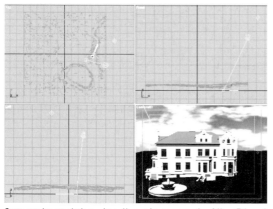

Screen layout showing the placement of the Direct light and Omni light within the scene.

In addition to the previous system for simulating an exterior scene, **3ds max** includes two systems that do all the difficult work for you. They are called the Sunlight System and Daylight System. Both use latitude and longitude location, along with the time and date on your computer, to position the sun. You can then edit these values to get the lighting at a location at any time of the day, in any month or year. The sun's intensity and color change realistically during the day as well. When you create a Sunlight or Daylight System, you get a compass rose, which determines north, south, east, and west in your scene. Second, you set the distance of the light. This distance is representational though, and only shows the angle of the sunlight hitting the scene.

The difference between the two systems is that the Sunlight System uses a directional light, while the Daylight System combines sunlight and skylight. With the Daylight System, sunlight can be from a direct light or an IES Sun- light, while the skylight can be from a Skylight or an IES Sky light. The IES Sun and IES Sky lights are photometric lights, and it is recommended to use Radiosity and Exposure Control with them. The Skylight is not photometric, however requires Light Tracing for best results.

You learn more about the Daylight System in Chapter 19.

Sunlight System

In the next exercise, you open an outdoor scene. You create a Sunlight and an Omni light to illuminate the scene.

1. On the menu bar, choose File > Open and open *eggboyplayground_sunlight.max* from the courseware CD.

2. On the command panels, choose Create > Systems > Sunlight.

3. In the center of the scene in the Top viewport, click and drag once to create a compass rose, and then drag and click to create the directional sunlight.

4. On the main toolbar, choose Select and Rotate.

5. In the Top viewport, rotate the compass rose **–90** along the Z-axis.

6. In the Left viewport, choose *Sun01*.

7. On the command panels, choose Motion.

SunO1

Selection Level:

Sub-Object

Parameters | Trajectories

+ Assign Controller

− Control Parameters

Azimuth | Altitude
249 | 59

Time

Hours | Mins. | Secs.
14 | 19 | 42

Month | Day | Year
7 | 7 | 2003

-8 Time Zone
Daylight Saving Time

Location

Get Location...

San Francisco, CA

Latitude: 37.618

Longitude: 122.373

Site

Orbital Scale: 70'11.412'

North Direction: 0.0

Accept the defaults for this exercise. However, you can make changes to the sunlight once you complete the exercise. This is where you change the latitude, longitude, time of day, and location of the Sun.

8. On the command panels, choose Modify.

9. In the General Parameters rollout > Shadows group, choose Adv. Raytraced Shadows from the drop-down list.

10. In the Intensity/Color/Attenuation rollout, choose the color swatch next to Multiplier.

11. In the Color Selector dialog, set Red = **220**, Green = **219**, and Blue = **225**.

12. Right-click in the Camera viewport to make it active.

13. On the main toolbar, choose Quick Render.

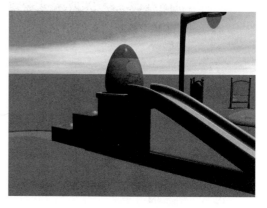

The rendering looks good, but next you add an omni light to brighten up the shadow areas.

14. On the command panels, choose Create > Lights > Omni.

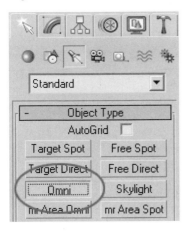

15. In the Top viewport, click to create an omni light anywhere.

16. On the main toolbar, choose Select and Move.

17. On the Status bar > Transform type-in area, set X = **2'2.346"**, Y = **52'5.789"**, and Z = **25'0.9"**.

18. On the Modify panel > Intensity/Color/ Attenuation rollout, set the Multiplier to **0.8**, and choose the color swatch.

19. In the Color Selector dialog, set Red = **225**, Green = **217**, and Blue = **214**.

20. Right-click in the Camera viewport to make it active.

21. On the main toolbar, choose Quick Render.

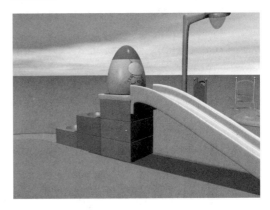

The shadow areas are now lighter than the previous rendering.

Light Lister

Treat the Light Lister like a mixing board for all lights in your scene. It provides access to the parameters of many of the scene lights. It also provides access to global settings such as ambient scene light, global light level, and global tint color. Access the Light Lister from the menu bar under Tools > Light Lister.

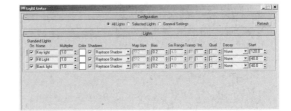

The Configuration Rollout

This rollout provides access to all lights in a scene or can show just selected lights. Each line represents the parameters of a light in a scene. You can select each light, name or rename it, turn it on or off, change its color, adjust the multiplier, along with any other parameters of the light.

All Lights—Lists all the lights in the scene in the Lights rollout.

Selected Lights—Lists selected lights only in the Lights rollout.

General Settings—Displays the General Settings rollout. This area provides an easy way to change the settings on many lights at once.

The Lights Rollout

This rollout is where you adjust each light in your scene separately. If you choose All Lights, all the lights in your scene are listed. If you choose Selected Lights, only selected lights are shown. Changing the selection in the viewport does not change the list of selected lights automatically. To update the list to reflect the newly selected lights, click Refresh after choosing them.

Select Button—This button appears to the left of each light name. Click the button to select the light and see where it is in the scene.

On—Turns the light on or off.

Name—Identifies the light by name. You can rename the lights here.

Multiplier—Adjusts the light's Multiplier value.

Color—Adjusts the light's color.

Shadows—Turn the light's Shadows on or off.

Shadow Type—A menu that allows you to pick the type of shadow you want.

Map Size, Bias, Sample Range, Transparency, Integrity, and Quality—These settings become available depending on which shadow type you choose. They are the same as the parameters listed in the section on shadows.

Decay and Start—Allows you to set the decay type, and when the decay starts.

If you have included a Sunlight System, Daylight System, and/or Sky Light in your scene, they are also included in the list. Available options depend on the light, such as no Multiplier control for sunlight and no shadow control for a skylight.

General Settings Rollout

This rollout provides options for globally changing the settings of a single light or more than one light. It also provides the following settings:

Global Tint—This is an environmental setting that sets an overall tint to the scene.

Global Level—This setting increases the brightness of all lights in a scene. A value of 0.5 dims the lights in a scene by half, and a value of 2.0 doubles the brightness of the lights in a scene.

Ambient—The Ambient color sets the ambient lighting in the scene. This color affects any material with an ambient color or level.

The Studio

In this exercise, you adjust the lighting of a three-point lighting setup. The scene consists of a simple, three-point lighting configuration, with a Key, Fill, and Back light. All lights in this scene are in position as Target Spots. You need to set the color and multiplier values for each light.

Setting the Lights

1. On the menu bar, choose File > Open and open *The Studio.max* from the courseware CD.

2. On the menu bar, choose Tools > Light Lister.

3. In the Light Lister dialog > Configuration rollout, choose All Lights.

4. In the Lights rollout, choose the color swatch next to Key Light.

5. In the Color Selector dialog, change the light color to R=**255**, G=**252**, B=**238**.

 Changing the light color to a more physical light color helps increase the level of realism in the scene. Keep in mind that in the real world, all lights have some color value, meaning none are pure white.

6. Choose OK to close the dialog.

7. In the Light Lister, choose the color swatch next to the Fill Light.

8. In the Color Selector dialog, change the light color to R=**246**, G=**233**, B=**228**.

9. Choose OK to close the dialog.

10. In the Lights rollout, set the Multiplier to **0.75**.

 Setting the Multiplier to a lower value keeps the Fill light from overpowering the Key light.

11. In the Lights rollout, choose the color swatch next to Back light.

12. In the Color Selector dialog, set the color to R=**219**, G=**235**, B=**245**.

13. Choose OK to close the dialog.

14.Set the Multiplier to **0.65**.

Setting the color of the Back light to a different color than the Key and Fill lights gives your scene some variation, keeping it from appearing flat.

15.Right-click to activate the Camera viewport.

16.On the main toolbar, choose Quick Render.

Conclusion

In this chapter, you have learned basic lighting theory. You've learned about different light types, how to create lights, and how to modify them. The lighting concepts covered in this chapter include how light parameters work and the use of shadows. You've also seen how different lighting configurations, such as three-point lighting, and the use of effect lights, change your scene. This chapter also introduced you to the basics of exterior lighting and the Light Lister, a valuable tool for lighting management.

Basics of Global Illumination

Objectives

After completing this chapter, you should be able to:

- Understand Global Illumination.
- Use Skylight with Light Tracer.
- Use Daylight with Radiosity.
- Use mr area lights and mental ray.
- Use Photometric lights.
- Use area and Linear lights.
- Understand Shadow parameters.

Introduction

Lighting has always been one of the toughest components of 3D rendering. When you begin to light a scene, you usually want to add lights where the physical lights would be in the real world. Sometimes, this logic doesn't work. You can render your scene, and realize the scene is either too bright or too dim. You are then forced to add more lights in places where no light exists in the physical world. Developing an eye for

lighting is crucial to getting decent renderings in a short period of time. One light in the wrong place with the wrong setting and your scene doesn't look quite right. Well, that's the way it was ... before global illumination. With the introduction of both global illumination and radiosity processing, you can place lights where you want them and then let the renderer do the rest. You can also use self-illuminated materials on your objects, turning them into lights. In this chapter, you learn to set up a scene using both skylights and photometric lights. You also learn to render your scene using both the Light Tracer and Radiosity renderers.

What is Global Illumination?

3ds max uses two methods to render a scene: local illumination and global illumination. Local illumination uses a rendering method where the shading of a surface at a particular point is calculated independent of other elements in a scene. Light is calculated from the light source to the camera directly. The

light hits a surface only once, and then is sent to the camera. Local illumination is non-physically based and therefore provides unrealistic lighting in a scene.

Local Illumination is the default method of illumination used in **3ds max**. When you render a scene using the scanline renderer in **3ds max,** you do so using local illumination. Lights are used to determine the color of a surface based on its material properties. The user must artificially create effects such as bounced light or color bleeding.

Global Illumination, however, works in a much different way. It renders using a method that calculates the shading of a surface at a particular point, taking into account other elements in the scene. Light is calculated from the light source to the camera, however the light might reflect off many surfaces before reaching the camera. Since global illumination uses physically based lighting, it can achieve much more realistic lighting in a scene than local illumination.

One unique advantage of using global illumination is its ability to render color bleeding effects and highlights from bounced light. Color bleeding is a phenomenon that occurs when the light reflected off an object affects the color of adjacent objects. For example, if you have a red box against a white wall, the red coloring of the box will cause part of the wall to have a red color.

More subtle color is achieved with highlights from bounced lights. This involves adding highlights to the surface of an object from the light bounced off objects around it.

The image on the left is rendered using local illumination, while the image on the right is rendered using global illumination. Notice the color bleeding in the global illumination rendered image at the base of the blue and red objects. Also notice additional highlights on the front cube.

Light Tracer

Light Tracer is a global illumination rendering solution that offers you a way to make scenes look more realistic. It is not designed to be a physically accurate method of rendering; it is designed for those more interested in the "look" of the image. Light Tracer does not require any pre-processing and provides a predictable and easy-to-animate rendering method. Light Tracer is best used for outdoor scenes or scenes lit mainly by direct light. However, Light Tracer is rarely used in a production environment due to its long rendering times.

Radiosity 551

The Light Tracer Advanced lighting control is accessible on the menu bar under Rendering > Advanced Lighting > Light Tracer > Advanced Lighting tab. Advanced lighting is part of the tabbed Render Scene dialog, and may get saved with the Render Presets option. Once you open the Advanced Lighting tab, you can choose between Light Tracer, Radiosity, or a Lighting plug-in.

Radiosity

Radiosity is another form of global illumination, which involves thinking about your environment in a different way. Picture a room in your home or office, with chairs, a desk or couch, and a few light fixtures mounted in the ceiling. Imagine all components of the room (chair, walls, ceiling, floor) are made up of mesh surfaces divided into smaller elements.

To calculate the lighting in the room, radiosity starts with the light fixtures. The fixtures emit light onto the surfaces that make up the room. The amount of light that reaches each surface element directly is calculated. Some surface elements are brighter than others, while some reflect light and others absorb light. After the direct light is calculated, a second step takes place.

The second step calculates the light reflecting off the surface elements lit directly by lights in the room. It starts by taking the surface elements that reflect the most light back into the room. The radiosity engine then uses these surface elements as light sources, casting the "bounced" light onto the surrounding surface elements in the room. This process is repeated until almost all the light energy emitted from the fixtures in the room is used. Once these calculations are complete, the radiosity solution is ready to be rendered.

Using radiosity has many advantages. First, radiosity provides an accurate method of rendering area lighting, diffuse reflections, color bleeding effects, realistic shadows, and soft shadows. Another advantage is that the radiosity solution is stored in the actual

geometry. This means you have to solve the radiosity solution only once if the lights and geometry aren't animated. In addition, you can render any view of your scene, including a flythrough, without recalculating the solution. You save a lot of time, especially on large models. Radiosity works well when rendering indoor scenes lit by many different light types.

mental ray

The mental ray® renderer is another renderer available in **3ds max**, and can be used to render a scene instead of the default scanline renderer. That is the biggest difference between the Advanced Lighting solutions; Light Tracer and Radiosity, from mental ray. Light Tracer and Radiosity still use the scanline renderer, whereas mental ray has its own renderer. Mental ray has its own form of radiosity solution called Indirect Illumination. If you plan to use the mental ray renderer, you do not need to use the Light Tracer or **3ds max's** Radiosity. In this chapter, you are introduced to the basics of the mental ray renderer. The chapter on rendering delves deeper into the topic.

3ds max Advanced Lighting vs. Lighting in 3ds max 4 and 5

Here are some differences among **3ds max 4**, **3ds max 5**, and **3ds max 6 and 7** regarding lighting and rendering.

Feature	max 4	max 5	max 6 max 7
Radiosity rendering	No	Yes	Yes
Light Tracer rendering	No	Yes	Yes
Ray-trace rendering	Yes	Yes	Yes
mental ray rendering	No	No	Yes
Photometric lights	No	Yes	Yes
Area Omni and Spot lights	No	No	Yes
Advanced Ray-traced shadows	No	Yes	Yes
Area shadows	No	Yes	Yes
mental ray Shadow Map	No	No	Yes
IES file support	No	Yes	Yes
Skylight	No	Yes	Yes
Advanced Lighting settings for Presets vs. Production rendering	No	No	Yes
Ray-tracer Parameters for Presets vs. Production rendering	No	No	Yes
Environment and Effects settings for Presets vs. Production rendering	No	No	Yes

Feature	Light Tracer	Radiosity	mental ray
Uses Photometric light properties	No	Yes	Yes
Bounced Lighting	Yes	Yes	Yes
Color Bleeding	Yes	Yes	Yes
Diffuse Shadows	Yes	Yes	Yes
IES file support	No	Yes	Yes
Skylight	Yes	No	Yes
IES Skylight	No	Yes	Yes
Architectural Material	No	Yes	Yes

Caustics	No	No	Yes
Area Omni and Spot lights	No	No	Yes

A crucial part in understanding the Light Tracer, Radiosity, and mental ray rendering types is to first identify different kinds of lights. The types of lights you use impacts the final rendering drastically. In the first exercise, you create a Skylight to use with the Light Tracer renderer. In the second exercise, you open a file with an IES Sun already created, and render using Radiosity. In the third and fourth exercises, you use the mr area lights with the mental ray renderer.

Skylight and Light Tracer

The Skylight object is a general-purpose, indirect light designed to work directly with the Light Tracer. The Skylight is a light that creates the effect of an illuminated sky dome. It is extremely useful for outdoor rendering where skylight is the main light source in a scene.

The Skylight itself is a very simple object with few controls. Since it is a physically inaccurate light, it has basic brightness and color controls. The color of the light can also derive from a texture map or the current environment map.

Note: The Skylight differs from the Sunlight and Daylight systems in **3ds max**. The Sunlight system is designed to simulate direct sunlight, and the Daylight system simulates direct sunlight plus a photometric skylight, whereas the Skylight is designed only to simulate the scattered light effect of general skylight.

Rendering with Light Tracer

You create a Skylight object in a scene, and make some changes to the light.

1. On the menu bar, choose File > Open and open *eggboyPlayground_start.max* from the courseware CD.

2. On the command panels, choose Create > Lights.

3. In the Object Type rollout, choose Skylight.

4. In the Top Viewport, click in the lower right of the viewport.

Note: The Skylight does not need to be moved or positioned to light the scene; it is just a marker to let you know that a Skylight lights the scene. Also notice the amount of light shown in the Camera viewport remains the same.

5. On the command panels, choose Modify.

6. On the Modify panel > Skylight Parameters rollout > Sky Color group, choose Use Scene Environment.

Setting the Sky Color to the Use Scene Environment colors the light from the Skylight, based on the current settings in the Environment Background. If the Sky Color is a solid color, then the Skylight is that color. If the Sky Color is a map, the Skylight is colored by the map used as the Environment Map. Using a map adds variation to the lighting of the scene, making it more realistic and natural. It's up to you to determine whether you want a realistic sky or something fanciful and exotic. In this case, a Sky bitmap is already assigned in the Environment options. Light Tracing must be active for the map to have an effect.

The Sky Color option allows you to set the sky color manually or assign it a custom map without having to use the environment.

7. In the Skylight Parameters rollout, set the Multiplier to **4.0**.

Setting the value of the multiplier varies, depending on the scene, map, or color used in the environment. In this case, a value of 4.0 gives the scene the correct brightness.

8. Right-click in the Camera01 viewport to make it active.

9. On the main toolbar, choose Quick Render.

Note: For this rendering, the Light Tracer rendering is set as the current renderer.

Light Tracer rendering is a computer-intensive rendering process. Using the Light Tracer renderer generally takes longer than using the default scanline renderer. While there are ways to optimize rendering times, a good rule is "the faster the computer, the shorter the render time."

10. On the main toolbar, choose Render Scene.

11. In the Render Scene dialog > Advanced Lighting tab, turn off Light Tracer, by choosing the check box next to Active.

Note: You could also set the Advanced Lighting drop-down list to <no lighting plug-in>, however this changes all Light Tracer settings to their defaults.

12. Make sure *Sky01* is still chosen.

13. On the Modify panel > Render group, Cast Shadows is now available.

This option is only available with the Scanline renderer. It is not recommended to use this option since it drastically increases rendering time. You can change the Rays per Sample option to improve render time.

14. In the Render Scene dialog, choose Render.

The image is washed out, and took slightly less time to render without the Light Tracer.

Daylight System and Radiosity

The Daylight System includes an IES Sun and an IES Skylight, which are both Photometric light types. Since Radiosity uses the energy from a light source to calculate a solution, you need a type of light that allows you to specify the amount of energy it emits. While **3ds max** can still use the standard light type to generate a radiosity solution, you have little control over the light and the results are less than desirable without some exposure control. However, a Photometric light provides you with the control you need to create an unlimited number of physically accurate light fixtures.

Note: When using the Light Tracer advanced lighting, the Photometric lights do not act as physically based lights. Photometric light properties are calculated as part of a radiosity solution.

Rendering with Radiosity

In the next example, you open a file with an IES Sun photometric light type. You render the radiosity solution to view the results, and then you render without radiosity to see the difference.

1. On the menu bar, choose File > Open and select *spanish_radiosity.max* from the courseware CD.

2. In the Front viewport, choose *Sun01*.

 Notice this is the only light in the scene.

3. On the command panels, choose Modify.

4. On the Modify panel > Sun Parameters rollout, notice the shadows are set to Advanced Raytraced.

 You learn more about the different shadows types later in this chapter.

5. Look in the viewports, and notice the "meshing" effect on the geometry.

6. Notice the lighting in the Camera viewport.

When Radiosity is calculated it displays in the viewport.

7. Make sure the Camera viewport is active.

8. On the main toolbar, choose Quick Render.

The rendering is calculated with radiosity.

9. On the menu bar, choose Rendering > Advanced Lighting > Radiosity.

10. In the Render Scene dialog > Advanced Lighting tab, turn off Radiosity by choosing the check box next to Radiosity.

 The lighting effect in the Camera viewport has changed, and the meshing effect on the geometry is gone.

Note: You could also have chosen <no lighting plug-in> from the drop-down list, but that removes the Radiosity solution and changes all Radiosity settings to their defaults.

11. On the main toolbar, choose Quick Render.

The rendering is drastically different from the Radiosity rendering.

mr Lights and mental ray

mr Area Lights

In **3ds max,** two light types work with the mental ray renderer: mr Area Omni and mr Area Spot lights. These lights cast light from an area instead of a point. When rendered with the mental ray renderer, the Area Omni light can emit light from a spherical or cylindrical area, while the Area Spotlight can emit light from a rectangular or disc-shaped area.

Note: When these lights are used with the default scanline renderer, mr area lights render as standard point lights.

mr Area Omni

This light acts exactly like a standard Omni light, except with an extra rollout named Area Light Parameters.

On—Can be used to turn the light's area parameters on and off individually. When turned on, this light renders as an area light in mental ray; when turned off, this light renders as a point light in all renderers.

Show Icon in Renderer—When turned on, mental ray renders a white spot where the area light is. When turned off, the light is invisible.

Type drop-down list—Allows you to choose between a Sphere and Cylinder shaped light.

Note: You can rotate a cylinder light, but no cylindrical gizmo indicating the light appears while rotating. You only have the rotate transform gizmo display.

Radius—Sets the radius of the Sphere or Cylinder. While adjusting, a gizmo appears to let you know the size and shape of the light.

Height—Sets the height of the Cylinder. A gizmo appears while adjusting height.

Samples: U and V—Allows you to adjust the quality of the shadows. Higher values cast higher-quality shadows at the cost of render time.

mr Area Spot

This light is just like a Standard Spotlight, except with an extra rollout named Area Light Parameters.

Several of this light's area parameters are the same as the area omni light. The different parameters are:

Type drop-down list—Allows you to choose between a Rectangle- and Disc-shaped light.

Note: Since area spotlights are targeted, they always point towards the target. However, you can rotate the orientation of a rectangle spotlight. Again, no rectangular gizmo appears while rotating.

Radius—Sets the radius of the Disc. While adjusting, a gizmo appears to let you know the size and shape of the light.

Height—Sets the height of the Rectangle. A gizmo appears while adjusting height.

Width—Sets the width of the Rectangle. A gizmo appears while adjusting width.

Using Area Lights in a Scene

1. On the menu bar, choose File > Open, and open *spanish_area_lights.max* from the courseware CD.

 This scene contains two mr area lights.

2. In the Front viewport, select the mr area omni light.

3. On the Command panels, choose Modify. Scroll down the Modify panel to the Area Light Parameters rollout and open it.

4. In the Area Light Parameters rollout, click and drag the Radius spinner to dynamically change the light's radius to approximately 40 units.

Notice the blue-green gizmo showing the size of the light.

5. Activate the Camera viewport, and then on the main toolbar, choose Quick Render.

The two lights in the scene render as point lights because the scanline renderer was used.

6. On the main toolbar, choose Render Scene.

7. In the Render Scene dialog, make sure the Common tab is selected.

8. Open the Assign Renderer rollout, and choose the button next to Production.

9. In the Choose Renderer dialog, double-click mental ray Renderer.

10. In the Camera02 Rendered Frame Window dialog, choose Clone Rendered Frame Window.

11. In the Render Scene dialog, choose Render.

The scene now renders with mental ray. You notice that mental ray renders differently than the scanline renderer. The

rendering time is longer, but the shadows are softer in certain areas.

Photometric Lights

In this section, you load a subway scene that uses many light types with various settings. You render the scene with and without Radiosity, and take a look at Photometric lights and see how they work. The settings are explained in theory and by way of example.

Choosing Photometric Lights

1. On the menu bar, choose File > Open and open *subway_photo_lights.max* from the courseware CD.

2. Right-click in Camera02 to make it active, and then choose Quick Render from the main toolbar.

 A still rendering of the image is displayed.

3. On the Rendered Frame Window toolbar, choose Clone.

This makes a copy of the Virtual Frame Buffer.

4. Right-click in Camera 01 to make it active, and then choose Quick Render from the main toolbar.

 Both camera renderings are displayed.

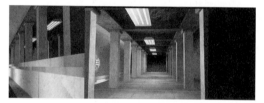

As you explore the light types, refer to the renderings to view the results.

5. Resize the dialogs so you can see the camera viewports and the renderings.

6. On the main toolbar > Selection Filter drop-down list, choose Lights.

7. Press **H** and choose *FArea04*.

8. Zoom in on the light in the Top viewport.

Notice that a sphere in the center represents the light's position, but there is also a rectangle showing the full size of the area emitting light. The size of this rectangle can be set on the Modify panel. This is an area light, and it is used to emit light for the three fluorescent lights in the light box. This is a typical use of an area light. In the Camera02 render, you see these lights illuminate large areas of the ground, and cast blurry shadows.

9. On the command panels, choose Modify.

```
-     General Parameters
-Light Type
 ✔ On  Area            ▼
 ☐ Targeted  20'0.0"   ▲▼
-Shadows
 ✔ On ☐ Use Global Settings
 Shadow Map           ▼
                Exclude...
```

Notice this is a Free Area light. There is no target, and the lights point straight down.

10. If it is closed, open the Intensity/Color/Distribution rollout.

```
- Intensity/Color/Distribution
Distribution:  Web            ▼
-Color
 ◉ Fluorescent               ▼
 ○ Kelvin: 3600.0  ▲▼  ☐
 Filter Color: ☐
-Intensity
 Resulting Intensity: 10164.0 cd
 ○ lm   ◉ cd   ○ lx at
 10164.0 ▲▼  3'3.37" ▲▼
 Multiplier:
 ☐ 100.0 ▲▼ %
```

Notice the Distribution is set to Web. This means that an IES file defines light distribution. Also, notice the color is set to that of a Fluorescent light, and the Intensity has been increased to 10164 candelas (cd). Photometric lights default to 1500 cd.

Since Photometric lights always follow the inverse square law for light intensity, light diminishes faster than prevalent with standard lights. In the real world, lights also follow the inverse square law, however the real world has instantaneous radiosity. Radiosity also solves the problem with Photometric lights in a **3ds max** scene to a degree. You still need to set an amount for the light's intensity. Remember, a 6000-watt movie light is much more intense than a 60-watt light in your house.

11. Open the Web Parameters rollout.

You see that the Web File loaded is named fluo.ies. It is an IES file included with the maps on the courseware CD. Many companies that manufacture lights now offer free IES files for their lighting on the Internet.

12. Open the Area Light Parameters rollout.

Here you set the actual size of the area light. This light is 1'8" x 7'0".

13. Press **H** and choose *FLinear03*.

14. Zoom in on the light in the Top viewport.

This light's position is shown with a sphere, and a line shows the full extent of the light in the viewport. It is a Linear Light used for the long thin lights along the side of the subway tracks. In the Camera01 render, you see that these lights cast blurry shadows along their length, but cast sharp shadows with objects perpendicular to their length.

15. Take a look at the General Parameters rollout.

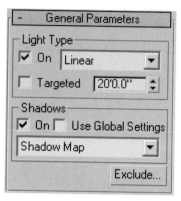

This is a Free Linear light. There is no target, and light is emitted almost perpendicular to the length of the light.

16. Take a look at the Intensity/Color/ Distribution rollout.

Notice the Distribution for this light is set to Web. Also, the color is set to a High Pressure Sodium light, which is more of an

orange color. The Intensity has been increased to 15164 candelas (cd).

17.Take a look at the Web Parameters rollout.

You see the Web File loaded is named rail.ies. This IES file is included with the maps on the courseware CD.

18.Open the Linear Light Parameters rollout.

The length of this light has been set to 6'3".

19.In the Camera viewport, choose the light on the warning sign, FPoint01.

20.Zoom in on the light and warning sign in the Top viewport.

This light is shown as a sphere. The light is a Point Light, which causes the glowing red-orange light on the wall behind the warning sign. The light from a point light emits from the center of the sphere. Point Lights cast relatively crisp shadows compared to Area and Linear Lights.

21.Take a look at the General Parameters rollout.

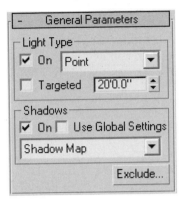

This is a Free Linear light. A target can affect a Point Light when it is given web distribution because the lighting depends on the orientation of the light.

22.Take a look at the Intensity/Color/Distribution rollout.

This light has its Distribution set to Isotropic, meaning that light is distributed

evenly in all directions. The color is set to Incandescent, and the Filter Color set to red-orange. This is similar to putting a red-orange filter over the light, causing it to emit red-orange light. The Intensity remains at the default of 1500 candelas (cd).

You can use five types of Photometric Lights when lighting a scene in **3ds max**. They are:

- **Point—** Is a good, general-purpose light type since it casts light from a single point in space. You can use it as a standard light bulb, or as a fixture with a standard bulb. This light can also be used as a spotlight.

- **Linear**—Casts light along a single axis. This is ideal for use as a fluorescent light tube.

- **Area—** Casts light from a flat, square area. This light type is ideal for use as a fluorescent ceiling fixture, or a large, flat light panel.

- **Daylight System—** Can be used with the IES Sun and IES Sky (see following items). The two systems take care of all the work needed to light an outdoor scene properly.

- **IES Sky—** Similar to the standard Skylight, but provides a different method to affect the Sky Color. This light provides general illumination, and is useful for outdoor scenes where you want general scattered skylight. This skylight is designed to work with the Radiosity renderer, although it can be used with the Light Tracer.

- **IES Sun—** IES Sun is a physically based light object that simulates sunlight. This light type is ideal for rendering a scene that requires bright, direct sunlight.

The Point, Linear, and Area lights can be either Free or Target lights.

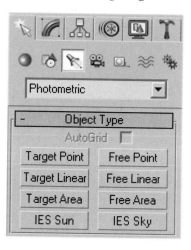

Photometric lights incorporate properties that describe the physics of the light source itself. The physical properties of a Photometric light are the type of distribution, color, and intensity. These settings define the physical properties of the light for the radiosity engine.

Photometric Light Properties

While Photometric lights share several options with standard **3ds max** lights, you need to become familiar with several property rollouts to use them correctly. Shadow Parameters, Atmosphere & Effects, and Advanced Effects are common properties of Standard and Photometric lights.

Area/Linear Lights as Point Lights

When you render with **3ds max's** default scanline renderer, the mr area omni light and the mr Area Spotlight behave like standard point lights, but render more slowly. Linear

and Area Photometric lights also render more slowly because it takes extra calculations to render the penumbra smoothly.

3ds max includes an option that saves time by rendering area and linear lights as point lights to make quick preliminary renderings with the scanline renderer. The Render Scene dialog includes an Area/Linear Lights as Point Lights check box. When this option is turned on, all lights render as point lights, and you get a faster render. Everything in the scene is accurate except the look of the shadows.

This check box does not affect Radiosity renderings.

Rendering area lights as point lights

1. On the menu bar, choose File > Open, and open *subway_photo_lights_norad.max* from the courseware CD.

 This is the subway scene without Radiosity calculated.

2. On the main toolbar, choose Quick Render.

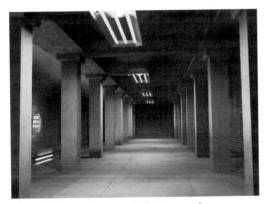

This image takes a while to render.

3. On the main toolbar, choose Render Scene to open the dialog.

4. In the Render Scene dialog, make sure the Common tab is selected.

5. In the Common Parameters rollout > Options group, turn on Area/Linear lights as Point Lights.

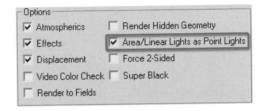

6. In the Camera02 Rendered Frame Window, choose Clone Rendered Frame Window.

7. On the Render Scene dialog, choose Render.

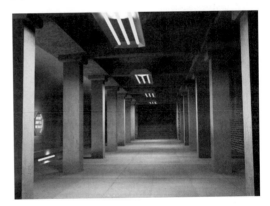

The lights are now rendered as standard point lights and the scene renders in considerably less time. Compare the two renders. Notice the difference in the lighting rails below the stop sign, and in the first fluorescent light.

General Properties Rollout

The General Parameters rollout contains three main sections: Light Type, Shadows, and Exclude.

Light Type

The Light Type group provides a way to turn on and off the light. It also allows you to change the light from Point to Linear or Area and to change the light from a target light to a free light.

When Targeted is turned off, you have a free light. When it is turned on, you have a targeted light. A free light is not tied to looking at a specific point, which you will

probably use for most lights you create. The target light, on the other hand, is tied to looking at a target object and can be used to make a light follow a subject.

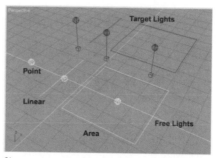

Shown are examples of Point, Linear, and Area lights, with both the Free and Target option.

Three light types appear in the subway scene.

Shadows

The shadows group gives you the option to turn on or off shadow casting for the light, change the light's shadow generator, and set the light to use the global shadow settings.

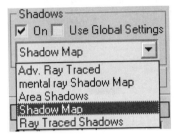

There are five shadow generators to select from:

- **Advanced Raytraced Shadows—** Is an updated version of Raytraced shadows. It offers soft edges and makes better use of system memory when rendering. It works in almost all situations where you do not need area shadows.

- **mental ray Shadow Map—** Can be quicker than Raytraced shadows with the mental ray renderer, however it is not as accurate as Raytraced shadows.

- **Area Shadow—**Casts a shadow as if from a large, solid source of light. You use this for a fluorescent ceiling fixture, or to get more diffuse shadows. You usually use area shadows with standard lights to make them behave like area lights.

- **Shadow Map—** The traditional method of generating a shadow is to use an image MAP as the source for the shadow. This shadow type can be used as a general shadow generator. While it is a fast way to render shadows, it is not as flexible or as accurate as Advanced Raytraced shadows.

- **Raytraced Shadows—** This shadow type uses ray tracing to render shadows. You can use this shadow type as a general shadow generator, however the edges of the shadow are hard.

You covered the various shadow types in the previous chapter. In this chapter, you continue to look at the properties of area shadows and Advanced Raytraced shadows.

Note: All shadows cast in the subway scene are shadow maps.

Exclude/Include dialog

Choosing this button opens the Include/ Exclude dialog. This dialog lets you define which objects the light affects. By default, a light affects all renderable objects. However, this tool allows you to override the default by specifying whether the light includes or excludes certain objects.

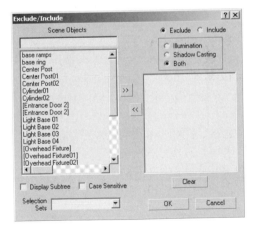

Intensity/Color/Distribution Rollout

This rollout contains the physical properties of the light source. There are three areas of interest in this rollout: the Distribution type, Color, and Intensity.

such as a traditional light bulb or as part of a lamp assembly.

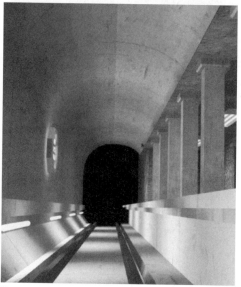

The top image displays the isotropic distribution in an empty room. The bottom image displays the isotropic distribution from the warning sign in the subway scene.

Distribution

Three types define the distribution of a point light: Isotropic, Spot, and Web. Linear and Area lights use Diffuse and Web distribution types.

- **Isotropic—** Resembles an omni light in that the light source distributes light evenly from a single point in all directions. This light type is used for general purposes,

- **Spot—** Works similar to a standard spotlight with a directional cone, but the light distribution within the cone is different. When the light reaches the spotlight's Hotspot/Beam angle, the light has fallen to 50%. When the light reaches the spotlight's Falloff/Field angle, the

light has fallen to 0%. (With a standard Spot Light, the light intensity is 100% all the way to the Hotspot/Beam angle.) You use the same options for the angle of the inner and outer cones as for standard spotlights. You can use this light type anywhere you want a directed light source, as in a flashlight, a spotlight mounted on a track, or a traditional spotlight for theaters or concerts.

- **Diffuse**—Distributes light evenly across the surface of the light area for Linear and Area lights only. It is the default setting for Linear and Area lights, and can be used as

individual fluorescent tubes of light or a complete in-ceiling fluorescent fixture.

Linear Light with Diffuse distribution

Area light with Diffuse distribution

- **Web**—A unique distribution pattern for a specific light source exclusively for Photometric lights. A special file called a Photometric Data, Web, or IES file describes the distribution of light for a specific light fixture. When manufacturers engineer a lighting fixture, they typically create an IES photometric web file to

represent that light fixture in a 3D environment.

Point light with IES distribution

Linear light with IES distribution

Area light with IES distribution

Note: Both the Linear and Area lights in the subway scene have IES distribution.

An IES file is a text file, and may be viewed in a text editor. Be careful though; do not change any data unless you know how IES files are written. You can find out more about the IES standard file format in the **3ds max** help file. Most light manufacturing companies now offer free IES files of their

lights on the Internet. A good place to start looking for IES files is to use your favorite search engine to search for **IES** and *lighting*. Some companies place all their lights in a single ZIP file, while others have a list and let you pick the exact light you are looking for.

You can save your IES files in a standard location, which involves adding a lighting folder to **3ds max**, and storing the files there. Another option is to take a look at ***http:// idrop.autodesk.com***. Autodesk's i-drop® technology allows you to drag and drop web content directly into Autodesk programs.

Example of an IES Photometric web, shown as an image.

Color and Color Temperature

The color of a Photometric light is derived from its color temperature. Color temperature is a measurement in degrees Kelvin that indicates the color of a light source. The drop-down list in this area provides you with some standard light color values. However, you might want to set the

color to meet a specific need at times. To enter a specific color temperature in Kelvin, you must choose the radio button to the left of the Kelvin label. To the right of the value, you see a representative color in the color swatch. The following list shows several common color values.

Degree Kelvin	Light source
1850-1930K	Candle flame
2500-2900K	Household tungsten bulb
3200-3500K	Quartz lights
5500-6500K	Daylight (no clouds)
8000-10000K	Partly cloudy sky

In **3ds max**, color temperature ranges from 1000 to 20,000. At 1000K, the color is light red. As you increase the temperature to about 5000K, the color changes from orange to light yellow. When the temperature reaches 6000K, the yellow lightens to pure white. As you raise the temperature above 6000K, up to 20,000K, the white becomes increasingly blue.

For a more in-depth lesson on color theory and color temperature, go to *http://www.cybercollege.com/tvp028.htm*.

For the most part, you will use the color presets for the lights you create. Also, several of the default lights tint the light a different color than what is available using the Kelvin system. This is because some light types, such as Mercury, tint the light color also.

Filter color

The Filter Color swatch is used as a color gel for the light. In the real world, and in **3ds max**, the true color of a light is derived from its color temperature. To give the light a specific color, use the Filter Color swatch.

In the Subway exercise, the color of the Point light on the warning sign is set to Incandescent. This is a **3ds max** light color preset that references the color of an Incandescent light bulb, which is a light yellow. The warning sign light is behind the sign, which is meant to be a red-colored piece of glass or plastic. It would tint the light color, so the Filter color is set to a red-orange color. Take note that the light shining on the walls is reddish in the rendering to enhance the realism.

Intensity

Many methods determine the intensity of a Photometric light. A major difference between traditional **3ds max** lights and Photometric lighting is that in the real world a 150-watt halogen and a 150-watt tungsten light do not emit the same amount of light energy.

3ds max provides several methods for specifying light intensity. They are:

- **Luminous Flux (lm)**— Measures the overall output of a light fixture in Lumens (lm).

- **Luminous Intensity (cd)**— Measures the maximum light intensity of a fixture in Candelas (cd).

- **Illuminance at a Distance (lx at)**— Measures the intensity caused by the light shining on a surface at a certain distance while the surface faces the direction of the source. It is measured in lux (lx) where 1 lux = 1 lumen/m^2. The distance is measured in the current units set in the scene.

- **Illuminance at a Distance (fc at)**—Similar to specifying the illuminance in lux, except the units are foot-candles, where 1 foot-candle=1 lumen/ft^2. Foot-candles are accessible when the lighting units are set to American.

- **Multiplier**—A percentage amount used to override the normal intensity controls.

The lighting units can be changed from International to American in the Units Setup dialog (Customize menu > Units Setup), in the Lighting Units group.

If you are using a certain form of lighting, you have access to the intensity values. If you do not, you might have to use trial and error to get acceptable results. Remember that Radiosity also changes the overall lighting in a scene.

Adjusting the Intensity

Continue working with the subway scene to adjust the intensity of the Point light.

1. Continue from the previous exercise, or choose File > Open from the menu bar, and open *subway_photo_lights.max* from the courseware CD.

2. Press **H** and choose *FPoint01* from the Select Objects dialog.

3. On the Modify panel > Intensity/Color/
Distribution rollout > Intensity group,
type **2500**.

This increases the brightness of the light.

4. On the menu bar, choose Customize >
Units Setup.

5. In the Units Setup dialog, set the Lighting
Units to American.

6. Verify *FPoint01* is still selected.

7. On the Modify panel > Intensity/Color/ Distribution rollout, the third option is now foot-candles, fc, instead of lux.

```
- Intensity/Color/Distribution

Distribution:  Isotropic        ▼

┌ Color ─────────────────────────┐
│  ◉  Incandescent          ▼    │
│                                │
│  ○  Kelvin:  3600.0  ▲▼  □      │
│                                │
│  Filter Color:  ▭              │
└────────────────────────────────┘

┌ Intensity ─────────────────────┐
│  Resulting Intensity:  2500.0 cd│
│  ○ lm    ◉ cd    ○ fc at        │
│   2500.0  ▲▼   3'3.37"  ▼       │
│  Multiplier:                    │
│   □  100.0  ▲▼  %               │
└────────────────────────────────┘
```

Note: Changing the lighting units to American simply makes foot-candles one option for setting the light intensity. It does not affect the value of 2500 candelas you set previously for the selected light.

8. Set the lighting units back to International.

9. Right-click in the Camera01 viewport to make it active.

10. On the main toolbar, choose Quick Render.

Note: The Multiplier setting allows you to increase the brightness by adjusting the percentage spinner. This option resembles the standard light Multiplier and disables the Intensity type-in when you use it.

11. Change the Filter Color and render again. Once you adjust the Intensity and Filter Color, change the settings back.

Notice that adjusting the light intensity and filter color does not invalidate the Radiosity solution. This can save precious time when working on a scene, because you can adjust the light intensity and color without recalculating the Radiosity solution every time.

Shadows

Area Shadows Rollout

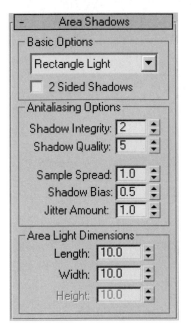

You see this rollout only if you select Area Shadows from the Shadow Type drop-down list.

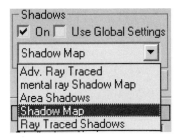

Area shadows provide you with a way to cast shadows from a light as if it were a solid object. This is an ideal shadow generator for any large light source, such as a fluorescent panel, or the globe of a street lamp. Area shadows are more realistic than shadow mapped or raytraced shadows, and advanced raytraced Shadows used with standard lights. Area shadows are soft shadows that blur and lighten as the distance between an object and its shadow increases. Area shadows can be set to respect transparency.

There are three groups in the Area Shadows rollout:

- Basic options
- Antialiasing Options
- Area Light Dimensions

Basic Options

In the Basic Options group, you choose the mode of the light and whether 2-Sided Shadows is active.

The modes of light are:

- **Simple—** Casts a single ray from the light towards the surface and provides no area light calculations. This setting is useful for test renders where speed is more important than quality.
- **Rectangle Light—** Causes the light to cast shadows as if the light is a flat, rectangular

plane. This setting is used for fluorescent light fixtures or flat light panels.

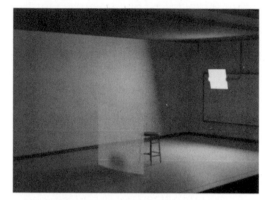

- **Disc Light**— Causes the light to cast shadows as if the light was a flat disc plane. This setting is used for circular light fixtures.

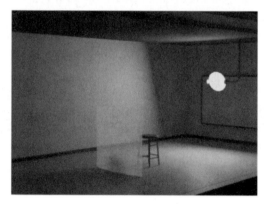

- **Box Light**— A 3D light shape that casts a shadow as if the light was a box with a Length, Width, and Height. You can use box lights for many special effects lighting setups, such as large cubes of light.

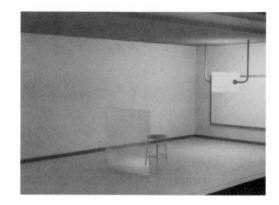

- **Sphere Light**— A 3D light shape that casts a shadow as if the light was a sphere with a Length, Width, and Height. This mode is used for globe lights like those on street lamps.

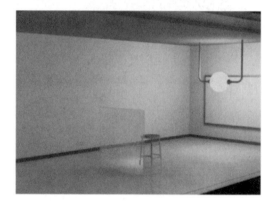

2-Sided Shadows

When this option is turned on, the front and the back faces of a polygon cast a shadow. This is most useful when you create single polygon objects such as curtains, tablecloths, and panes of glass.

Antialiasing Options

Before you explore the Antialiasing options in the Area Shadows rollout, you need to understand some terminology. The shadow an object casts contains two parts, the Umbra and the Penumbra. The area in full shadow is the Umbra, and the area surrounding the Umbra is the Penumbra. The Penumbra is not a solid area but a gradient that goes from the shadowed area to the light. This is illustrated in the following rendering.

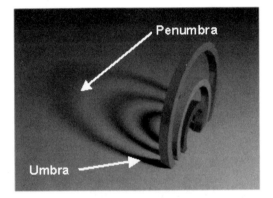

Shadow Integrity—Sets the number of rays in the initial bundle of rays cast to calculate the shadow. These rays are fired from the surface of the area light source. The number of rays is determined by the quality setting, with 1 to 5 out of 15 as recommended numbers. This is the primary control for casting shadows with small objects and thin spaces between objects. If the shadows omit a small object in your scene, try increasing Shadow Quality, one step at a time. Also, increase this setting if there are blotches in the Penumbra.

Shadow Quality—Sets the total number of rays cast in the Penumbra region. These rays are fired from every point in the Penumbra, or antialiased edge of the shadow, to smooth it out. Shadow Quality should always be greater than Shadow Integrity. This is because secondary rays overlay the Shadow Integrity rays. Increase Shadow Quality to fix banding in the Penumbra, and eliminate the noise pattern from jittering.

Sample Spread—The radius, in pixels, to blur the antialiased edge. The larger this value, the higher the quality required. Increasing the Sample Spread also increases the likelihood of missing small objects. In this case, increase Shadow Integrity.

Shadow Bias—The minimum distance to cast a shadow from an object and the point being shaded. It prevents blurred shadows from affecting surfaces they shouldn't. The higher the blur, the higher the required bias for the shadow.

Jitter Amount—The amount of randomness to add to the ray positions. The rays are initially in a regular pattern, which can show up in the blurry part of the shadow as regular artifacts. Jittering converts these artifacts to noise, which is generally less noticeable to human perception. Recommended values are 0.25 to 1.0. Very blurry shadows require more jitter.

Area Light Dimensions

This area allows you to set the size of the area shadow surface. You set the Length, Width, and Height in units and work on the light source's local axis where the Width = X, Height = Y, and Length = Z. All three fields are disabled for simple lights, Width and Height are available for Rectangle and Disc lights, and all three are available for Box and Sphere lights.

Advanced Raytraced Parameters Rollout

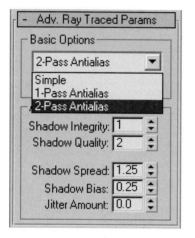

This rollout is displayed when Advanced Raytraced shadows are selected from the General Properties rollout, Shadow type drop-down list.

Advanced Raytraced shadows are similar in function to Area shadows, however the shadow source is a point, not an area, for standard lights. With the area and linear photometric lights, advanced raytraced shadows produces appropriate shadows for the light source. Advanced Raytraced Shadows can also be set to respect transparency. The difference between

shadow types lies in the Mode drop-down list. Whereas the Area shadow has many options, the Advanced Ray-traced shadow provides you with three.

- **Simple**— Resembles the Simple setting in the Area shadow modes list.

- **1-Pass Antialias**— Casts a single bundle of rays. The number of rays is set using the Shadow Integrity spinner.

- **2-Pass Antialias**—Casts two bundles of rays. The first batch of rays determines if the point in question is fully illuminated, shadowed, or in the penumbra (soft area) of the shadow. If the point is in the penumbra, a secondary batch of rays is cast to further refine the edge. The number of initial rays fired is specified using the Shadow Integrity spinner. The number of secondary rays is specified using the Shadow Quality spinner. This value is used when you blur the shadow with Shadow Spread, or render shadows with photometric Area and Linear lights.

In the Antialiasing Options group:

As previously mentioned, **Shadow Integrity** determines the quality of the shadow's edges, while **Shadow Quality** smoothes the penumbra. Higher values give you better shadows at the cost of render time.

- **Shadow Spread**—blurs the edges of the shadow.

- **Shadow Bias**—is the minimum distance to cast the shadow from an object. You might have to adjust Shadow Bias if you increase Shadow Spread.

- **Jitter Amount**— adds noise to the penumbra to remove any visible artifacts.

Optimizations Rollout

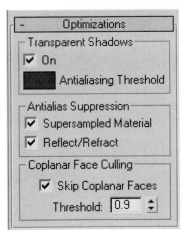

When you use area shadows or advanced raytraced shadows, an Optimizations rollout also appears. The settings in the rollouts are the same for both shadow types. The Optimizations rollout gives you access to several options designed to speed up the rendering process.

Transparent shadows —When this option is turned on, transparent surfaces cast the properly colored shadow. If it is turned off, all shadows are black, speeding up the rendering.

Antialiasing Threshold—The maximum color difference allowed between transparent object samples before antialiasing (Shadow Quality) is triggered. Increasing the value of this color makes the shadow less sensitive to aliasing artifacts and improves speed. Decreasing the value increases the sensitivity, improving quality at the sacrifice of speed.

Supersampled Material—If 2-Pass Antialiasing is selected, and the renderer is shading a supersampled material, only 1-Pass Antialiasing is used. If it is disabled, it might impact the rendering time without resulting in a better image.

Reflected/Refracted—If 2-Pass Antialiasing is turned on and the renderer is shading reflections/refractions, only 1-Pass Antialiasing is used. If it is disabled, it might impact the rendering time without resulting in a better image.

Skip Coplanar Faces—Prevents adjacent faces from shadowing each other. It is of particular concern at the edge of a curved surface such as a sphere.

Threshold—The angle at which the coplanar faces are ignored by the renderer (range 0.0=perpendicular to 1.0=parallel).

Using Shadow Types

In the following exercise, you open the scene of a Spanish home and adjust the shadows cast by the Sun. The scene uses two omni lights, and no advanced lighting. You use the Sun along with two omni lights and the Scanline renderer to test the various shadow options.

1. On the main toolbar, choose File > Open and open *spanish_shadows.max* from the courseware CD.

 This is similar to the scene you used before, however this time two Omni lights are being used to simulate Radiosity.

2. Make sure the Camera viewport is active.

3. On the main toolbar, choose Quick Render.

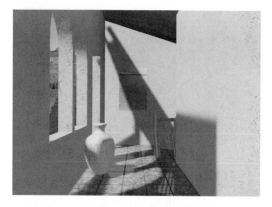

The scene is rendered with shadow mapped shadows. The shadow isn't very accurate, and you can see pixelation in the map.

4. In the Top viewport, choose the Sun.

5. On the Modify panel > Sun Parameters rollout > Shadows group, choose Adv. Ray Traced shadows from the drop-down list.

6. Make sure the Camera viewport is active.

7. On the main toolbar, choose Quick Render.

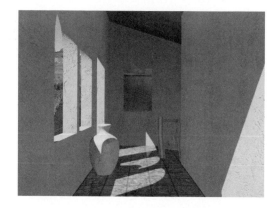

The scene is rendered with Advanced Ray Traced shadows. These are more accurate shadows. Although the shadows look good, their edges are quite sharp. This is because you are using the Scanline Renderer, and the Sun had no area light parameters.

8. On the Modify panel > Sun Parameters rollout > Shadows group, choose Area Shadows from the drop-down list.

9. On the main toolbar, choose Quick Render.

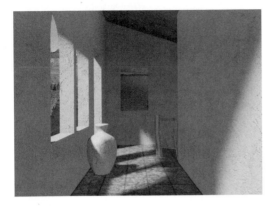

The scene is rendered with area shadows. The shadows are soft, and simulate the natural blurring of shadows as they move farther from the casting object. The blurred area is a little grainy.

10. On the Modify panel > Area Shadows rollout > Basic Options group, choose Disc Light from the drop-down list.

11. In the Antialiasing Options group, set Shadow Integrity to **5** and Shadow Quality to **12**.

12. In the Area Light Dimensions group, set both Length and Width to **20**.

Now the shadows look more realistic.

13. On the main toolbar, choose Quick Render.

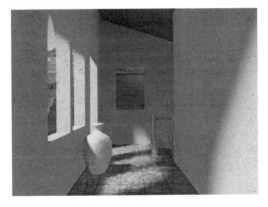

Now the shadows look more realistic.

Conclusion

This chapter exposed you to the basic workings of the **3ds max** Light Tracer and Radiosity engine, their uses, and how to adjust them. You concentrated on the importance of lights and their options. You've become familiar with both Skylight and Daylight. You used photometric lights to understand how to set them up for your scenes.

20

Rendering with Global Illumination

Objectives

After completing this chapter, you should be able to:

- Use Light Tracer.
- Use Radiosity.
- Generate a high quality Radiosity solution.
- Use Exposure control.
- Control Radiosity parameters by object.
- Use Advanced Lighting Override Material.
- Use Architectural Material with Radiosity.

Introduction

In the previous chapter, you were introduced to the basic concepts of the Advanced Lighting options in **3ds max**. In this chapter, you explore the Light Tracer and Radiosity solutions further. You work with both options to generate high-quality renderings.

Light Tracer

Light Tracer in **3ds max** is designed as a simple Global Illumination renderer, and provides you with high-quality photo-realistic renderings. Next you learn to use the Light Tracer rendering and become familiar with various interface options. Once you have mastered it, you set up a scene and render it using the Light Tracer.

Accessing Advanced Lighting

There are two ways you can activate the Advanced Lighting options:

- On the menu bar, choose Rendering > Advanced Lighting > Light Tracer or Radiosity.

- On the main toolbar, choose Render Scene, and then choose the Advanced Lighting tab.

This option in the Render Scene dialog means you can set different advanced lighting setups and save the setups as Presets. So it is possible to have one Preset with no advanced lighting, and another Preset with the Light Tracer. It is also possible to have one Preset render with a low-quality Radiosity Solution, while another Preset renders with a high-quality solution.

The Interface

Light Tracer consists of two groups: General Settings and Adaptive Undersampling.

General Settings

Global Multiplier—Makes the Light Tracer effect more or less apparent. High values bounce more light, and can cause surfaces to be too bright, creating unrealistic highlights.

Sky Lights—Adjusts the Sky light amount, which varies the brightness of the sky. A lower value darkens the render of the sky, whereas a higher value brightens the sky. This differs from the Global Multiplier in that

it affects the light coming from the skylight only, not the overall scene lights. The Sky Lights check box allows you to turn off the skylight used in the scene.

Rays/Sample—Specifies how many rays are cast from each sample of a surface in a scene. Rays are cast randomly from a sample and they in turn sample the surrounding environment to calculate how much diffuse light hits that sample point. The more rays you cast, the more accurate your rendering looks. But there's a catch: more rays require more time to calculate, and longer rendering time.

Filter Size—Calculated in screen pixel size. To optimize render time, Light Tracer does not calculate the color value for each pixel. It uses the filter to smooth the results of the rendering to give you a smooth representation of the final image. This allows you to lower the Rays/Sample value to speed up render time, while maintaining a good quality image. Be careful though, since lower values might cause excess graininess and higher values might cause the image to look too smooth.

Ray Bias—Fixes bounced light artifacts, such as banding, that can occur when an object casts a shadow on itself.

Cone Angle—Fixes artifacts or controls the look of the image. Basically, cone angle controls the angle at which rays spread out from one sample point to another. A value of 90 degrees shoots rays perpendicular to the current plane, which is generally not a good idea. Smaller angles can give more contrast to areas with a lot of detail.

Object Mult.—Controls the strength of the objects samples.

Color Bleed—Multiplies the color bounce off objects. A higher value causes more color bleeding, while a lower value causes less. A value of 0.0 eliminates color bleeding completely.

Color Filter—Adds global color to the rendered image.

Extra Ambient—Adds more light to the scene on a global level. It works the same as the traditional Ambient value in the **3ds max** environment.

Bounces—Specifies how many times the Light Tracer bounces the light between samples. A low value produces an inaccurate result and often renders a darker scene. Higher values increase the accuracy of the rendered scene, but also increase render time. This setting has a maximum value of 10.

Enable Volumetrics—Causes the Light Tracer to take scene volumetrics, such as volume lights, into effect when rendering the scene. Be aware, since it can significantly increase rendering time.

Adaptive Undersampling—Provides settings to improve rendering time by allowing you to sample certain parts of the scene only.

Adaptive Undersampling check box—Turns on and off the Adaptive undersampling option. Turning off Undersampling can enhance the detail of the final render at the cost of render time.

Initial Sample Spacing—Sets the initial sample spacing. The sample spacing is laid out as an N x N grid. For example, an initial sample spacing of 16 x 16 places a sample point every 16^{th} pixel both horizontally and vertically. Smaller sampling gives you more accurate lighting, but takes longer to render.

Subdivision Contrast—Controls when a spacing grid block should be further broken down. Higher values cause less subdividing to occur, while lower values cause excess subdividing to occur.

Subdivide Down To—Sets the minimum grid size for the sample spacing. If the value is set to 1 X 1, the block subdivides to the individual pixel. Larger grid sizes lowers rendering time and quality.

Show Samples—When this option is turned on, the samples are shown as part of the rendered image. This helps you gauge how to subdivide your scene to optimize render time and quality.

Rendering a Scene using the Light Tracer

In this exercise, you open an Egyptian Bath scene and render the scene using the Light Tracer. You first render without changing the Light Tracer settings. Then you adjust the settings and view the changes to the rendering.

1. On the main toolbar, choose File > Open and open *bathscene_start.max* from the courseware CD.

 This scene contains omni lights casting shadows and one Skylight.

2. Make sure the Camera viewport is active.

3. On the main toolbar, choose Quick Render.

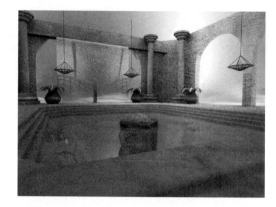

The rendering is a little dark and very grainy looking.

4. On the menu bar, choose Rendering > Advanced Lighting > Light Tracer.

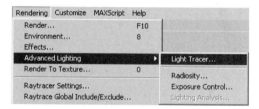

Note: In the Render Scene dialog > Advanced Lighting tab, the Light Tracer is chosen for you.

5. Make sure the Camera viewport is active.

6. On the main toolbar, choose Quick Render.

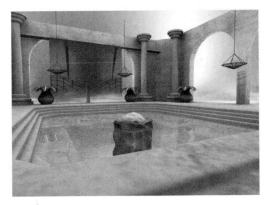

The rendering settings are set to render at 320 x 240. The Light Tracer rendering takes much longer to render than the scanline rendering. You see that the Light Tracer rendering looks superior to the original rendering. Next, you adjust the Light Tracer parameters.

7. In the Parameters rollout > General Settings group, set Rays/Sample to **100**.

This reduces the number of rays calculated by the Light Tracer while still providing a good quality image.

8. In the General Settings group, set Bounces to **1**.

This allows for enough bounces to get a good idea of how the light interacts with the scene. Since the Light Tracer is meant for outdoor renderings, try to keep this number to a minimum. Increasing this number increases rendering time drastically.

9. In the Parameters rollout > General Setting group, set Color Bleed to **1.5**.

This value multiplies the colors bounced off objects.

10. In the Adaptive Undersampling group, change Subdivide Down To to **2 x 2**.

This keeps the Light Tracer from sampling each pixel while still providing a good quality final image.

11. Right-click in the Camera viewport to make it active.

12. On the main toolbar, choose Quick Render.

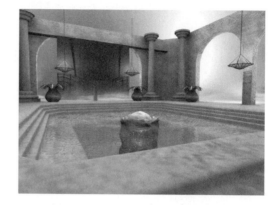

This image took longer to render. The differences are subtle; most noticeable are the changes in lighting on the vases and columns. In the end, you must decide what gives the best results, with the least amount of rendering time.

13. On the menu bar, choose File > View Image file, and open *egypt_bath_lighttracer_photo.jpg* from the courseware CD. This rendering was done using Photometric Point lights with

Isotropic distribution rather than omni lights.

Note: The Light Tracer disregards the real-world parameters of the Photometric lights, however they can still be used for the rendering.

Radiosity

Now you learn to harness the power behind the radiosity engine in **3ds max**. In this section, you learn more about the radiosity process and its function.

Concepts

Radiosity is the process of simulating the propagation of light in an environment. The distribution and intensity of the light depends upon how materials reflect and receive the light energy.

When you create a scene for rendering with radiosity in **3ds max,** no special materials are needed, except in certain circumstances. For example, special materials are needed to make a geometric object that emits light, such

as neon tubing. Special materials are also needed when an object doesn't reflect enough light or adds too much color to the scene.

3ds max has a special material type called the Advanced Lighting Override Material for these special cases. You learn about this material type in the next section.

Turning on Radiosity

In **3ds max,** there are two methods of initializing a radiosity solution. One is to activate it at render time and have the solution calculated at render time, which is selected in the Render Scene dialog. The second is to start the solution manually and allow it to generate a solution before you render the scene, a process done by choosing the Advanced Lighting tab in the Render Scene dialog.

Creating the solution at render time is accomplished by turning on the Compute Advanced Lighting when Required option from the Common tab in the Render Scene dialog. You must also turn on the Use Advanced Lighting otherwise the solution is generated but not used in the renderer.

The Render Scene dialog with both Radiosity options turned on.

The Advanced Lighting tab in the Render Scene dialog contains the controls for solving a radiosity solution without rendering the scene. To access the Radiosity dialog, choose Rendering > Advanced Lighting > Radiosity from the menu bar. To start a solution, simply choose the Start button.

Generating a Solution

In the next exercise, you process radiosity for an enclosed version of the Egyptian Bath scene.

1. On the main toolbar, choose File > Open and open *egyptianbath_rad.max* from the courseware CD.

2. On the menu bar, choose Rendering > Advanced Lighting > Radiosity.

3. In the Render Scene dialog > Radiosity Processing Parameters rollout, choose Start.

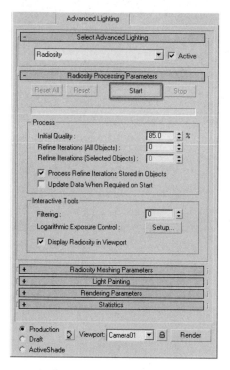

This takes some time to process. The scene is undergoing a radiosity solution calculation, objects are broken down into elements, and light is calculated for the scene. What you end up with is a mesh that contains the radiosity solution.

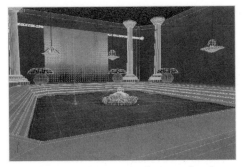

The previous image is the result of a radiosity calculation. The lighting for the solution is stored in the mesh as vertex colors. This allows you to see your solution from any angle and render that view without recalculating the solution. Another benefit of storing the solution in the mesh is that the solution can be saved with the file, so when you reopen the scene you don't have to recalculate the solution. The solution looks unimpressive and you learn to generate a superior-looking radiosity solution later in the chapter. Radiosity offers an advantage when rendering certain types of animations (such as a camera flythrough) since calculating the Radiosity Solution happens on the first frame of the animation only.

4. Right-click in the Camera viewport to make it active.

5. On the main toolbar, choose Quick Render

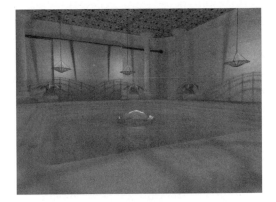

Using the Radiosity Engine

So far, you've become aware that radiosity uses light energy to accurately simulate how light reacts in an environment. Now you learn how it works in **3ds max** and how to control the quality of the solution and the final rendering.

The radiosity engine works on an internal copy of the scene model, essentially a snapshot of the **3ds max** file. The results of the solution are then added to the existing model as vertex colors.

Vertex Color—Each face of a model in **3ds max** is made up of connected vertices. Each vertex contains information about itself, with color as one parameter. When a vertex is given a specific color, that color can be displayed in the shaded viewport and used when rendering a model.

Many factors go into radiosity rendering, including types of lighting and their intensity, surface properties such as color and transparency, and the overall scale of the

scene. There are more technical items but **3ds max** simplifies the process by providing adjustments for only the parameters you are concerned about.

One issue that becomes critical when rendering with radiosity is the size of objects. Since lighting in a radiosity solution is based on real-world light properties, the size of your scene becomes very important. For example, if you light a candle in a small closet, it lights up the closet. However, if you light the same candle in a large warehouse, you won't even notice it. So, when you build your scene, set the units to either Metric or U.S. Standard units instead of Generic Units and build objects to their real size.

Advanced Lighting Panel

You adjust the quality of the Radiosity Solution in the Advanced Lighting panel of the Render Scene dialog. While many methods exist for increasing the quality level on individual objects, here you work on a global level.

The Radiosity option contains several rollouts with components you need to understand to control your solution properly. They are:

• Select Advanced Lighting

• Radiosity Processing Parameters

• Radiosity Meshing Parameters

• Light Painting

• Rendering Parameters

• Statistics

The following section explains each rollout and its properties.

Select Advanced Lighting Rollout

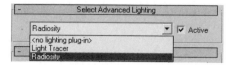

This rollout has two options: a drop-down list and an Active option check box. Since the Radiosity renderer in **3ds max** is developed as a plug-in, future radiosity engines are possible. You select the radiosity renderer you want to use in the drop-down list. Currently, the Discreet Radiosity renderer is the active engine. The Active check box allows you to turn on or off the current radiosity solution.

Radiosity Processing Parameters Rollout

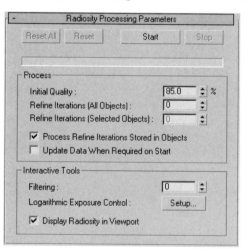

This rollout contains several options critical to the quality of the radiosity solution. The two groups in this rollout are Process and Interactive Tools.

The Process group contains a series of buttons that allow you to start, stop, and reset the radiosity solution. Along with the buttons is a progress bar that indicates the completion of the current solution.

Reset All—Resets both the Radiosity Solution and the geometry. If you change or move an object in the scene, the existing solution becomes invalid and you need to reset the solution and geometry.

Reset—Resets the solution only. If you adjust the intensity of a light or certain Ray-trace parameters, you need to reset the solution.

Start—Starts the Radiosity Solution processing.

Stop—Stops the Radiosity Solution. The solution can be restarted without resetting it by choosing the Start button.

Process Group

Initial Quality—This is the first solution pass performed on the scene. The engine is shooting rays from the light sources. As rays bounce around the model they deposit energy on the faces. With this setting you can tell the engine to stop when a certain level of quality is reached. The higher the quality, the longer the solution takes to complete.

Refine Iterations (All Objects)—Iteration Processing is an additional procedure for the entire scene or on a per object basis. This option sets the number of iterations for the entire scene. You set the iterations' value as you want. This is an error reduction process and designed to reduce variation of light levels between small surfaces.

Refine Iterations (Selected Objects)—Performs the same function as the Refine Iterations (All Objects), but on currently selected objects. You might want to increase the value on objects that look 'noisy' such as railings, chairs, etc.

Process Refine Iterations

Stored in Objects—Overrides the global Refine iterations and uses the value defined in the Object Properties dialog.

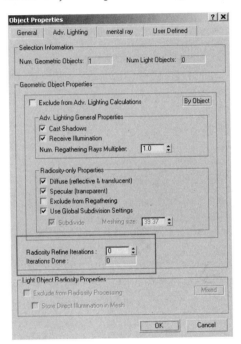

Update Date When Required on Start

When turned on, the radiosity engine must be reset and then recalculated if the solution is invalidated. When this option is off, the radiosity solution does *not* need to be reset if it is invalidated. You can continue processing your scene with the invalid solution.

Interactive Tools Group

Filtering—he Interactive Filtering works in real time and does not prevent you from continuing with the Radiosity calculation. Filtering blends the light levels between vertices and fixes variation in the intensity between small faces. Here are some examples of different filtering levels.

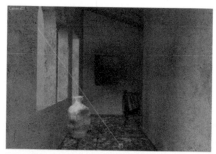

Filtering set to 0.

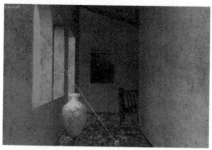

Filtering set to 4.

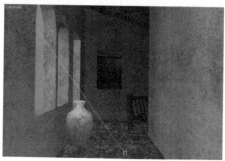

Filtering set to 15.

Setup—Links you to the Exposure control rollout of the Environment panel on the Environment and Effects panel. You want to use Exposure Control typically when using Radiosity with standard lights. More about Exposure controls appears later in this chapter.

The Logarithmic Exposure Control and parameters.

Display Radiosity in Viewport—Turns on or off the display of the radiosity solution in the viewports. If the option is off, you see a standard viewport representation.

Note: The radiosity solution is only displayed in viewports set to Shaded + Highlights.

Shows the Radiosity solution turned on.

Shows the Radiosity solution turned off.

Radiosity Meshing Parameters Rollout

Radiosity works by distributing light energy correctly throughout the scene polygons. Subdividing objects into a greater number of polygons can yield a more realistic radiosity solution. This section illustrates a technique to change the subdivision of all scene objects with a single control. This is termed global subdivision.

There are also methods to control subdivision on an object-by-object basis. One method is to specify the level of subdivision in the object properties dialog. This local subdivision setting then overrides the global setting. Another method is to apply a Subdivide modifier.

The purpose of object subdivision is not only to increase the number of polygons but also to reform the mesh so each polygon approaches an equilateral triangle. This contributes to solution quality.

Enable—This option turns on or off the global subdivision.

Meshing size—Determines the size of the subdivisions on a surface in units. The smaller the value, the higher quality the model, but the longer it takes to solve. The limit for this value is 10,000.

Subdivisions set to 20.0.

Subdivisions set to 5.0.

Keep in mind, the finer the mesh, the larger the file size will be when the file is saved with the Radiosity Solution.

The Light Painting Rollout

The Light Painting rollout in the radiosity panel gives you tools for post radiosity solution touch-up to the lighting in your scene. You can brighten or darken the surface by painting an illumination value onto it. You can use the eye dropper to select an illumination level from the scene.

You add or remove illumination by selecting an object and an illumination value and simply painting the value onto the surface. You can adjust the pressure used to apply the illumination. Lowering the pressure gives you finer control over the levels, whereas decreasing the pressure applies the illumination in a much stronger manner.

Rendering Parameters Rollout

This rollout contains options that do not affect the Radiosity Solution directly. These rendering options provide ways to either speed up rendering or increase the quality in the final image.

Re-Use Direct illumination from Radiosity Solution—Renders the radiosity solution directly and does not render any illumination from lights in the scene. Use this option when you need to render a scene or animation quickly. Since you gain speed by sacrificing quality, this option renders almost exactly what you see in the viewport.

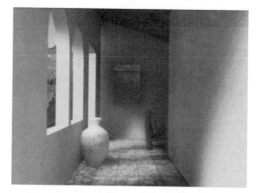

Render Direct Illumination—Represents the next level of quality for rendering a final image. This option incorporates the direct illumination from each light in the scene. This method can be used to render a scene quickly and maintain the illumination of the lights in the scene. This method is slower than the previous option but provides a higher-quality image.

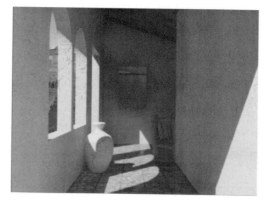

Regather Indirect Illumination—Recalculates the indirect illumination on a per-sample basis. It does so by casting rays in all directions from sample points on each surface. These samples are maintained in a cache and re-used within a certain radius and between frames. Regather Indirect Illumination solves traditional artifacts related to radiosity, such as shadow and light leaks. It also renders subtle effects such as indirect lighting and soft shadowing. This method of rendering provides the highest level of quality when rendering a radiosity solution in **3ds max**. This quality comes at the sacrifice of rendering time, but if you are quality-oriented, you should always use this option.

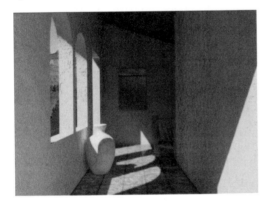

Rays per Sample—Controls the number of rays sent out from each sample in a random direction. It has a direct impact on precision and processing speed. The higher the parameter, the less noise you see in your final rendered image. It also renders subtle indirect shadows with a high quality. However, the higher the value, the longer your rendering time.

Filter Radius—Controls the radius for the samples in world units. If you set it too small, you create more samples than required in the flat areas. This setting has a range of 0.5 to 30, and defaults to 3.

Clamp Values (cd/m^2)—Limits the brightest light in a rendered scene by clamping any value above the specified value. It is commonly used to remove artifacts caused by light reflecting off a bright surface. These artifacts look like random spots of light in your scene. Be careful not to set the level too low, or you start to remove light from your scene.

Adaptive Undersampling—Works the same way as the Adaptive Undersampling from the Light Tracer. It is used for optimizing your rendered image.

Statistics Rollout

This rollout provides you with general information about your Radiosity Solution.

Statistics		
Radiosity process		
Solution Quality : 85.41%	Refine Iterations :	2
Elapsed Time: 0:16:00		
Scene Information		
Geometric Objects : 111	Meshing Size :	20.0
Light Objects : 7	Mesh Elements :	141842

The first group, Radiosity Process, provides feedback about Solution Quality, the Refinement iterations, and how long the Radiosity Solution has run. This group is updated while the Radiosity is processed, and you can watch the progress.

The second group, Scene Information, provides you with feedback about the current scene. It lets you know the number of geometric and light objects in your scene. It also gives you information about the size of the Radiosity mesh and the number of mesh elements used to calculate the Radiosity in the scene.

Generating a High Quality Radiosity Solution

In the next exercise, you continue to work with the Egyptian Bath scene from the previous exercise, but this time you change the Radiosity settings. It is important to note that the objects in this scene were built relatively close to scale using the U.S. Standard units.

1. Continue from the previous exercise, or choose File > Open from the menu bar, and open *egyptianbath_rad.max* from the courseware CD.

2. On the menu bar, choose Rendering > Advanced Lighting > Radiosity. answer yes

3. In the Radiosity Processing Parameters rollout, Set Refine Iterations (All Objects) to **2**.

 This refines the solution and gives you a higher-quality, more accurate solution. The higher the number, the more refined the solution and the better the quality. The recommended range for this value are between 2 and 5 depending on the speed of your computer.

4. In the Interactive Tools group, set Filtering to **4**.

 This smoothes out the final solution and gives you a cleaner image.

5. Also in the Interactive Tools group, turn on Display Radiosity in Viewport if it is turned off.

 This displays the completed solution in a shaded viewport.

6. In the Radiosity Meshing Parameters rollout > Global Subdivision Settings group, turn on Enabled.

 This subdivides the mesh objects in the scene to generate a cleaner solution.

7. Set Meshing size to **20.0**.

 This subdivides the mesh elements in the existing scene at a size of 20.0 units.

8. In the Rendering Parameters rollout, turn on Regather Indirect Illumination.

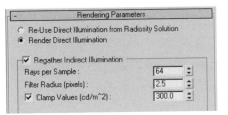

This causes **3ds max** to re-render a portion of the reflected light throughout the scene, and gives you a cleaner, better-looking image.

9. Leave the Rays per sample at 64 and the radius at 2.5.

10. Turn on the Clamp Values (cd/m^2) option and set the value to **300.0**.

This prevents irregular lighting patterns by limiting the brightness of the light falling on a surface.

11. Turn on Adaptive Sampling and set Subdivisions Down To **1 x 1**.

This provides the highest quality rendering while optimizing the rendering time.

12. In the Radiosity Processing Parameters rollout, choose Start to generate a solution.

If Start is unavailable, click Reset All first, and then click Start.

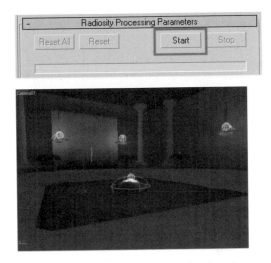

The Radiosity solution is recalculated. This step might take considerable time.

13. In the Render Scene dialog > Common tab, make sure the Use Advanced Lighting option is turned on and the Compute Advanced Lighting when Required option is turned off.

This tells the renderer to use the Radiosity Solution when rendering the scene and not to recompute the radiosity solution.

14. Choose Render at the bottom of the dialog.

An advantage of the radiosity renderer is you don't have to place additional lights in the scene to illuminate the entire room.

The Radiosity renderer calculates all the lighting, diffuse, and bounce for you.

The Radiosity in this scene has been calculated. However an important option, Exposure Control, has not been addressed. You first read about this option and then make adjustments in the next exercise.

Exposure Controls

Exposure Controls allow you to adjust the way you perceive rendered colors and light intensities in the radiosity solution. It acts like the iris of a camera, giving you the ability to brighten or darken a scene.

The reason you need to control the exposure in a solution is due to the way **3ds max** stores the illumination information within a solution. **3ds max** stores the information as energy levels per color. There are 32 bits per color stored in a solution. **3ds max** must change these intensity values to be viewed at the eight bits per color limit of your graphic card. **3ds max** accomplishes this by mapping intensity levels to valid RGB colors. Adjusting the exposure changes the way **3ds max** performs this mapping. Since the Exposure Control does not affect the Radiosity Solution, it is recommended you use the Exposure Control in the early stages of your project.

The Exposure Control options are found in the Environment dialog and consist of two rollouts: Exposure Control and Parameters for the selected Exposure Control type. There are four types of Exposure control:

- **Automatic**—Provides a simple way to lighten and darken your scene with a global brightness level.

- **Linear**—Uses a linear adjustment scale to lighten and darken your scene. It provides a bit more control than automatic.

- **Logarithmic**—Provides the greatest flexibility and control of all exposure settings. This option most closely approximates the way real-world exposure is adjusted.

- **Pseudo Color**—Differs greatly from other controls by remapping the colors of the solution based on various parameters. It can be used to perform lighting analysis.

The Exposure Control Rollout contains three options: a drop-down list for the type of exposure control; a check box to turn on or off exposure control; and an option to process the background and environment maps when adjusting the exposure of a scene.

Common Exposure Control Parameters

While individual types of exposure control exist, they share several parameters.

Brightness—Raises and lowers the brightness of the solution.

Brightness set to 40.0.

Brightness set to 60.0.

Contrast—Increases and lowers the contrast of the solution.

Contrast set to 10.0.

Contrast set to 80.0.

Mid Tones—Raises or lowers the value of the mid-tone color values in a solution. A level of 1.0 is no change.

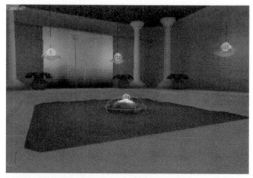

Mid Tones set to 0.2.

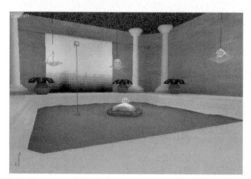

Mid Tones set to 1.8.

Physical Scale—Sets the scale in units of the Radiosity Solution. Since radiosity is highly dependent on the size of your environment, use this value to adjust the scale when calculating the Radiosity Solution. This value is used in the Automatic and Linear exposure controls only.

Color Correction—Acts as a color filter for the solution, allowing you to compensate for lighting or for a solution that does not suit your color specifications. It is a global setting and works on the solution as a whole. Color Correction filters out the selected color from the solution. It is a non-visual type of filter.

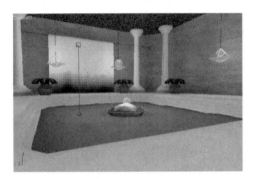

Desaturate Low Levels—Lessens the amount of color present in dimly lit objects. In the real world, objects with very little light cast on them do not have saturated colors. This option compensates for the lack of saturated color in the solution.

Affect Indirect Only—Adjusts the exposure levels for indirect (bounced) light only in a scene. If you use the renderer to provide direct illumination, you can select this option. It affects the overall scene but does not change the direct light. This option is available with the Logarithmic Exposure control only.

Exterior Daylight—Use this option if you render an exterior scene. This option is available with the Logarithmic Exposure control only.

Automatic Exposure Control

Automatic Exposure control uses the Physical scale of a solution to provide you with the correct exposure. Adjust the Physical scale control to change the way the exposure is set. Lower values brighten a scene and higher values darken it. This control looks at the scene and gives it one exposure level overall.

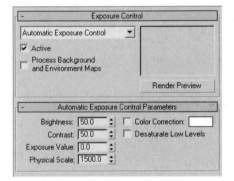

Linear Exposure Control

Linear Exposure Control uses the Physical scale of a solution to provide you with the correct exposure. Adjust the Physical scale control to change the way the exposure is set.

Lower values brighten a scene and higher values darken it. This control looks at the scene and uses a linear scale to adjust the exposure level.

Logarithmic Exposure Control

The Logarithmic Exposure control differs from other exposure controls in that it does not use the Physical scale to adjust the exposure. Instead, this exposure control looks at the scene in much the same way a real camera does. It uses a Logarithmic (non-linear) brightness scale based on the current solution. This provides for not only a more realistic rendering of the illumination, but also a more flexible exposure control.

Adjusting the Exposure

In the next few steps, you adjust the Logarithmic Control for the Egyptian Bath scene.

1. Continue from the previous exercise, or choose File > Open from the menu bar, and open *egyptianbath_rad_done.max* from the courseware CD.

2. On the menu bar, choose Rendering > Advanced Lighting > Radiosity.

3. In the Radiosity dialog that displays, answer No. You assign the Exposure Control manually next.

4. In the Interactive tools group, choose the Setup button.

 This displays the options in the Environment and Effects dialog.

5. In the Exposure Control rollout, choose Logarithmic from the drop-down list.

6. In the Exposure Control rollout, turn on Render Preview.

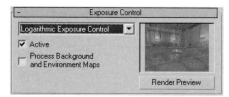

7. Set Brightness to **55.0** and the contrast to **60.0**.

8. Right-click in the Camera viewport to make it active.

9. On the main toolbar, choose Quick Render.

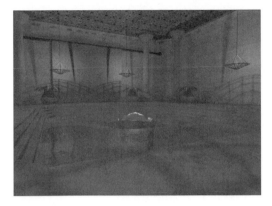

You've seen how to control scene polygon subdivision and refine iterations on a global level. In this exercise, you specify them for a particular object.

1. On the menu bar, choose File > Open, and open *subdivide.max* from the courseware CD.

2. The radiosity solution has been calculated for this scene. Press **F4** to view the mesh.

3. On the main toolbar, choose Quick Render.

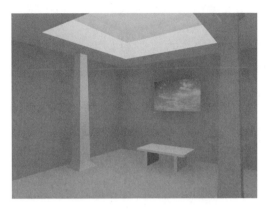

Notice the area below the lighting and the shadows below the seat are somewhat vague.

4. Press **H** and select the Floor.

5. In the Camera viewport, right-click and choose Properties from the quad menu.

6. In the Object Properties dialog, select the Adv. Lighting tab.

7. In the Radiosity-only Properties group, turn off Use Global Subdivision Settings and turn on Subdivide.

8. Set Meshing size to **0.2m**.

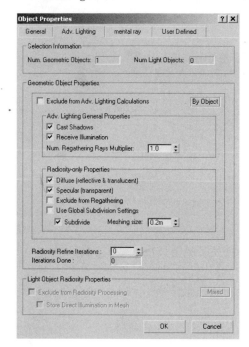

9. Click OK to exit the dialog.

10. Press **H** and select *Seat Support 1* and *Seat Support 2*.

11. Right-click and select Properties from the quad menu.

12. In the Adv. Lighting tab, turn off Use Global Subdivision Settings.

13. Turn on Subdivide and set Meshing size to **0.1m**.

14. Set Radiosity Refine Iterations to **3**.

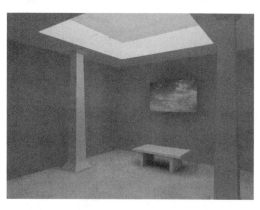

15. Click OK to exit the dialog.

16. In the Render Scene dialog > Advanced Lighting tab > Radiosity Processing Parameters rollout, choose Reset All. If a dialog displays, answer Yes to it. Click Start to remake the Radiosity Solution.

The changes you made to the Floor and Seat Supports have invalidated the current radiosity solution, so you have to reprocess it.

17. In the Render Scene dialog, choose Render.

Notice the improved shadows and lighting in the area below the seat.

18. The Camera viewport illustrates the finer subdivision on the floor and seat supports

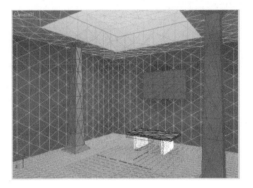

Advanced Lighting Override Material

You have learned that the radiosity renderer is a physically based rendering system. As such, it requires a specific description of the intensity, color, and energy distribution of the scene lights. Not surprisingly, a specific description of scene materials is also required. While the Material Editor offers considerable flexibility in the design of scene materials, it does not provide a quantitative description of characteristics such as reflectance, color bleed, and transmittance. To overcome this, **3ds max** includes a material type termed Advanced Lighting Override. This material is applied over an existing material to control its Photometric properties.

Note: This material override is not mandatory for radiosity. You want to apply the material override only to those materials whose properties you need to control specifically in the scene. In a typical workflow, you make the Radiosity solution followed by a sample

render. Then you use material override to fix the materials that exhibit problems.

The interface for the Advanced Lighting Override material is provided in the following illustration.

The quantities in the Override Material Physical Properties group are:

- **Reflectance Scale**—Controls the proportion of light energy absorbed and reflected. Materials that are too reflective can result in an overexposed, washed-out appearance, and materials that are not reflective enough can result in a dark render.

- **Color Bleed**— Specifies the proportion of color transferred from the material. For example, a blue chair positioned close to a white wall transfers some of its color to the wall. Occasionally, too much color is transferred from one object to another within a **3ds max** scene. This is often the case when bitmaps are applied to the diffuse channel of scene materials. The map colors can saturate the rest of the scene with a particular hue.

- **Transmittance Scale—** Specifies the amount of light energy that passes through a translucent material.

The quantities in the Special Effects group are:

- **Luminance Scale—**Takes the material's Self-Illumination into account when making the Radiosity solution and rendering the scene. Increasing the Luminance Scale increases the amount of light produced.

- **Indirect Light Bump Scale—**Allows you to adjust the quality of the bumping in areas of indirect lighting. Sometimes indirect lighting washes out the bump map and you want to increase it. There are also times where the lighting enhances the bump too much, and the scale needs to be reduced.

- **Base Material—**Is the original material.

Using the Advanced Lighting Override Material

The Advanced Lighting Override Material allows you to control several photometric properties of a material. In the following exercise, you render a scene and then apply the Override material to one of the scene objects.

1. On the menu bar, choose File > Open, and open *advanced_lighting_override_material.max* from the courseware CD.

2. On the main toolbar, choose Quick Render

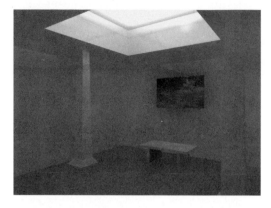

There is excessive transfer of color from the parquet flooring map to the rest of the scene geometry, tinting everything brown.

3. Press **M** to open the Material Editor and choose the sample slot containing the Floor material.

4. Choose the button labeled Standard.

5. In the Material/Map Browser, double-click Advanced Lighting Override.

6. In the Replace Material dialog, choose Keep old material as a sub-material.

7. In the Advanced Lighting Override Material rollout, set Color Bleed to **0.5**.

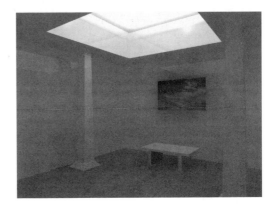

Note: If necessary, you can access the base material by pressing the button labeled Floor (Standard).

8. On the main toolbar, choose Quick Render

The color bleed from the floor material is reduced.

Note: The Radiosity Solution is reprocessed as a result of your changes, and because Compute Advanced Lighting when Required is turned on in the Render

Scene dialog > Common tab > Advanced Lighting group.

You might want to continue to experiment with adjusting the Reflectance Scale and Color Bleed values to see how they affect each other.

Architectural Material with Radiosity

Since the Architectural Material was made as an accurate material when used with Radiosity, it is important to know what effects you can achieve with it. You learned to make Architectural materials in Chapter 14, so in this section you open a version of the Egyptian bath that has four bright light objects created with an Architectural material. You make a few adjustments to see how they render with Radiosity.

1. On the menu bar, choose File > Open, and open *Egyptian_bath_no_lights_rad.max* from the courseware CD.

 The Egyptian Bath scene is displayed. The radiosity is calculated with all Hedra objects' emitting light. There are no other light sources in the scene, except for the material on the Hedra objects.

2. Press **M** to open the Material Editor and choose the sample slot containing the Glowing Yellow material.

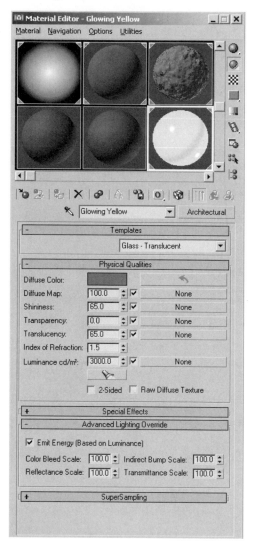

It is set as a Translucent Glass material with its luminance set to 3000 cd/m^2. If you look at the Advanced Lighting Override rollout, notice that this material is set to Emit Energy (Based on

Luminance). This material is applied to all Hedras.

3. On the main toolbar, choose Quick Render

Conclusion

In this chapter, you have learned a great deal about how **3ds max** uses Advanced Lighting features such as Light Tracer and Radiosity. You generated high quality Radiosity solutions by adjusting the Radiosity options and using Exposure control. You learned how to control Radiosity through an object's parameters and by using the Advanced Lighting Override Material. Finally, you used the Architectural Material to create a light emitting translucent glass material.

Cameras & Rendering

Objectives

After completing this chapter, you should be able to:

- Understand some basic principles of camera use.
- Use both free and target cameras.
- Understand camera parameters (Lenses, Environmental Ranges, Clipping Planes, etc.).
- Use depth of field.
- Use the interactive viewport renderer.
- Understand and modify rendering parameters.
- Render both stills and animation.
- Render using the mental ray® renderer.

Introduction

Your eyes function like a camera does in that both use light to create images. Those images, whether still or moving, can have a great impact upon the viewer. Filmmakers and photographers use cameras to do more than simply capture the images that fit in the viewfinder. They use cameras to tell stories, evoke emotion, and set a mood for the image.

In centuries past, artists interpreted what they saw and transferred that vision to canvas. An artist chose the point of view from which to begin and remained there until the work was completed. The artist used that point of view with a specific intent. Whether to tell a story, or create a majestic and inspiring scene, the artist made a conscious decision about how to look at a subject.

Things didn't change very much until the invention of still photography in the 1830's and the subsequent advent of portable cameras. This allowed many people, including those who didn't paint but still had an artistic eye, to create fantastic imagery. The images were true to life and finely detailed, even though the image still came

from one point of view. This was a turning point for art. However, photographers, unlike painters, could change their point of view quickly and easily. Because of this, a photographer could experiment with various camera angles and lens settings, thus obtaining various points of view.

The invention of the motion pictures in the 1890's, with its new challenge of filming moving pictures, was a mixed blessing for eager photographers. Unlike the easy-to-handle still cameras of the time that gave the photographer a great amount of freedom, early film cameras were big and heavy. However, as time went on, motion picture cameras became more flexible, and filmmakers began to use the camera to achieve their vision instead of it being compromised by the camera's limitations.

In the 1920's, huge strides were made in the art of filmmaking. During this decade, cinematography was truly refined as an art form. Through the advent of sound, color, and special effects, the camera was the one element of cinematography that remained constant. It's the person behind the camera, however, that makes the difference; a camera doesn't know the difference between the floor and an actor's face. The camera alone does nothing,

The camera can be a powerful tool in the right hands. When a professional photographer or cinematographer gets behind the camera, they use it with purpose. That purpose might be storytelling, newsgathering, or purely artistic. It makes no difference; the person behind the camera determines the point of view.

Camera Basics

The effective use of a camera depends on the desired result. The easiest way to change the look of a scene is to change the camera angle. High camera angles provide different visual information than low ones and result in different responses from viewers. Changing the camera's field of view is also an effective way of changing the visual feel of a shot. A wider field of view provides more information about the scene, while a close-up shows more detail. Another popular feature is depth-of-field (DOF). It can be adjusted to focus on any object, or to change the focus from one object to another.

Camera Angles

When using a camera to tell a story or evoke an emotion, the camera angle deserves careful consideration. The proper use of camera angles can greatly enhance a scene, making you more effective in getting your message across to the viewer. The wrong camera angle can give a different visual message than the one you are trying to portray. Remember that every camera angle has a purpose.

High Camera Angles

High angles tend to distance the viewer from the action in the scene by making people and objects look small. It gives the viewer the feeling of being a spectator to the action.

Low Camera Angles

On the other hand, low angles make viewers feel small and bring them into the action. A low angle used in certain contexts can make the viewer feel vulnerable and powerless.

Point of View

Point of View angles allow the viewer to get close to the action, and become an active participant in the scene. An example of this is an over-the-shoulder shot, where the viewer is looking at the scene from right behind one of the actors.

Reverse Point of View

A reverse Point of View angle shows the action or reaction of an opposite actor.

Objective Camera Angle

An Objective camera angle is a common shot; it shows a scene pretty much as the viewer sees it in real life. This angle places the viewer in the scene, and gives a natural view of the action unfolding.

Subjective Camera Angle

The Subjective angle is shot as if through the eyes of one of the actors. This allows the viewer to see the scene as if he were that actor.

Dutch Camera Angle

A Dutch angle is an odd one where the camera is rotated to the scene. While it is a rarely used shot, it serves to disorient the viewer or give the shot a particular emphasis.

Lenses

Lenses used for cinematography and photography come in two types, fixed or zoom. Lenses are measured in millimeters, the smaller the lens the wider the field of view (FOV). This measurement is known as the focal length. So, a 50mm lens provides you a wider FOV than a 200mm lens. Zoom lenses can change focal lengths and allow you to zoom in on a subject over time. There are four basic zoom shots, which serve as general guidelines for camera shots.

Long Shot

A Long shot (LS), or establishing shot, shows the viewer the overall scene. It establishes where and when the scene takes place, and the relative position of the actors. A prolonged wide shot can quickly become boring and you might lose the interest of your audience, so keep that in mind while planning your production.

Medium Shot

A Medium shot (MS) gets the viewer closer to the action than a long shot. A medium shot provides much more detail, while showing the scene location. In general, medium shots are more exciting than long shots and can be used more often.

Close-Up Shot

The Close-up (CU) is one of the most interesting shots used because it has more visual detail than the Long or Medium Shot. The Close-up takes the viewer into the scene, creating a link between the action and the viewer. Close-up shots help to keep viewer's attention directed where you want it. A scene comprised of close-ups only can become confusing, so you need to establish the scene before getting too close to the action.

Extreme Close-Up

The Extreme Close-up (ECU) has the greatest impact on a viewer because it shows the detail in an emotion or object. Used properly, an Extreme Close-up is a powerful shot, evoking a strong reaction from the viewer.

Depth of Field

Many cinematographers and photographers use the phenomenon of depth of field (DOF) to draw attention to specific parts of a scene. Adjusting the focal length and the aperture of the lens controls DOF. One component of DOF is the plane of critical focus; this is an invisible plane some distance from the camera, where the elements in a scene are in crisp focus. The distance of the DOF can vary greatly, from everything in a scene in sharp focus to a short DOF where only elements lying on the plane of critical focus remain sharp.

The Depth of Field with the farther element in focus keeps the viewer's eyes on the subject in the background.

No Depth of Field causes the viewer's eyes to wander around the scene. Viewers lack a queue showing them where to look.

Creating Cameras

In **3ds max,** there are two basic types of cameras, free and target. Both cameras have the same basic parameters, yet each has a different purpose.

The Depth of Field with the closer element in focus keeps the viewer's eyes on the subject in the foreground.

The Free Camera

The Free camera functions like a real camera, it able to pan, tilt, and move with total freedom. The Free camera shows whatever falls within its field of view, and has only one icon in the viewport. One use for a Free camera is as a POV camera animated along a path. You use a Free camera to depict walking through a building or looking through the eyes of a motorcyclist driving down a road, for example. The Free Camera does not have a target.

Creating a Free camera

When adding a Free camera to a scene, the initial direction of the camera points into the screen. The viewport into which you add the camera determines the orientation of the camera. If you create the camera in the Top viewport, the camera points in the negative Z-axis of the World.

1. On the menu bar, choose File > Open and open *Street_Scene_01.max* from the courseware CD.

2. On the command panels, choose Create > Cameras > Free.

3. In the Left viewport, click once to create the camera.

4. Right-click in the Perspective viewport to make it active.

5. On your keyboard, press **C**.

This is the default keyboard shortcut for the Camera viewport.

Note: The viewport navigation controls have changed to the camera controls. Using these controls, you can make various adjustments to the camera parameters.

6. In the Camera viewport navigation controls, change Orbit camera to Pan Camera.

7. In the Camera viewport, click and drag to get a view similar to the following one.

Note: After you've created the camera, you can adjust the various settings and animate the camera as needed. These settings are accessed through the Modify panel.

Tip: One of the advantages of using a Free camera is that you can use a path or trajectory for camera animation. A Free

camera can be set to follow the path without any added animation. This is discussed in more detail in the Animation module.

The Target Camera

While the Target camera has similar features as the Free camera, it functions with two elements. The first element is the camera, which is tied to always look at the second element, the Target. The Target is a non-rendering element that enables you to point the camera at specific locations. Once the Target is located, whenever the camera moves, it turns to look at the Target. The Target also serves a second purpose: it determines the Target distance, which can help in DOF rendering. Each new Target camera creates two objects, the camera and the target.

The image shows a Target Camera.

Adding a Target Camera

You add a Target camera to the previous scene.

1. On the menu bar, choose File > Open and open *Street_Scene_02.max* from the courseware CD.

2. Right-click in the Top viewport to make it active.

3. On the command panels, choose Create > Cameras > Target.

4. In the Top viewport, click and drag to create the camera, and then the target.

 See the next image for placement.

5. In the viewport navigation controls, choose Zoom.

6. In the Front viewport, zoom in so the Camera and the Target are in view.

7. In the Front viewport, make sure *Camera02* is selected.

8. On the main toolbar, choose Select and Move.

9. In the Front viewport, move the Camera on the Y-axis approximately 16.0 units.

10. In the Front viewport, choose the Target.

11. In the Front viewport, move the Target on the Y-axis approximately 3.5 units.

Note: When you move the Camera or the Target, the camera always follows the target's position.

12. Right-click in the Camera01 viewport to make it active.

13. To change the viewport to the camera view, right-click the Camera viewport label in the upper left of the viewport.

14. From the drop-down menu, select Views, and then choose Camera02 from the menu

Note: You could also press C on the keyboard. Pressing C switches the active viewport to the selected camera's view. If you have more than one camera, and none are selected, pressing C opens a dialog that allows you to switch cameras.

Camera Parameters

When you create a camera, it is set to its default parameters. You usually want to change these parameters. The Parameters rollout is the place you make these changes.

Parameters
Lens: 35.0 mm
FOV: 54.432 deg.
Orthographic Projection

Stock Lenses

15mm	20mm	24mm
28mm	35mm	50mm
85mm	135mm	200mm

Type: Target Camera

Show Cone
Show Horizon

Environment Ranges

Show
Near Range: 0.0
Far Range: 1000.0

Clipping Planes

Clip Manually
Near Clip: 1.0
Far Clip: 1000.0

Multi-Pass Effect

Enable Preview

Depth of Field

Render Effects Per Pass

Target Distance: 244.935

The Camera Parameters rollout is separated into seven groups. The first group is the Lens adjustment settings.

Lens and FOV—The lens and FOV function together; changing the lens setting to millimeters also adjusts the camera's Field of View. In real cameras, the lens and the FOV function together, but various camera and lens setups have differing lens to FOV ratio. The other factor influencing the FOV is the aspect ratio of the image, expressed as x/y. For example, a 20mm lens with an aspect of 2.35 has a FOV of about 94 degrees, whereas a 20mm lens with an aspect of 1.33 has a FOV of about 62 degrees.

Note: This is important when matching live footage to animated footage.

Lens = 15mm, wide angle

Lens = 85mm, narrow angle

FOV measurement buttons—Determine how the FOV is calculated with three options in a drop-down list.

- ↔ The FOV is measured horizontally. This is the standard method of measuring Field of View.

- ↕ The FOV is measured vertically.

- ↗ The FOV is measured diagonally.

Orthographic Projection—Has the effect of removing the perspective qualities of the camera. Through an orthographic camera, all parallel lines remain parallel, and there is no vanishing point.

Note: When using orthographic cameras, atmospheric rendering options are not rendered, since they require a perspective camera to render correctly.

Orthographic projection

Perspective projection

Stock Lenses group—Provides several standard presets for camera lens settings.

Type—Allows you to convert a Target camera to a Free camera, or vice versa in a drop-down list. This option is helpful if you create one type of camera and later realize you need a different one.

Show Cone—Activating the Show Cone option keeps the camera's FOV cone visible even when the camera is unselected.

Show Horizon—When the Show Horizon is activated, a line is drawn in the camera viewport that shows where the horizon is

Environmental Ranges—Sets the distance from the camera in units. The Near setting determines where the environment begins to affect the scene. The Far setting determines where the environment is at its densest. Turning on the Show check box makes the range settings visible in the viewports.

Near set to 4.0, Far set to 20.0.

Near clip set to 10.0, Far clip set to 20.0.

Clipping Planes—Sets the range in which 3ds max renders objects. Any object outside these ranges is not rendered. By default, the clipping values are determined automatically. You might want to manually set the clipping values at times. As with Environmental ranges, the Near and Far Clipping is determined by units from the camera. Activating the Clip Manually option makes the clipping planes visible in the viewport.

Multi-pass Effect—Renders multiple passes for the same frame. It allows for the rendering of accurate Depth of Field and Object Motion Blur. Turning on Enable activates both the Multi-Pass rendering and the viewport preview button. The Preview button lets you test your settings from the camera's viewport.

Note: Whether you choose Depth of Field or Motion Blur, there is a corresponding rollout with different options. If you set DOF, you are unable to adjust Motion Blur, and vice versa.

Depth of Field—Activates the DOF for the selected camera.

Viewport preview of the DOF feature

Motion Blur—Activates the motion blur for the selected camera.

Viewport preview of the Motion Blur feature

Render Effects Per Pass—Activates the feature that causes render effects, such as glows, to render on each pass. It allows you to apply DOF and motion blur to render effects.

Target Distance—Represents the distance in units from the camera to the target. It can be adjusted up or down, thereby moving the target away from or towards the camera. This setting is helpful when using Depth of Field. In a Target camera, you can move the target to adjust this setting. In a Free camera, it is a useful feature because it does not have a target to move.

Depth of Field

In cinematography and photography alike, the use of depth of field is a powerful tool. Depth of Field is used to make something stand out from a crowd, or to bring the viewer's attention to a specific element in the scene.

Depth of Field Parameters

The Depth of Field Parameters rollout is located on the Modify panel for a camera. This rollout has four groups: Focal Depth, Sampling, Pass Blending, and Scanline Renderer Parameters.

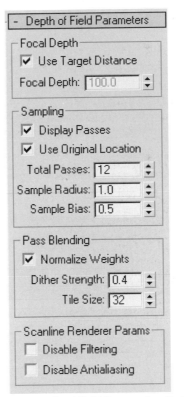
The Depth of Field Parameters Rollout

Focal Depth—Focal Depth is the distance from the camera to the plane of critical focus. When the Use Target Distance check box is turned on, the distance is taken from the Target Distance parameter of the camera. If turned off, the distance can be entered manually. Both settings allow for animated or Rack focusing.

Note: A Rack focus is a camera trick that changes the focus in a scene from an object in the foreground to one in the background, or vice versa. Rack focus is used in movies to change the viewer's attention from one scene element to another.

Rack Focus with Focal Depth = 7.0.

Rack Focus with Focal Depth = 19.0

Sampling—Sets the number of passes for the DOF effect of the final image.

Display Passes—When this box is turned on, each pass of the Depth of Field rendering is displayed as it is rendered. This provides you with a progressive view of the Depth of Field as it renders. If turned off, the entire image is rendered with all the passes before it is displayed.

Use Original Location—When turned on, the first pass in a multi-pass effect starts from the camera's current location. When turned off, the first pass is rendered offset from the camera's current location based on the Sample Radius offset amount.

Total Passes—When rendering a multi-pass effect, the Total Passes value determines the number of passes rendered. The higher the value, the more passes made, the longer the render takes, and the higher the final quality of the image.

Total passes = 12.

Total Passes = 3. Notice the quality difference compared to the previous image.

Sample Radius—Sets the amount the camera moves from its original position in the scene. The Depth of Field is obtained by moving the camera a little bit on each render pass. Thus, the higher the value, the more the camera moves, creating a more pronounced Depth of Field effect. However, if the camera is moved too far on each pass, the image can become distorted and unusable.

Sample Radius = 0.2

Sample Radius = 0.6

Sample Bias—When the camera moves for each pass, the camera uses the Sample Bias to determine how it moves. A low sample bias keeps the camera closer to its origin point, and a high bias causes the camera to move farther from its origin.

Sample Bias = 0.0

Sample Bias = 1.0

Normalize Weights on

Pass Blending——When rendering a multi-pass camera effect, the renderer dithers each pass slightly in order to try to blend each pass together. You set up the dithering in this group.

Normalize Weights—When this option is selected, the passes are blended using normalized weights. If it is not selected, the passes are blended using random weights.

Normalize Weights off

Dither Strength—This value determines the amount of dithering for each render pass. The higher the value, the more each pass dithers; as settings increase, the blurred area tends to get grainy.

Note: Dithering is a method of simulating colors, or blending images by mixing different colored pixels. This also works for color reduction by taking a 24-bit image and recreating it with 256 colors by dithering various colors together. This effect is made possible because the human eye naturally tends to blend colors that closely resemble one another.

Tile Size—This value sets the size of the dither pattern in each pass.

Scanline Renderer Parameters—These parameters allow you to disable both the filtering and the antialiasing for multi-pass rendering.

Multipass Motion Blur

Like Depth of Field, the multi-pass motion blur is accessible through the Modify panel for the currently selected camera. Motion blur is a phenomenon that occurs in cameras due to the length of time the film is exposed. When an object moves in front of a camera, the shutter opens long enough to expose the film. While the shutter is open, the object moves a certain distance; this causes a blurred image of the object to appear on film.

The Motion Blur Parameters

The Motion Blur Parameters rollout has three groups: Sampling, Pass Blending, and Scanline Renderer Params. The only unique group between the multi-pass render options is the Sampling group.

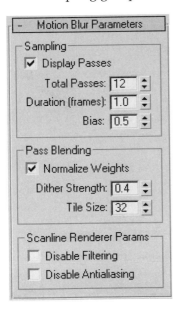

Display Passes—When this box is turned on, each pass of the Motion Blur rendering is displayed as it is rendered. This provides you with a progressive view of the Motion Blur as it renders. If turned off, the entire image is rendered with all the passes before it is displayed; this helps speed things up a bit.

Total Passes—Has the same effect as in the Depth of Field parameters.

Duration (frames)—This sets the length of time in frames that the camera's shutter remains open. The longer the duration, the greater the blur.

Duration set at 0.5 frames, 1.0 frames, and 2.0 frames.

Bias—The Bias setting provides a way to change the position of the blur effect. This value ranges from 0.01 to 0.99. A low value causes the blur to lead the object, a value of 0.5 causes the blur to be centered on the object, and a high value causes the blur to follow the object.

Bias set to 0.2 and 0.8.

Rendering

Rendering is the process of creating an image. **3ds max** uses two rendering processes. One process combines both scanline rendering and ray tracing. During scanline rendering, the scene is rendered by passing a ray from each pixel into the scene. If the ray hits an object, the color of the pixel is based on lighting the object's normal direction and other information. Using this method, reflection and refraction are faked. Ray tracing goes one step further by tracing the complete path of each ray. This method provides a true reflection and true refraction by following rays that are bounced off, or passed through, objects. Because the **3ds max** scanline renderer is a hybrid, it can selectively ray trace objects, providing for high quality and speed, while remaining flexible and easy to use.

The second rendering process is achieved using the mental ray renderer. This renderer renders differently from the scanline renderer. The mental ray renderer is covered later in this chapter.

Note: The use of Radiosity and Global Illumination is discussed in Chapter 19.

ActiveShade

Along with the final render quality, **3ds max** offers interactive shading that provides a quick, lower-quality rendering that updates as you change your scene. This provides an effective way to preview your scene in a fully rendered viewport. The ActiveShade view can be either a floating dialog or placed in one of the viewports.

The quality of the rendering is superior to that found in the viewport shading options. When you activate Active Shade, interactive changes, such as light adjustments, are displayed. It has its own quad menu that allows you to select objects and render regions. Also, you can drag and drop materials from the Material Editor onto objects in the ActiveShade dialog or viewport.

There are three ways to activate the ActiveShade rendering:

- Right-click the viewport label and choose Views > ActiveShade.

- Choose ActiveShade from the Quick Render flyout on the main toolbar.

- Choose Rendering > ActiveShade Floater or Viewport from the menu bar.

Right-click viewport label

Main Toolbar Button

Floating ActiveShade dialog

Using ActiveShade

In this exercise, you open an ActiveShade dialog, and replace a material on an object using the Material Editor.

1. On the menu bar, choose File > Open and open *Ireshade.max* from the courseware CD.

2. Right-click in the Main Camera viewport to make it active.

3. On the menu bar, choose Rendering > ActiveShade Floater.

The Rendering drop-down list

ActiveShade in a viewport

This opens the ActiveShade floating dialog.

Note: It takes a moment to initialize, after opening the window.

4. On the main toolbar, choose Material Editor.

5. In the Material Editor, choose the Marble material.

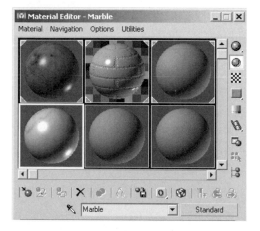

6. Click and drag this material onto the gray bowl on the right in the ActiveShade dialog.

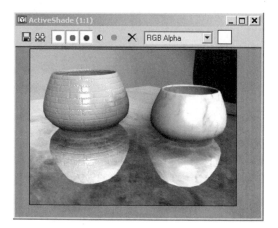

This replaces the material on the gray bowl with the new marble material.

You can also change the materials interactively in the Material Editor while they are updated in the ActiveShade floater.

The Render Scene Dialog

Once you've completed your animation, or when you want to render test frames, you need to use the Render Scene dialog. This dialog contains five tabs, each with their own rollouts that help you to set up your final render.

- The **Common** panel is where you set up the parameters used by any renderer. It includes specifying the frames you want to render, the size of the frames, and where you save your animation. You can also choose alternate renderers here. Alternative renderers offer you more options for the final appearance of the scene. For instance, mental ray is a high-end radiosity renderer that makes your images appear more realistic, whereas Illustrate is a renderer that outputs images with a cartoon-like appearance.

- The **Renderer** panel is where you access the renderer's specific parameters. With the default scanline renderer, the Renderer panel is where you can change options, such as antialiasing and motion blur. These options are explained in detail below.

- The **Render Elements** panel provides a way of rendering specific elements of the final image. It also provides a connection to **combustion,** a 2D paint and

compositing software package by **discreet**.

- The **Raytracer** panel gives you access to the Global Raytracer settings. For more information about the Global Raytracer, and how to use it, see the **3ds max** help file.

- The **Advanced Lighting** panel is where you access the Advanced Lighting parameters for your scene. If you have already set up the Light Tracer or Radiosity, you can adjust the parameters here. Otherwise, only the Select Advanced Lighting rollout is available, and you can add Advanced Lighting to your scene.

Advanced Lighting is covered in detail in Chapter 19.

The Render Scene dialog

In this section, you learn about the Common, Renderer, and Render Elements tab.

Common Panel

The Common panel includes three rollouts: Common Parameters, Email Notifications, and Assign Renderer.

Common Parameters Rollout

The Common Parameters rollout has five main groups explained below. Each group provides you with parameters to customize your rendered output.

Time Output—This group has four options for selecting frames for rendering. Along with the four options, there are two options that provide added flexibility.

Single—Renders the current frame

Active Time Segment—Renders the current range of frames shown on Track Bar.

Range—Allows you to choose which frame to start and stop rendering.

Frames—Provides a way to render non-sequential frames, which are separated by a comma (2,6,10), or several short sequences separated by a hyphen (2-8, 15-22).

Every Nth Frame—Causes the renderer to render frames at set intervals. For example, if the Nth frame is set to 3, every third frame is rendered.

File Number Base—When this number is set to a number other than 0, it is used as the number of the first rendered frame. For instance, if you were rendering a range from 0 to 10 and the File Base Number is set to 25, the first frame is rendered as "file0025" with subsequent frames numbered 0026, 0027 through 0035. This is helpful if you are working on a short sequence and another artist is working on a second short sequence. By setting the base number, you can render images from both sequences, as well as maintain a continuous numbering sequence for all frames.

Output Size—Gives you control over the size and aspect of the final rendered image. There is a drop-down list of standard industry presets, image width and height type-in areas, custom preset options, and image and pixel aspect adjustments.

Preset drop-down list—This list provides instant access to a variety of industry image formats.

Custom ▼
Custom
35mm 1.316:1 Full Apertu
35mm 1.37:1 Academy (c
35mm 1.66:1 (cine)
35mm 1.75:1 (cine)
35mm 1.85:1 (cine)
35mm Anamorphic (2.35:1
35mm Anamorphic (2.35:1
70mm Panavision (cine)
70mm IMAX (cine)
VistaVision
35mm (24mm × 36mm) (
6cm × 6cm (2 1/4" ×
4" × 5" or 8" × 10" (slid
NTSC D-1 (video)
NTSC DV (video)
PAL (video)
PAL D-1 (video)
HDTV (video)

Aperture Width (mm)—This is active in Custom size only, and affects the ratio of the camera lens value to the camera FOV. It does not change the image in the viewport.

Width and Height—These settings allow you to customize the size of the rendered image as a value in number of pixels. If your Image Aspect is locked, changing one value automatically changes the other.

Resolution Preset Buttons—Choosing one of these buttons changes the rendered image size to that of the selected button. Right-clicking the button allows you to customize the settings for that button.

Configure Preset	? X
Width: 320	OK
Height: 240	Cancel
Pixel Aspect: 1.0	
Get Current Settings	

Image Aspect—Determines the ratio of width to height for the rendered image. This can work in two ways: set the width and height, and you get the image's aspect; or set the image width, then change the Aspect, which automatically sets the height. When the Image Aspect Lock is activated, the aspect is fixed.

Image Aspect = 2.0

Image Aspect = 0.5

Pixel Aspect—Sets the aspect of the image pixel itself. Pixel Aspect is necessary for rendering images that go to devices that display non-square pixels. For example, a standard NTSC television displays pixels with an aspect of approximately 0.9, not 1.0. Choosing the Pixel Aspect lock causes the Pixel aspect to remain fixed.

A Pixel aspect of 0.5 causes the pixels to be squeezed vertically.

A Pixel aspect of 2.0 causes the pixels to be squeezed horizontally.

Options—This group contains nine check boxes for activating or deactivating different rendering options.

Atmospherics—Turning this option off causes **3ds max** not to render any atmosphere effects, such as volume lights or fog. This can help speed up rendering for test renders where Atmospherics are unneeded.

Effects—Similar to the Atmospherics check box, turning off the Effects option keeps all Render Effects from rendering. This helps speed up rendering for test renders.

Displacement—When this option is turned off, **3ds max** does not render any displacement maps. This helps speed up rendering for test renders.

Video Color Check—This option scans the rendered image for colors that are out of the legal range of broadcast video colors. When this option is turned on, it uses the Video Color Check option from the **3ds max** preferences.

Video Color Check Preference options

Render to Fields—This causes **3ds max** to render to video fields instead of full frames. This is a must when rendering for video. A field is half a frame. There are two fields per frame.

Render Hidden Geometry—This option, when active, renders all hidden objects in a scene. This is useful when your scene is quite complex; you can hide objects so that you can work in the viewports while still rendering all objects in the scene. It also renders objects that you wish to remain hidden.

Area Lights/Shadows as Point Lights—Turning this option on causes all area lights to render as point lights. It helps speed up test renders.

Force 2-Sided—This option forces **3ds max** to render the backsides of all faces in the scene. This is useful when working with models from outside sources that have face normal problems.

Super Black—This is used for compositing. When active, it keeps the background at a color of 0,0,0 and increases the level of black in the rendered scene.

Advanced Lighting—This group decides whether to use Light Tracing or Radiosity to render the scene.

Use Advanced Lighting—When turned on, the scene renders with Light Tracing or the calculated Radiosity solution from the Advanced Lighting dialog.

Compute Advanced Lighting when Required—This option uses the settings found in the Advanced Lighting dialog. However, it calculates the radiosity solution during the rendering process if necessary, such as when an object moves, a texture changes, or a light moves or changes intensity.

Render Output—You set how and where your files are rendered.

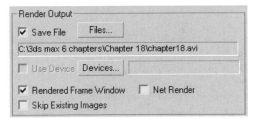

Save File and the File button—When the Save file check box is turned on, rendered images are saved to your hard drive. The File button allows you to save rendered images in the location and image format of your choice.

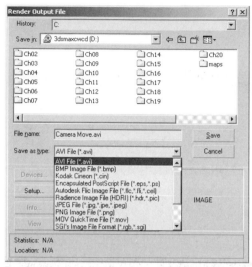

The Render Output File dialog with the AVI animation format selected

Use Device—This check box is unavailable unless a supported video output device is chosen. This provides a way to render directly to a video output device, instead of still images.

Rendered Frame Window—This option displays the rendered image on- screen in the Rendered Frame Window.

Net Render—When turned on, the network rendering configuration dialog is displayed when you start the render process. This allows you to render your animation on multiple computers simultaneously. Rendering with this option saves you a lot of time.

Skip Existing Images—This caues **3ds max** not to render frames that already exist in the render output directory.

Email Notifications Rollout

This rollout contains options for sending emails to various people once the rendering is complete, or if any problems were encountered during the rendering. This rollout has two groups.

- •Categories
- •Email Options

- **Categories**—You must first turn on Enable Notifications to access the check boxes. You decide if you want to be emailed: as the rendering progresses based on a frame setting; if the rendering has failed; or when the rendering is complete.

- **Email Options**—This group allows you to type where the email is coming from, where it is going, and which server to use.

Assign Renderer Rollout

The Assign Renderer rollout contains the Current Renderers' group. This group gives you the opportunity to change the renderer to one of three settings:

- Production
- Material Editor

- Activeshade

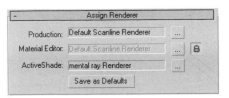

Choosing the "..." button for the corresponding renderer allows you to select other renderers, like mental ray, which ships with **3ds max**. If you have any 3^{rd} party renderers loaded, you can also choose them. The Choose Renderer dialog display allows you to pick the renderer from a list.

The Material Editor Renderer allows you to choose the renderer used to render the sample slots in the Material Editor. The Lock button next to the Material Editor renderer sets the Material Editor to use the same renderer as the Production renderer.

Renderer Panel

When the default scanline renderer is the current renderer, the Renderer panel has one rollout, the Default Scanline Renderer rollout.

Default Scanline Renderer Rollout

This rollout provides access to various options that affect the look of the final rendered image. This rollout has eight groups:

- Options
- Antialiasing
- Global SuperSampling
- Object Motion Blur
- Image Motion Blur

- Auto Reflect/Refract Maps
- Color Range Limiting
- Memory Management

- **Options**—This group contains four options that can be used to globally turn on or off the Mapping, Shadows, Auto-reflect/Refract Maps, and forced wireframe rendering. The Wire thickness type-in controls the thickness of the rendered wireframe objects. These options can be useful time-savers when making test renders. There is one other option, named Enable SSE.

 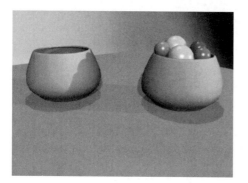

- **Mapping**—Deactivates ALL maps in the scene at render time.

 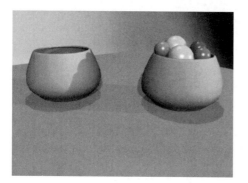



- **Shadows**—Turns off ALL shadows at render time.

 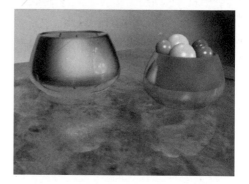

- **Auto-reflect/Refract Maps**—Causes ALL Reflect/Refract Maps not to render.

 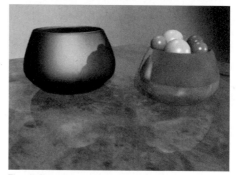

 The left pot now has no reflection.

 Note: The Auto-reflect/Refract Maps option does not affect the Raytraced reflections in the rendered scene.

- **Forced WireFrame**—Renders ALL objects in the scene as wireframe. The Wire thickness setting adjusts the thickness of the wires in pixels.

Forced Wireframe, Wire Thickness set to 1.0

- **Enable SSE**—When turned on, rendering uses Streaming SIMD (Single Instruction, Multiple Data) Extensions (SSE). Depending on the CPU(s) of your system, SSE can improve render time. Default=off.

Antialiasing group

This group provides control over both the antialiasing parameters and the option to deactivate the Filtering of maps used for textures. Turning off either of them speeds up rendering, but causes the image quality to suffer, a handy feature when rendering test images.

- **Antialiasing**—The antialiasing check box toggles whether the final rendered scene is antialiased. Antialiasing is the process of smoothing the edges of objects in a rendered image.

No antialiasing.

The same image with Area antialiasing.

- **Filter Maps**—This option turns on or off the filter option for Maps used in materials.

The Map filtering option in the Bitmap Parameters rollout

- **Filter: 3ds max**—offers a variety of antialiasing filters, each of which has a unique look. By using different filters, you change the way the final render is antialiased. Many antialiasing filters have adjustable parameters. Adjusting these

parameters applies unique antialiasing to the final render. The information box (under Filter Maps) gives you information about how the filter is used.

Filter: Area
Area
Blackman
Blend
Catmull-Rom
Cook Variable
Cubic
Mitchell-Netravali
Plate Match/MAX R2
Quadratic
Sharp Quadratic
Soften
Video

Rendered using the default Area filter.

The same image rendered using the Mitchell-Netravali filter, which can sharpen and enhance detail in the image.

Global SuperSampling group

SuperSampling is an additional antialiasing step that provides a "best guess" color for each rendered pixel. The SuperSampler's output is then sent to the renderer, which performs its final antialiasing pass. This requires more time, but improves image quality. In **3ds max**, the default is to add a single SuperSampling method to all materials, and then allow you to control it globally from the Render Scene dialog.

Global SuperSampling
☐ Disable all Samplers
☑ Enable Global Supersampler ☑ Supersample Maps
Max 2.5 Star
5 samples, star pattern

This group has four options:

- **Disable All Samplers**—When this option is activated, any material with the SuperSampling option turned on does not incorporate the SuperSampling into the final render. It speeds up rendering and is another option used in the rendering of test images.

- **Enable Global SuperSampler**—When turned on, this applies the same SuperSampling to all materials. When turned off, materials

must have their SuperSampling set individually.

The SuperSampling rollout from the Material Editor

- **SuperSample Maps**—Turns on or off SuperSampling for mapped materials. Turn it off when making test renders to save on render time and RAM usage.

- **Sampler drop-down list**—Lets you choose which method to apply. Some methods offer extra options for better control of the quality of the rendering. The information box (under the drop-down list) gives you information about how the method is used.

Object Motion Blur group

The object motion blur group provides a global method to turn on or off Object Motion Blur, as well as provides adjustments for the Duration, Samples, and Duration Subdivisions. Object Motion Blur creates the illusion of motion blur by rendering an object over a set timeframe determined by the Duration value. Motion blur itself results from the length of time a camera's shutter is

open when an element moves within the camera's FOV. The longer the shutter is open, the more blurry the object; the less time the shutter is open, the sharper the object.

Object Motion Blur differs from Camera Multi-Pass Motion Blur in that only the object(s) with motion blur receive(s) the effect. With Multi-Pass Motion Blur, the blurred objects can be seen in reflections and through transparent objects. With the rendered motion blur option, the effect is similar, although it renders more quickly, and some quality is sacrificed.

By default, objects do not have any motion blur applied to them. You set the Motion Blur option in the Properties dialog for each object. Enabled turns on motion blur, and the Object radio button sets it to Object Motion Blur.

Motion Blur group from the Object Properties dialog

- **Apply**—Turns on or off the Object Motion Blur rendering.

- **Duration (frames)**—Sets, in frames, the length of time the camera shutter remains open.

- **Samples**— Sets the number of times the rendered object is sampled within the Duration Subdivisions.

- **Duration Subdivision**—Sets how many copies of the object are rendered within the Duration period.

An image rendered with Samples and Duration Subdivisions set to 10.

The same image, with Samples changed to 3. Notice the grainy look.

Image Motion Blur group

Like Object Motion Blur, Image Motion Blur blurs an object based on the Duration value. However, Image Motion Blur works on the final rendered image, not the object's level. It blurs objects by smearing the final rendered image. One advantage is that this type of motion blur takes camera motion into

account. This setting is activated through the Properties settings of each object by selecting the Image radio button in the Motion Blur group.

- **Apply**—Turns on or off the Image Motion Blur option.
- **Duration (frames)**— Sets the length of time the cameras shutter is open.
- **Transparency**— Causes the motion blur effect to render when the object goes behind a transparent object. Turn it off to save render time.

Image Motion Blur seen through a transparent object.

- **Apply to Environment Map**—Activating this option causes the environment map to blur when the camera moves through a scene.

Auto Reflect/Refract Maps group

The only setting in this group is the Rendering Iterations value. This value determines how many reflections are visible in the surface of objects using the Reflect/Refract Map in Auto mode. A setting of 1 only shows the object reflected in the surface. Increasing this value adds more levels of reflection and longer rendering time. However, more than one iteration renders a more convincing reflection.

An image rendered with Rendering Iterations set to 1.

The same image with Rendering Iterations set to 3. Notice the multiple reflections in each sphere.

Color Range Limiting group

The options in this group provide two methods of dealing with colors that exceed or fall short of the maximum or minimum brightness. It works by either Clamping or Scaling the RGB components that fall outside the 0 (black) to 1 (white) range.

- **Clamp**—Changes any color value that falls outside the range above 1 to 1, and any color value below 0 to 0. It is the default, and often causes bright colors and strong specular highlights to render as white.

The image shows illumination from a pure green lamp above a white surface with the color value Clamped.

- **Scale**— Scales the color values so that all values fit between 0 and 1. It preserves the

color of the out-of-range values, but can change the look of highlights.

The image shows the same light as previously, however the Limit is set to Scale. Notice the change of color value in the center of the illuminated area.

Memory Management group

The Conserve Memory option in this group causes the scanline renderer to perform certain calculations on-the-fly, instead of placing them into memory. While this feature frees up memory, it also causes a slight drop in rendering speed.

Memory Management
☐ Conserve Memory

Render Elements Panel

The Render Elements panel has only one rollout, the Render Elements rollout.

Render Elements Rollout

Render Elements are useful when compositing layers of an animation. Think of each element as a layer where you combine specular, diffuse, shadow, and reflection to get a composited image. Using Render Elements gives you the flexibility to control every aspect of your final composite. It is particularly useful for rendering shadows separately, because they normally increase rendering times.

Note: Render Elements are like layers; when combined correctly, they create a complete image.

dialog. In this dialog, you can select from one of several elements to add to the Element queue.

Added elements are listed in the Element Rendering List.

- **Merge Button**—Provides a method of merging Elements from other **3ds max** scenes.

- **Delete Button**—Deletes the selected elements.

- **Selected Element Parameters group**—This group provides options for individual render elements. Select the element in the Element Rendering List, and adjust its parameters here.

The Render Elements Rollout

- **Elements Active**—When this check box is turned off, the Render Elements do not render.

- **Display Elements**—Shows each element on-screen after it is rendered.

- **Add Button**—Choosing the Add button opens the Render Elements selection

- **Enable**—Enables or disables the selected element; if disabled, it does not render.

- **Enable Filtering**—Enables the use of the current antialiasing filter for the rendered element.

- **Name**—Allows you to change the name of the selected element.

- **"..." button**—Specifies a directory and name for the element.

- **Output to combustion**—Allows you to save a combustion Workspace (CWS) file with your Render Elements files. You can use the CWS file in **combustion**. The layers are set up correctly for you or you can use it in the Combustion map.

- **Enable**—When turned on, this option generates a CWS file that contains layout for the elements you are rendering.

- **"..." button**—By default, the CWS file is saved to the same directory as the render elements. This section allows you to save the CWS in a different location, and give it a different name.

Rendering an Atmosphere Element

1. On the menu bar, choose File > Open and open *Street_Scene_03.max* from the courseware CD.

2. Use the time slider to go to frame **275**.

3. On the main toolbar, choose Render Scene.

4. In the Render Scene dialog > Render Elements panel > Render Elements rollout, choose Add.

5. In the Render Elements dialog, choose Atmosphere, and then choose OK.

The Render Elements dialog

6. In the Common panel > Common Parameters rollout, make sure the Time Output is set to Single.

7. In the Common Parameters rollout > Render Output group, choose the File button next to Save File.

8. In the Render Output File dialog > Save as type drop-down list, choose TIF.

9. In the Render Output File dialog > Save in area, go to a local directory of your choice.

10. In the Render Output File dialog > File name area, give the file a unique name.

11. In the Render Output File dialog, choose Save.

12. The TIF Image Control dialog might display; if it does, accept Color and then choose OK.

13. In the Render Scene dialog > Viewport group (at the bottom of the dialog), make sure Camera02 is active.

14. In the Render Scene dialog, choose Render.

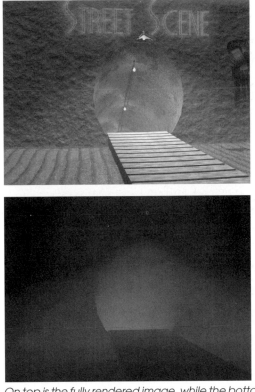

On top is the fully rendered image, while the bottom is the Atmosphere only image.

Render Scene Dialog Options

At the bottom of the Render Scene dialog are several options: the Current renderer selection radio buttons, the Viewport drop-down list, the Preset drop-down list, and the Render scene button.

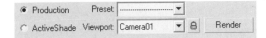

Radio buttons—Allow you to select the render option you want to use for the current rendering. The two selections are Production and ActiveShade. Each option can have its own rendering parameters for each

respective panel. So you can set up Active Shade to render a 320 x 240 image with no Advanced Lighting, and Production to render a 1024 x 768 image with Atmospherics and Radiosity.

Preset drop-down list—Allows you to load default presets that ship with **3ds max**, or save custom presets that you specify. The default presets are found in the 3dsmax\renderpresets directory. You can make changes in each panel in the Render Scene dialog, and then save your presets to this directory. Using Presets is a time saver for trying different settings while testing Advanced Lighting options with the Radiosity and Light Tracer. It is also helpful when using different render types, such as the scanline and mental ray renderers.

Viewports drop-down list—The Viewports drop-down list makes it easier to switch from one camera or viewport to another. The Lock button keeps the viewport from changing accidentally. When the Lock button is turned on, the selected viewport renders, regardless of which viewport is active.

Render button—Starts the rendering process. You can also choose the render mode from the Quick Render flyout on the main toolbar. When ActiveShade is chosen, it opens the ActiveShade floater with the chosen viewport.

To close the Render Scene dialog, press the "X" in the upper right corner. When the dialog closes, changes made to the rendering parameters are saved.

Rendering a Scene

In this exercise, you open a file, set different settings to save a Preset, and then render the scene to an AVI file.

1. On the menu bar, choose File > Open and open *Street_Scene.max* from the courseware CD.

2. On the main toolbar, choose Render Scene.

 The Render Scene dialog is displayed.

3. In Common panel > Common Parameters rollout > Time Output group, set the Active Time Segment from **0** to **300**.

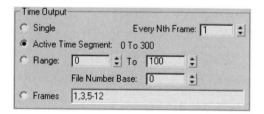

4. In the Output Size group, choose **320 x 240**

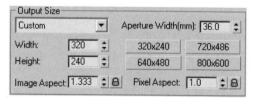

5. In the Options group, turn off all options

6. In the Renderer panel > Default Scanline Renderer rollout > Options group, turn off Auto-Reflect/Refract and Mirrors option.

7. In the Antialiasing group, turn off all options.

8. Turn off both the Object Motion Blur and the Image Motion Blur check boxes.

9. At the bottom of the Render scene dialog, choose Save Preset from the drop-down list.

The Render Presets Save dialog is displayed. All files default to the renderpresets directory.

10. In the Render Presets Save dialog, type **StreetScene** next to File name, and then choose Save.

11. In the Select Preset Categories dialog, choose Common and Default Scanline Renderer.

12. On the Common panel > Render Output group, choose the Files button next to Save File.

13. In the Render Output File dialog, choose a directory in which to save the file. From the Save as Type drop-down list, choose AVI.

```
AVI File [*.avi]                               ▼
AVI File [*.avi]                               ▲
BMP Image File [*.bmp]
Kodak Cineon [*.cin]
Encapsulated PostScript File [*.eps,*.ps]
Autodesk Flic Image File [*.flc,*.fli,*.cel]
JPEG File [*.jpg]
PNG Image File [*.png]
MOV QuickTime File [*.mov]
SGI's Image File Format [*.rgb]
RLA Image File [*.rla]                         ▼
```

14. In the File Name type-in area, enter *Preset.avi*, and then choose Save.

15. Set Compression Quality to **100**.

16. In the Video Compression dialog > Compressor drop-down list, choose

Cinepak Codec by Radius, and then choose OK.

AVI File Compression Setup

Compressor
Cinepak Codec by Radius

Quality (100 = Best) 100

Keyframe Rate: Default
P Frame Rate: Default

Setup OK Cancel

Render Output
☑ Save File Files...
C:\3ds max 6 chapters\Chapter 18\Preset.avi
☐ Use Device Devices...
☑ Rendered Frame Window ☐ Net Render
☐ Skip Existing Images

17. Render At the bottom of the Render Scene dialog, choose Render.

The scene begins to render one frame at a time. Depending on your hardware, you might have noticed that rendering normally takes a while. If you don't want to wait for the rendering, press Escape and

re-commence the rendering when you have more time.

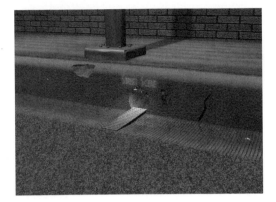

Saving Presets does not save the file name or the directory. To Delete a Preset, open Windows Explorer, choose the file from th render presets directory, and then delete the file.

Using mental ray ®

The mental ray renderer from mental images® is a rendering choice. It offers an alternate method of rendering your scenes. The mental ray renderer generates physically correct simulations of lighting effects, including ray-traced reflections and refractions, caustics, and global illumination.

When rendering global illumination with mental ray, you do not generate a Radiosity Solution. Instead, mental ray uses a feature called Indirect Illumination, and generates its own light map of the scene.

Caustics are an effect of light cast on an object through reflection or refraction. To use caustics in mental ray, you must set up: which objects can generate caustics; which objects can receive caustics; and which lights can create caustics. Also, transparent objects that are meant to generate caustics must have their materials set to 2-Sided for the caustics to be correct.

When you first use the mental ray renderer, notice that it renders differently from the scanline renderer. Instead of rendering from top to bottom, mental ray renders square areas called *buckets*. The order in which buckets are rendered might look confusing at first, but the default method renders all the buckets around certain objects first, so they are removed from memory as soon as they are rendered.

You can choose the mental ray renderer in the Render Scene dialog > Common panel > Assign Renderer rollout. When you choose mental ray, it changes three panels in the Render Scene dialog:

Renderer Panel

The Renderer panel contains four rollouts for mental ray: Sampling Quality, Rendering Algorithms, Camera Effects, and Shadows & Displacement.

Sampling Quality rollout—The parameters in this rollout control how mental ray performs Sampling. It takes the place of SuperSampling in the scanline renderer.

Rendering Algorithms rollout—Lets you choose which rendering algorithms mental ray uses. Scanline rendering is used for direct illumination only; Ray Trace rendering is used for caustics, global illumination, reflections, refractions, and lens effects.

Camera Effects rollout—This is where you set up Depth of Field and Motion Blur for mental ray.

Shadows & Displacement rollout—From this rollout, you can control the shadows and displacement maps globally in a scene.

Indirect Illumination Panel

The Indirect Illumination panel appears in the place of the Advanced Lighting panel. It is where you control the caustics and global lighting in a scene. It contains only one rollout, Indirect Illumination.

The Indirect Illumination rollout contains several important groups:

Caustics—Turns on and off rendering of the caustics. You can also control the look of the caustics in your scene.

Note: If you wish to use caustics in a scene, remember to set: at least one object to generate caustics; at least one object to receive caustics; and at least one light to generate caustics.

Global Illumination—Turns on and off the rendering of global illumination. You also have some controls to adjust the global illumination.

Photon Tracing and Map—Controls the photon maps used to calculate caustics and global illumination. They also include special controls for volumetric caustics.

Final Gather—Improves the quality of global illumination. Without final gathering, global illumination can be patchy, but final gathering increases render time.

Global Light Properties—Global values that every light uses initially for indirect lighting. If necessary, you can set a light to use unique values instead.

Processing Panel

The Processing panel appears in place of the Raytrace panel. This panel contains three rollouts: Translator Options, Diagnostics, and Distributed Bucket Rendering.

Translator Options rollout—Affects the operation of the mental ray translator.

Diagnostics rollout—Contains some tools that allow you to render a diagnostic view of your scene, rather than a photo-realistic view. If you are having trouble rendering with mental ray, use these features to help find problem areas in your scene.

Distributed Bucket Rendering rollout—Allows you to use multiple systems to run a mental ray render.

To find out more about the mental ray panel options, take a look at the **3ds max** help file under *Rendering with the mental ray Renderer*.

There are also three areas with important information for rendering with mental ray: two new rollouts for each light, and a new panel in the Object Properties dialog.

mental ray Indirect Illumination rollout

When you create a light, and switch to the Modify panel, you see a rollout named mental ray Indirect Illumination. This rollout includes parameters that control how a lights works with the mental ray renderer.

Use Global Settings—Keep it turned on to use the global settings set in the Render Scene dialog > Indirect Illumination panel > Global Light Properties rollout. When turned off, the light is not part of indirect illumination, and you can set unique properties.

Global Multipliers group—Multiplies the global settings to find the actual settings for the light.

On—When turned on, it sets unique values for the light's settings. It is available only when Use Global Settings is turned off.

Energy—The amount of light energy the light adds to indirect lighting. This value is independent of the light's intensity.

Decay—Use this value to determine how quickly the light energy decays as it moves away from the light source.

Caustics group—Photons set the number of photons used for determining caustics. Higher values are more accurate, but take more RAM and more render time.

Global Illumination—Photons set the number of photons used for global illumination. As with caustics, higher values are more accurate, but take more RAM and more render time.

mental ray Light Shader rollout

This rollout is available from the Modify panel only. The options in this rollout allow you to add mental ray shaders to lights. These shaders alter the light's effect when using the mental ray renderer.

Enable—When turned on, the renderer uses the shader to affect the light. When turned off, the shader does not affect the light.

Light Shader—Choose a Light Shader from the Material/Map browser. Drag and drop this shader to an empty slot in the Material Editor to adjust its parameters.

Photon Emitter Shader—Available only for users with access to light map shaders via other shader libraries or custom shader code.

Object Properties > mental ray Panel

In the tabbed Object Properties dialog, every object has a panel named mental ray. This panel contains one group, mental ray Rendering Control.

- **mental ray Rendering Control group**— Contains four check boxes. Generate Caustics and Receive Caustics determine whether the object is capable of creating and/or receiving caustics. Generate Global Illumination and Receive Global Illumination determine whether the object adds to global illumination and/or receives global illumination.

By default, all objects are set to receive caustics and global illumination. Set only transparent, reflective or shiny objects to generate caustics. Also, lights that you want to cast caustics need to be set to generate caustics.

Set lights and objects with a self-illuminated material to generate global illumination.

You can set objects to not receive caustics and/or global illumination to save render time.

Rendering with mental ray

In this exercise, you render a scene with mental ray, add global illumination, and then add caustics.

1. On the menu bar, choose File > Open and open *spanish_mental_ray.max* from the courseware CD.

 This scene contains photometric lights to light the scene.

2. On the menu bar, choose Quick Render.

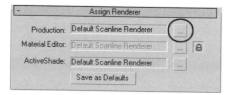

The scene renders quickly with the default scanline renderer.

3. On the Rendered Frame Window toolbar, choose Clone Rendered Frame Window.

4. On the main toolbar, choose Render Scene.

5. In the Render Scene dialog > Common panel, open the Assign Renderer rollout.

6. Click the "..." button to the right of Production.

7. In the Choose Renderer dialog, choose the mental ray Renderer and click OK.

8. Make sure the Camera01 viewport is active.

9. In the Render Scene dialog, choose Render

10. Compare the scanline and mental ray renderings.

 The differences are subtle; however, the detail in the vase and wall textures is noticeable. The mental ray renderer takes slightly longer to render but the detail is more pronounced.

11. In the Render Scene dialog > Indirect Illumination panel > Global Illumination group, turn on Enable.

12. In the Geometry Properties group, turn on All Objects Generate and Receive Caustics and GI.

 Since this option is turned on, you do not have to manually set Global Illumination at the object level.

13. In the Render Scene dialog, choose Render.

 The rendering takes longer, but now has a nice pink tone because of global illumination.

14. Press **M** to open the Material Editor.

15. In the Material Editor, choose Glass and drag and drop it onto the vase object in the scene.

16. In the Shader Basic Parameters rollout, make sure 2-sided is turned on.

 The glass material has a high Specular and Glossiness setting and a Raytrace Map type assigned to the Refraction Map channel.

17. Press M to close the Material Editor.

18. In the Render Scene dialog > Indirect Illumination tab > Caustics group, turn on Enable.

19.Right-click to activate the Camera viewport.

20.In the Render Scene dialog, choose Render.

The rendering takes longer, however the caustics display.

21.In the Render Scene dialog > Indirect Illumination panel > Caustics group, change Max Num. Photons per Sample to **60**, turn on Maximum Sampling Radius, and set the amount to **2.5**.

22.In the Render Scene dialog, choose Render.

The size of the caustics have increased.

Continue to experiment with the settings. Try turning on Final Gathering for global illumination. Keep in mind the render takes considerably longer with Final Gather turned on.

A rendering has been completed with Final Gather turned on. To view the result, do the following:

• On the menu bar, choose File > View Image File, and choose *mental_ray_render_gi_caustics_fg.bmp* from the courseware CD.

Conclusion

In this chapter, you learned some basic principles of camera use for both free and target cameras, as well as various camera parameters. You have been introduced to camera Depth of Field and Motion Blur. In addition to discovering the purpose of the interactive viewport renderer, you learned

the functions of various rendering
parameters, and how to render to a file.
Lastly, you learned to make successful
renderings with the mental ray renderer.

22

Scene Assembly

Objectives

After completing this lab, you should be able to:

- Use the Asset Browser and Merge to add objects to a scene.
- Create and apply materials to embellish the scene.
- Create effective lighting to bring the scene to life.
- Render the scene using Advanced Lighting Radiosity.
- Render Preview and Final renders of a scene.
- Choose between the various Antialiasing options when rendering.
- Decide which file types to use.
- Know when to use Render Elements.
- Use Save Selected to save objects to a new file.
- Archive a scene to save a backup with all associated files.

Introduction

The creation of a scene requires many aspects of **3ds max**, from modeling and textures to lighting and rendering. In this lab, you complete a scene inside a cave. The modeling is kept to a minimum since you concentrate on bringing the scene to life with the help of materials and effective lighting.

The Cave Scene

The scene you create involves a character lost in a cave. This lab is divided into the following sections:

- Adding geometry.
- Creating materials to reflect the "creepy" nature of the cave.
- Creating effective lighting to bring the scene to life.

- Deciding how you want to render your animation.

Adding Scene Elements

In this section, you add a few elements to the scene. You use Merge and the Asset Browser to add objects. You use Save Selected to save an object to a file that can then be added with the Asset Browser.

Merging the Iron Gate

You use Merge to have an iron gate that uses the Lattice modifier in your scene.

Using Merge

1. On the menu bar, choose File > Open and open *Ch22_01.max* from the courseware CD.

2. On menu bar, choose File > Merge.

3. In the Merge File dialog, choose the file *Ch22_Gate.max* from the courseware CD, and choose Open.

4. In the Merge dialog, choose the Gate and click OK.

The gate is added to your scene. It is in the same loaction it had been in from the file you merged it from. Next you move it into place.

5. On the main toolbar, choose Select and Move.

6. In the Status Bar > Transform Type-In area enter the follwing coordinates: X = 0.936, Y = 0.0, Z = 12.162.

Adding the Water Surface

The cave is humid and dirty water covers the ground. Since the water is calm, all you need is a flat surface that you adjust with the help of materials.

Adding the Water

1. Continue from the previous exercise or choose File > Open from the menu bar, and open *Ch22_02.max* from the courseware CD.

2. ⊤ On the command panels, choose Utilities.

3. In the Utilities rollout, choose Asset Browser.

The Asset Browser loads with a warning about lisence rights. This is because files that have been downloaded on the Internet might be copyrighted.

4. In the Asset Browser, navigate to the courseware CD and drag *Ch22_Water.max* over the Top viewport.

5. When you release the mouse button, choose Merge File from the menu.

Notice that the water is connected to the mouse.

6. Click to place the water in the scene.

7. In the Status Bar > Transform Type-In area set X = -1.898, Y = 0.0, Z = -25.

8. Close the Asset Browser.

Creating Materials

Now that you have all the geometry in place, it is time to design the materials that make the scene more realistic.

The Gate Material

You start with the gate's material, which is shiny black and partially rusted.

Creating the Material for the Iron Gate

1. Continue working with your file or choose File > Open from the menu bar, and open *Ch22_03.max* from the courseware CD.

2. On the main toolbar, choose Material Editor.

Tip: The letter M is the keyboard shortcut.

3. In the Material Editor, choose the second material slot, and rename the material **Iron Gate**.

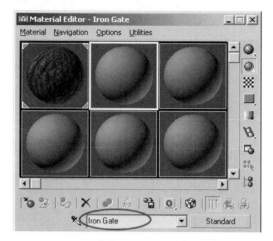

4. In the Shader Basic Parameters rollout > Shader drop-down list, choose Metal.

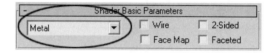

5. In the Metal Basic Parameters rollout, choose the blank box next to the Diffuse color swatch.

This blank box displays the Material/Map Browser dialog.

6. In the Material/Map Browser, double-click Noise.

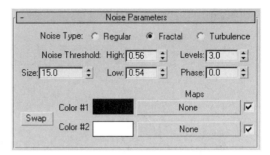

7. In the Noise Parameters rollout, change Noise Type to Fractal.

8. Set Size to **15.0**.

9. Set Noise Threshold: High to **0.56** and Low to **0.54**.

This creates a sharp distinction between the two colors.

10. Choose the Color #2 swatch.

11. In the Color Selector dialog, change the settings to R=**144**, G=**53**, B=**31** to make it look more like rust.

12. In the Material Editor bottom toolbar, choose Go To Parent.

13. In the Metal Basic Parameters rollout > Specular Highlights group, set Specular Level to **60** and Glossiness to **50**.

```
-            Metal Basic Parameters
                              ┌ Self-Illumination ─
   ┌─ Ambient: ▐▐▐▐▐          │ □ Color  0   ⬍  □
   C  Diffuse:  ▐▐▐▐▐    M│  ⬭
                               Opacity: 100  ⬍  □
  ┌ Specular Highlights ─────────────────
     Specular Level: 60  ⬍  □   ▐▐▐▐▐▐▐▐
        Glossiness: 50  ⬍  □    ▐▐▐▐▐▐▐▐
```

This makes the material shinier.

14. Open the Maps rollout.

15. Drag and drop the Noise from the Diffuse Color onto the Bump map slot.

16. In the Copy (Instance) Map dialog, select Instance and then choose OK.

```
Copy (Instance) Map          ✕
 ┌ Method ──────────────
   ⦿ Instance
   ○ Copy
   ○ Swap

   ┌───── OK ─────┐   Cancel
```

17. In the Maps rollout, set Bump amount to **10**.

```
-                        Maps
                       Amount          Map
 □ Ambient Color . . . 100  ⬍      None          │⊟
 ☑ Diffuse Color . . . 100  ⬍      Map #15 ( Noise )
 □ Specular Color .    100  ⬍      None
 □ Specular Level .    100  ⬍      None
 □ Glossiness . . . .  100  ⬍      None
 □ Self-Illumination . 100  ⬍      None
 □ Opacity . . . . . . 100  ⬍      None
 □ Filter Color . . . . 100  ⬍      None
 ☑ Bump . . . . . . . . 10   ⬍      Map #15 ( Noise )
 □ Reflection . . . . . 100  ⬍      None
 □ Refraction . . . . . 100  ⬍      None
 □ Displacement . . 100  ⬍      None
```

18. Drag and drop the Material onto the Gate in the Front viewport.

19. Right-click in the Camera viewport to make it active.

20. 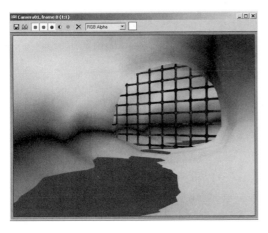 On the main toolbar, choose Quick Render.

The Cave Material

The inside of the Cave is made of an irregular rocky pattern. You use a bitmap for that effect.

Creating the Material for the Cave

1. Continue from the previous exercise, or choose File > Open from the menu bar, and open *Ch24_04.max* from the courseware CD.

2. If the Material Editor is not open, press **M**.

3. In the Material Editor, choose an unused sample slot.

4. Rename the Material to Cave Walls.

5. In the Maps rollout, choose None next to Diffuse Color.

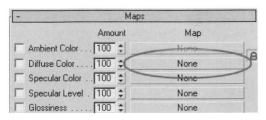

6. In the Material/Map Browser dialog, double-click Bitmap.

7. In the Select Bitmap Image File dialog, browse to your courseware CD and choose *CRAGGY_R.TGA*.

8. In the Coordinates rollout, set U and V tiling to **4.0**.

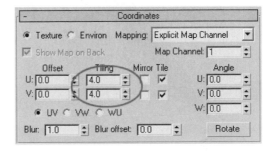

9. In the Material Editor bottom toolbar, turn on Show Map in Viewport.

10. Drag the newly created material from the Material Editor to the two cave objects in the Top viewport.

The rocky pattern is displayed in the viewports.

11. Right-click in the Camera viewport to make it active.

12. On the main toolbar, choose Quick Render.

The Water Material

Of all the materials you build for this scene, the water material is the most complex. One reason for this is the water surface needs to reflect the environment. The most complex aspect of the scene involves the character standing in the water, which creates a ripple. Although various ways to create ripples are available in **3ds max**, in this lab you use a Bump map to simulate the effect.

Creating the Material for the Water

1. Continue from the previous exercise, or choose File > Open from the menu bar, and open *Ch22_05.max* from the courseware CD.

2. If the Material Editor is not open, press **M**.

3. In the Material Editor, choose an unused sample slot.

4. Rename the Material to Water.

5. In the Blinn Basic Parameters rollout, choose the color swatch next to Diffuse.

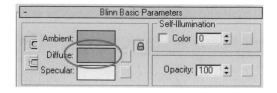

6. In the Color Selector dialog, change the settings to R=**140**, G=**120**, B=**100**.

7. In the Blinn Basic Parameters rollout, choose the color swatch next to Specular.

8. In the Color Selector dialog, change the settings to R=**170**, G=**190**, B=**185**.

 Note: Both the Diffuse and the Ambient colors are the dirty brown color you have assigned. This water is murky but has a few blue/green highlights at the Specular level, where the lights hit the surface.

9. Close the Color Selector dialog.

10. In the Specular Highlights group, set Specular level to **80** and the Glossiness to **20**.

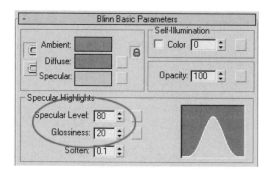

This makes the water surface shinier.

11. In the Maps rollout, choose None next to Reflection.

12. In the Material/Map Browser, double-click Raytrace.

13. In the Material Editor bottom toolbar, choose Go to Parent.

14. Set Reflection Amount to **30**.

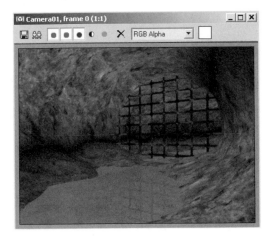

15. Drag and drop the material onto the Water surface.

16. Activate the Camera viewport, and then choose Quick Render.

Note: Reflection and Bump Maps do not display in the **3ds max** standard viewports.

Creating the Ripple

1. Continue from the previous exercise.

2. In the Maps rollout, set Bump Amount to **100**, and then choose None.

3. In the Material/Map browser, double-click Waves.

4. In the Waves Parameters rollout, set the following:

Num Wave Sets: **10**

Wave Radius: **5**

Wave Len Max: **5**

Wave Len Min.: **2**

Distribution: **2D**

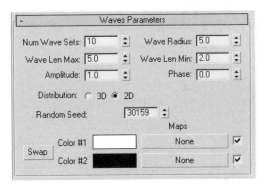

Note: Although you can activate the Show Map in Viewport option for procedural maps, such as Wave or Noise, what you see in the viewport doesn't always match the final rendered image. You use a more accurate method instead.

5. On the command panels, choose Display.

6. On the Display panel > Hide rollout, choose Unhide by Name.

7. In the Unhide Objects dialog, choose *SUPERGIRL*.

 A young woman now stands in the water.

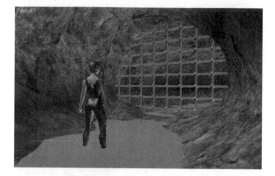

8. Right-click in the Camera viewport to make it active.

9. On the menu bar, choose Rendering > ActiveShade Viewport.

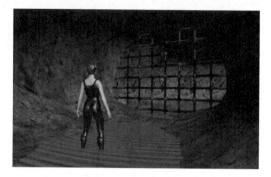

 3ds max takes a few seconds to compute the scene and display a rendered result in the ActiveShade viewport. If you make changes to any material, the viewport updates the rendered image.

10. In the Material Editor > Coordinates rollout, change the X and Y offsets to **–15** and **115** respectively.

 This centers the ripple on the girl's feet.

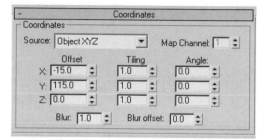

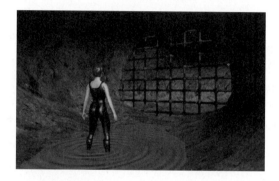

11. Right-click in the ActiveShade viewport, and choose Close from the quad menu.

Creating Effective Lighting

The scene is coming together now but you need to address one important aspect: lighting. No matter how good a modeler you are or how well you design materials or animate, if you hope to achieve award-winning renderings, you have to put a lot of thought into lighting your scene. How many main light sources are there? How many secondary or fill lights? How is the light bouncing off surfaces and how is the light carrying the color of that surface? Is the color attenuating as it travels, and if so, by how much?

You have evaluated lighting in this way while putting together the scene in previous versions of **3ds max**. In **3ds max 7** it's a bit different because you use Photometric lights to light the scene. These lights allow you to render the scene using the Advanced Lighting Radiosity renderer, eliminating the guesswork involved in placing lights and providing a realistic method to light the scene.

Lighting the Scene

The cave has four torches that you need to unhide. These simulate the main light sources in the scene.

Creating the Torchlights

1. Continue from the previous exercise, or choose File > Open from the menu bar, and open *Ch22_06.max* from the courseware CD.

2. Right-click in the Camera viewport, and choose Unhide All from the quad menu.

 Four Torchset groups are now visible in the scene. Each group consists of a cylinder and plane object mapped with an animated flame. The latter has been assigned with a LookAt Constraint so that it always faces the camera.

 Note: For more information on Constraints and Controllers, please refer to the Animation module of this book.

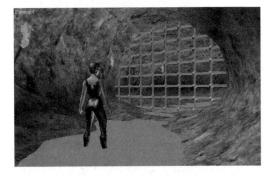

 Since these four torches represent the only physical light sources in the scene, they should affect the environment in a certain way. For example, the light should be concentrated on the left wall and should display a fiery tint. Also, because the light emanating from a torch doesn't travel a lot, it attenuates as it nears the right wall, thus making the right wall darker.

3. In the viewport navigation controls, choose Region Zoom.

4. In the Top viewport, zoom in on the girl and the torch to her left.

5. On the command panels, choose Create.

6. On the Create panel, choose Lights > Photometric.

7. In the Object Type rollout, choose Free Point.

The Free Point light acts like a light bulb and casts rays in all directions. This is what you need for the torch.

8. Click in the Top viewport to create the light between the girl and the torch, closer to the torch.

9. On the main toolbar, choose Select and Move.

10. In the Left viewport, move the light up so that it is slightly higher than the torch at the flame level.

11. On the command panels, choose Modify.

12. On the Modify panel > Intensity/Color/ Distribution rollout > Color group, choose Kelvin, and set color to Kelvin: **1800**.

This gives the light a reddish color, but it lacks enough color to seem realistic.

13. Set the Filter Color to R=**255**, G=**151**, B=**100**.

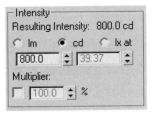

This colors the light to look more like a torch flame.

14. In the Intensity group, set Resulting Intensity to **800.0 cd**.

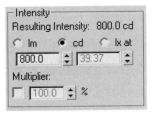

This lowers the amount of light emitted from the torch.

15. Right-click in the Camera viewport make it active.

16. On the main toolbar, choose Quick Render.

The scene is a little dark. You have one active light in the scene now. The default lights you had earlier have been turned off.

Instancing the Light

1. In the Top viewport, Shift + Move to duplicate the light you created by placing a clone near the second torch.

2. In the Clone Options dialog, choose Instance.

This way, if you decide to edit the parameters of one light, the others are affected as well.

3. Repeat the procedure to create two more instances of the light for the remaining torches.

4. Right-click in the Camera viewport to make it active.

5. On the main toolbar, choose Quick Render.

Generating a Radiosity Solution

In the last test render, you might have noticed the following issues:

- The right wall is still too dark.

- The back of the girl is in darkness.

If the light from the torches is hitting the water, some of its intensity should bounce back and illuminate the girl from below. As for the right wall, you could use an "all around" light to make the scene a little lighter.

Using Radiosity solves these issues for you. It calculates the light bouncing off the surfaces in the cave and provides you with a more realistic rendering.

Generating the Radiosity Solution

1. Continue from the previous exercise, or choose File > Open from the menu bar,

and open *Ch22_07.max* from the courseware CD.

2. On the menu bar, choose Rendering > Advanced Lighting > Radiosity.

Answer No to the Warning dialog since you add Exposure manually, later in the exercise.

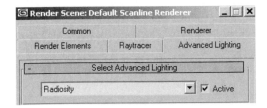

The Render Scene dialog is displayed with the Advanced Lighting tab showing, and Radiosity selected.

3. In the Radiosity Processing Parameters rollout, set Refine Iterations (All Objects) to **2**.

4. In the Interactive Tools group, set Filtering to **1**.

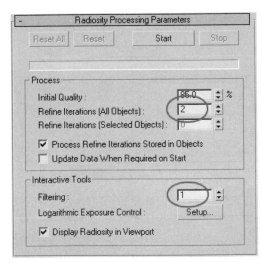

5. In the Radiosity Meshing Parameters rollout, turn on Enabled.

6. Set Meshing Size to **20.0**.

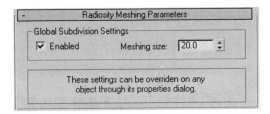

This subdivides the scene mesh objects automatically and gives a smoother-looking result.

7. In the Rendering Parameters rollout, turn on Regather Indirect Illumination. Turn on Clamp Values, and then set the value to **3000.0**.

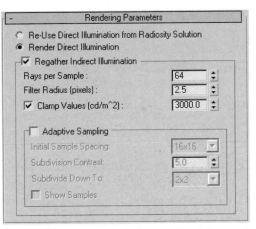

This eliminates lighting artifacts by not rendering the brightness on a surface beyond the set value.

8. Turn on Adaptive Sampling. Keep these settings at their default values.

This speeds up rendering by concentrating the rendered samples only where they are most needed.

9. In the Radiosity Processing Parameters rollout, choose Start.

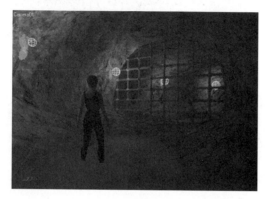

This is the viewport view of the radiosity solution.

10. In the Render Scene dialog > Common tab > Advanced Lighting group, make sure Compute Advanced Lighting when Required is turned off. If this option is turned on, the Radiosity solution is recalculated.

11. Right-click to activate the Camera viewport.

12. On the Render Scene dialog, choose Render.

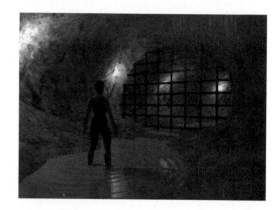

Adjusting the Exposure

Now that you have a radiosity solution, you probably want to adjust the exposure of the solution to light the scene the way you want it.

1. Continue from the previous exercise, or choose File > Open from the menu bar, and open *Ch22_08.max* from the courseware CD.

2. In the Advanced Lighting tab > Radiosity Processing Parameters rollout > Interactive Tools group, choose Setup.

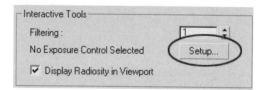

The Environment and Effects dialog is displayed.

3. In the Exposure Control rollout, choose Logarithmic Exposure Control from the drop-down list.

Exposure Control looks at the scene in much the same way a real camera does. It uses a Logarithmic (non-linear) brightness scale based on the current solution. This provides not only a more realistic rendering of the illumination, but also a more flexible Exposure Control.

Next, you adjust the values in the Logarithmic Exposure Control Parameters rollout so the brightness of the scene looks correct.

4. In the Logarithmic Exposure Control Parameters rollout, set Brightness to **55.0**, the Contrast to **65.0**, and the Mid Tones to **1.3**.

This lowers the brightness, adds more contrast, and raises the mid tones in the scene.

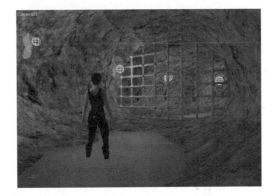

5. Right-click in the Camera viewport to make it active.

6. On the main toolbar, choose Quick Render.

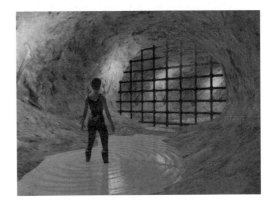

Radiosity Rendered Animation

You might have noticed that using Radiosity to render an image significantly extends rendering time, especially when Regather Indirect Illumination is turned on. The time factor becomes increasingly important when you have to render an animation. The

radiosity solution is based on the state of scene lighting and geometry. For each frame in which lighting or geometry changes, the radiosity solution is recalculated. However, for frames in which the lighting and geometry remain static, the last valid solution can be reused. This is typically the case for camera flythrough animations.

If you have animated geometry in your scene, here are a few suggestions to minimize the time it takes to generate a solution.

1. Set up your geometry on an object-by-object basis using the Subdivide modifier to add enough geometry to obtain a good-quality solution.

2. Do not enable the Global Subdivisions in the Radiosity Meshing Parameters rollout.

3. Reduce the Initial Quality percentage for the radiosity process. This reduces the number of calculations the radiosity processor uses to generate a solution. The lower the percentage, the less time it takes to generate a solution; however, the solution is less accurate.

4. Increase the filtering value to clean up the final solution without adding geometry.

5. Turn off Regather Indirect Illumination.

Rendering a Preview

In this exercise, you render a 91-frame animation. It contains just one camera move so you can calculate the Radiosity solution once and render the animation without regenerating the solution.

First you render a Preview of the animation to make sure you are happy with how it looks. This feature is accessed on the menu bar by choosing Animation > Make Preview.

Choosing Make Preview opens a very condensed version of the Render Scene dialog. In it you can decide on the animation range, frame rate, image size, what to render in the preview, if you want multi-pass camera effects, what rendering level to use, and what type of file to output.

The Preview animation is saved with a default name in the animations folder, so you do not need to name the file.

1. On the menu bar, choose File > Open and open Ch22_Animated camera.max from the courseware CD.

2. On the menu bar, choose Animation > Make Preview.

3. In the Make Preview dialog, keep the settings at their defaults, and click Create.

4. In the Video Compression dialog, accepts the default settings.

The animation is rendered quickly. When it is finished, the Windows Media Player opens and plays the preview.

Note: While the preview is rendering, do not open any windows in front of the animation, otherwise the frames do not render properly. When the preview is blocked, the last rendered frame is repeated, instead of rendering new frames; and if you are moving the window, you might get grey spots.

If you close the Windows Media Player, and want to see the preview again, on the menu bar choose Animation > View Preview.

Rendering a Camera Move Using Radiosity

Next you continue to render a final version of the 91-frame animation.

1. Continue from the previous exercise, or choose File > Open and open *Ch22_Animated camera.max* from the courseware CD.

2. On the menu bar, choose Rendering > Advanced Lighting > Radiosity.

3. In the Radiosity Processing Parameters group, set Refine Iterations (All objects) to **2**.

4. In the Interactive Tools group, set Filtering to **1**.

5. In the Radiosity Meshing Parameters rollout, turn on Global Subdivision, and set Meshing size to **40.0**.

6. In the Radiosity Processing Parameters rollout, choose Start.

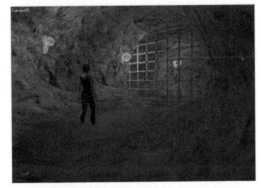

Wait while the solution is processed.

7. In the Render Scene dialog, choose the Common tab.

8. In the Common Parameters rollout > Time Output group, choose Active Time Segment.

9. In the Common Parameters rollout > Advanced Lighting group, turn off Compute Advanced Lighting when Required.

This keeps **3ds max** from recomputing the radiosity solution.

10. In the Render Output group, choose the "..." button next to Save File.

The Render Output File dialog is displayed.

11. In the File name type-in area, enter **Cavecamera**.

12. Set the Save as type to AVI File (*.avi), and then choose Save.

13. In the Video Compression dialog, select Cinepak Codec by Radius from the list.

14. Change Quality to **100**, and choose OK.

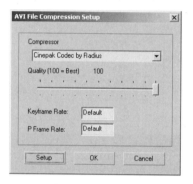

15. At the bottom of the dialog, choose Camera01 from the Viewport drop-down list.

16. In the Render Scene dialog, choose Render.

Your scene takes some time to render. When it's done, view your animation by choosing File > View Image File from the menu bar.

Rendering Options and Output

In the previous exercise you saved the animation to an AVI file using the default options and Antialiasing Filter. Depending on your goal for the final file, you might want to change some of these settings.

On the Render Scene dialog > Common tab > Common Parameters rollout > Options group, there is the list of nine options you may turn on or off to change your renders. Many of these are there to help speed up the render time. For example, you can turn off Atmospherics, Effects, or Displacement; or you can turn on Area Lights/Shadows as Points. Also, in the Advanced Lighting group below, you can turn off Advanced Lighting for when you need to make a quick test render.

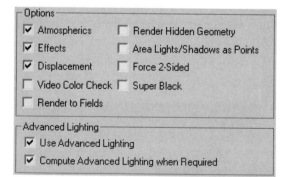

On the Render Scene dialog > Renderer tab > Default Scanline Renderer rollout > Antialiasing group, you can control the antialiasing in the scene. When preparing for the final render, it is advisable that you test the scene with several of the Filter options first to get the effect you want. Some of the filters enhance the detail at the expense of the edges between objects, while others smooth out the detail to give an ethereal feeling to the picture. Remember to use the inforation box to see how the filter is used.

A third factor you need to think about when rendering is the output file type.

When rendering a still image, you have quite a few options to choose from. The most common of these are BMP, PNG, TIF, TGA, and JPG. Each of these file types has a reason for being used. For example:

- BMP is a universal Windows format, but the file size is large.
- PNGs have some compression, and are gaining in popularity.
- TIFs (TIFF) are another standard file, especially for Print and they can have compression.

- TGA (Targa) files were often used in game and broadcast design, however other file types are starting to be used.
- JPG files are the smallest in size, but their compression is lossy: you lose some data. JPG files can be shown on the Internet.
- Also of interest is that PNG, TIF, and TGA files support alpha channels, while most image formats don't.

When rendering an animation, you have several formats to choose from, with AVI and MOV being the most common. MOV files use QuickTime compression, However users need to download QuickTime to view the file.

On the other hand, AVI files can be saved using quite a few different codecs (compression algorithms), but most of the codecs come standard with the Windows Media Player, which plays AVI files by default. The two most common codecs are the Cinepak codec by Radius and the Div-X codec. You have to experiment with the codecs to find which ones you like the best. Keep in mind that if you use a newer codec, some poeple might not be able to view your animation without finding and loading the codec first.

Last, you might decide to use Render Elements. This is an option found in the Render Scene dialog. It allows you to render details such as Shadows, Z-Depth, Diffuse etc. from one image. You can then combine these components in a painting and compositing package such as combustion. For example, take one frame out of an animation. You render each frame separately with an extension such as PNG, TGA, or BMP etc. Each image is made up of a variety of

components such as Diffuse Color, Shadows, Specularity, Transparency etc. So one image has all these components rendered separately. You can choose to save this information as a CWS (combustion) file and when you open combustion and load the CWS file all these components are displayed as separate layers. This allows you to manipulate these components separately hence giving you greater control.

Alternatively, you can save many of the above components such as Z-Depth, Color, Transparency as part of an RPF (Rich Pixel Format) extension. Once they are saved with this type of extension, you can open these single images in combustion to add glows, fog, or change an existing material. Using Render Elements or saving as an RPF extension allows you more flexibility because the special effects aren't embedded in the image, rather they are separate components to be manipulated in a variety of ways without having to re-render the entire animation in 3ds max.

Light Tracer Rendering

Now that you have learned to render using the Radiosity renderer, you use the Light Tracer. The Light Tracer rendering process differs from Radiosity and lends itself to scenes lit by either direct or indirect sunlight. Although you can use Light Tracer for interior scenes, it is much better suited for outdoor scenes.

Even though Light Tracer is not considered a production tool, you explore some of its options only to see how different your renderings can be based on the features you choose.

In this exercise, you render the same cave scene, only this time it is the cave entrance. One end of the cave is opened up to make an entrance, and a Skylight now lights the outside.

The Cave Entrance

1. On the menu bar, choose File > Open and open *Ch22_cave entrance.max* from the courseware CD.

The scene has a Standard Skylight in addition to the torchlights. Remember, the position of the skylight won't affect the

light it produces in the scene because it is a skydome over the entire scene. Also, the Camera01 viewport looks dark because the skylight isn't added to the viewport lighting.

2. On the menu bar, choose Rendering > Advanced Lighting > Light Tracer.

The Render Scene dialog opens on the Advanced Lighting tab, with the Light Tracer chosen.

3. In the Parameters rollout, General settings group, set Rays/Sample to **50**.

This reduces the number of rays the renderer calculates and speeds up rendering time a bit. Be aware that fewer rays mean faster rendering, at a sacrifice to quality. Experiment with this number, starting at 25 and then in crements of 25, to see the results.

4. In the Parameters rollout, General settings group, set Bounces to **1**.

This tells the renderer how many times to bounce each calculated ray. The Light Tracer renderer is best used for outdoor scenes where there are no bounces. Increasing the Bounces setting inflates rendering time drastically.

5. Activate the Camera viewport.

6. On the Render Scene dialog, choose Render.

Rendering with mental ray

In this example, you render the same cave scene using the mental ray renderer.

1. On the menu bar, choose File > Open and open *ch22_mentalray.max* from the courseware CD.

2. Right-click in the Camera viewport to make it active.

3. On the main toolbar, choose Quick Render.

The image renders rather quickly using the scanline renderer, and gives a good result.

4. On the main toolbar, choose Render Scene.

5. In the Render Scene dialog > Common tab > Assign Renderer rollout, choose the button next to Production Renderer.

6. In the Choose Renderer dialog, choose mental ray.

7. On the Rendered Frame Window toolbar, choose Clone Rendered Frame Window.

8. In the Render Scene dialog, choose Render.

9. Compare the renders.

The mental ray render has a pronounced soft shadow in the water, and the textures have more detail. Next, you turn on Global Illumination.

10. Press **H** and choose *Cave01*, *Cave02*, and *Water* from the list.

11. Right-click and choose Properties from the quad menu.

12. In the Object Properties dialog > mental ray tab, turn on Generate Global Illumination.

13. In the Render Scene dialog > Indirect Illumination tab > Global Illumination group, turn on Enable.

14. Change Photons to **80**.

 Note: The higher this number, the longer the image takes to render.

15. In the Rendered Frame Window toolbar, choose Clone Rendered Frame Window.

16. In the Render Scene dialog, choose Render.

17. Compare the three renders.

 This rendering is much brighter. Next, you change the Energy to adjust the brightness.

18. In the Render Scene dialog > Indirect Illumination tab > Global Light Properties group, change Energy to **12000.00**.

19. In the Render Scene dialog, choose Render.

The rendering is not as bright, and looks quite good.

Finally, you increase the Energy and change other settings to display Caustics.

20. In the Render Scene dialog > Indirect Illumination tab > Caustics group, turn on Enable. Leave Samples at 100. Samples sets how many photons are used to compute the intensity of the caustic.

21. Turn on Radius and set it to **5.0**. This sets the size of the Photon.

22. Change Filter to Cone, and leave Kernel at 1.1. This makes the caustic appear sharper, but adds rendering time.

23. In the Global Illumination group, turn off Enable.

24. In the Photons group, turn on All Objects Generate and Receive Caustics & GI.

25. In the Global Light Properties group, change Energy to **500000.0**, Caustic Photons to **10000**, Decay to **2.0**, and GI Photons to **10000**.

26. In the Camera viewport, choose *Cave01*.

27. Right-click and choose Properties from the right-click menu.

28. In the Properties dialog > mental ray tab, turn on Generate Caustics.

29. On the main toolbar, choose Quick Render.

As you see, lighting and rendering can make your scene look very different. Continue to experiment with various settings and settle on one that is right for you.

Saving Objects to a New Scene

When working in **3ds max**, there are times when you need to save one or more selected objects to a new scene. You might need to isolate the object(s) for a new scene, or you might be sending specific objects to someone. To save selected objects, use File > Save Selected, located on the menu bar.

1. Continue from the previous exercise, or choose File > Open and open *Ch22_Final.max* from the courseware CD.

2. In any viewport, select *SUPERGIRL*.

3. On the menu bar, choose File > Save Selected.

4. In the Save File As dialog, name the file *Cave Explorer.max* and click Save.

You now have a new file named *Cave Explorer.max* with just the girl in it.

Archiving a Scene

When you are finished with a scene and would like to make a backup, or if you have to send your scene to someone else who needs to work on it, you want to save an Archive of the file. Archive saves your scene and all associated files into one .*zip* file using standard ZIP compression.

This is an excellent feature because it saves all the maps along with the file, saving you time searching through your materials and files trying to find all the bitmaps you used.

1. Continue from the previous exercise, or choose File > Open and open *Ch22_Final.max* from the courseware CD.

2. On the menu bar, choose File > Archive > Archive.

3. In the File Archive dialog, name your file and click Save.

 If you navigate to the .*zip* file on your hard drive and open it, you see that it contains

the MAX file, along with all the maps used in this scene.

Conclusion

In this lab, you learned to populate a scene with geometry using Merge and the Asset Browser. You also learned to design and apply interesting materials to embellish your scene. Furthermore, you created and adjusted lights in the scene to accomplish effective lighting that bring your designs to life. Next, you used Radiosity, Light Tracer, and mental ray as ways to render a scene. Finally, you learned how to save specific objects to a new scene, and how to archive your scenes. If you have time, experiment a little more: add some geometry, design new materials, and achieve various lighting effects.

23

Scripting

Objectives

After completing this chapter, you should be able to:

- Understand how to use the MAXScript Listener.
- Know basic script syntax and formatting.
- Create objects, transform them, and add modifiers using script commands.
- Create a simple script.

Introduction

When people talk about scripting in **3ds max**, they are referring to the use of **3ds max**'s scripting language, MAXScript. MAXScript provides a way for to you to interact with a **3ds max** scene and control actions automatically via script statements. You write the statements in text form, then **3ds max** interprets the script and executes the operations. These text scripts can be saved and called at any time.

MAXScript encompasses almost all of **3ds max**'s features. In this chapter, you review the basics to help get you started.

Learning to script takes time. You must study scripts written by other people. Also, an understanding of basic math is important. You can do a lot with a knowledge of simple mathematics only, but a good foundation in trigonometry helps. Lastly, some prior programming experience is helpful, but not necessary.

The best resource of a complete list of MAXScript topics and commands is the MAXScript Help file that ships with **3ds max**. It contains everything you need to know, but keep in mind that the primary purpose of the Help file is for reference. It is not intended to show you how to script, or to explain the reasoning behind scripts.

One way to access the MAXScript interface is through the Utility panel. There are several ways to execute script commands. You start with the Listener Window, which is an interactive environment for executing MAXScript commands.

MAXScript Listener

The MAXScript Listener window is an interactive interpreter for the MAXScript language. You enter MAXScript commands in this window, and when you press ENTER, they are executed immediately.

The Listener window is appropriate for performing interactive work and developing small code fragments. Each command you execute in the Listener is actually an expression with a result, which the Listener prints after each execution. You can enter any MAXScript expression or sub-expression in the Listener for evaluation, and the Listener prints its result.

You can use the Listener in two ways. You can type statements into the window one at a time, pressing the ENTER key after each one. When you press the ENTER key, **3ds max** executes the statement. Second, the Listener can also be left open while you run scripts, and you can watch it generate text statements as your program runs.

The Listener window itself is actually a text editor, so you can copy, paste, undo, etc. Typed text is black, and text that the Listener generates is normally blue, except when an error is encountered. In that case, it is red.

There is also a Mini Listener located in the lower left of the **3ds max** window. It is divided into two sections: pink on top, white on bottom. The white area shows the latest result from the Listener.

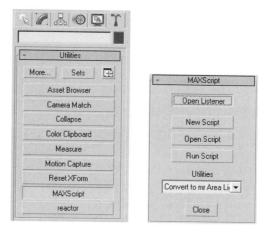

Typically, there are three ways to access the Listener:

On the Utilities panel > Utilities rollout, select MAXScript. The MAXScript rollout appears with five buttons labeled Open Listener, New Script, Open Script, Run Script, and Close. There is also a Utilities drop-down list. Select Open Listener to open the Listener.

You can right-click the Mini Listener and then choose Open Listener Window to open the Listener.

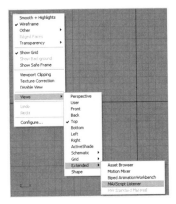

You can also open the Listener in a viewport. Right-click the viewport name and then choose Views> Extended > MAXScript Listener from the right-click menu. Right-click the Listener menu bar and then choose a view to switch the viewport back to a standard viewport.

Like the Mini Listener, the Listener is divided into two regions: pink and white. However, it usually starts with the pink region closed. If you do not see both areas, use your mouse to grab the horizontal split bar at the top of the window and pull it down.

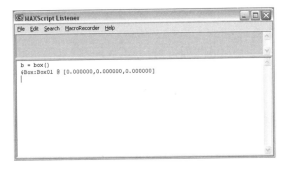

This is the area where MAXScript macro commands are displayed as they are recording. You can leave the upper pane closed when you aren't using it.

Using the Listener

You use the Listener to enter a simple script statement.

1. Start **3ds max**.

2. Right-click the Mini Listener and then choose Open Listener Window.

3. In the Listener, type:

 b = box()

4. Press ENTER.

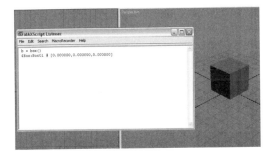

A box has been created in your viewports and the Listener has generated some text. You see "$Box:Box01 @ [0.000000, 0.000000, 0.000000]". This text indicates that the command is executed successfully.

5. In any viewport, select the box and then delete it.

6. In the Listener, type:

 s = sphere()

7. Press ENTER.

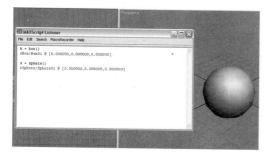

You notice similar results, except you have created a sphere.

8. In the Listener, type:

 t = triangle()

9. Press ENTER.

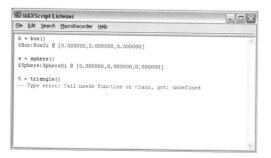

You should get the following message in the Listener window "--Type Error: Call needs function or class, got : undefined".

This message means MAXScript does not recognize the function "triangle()" because it is an invalid function.

Note: There are other ways to execute commands in the Listener. If you place the cursor anywhere on any line that contains a command and press SHIFT + ENTER, that line will be executed. You can also select a group of lines, and press SHIFT + ENTER to execute the group. If you have a number pad on your keyboard, the Number Pad Enter key is an alternative to SHIFT + ENTER, and can be used to execute commands.

Tip: To clear text from the Listener Window, choose Edit > Clear All from the menu bar.

Syntax & Organization

A script is nothing more than a series of statements written in text form. Predictably, if the statements are not written correctly, your script will not execute properly, or it may not run at all. The script grammar (called "syntax") is precise. **3ds max** cannot figure out what you mean if the script statement is incorrect. Deviations from precisely correct syntax are unacceptable, and MAXScript lets you know it does not understand your script by printing it in red in the Listener.

Keep scripts neat and readable because it is easy to create sloppy scripts that are difficult to read by others, or even yourself at a later date. If you can't read the script, it is difficult to change, add to, or fix. Effective use of indenting with tabs and spaces can help delineate special items or functionality. Everyone has their preferences for when and where to indent. **3ds max** doesn't care about

this because it ignores *whitespace* characters (extra spaces, returns, and tabs) when processing scripts. The examples in this module demonstrate one way to indent. You are free to do things differently if you like, but you should be consistent.

To make your script more understandable to yourself and others, the use of comments is instrumental. Comments are blocks of text you put in your script to explain or document what your script is doing, or how it is doing it. Many people don't want to bother with commenting, and this is fine for small scripts. However, if a script begins to get large or complex, you should try to add comments. Obviously, comments are not intended to be executable script statements, so you need to make sure **3ds max** does not try to process them.

There is a way to indicate when a line of text is not part of the actual script. The syntax for a comment is a double hyphen "--" at the beginning of the comment. Comments can occur on a new line of text, or they may be present on the same line as a script statement. All text following the "--" is ignored until you end it with a return. If you have a comment that spans multiple lines, you must include the "--" on each line. Here is an example:

```
b = box()
b.length = 20.0
-- Here is a comment.
-- Here is a second comment that continues
-- on this line. The next line is part of the script.
b.width = 30.0
```

If you place a comment on the same line as a script statement, do so like this:

```
b = box()  --Create a box, comment is ignored
```

Script statements are executed one line at a time. The return at the end of the line indicates that the statement is finished. This is fine provided the statement fits on one line, but sometimes a MAXScript statement is quite long. There is a way to place long statements on multiple lines and have **3ds max** read it as one statement. To do so, you must indicate that even though there is a return, the statement is incomplete. You use the backslash character "\" to indicate that a statement continues. The next example shows a long script statement written across several lines:

Original script command:

```
torus radius1:10 pos:(0, 0, 20) wirecolor:(225, 230, 100)
```

And here's the same command spread over several lines:

```
torus radius1:10 \
    pos:(0, 0, 20) \
    wirecolor:(225, 230, 100)
```

Notice that the script is indented several spaces on each new line. **3ds max** ignores the spaces, but they make the script much more readable.

Sample Script

To familiarize yourself with MAXScript and how it looks, you examine a simple MAXScript.

1. Start **3ds max**.

2. On the command panels, choose Utilities.

3. In the Utilities rollout, choose MAXScript.

4. In the MAXScript rollout, choose Open Script.

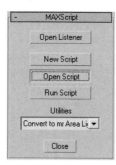

5. Open the file named *Ch23_Sample_Script.ms* located on the courseware CD.

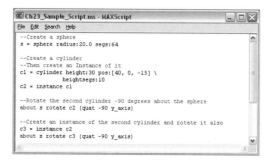

An edit window appears, showing the MAXScript text in colors. Notice the effective use of formatting and comments. Comments are green, and commands are blue.

Reading through the text, you can tell what is going to happen. A sphere will be created, followed by several instanced cylinders, some of which are rotated. A Bend modifier is then applied to one of the cylinders.

6. On the window's menu bar, choose File > Evaluate All.

It takes about a second to see the objects being created and manipulated.

7. Close the window.

Common Script Commands

Before delving into MAXScript and all its commands, you must build an understanding of the basic script commands and how they work.

Variables and Operations

There are many different types of data in MAXScript, and it is most important to know the four most common data types:

- Integers
- Floats
- Strings
- Booleans

You usually use these values in an operation.

The operations are shown by using the operators: +, -, * (for multiply), and / (for divide). There are more operators, such as ^ for exponential or "to the power of," and < > for greater than and less than. You learn more about them as you learn more about MAXScript.

Integers are whole numbers, and they are used quickly. You tell MAXScript that you have an integer by excluding a decimal point with the number. Examples of integer equations are:

```
3 + 4 = 7
2 * 12 = 24
17 / 5 = 3
```

Notice that the division equation gave an incorrect answer. You would expect to see 3.4, but since 17 and 5 are both integers, the answer is rounded down to the nearest integer.

Floats are floating point numbers, or numbers with a decimal point. You show a number as a float by including the decimal. For example:

```
3.0 + 4.0 = 7.0
17.0 / 5.0 = 3.4
```

If an expression is mixed, with one integer and one float, the answer is a float.

Strings are lines of text, such as:

```
"File not found."
"Try again."
```

You use Booleans when you want to represent a True/False or On/Off value. Booleans only hold one bit of information, and are often used in tests. Examples of Booleans include:

```
17 > 5 = true
24 < 2 = false
```

Variables are place holders or containers that represent data in a program. You identify variables by giving them a name. The information or data that a variable holds at any time is called its *value*. Normally, once you create or define a variable, you use it to hold one particular data type. However, in MAXScript, it is possible to assign different data types to the same variable at different points in a script.

When you set a variable equal to a value, it is called an *assignment*. For example:

```
x = 5
```

This assigns the value of 5 to the variable x. Obviously, the data type in this example is an integer.

You can perform operations on variables. The types of operations that are allowed depend upon the data type the variable holds. If you define a variable called x and assign numbers to it, you can perform mathematical operations on it:

```
--Assign 5.0 to x
x = 5.0
--Assign 6.0 to y
y = 6.0
--Multiply x and y and assign the result to z
z = x * y
```

The string data type holds text values. Suppose you have a variable called msg. This could be set to the text string *File not found*. The following example displays a message box with a message to the user:

```
msg = "File not found."
messagebox msg
```

Text values must always be placed inside quotes to distinguish them from other data types. Consider this example:

```
message1 = 5.0
message2 = "5.0"
```

Note that you never have to define beforehand specifically what data type a variable is allowed to hold. Simply by making the assignment, **3ds max** allows you to manipulate the variable automatically according to the rules associated with that data type. You can legally write the following:

```
msg = "File not Found"
messagebox msg
msg = 5.6
z = msg + 7.0
```

When creating a Boolean variable, you can assign it a value of true or false, or you can use on and off. **3ds max** treats true and on as the same value, and false and off as the same value.

```
a = true
b = on
```

Creating Geometry

In the Listener section, you created a box by typing

b = box().

The expression box() is called a function. A function is simply an operation represented by a name. In this example, the function name is box. You use the parentheses so **3ds max** knows you are calling the box function.

When you typed b = box() you called the box function, and a lot of work went on behind the scenes. One important feature of functions is that after they are performed, they return a value to you. In the example, you assigned this value to the variable b. When an object is created, MAXScript generates what is called a *reference* to the

object. The reference allows you to access and work with this object and all its properties. From this point on, when you refer to the box, you can just use the reference b.

In the example, using b = box() creates a box with its default parameters: length, width, and height = 25; all segments = 1; and located at 0, 0, 0.

Rather than create the box with the parentheses, you can include values for some or all of its parameters. The syntax is to type the parameter name:value after the function name. This is also a valid function call, which creates a box with the parameters you specified. The other parameters remain at their defaults.

b = box height:50 width:10

This creates a box for you with a length of 25 (default), width of 10, and height of 50. Notice that you do not have to enter the parameters in any particular order because they are preceded by their names.

Here is an example of setting a box's position and name:

b = box pos:(10, 10, 20) name:"New Box"

You can create any predefined primitive object with functions similar to box(). In this way, you can create any object in **3ds max**: primitives, lights, cameras, particle systems, etc. To see the correct function call syntax for a particular object, refer to the MAXScript Help file.

Position

There are two ways of setting the position of an object: the .pos property and the move command. Both are Point3 types. The .pos property also has .x, .y, and .z properties.

A Point3 type is a group of three numbers enclosed in brackets [] that denotes the x, y, and z values. These points are in the form of [x, y, z]. With .pos and move, x, y, and z are the coordinates of the object.

The following examples use the same box as previously.

Using .pos is absolute. In other words, it places the object exactly where you tell it to. To set an object's position, add .pos to use the Point3 coordinates:

b.pos = (10.5, 20, -15)

To set the position on just one axis, add .x, .y, or .z and the position:

b.pos.x = 25

Using the move command is relative. The object starts at its current location and is moved a specified amount. You must specify the Point3 value:

move b (20, -10, 20)

Rotate

Rotating is more complex than moving or scaling because of the mathematics involved. There are several methods of accomplishing rotation. In this section, you learn two ways of rotating, plus the .rotation property.

Two ways of rotating are referred to as using Euler angles and using Quaternions. Both methods are relative and rotate the object from its initial orientation to a new one.

Euler angles allow you to specify the rotation in degrees about the X, Y, and Z-axes. This method is easy to use, but always rotates about the X-axis first, followed by the Y and Z-axes. Euler angles can be tricky because rotation about the X-axis followed by the Y-axis is not the same as rotation about Y followed by X. The syntax for Euler angles is relatively easy to use, and you can set a variable to an Euler angle.

```
rotate b (eulerangles 0 45 0)
```

```
ang = eulerangles 90 45 -45
rotate b (ang)
```

Quaternions are a little different. They allow you to define a rotation amount, followed by an arbitrary rotation axis. Three default axis variables are set up for you: x_axis, y_axis, and z_axis. To define your own axis, you enter a Point3 type. The following examples produce almost the same results as the previous ones:

```
rotate b (quat 45 y_axis)
rotate b (quat 45 (0, 1, 0))
```

```
ang = quat 90 (1, 0.5, -0.5)
rotate b (ang)
```

Notice that the Y-axis is the same as [0, 1, 0]. The X-axis is [1, 0, 0], and the Z-axis is [0, 0, 1]. When you create your own rotation axis, **3ds max** essentially multiplies the angle by the three numbers to find out how much the object should be rotated on each individual axis. The benefit of using Quaternions is that they are order independent.

The last rotation method to look at is the .rotation property. When using this property, it is best to include the .x_rotation, .y_rotation, and .z_rotation properties.

```
b.rotation.y_rotation = 45
```

```
b.rotation.x_rotation = 90
b.rotation.y_rotation = 45
b.rotation.z_rotation = -45
```

Scale

The scaling methods are similar to changing the object's position. There is a .scale property, with .x, .y, and .z properties, and a scale command. Both are Point3 types.

To set the absolute scale of an object or one of its axes, use:

```
b.scale = (2, 2.5, 0.5)
b.scale.z = 3
```

To relatively scale an object, use:

scale b (0.75, 1, 2)

To uniformly scale an object, you can multiply its .scale property like this:

b.scale = 2.0 * b.scale

Adding Modifiers

To add a modifier, you use the command addmodifier. The syntax to use is *addmodifier objectname (modifiername parameters)*.

Note: You can also set a variable equal to a modifier followed by its parameters, and use it in the parentheses.

For example:

c = cylinder height:50 heightsegs:20
addmodifier c (bend angle:90)

This creates a cylinder with a height of 50 and 20 height segments. Then it adds a Bend modifier with an angle of 90 degrees. Here is another example:

t = twist angle:360
b2 = box height:60 heightsegs:25
addmodifier b2 (t)

This creates a Twist modifier, and then the box, and finally adds the modifier to the box.

Instances

The last basic script command to understand is making instances. Making instances is quite simple. For example:

b3 = instance b

This creates box b3. It is an instance of box b, at the same location. You can specify a new location and name when you make an instance. For example:

b4 = instance b pos:(-20, -20, 30) name:"fourth box"

Now take a look at the sample script and see if it makes sense to you.

Script Writing

In this section, you write a sample script using the information you learned in the previous sections. You write a script that prepares a planet for orbiting around a sun.

1. Start or reset **3ds max**.
2. On the command panels, choose Utilities.
3. In the Utilities rollout, choose MAXScript.
4. In the MAXScript rollout, choose New Script.

An edit window is displayed with all the standard menu items you expect for a basic text editor, much like Wordpad. From this window, you can generate scripts, save them, open them, and run them. MAXScript files normally use the extension *.ms*.

The menu command you use the most is File > Evaluate All (Ctrl + E). When you choose Evaluate All, whatever script is in the window is evaluated for correct syntax and is executed. This is how to run an entire script.

5. In the Mini Listener area, right-click and then choose Open Listener Window.

Note: When you evaluate the MAXScript dialog, the Listener displays comments. If there is a mistake, you are able to see where the mistake occurs.

6. In the MAXScript Listener dialog, choose Edit > Clear All if there is text in the window.
7. In the MAXScript window, type this script into the script edit window (you can exclude the comments if you wish, but it's good practice to keep them in):

```
--Create a yellow sun
sun = sphere radius:10.0 \
        wirecolor:[255, 255, 50] \
        name:"sun"
```

8. Next, you create the planet's orbit, and the planet. You then move the planet into orbit:

```
--Create a circle for the planet's path
orbit1 = circle radius:50.0 name:"orbit1"

--Create a small red planet
--Also move the planet to the circle
planet1 = sphere radius:2.0 \
            wirecolor:[200, 0, 0] \
            name:"planet1"
move planet1 [50, 0, 0]
```

9. Now you want the planet to move along the orbit, so you create a PathDeform modifier and apply it to the planet:

--Create a pathDeform modifier
--Pick the path to be orbit1 and the axis
--as the Y-axis
pd1 = pathdeform path:orbit1 axis:1
addmodifier planet1 pd1

--Rotate the orbit for interest
rotate orbit1 (quat 5.0 y_axis)

Note: Typically, you use a Path Follow constraint to make a planet follow an orbit, however Path Deform works in this case.

10. Using a little trigonometry, you move the planet so it remains on the orbit:

--Move the planet to coincide with the
--rotated orbit
--Note: 50*sin(5.0) = 4.36
--50 - (50*cos(5.0))=0.19
move planet1 [-0.19, 0, -4.36]

11. On the MAXScript menu bar, choose File > Evaluate All.

As your script executes, you see the Listener respond. If there was an error in your script, the Listener shows it to you. You can then go back and correct your mistake.

12. In any viewport, choose the planet.

13. Auto Key Turn on Auto Key.

14. Move the time slider to frame **100**.

15. On the Modify panel > Parameters rollout, set Percent = **100**.

16. Auto Key Turn off Auto Key.

17. In Track Bar, right-click the first keyframe and then choose planet1: Percent along path from the right-click menu.

18. Set the In and Out curves to linear.

19. Choose the far left and far right arrows to set the second key's curves to linear also.

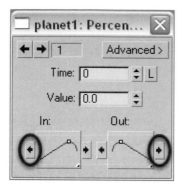

20. Play your animation.

21. In the New Script window, choose File > Save and save your script to a convenient directory. Name it *Solar_System.ms*.

This script and the scene it generates can be found on the courseware CD. They are named *Ch23_Solar_System.ms* and *Ch23_Solar_System.max*.

Conclusion

In this chapter, you explored the basics of MAXScript and used the MAXScript Listener. You learned about operators, variables, and basic script commands. The commands enabled you to create objects, transform them, add modifiers, and make instances of them. You also wrote a sample script that prepared a planet for orbit around a sun, and then animated it. If you wish to learn more about scripting, the MAXScript Help file that ships with **3ds max** is an invaluable resource.

Dynamics

Objectives

After completing this chapter, you should be able to:

- Understand what dynamic simulations are, and why they are used.
- Know the features of the Reactor toolbar.
- Know when and why to use the different Reactor collections.
- Set up and run a sample Rigid Body simulation.
- Run a Cloth simulation and update **3ds max** to show the new cloth shape.

Introduction

A dynamic simulation allows you to enter data for objects in your scene, set up initial motions if necessary, and add space warps. The program then determines how the objects move and are shaped. A simple example is when you want an object to crash into other objects in your scene. Rather than having to keyframe all the animation by hand, which takes many hours to make it look right, you can make a dynamic simulation that handles the collisions and reactions for you.

Other examples of possible dynamic simulations include cloth, a light hanging on a chain, a hanging sign, a falling body, and water.

3ds max has a built-in dynamics tool called Reactor, which allows animators to simulate dynamic interactions in their scenes.

Using Reactor

Once you have created objects in **3ds max**, you can assign physical properties to them with **Reactor**. These properties include characteristics such as mass, friction, and elasticity. By assigning characteristics to objects, you can model real-world scenarios quickly and easily. These scenarios can then be simulated to produce physically accurate animations.

After you set up your **Reactor** simulation, you can preview it quickly using a real-time display window. This feature allows you to test and play with a simulation interactively.

As was mentioned before, **Reactor** frees you from having to animate difficult effects by hand, such as exploding objects or curtains. **Reactor** also supports standard **3ds max** features such as keyframes and skinning, so you can use both conventional and dynamic animation in the same scene.

Reactor deals with two types of objects: Rigid Bodies and Deformable Bodies.

Rigid Bodies —Refers to objects that do not change shape. They are used most often in a simulation. **Reactor** simulates most rigid bodies quickly and efficiently, making it easy to preview the simulation in real time.

Deformable Bodies —Refers to objects such as cloth, rope, and hair, which change shape over time. Collisions with deformable objects are more difficult to detect than objects with rigid bodies. Furthermore, the objects can change shape dramatically over time, slowing a simulation down considerably. For this reason it is important to keep the number of deformable bodies in a scene to a minimum.

For deformable bodies to work, **Reactor** requires you to add a modifier to your object, setting up how your object will deform. The modifiers are named *reactor Cloth*, *reactor Rope*, and *reactor SoftBody*.

When you are ready to use **Reactor**, you want to organize your objects into collections based on the type of object you want them to be: rigid body, cloth, soft body, rope, or

deformable mesh. Next, you set up any necessary global parameters, and then let **Reactor** take over. **Reactor** handles all the interactions among objects for you.

When you are happy with the simulation, you turn it into a keyframed **3ds max** animation that can then be further adjusted, rendered to still images, or rendered to an animation.

Reactor Sample

In the following example, you open a sample scene with a Reactor simulation and examine it.

1. Start **3ds max**.

2. On the menu bar, choose File > Open and open *Ch24_Reactor_Sample.max* from the courseware CD.

3. In the Front viewport, choose the RBCollection object.

4. On the command panels, choose Modify.

5. In the RB Collection Properties rollout, verify that the Bowl, Connector, and all six Balls are in the collection.

- RB Collection Properties	
Rigid Bodies	highlight

Bowl
Connector
Ball 1
Ball 2
Ball 3
Ball 4
Ball 5
Ball 6

Pick	Add	Delete

☐ Disabled

6. In the Front viewport, choose the RB Collection object.

7. In the Properties rollout, verify that the Top Rope and all four Side Ropes are in the collection.

- Properties	
Rope Entities	highlight

Top Rope
Side Rope 2
Side Rope 3
Side Rope 4
Side Rope 1

Pick	Add	Delete

☐ Disabled

8. Scrub the time slider to verify that there is no animation in the scene.

9. On the **Reactor** toolbar, choose Preview Animation.

10. Press **P** to watch the simulation.

The balls roll and don't intersect because certain properties have been applied to all objects in the scene. Next, you learn about the various reactor tools and then set up your own simulation.

11. Press Esc to close the window.

Reactor Tools

In this section, you go over various **Reactor** features in **3ds max**, and then make a sample dynamic simulation.

Reactor Toolbar

3ds max includes a Reactor Toolbar docked to the left of the viewports. The toolbar includes most features needed to use Reactor, divided into six groups.

The first group is the five different collections you can create:

- Rigid Body
- Cloth
- Soft Body
- Rope Collection
- Deforming Mesh Collection

The reason they are called collections is because they hold a list of the objects in a scene that Reactor will simulate. For example, the Rigid Body Collection contains a list of all the objects that are simulated as rigid bodies in the scene. When you add a collection to your scene, you create an object that shows in the viewports, but is not rendered.

The Rigid Body, Cloth, Soft Body, and Rope collections are straightforward. The Deforming Mesh Collection is a little different. It is a collection allowing you to add objects to a simulation that deform, such as a character using the Skin modifier. The simulation does not affect the deforming mesh but the mesh does affect other objects. This allows you to have a character interact with a simulation; for instance, you can simulate clothing, or have a character knock over a display of soup cans in a store. You can also add deformable bodies to a Deforming Mesh Collection to get secondary motion.

When a collection is created, all selected objects in the scene are added automatically to the collection's list. When a collection is selected, you can use the Modify panel to add and remove objects from its list.

The second group of buttons are effects you can use to enhance your simulation. These effects include adding a Plane, Spring, Linear Dashpot, Angular Dashpot, Motor, Wind, Toy Car, and Fracture. You can also add a Water simulator.

The most useful effect from this list is Wind, which allows you ad add various wind effects to your simulation.

Note: This is not the same as the Wind space warp. Only **Reactor** wind works with **Reactor** simulations, while the Wind space warp only affects **3ds max** objects.

The other options are useful for various special effects in your simulations.

The third group holds seven constraints. Constraints are special objects that help control how attached objects react in a simulation. For example, the Rag Doll Constraint can be used to make a character flop around like a rag doll (by simulating a ball and socket joint), and the Hinge Constraint causes an object to react and swing as if it were connected by a hinge. The seven constraints are:

- Constraint Solver
- Rag
- Hinge
- Point-Point
- Prismatic
- Car-Wheel

• Point-Path

The fourth group has three buttons for adding the Cloth, Soft Body, and Rope modifiers to selected objects.

The fifth group is a button to open the Property Editor. It allows you to edit how objects act in the simulation.

The last group has three buttons:

- Analyze World -- Checks your scene for any problems that might cause undesirable effects in the simulation and lists them for you.

- Preview Animation -- Allows you to watch a simple preview of how the simulation progresses.

- Create Animation -- Creates keyframes for all objects in the simulation so it can be rendered or used with other effects.

Property Editor

Selecting the Open Property Editor button opens the Property Editor dialog. This dialog contains several parameters you can adjust to control how the selected objects react as a rigid body.

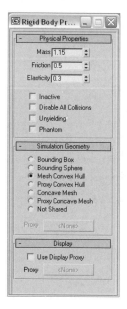

You can set the physical properties such as Mass, Friction, and Elasticity, as well as making it inactive, disabling all collisions, making it unyielding, or making it a phantom. You can also set the geometry it uses for the simulation. The simpler the geometry, the quicker the simulation. The selections get more complex the lower they are in the list; however a proxy allows you to use a different object to determine the surface used in the simulation. Proxies are often a low-poly or optimized version of the mesh. Lastly, you can choose to display the object with a proxy if it is slowing down the preview.

Preview Animation

The Preview Animation button opens the **Reactor** Preview window. This window allows you to preview your simulation in simple shaded mode to see if it is working as expected.

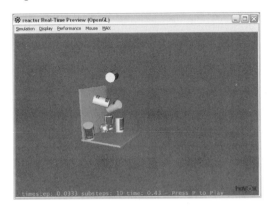

When the window is active, pressing **P** plays the animation, and pauses it if it is playing. Pressing **R** resets the animation. The left mouse button rotates the scene, while dragging the middle mouse button pans the scene. Rolling the middle mouse button zooms in and out.

When you are finished, press Esc to close the window, or choose X in the upper-right corner.

Reactor Utility

Reactor also has its own utility, available on the Utility panel, accessed by selecting the reactor button. Although you can set up most of **Reactor**'s features using the toolbar, there are several that you need the utility to set up. These include animation start/end and

several global values for controlling the world, collisions, and display. It also contains a Properties rollout that lets you set the same information as the Property Editor.

The Preview & Animation rollout is where you can set the start and end times of your simulation. Notice that Reactor defaults to starting on frame **0** and ending on frame **100**. If you make your animation longer, you will have to change the end time of the simulation.

The World, Collision, and Display rollouts let you control several global effects, such as the strength of gravity, collision storage, and the texture quality and camera to use in the preview window.

The Utils rollout has several key management buttons. You use these after you have selected Create Animation. You can reduce the number of keys on selected objects to simplify them for further animation, or remove all the keys.

Making a Simulation

Now that you have an idea of what goes into dynamic simulations, you open a scene and set up a Reactor simulation using a Rigid Body Collection.

1. Start **3ds max**.

2. On the menu bar, choose File > Open and open *Ch24_Rigid_Body_Collection.max* from the courseware CD.

This scene contains a ball, a pyramid of six cans, two flat boxes, and a camera.

3. Scrub the time slider to see that the ball has some initial animation from frames **0** to **2**.

4. Return the time slider to frame **0**.

5. Select all the items in the scene except the camera and its target.

6. On the **Reactor** toolbar, choose Create Rigid Body Collection.

This creates an RBCollection object in your scene. Notice on the Modify panel that all the selected objects are added to the collection. You can add or remove objects from the list.

RB Collection Properties

Rigid Bodies	highlight
Box01	
Box02	
Can01	
Can02	
Can03	
Can04	
Can05	
Can06	
GeoSphere01	

Pick	Add	Delete

☐ Disabled

7. In the Top viewport, choose the ball.

8. On the **Reactor** toolbar, choose Open Property Editor.

9. In the Physical Properties rollout, set Mass to **1.15** and Friction to **0.5**.

Rigid Body Pr...

Physical Properties

Mass 1.15
Friction 0.5
Elasticity 0.3

The friction keeps the ball rolling as it moves across objects.

10. In the Front viewport, choose all six cans.

11. In the Physical Properties rollout, set their Mass to **0.7** and Elasticity to **0.85**.

Rigid Body Pr...

Physical Properties

Mass 0.7
Friction 0.3
Elasticity 0.85

Note: Notice you do not set any values for the two boxes. Keeping their masses at **0** causes them to be treated as immovable objects.

12. On the Command Panels, choose Utilities.

13. In the Utilities rollout, choose reactor.

14. Open the Preview & Animation rollout and make sure the Start Frame is set to **1**.

This causes Reactor to use the ball's initial motion in the simulation. Otherwise the ball would just fall straight down due to gravity.

15. On the **Reactor** toolbar, choose Preview Animation.

16. In the review window opens, press **P** to watch the simulation.

17. Close the preview window.

18. Scrub the time slider.

Notice your scene remains unchanged.

19. On the menu bar, choose Edit > Hold. This allows you to keep the current settings in a buffer. So, you can return to any changes you make after the Hold by choosing Edit > Fetch.

20. On the **Reactor** toolbar, choose Create Animation. When the warning displays, choose OK.

21. When the keyframes have been created, scrub the time slider to see the simulation.

The cans start moving prior to the ball hitting it.

22. On the menu bar, choose Edit > Fetch.

23. In the Front viewport, choose the six cans.

24. Make sure the Property Editor is open.

25. In the Physical Properties rollout, turn on Inactive.

This means it requires interaction with another object, system, or the mouse, before it becomes active in the simulation.

26. On the **Reactor** toolbar, choose Create Animation. When the warning displays, choose OK.

27. Scrub the time slider.

The cans do not move.

The scene can now be further enhanced or rendered to an AVI file.

Update MAX

You might have noticed that the **Reactor** Preview window has its own menu bar. The menus allow you to play and reset your simulation, change how the simulation is displayed, and change the preview performance. You can also find out about the mouse commands and share information with **3ds max**.

Simulation Display Performance Mouse MAX

Perhaps the most useful menu item is Update MAX in the MAX menu. When you select Update MAX, your **3ds max** scene is changed to reflect the state of your scene in the preview window. This only works with objects that are used in the simulation, so other objects in your scene are unaffected. This is useful when you want to simulate the look of cloth in your scene without having to model it by hand. You can also use it to get a good starting point for cloth in a simulation.

Note: When you choose Update MAX, you have to close the preview window to see the change in the viewports.

In the following exercise, you start with a table and create a plane object to act as a tablecloth. You then run a Reactor Preview to make the tablecloth look real.

1. Start **3ds max**.
2. On the menu bar, choose File > Open and open *Ch24_Table.max* from the courseware CD.

3. In the Top viewport, create a Plane with Length = **76**, Width = **112**, Length Segs = **20**, and Width Segs = **30**.

4. In the Name and Color rollout, type Tablecloth.

5. In the Front viewport, move the tablecloth up about **50** units.

6. On the **Reactor** toolbar, choose Apply Cloth Modifier to add a reactor Cloth modifier to the stack.

7. On the **Reactor** toolbar, choose Create Cloth Collection.

A CLCollection is added to the scene, with the Tablecloth in its list.

8. Select the table and its legs.

9. On the **Reactor** toolbar, choose Create Rigid Body Collection.

10. On the **Reactor** toolbar, choose Preview Animation.

11. In the Preview window, press **P** to watch the simulation.

12. Press **P** again to pause the simulation when you like the look of the tablecloth.

Note: If you miss the frame you wanted, you can press **R** to reset the simulation, and then press **P** to start over.

13. On the preview window menu bar, choose MAX > Update MAX.

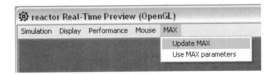

14. Close the window and your tablecloth is draped on the table properly.

Conclusion

In this chapter, you learned about dynamic simulations and how they are created in **3ds max**. You learned the basics about how to use **Reactor** by creating your own rigid body simulation and by making a tablecloth using a cloth simulation. If you wish to learn more about using **Reactor**, the **3ds max** Help Guide is an excellent place to start.

```
7  7  9        7
3  9  10       7
3  5  5        5
10 3  5        6
10 3 10       10
5  9  5        5
9  7  5        7
10 10 5       10
10 9  5        7
10 9 10       10
              74
```

Brkrun b.JPG

area

11" 10' 12 x 11

10' 11' and

8' 1" tall keep

 an

 B

blanket / cloth ps. 712

Effects

Objectives

After completing this chapter, you should be able to:

- Use a standard particle system to make a simple effect, such as snow.
- Make an object explode into pieces.
- Understand why and when to use Particle Flow.
- Use Particle Flow's Operators and Tests.
- Use Space Warps, Forces, and Deflectors with Particle Flow.
- Make a working Particle Flow System.

Introduction

When people talk about creating effects in **3ds max**, most likely they are talking about using a particle system. Particle systems are best suited for making effects that require a large number of objects. However it can be difficult to determine which effects look good with a particle system. Particle systems are excellent for simulating effects such as rain,

snow, fountains, waterfalls, splashes, dust, fire, smoke, explosions, fireworks, clouds, tornadoes, missiles, bombs, and anything else that requires a large number of objects. Particle systems can even be used to generate an initial layout for leaves in a tree.

Particle systems are a specialized form of object in **3ds max** used to create a large number of small objects. When you add a particle system to a scene, an object is added to the scene to show where the particles first appear. This object is called the emitter because it emits the particles. Some particles can be set to use another object in your scene as an emitter. In this case, the original emitter object remains in your scene to let you know you have a particle system and give you access to its parameters.

Generally, the particles themselves cannot be selected, and are uneditable except by changing the parameters through the emitter object.

3ds max's particle systems are divided into two groups: Standard Particles and Particle Flow. Particle Flow can achieve most of the same effects as the standard particles, but the standard particles are considered easier to use. It is important to have a basic understanding of how particle systems work before jumping into Particle Flow.

To find the particle systems, go to the Create panel and choose the Geometry button. Choose Particle Systems from the drop-down list. All seven particle systems are mentioned in the Object Type rollout.

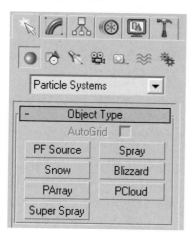

Basic Particles

In this section, you explore the standard particle systems in **3ds max** and add snow to a scene to see how they are used.

The standard particle systems are: Spray, Super Spray, Snow, Blizzard, PArray, and PCloud. Each has its own use, and is geared towards a specific type of effect.

Spray —Simulates water drops such as rain, a fountain, and water from a hose.

Super Spray —Emits a controlled spray of particles. It is a more powerful version of Spray. It has the same functionality as Spray, plus additional features.

Snow —Simulates falling snow or confetti. It is similar to Spray, but has additional parameters to make its particles tumble as they fall.

Blizzard —Simulates a more powerful effect than Snow. It has the same functionality as Snow, plus additional features.

PArray —Creates two types of particle effects. It can use a second object as an emitter for particles, and it can be used to make objects explode. Other than that, it has parameters similar to Super Spray.

PCloud —Fills a specified volume with a *cloud* of particles. This is useful for making a school of fish, flock of birds, or a star field. Particles can travel outside the volume, but then the volume effect is diminished.

Emitters

The emitter objects for Spray, Snow, and Blizzard look the same: they are all a rectangle with a line pointing down to show where the particles go. After creating the emitter, you can move and rotate it, and change its dimensions on the Modify Panel. The Super Spray emitter is different; it is circular and has an arrow pointing up. This orientation is ideal for making a fountain or fire. As with the other emitters, you can move and rotate it, and change its radius on the Modify Panel.

The emitters for Particle Array and Particle Cloud are different. The Particle Array emitter is a cube with three pyramids inside. The emitter has no arrows on it because it does not emit particles. Instead, you must pick an object in the scene to emit the particles. Particle Cloud has a special emitter. Initially, it is a block-shaped volume, with a C

inside. The emitter can be set to a sphere or a cylinder, or it can use another object in the scene. All its particles are generated within this volume.

After creating a Particle System, you can access its parameters on the Modify panel by selecting the emitter. Spray and Snow have a similar small set of parameters. The other particle systems also have similar parameters, but the list is divided into eight rollouts (seven for Blizzard).

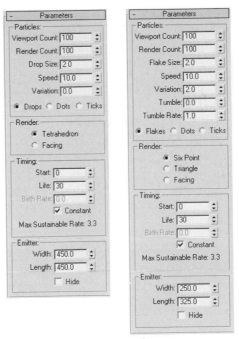

Spray and Snow's parameters.

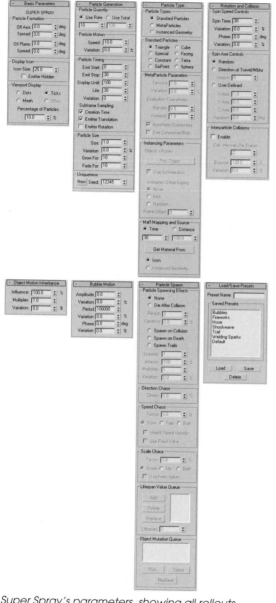

Super Spray's parameters, showing all rollouts.

Snow's Parameters

Snow's parameters are divided into four groups: Particles, Render, Timing, and Emitter.

In this section, you explore Snow's various parameters to get a basic understanding of how a particle system works.

The Particles group contains parameters that control the particles themselves. Viewport Count determines how many particles can exist at any given time in the viewports. Render Count does the same thing, but determines how many particles are in a render. Flake Size is the size of the particles, while Speed is how fast they move. Variation is how much the speed varies between particles. For example, with a Speed of **10** and a Variation of **2**, particles have a chosen random speed between **8** and **12**.

Tumble causes the snow particles to randomly rotate as they fall. The value ranges from **0** to **1**. Tumble Rate is how fast the particles tumble. The higher the rate, the faster they rotate.

Flakes, Dots, and Ticks determine how the particles are shown in the viewports. Flakes look like snowflakes, dots are points, and ticks are small plus signs.

Render:
- ● Six Point
- ○ Triangle
- ○ Facing

The Render group determines the look of the rendered particles. Six Point are six-pointed stars that look like snowflakes. They have one face on each side, so you can apply a material with Face Map to make the particles more realistic. Triangles are small triangles that only have a face on one side. Facing particles are squares that always face the Camera or Perspective viewport. Facing particles are meant to be face mapped with an opacity map to hide the squares' edges. They are perfect for many different special effects.

Timing:
Start: 0
Life: 30
Birth Rate: 0.0
☑ Constant
Max Sustainable Rate: 3.3

The Timing group gives you control over the particles' lives. Start is when the particles are born, and Life is how long they live. Birth Rate is how many particles are born per

frame. Timing is disabled if Constant is on. When Constant is on, the maximum birth rate is sustained, based on the life span and the particle count from the first group

Emitter:
Width: 250.0
Length: 325.0
☐ Hide

The Emitter group allows you to change the Width and Length of the emitter. It also has a check box to hide it.

Making Snow

Now that you have some general knowledge about particles, and Snow in particular, you open a scene and add snow.

1. Start **3ds max**.

2. On the menu bar, choose File > Open and open *Ch25_Snow_1.max* from the courseware CD.

3. Right-click to activate the Camera viewport.

4. On the main toolbar, choose Quick Render.

 The Scene renders without Snow.

5. Close the Rendered Frame Window.

6. On the Create panel, make sure Geometry is chosen, and then choose Particle Systems from the drop-down list.

7. In the Object Type rollout, choose Snow.

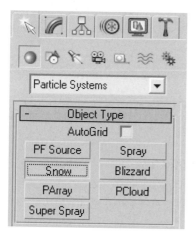

8. In the Top viewport, create a snow emitter over the snowman.

9. In the Front viewport, move the emitter up about **400** units.

10. On the Modify panel > Particles group, set: Viewport Count = **400**, Render Count = **1500**, Flake Size = **4**, Speed = **5**, Variation =

3.57, Tumble = **0.44,** and Tumble Rate = **1.98**.

Scrub the time slider. You are able to see up to **400** particles at one time in the viewports, but there are **1500** when you render. You do this so **3ds max** won't slow down when you move the time slider.

11. In the Render group, keep Six Point selected.

12. In the Timing group, set Start = **-150** and Life = **150**.

When you set Start to **-150**, snow is displayed Setting the Start time to the

negative of the life ensures hat the particles fill the scene at frame **0**.

13. In the Emitter group, set Width = **700** and Length = **700**.

14. Scrub the time slider or play the animation in the Camera viewport to see the snow fall.

You can also render an image to see how the scene looks with the snow. You might want to make a material for the snow, or use the one in the Material Editor.

Wind Space Warp

Space warps may be added to a particle system to make it more realistic. Space warps can simulate wind, water and gravity, cause particles to stop, bounce, or explode, and much more **3ds max** has many space warps available. To find them, choose the Create panel and then select the Space Warps button.

In the drop-down list you can choose among Forces, Deflectors, Geometric/Deformable, Modifier-Based, Particles & Dynamics, and **reactor**.

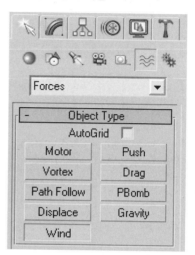

There are one to nine space warps under each menu selection. In the following example, you use the Wind space warp, located under Forces. You look at more space warps later in this chapter.

Adding a space warp to a scene doesn't automatically make it affect the standard particles or other geometry. After adding a space warp, you must use the Bind to Space Warp option located on the main toolbar to make the warp affect the particles. This tool works like the Select and Link tool, except that after binding, the particles have a modifier added to the Modifier Stack to alert you to the space warp binding.

1. Continue from the previous exercise, or on the menu bar, choose File > Open and open *Ch25_Snow_2.max* from the courseware CD.

2. On the Create panel, choose Space Warps.

3. In the Object type rollout, choose Wind.

4. In the Left viewport, create a Wind space warp anywhere in the scene.

Notice that you created a square with an arrow pointing out of it. This is the wind direction.

5. On the main toolbar, choose Bind to Space Warp.

6. In the Left viewport, click and drag from the Wind to any Snow particle.

7. Scrub or watch the animation in the Camera viewport.

The Wind is too strong.

8. Make sure the Wind space warp is still selected.On the Modify panel, set Strength = **0.3**, Turbulence = **5**, and Frequency = **2**.

![Parameters panel]

9. Select the Snow emitter.

10.On the main toolbar, choose Select and Move.

11.In the Top viewport, move it to the right (about **220** units) until the snow fills the Camera viewport.

12.Scrub or watch the animation in the Camera viewport.

Exploding Objects

To make an object explode requires several steps. First, add a Particle Array and set it to be fragments of the object. The fragments can be set to fly out, away from the original object, but this effect looks commonplace. Instead, in the second step, add some space warps to control the fragments. You then finish with some animation and put the material on the particles.

1. Start **3ds max**.

2. On the menu bar, choose File > Open and open *Ch25_Explode_1.max* from the courseware CD.

3. On the Create panel, choose Geometry > Particle Systems > PArray.

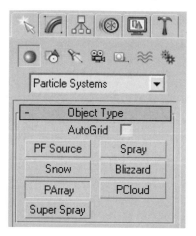

4. In the Top viewport, create a PArray anywhere.

5. On the Modify panel do the following:

 In the Basic Parameters rollout, choose Pick Object and then choose the Barn. In the Viewport Display group, choose Mesh.

 In the Particle Generation rollout, set Speed = **0**, Emit Start = **60**, Display Until = **180**, and Life = **180**.

 In the Particle Type rollout, choose Object Fragments. Set Thickness = **6.** Choose Number of Chunks, and then set Minimum = **250**. In the Mat'l Mapping and Source group, choose Picked Emitter.

In the Rotation and Collision rollout, set Spin Time = **100** and Variation = **60**.

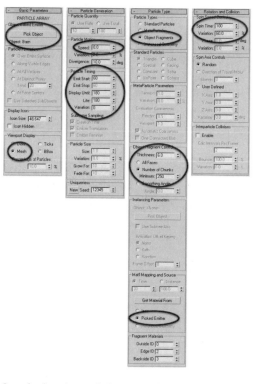

6. Scrub the time slider past frame **60**.

You see that the particles appear when they should, but they're not doing what

you want them to. They are just rotating on the surface of the barn. Next, you set up the space warps to make them behave correctly.

Adding Space Warps

After setting up the Particle Array, you add space warps to your scene to control how the particles act during the explosion. In this example, you add a Particle Bomb, Gravity, and a Deflector.

The Particle Bomb, or PBomb, causes the particles to explode outward. The Gravity space warp pulls the particles back down. The Deflector acts as the ground so the particles bounce and come to rest.

1. Continue from the previous exercise, or choose File > Open and open *Ch25_Explode_2.max* from the courseware CD.

2. Make sure the time slider is set to **0**.

3. On the Create panel, choose Space Warps > Forces > PBomb.

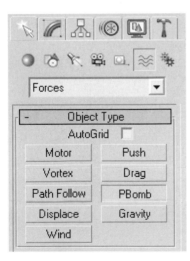

4. In the Top viewport, create a PBomb at the center of the Barn.

5. In the Front viewport, move the bomb down so it is about one barn height below the Barn.

6. On the Modify panel > Basic Parameters rollout, make sure Spherical is selected. Set Chaos = **20**, Start Time = **60**, and Strength = **3**.

7. Scrub the time slider.

 The PBomb doesn't affect the barn because you have not used Bind to Space Warp.

8. On the main toolbar, choose Bind to Space Warp.

9. In the Front viewport, click and drag from the PBomb onto the PArray.

10. Scrub the time slider.

 The PBomb now affects the barn.

11. On the main toolbar, choose Select and Move.

12. Make sure you are at frame 0.

13. On the Create panel, choose Space Warps > Forces > Gravity.

14. In the Top viewport, create a Gravity space warp.

 The size and location is irrelevant.

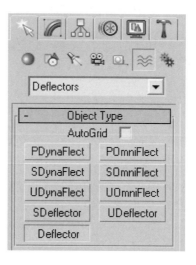

15. On the Create panel, choose Space Warps > Deflectors > Deflector.

16. In the Top viewport, create a large Deflector centered on the Barn.

17. In the Front viewport, move the deflector down so it is at the ground level of the Barn.

18. On the Modify panel, set Bounce = **0.6**, Variation = **50**, Chaos = **33**, Friction = **66**, Width = **1200**, and Length = **1200**.

Parameters
Bounce: 0.6
Variation: 50.0 %
Chaos: 33.0 %
Friction: 66.0 %
Inherit Vel: 1.0
Width: 1200.0
Length: 1200.0

19. On the Main Toolbar, choose Bind to Space Warp.

20. Click and drag from the Deflector to the PArray emitter to bind them. Repeat for the Gravity.

21. Select the PArray emitter and then check the Modify panel.

PArray01
Modifier List
Deflector Binding (WSM)
Gravity Binding (WSM)
PBombBinding (WSM)
PArray

22. Scrub the time slider to watch the Barn explode.

Your exploding barn is set up. In the next section, you add some finishing touches.

Finishing the Explosion

To finish the barn explosion, you need to:

- Animate the original Barn's visibility so it disappears when the particles appear.

- Animate the particles' rotation so they slow down after hitting the ground.

- Give the particles the same material as the Barn.

1. Continue from the previous exercise, or choose File > Open and open *Ch25_Explode_3.max* from the courseware CD.

2. Auto Key Turn on Auto Key.

3. Move the time slider to the frame **60**.

4. Select the Barn.

5. Right-click and then choose Properties from the quad menu.

6. In the Object Properties dialog > Rendering Control group, set Visibility = **0.0**. Click OK.

7. Move the time slider to frame **59**.

8. Right-click and then choose Properties from the quad menu again.

9. Set Visibility = **1.0** and then click OK.

The Barn disappears when the particle system starts and explodes. The barn is still visible as a ghost in the viewports, but it does not render.

10. Select the PArray.

11. On the Modify panel > Modify Stack display, choose PArray.

12. Move the time slider to frame **95**.

13. On the Modify Panel > Rotation and Collision rollout, set Spin Time = **101**.

14. Move the time slider to frame **125**.

15. Set Spin Time = **1000**.

16. Move the time slider to frame **165**.

17.Set Spin Time = **10000**.

This sets the spin so the fragments spin quickly at first, and then slow down to barely moving after they land on the ground.

18. Turn off Auto Key.

The final step in making the barn explode is to assign the Barn material to it.

19. Press **M** to open the Material Editor.

20.Select an empty material slot.

21.Next to the material name, choose Pick Material from Object.

22.Press **H** and choose the Barn from the list.

23.Click and drag this material onto the PArray.

24.Scrub the time slider to watch the explosion.

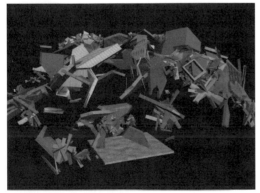

The explosion is finished.

Particle Flow

Particle Flow is an event-driven particle system that offers a high degree of control over the behavior of particles. Basically, you write a small program that controls the particles over their life spans. In the program, you can specify the particles' appearance, motion, speed, rotation, size, and more. You can also test for certain changes in particles states, and then give them a new list of parameters.

To understand how it works, look at how particles are controlled. First, particles are born. When a particle is born, you give it a list of how it should look and act. The particle then continues to look and act this way as long as it can. You then set up tests; for example, if a particle hits a certain deflector. If the particle passes the test, you can then give it a new list of how you want it to look and act. You can continue to test the particles, and they act the way you tell them to until they are removed, or the animation ends.

The set of rules that define an object's behavior are called flows. Each flow can be segmented into several events. And each event holds a list of how you want the particles to act while they are in the event. Events can be segmented into actions: initial flows, operators, and tests.

There is one special event called the global event. This is the first event in a flow, and often simply holds the rendering parameters for the particle system. You can also add operators to this event, and they are valid for

all events in the flow. When an operator appears in a global event, it overrides all versions of the same operator in the flow's events.

Note: You can add tests here, but they won't do anything because particles have not been born yet.

While in a global event, operators specify the particles' characteristics and tests allow you to check the particles against various parameters. If the particles pass the test, they are sent to another event.

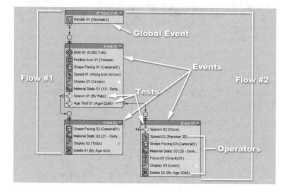

The Particle Flow emitter, called a PF Source, can be found on the Create panel with the other Particle Systems. It is the first button in the Object Type rollout. You create it in the viewports the same way you created the other particle systems.

After creating a PF Source, on the Create panel > Setup rollout, click the Particle View button. After creation, you can open Particle View on the Modify panel, or open it by typing 6.

The Particle View window is the editing tool for your flows and events. It is divided into four regions. The work area is the largest, which shows the flows and events. Inside each event you see the list of operators and tests. To the right of the work area is the options area. Options for the selected action are shown in this area. Below the work area is the depot. The depot stores all actions. Actions can be selected and dragged into

events, or into an empty area to start a new event. The fourth area is the description panel, which shows an explanation of the selected action.

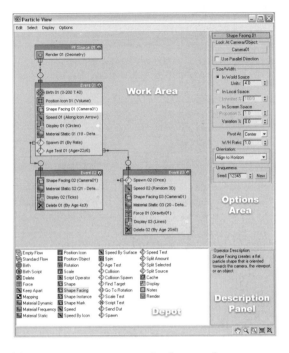

You set up your events in the work area, while the operator and test parameters are available in the options area. To wire or connect the results of a test to another event, click and drag from the blue knob at the end of the test to the circle at the top of the event.

Flows, Operators, and Tests

Actions are the core of using Particle Flow, for its flows, operators, and tests. Once you understand how they work, it is easy to make complex particle systems.

All operators and tests are located in the Particle Flow depot, where they are divided into four groups: flows, operators, tests, and utility operators. They are in alphabetical order in each group.

Flows

There are two flows in the depot. The flows are included so you can start new particle systems while in the Particle View window.

Empty Flow —Allows you to add a starting point for a particle system. Empty Flow consists of a single global event containing a Render operator. It lets you build a system completely from scratch. Adding an Empty Flow also creates a PF Source at the world origin.

Standard Flow —Provides a starting point for a particle system. Standard Flow consists of a global event containing a Render operator wired to an event. Events contain a Birth, Position, Speed, Rotation, Shape, and Display operator, with all parameters set to

default values. This is the same system you get when you create a PF Source in a scene. Adding a Standard Flow also creates a PF Source icon at the world origin.

Operators

The operator is the basic element of a particle system. You combine operators in events to specify the particles' characteristics over a given period of time. Operators let you describe particle speed, direction, shape, appearance, and more.

Each operator has a blue background, except for Birth operators, which are green.

Birth —Enables creation of particles using a set of simple parameters.

Birth Script —Enables creation of particles using MAXScript.

Delete —Removes particles from the particle system. You can set them to be removed at a certain age.

Force —Allows you to influence particles with space warps from the Forces category.

Keep Apart —Minimizes collisions between particles.

Mapping —Lets you assign UVW mapping coordinates to the entire surface of the particles.

Material Dynamic —Allows you to apply a material and change the particles' material IDs during the event. Also allows you to assign different materials based on each particle's material ID.

Material Frequency —Allows you to apply a material and specify the relative frequency of sub-materials on the particles.

Material Static —Lets you give particles material IDs that remain constant throughout the event.

Position Icon —Allows you to control the particles as they are emitted from the emitter.

Position Object —Lets you choose an object in your scene as the emitter and allows control over them.

Rotation —Lets you set and animate particle orientation during an event, with optional random variation.

Scale —Lets you set and animate particle size during an event, with optional random variation.

Script Operator —Enables control of particles using MAXScript.

Shape —Is the default operator for defining the geometry in the particle system. You can use it to specify particles in the shape of pyramids, cubes, spheres, or vertices, as well as particle size.

Shape Facing —Creates each particle as a rectangle that always faces a particular object, camera, or direction. This is perfect for effects like smoke, fire, water, bubbles, or snowflakes, along with a material containing appropriate opacity and diffuse maps.

Shape Instance —Lets you use any object in the scene for the particles' shape.

Shape Mark —Replaces each particle with either a rectangle or a box with an image mapped onto it. It is normally used to leave marks on an object after particles hit it in the scene.

Speed —Provides basic controls over particle speed and direction.

Speed by Icon —Lets you use a special, non-rendering icon to control particle speed and direction.

Speed by Surface —Allows you to control particle speed and direction with any object(s) in the scene. It also provides options for controlling speed using materials. Typically, you assign speed and direction characteristics based on the same objects used as emitters with the Position Object operator.

Spin —Gives an angular velocity to particles in an event, with optional random variation.

Tests

In Particle Flow, tests determine whether particles satisfy one or more conditions, and if so, make them available for sending to another event. In the new event, you can have a new set of operators controlling the particles. You can have multiple tests in an event. The first test checks all particles in the event, and each subsequent test checks particles that remain in the event only.

To send eligible particles to another event, you must wire the test to that event. Particles that don't pass the test remain in the event and are repeatedly subjected to its operators and tests. If the test isn't wired to another event, all particles remain in the event.

Tip: Always place a test at the end of its event unless you have specific reasons for placing it elsewhere. This way, all preceding actions can take effect during each integration step, before the test is evaluated.

All test icons have a yellow diamond background with a simplified diagram of an electrical switch, except for the Switch test, which has an **S**.

Age —Checks whether a specific amount of time has passed since the start of the animation, how long a particle has existed, or how long a particle has been in the current event, and branches accordingly.

Collision —Tests for particles that collide with specified Deflector space warps. It can also test whether a particle slows or speeds after collision(s), has collided more than once, and even if it will collide soon.

Collision Spawn —Creates new particles from existing ones that collide with one or more Deflector space warps.

Find Target —Sends particles to a specified target(s), where they become eligible for redirection to another event.

Go to Rotation —Enables a smooth transition in the rotation of a particle so the particle rotates to a specific orientation over a specific period. An example is falling leaves, which spin chaotically as they fall, but land on a flat side rather than an edge.

Scale —Checks particle scaling, or particle size before or after scaling, and branches accordingly. For example, a bubble grows to a certain size, and then pops.

Script —Lets you test particle conditions using MAXScript.

Send Out —Sends all particles to the next event without conditions.

Spawn —Creates new particles from existing ones. The spawned particles can be sent to a new event.

Speed —Checks particle speed, acceleration, or rate of circular travel, and branches accordingly.

Split Amount —Lets you send a specific number of particles to the next event, keeping all remaining particles in the current event.

Split Selected —Splits the particle stream based on each particles' selection status.

Split Source —Splits the particle stream based on the particles' origin.

Utility Operators

The four utility operators are listed separately because they serve a utility function in Particle Flow events.

Cache —Optimizes particle-system playback. After Cache is added, particle states are stored in memory so scrubbing the time slider shows smooth animation.

Display —Determines how particles appear in the viewports. It includes dots, ticks, circles, and many others. You can also specify the percentage of particles appearing in viewports.

Notes —Used for adding comments.

Render —Specifies render-time characteristics.

Sample Scene

Now you open a **3ds max** file with a working Particle Flow system and examine the scene. The scene is of a helicopter shooting heat seeking missiles at another helicopter. The missiles, smoke trails, and explosions are made with the same particle system.

1. Start **3ds max**.

2. On the menu bar, choose File > Open and open *Ch25_PFlow_Sample.max* from the courseware CD.

When you open the scene, you see two helicopters over a ravine in the Perspective viewport. Two paths are set

up for them to follow during the animation: green for the helicopter in front and purple for the one in back.

3. Scrub the time slider forward to watch the animation in the Perspective viewport. Return to frame **0**.

4. Look at the User viewport.

The User viewport shows the helicopter in back. The PF Source emitter is aligned to the helicopter.

5. Look in the Front viewport. Notice the front helicopter has a pyramid over it:

This is a Bomb space warp icon. The Bomb space warp is a simpler version of the PBomb that works with geometry instead of particles. It makes the object explode into faces with no thickness.

6. Select the Bomb icon called MeshBomb01.

7. On the Modify panel you can see that the helicopter detonates at frame **150**.

8. Still in the Front viewport, select the front helicopter more than once.

 There are two helicopters here. One is invisible, and the other has the Bomb binding.

9. In the User viewport, select the PF Source emitter.

10. On the Modify panel, choose Particle View, or press **6**.

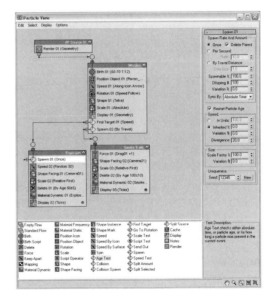

There are four events in Particle View: Global Event, Missiles, Explosion, and Smoke Trails. Look at each of these to see what they do.

11. In Particle View, choose the light bulbs next to Explosion and Smoke Trails to turn off the events.

12. Scrub the time slider to watch the missiles only. Notice the missiles are set to appear between frames **50** and **70**.

13. In the Missiles event, select Position Object 01.

In the options area, the particles are set to use the Raven_chopper as an emitter object. Selected Faces is also chosen in the Location group. If you select the back helicopter and look in Polygon mode, you see only the four polygons inside the missile launchers are chosen.

The rest of the operators in the Missiles group make elongated Tetrahedrons for the missiles, set their speed, and have them point in the direction they are traveling.

14. Select the Find Target test.

The particles are set to find the target named Huey_invisible. When they find it, they are sent to the event named Explosion.

15. Choose the light bulb next to Explosion to turn it on.

16. Scrub the time slider to watch the missiles and the explosion.

17. In the Explosion event, choose Spawn 01.

The missiles are set to spawn 100 particles and then disappear.

The rest of the operators set the particles to move randomly, get larger as they spread out, and die when they are 45 to 55 frames old. The particles are squares that always face the camera and they use a dynamic material named Explosion.

18. In the Missiles event, select Spawn 02.

The missiles are set to spawn two particles for each unit of distance travelled. These particles move at only 5 to 15 per-cent of the missiles' speed, and are sent to the Smoke Trails event.

19. Choose the light bulb next to Smoke Trails.

The smoke particles are also squares that always face the camera. They use a dynamic material named Smoke Trails. The other three operators set them to grow with time, be affected by Drag and Wind space warps, and die when they are 90 to 110 frames old.

Space Warps, Forces, and Deflectors

You have already looked at the Wind, PBomb, and Gravity space warps. In this section, you learn the other space warps and how to add them to a Particle Flow system.

As mentioned previously, the space warps are located on the Create panel by choosing the Space Warps button. Selecting the drop-down list lets you choose among six different categories, each with their own object types.

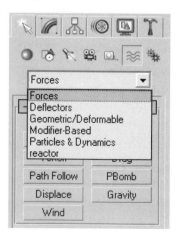

These space warps serve three purposes:

- Affect particle systems;
- Affect geometry globally;
- Affect a **3ds max** dynamic simulation.

Space warps affect objects bound to them with Bind to Space Warp only, while the other objects in the scene don't take them into account.

The exception to this rule is when you are using Particle Flow. In Particle Flow, you set a space warp to affect particles by using the Force operator for Forces, and a Collision test for Deflectors. The Vector Field, under Particles & Dynamics, is also considered a force. The rest of the space warps do not affect the Particle Flow system.

Forces

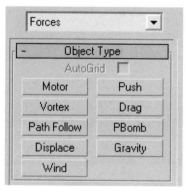

These space warps are used to affect particle and dynamics systems. Forces can be used with particles, and some of them can be used with dynamics.

Motor —Causes particles to rotate about a central axis.

Push —Pushes all particles in one direction.

Vortex —Causes particles to rotate about a central axis and get closer over time. It is useful for making whirlpools and tornados.

Drag —Slows particles down over time.

Path Follow —Makes particles follow a linear path. It does not work with Particle Flow.

PBomb —Blows up a particle system.

Displace —Acts as a force field to push and reshape an object's geometry or a particle system.

Gravity —Simulates gravity. It can be rotated.

Wind —Simulates various wind effects.

Deflectors

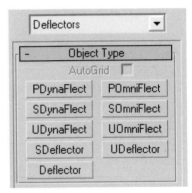

Deflectors are used to detect collisions with other objects. There are three types of deflector: a dynamics deflector, an omniflector, and a standard deflector. They each have three sub-types: **P** for planar, **S** for spherical, and **U** for universal. The universal deflectors allow you to choose an object in the scene as the deflector. The standard planar deflector is used so often that it is listed without the **P** in front of it.

Deflectors affect both particle systems and **3ds max** dynamic simulations.

Deflector, SDeflector, UDeflector —These deflectors simply detect if a collision occurred. You can set them to affect the particles accordingly.

POmniFlect, SOmniFlect, UOmniFlect —The omniflectors are similar to the standard deflectors, with enhanced functionality.

PDynaFlect, SDynaFlect, UDynaFlect —The dynamics deflectors are a special version of the deflector that allows particles to affect objects in a dynamics simulation. The dynamics deflectors do not work with Particle Flow.

Geometric/Deformable

The Geometric/Deformable space warps are included to affect geometry in your scene globally. Any object bound to one of these space warps is affected. You can chose among seven types. The first four are FFD(Box), FFD(Cyl), Wave, and Ripple. They work just like the modifiers with the same name. Use them to affect a large group of objects. Displace is the same space warp that you saw in the Forces category. The last two are Conform and Bomb.

Conform —Modifies its bound object by pushing its vertices in the direction indicated by the space warp icon until they hit a specified target object, or until the vertices move a specified distance from their original position.

Bomb —Causes an object to explode into pieces made from its faces.

Modifier-Based

The Modifier-Based space warps are also included to affect geometry in your scene globally. There are six to choose from: Bend, Noise, Skew, Taper, Twist, Stretch. They work just like the modifiers with the same name. Use them to affect a large group of objects.

Particles & Dynamics

This category gives you access to one space warp named Vector Field. It is considered a force by Particle Flow.

Reactor

This gives you access to a special Water space warp that works specifically with **Reactor** to simulate water realistically. It needs to be bound to an object for the effect to be visible in a render.

Making a Particle Effect

Now that you know about what goes in to a
Particle Flow system, you use that
knowledge to make a fireworks display.

Making the Rockets

1. Start **3ds max**.

2. On the menu bar, choose File > Open and
 open *Ch25_Fireworks_1.max* from the
 courseware CD.

 The scene contains a Camera, and the
 Perspective viewport has been changed to
 a Camera viewport.

3. On the Create panel, choose Geometry >
 Particle Systems > PF Source.

4. In the Top viewport, create a PF Source
 emitter near the origin, with a Length and
 Width of about **10**.

5. In the Setup rollout, choose Particle View.

6. Right-click Event 01's name and choose
 Rename. Rename Event 01 Rockets.

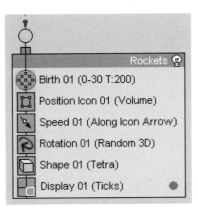

7. Select Birth 01 and set Emit Stop = **200** and
 Amount = **40**.

This sets the event so that 40 particles are
emitted over the 200 frames of the
animation. It amounts to one particle
every five frames.

With the rectangle emitter, and Position
Icon operator set to Volume, these
particles are created at random locations
on the emitter.

8. Select Speed 01 and set Speed = **70**,
 Variation = **12.5**, and Divergence = **35**.
 Turn on Reverse.

–	Speed 01
> | Speed: | 70.0 |
> | Variation: | 12.5 |
> | Direction: | |
> | Along Icon Arrow | ▼ |
> | ☑ Reverse | |
> | Divergence: | 35.0 |
> | Uniqueness: | |
> | Seed: 12345 | New |

The default speed of 300 is too fast for the
rockets. After some experimentation, 70 is
determined to be a good speed. The
Variation ensures that the rockets travel at
different speeds, and with the divergence
they can travel at up to 35 degrees off
vertical. Also, turning on Reverse makes
the particles travel up instead of down (the
direction of the arrow).

9. Select Rotation 01 and press Delete.

10. In the depot, choose Shape Facing.

11. Click and drag over the Shape 01 operator.

 A red line is displayed to let you know you
 are replacing an operator.

12. In the Rockets event, choose Shape Facing
 01.

13. In the Shape Facing 01 rollout, choose
 None under Look At Camera/Object.

14. In the Front viewport, choose Camera01.

15. In the Size/Width group > In World Space,
 set Units = **4**.

–	Shape Facing 01
> | Look At Camera/Object: | |
> | Camera01 | |
> | ☐ Use Parallel Direction | |
> | Size/Width: | |
> | ● In World Space | |
> | | Units: 4.0 |
> | ○ In Local Space: | |

This sets the facing squares to be 4 x 4
units. These faces are the largest of the
particles in the fireworks events.

16. In the Rockets event, choose Display 01.

17. In the Type drop-down list, choose Circles.

18. Choose the color swatch and then change the color to yellow.

Remember the Display operator is only used to adjust how the particles look in the viewports. If you were to render now, you would see a square at each particle's location.

You add materials to your particles later.

19. Scrub the time slider to see circles come out of the emitter.

Adding Sparks

Next, you add sparks from the backs of the rockets as they shoot up.

1. Continue from the previous exercise, or choose File > Open and open *Ch25_Fireworks_2.max* from the courseware CD.

2. Make sure the Particle View window is open.

3. Make sure you are at frame **0**.

4. In the depot, choose Spawn.

5. Click and drag the Spawn test to the bottom of the Rocket event. A blue line shows you that the test is added.

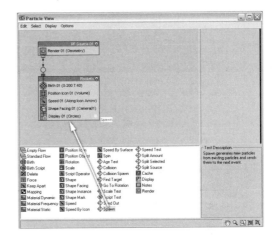

6. Select Spawn 01 and in the Speed Rate and Amount group, select Per Second. Set Rate = **90**, and make sure Offspring # = **1**.

Selecting Per Second and setting Rate to 90 causes the rockets to spawn 90 times per second. By setting Offspring # to 1, Spawn only creates one particle during each spawn. Combined, it amounts to three particles per frame running at 30 fps.

This creates a lot of sparks as the rockets fly up and away from the emitter.

7. In the Speed group, set Inherited % = **50**, Variation % = **10**, and Divergence = **10**.

Spawn 01

Spawn Rate And Amount:

- ○ Once ☐ Delete Parent
- ● Per Second
 - Rate: 90.0
- ○ By Travel Distance
 - Step Size: 1.0

Spawnable %: 100.0

Offspring #: 1

Variation %: 0.0

Sync By: Absolute Time ▼

☑ Restart Particle Age

Speed:
- ○ In Units: 100.0
- ● Inherited %: 50.0
 - Variation %: 10.0
 - Divergence: 10.0

Size:
- Scale Factor %: 100.0
- Variation %: 0.0

Uniqueness:
- Seed: 12345 New

This sets the speed of the spark particles to half the speed of the rockets, with a variation of 10 percent. If the inherited speed is too high, the particles cluster around the rockets. If the speed is too low, they trail too far behind. Adding a Divergence of 10 degrees makes the sparks fly from the path of the rocket by a small amount.

8. Click and drag a Shape Facing operator to an empty spot in the work area. A new event is created with the Shape Facing operator and a Display operator is also added.

9. Name this event Sparks.

10. Click and drag a Delete operator to the bottom of this event.

Sparks
- Shape Facing 02 (None)
- Display 02 (Ticks)
- Delete 01 (All)

11. Select Shape Facing 02 and set Look At Camera/Object to Camera01.

12. In the Size/Width group > In World Space, set Units = **3**.

This sets the sparks to be 3 x 3 units, slightly smaller than the rockets.

13. Select Display 02.

14. Change the color of the ticks to orange.

15. Select Delete 01. In the Remove group, select By Particle Age, and then set Life Span = **4** and Variation = **3**.

Choosing By Particle Age sets the sparks so they die after a specified number of frames. Giving the sparks a Life Span of 4 with a Variation of 3 means that sparks can last from one to seven frames before removal .

Giving the sparks a short life span prevents Particle Flow from making too many sparks at once because 90 sparks are created per second. Also, a short life span for sparks is realistic.

16. Click and drag from Spawn 01's blue handle to the circle above the Sparks event to wire the event to the test.

17. Scrub the time slider to see the ticks coming out of the circles like sparks.

Ending with a Bang

You add another test and event for the firework explosions.

1. Continue from the previous exercise, or choose File > Open and open

Ch25_Fireworks_3.max from the courseware CD.

2. Make sure the Particle View window is open.

3. Click and drag an Age Test to the bottom of the Rocket event.

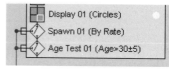

4. Select Age Test 01 and set Test Value = **22** and Variation = **6**.

In this situation, Age Test sends the particles to a new event if they are older than a specified value. Here, the rockets are sent to an explosion event when they are at a random age between 16 and 28 frames.

5. Click and drag a Spawn test to an empty spot in the work area to create a third event.

6. Name this event Explode.

7. Select Spawn 02. In the Speed Rate and Amount group, keep Once selected, and turn on Delete Parent, Set Offspring # = **60**.

Putting Spawn at the top causes any particles that enter this event to spawn more particles immediately. With these settings, the entering particle (a rocket) is removed and replaced with 60 particles. With Once selected, you make sure that these particles can't spawn more particles.

You do not wire this Spawn test to another event so the new particles use this event for their attributes.

8. Click and drag the following operators below the Spawn test: Speed, Shape Facing, and Delete.

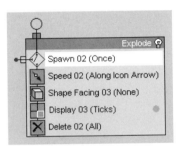

Note: Since the Spawn test is at the top of the list and Delete Parent is on, all particles entering this event are deleted and replaced with 60 new spawned particles.

9. Select Speed 02 and then set Speed = **25** and Variation = **0.5**.

10. In the Direction group, choose Random 3D from the drop-down list.

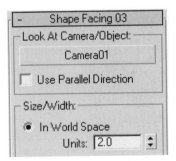

11. Select Shape Facing 03 and set Look At Camera/Object to Camera01.

12. In the Size/Width group > In World Space, set Units = **2**.

This sets the explosion particles to be 2 x 2 units. With a bright material, these look like small, brightly glowing embers.

13. Select Display 03 and then change the color to light red.

14. Select Delete 02. In the Remove group, choose By Particle Age, and then set Life Span = **20** and Variation = **6**.

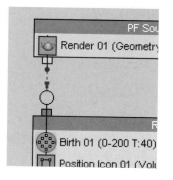

This sets the embers to be removed when they are at a random age between 14 and 26 frames so they won't last too long.

15. Click and drag from Age Test 01's blue handle to the circle above the Explode event to wire the event to the test.

Tip: To move the handle to the other side, click and drag the gray square at the base of the handle to the other side of the event.

16. Scrub the time slider to see the fireworks.

The fireworks would look realistic if the end explosions fall due to gravity.

17. On the Create panel, choose Space Warps > Forces > Gravity. Create a Gravity space warp anywhere in the Top viewport.

18. In Particle View, click and drag a Force operator into the Explode event.

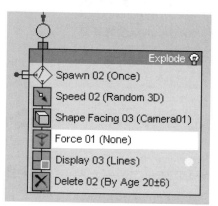

19. Select Force 01. In the Force Space Warps group, choose Add and then pick the

Gravity object in the scene. Set Influence % = **30**.

The Force operator defaults to an influence of 1000 percent. Testing the particle system shows that this is far too strong for the fireworks. Setting the Influence % to 30 looks more realistic.

20. Scrub the time slider to see the fireworks.

The explosions now fall slowly and realistically.

Adding Materials

The fireworks look great, but if you render the scene, you see a bunch of squares. You finish your fireworks by adding materials.

1. Continue from the previous exercise, or choose File > Open and open *Ch25_Fireworks_4.max* from the courseware CD.

2. Make sure the Particle View window is open.

3. Click an drag a Material Static operator to the Rocket, Sparks, and Explode events.

4. Press **M** to open the Material Editor.

5. In the Rocket event, choose the Material Static operator.

6. Click and drag the first material in the Material Editor, Fireworks - Rocket, to the None button in the options area.

Note: You might have to scroll the display of the material samples to see the top three samples.

7. In the Instance (Copy) Material dialog, keep Instance selected and then click OK.

8. Repeat step 6 to add the Fireworks - Spark material to the Spark event's Material Static, and the Fireworks - Explode material to the Explode event's Material Static.

9. Activate the Camera viewport.

10. Scrub the time slider to about frame **80**.

11. On the main toolbar, choose Quick Render.

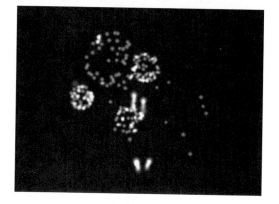

The finished fireworks particle system is included on the courseware CD and is named *Ch25_Fireworks_Final.max*.

Conclusion

In this chapter, you learned about effects, and particle systems in particular. You learned how to: use standard particle systems, make an object explode, and use space warps. You also explored the basics of how to use Particle Flow. You created your own Particle Flow system that simulates a fireworks display. If you wish to learn more about using particle systems, space warps, and Particle Flow, the **3ds max** Help Guide is an excellent place to start.

Full Day Lab

Objectives

By now, you have learned to tackle almost every aspect of **3ds max**. The idea of this lab is to test everything you have learned and produce a complete project. Ideally, you should be able to create your own models, design your own materials, animate various objects in the scene, apply proper lighting, and render the final output to an AVI file. There are a few helpful hints along the way, but no step-by-step instruction.

Introduction

In this chapter, you are presented with two scenarios. The first is based on a 10-second animation of an airplane landing, and the second is based on building a village using the Weeble Wobble characters. Read each scenario, and decide which one you want to spend the day creating.

How to Proceed

A new gaming company that specializes in simulations has approached you. Their newest product, a flight simulator game, needs a 10-second animation that shows an airplane landing.

You have met with their representative who explained what the game is all about.

It is a game that includes time travel as well as flying airplanes. Basically, the player may be flying WWI biplanes, contemporary aircraft, or futuristic space shuttles.

This comes as an added bonus for you since the client is not restricting you to one particular type of plane. In other words, you have the choice of building any aircraft that appeals to your talents as a 3D artist. However, the client did provide data on a Boeing 747 in case you choose that popular commercial vessel. The data includes some reference images, some bitmaps you can use to design your materials, and a storyboard to give you an idea of what the client expects.

Again, the storyboard is provided as an example, since the client is open to alternative camera shots showing the plane landing.

The Client's Storyboard

How to Proceed

Start by outlining the various tasks you need to achieve.

Things to Consider

Refining or Redefining the Storyboard

The first topic you need to address is the storyboard itself. The client provided a storyboard to guide you, but did not restrict you to it. You may decide to create a different scene altogether with a different plane and surroundings. However, what remains constant is the important role of a storyboard in defining the action, timing, and camera shots in the scene. Take a look at the client's storyboard as an example.

Camera Issues

You already have a good idea about how to position the camera to achieve the shot shown in the client's storyboard. You might decide to animate the Field-Of-View of the camera for zoom effects. Also, you have to keep the plane in the shot as it lands. A Target camera allows you to create that effect once you position and link the camera target to the 747.

Timing

You are restricted to 10 seconds or 300 frames for this shot. Of these 300 frames, how many are allocated for the plane in the air (just before touchdown) and how many once it's on the ground? In this particular case, the storyboard has been designed in a half-and-half situation (150 frames in the air, 150 frames on the ground) but you might decide to do it differently.

Action

On final approach, you notice that the plane is tilted backwards. Once the plane is on the runway, it rolls on its back wheels as it dips forward to a horizontal position. This rotation effect takes about 50 frames. Keep in mind that the larger the plane, the more tilt it has, and the more time it takes to get it back to a horizontal position. WWI and some WWII planes hardly had any tilt at all.

Modeling

How many objects do you need to model? Obviously, the plane is a major part. How do you create it? The shape of the fuselage may be derived from a simple cylinder that you manipulate at the vertex and face levels.

What about the wings and the tail? Are they separate objects or are they extruded from the fuselage? Try to plan ahead. It saves you time later.

Effects

Another important factor to consider is effects. Since you are rendering a a movie, rather than creating an in-game model, effects add to the realism of your scene. For example, you might want to have dust fly off the wheels as the plane lands. You should also consider adding fog or clouds.

Reference Images

Three images have been provided that show sketches of the 747 from the top, front, and side views:

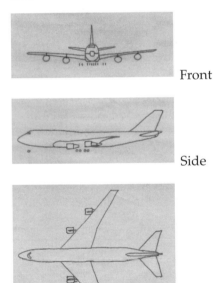

Front

Side

Top

Try creating a "Virtual Studio" in **3ds max**. It involves creating three plane objects with dimensions matching those of the bitmaps. Orient the three planes in the three different axes in the scene and map each one with the appropriate bitmap. (Use Self-Illumination materials so you don't have to rely on the lights in the scene).

The plane is not the only player; you also need a landing strip. It can be modeled easily as a flat surface mapped with the proper material, but you might want to enhance the site. Try to build a few fences around the landing area. A few simple buildings in the background also add a realistic touch. Is the plane supposed to be landing near the desert, or in a mountainous region? Add details to suggest these features.

Materials

Once your models are done, you need to design materials to apply to them. You are encouraged to create your own materials. If an image editing software is not available, the courseware CD provides you with bitmaps to help with your task.

Textures

(Texture for the plane)

(Bump texture for the wings)

(Bump texture for the Tail)

You have a cloud cover selection included on the courseware CD, as seen in the previous thumbnails. Remember also that you can always use stock images (included with **3ds max**) for the ground and the sky.

Animation

Once the Modeling and Materials are complete, you are ready to animate the scene. Again, planning is very important. The client gave you only two restrictions: limiting the animation length to 10 seconds (300 frames and rendering the final AVI output in 70mm Panavision standard of 440 x 200 pixels to convey a wide-screen, cinematic impression to the gamer.

Consider the best approach to animate the plane. Do you transform the plane using Move and Rotate or do you have it travel on a path? If it's traveling on a path, should you constrain it directly to the path or should it be linked to a dummy object? These are issues you need to consider before you even activate the Animate button. If you don't know which method is easier, try them both, and see which you prefer.

Lighting

Lighting is a very important part of any 3d scene. It is a make-or-break issue to any rendered output. Proper lighting can make the simplest scene look impressive, whereas ineffective lighting makes a well-designed scene look bland and boring. Before you begin, consider what you are trying to achieve. What time of day does the action take place, and where does the main light source originate? What color and intensity is the light? Are there other lights in the scene? How about secondary lights and lights bouncing off surfaces? It is important that you ask yourself these questions as you design the lights for your scene.

Rendering

Before you do a final render, always make a preview of your animation. Show this to your instructor. A preview renders more quickly, and is generally enough to test the behavior of your animation before you commit the time to a final rendering. A few fixed image renders gives you an accurate sense of whether the lighting and materials are correct in your scene. Once you are satisfied with the test renders of the plane landing, render the scene to an AVI file at 440 x 200 resolution.

Scenario 2

A client has asked you to design a scene for her. She wants a short scene for a children's show using Weebles characters. There are four characters: grandpa, a young boy, mom, and dad. She wants them in a small town setting that includes a school, barn, and house. You are given creative license designing the buildings, but she wants them to look cartoon-like and/or cute. You are also allowed to decide your own textures. She tells you that grandpa is at the barn, mom and dad at home, and the young boy at school. She is not sure about the animation for the scene, but she would like to see the scene, with a sample animation, by the end of the day.

Here is a sketch she has drawn of the four Weebles:

Workflow

Before jumping into the creation of a **3ds max** scene, you should have a good understanding of the proper workflow to follow. This helps you finish the scene quicker, and keeps you from spending a lot of time on one part of the project, only to find out you have to redo it later.

Follow these general guidelines:

- **Storyboard**—Helps organize your ideas, maintain focus, and communicate your ideas to others.
- **Modeling**—Builds all objects in the scene.
- **Textures**—Makes materials for your scene.
- **Lights**—Decide which lights to use.
- **Cameras**—Decide whether to use Free or Target cameras.
- **Still Render**—Serves as a rendering to be used for print, the web, or promotional material.
- **Animation**—Adds motion to the scene. Are you animating geometry, lights, or cameras? Are you animating a combination of all three?
- **Preview Render**—Makes a preview of your animation to make sure your timing is right.
- **Test Rendering**—Renders a series of still images to make sure your materials and lights look right throughout the animation.
- **Final Render**—Renders an animated file with all of the above elements completed to show the client.

Storyboard

You might want to jot down some ideas of what you'd like to include in your scene. You want a storyboard to include pictures of the look of the various characters, objects, and architecture, along with any texture ideas and animation that takes place. For this scene, you have been provided the sketches of the four Weebles, but you need to design what you want the school, barn, house, and

landscape to look like. We drew up sample pictures of each and used some images found on the Internet for the barn and house. As far as a story goes, we decided the young Weeble would be coming home from school, visit his grandpa at the barn, and then head home to mom and dad.

Here is a rendering of a completed Weeble village provided on the courseware CD.

You may choose File > Open from the menu bar, and open *Weebles Village.max* from the courseware CD to view the environment, and get some ideas for your scene.

Modeling

The modeling can be done mostly with primitives and extruded splines. This keeps the objects simple and cartoon-like.

The barn and the house are constructed in a similar fashion. Design each wall with rectangles for the shape plus window and door openings. They are then put together into a single editable spline using Spline mode's Boolean Union feature. Then you extrude to get the wall's thickness. This is far easier than starting with a box and using the

Boolean compound object to make windows. The windows and doors are designed the same way, with thin boxes filling in the shutters and the door on the barn. The roofs are designed with the Line tool: start with a slightly reduced version of the cross-section and add a Bevel modifier. The Bevel modifier gives the ends of the roof a smoother appearance, rather than having one sharp angle. It also adds thickness to the shape.

The house is easy to finish after that. To make the foundation, you can use boxes under the house and for the upstairs floor. You can design a patio roof the same way as the roof, and use two tall boxes for posts. Extruding a spline and topping it off with a box and four cylinders makes the chimney. The weather vane is a skinny cylinder with a thin extruded arrow above it. The arrow can have any shape above it: a good choice is a chicken, since it's near a barn. Last is the cupola on the roof. The cupola itself is just a box. Its roof is actually a chamfer box converted to an editable mesh and all its top vertices were welded together. The antenna on top can be made with another thin cylinder and two editable splines with a Bevel modifier applied. Each editable spline is made from two Boolean rectangles with corner radii set so they are rounded.

The barn is almost finished also. The hayloft floor and inside walls can be designed the same way you made the outer walls. The ceiling vents are made from a line with a Lathe modifier applied. The silo can be made with a cylinder with two shorter cylinders on it for metal rings. The silo's roof is another Lathed line with a low-strength MeshSmooth modifier applied on top of Lathe to round its edges a bit. To add hay inside the barn, use a sphere with Slice turned on and add a Noise modifier.

To finish off the house, barn and silo, it's preferable to taper them for this scene so the base is smaller than the top. This gives the architecture a more childlike feel necessary for the Weeble's world. To do this, select all objects that make up the house and add a Taper modifier. The same modifier is be applied to all components as a whole. You have to move the taper's center to the top of the house, and decide how much you want it to taper. Follow the same procedure with the barn and silo.

The schoolhouse was modeled in a similar way, and you might want to model it the same way you modeled the house and barn. To keep it simple, you can make the school from an extruded spline that is then tapered. The door and windows can be designed as before, and then rotated into place. The roof can be made from an extruded spline, and the steps from flat boxes. Lastly, make the clock with two cylinders and use another extrude to make the hands.

Now that the buildings are done, enjoy creating the trees and Weebles.

To make the trees, all you have to do is design it in cross-section using the line tool and extrude it. These trees are simple, with all the branches in the same plane, as you'd expect from a toy. After extruding, consider adding a taper to make the branches thinner than the trunk, and then add a MeshSmooth modifier,

with one iteration, to round out the branches and trunk. Lastly, you can make simple leaves with spheres placed at the end of each branch.

The Weebles should probably start as capsules – cylinders with hemispheres on the ends. You can then add a FFD 4 x4 x 4 modifier, and in Control Points mode, select the upper two levels of points and scale them down to make the head smaller then the body.

The basic scene is a flat plane for the ground with a sphere on it for the sky. The sphere has a Normal modifier added to it, with Flip Normals turned on, so the sky appears on the inside of the sphere and be transparent from the outside. The road and pond can be made from extruded lines.

Before you finish modeling, you should consider adding effects to your scene. For example, you could add rain, snow, or falling leaves. You may also want to use a particle system to add a fountain to the scene. Remember to keep the effects simple to maintain the children's theme. Also use Wind, Gravity, and Deflectors as necessary to get the effects you want.

Textures

Map the school first. A brick material can be made with the Tiles procedural map. You may need to add a UVW Map to the schoolhouse so all the bricks appear correctly. You can make a roof material with one of **3ds max**'s built-in shingle maps, and a wood material for the door and window frames with a wood map. The rest of the school's parts are left with no map, and they simply use a color.

Mapping the barn comes next. You can make the wood texture with one of **3ds max**'s Wood maps, found in its *maps* directory. Other possibilities are to use a solid color with a procedural wood bump map to get a painted wood effect. You may also want a painted metal material to put on the bands around the silo and the vents. The materials for the barn and silo roofs can sport a reflective look by adding one of **3ds max**'s Reflection maps to the Reflection map channel. Also give them a high specular highlight and glossiness. You can create hay with Noise maps for the Diffuse and Bump map channels.

One process you can try with the wood texture on the barn is to use the Mix map to mix the texture with a color. You can set the mix amount to control how much of the texture is visible.

Mapping the house is easy after the barn. You can use a flat color with a procedural Tiles bump mapped on the walls, along with a flat color and a wood bump map for the rest of the wood. The roof material can use another of **3ds max**'s shingle textures, and a shiny metal texture for the top of the chimney and the antenna.

Lastly, to make the maps for the Weebles, you have to draw them in a paint program, such as Adobe Photoshop. Start a new file that's 256 x 256. Divide it into five vertical columns with markings, or guides, at 32, 96, 160, and 224. These columns mark half of the back, the right side, the front, the left side, and the other half of the back. Also make two horizontal markings or guides at 85 and 171. This divides the picture into three rows – the head, body, and legs. This should serve to help you design the look of the Weebles.

Divide the colors into three groups: flesh along the top row for the face, a color along the middle row for the shirt, and another color along the bottom row for the pants. The face is in the top center section. Have fun adding hair, a hat, suspenders, shoes, etc.

When adding the materials to the Weebles, you need to add a UVW Map modifier set to Cylindrical. Add the bitmap to the Diffuse map channel and turn on Show Map in Viewport. If your material appears upside down on the Weeble, select that Weeble's UVW Map modifier and set its U Tile and V Tile values to –1.

Feel free to design and use as many other textures as you like for the scene.

Lights

There are several ways to light your scene. You might want to set up a spotlight that casts shadows and follows the action, or you might want a Target Direct light to act as the sun. You should also add other lights and adjust the Multiplier amounts to soften the shadows and keep the light from getting too bright.

Unless you want a specific look, a good idea is to place several lights around your scene, above it. Set one to cast shadows and use others to lighten the shadows. You can also add an extra ceiling light for more lighting. You can have more than one light casting shadows, which enhances an artificial lighting effect.

You might also decide to use the Advanced Lighting options. The Light Tracer works particularly well with outdoor scenes.

Cameras

Most likely for this scene, you want only one camera to follow the action. A Target camera is a perfect solution. If you'd like to make a fly-through instead, a Free camera is what you want to use. If you are making a fly-through, you also want to create a line for the camera to follow.

Single Render

You have probably made several renders during the process of creating the scene and textures. Now is the time to make sure everything looks the way you want it to. Single rendering is ideal for still images to be used in promotional material.

Animation

If you are going to have a fly-through, all you have to do is select the camera, change its position controller to the Path constraint, and then choose the path you made for it.

If you have action in your animation, now is the time to set it up. Remember to use either the Set Key or Auto Key buttons to create keyframes.

As in our example, decide how long it takes the young Weeble to get to his grandpa's house, move the time slider to that time frame, and then move the Weeble to its new location. You can also change his rotation and scale. The storyboard is crucial for this stage because you want to have the animation planned out completely before you start tackling it in **3ds max**. This way you have a good idea of where to put the keyframes, and you won't have to keep updating them, trying to figure out how to make them look.

Keep in mind, the more complex the animation, the more work must go into the storyboard beforehand.

While animating, use the play and stop buttons to watch how the action is coming along. This way you might catch a mistake or see examples of poor timing, before getting too far along in the animation.

Preview Render

Once your animation is complete, render a preview to test your timing. You are not be able to see your lighting effects or some material effects. However you get a good idea of the interaction of objects within the scene.

Test Render

Perform a series of test renders. In the Render Scene dialog, render every fifth or seventh frame. This gives you a reasonable idea of how the lights and materials look at various frames in the animation.

Final Render

When everything is done and looking good, it's time to make the final render. Render your movie to a high-quality AVI and enjoy it!

Conclusion

In this chapter, you have enough information to complete a project. If you take into account all the directions previously discussed, and if you take the time to plan your work, you should complete one of these projects successfully. More importantly, the whole process gives you a feel for production work and the extensive planning it entails.

3ds max Glossary

2D—*adjective:* in computer animation, 2D is short for 2-dimensional; when something has length and width but no height. Or, it has height and width but no depth. For example, lines, squares, flat pictures, etc. are 2D.

3ds max®— *noun:* powerful computer animation software produced by Discreet, a division of Autodesk, Inc. "3D" means three dimensional (it has height, width and depth). The "s" stands for studio (where art is made). "Max" is short for maximum (the best possible). Currently, **3ds max** is the leading software in the world of computer animation.

absolute world—*noun:* the location of an object in the World Coordinate System. The World Coordinate System in 3ds max defines the Z-axis as up, the X-axis as horizontal (when the length of something is level with the ground) and the Y-axis coming into and out of the screen. Where the three axes meet is the absolute world point with the coordinates X=0, Y=0, Z=0.

additive—*adjective:* having to do with or resulting from the combining of two or more things; in 3ds max materials, an option which sums the transparency values of two colors instead of blending the colors with the result being a color that is brighter than a blend or the original colors.

align—*verb:* to move or position objects so they are straight or parallel when compared to each other.

alignment—*noun:* the position of an object based so it is straight or parallel when compared to other objects.

alpha channel—*noun:* the information stored in a computer picture file which holds the transparency settings for every part of the image.

ambient—*adjective:* in 3ds max, a characteristic (one of the things than make something what it is) of a material that defines the color in shadow.

ambient light—*noun:* also called "existing" or "available" light; it is the surrounding light within an environment. It does not come from any one direction more than another.

angle snap—*noun:* in 3ds max, an option used when rotating objects. When turned on, angles quickly rotate to a specific point, such as turning exactly 5 degrees or turning exactly 10 degrees.

3ds max Glossary

animate—*verb:* to give something life-like qualities by adding realistic movement, squashing and stretching, etc.

aperture—*noun:* a small, adjustable opening that is used to control the amount of light that is allowed into a camera, telescope, etc.

array—*noun:* a collection of objects spaced in an orderly manner.

aspect ratio—*noun:* it is a group of numbers that shows how the width of something compares to the height. If the width of something is twice whatever the height is, this would be written "2:1" and said, "two to one". This is most often used when talking about pictures and is good to know when changing the size of a picture. If the original picture size is 2:1 (the width of it is twice whatever the height is) and someone wants to change the size, then they will make the new size so that the picture is still 2:1 (the width is twice whatever the height is). If they make the picture's new size different (the width of is no longer twice whatever the height is), then the picture will look stretched out of shape.

asset—*noun:* in 3ds max, the pictures, animations and other computer files that are used as sources in the artist's work. 3ds max has a feature (a special part) called the "Asset Browser" which makes it easier to find, view and use these files.

assign—*verb:* to give or transfer ownership; to decide where something belongs.

atmospherics—*noun:* in computer animation, a particular group of special effects created using random specks, i.e. fog, smoke, etc.

attenuation—*noun:* the weakening or dimming of light as the distance from the light source increases.

auto key—*noun:* in 3ds max, a part of the animation system. When turned on, it starts a *record* mode. Any changes made after the first frame are recorded.

AutoGrid—*noun:* in 3ds max, an optional setting that makes it easier to create an object directly on another object's surface. AutoGrid reads the surface normals on the existing objects in the scene.

AVI—*noun:* a common computer video file type whose names ends in .AVI. These files usually contain a sequence of pictures and sound which when played back quickly appears as animation or video.

3ds max Glossary

axis—*noun:* a straight line through the center of a body, figure or shape; in a grid, the middle line, which is given a value of zero and is used as a starting point or central point when figuring out where or how far away other things are.

axis of rotation—*noun:* that line through the center of an object around which the object spins.

background channel—*noun:* in 3ds max, an option used to store images that appear in the background when an effect, such as reflections, cannot be created.

bank—*verb:* to lean to the inside when following a curve.

bank—*noun:* in 3ds max, an option for a Path Constraint which causes objects to lean into the curves on the path.

beam—*noun:* a column of light that comes from a bright source of light, such as the sun or a spotlight.

beam—*verb:* to send out a bright column of light.

bevel—*noun:* an angled cut that replaces the edge between two surfaces.

bevel—*verb:* to replace an edge with an angled cut.

Bezier—*noun:* in computer animation, geometry methods developed by a computer scientist named Pierre Bezier (1910-1999). These methods are used to create curves and surfaces. One of these objects would normally be called a "Bezier curve", a "Bezier surface", etc. but are sometimes called simply a "Bezier" for short. He used these computer methods to design automobile bodies, which have curves and surfaces that are smooth but in some places they are simple and in other places they are complex.

Bezier corner—*noun:* curved lines made with methods developed by Pierre Bezier. In these methods, at a point on a curve, there is a "handle" that the artist can use to accurately and quickly create the right curve.

Bezier float—*noun:* in 3ds max, a type of animation controller. It allows for a calculation of motion values between keys that are on a curve or the calculation of motion values when the amount or speed of change is not always the same.

3ds max Glossary

bias—*noun:* a value which needs to be added to a correct a calculation for some reason; a constant value added to a measurement or position; in 3ds max, an option found in several places in 3ds max. For example there is a bias parameter for the helix object. When adjusted it moves the loops of the helix either closer to the top or bottom. There is also a bias control for shadows which moves the shadow either: closer or further away from the object.

bitmap—*noun:* a flat (2D), computer image from a camera, scanner or painting which is made up of lines of colored dots; all of these colored dots will look like a picture when it is viewed from a little distance away.

Blinn—*adjective:* in computer animation, a shading method developed by a computer scientist named Jim Blinn. These methods look at how a material responds to light and the angle from which the surface is viewed to create good color shading with reflected highlights.

Boolean—*adjective:* a method for combining things created by George Boole (1815-1864). Two things are combined using one of these methods: something AND something else, something OR something else, something but NOT something else, etc.

Boolean—*noun:* in computer graphics, objects created with these methods.

box modeling—*verb:* a method of creating objects in computer animation starting with a simple object like a box and extruding parts of it and adding complexity only where it is needed. It is a very accurate way to make simple, efficient models.

brightness—*noun:* A measure of the overall light in an image in a range from black to white. The lower the brightness value, the darker the image; the higher the value, the lighter the image will be.

browser—*noun:* in computer science, a program or part of a program which allows you to view the data that is in computer files such as documents, pictures, animations, etc.

bump map—*noun:* a gray scale computer image which is used to create a different consistency on a material's surface, i.e. rough, smooth, bumpy, etc. The picture in a bump map is not visually displayed on the surface of an object, but used to calculate how rough, smooth or bumpy the surface will look.

3ds max Glossary

chamfer—*noun:* in classical architecture, a long, thin depression cut lengthwise into the shaft of a column.

chamfer—*verb:* to cut or form a groove or bevel.

channel—*noun:* a place or pathway that something can be in or move through. A wire can be a channel for electricity. A pipe can be a channel for water. In computer graphics, the color an artist chooses goes through a channel in the software, through the computer, to the screen, and the final image or animation.

Cinepak—*noun:* a method of compression and decompression (or "codec") for computer video files.

clone—*noun:* a copy which appears identical to the original.

clone—*verb:* to make an apparently identical copy.

codec—*noun:* short for "COmpress / DECompress;" a computer method for squeezing files to make them more compact for storage and expanding them back to the original as they are used. Some popular codecs for computer video include MPEG and Cinepak.

compass—*noun:* in technical drawing, a two pronged device that is hinged where the prongs meet and is used to draw circles and arcs (any part of the circle). One prong has a sharp point on one end and the other prong holds a pencil or pen. The sharp end stays in place on the drawing surface while the device is spun so that the marking end draws a circle or arc.

compound—*adjective:* when something is made up of two or more like parts, such as a pen that has 2 or 3 different colors of ink inside.

3ds max Glossary

compress—*verb:* to cause recorded information (often computer files) to be squeezed and made smaller. One way this is done is by taking out extra or repeating parts. The removed parts are replaced with a very small marker that shows what went there. In this way, information is never lost. The information or file can be brought back to its exact original form. Another way to compress pictures, movies and sound is to group points or patterns that are very alike and make them the same. In this method, information (small color or sound differences) are lost when making the file smaller. The smaller they get, the more they lose. So, there many ways and many programs that compress, but its good to know which ones loose information (are lossy) and which ones don't (are lossless.)

cone—*noun:* a shape which starts at a point and fans out in an expanding ring; in 3ds max, the shape of the light rays or beam from spotlight.

configuration—*noun:* the setup of the parts of something so that they work together to do what they should or the way that thing is when its parts are set up so that they work together to do what it should.

configure—*verb:* to setup or arrange for a particular purpose.

constrain—*verb:* to limit or restrict; to hold back.

constraint—*noun:* a limit or restriction placed on something; in 3ds max, an animation option which ties one object to another. For example, to create a fly-through animation by moving a camera through a scene, you could use a path constraint. The path constraint applied to a camera would require the camera to follow a 2D shape for its path.

contrast—*noun:* the amount of the difference in brightness or color across an image or scene. The smaller or fewer the differences in different places on an image, the lower the contrast—the greater or more frequent the differences, the higher the contrast.

controller—*noun:* in 3ds max, also called animation controllers, the property which determines how changes are calculated between known points called keys. All objects in 3ds max use controllers. You can change an object's animation controller properties.

coordinate—*noun:* numbers that shows where something is or how far away it is from a point, base line, or an axis.

3ds max Glossary

coordinate system— *noun:* a way of showing and measuring where things are located. These systems use grids (rows and columns of lines that show measurements.) Three grids are used and they go out in three different directions. Each grid is at a ninety degree angle (at a right angle) from the others. Each grid has its own name—usually X, Y and Z, but other names are sometimes used. The three grids deal with length, width and height. The center line of each grid (which is called the "axis") is where things are measured from and usually has a value of zero (0). If the name of the grid is "X", then the center line (the axis) is called the "X-axis," etc. In 3ds max, there are several different coordinate systems (groups of grids using different names) that are used for different things.

cropping— *verb:* to remove outside portions of an image to size it for a particular purpose or improve the way that it looks.

cross-section— *noun:* a view of an object showing parts that would be seen when a cut is made through it. Doing this shows the inside and inside edges of parts of the object.

curve editor— *noun:* in 3ds max, the curve editor is a dialog box used to view and control how the software computes the points it fills in between keys. For example, the user may specify the position of an object in the first frame and then again where it should be after 10 seconds on the 300th frame. The computer calculates the positions in between those start and stop points for frames 2 through 299. With the Curve Editor, 3ds max lets you see and even change how it is going to calculate those in-between positions.

customize— *verb:* to make something or change something so that it is useful, more useful or pleasant for a person or for a group of people or for a special use.

cylinder— *noun:* a round, tube or can shaped object (either hollow or solid). The sides are straight and the circular ends are flat and parallel with each other

3ds max Glossary

default—*verb:* in computer science, the options set or used by the software when the user does not change how they should be set or how those things should be done. The default settings are usually the most common or most desired, so they allow the software to continue and save the user time by not having to set every little thing unless there is a special need.

diagonal—*noun:* an angled line that connects two separated corners on a flat shape or connects two separated faces (sides) on a 3D object.

dialog—*noun:* in computer science, also called "dialog box;" a window that appears temporarily in programs to request information from or to provide information to the user.

diameter—*noun:* the length of a line which passes through the center of a circle or sphere from a point on one side, to a point on the opposite side.

diffuse—*adjective:* spread out, not in or going to one place; in 3ds max, the color or brightness of objects not lit by a direct light source

diffuse map—*noun:* in 3ds max materials, a map channel used to pick a color to be used that will be spread out over the surface of an object.

directory—*noun:* in computer science, a list of the names of the files (and sometimes their sizes, dates of creation, etc.) that have been saved to or copied to a disk or to an area of a disk

displace—*verb:* to move something out of its normal place, position or shape; in 3ds max, to deform an object using a modifier which requires a gray scale map.

distribution—*noun:* the way a group of things are scattered across an area or volume, how many here, how many over there, etc.

distribution object—*noun:* in 3ds max, a part of Particle Flow® that acts as a target or limit for scattering particles.

dolly—*verb:* to move a camera that is pointed at an object either toward the object or away from the object.

download—*verb:* in computer science, to cause a copy of a file that is located on another computer to be sent to and received by the computer that the person is using.

3ds max Glossary

dummy—*noun:* in 3ds max, a specific type of object that doesn't appear in the final image or animation but is used as a working placeholder, link or connector to help the user manage complex operations and structures.

dxf file—*noun:* in computer science, a file containing a technical drawing and the data about the drawing. Autodesk, Inc. came up with the dxf file, and shares how they are made with other companies, so they can use the data in this type of file, or make this type of file too. Having the ability to save a drawing using this organizing method means that the person that made the drawing can give it to someone that owns a different drawing program and that person will be able to use it. DXF stands for Drawing eXchange Format. (The way that data is organized for use or for viewing is called the "file format" or the "format", for short.)

edge—*noun:* the border of a surface or the line where two surfaces meet

effects—*noun:* when used in film, video and computer animation, an attempt to make fake things or events look or sound real. Effects are usually planned in advance because they are difficult to obtain naturally. *Special effects* usually refer to those effects carried out with props, stunts and physical models recorded on camera. *Visual effects* usually refer to those done by artists after recording by changing the recorded images – usually on a computer.

ellipse—*noun:* a flat, closed, "egg" or stretched circle shape. The stretch can be very little, so that the ellipse is almost a circle or the stretch can be a lot so that the ellipse is almost an oval.

emitter—*noun:* in 3ds max, the thing in a particle system that creates and sends out particles.

exposure—*noun:* the amount of light recorded on a picture taken with a camera. Exposure is controlled by opening up or closing down the size of the opening which lets light in to strike the film or sensor, and lengthening or shortening the time the shutter is left open to the light. Thus, exposure is a combination of the intensity (strength) and duration of light recorded.

extrude—*verb:* reshaping objects by pulling out or pushing in one or more parts of the object.

3ds max Glossary

face—*noun:* in computer animation, a small, flat, three-sided part of a mesh surface.

face map—*noun:* in 3ds max, a texture placed on the small, flat parts in an object's surface.

facet—*noun:* the small, flat part of a surface like those found on a cut diamond; in 3ds max, an option that makes objects appear angular rather than smooth.

falloff—*noun:* the fading of light as the distance from the bright center of its beam increases; in 3ds max, a measurement having to do with how a beam of light fades as you move away from a brighter center. Falloff is also a map type that can be used to help make glass and other materials.

field—*noun:* in 3ds max, when making a spotlight, the size of the area of a scene to be brightened by the spotlight, but outside the brightest center area called the hot spot; in television, a field is one half of a frame. One field consists of the odd numbered lines in the frame and the other field consists of the even numbered lines.

fillet—*noun:* a curved edge joining two surfaces that would otherwise meet at a sharp angle

flyout—*noun:* in the 3ds max user interface, a black triangle at the bottom, right side of many icons. The triangle means more choices for that icon are available. If you click-and-hold it with the mouse, more choices for that icon appear.

format—*noun:* in computer science, the way that data is organized so that a program or person can easily view, print or save the data.

format—*verb:* to prepare a disk to be able to receive and save data, such as a document, picture or music file.

fps—*noun:* abbreviation for Frame Per Second. The rate images are displayed in sequence to give the appearance of continuous motion. Film is 24fps, Video is 30fps, Animation can vary, but 30fps is often used.

fractal—*noun:* irregular patterns of points, lines and curves. These are found commonly in nature but cannot be made using standard math operations. They are made using random numbers and simple equations that are repeated over and over.

3ds max Glossary

frame—*noun:* a single image that is a part of a series of images that make up a movie or animation.

g-buffer—*noun:* in 3ds max, also called a graphics buffer; special data that 3ds max puts into a file that can be used later by a person in a different computer program. This special data can be used to create or change things like shadows, glows, motion blur, etc. without having to go back into 3ds max. This can save time and create a better work better in some cases.

geometry—*noun:* the study of objects using numbers and other symbols to describe and work with points, lines, curves, surfaces and/or solids; in computer graphics, the objects which are represented by points, lines, curves, surfaces and/or solids

geosphere—*noun:* in 3ds max, a ball-like object made up of triangles all at an equal distance from a center point.

gizmo—*noun:* in 3ds max, a device that allows the user to manipulate objects and do certain effects. If you select an object and choose a command that uses a gizmo, the gizmo device will appear. Changing the gizmo will cause those changes to be made to objects that the gizmo belongs to.

global—*noun:* neither limited nor local; in computer animation, related to or affecting the entire scene.

global illumination—*noun:* in computer animation, a method used to copy the way light really works to create realistic images. Global illumination is designed to be able to figure out and show the changes that happen to light when it bounces off of objects, and then bounces off of other objects, and so on, until it reaches the view point. It not only lights and shades the objects in the scene correctly, it also picks up colors from the objects in bounces off and carries those colors through the scene. Real light does this naturally. Try this, get pieces of paper or cloth with different, bright colors on them. (Large pieces of bright red, orange, blue and green work well.) Find a window in a white wall that has sunlight coming in. Hold the bright pieces of cloth or paper into the light coming in the window. Move them around to bounce the light on the walls around the window. You should see the colors from the pieces appear in the light that bounces onto the white wall.

3ds max Glossary

glossiness—*noun:* a description of the smoothness/shininess of a surface; in 3ds max materials, an option that controls the amount of reflected light from a surface. A material's glossiness (or dullness) depends on the size and intensity of its specular highlight. In the 3ds max material editor, the glossiness spinner affects the size of the specular area, and the specular level spinner affects the intensity of the glossiness.

glossy—*adjective:* having a smooth, shiny surface.

gradient—*noun:* a smooth or easy stepped change in a quantity or quality.

gradient ramp—*noun:* in 3ds max, a map type which can define a map channel such as diffuse color, bump, or opacity. The gradient map type adds a series of colors in a pattern such as linear, radial or other options.

grayscale—*adjective:* using only shades of gray, from black to white, to produce an image.

grid—*noun:* in computer graphics, a group of lines arranged up-down and side-to-side similar to those on graph paper which are used as reference lines.

group—*noun:* a named set of objects collected together to make working with them easier; in 3ds max, a collection of objects or parts of objects.

helix—*noun:* a 3D spiral structure consisting of a series of loops around a cylinder or cone. A spring is an example of a helix.

helper—*noun:* an assistant or aid giver; in 3ds max, an object type that is used as a visual, drawing, or animation aid. For example, a tape measure is a helper object type.

hemisphere—*noun:* half of a sphere; half of the earth or globe; the north and south half of a planet split by its equator.

hierarchy—*noun:* an organization of objects in a system of rank or priority.

highlight—*noun:* an area of reflected direct light or sparkle (little flashes of light) in an image or on an object.

home grid—*noun:* in 3ds max, the default grid from the World Coordinate System that can be used to create objects, to place them, move them, align them and scale them. It is the default grid shown when 3ds max starts.

3ds max Glossary

hotspot—*noun:* in 3ds max, the brighter circle of light appearing in the center of a spotlight's beam.

icon—*noun:* in computer science, a small picture, drawing, etc. that is used as a symbol for some action that happens when you select it. The thing that the picture, drawing, etc. stands for can be a program, a command or anything that is a thing-to-be-done or a thing-that-can-be-used

.illuminate—*verb:* to shed light on or make lighter, brighter.

import—*verb:* in computer science, to cause data (a picture, drawing, etc.) that was made using a different program to be translated, copied and put into use by the program that is being used. Example: you can import a drawing that was created using a drawing program, to be used by a word processing program. Most programs are made to use a special kind of data, but have the ability to use other kinds of data as well.

increment—*noun:* a unit of measure for the amount or degree by which something changes.

inherit—*verb:* to receive a part of something when a relationship or a link with it exists. The relationship could be age, birth, or a ranking of seniority; in computer animation, when objects are linked in some way, the lower ranking objects can receive traits and information from the higher ranking objects they are linked to.

instance—*noun:* a copy of an object. In 3ds max, it is a copy with a "two-way" link between the original and copies. They share all the same properties and if a person changes a copy, the original will change and all other copies will change too. This is different from another kind of copy called a "reference copy" which only has a "one-way" link, from the original to the copy.

intensity—*noun:* strength (including the brightness of light); in computer animation, the strength of a color, which has to do with the amount of pure color there is compared to the same color with a little lightness added or the same color with a little darkness added. A color has its highest intensity when there is no lightness or darkness added.

3ds max Glossary

interactive—*adjective*: a way of exchanging information where the participants act on or influence one another like in a conversation. Interactive could refer to person-to-person, person-to-machine, or even machine-to-machine exchanges.

interface—*noun*: in computer science, that part of a program which controls what is displayed for the user and allows the user to interact with the software; any method used to get information from and put into computers.

interpolate—*verb*: to calculate or make a good guess for the value of a point between two known values.

interpolation—*noun*: the methods used for calculating values of points between known values.

inverted—*adjective*: being in a position where the top and bottom have been reversed; turned upside-down.

iteration—*noun*: the act of doing a series of steps over and over again until what is wanted is done. Sometimes, it refers to one time through the series of steps.

JPG or JPEG—*noun*: a type of computer file used to hold compressed pictures. The name of the file usually ends in .JPG. "JPG" is short for the Joint Photographic Experts Group, or J.P.E.G., who created the method of compressing images or pictures. To compress images into JPG files, colors and patterns that are very close are grouped together and made the same. So, the more an image is squeezed with JPG compression, the more information in the picture is lost. This lost information cannot be recovered without the original information – but JPG files can be good enough and quite small.

key—*noun*: in computer animation, a value which marks the starting point or ending target value for any change in position, shape, form or appearance.

keyframe—*noun*: any frame of an animation upon which the animator has placed a key to mark the start or end point of a change in position, shape, form or appearance.

landscape—*noun*: a picture or painting showing a wide view of natural scenery; *adjective*: the positioning of a rectangular shape where its longest side is horizontal; the opposite of "landscape" is "portrait" where the longest side is vertical.

3ds max Glossary

lathe—*noun:* a tool for shaping wood or metal by cutting it with a knife as it rotates;
in 3ds max, a modifier that creates an object by spinning a 2D shape through an angle or in a complete circle to create round objects such as glasses, vases, and plates.

lattice—*noun:* an arrangement of things where they are placed on a framework of equally spaced, crossing lines in 2D or 3D space. In 3ds max, a lattice is a 3D grid on a box placed over an object. In the FFD (Free Form Deformation) modifier, it is used to stretch and bend the object by moving any of the crossing points or corners on the grid. There is also a lattice modifier which can be used to create wire frame objects.

library—*noun:* a collection of items that have been saved and organized so that quickly finding and using them is possible.

light tracer—*noun:* in 3ds max, a way to check how light acts in a scene so the scene can be rendered (made into images) the way the user wants.

linear—*adjective:* dealing with only one direction; having constant speed and direction.

linear curves—*noun:* in 3ds max, an animation controller that calculates the values used between keys so changes are made in a constant way over time, instead of speeding up or slowing down.

load—*verb:* in computer science, to cause a copy of the data in a file to be placed into the working area of the computer. This is also called "open", "read" or "run (when talking about a program)". The file is kept on a disk, which keeps the file even when the computer is turned off or loses power. When a file needs to be used, a copy of it is made and sent to the working area of the computer which is called "memory". Think of it this way, a disk is like a desk drawer and memory is like the top of the desk.

logarithmic—*adjective:* when changes speed up or slow down more and more as time goes by; in mathematics, logarithmic means "having to do with how many times a number is multiplied by itself to reach another number." Large numbers can be reached very quickly this way.

3ds max Glossary

logarithmic curves— *noun:* in 3ds max, an animation controller that calculates the values that will be used between keys to make changes that speed up or slow down more and more as time goes by.

loop—*verb:* 1 to repeat; in film, video and animation, to start again as soon as it ends.

loop—*noun:* a closed curve like a circle, oval or ellipse.

map—*noun:* in computer animation, a term that can have several meanings. It can refer to a map type – a bitmap for example. It can also refer to a map channel – which holds the specific options for given a material type.

map channel—*noun:* in 3ds max, for any given material type, the map channel holds the specific set of options for that material type. The most common map channel option is diffuse color. A map channel is defined by entering a value for the options or by selecting a special map type. For example if you wanted to create a tiled floor. You would consider the following: Step 1) Define a material type, such as "standard." Step 2) Use the diffuse map channel to define color. The color can be a color you pick or you can use an image instead of a solid color by selecting "bitmap" for a map type

mapping—*verb:* in computer graphics, mapping usually refers to placing and positioning a 2D map type such as a bitmap on a 3D Object. In 3ds max, one option is to use the UVW map modifier to place your map correctly on an object. Mapping sometimes could refer to making the maps as well.

material—n*oun:* in computer animation, the complete description of a surface's appearance, including its shininess, smoothness, color, etc.

material—*noun:* in computer animation, the whole definition of a surface's appearance including its shininess, smoothness, color, etc.

3ds max Glossary

material ID—*noun:* In this case, "ID" is short for "identifier", which is a special name, number or symbol that is given to each item in a set; in 3ds max, a material ID is a number used to specify one material out of the several materials that may be defined inside a complex material type called a Multi/Sub Object Material. The standard 3D objects that are built into 3ds max like boxes, spheres, cones, etc. have material IDs already on their different parts. More complex, custom objects might need their material IDs assigned or set up if they are needed. You can define Material IDs manually for any object in the scene.

— in 3ds max, "operators" control how particles look and behave in the Particle Flow system. In this case, "static" means "not changing." The material static operator assigns a material for a particle flow.

Mental Ray® —*noun:* in animation, a method of making and showing very high quality computer images using very high quality surfaces, lights, shadows, etc. usually for an animation. Mental Ray is a render type which is produced by Mental Images, Inc.

mesh—*noun:* in computer animation, a surface or group of surfaces made of faces; geometric objects.

mesh smooth—*noun:* in 3ds max, a method of replacing the sharp corners on an object with smooth corners. More geometry is created by the computer program, but it lets a person make something look the way that they want it to.

model—*noun:* a form or pattern meant to represent something else; a replica; –*verb:* to create such forms, patterns and representations.

modifier—*noun:* in 3ds max, procedures that are applied to objects to change or affect them in some way.

3ds max Glossary

multi/sub object material—*noun:* in 3ds max, a complex material type. "Multi" means more than one. "Sub Object" refers to the parts that make up an object. Normally, when you assign a "standard" material type to an object in 3ds max, that material would cover the whole object, not individual parts. However, when you want different materials on different parts of an object, the multi/sub object material type would be used. For example, if you had a box and you wanted all six sides of the box to display a different material (such as a picture of your cat on one side of the box and a picture of your dog on another side of the box, etc.) you would use a multi/sub object material. You would create a multi/sub object material that included pictures of your cat, your dog etc.

multiplier—*noun:* a number by which another number is multiplied; a number used to scale an object or effect, i.e. half it, double it, triple it, etc.

nested—*adjective:* in computer science, when something is fully contained inside something else of its kind. For example, an object inside another object would be called a nested object; a material inside another material would be called a nested material, etc.

net —*noun:* in computer science, net is short for network, which is a group of computers usually within the same building which are connected in some way so they can work together. It is also common as a short form of the word "Internet." The internet is a large, public system for connecting computers and sharing information all over the world.

net render—*verb:* in computer animation, the action of making an image or animation with two or more computer programs that are working together and are each inside of a different computer. These computers are connected in some way so that the computer programs running on them can send data to each other when one program needs the data that another program has created. These computers are usually all in the same room or all in the same building. Computers that are connected in this way are called a "network" or "net" for short.

N-gon—*noun:* any flat, closed shape with "N" number of sides, where N is any whole number

noise—*noun:* random signals, sounds or disturbances

3ds max Glossary

noise map—*noun:* in 3ds max materials, a property that creates random changes in the appearance of surfaces to which it is applied.

normal—*adjective:* regular; in computer animation, when objects meet at ninety degrees which means together they make a right angle;

normal—*noun:* in computer animation, an indication on a surface as to which of its sides faces out, usually shown as a short line extending up from the surface at ninety degrees.

NTSC—*noun:* Abbreviation for National Television Standards Committee. This group was in charge of deciding which method to use for sending television broadcasts that are received by the televisions in the United States. The name of this format is also called NTSC after the group that developed it.

object—*noun:* a thing that exists; in computer animation, a geometric shape, often meant to look like a real-world (non-computer) thing; in computer animation, any of the things that a person uses when creating animation, such as lights, cameras, geometry, etc.

offset—*noun:* the distance put between two places or things

offset—*verb:* to separate two places or things by a known distance.

omni light—*noun:* in 3ds max, a light that shines in all directions.

opacity—*noun:* a property of an object which describes how much light is stopped from passing through it. 100% opacity means no light passes through the object.

operand—*noun:* a number on which a math function is performed, like addition, subtraction, multiplication, etc.; in 3ds max, the objects used inside a Boolean compound object type

operator—*noun:* in the 3ds max system, operators control the look and behavior of the particles in actions and events where they are used

orientation—*noun:* the position or alignment of an object relative to something else or itself

outline—*noun:* a list of items with detail in varying levels beneath each item; the boundary or outer most shape of an object; in 3ds max, a parameter in the Bevel modifier which defines the boundary of the edge.

output—*noun:* the final product or result coming out of a process; in 3ds max materials, an option available for most map types which affects the color information.

3ds max Glossary

overshoot—*noun:* that which is beyond, above or past the target: in 3ds max, a parameter for spotlights and direct lights. Outside of where the beam is going the light behaves like an omni light, brightening the scene in all directions.

PAL—*noun:* abbreviation for Phase Alternating Line. A television broadcast method used in many European countries.

parallel—*adjective:* being an equal distance apart and facing the same direction; straight lines that are an equal distance apart along their length and so will never meet.

parameter—*noun:* one value in a group of values that specify a quantity or quality of a thing or action and which together define it entirely.

parent—*noun:* the person or thing that is defined as the source or senior part in a relationship; in 3ds max, the object that is made the higher ranking object when objects are linked together. This is often done when the user wants to be able to change only the higher-ranking object (the parent) and know that the lower-ranking object or objects (the child or children) will also be changed as the changes flow down through the links.

particle—*noun:* an incredibly small speck of matter; in computer animation, particles can be organized to look like dust, water, smoke, explosions, etc.

particle system—*noun:* in computer animation, a group of parts in the computer program that work together so that a person can make many small specks look and move like they do in the real world, such as flowing water, rain, smoke and explosions.

Pbomb—*noun:* in 3ds max, "Pbomb" is short for "particle bomb" or "a bomb that creates particles." It is a part of a particle system used to make real-looking explosions.

perpendicular—*adjective:* when lines or surfaces meet at right angles, which is exactly 90 degrees apart. For example, a flagpole pointing straight up is perpendicular to the ground.

perspective—*noun:* how things look when they are compared to each other based on their distance from the viewer; a realistic way of viewing a scene by changing the size and shape of objects depending on their distance from the viewpoint.

3ds max Glossary

pflow—*noun:* in 3ds max, short for "Particle Flow", a powerful particle system that has many uses. Pflow also refers to the particles that act together from one event and their actions created by the system.

pflow—*adjective:* in 3ds max, having to do with a particle flow.

phase—*noun:* one action or set of actions that are a part of a larger system or cycle; in television, the exact timing of a TV signal. The exact timing is needed to insure all the parts in the system work together. The people making the content for a TV show, the people sending it out over the air, and the televisions receiving it, all need to know that the expecting signal will appear at the expected time. The expectations shared with and agreed to by the people creating the television systems for an area are called standards. In the US, the standard is called NTSC. In many European countries, the standard agreed upon is called PALv

ping-pong—*noun:* the game of table tennis

ping-pong—*verb:* in computer animation, creating motions or actions which go back-and-forth (backwards and forwards), side-to-side or in-and-out.

pixel—*noun:* the smallest part of a computer picture, usually a small, colored dot or block. Pixel is a short version of 'picture element'. The short version of pictures is "pics" but it is sometimes written "pix" because of the way that it sounds.

planar—*adjective:* having to do with a flat plane; in 3ds max, having to do with a type of UVW mapping that helps position a flat texture onto a 3D object

plane—*noun:* in geometry, a flat object that has length and width, but no height

pole—*noun:* either of two points on a sphere such as the Earth, one on the top and one on the bottom of the sphere. These points are at the ends of an imaginary center line around which the sphere spins.

poly—*noun:* short for polygon. "Poly" is a prefix meaning "multiple."

polygon—*noun:* a flat closed shape with a minimum of three sides; in computer animation, this usually refers to the smallest triangular element in a model.

3ds max Glossary

procedural—*adjective:* created or described by an organized method of rules which details in steps, each part or characteristic of an object and the relationships between the parts until the whole of the object is complete.

procedure—*noun:* an organized series of steps used to make something or do something.

proportion—*noun:* the size, shape or amount of something, usually when one thing is being compared to something else;

proportion—*verb:* to adjust something's size as compared to something else.

quad menu—*noun:* in 3ds max, a list of commands or choices that is shown in one to four boxes that look a little like the four panes of glass in a window frame. The names of each list are shown in dark gray boxes in the center area where all of the boxes are joined together. Commands or choices in a list that are like each other are placed together and separated from other commands or choices using a line. "Quad" is a slightly shorter version of the word "quadrant" which means it has four distinct areas.

radial—*adjective:* arranged in a circular or spherical pattern coming from a common center point; related to the fan-like spread of light from its source point.

radii—*noun:* plural of radius

radius—*noun:* half the diameter of a circle; the length of a line from the center to the outside of a sphere, circle or curved line.

random—*adjective:* when something shows no plan or pattern

ratio—*noun:* the relationship between the amount or size of one thing (or group) and another thing (or group). Example: there are 5 pieces of fruit – 1 banana and 4 oranges. The relationship of one thing (the banana) to another (the oranges), having to do with amount, is one to four (which is written either 1:4 or 1/4, but always spoken, "one to four"). If the 5 pieces of fruit were mentioned in a different order (4 oranges and 1 banana), then the way that the relationship numbers are written or spoken would change to: 4:1 or 4/1 and "four to one". The idea is that for every four oranges there is one banana.

3ds max Glossary

raytracing—*noun:* in computer animation, a method for creating images from the animators work by following the light bouncing through the scene from the source, to objects in the scene and finally to the view point.

reference—*noun:* in 3ds max, a copy of an object made from an original (source) object. A reference has a "one-way" link between the original object and the copy: changes made to the original are sent to the copies, but changes to the copies are not sent back to the original source object. In 3ds max, compare it to an *instance* which is a copy that has a "two-way" link between the original and the copy so changes to a copy are sent back to the original object.

relative—*adjective:* having to do with comparing things instead of describing how they are alone; having to do with a relationship

relax—*verb:* to loosen; to make less severe or less firm; in 3ds max, an option that makes an model appear smoother without adding more geometry.

render—*verb:* in computer animation, to create images; what the computer and software does with your all your input to calculate, create and output images and animations.

replica—*noun:* a very close model or copy of an original object or piece of art

re-scale time—*noun:* in 3ds max, an option in the time configuration dialog. Allows changes in the total number of frames it takes to perform the animation while keeping all the keyframes set for all the objects in the scene. With it, the artist can lengthen or shorten an animation.

resolution—*noun:* in computer animation, the amount of detail in an image on a computer screen, TV, etc based on the size of the small or very small parts in the image and how many parts are used to make up the image. If the amount of detail is high, then it is called "high resolution". When referring to computer animation models, resolution is also called "level-of-detail (or LOD for short)."

3ds max Glossary

rollout—*noun:* in 3ds max, part of a dialog box that can be hidden or expanded to present additional options in an outline style. Selecting an item with a plus sign expands the dialog to show more in-depth choices on a topic. Selecting an item with a minus sign hides the in-depth choices and makes room to see more of the main topics.

safe frame—*noun:* in computer animation, markings in the shape of one or more boxes which show the area on the borders of a computer image that can be seen on the computer, but might not display on TV screens. A person that is creating an animation (or image) can be working on it in a way that they can see everything easily on the computer, but the borders of the picture might not display on a television because of the way televisions are made. Using a safe frame makes sure the person creating the images knows that the important parts of the pictures are inside the safe frame boxes so those viewing them on TV will see them.

sample—*noun:* a small selection from a larger population with the idea that looking at that sample will show what the whole population is like.

scale—*noun:* the relationship between the size of a model compared to the size of the original object, usually as a percentage or ratio.

scale—*verb:* to make or size a model using a fixed size relationship or percentage of the original. For example, a scale of 50% (or 1:2) would make a model half the original size.

scene—*noun:* a series of actions that make up one small part of a play, video, film or animation; a situation treated as one observable event or one small part in a larger visual experience.

scrubbing—*verb:* in computer animation, the side-to-side action of scanning through a time line to preview motions or find a particular point in the motion

segment—*noun:* in 3ds max, one of the several parts or pieces that together make up a whole 2D object such as a line or circle; the line or edge between any two vertices.

segs—*noun:* short for segments.

3ds max Glossary

self-illumination—*noun:* in 3ds max, it is one of the map channels of a material that can be used with certain material types. When used, the object appears brighter, as though it is lit from the inside, but this option does not give off light, the object just appears brighter

shade—*noun:* a color made slightly darker by mixing it with black or a dark color.

Shade—*verb:* to block the light from reaching something; to cast a shadow on.

shape facing operator — *noun:* in 3ds max Particle Flow system, a choice that a person can make about all the particles so their broad (widest) side always faces the camera or view point. In computer animation, this way of lining up is sometimes called "bill-boarding."

shellac—*noun:* a liquid finish usually applied to wood that makes its surface shiny when it hardens; in 3ds max materials, a way of showing that kind of shiny finish

shutter—*noun:* the part of a camera which opens and closes with accurate timing to control the time that light is let into a camera to reach the film or sensor.

slider—*noun:* in computer science, a control in a graphical user interface that consists of a line and a marker that can be moved back-and-forth along that line. The line stands for values such as time, amount, etc. The marker can be moved or "slid" from side-to-side to quickly move through the range of values. For example, in 3ds max, the time slider can be moved to quickly scan over time in the animation to see a quick preview of the motion or to find a particular point in the motion.

slot—*noun:* in 3ds max, a viewport that displays the characteristics of a material in the material editor.

SMPTE—*noun:* abbreviation for Society of Motion Picture and Television Engineers. This organization created a method of numbering each small part (frame) of a movie, film, etc. so that an exact frame can be found quickly and easily. This makes it easy and accurate to add sound (mostly, music) to film or video pictures and make sure that it is heard at exactly the right time.

soft selection—*noun:* in 3ds max, a feature which allows the user to select part of an object with a gradual falloff between the selection and the parts immediately surrounding that selection.

3ds max Glossary

space warps—*noun:* in 3ds max, a type of object which doesn't show up in the final image or animation but are used to apply a variety of different effects to other objects in the scene. For example, the gravity space warp makes objects connected to it appear to be pulled down by gravity.

specular—*adjective:* refers to light that is reflected off an object. The light reflected off surfaces is called a highlight. For example, specular color is the color of the highlight on a shiny surface.

specular level—*noun:* in 3ds max materials, the option for specular level is used to control how strong the highlight on a surface will be

spinner—*noun:* in the 3ds max, a pair of small up-and-down arrows next to a type-in box used to enter numbers. They let a person enter the number by clicking the arrows using a mouse until the number they want to use shows in the type-in box.

spline—*noun:* in 3ds max, a spline is any 2D object such as a line, text, circle, ellipse etc. You can edit these objects by using the edit spline modifier. This modifier allows you to access the sub-object parts of a 2D object. These parts include vertices, segments and splines. A vertex is a point where linesmeet or where three or more edges meet. A segment is the line or edge between two vertices. The spline is one continuous open or closed line. For example if you had the letter V, this text object has vertices, segments, and one closed spline that make the V shape.

spotlight—*noun:* a light with a strong, focused beam; in 3ds max, an object that illuminates (puts light on or into) a scene in a particular way that is brighter at the center of the target and less and less bright as the beam falls away from its target.

stack—*noun:* in 3ds max, short for "modifier stack" or "modify stack display." It is an outline showing the objects created in 3ds max and any changes that have been made to those objects. It is used to quickly and easily see everything that has been made or done, to undo changes made earlier, or to correct them. Because objects and changes in the stack are handled in order from bottom to top, moving items in the stack can also cause changes to the scene. The modifier stack is very handy because changes can be made to earlier work at anytime without having to start over.

3ds max Glossary

standard primitives— *noun:*	in 3ds max, simple, pre-made objects included with the computer program, such as spheres, boxes, etc.
still—*noun:*	a single picture; one frame of animation.
sub-map—*noun:*	in 3ds max materials, one map type nested inside another.
subtle—*adjective:*	a difference that is not easy to see because the difference is very small or the change is very smooth.
subtraction—*noun:*	in math, this is the action of taking away an amount; it is also a Boolean action that removes the area where one object is covering another object or removes the area that is being shared with another object. Example: to create a hole using a Boolean action, a box would be created, and then a cylinder is created and placed inside the box. Finally, the cylinder is subtracted (removed) from the box, which creates a hole.
tangent—*noun:*	a line which touches but does not cross (go through) a curve; in 3ds max, an animation controller that lets a person speed up or slow down how fast changes are made moving into or away from a keyframe. It is a tiny box with a thin bar going through it that is placed on a curve, which shows the rates of change that will be used.
taper—*verb:*	a gradual decrease in thickness, diameter or width along the length of an object.
target camera—*noun:*	in 3ds max, a type of camera that has both a head object (a marker showing where the camera is) and a target. The camera stays pointed at the center of its target.
target direct light—*noun:*	in 3ds max, a type of standard light with a light source and a target whose beam is a cylinder because its light rays are parallel. The light stays pointed at the center of its target.
technical drawing— *noun:*	the act of drawing something, using special techniques (usually a scaled drawing), so that very accurate measurements or amounts are shown. It is also called drafting. Much of the technical drawing today is done on Computer Aided Design (or CAD) systems like AutoCAD®. AutoCAD is another industry-leading computer program produced by Autodesk.
technique—*noun:*	an artistic or effective way of doing something, including how the tools and materials are used; a skill which comes from practice or familiarity.

3ds max Glossary

template—*noun:* an example or standard; used for allowing comparisons or as a starting point for making something more specialized.

texture—*noun:* in computer animation, a material placed on a geometric object which can be as simple as a *bitmap* picture or one created by more complex procedures. It is also called a texture map.

TIFF—*noun:* a type of computer picture file that is often used in the printing business. The name of the file usually ends in .TIF. "T.I.F.F." stands for Tagged Image File Format. In this case, "tagged" means that the parts of the image are labeled with a word or a group of words in order to tell what the part are. "Format" refers to the way that data is organized so that a program or person can easily view, print or save the data

tile—*verb:* in computer animation, to place many copies of a small piece of texture next to each other on a surface or background until it is completely covered.

time configuration—*noun:* in 3ds max, a dialog box that allows you to change the total time and number of frames in your animation.

time slider—*noun:* in 3ds max, a marker on the time line that can be moved or slid from side-to-side using a mouse or computer pen, running back and forth through the animation in time. This action is called "scrubbing".

tint—*verb:* o make a color more pale by mixing it with white or another lighter hue; to change a color by mixing it with another color

tint—*noun:* a pale color

torus—*noun:* a 3D object that is shaped like a plain, round ring, like the doughnuts that have the hole in the center

track bar—*noun:* in 3ds max, a dialog box which displays a list of all objects and shows all their keys and keyframes in an outline.

trajectory—*noun:* the curved path of an object that is moving through space.

transform—*verb:* to change the location, direction or scale (size) of an object.

transform—*noun:* in 3ds max, an operation that changes the location, direction or scale (size) of objects.

transparency—*noun:* a property of an object which describes how much light passes through it. 100% transparency means all light passes through the object

3ds max Glossary

truck—*verb:* to move a camera from side to side

type-in—*noun:* in computer science, a box displayed by a program where the user can enter information with the keyboard

uniform—*adjective:* being the same throughout; being the same in all cases

unit—*noun:* the smallest, whole amount for a measurement or a quantity

unzip—*verb:* in computer science, to cause a compressed file whose name ends in .ZIP to be returned to normal so that it can be used, viewed, or printed in the way that it was originally created.

utility—*noun:* in computer science, a part of a computer program that provides some additional service. In 3ds max, they are shown in a list when "Utilities" is selected on the Command Panel.

UVW map—*noun:* in 3ds max, a local coordinate system used to place a 2D map on a 3D object.

veining—*noun:* the random thin lines and feathering like those found in marble

velocity—*noun:* speed; distance traveled per unit of time.

vertex—*noun:* the point where lines or edges intersect. The plural for vertex is *vertices*.

viewport—*noun:* in 3ds max, one or one of several main display windows which show the artist's work-in-progress.

weld core—*noun:* in 3ds max, an option in the lathe modifier which is selected when the user wants to connect overlapping points in the resulting object to avoid creating a seam.

wireframe—*noun:* a simple, skeleton-like way of showing objects in a computer graphics or computer-aided design program. Only lines and curves at the edges of things and where things meet or join are shown. A wireframe view appears on the screen very quickly so it is used when a person wants to move around a scene quickly or move it often.

World Coordinate System (WCS)—*noun:* in 3ds max, the coordinate system for the modeling space as a whole. It is not based on any local object or point of view. This default coordinate system is visible when 3ds max is first started.

3ds max Glossary

zip—*verb:* in computer science, to cause a copy of a file or files to be compressed or squeezed smaller in a particular way that doesn't lose any information into a file with a name usually ending in .ZIP. Smaller files use less room on a disk and can be shared faster (such as when it is being sent to someone in a message.) Zipped files can be restored to their original form and size.

zip—*noun:* in computer science, compressed files that hold information in this way and have a name that ends in ".ZIP;"

zip—*adjective:* in computer science, having to do with .ZIP files

LIMITED WARRANTY AND DISCLAIMER OF LIABILITY